No Brief:
Graphic Designers' Personal Projects

R
Sa
Sh
112
Ho
Tel
Fac
e-r
wet

ISBN 2-

Book d
Photog

Origina
Printed

00
the introduction

No Brief is a book about the work that designers do 'off-the-clock'. It's about work they do in their own time, for themselves. It's about the promotional material they make to promote themselves rather than a client, and the work they do that's completely unrelated to any professional, or careerist purpose. In brief, that's the brief of *No Brief*. →

→ But like any commercial brief that aims to simplify, to reduce a whole variety of purposes and motives and aims to one basic concept, it hides something more complex.

As we enter the 21st century it has never been more clear that the definition of what designers do and who they are has never been more ambiguous. Mieke Gerritzen's manifesto is called *Everyone is a designer*, which at the very least nods to the idea that in the age of the internet, of web pages and cheap design technology, anyone can at least play at being a designer. If everyone's a designer the status of the designer is obviously diminished.

On the other hand, the designer has never been so crucial to commerce and business. In the last 20 years the designer has been promoted up the order from being the tea-boy of business, fetching a brief and running with it, to being on the front line. In the information age – the attention economy, the brand economy – however you designate it, design can make the difference between commercial success and failure. In a fiercely commercial global economy, logos, packaging and image are often the only difference between generic products.

And then of course there's the training and educational background of designers which sees them entering schools of 'art and design'. This relationship with art is something that simmers away at the back of the minds of most designers. Their sense of themselves is bound up with the idea of being 'creative', yet this existential imperative comes face to face, on a daily basis, with the demands of a client. Addressing, feeding this sense of self, is at the heart of much of the work in this book. But this dilemma is what makes graphic design the most exciting art form of our times. It is precisely because it is a discipline where art and commerce face-off against each other that it becomes a graphic benchmark of where society is.

A shaggy hair story
In an appendix to his diary *A Year With Swollen Appendices* Brian Eno puts forward the suggestion that most of us have been brought up to think in terms of polarities, something is either 'this' or 'that'. But in fact there is another type of thinking that actually corresponds to the way we actually live our lives. He calls this 'Axis thinking'. He defines an axis as 'a name for a continuum of possibilities between two extreme positions: so the axis between black and white is a scale of greys'. It's more sophisticated than it sounds and is actually a model for creative thinking. Say you wanted to explore the possibilities of a haircut. You could create a two-dimensional graph with one axis going from masculine to feminine and another from neat to shaggy. More possibilities such as natural-contrived add more axes and dimensions and more possibilities to generate something new.

Most designers have some private negotiation with themselves about the contract they make between art and money. On the surface, they simply find a spot nearer one end or another on the 'Job axis' between cash and culture. Some take dull big-paying jobs to fund the hours on more rewarding cash-poor jobs, or take the money to spend on their own work. The latter, design writer Rick Poyner calls a 'Robin Hood' tactic.

Other designers like Jonathan Barnbrook pitch camp firmly at the culture end. Responding to a question about his controversially named typeface Manson he replied, 'The motivation was to add something to culture; this is always the motivation – culture first, money last...The plan was not to shock, it was to give it a contemporary reference, as it is taken from sketches of lettering from churches and other monumental buildings...it was meant to create a double-take. You thought, hmm...Manson, it sounds sort of elegant, and then maybe you realised where the name actually came from...and it would change your whole attitude towards using it.'

But if we use Eno's model we can see that the simple opposition between cash and culture is more complex. You might think that the work in the art section is purely cultural in intent. But Tony Linkson's artwork, for example, feeds off his commercial work, and is itself a working through of the idea of creative freedom versus commercial restraint. So you could, in Eno's terms, plot another axis alongside 'cash-culture' of 'rules-freedom'. But as every designer who is interested in process knows, 'rules' become an aesthetic instrument.

Then there's Ian Holcroft, currently 'a stay-at-home-dad' who produces remarkably conceptual work. This would appear to be a straightforwardly cultural activity. But he is using his work as a means of thinking through exactly where he wants to be in graphic design.

Or take, for example, design company Pentagram and their Pentagram Papers. What on the surface is simply a sophisticated treat for their wealthy clients is in fact a complex exploration of the nature of graphic design itself. Most of the examples of work in this book are implicitly, instinctively, sometimes unconsciously addressing fundamental questions about what it means to do graphic design. And, if you've got this far, you might think this is interesting, fascinating or stupidly obvious. But you would hardly think it's controversial. Yet the most well known recent attempt to question the role and function of the graphic designer caused such a stir, that you would be led to believe that asking questions about graphic design is tantamount to denying the existence of Santa Claus.

First things first

There has perhaps been no more controversial piece of work in the world of graphic design than *The First Things First 2000* manifesto, a work that seemed to challenge the very assumptions of graphic design itself.

The manifesto was an update of Ken Garland's original manifesto delivered at London's Institute of Contemporary Arts in 1964. Written on the spur of the moment at a meeting of the Society of Industrial Artists in London and delivered by Garland, *First Things First* was not so much a call-to-arms as a call-to-question the role of the graphic designer in '60s Britain.

Britain was in the midst of an economic boom. But the fact that this manifesto emerged from British designers rather than, say, the US where there was a long established and uninterrupted consumer culture, may have partly been down to the fact that the experience of post-war rationing in the UK hadn't yet become a distant memory. The manifesto also gives the impression that the purpose and meaning of 'graphic designer' was still up for grabs. As Garland declares, 'We the undersigned, are graphic designers, photographers and students who have been brought up in a world in which the techniques and apparatus of advertising have persistently been presented to us as the most lucrative and desirable means of using our talents. We have been bombarded with publications devoted to this belief, applauding the work of those who have flogged their skill and imagination to sell such things as...' Garland then goes on to provide what is intended as a list of the mundane and the useless such as toothpaste, aftershave, fattening diets, slimming diets and so on.

He argues that these things contribute little to the 'national prosperity' and that there are other activities more deserving of designers' skills and imagination in the social realm. These would include public information systems, educational aids and generally 'media through which we promote our trade, our culture, and our greater awareness of the world.' The manifesto declares it is not against consumer advertising as such but merely wants to redress the balance of the kinds of work designers do in favour of more socially purposeful projects.

Labour politician Tony Benn reprinted the manifesto in his weekly *Guardian* newspaper column. No-one but the most ardent free-marketeer or libertarian would argue that market-based activities can provide everything a society needs. And that graphic designers have a contribution to make.

The reason the manifesto is interesting and important is not because of the social aspiration but because it puts the role, purpose and meaning of the graphic designer into question. As Herbert Spencer pointed out in an essay in the same year for the *Penrose Annual*, by the 1960s, graphic design was only 30 years old as a profession, having escaped from other longstanding disciplines like architecture and painting. And despite all the magazines, books and professional institutes which have grown up around graphic design in the 40 years since *First Things First*, this question surrounding the place of the graphic designer in society still remains.

Given that Garland's manifesto was written on the spur of the moment one can't expect the kind of philosophical rigour illustrated in Jan Tschichold's *New Typography*. As we will see, Tschichold's views on typography and layout are actually political; they are inseparable from a particular view of the world. In any case the lack of systemic content in Garland's manifesto is a characteristic of English engagements in politics since Thomas Hobbes and John Locke. Whereas European philosophers such as Marx and Hegel put forward integrated systems, English political philosophies have always put forward ad hoc political and social arrangements.

Garland's manifesto was largely forgotten. Returning to the manifesto in 1994, on the 21st anniversary of its reading, both the *Typographica Review* and *Eye* magazine tried to assess its impact. *Typographica Review* elicited fax responses from designers. Maggie Lewis, a typographer in London wrote back, 'I do not agree with the manifesto. What pious, pompous piffle!' Malcolm Garrett was typically flamboyant, replying with his own designery mini-manifesto. He wrote in caps: 'SOCIETY THRIVES ON A DIET OF STATUS MASSAGE! GIMMICKRY! & MINDFUL VIOLENCE! ANYTHING ELSE IS MERE EXISTENCE.' As to whether it has any relevance to his own work Garrett suggests self-mockingly, 'Not really, because we are all in the waste paper business.' There were also positive responses, but perhaps the most interesting reply in the light of the follow-up manifesto was from Tibor Kalman.

In the 1980s and 1990s the spiky figure of Tibor Kalman yolked together politics and graphic design in a way not seen since the 1960s. As a student at NYU in the late 1960s and early '70s Kalman was a member of the radical SDS (Students for a Democratic Society) and he carried this political baggage with him into his work. Famously, one Christmas his company M&CO sent out as their Christmas greeting to clients a box called Bon Appetit, 1990. The white paper covering the contents inside carried the message, 'Pretend for a minute that you just stood in line for two hours in the freezing cold, and at the head of the line they gave you this. Bon appetit. Happy holidays from M&CO.'

The box contained the same meal given to the homeless in New York City on Christmas Day by the Coalition for the Homeless and was padded with paper from the *New York Times* real-estate section. Kalman, of course, hitched a ride with Benetton, and with Oliviero Toscani created *Colors* magazine, one of the most important magazines of the '90s both in terms of its issue-led content and because it was a magazine whose narrative was entirely carried by images. The criticism that the magazine →

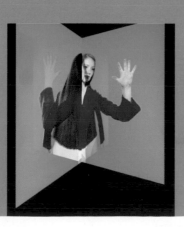

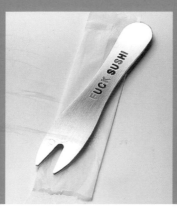

Tony Linkson
UK, 2001
Figurine

Roast
Norway, 2001
Chip fork 'campaign edition'

→ was there to sell sweaters was kindergarten thinking. Like all design, *Colors* sold ideas. What is important about Kalman's work at *Colors* was that the magazine (and Toscani's advertising) made ambiguity, uncertainty and doubt a central feature of a media world saturated with one-dimensional advertising and design – of media speaking to itself. Here was a designer using his discipline to make people think in images, and think about images.

In 1994, Kalman's response to Garland's original manifesto was cool. He didn't agree with it but was sure 'any self-respecting cat-food advertising designer and even Margaret Thatcher would.' Perhaps you could find some irony in his replies but his final response suggests he is being entirely serious: 'PS I [sic] love that reverse alphabetical order idea for the list of names. It's so cute. Maybe [sic] the energy used to come up with it could have gone towards thinking about a realistic achievable solution to this problem.' Kalman's comments suggest that the moral plea at the heart of Garland's manifesto was something that anyone could agree on and that perhaps the issue was as much a political issue rather than simply a matter of designers re-organising their timesheets to do charity or pro-bono work.

But by the late 1990s he had a change of heart because Kalman was one of the movers and signatories of the updated manifesto. *First Things First 2000* is as freeform as the original in its observations and suggestions. This is partly because it consciously shadows Garland's original text listing the inessential products graphic designers employ their skills for, and setting out more socially useful areas which could benefit from the imagination of designers. It had 33 signatories and was published in *Adbusters*, *Émigré* and the AIGA Journal in North America, *Eye* and *Blueprint* magazines in the UK and *Items* in the Netherlands.

Unlike the original manifesto which was launched into a comparative media desert, the second version spread like a media virus into design publications such as *I.D.* and *Communication Arts* in the US, *Form* in Germany and Japan's *Idea* among many others. And unlike the original, the Y2k manifesto didn't have a hotline to the corridors of power in the UK, which is historically instructive. The nature of the work that graphic designers do has changed during the quarter century since the original publication. Like the businesses it serves, it is internationalised and though the Y2K debate mightn't have had a forum in a national newspaper it took place over the internet and in the multitude of new design magazines that have also appeared since the original.

The response was equally divided. Some believed the signatories were a collection of the 'great and good', preaching from the mount, removed from the day-to-day realities of designers having to make a living. Others argued that designers could make a meaningful social contribution by getting involved in organisations such as Greenpeace and that the manifesto was irrelevant because graphic design itself was of little importance compared to the range of social and political problems we face. The assumption was that the manifesto writers had overplayed the significance of graphic design.

One signatory who changed his mind was Jeffery Keedy. In an article in *Eye* magazine (Vol 4 no.13) entitled 'There Is Such A Thing As Society' Andrew Howard (another signatory of the second manifesto) quotes Keedy from a previous issue of *Eye* saying, ' It was the poetic aspect of Roland Barthes which attracted me, not the Marxist analysis. After all, we're designers working in a consumer society, and while social criticism is an interesting idea, I wouldn't want to put it into practice.'

Keedy is a former student of Cranbrook Academy of Art, and Howard's article implies that his disinterest stems from a formalist approach to design that critics of the school associated it with. What's interesting about Keedy's signature is that the *First Things First Manifesto 2000* that he signed up to as an idea of getting 33 designers and critics with strong views and opinions to agree on a more adventurous format was too remote to contemplate. Perhaps a more visually-led design would have distracted from the message. Even the original manifesto had a performance element with Garland getting up on a stage to proclaim it.

The Y2K manifesto was more like a constitution than a manifesto. Certainly it was completely unlike any other art or design manifesto both in its form and in the fact that it didn't champion any particular style of design. Take, for example, Futurist artist FT Marinetti's 1913 declaration of war on traditional typography: 'My revolution is aimed at the so-called typographical harmony of the page, which is contrary to flux and reflux, the leaps and bursts of style that run through the page. On the same page, therefore, we will use three or four colours of ink, or even twenty different typefaces if necessary. For example, italics for a series of similar or swift sensations, boldface for the violent onomatopoeias, and so on. With this typographical revolution and this multi-coloured variety in the letters I mean to redouble the expressive power of words.' (Destruction of Syntax – Imagination Without Strings – Words – In – Freedom, FT Marinetti). For Marinetti design was politics. Each element of design, type, colour and layout spoke a politics of the dynamic versus the static, change versus the stolid, and speed versus the slow.

Marinetti did admit that he didn't care about 'the comprehension of the multitude', which was a factor in *First Things First*. Both *First Things First* manifestos backed off addressing issues of representation, of the politics of design communication, of layout, of typography. Both manifestos stepped outside of design to ask questions about design. The most interesting response to the Y2K manifesto in a letter to

010.011

Pentagram
UK, 1975–2001
A selection of *Pentagram Papers*.

graphic design that provides the images, logos and styling of a design-hungry consumer culture. In cinematic terms, 'advertising' merely provides the backstory, sells a pitch to a client, suggests an idea of what a product is saying. The designer tells the story. In sporting terms it's the designer who executes the play. Over the last 20 years the real exercise of power has shifted ever more clearly from the large scale, macro-level, from exercising the State's instruments and levers of power, to the micro-level, to the logo, to signage.

Design is everywhere. And it is this simple fact, the sheer ubiquity of design that propels designers, whether they like it or not, to recognise that their work carries a huge political and social impact. In the quarter century since the original manifesto, designers have become in effect social engineers, defining and shaping space, whether that is public space, consumer space, corporate space or media space.

No brief

Some argue that *First Things First* worked because it got people talking. Fair enough. But more importantly it got designers thinking about what they do. And this is the intention of *No Brief*. Design is still a relatively young profession. Graphic design hasn't the mechanisms of legitimation and evaluation of art, which has its historical infrastructure of museums, its famous public galleries, curators, academics, journals, magazines, newspaper columns, which all help to create a critically informed culture around art. Even when art has its controversies of the 'my-five-year-old-can-do-better-than-that' kind, people don't see it as an excuse to deny the value of all art. They still have a belief that art is somehow valuable, important.

If designers reacted against *First Things First 2000* it was perhaps because for designers the comforting sources and institutions with which they can measure themselves have yet to acquire the authority that comes with age. And design criticism has only grown up really in the last decade, and begun to distinguish itself from trade journalism and establish a voice that isn't simply publicising the work.

The work shown in *No Brief* is about designers reflecting on what they do and on how they imagine themselves. It's about how the conflict of commerce and creativity is played out. And ultimately it's about the existential brief they set themselves.

Adbusters argued that 'design may be very important and will surely grow in its importance, but it is not of any greater significance than any other activity that produces positive social results.'

Inadvertently, the writer nails the key reason why the *First Things First* manifesto was one of most important political documents of the late 20th century. The fact is, when it comes to addressing social and political issues, there is perhaps nothing more important than design. Ken Garland in the early '60s could not have imagined the extent to which design would completely colonise the world by the beginning of the 21st century.

Graphic design has taken over every space, from the virtual world to material world and everything in between. In a footnote to his essay *Myth Today in Mythologies*, French writer Roland Barthes pointed out the extent to which it was practically impossible to have an experience of the world that is free from design, from its imagination and signs: 'The development of publicity, of a national press, of radio, of illustrated news, not to speak of the survival of a myriad rites of communication which rule social appearances makes the development of a semiological science more urgent than ever. In a single day, how many really non-signifying fields do we really cross? Very few, sometimes none. Here I am, before the sea; it is true that it bares no message. But on the beach, what material for semiology! Flags, slogans, signals, sign-boards, clothes, suntan even, which are so many messages for me.' (*Mythologies*, p.112, note 2). Barthes wrote this in 1957. The signs of graphic design are now even more ubiquitous. It is impossible to have an innocent, virgin experience of something as natural as the beach or the seaside. It has already been colonised by design in ads for chewing gum, soft drinks, beer ads and tampons.

If the writers of the second manifesto missed a beat it was in the list of products. The political issue isn't designers producing work for useless products. The politics of graphic design is highlighted in the third part of the manifesto which says that designers are 'implicitly endorsing a mental environment so saturated with commercial messages that it is changing the very way citizen-consumers speak, think, feel, respond and interact.' Whether graphic designers are 'implicitly endorsing' a commercially saturated environment is open to question.

But the fact is, graphic designers are now the rulers of our contemporary empire of signs. This is why the idea that the graphic designer is purely a technician, a neutral craftsman providing a service, displays a kind of naïve thinking you wouldn't expect from designers. Brand packaging and design stoke desire and consumption. Where once graphic design might have seemed tainted by its association with advertising, now it is

01
the politician

The Communist hammer and sickle. The Nazi swastika. The Socialist red rose. The CND sign. Politics has always communicated at its most basic level through graphics. Policies and manifestos may be the bread and butter of politics but it's signs, images and banners that inspire people. Even in our post-political, post-ideological age, anti-globalisation protestors are not roused by economic plans but by the symbols and signs of multinational capitalism, of Nike and McDonald's.

\rightarrow

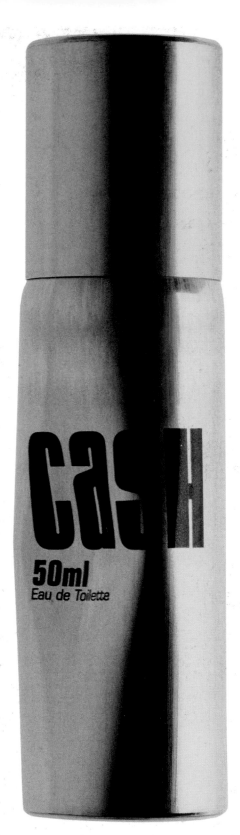

→ But as we saw in the introduction, despite a rich history in which political life and activity have been inseparable from graphic design, contemporary graphic design's relationship to social and political questions is a fraught issue. And this is despite the fact that what politics and commerce have in common is the deep-rooted emotion of belief. Strip away the market research, the strategy meetings, the analysis of competitors, what branding consultancies are essentially about is creating belief. Before they can sell us anything, they sell a story to the client. The designer pitches belief to the client. Then designers focus the product story...run faster, look sexier, smell beautiful. Belief translates into money.

Belief in the power of products to change your life is obviously shallower than belief in the possibility of making a difference. It's not necessarily shallower in a moral sense, just in the psychological sense. Belief that one aftershave can make you a 'winner' is easily replaceable by belief in another. German designer Christoph Steinegger's eau de toilette *Cash* is based on the faux-marketing idea that 'He who smells like money, smells like high reputation, luxury, lust and power...*Cash* provides the means that everybody can smell like money: rich cab drivers and bankrupt consultants, the unemployed and students. The element that unites the world, the reason why people work or not, is also noticeable in future through the sense of smell. What was only visual previously, can be smelt now without using a single instinct.'

Cash is a silver-coloured atomiser with a spray whose scent, according to the text on the accompanying $100 bill, 'was modelled on a fresh-printed $100 bill that had been examined for its essential olfactory components. *Cash* differs greatly from usual perfumes and offers the nose a completely new experience of smell.' The sweet smell of success is actually quite foul. *Cash* is about belief in money. It's the scent that sets in motion a virtuous cycle of belief. Money attracts money; and those who smell like money, attract money.

In different ways, all the designers in this section address the idea of belief. They all address the assumptions of beliefs, whether that's in conventional politics or office politics. Some examine the unquestioned belief in the superiority of commercial versus 'folk design'. But what all the work in this section demonstrates is that graphic designers are capable of providing a sophisticated political critique; political thinking that is at least comparable with commentators in other fields. And its emotional impact is certainly more powerful. →

Christoph Steinegger
Germany, 1998
You too can smell like money. Called *Cash –*
***The Scent of Money*, the perfume in this battered**
atomiser was modelled on the scent from a
freshly printed $100 bill.

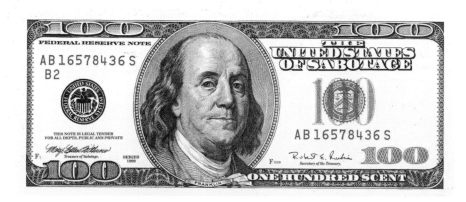

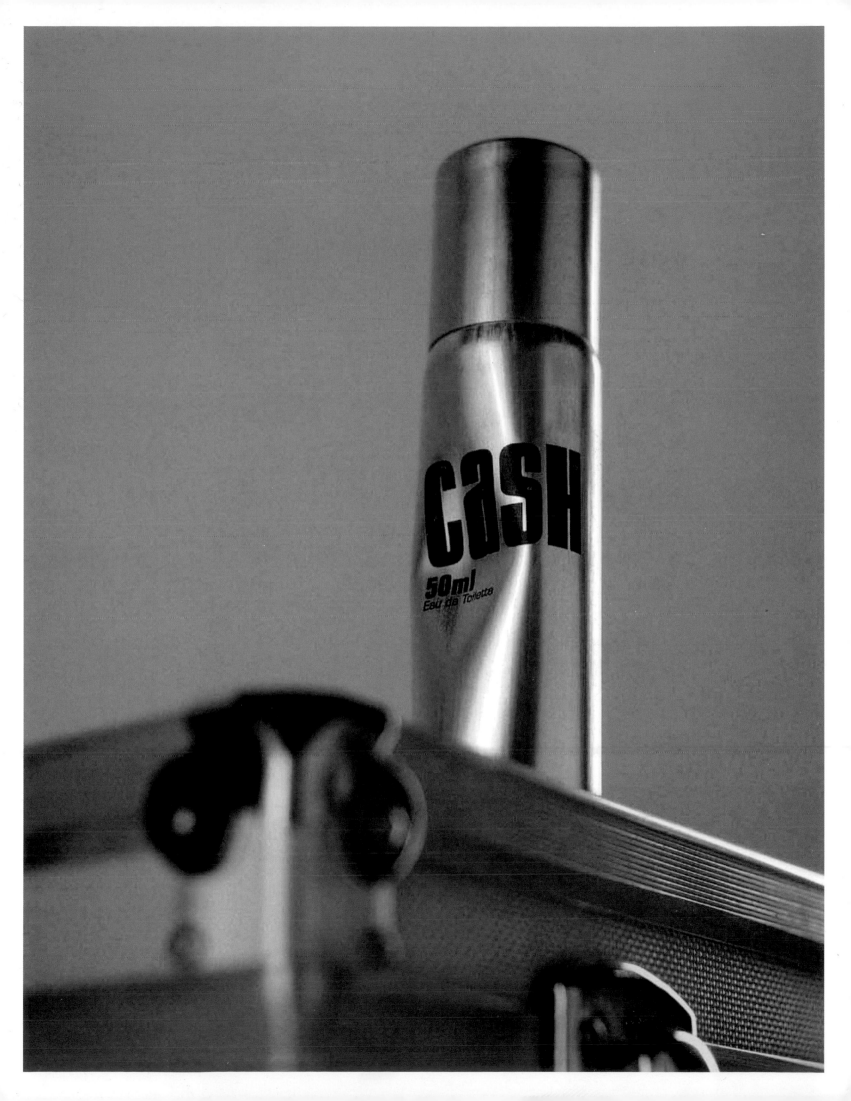

→ Graphic design: child of money and modernism.

Many argue that graphic design is simply a business service, but the fact is that the distinct discipline that was born at the beginning of the 20th century was the child of both commerce and politics. The term 'graphic designer' began to be commonly used in the 1920s. Alongside the emergence of industrial giants and the service industries that supported the new business culture, the citizen of the early 20th century was a political animal created by the new economic, geographical and social circumstances he/she found themselves in. The new design championed by people like El Lissitsky and Jan Tschichold wasn't just an evocation of a particular style, it was a way of graphically picturing a new society, with new ways of thinking. As Jan Tschichold wrote, 'We too must look for a typeface expressive of our own age. Our age is characterised by an all-out search for clarity and truth, for purity of appearance. So the problem of what typeface to use is necessarily different from what it was in previous times. We require from type plainness, clarity, the rejection of everything that is superfluous...A good letter is one that expresses itself, or rather 'speaks' with the utmost distinctiveness and clarity.' (*New Typography*, p. 78)

But if modernism inspired a political vision, it also inspired commerce. Earnest Elmo Calkins, the co-founder of the Calkins & Holden agency, found in modernism the perfect vehicle for communicating new messages about goods. These new commodities such as cars, fashion and toiletries needed more than a utilitarian approach. 'Modernism offered the opportunity of expressing the inexpressible, of suggesting not so much a motor car as speed, not so much a gown as style, not so much a compact as beauty.'

Design became the most powerful and significant instrument of 20th century capitalism, a necessary element in persuading people to choose one →

CHAPTER 4

AN APOLOGY OF MONEY
BY RICHARD BREM AND ANDREAS L. HOFBAUER

POSTER "SABOTAGE CASH TOUR" POSTER, GENÈVA 11/98 © SABOTAGE ARCHIVES / PHOTO © OLIVER OTTENSCHLÄGER

SABOTAGE COMMUNICATIONS

**Christoph Steinegger
Germany, 2000**
Steinegger's Christmas promotion for Büro X is a bag of air attached to a poster. Open up the poster and there is a graphic account of the chemistry involved in producing air from the Brazilian rainforest. The eco-conscious message of good will says, 'Our Christmas tree stands in Brasilia this year.'

016.017

**Sabotage Communications
Germany, 1999**
Subetage is a pocket book of cultural and political essays published by Sabotage Communications. Sabotage is a personal project. As Christoph Steinegger explains, 'I've been working with my partner from Sabotage Communications for ten years working on a variety projects/books/diverse labels. It's not about earning money but a means of checking out different things and then using them in some way. The budget goes to the artists or contributors themselves or is put into production.'

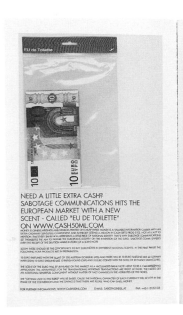

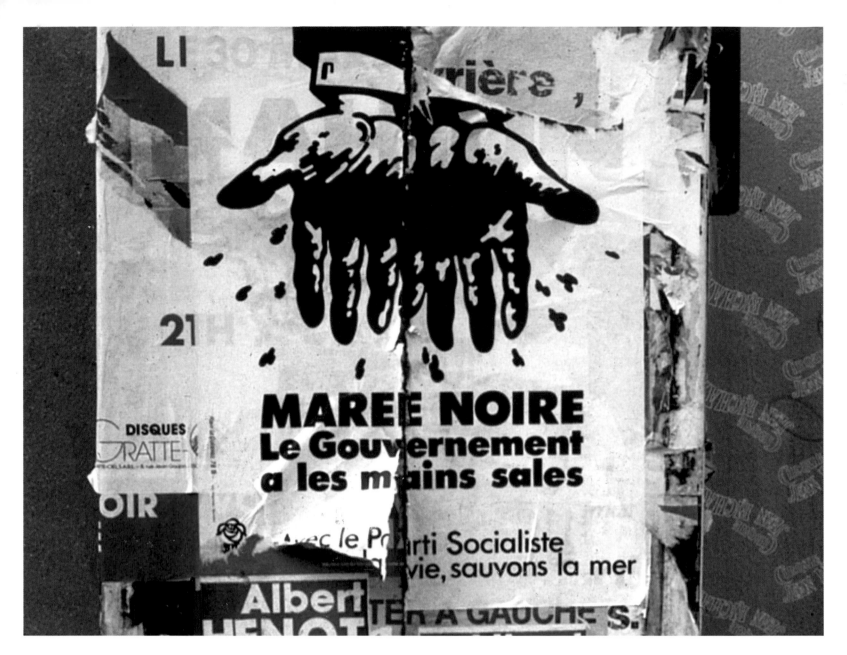

Alain Le Quernec
France, 1978 (above)
*The Government has dirty
hands*, created after the tanker
Amoco Cadiz polluted the north
coast of Brittany. The identifying
feature of a great poster is that
while it just might spark debate,
the image itself is direct, lays
blame and morally indicts the
bad guys.

Alain Le Quernec
France, 2001 (right)
Anti–Capital punishment
postcard, one of six being sent
by a group of Members of the
European Parliament to the
White House.

018.019 Alain Le Quernec
France, 1995 (far right)
Bosnian concert poster.

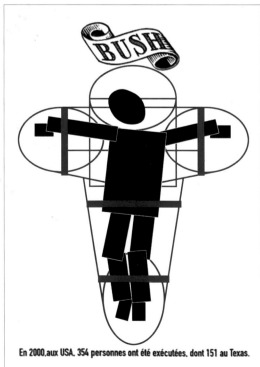

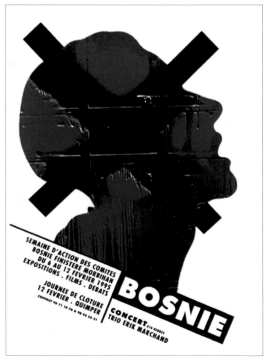

→ similar product over another. In this way, commerce and politics are at the heart of graphic design. As Susan Sontag argues in her essay on Cuban revolutionary posters, 'The advent of political posters may seem like a sharp break with the original function of posters (promoting ownership). But the historical conditions which produced posters first as commercial advertising and later as political propaganda are intertwined. If the commercial poster is an outgrowth of the capitalist economy, with its need to attract people to spend more money on nonessential goods and on spectacles, the political poster reflects another specifically 19th- and 20th-century phenomenon, first articulated in the matrix of capitalism: the modern nation-state, whose claim to ideological monopoly has as its minimal, unquestioned expression the goal of universal education and the power of mass mobilisation for warfare.'

Sontag is referring to posters like Leete's famous Lord Kitchener poster which underlined the power of uppercase lettering in declaring 'Your country needs YOU'. The power of the poster in the hands of the skilled graphic designer sold soap, war, brotherhood and revolution. From John Heartfield and George Grosz to the

ubiquitous face of Che Guevara, graphic designers have used their skills to persuade, exhort and inspire political commitment. These kinds of posters are, by their nature, polemical; aimed at rousing crude emotions though the presentation of a highly prejudiced and exaggerated form of truth. The designer of the political poster is part cartoonist, part provocateur. Alain Le Quernec's anti-death penalty posters are a good example of this. His series of posters on the death penalty puts the finger of the President on the trigger. A series of images on the death penalty are excellent examples of the virtues and limitations of the political poster. Political posters mostly speak to the converted. They're not aimed at persuading an opponent (most US politicians would pay good money to be associated with the death penalty) but at encouraging sympathisers to become active.

But the definition of the political has become clouded, blurred, ill-defined, in a world where the ideological struggle of the 20th century was finally settled. The political dimension of the work by some graphic designers has become ever more intriguing, subtle and in some respects far more encompassing than the single-issue politics that much poster-work has supported. →

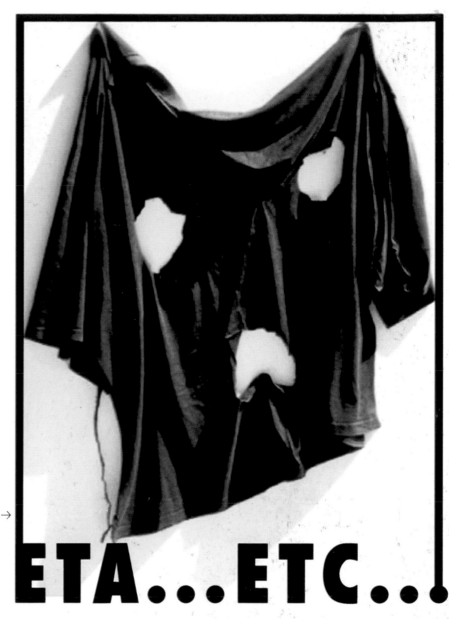

**Alain Le Quernec
France, 2001 (right)
This bullet-riddled sheet is a
protest against ETA terrorism
in Spain.**

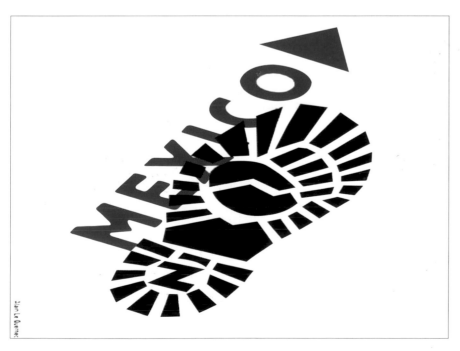

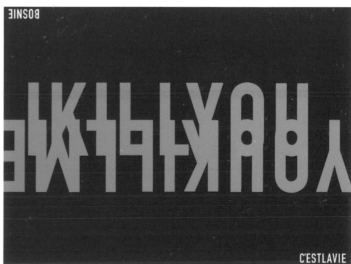

**Alain Le Quernec
France, 2001 (left)
Drawing about the Zapatista
march to Mexico, initially
printed as a stamp in Mexico.**

**Alain Le Quernec
France, 2001 (above)
Le Quernec says 'You Kill Me'.
This existed as a 3x4-metre
painted wall in Bosnia during
the war, and was transformed
into a drawing for *Le Monde*
for an article about violence
in Bosnia.**

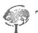

Alain Le Quernec
France
Another postcard to be sent from some members of the European Parliament.

Alain Le Quernec
France, 2001
The smoking fingers polluting the atmosphere are expressing a protest against the cancellation of the Kyoto agreement.

BUSH IT

BUSH

020.021

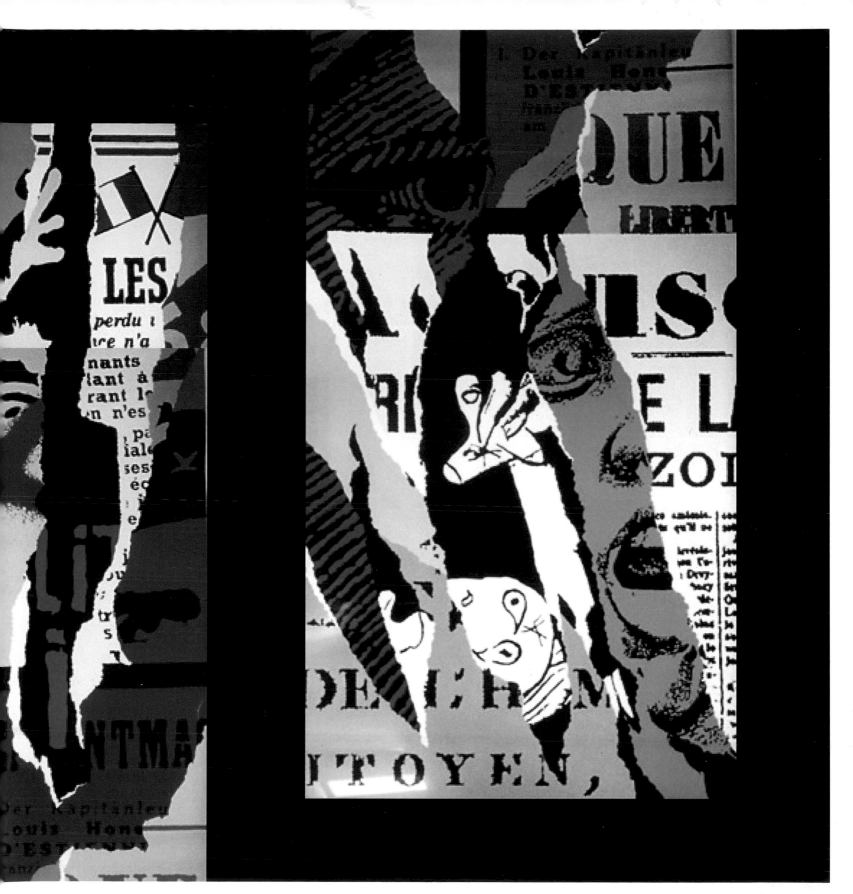

Alain Le Quernec
France
This collage is a painted wall at the University of
Quimper in France. It's the idea of the wall as the
rings in a tree, but in this case each layer tells a
political, human story. According to Le Quernec,
the 10x3 metre wall 'pictures the university as a
place and a time for young people to say "I
Protest! I Resist!". The collage imagines a wall
covered by stickers and posters throughout
history. If you tear one layer off you discover
another revolt, from the declaration of human
rights to the revolution of '68, passing by the
Dreyfus affair or the Resistance in World War 2.'

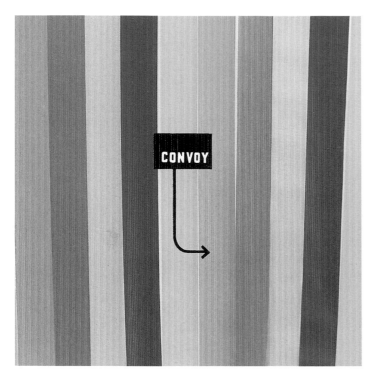

Letterbox
Australia, 1999
Ampersand Three: Convoy

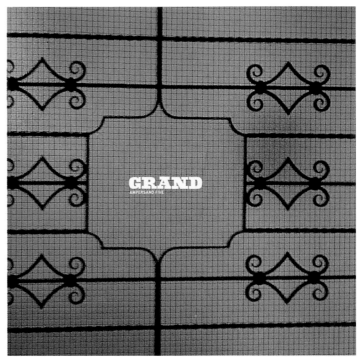

Letterbox
Australia, 2001
Ampersand Five: Grand

→ **'Would you be taking these words seriously if they were set in Hobo?' Letterbox's *Convoy*.**
Letterbox, a design company based in Melbourne, Australia, address the idea of graphic designers as the guardians of our contemporary 'Empire Of Signs' in their *Ampersand* series of booklets. From their attack on the idea of neutral typography and monolothic Helvetica culture in *Grand*, to the aimless drift of the graphic design profession in *Convoy*, Letterbox tease out the unquestioned assumptions behind modern design.

The square-shaped *Ampersand* series began in 1996 with *Ampersand One: Lifecycles of Corporate Identity*. Each booklet offers a graphic politics of design. *Ampersand Two: Rentfont* is a futuristic satire, showing the social and economic distance travelled since the design of Futura in 1928. As Jan Tschichold suggested, Futura was of its time – a

functional, sleek and spartan typeface of the new machine age. What font, in Tschichold's words, is expressive of our age? Letterbox suggest it is not Futura but 'futures', a name appropriate both to the liberal capital flows of our times and the attention given to corporate identities. 'With each part of the letterform available on 99-year leases to corporations, these rentfonts, distributed free to the public, may eventually supersede the expensive proprietary fonts that are struggling for existence against piracy even now.'

Over several pages *Rentfont* gives examples of different lettering, and of course the font even has its own advertising copy (not written in futures): 'futures. The font that makes the business of language the language of business.'

Ampersand One is not just a good, well-executed, graphic joke, it is also an exercise in

demythologising the power of the logo.' Futures invests the alphabet with the emotional inferences of the logotype – trust, reliability, fear, respect and so on. In doing this, the corporate identity's capacity for these emotional triggers is diminished to the point where it is stripped to the bare essence of what a type is – line and form.' The graphic design of the successful corporate logo often turns the literal into the visual. The colour and swirl of the type, for example in the Coca Cola logo, carries the whole impact. The letters and words Coca Cola are meaningless. The word 'cola' on generic bottles of cola is not so much an invitation to buy as a opportunity for reflection (just what does 'cola' mean anyway?) Lettterbox reverse the procedure, returning the logo-image into logotype. The last note on the credits page is a warning: 'never trust fonts named after cities.'

You are here
The themes and ideas of *Rentfont*, surrounding typography, graphic design and logos, are played out in different ways throughout their series of booklets. *Convoy* is a work more explicitly focused on one central question – just what do graphic designers believe that they are doing? They use a visual analogy to explain this lack of direction using white lowercase text on a red arrow that has lost its point: 'not far from my office there is a street sign which features a map intended to show the Melbourne city grid and tourist highlights. Over time, however, the sign has been badly sunbleached so that the surrounding map has totally vanished, leaving only an arrow in a void absurdly declaring a lonely YOU ARE HERE, but where exactly is that?'

The basic idea at the heart of *Convoy* suggests that graphic design culture is impoverished by →

Letterbox
Australia, 1998
Ampersand Two: Rentfont

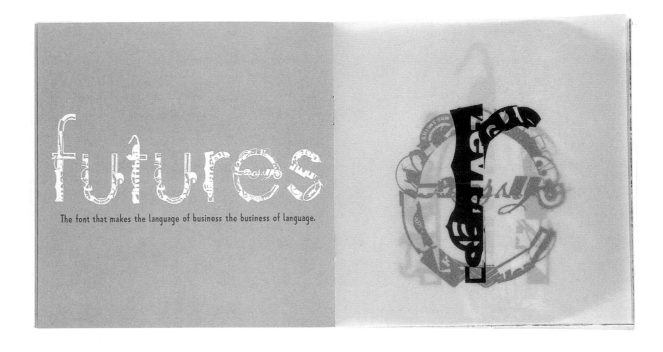

futures

The font that makes the language of business the business of language.

Letterbox
Australia, 1999
Ampersand Three: Convoy

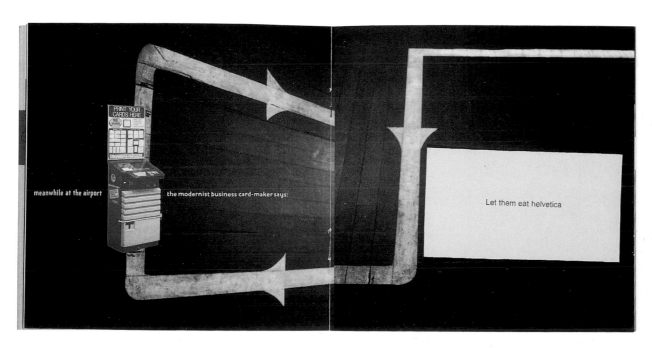

meanwhile at the airport the modernist business card-maker says:

Let them eat helvetica

→ a lack of awareness of its role in society at large. It has lost its reference points. It doesn't take itself seriously. And paradoxically this lack of a reflective or social dimension impairs the very business of graphic design itself, which is making work that can connect to the social psyche.

What's most interesting about *Convoy* is the argument that graphic design, precisely by having given itself over to market research and focus groups, simply replicates pre-existing attitudes. Ironically, by being in thrall to the pseudo-sciences of marketing and branding, graphic design loses a sense of itself and becomes incapable of producing quality work for the client. As *Convoy* asserts, wryly imitating the irritatingly patronising vernacular of management consultancy-speak, 'If you wish to take the car metaphor further, instead of designers driving the practice forward, we're parked, sitting in the back seat, and snogging the marketing manager.'

Convoy is graphic sociology that examines and links the back-end and front-end of graphic design, the business structure and the graphic imagination. If graphic design has lost a sense of direction it is partly because it has vacated its historical ground as the source of visual imagination for businesses and ceded that space to a variety of new business experts. And in turn some graphic designers have re-invented themselves as brand and image consultants. This is because everyone wants a piece of the graphic design action. The new media revolution ought to have seen graphic designers set the →

024.025

Letterbox
Australia, 2000
Inside the packaging of *Ampersand Four: Assembly* is a poster. On the one side there is an image of a sheep who uses Helvetica like everyone else. It's not even a lifestyle choice, or editorial choice any more. Helvetica is a destiny. On the other side there is a full-size poster. It offers a refreshing child's-eye view of the corporate logo. The point of the poster isn't to show the brainwashing of our playgrounds. It's to show just how logos and signage are actually seen and represented by kids. It's another example of folk design.

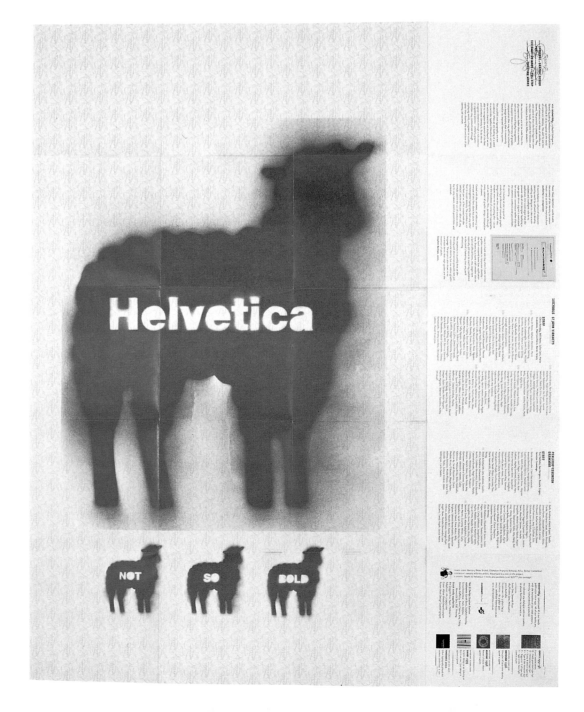

Letterbox
Australia, 1998
Ampersand Two: Rentfont

→ agenda for information design. Instead, graphic designers have seen new professionals of various kinds either move on to their ground, or bring to design agencies their own agendas, slipping into a space between designer and client. And this shouldn't have happened. As *Convoy* argues, 'Graphic designers are now the "keepers of signs", a powerful role in society once that of the artist. Now that much of fine art has been disempowered by sheer commodification or just plain irrelevance, it is a curious irony that a profession as scorned as graphic design should pick up this mantle.'

By identifying graphic designers as the historical descendants of artists as the 'keepers of signs', Letterbox contextualise in a very general way the place and social role of the graphic designer.

Commercial Art vs. Folk Design
Ampersand Four: Assembly, moves the idea of the 'keepers of signs' along through some unusual graphics research. *Assembly*, named after the morning assembly of schoolchildren, comes as a poster packaged inside a tiled folder. The poster initially unfolds on to five square sections of text explaining the project along with credits for the staff and 8–16-year-old children involved. The children were asked to draw in five minutes the first logo that came to mind. Each interview was conducted separately. Unfold the poster again and there's the word Helvetica stencilled (branded) on a red sheep. Underneath, three sheep make up a sentence with the words 'NOT', 'SO' and 'BOLD'.

Throughout the *Ampersand* series Letterbox ask questions about the mono-stylism of typography, its sameness. It's not that they have a problem with Helvetica – though you can also buy a T-shirt with the slogan 'Let them eat Helvetica' – it's that the ubiquity of this typeface illustrates a lack of what they call 'typo-diversity'. But in the Letterbox philosophy, Helvetica also stands for a lazy professionalisation of design. The back cover of *Convoy*, for example, contains the slogan 'modernists make design look like a job'.

The kind of design that doesn't look like a job is found on the reverse side of the *Assembly* poster, the collection of drawings by the schoolchildren. At first glance you would be tempted to reject the Letterbox claim that *Assembly* is not about brand-recognition as columns of the Nike swoosh and the Adidas stripes and the McDonald's letter colonise the page. It's a kind of folk art. It's unprocessed, unproduced graphics, unspoilt by slick, digital design tools.

A similar design logic is at work in Philip Carter's book *1057*. Though not overtly political, it offers a secret contemporary history of graphic folk design. You could call *1057* a work in an imaginary new discipline of Urban Graphic Anthropology which reveals the odd markings of a strange metropolitan tribe. The title is explained in the official legalese at the beginning of the book 'Code 1057, cycle lane, track or route, schedule 6 (road markings), Traffic Signs Regulations 1982.'

As someone who cycled every day Carter noticed a →

'Let them eat Helvetica.'

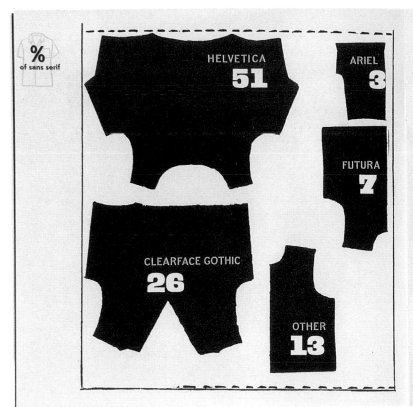

% of sans serif

HELVETICA
51

ARIEL
3

FUTURA
7

CLEARFACE GOTHIC
26

OTHER
13

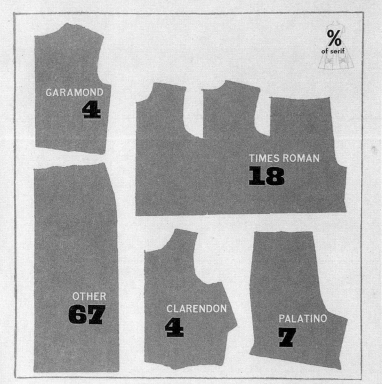

% of serif

GARAMOND
4

TIMES ROMAN
18

OTHER
67

CLARENDON
4

PALATINO
7

3

COLLINS ST

LT COLLINS ST

4

LT COLLINS

BOURKE ST

**Letterbox
Australia, 2001
Letterbox reveal a typography of everyday life.
In *Ampersand Five: Grand* a trip through the
department store reveals the font distribution on
clothing. Other spreads divide up and map
geography in terms of typography.**

→ remarkable degree of *laissez-faire* in how bikes were painted on cycle routes. The official guidelines are rigorous. The cover of *1057* displays the 'Platonic ideal of the Department of Transport' bike sign. It has its own clinical, diagrammatic beauty. But contractors and road-sign painters have transformed these design rules by a kind of graphic free-jazz. As Carter writes in his introduction, 'These painted bikes have evolved into fantasy contraptions, blissfully ignorant of the laws of mechanics, instruments of torture unable to be ridden, whilst those with missing parts echo the reality of bike ownership in an urban environment…these pictograms are as individual as the three-dimensional machines and riders that follow their trail. They turn the humble cycle lane into a gallery of the bizarre, the charming and the comical.'

1057 has over 90 examples of what Carter calls 'tarmac art'. The matt-black cover with the white pictogram opens up to reveal a black version of part of the London A–Z. The images of the bikes are funny, peculiar and occasionally betray the handiwork of a five-year-old. *1057* is a remarkable piece of documentary work. It is a slice-of-life, a kind of work that is rarely attempted in graphic design. The final collection was edited from over 300 images collected over three years. The pictograms in *1057* are an

extraordinary example of the individual erupting into the vocabulary of the official. As our urban centres are filled with expensively designed images of graphic perfection selling everything you can imagine, *1057* is a bizarre example of government-sponsored graffiti. The charm of *1057* is partly delivered through its graphic intrigue that sparks your imagination. Are there no '*1057* police' to come and check the dimensions of each bike? Or does the Department of Transport harbour graphic anarchists dedicated to infringing the graphic prison of rule 1057? It's also a reminder that beneath the urban surface of the functional, the shiny and the slick, it's possible to insinuate something of the idiosyncratic, even in an order as bureaucratic as the public information system. →

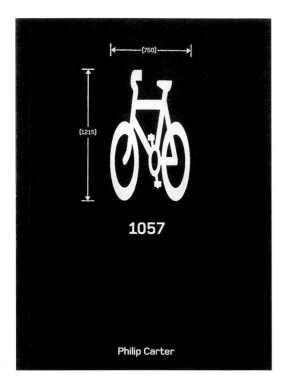

1057

Philip Carter

Philip Carter
UK, 2000
These photographs by Philip Carter in *1057* tell the unofficial graphic story of urban signage. Like crop circles, these strange markings could be messages from an alien species. Or a form of folk design.

028.029

Code 1057: cycle lane, track or route, schedule 6 (road markings), Traffic Signs Regulations 1982.

The official Department of Transport template for the simple cycle lane bicycle: not a model of comfort, maybe, but a template for conformity in a non-conformist city, defined to the last millimetre for instant recognition and safer cycling. As unambiguous as the original was, it has been open to interpretation ever since.

Travel any distance by bike in London and you'll come across, quite literally, all manner of distortions and obliterations – the handiwork of various contractors and road sign painters who, following the guidelines (or not in most cases), have left their own individual interpretations.

These painted bikes have evolved into fantasy contraptions blissfully ignorant of the laws of mechanics, instruments of torture unable to be ridden, whilst those with missing parts echo the reality of bike ownership in an urban environment.

In their infinite variety, these pictograms are as individual as the three dimensional machines and riders that follow their trail. They turn the humble cycle lane into a gallery of the bizarre, the charming and the comical.

Get on your bike and discover this tarmac art.

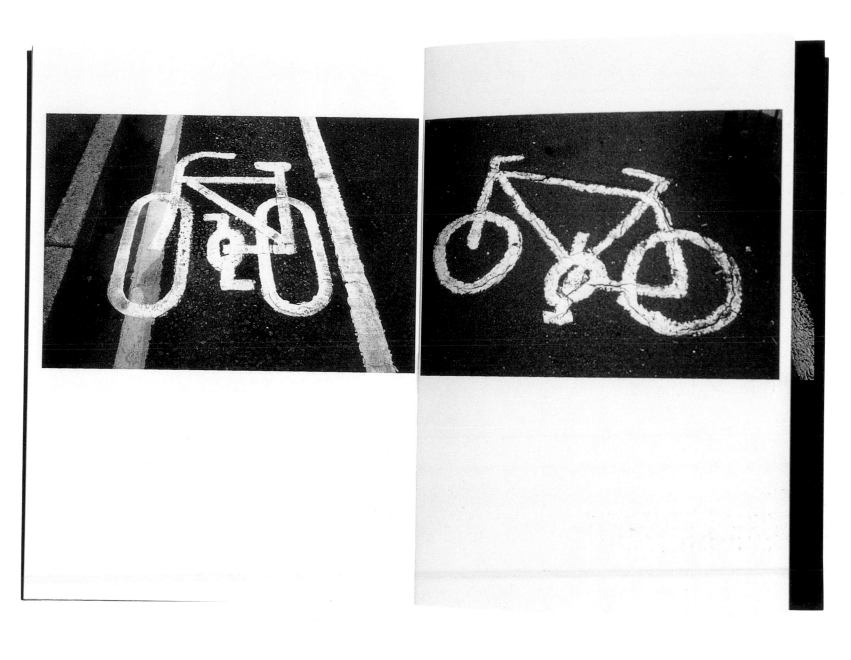

...government–sponsored graffiti

World of Money

→ This is not a manifesto

But at the heart of every political party, every political movement is the manifesto. The modern party political manifesto is a statement of aims of policy objectives. But the manifesto has a glorious tradition as a statement not of the possible, but of the impossible. The manifesto has been a utopian calling, a declaration of dreams. And as was mentioned in the introduction, the manifesto has long been a part of graphic design history. Just as there are many ways to tackle a brief, so the concept of the manifesto is a challenge to the graphic designer.

Experimental Jetset were asked to speak at the AIGA Voice conference that was called off because of the events on September 11th. Rather than give a lecture about their work they opted instead to do a project that gave a flavour of what they do. Experimental Jetset have an eye for bureaucratic context and matter, so they decided to produce a specific set of conference 'bumf' such as stickers in various shapes like buttons, nametags and wristbands that were represented as colourfields in three different colours, what they called 'some sort of three-party system'.

As the conference was about the social and political role of graphic design they also included a manifesto called Disrepresentationism. Written on the back of the sheet containing the conference paraphernalia, the Experimental Jetset manifesto is characterised as 'More an attempt than a manifesto'. It's possibly out of modesty, but perhaps also because they didn't want to adopt at this conference the moral high-ground that any manifesto, by definition, lays claim to.

The politics of the Disrepresentationism are extracted from graphic design itself. Its theory, such as it is, is internal to graphic design itself, drawing on questions surrounding representation, working outwards to provide a suggestion of what it might mean to create socially engaged graphic design.

The immoral image

Moral, political and religious arguments about the correct form of representation, of picturing the world, go back in Western history at least as far as Plato. Art, at the very least according to Plato, had no serious value as the artists and creators knew how to picture things but knew nothing of what they were representing. Plato argued that Homer's works, for example, told stories of great epic battles, but as Homer himself wasn't a great military general how could he do anything other than give a superficial account. At worst, the arts were immoral because not only were they superficial, but they had the ability, through the skill of the creator, to arouse strong emotions and feelings which make us incapable of assessing things rationally. The deficiencies in these arguments are obvious. In the middle ages the Orthodox Church only allowed icons to hint at the divine. The more realistic statues were, the more dangerous they would be to believers because they could encourage idolatry.

→

Experimental Jetset
Netherlands, 1998
Their one-off magazine *World of Money* spells out the capitalism's heart of darkness – depression, bursting dotcom bubbles and the millennium bug.

1.IT IS FINAL;
THE ECONOMIC
APOCALYPSE

1999
2000

ECONOMIC ANGST

THE LIBRARY

THE SURREY INSTITUTE OF ART & DESIGN

Epsom Campus, Ashley Road, Epsom, Surrey KT18 5BE

'Everyone is not a designer.'

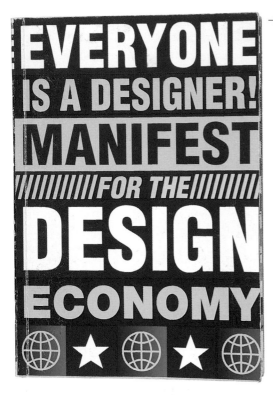

→ In the 20th century we are more familiar with debates surrounding modernism and modernist abstraction versus conventional forms of realism. Marinetti, for example, believed that the impression of pictorial dynamism was truer to modern life than realistic representations of cars, vehicles or trains. And no one could deny, for example, that Pasolini's experimental documentary style in his film *The Gospel According to Saint Matthew* contains a greater degree of truth than the *King of Kings*, Hollywood's realist version of Jesus with John Wayne.

This issue is at the heart of Disrepresentationism. Experimental Jetset quote De Stilj-founder Theo van Doesberg's 1923 manifesto *Anti-Tendenzkunst*. Van Doesberg argues that there is no political difference between a painting of Napoleon going into battle and a painting of Trotsky going into battle. According to this modernist both realist paintings are false in some way.

The Experimental Jetset argument is highly sophisticated. They assert that graphic design in advertising is always representative; it is always about something else. The medium of advertising must always disappear, must be invisible in order to picture the product. This leads them to explicitly state that their criticism of advertising is fundamentally different from that of the *First Things First 2000* manifesto. 'We see no structural difference between social, cultural and commercial graphic design. Every cause that is formulated outside of a design context, and superficially imposed on a piece of design' is deeply problematic. They conclude with a credo, 'We believe that abstraction, a movement away from realism but towards reality, is the ultimate form of engagement. We believe that to focus on the physical dimensions of design, to create a piece of design as a functional entity, as an object in itself, is the most social and political act a designer can perform. That's why we believe in color and form, type and spacing, paper and ink, space and time, object and function, and most of all, context and concept.'

Is this argument utopian? Abstract? Removed from the real world? Perhaps. But the principle of Experimental Jetset's argument looks back to designers who try to derive politics from design rather than impose it from the outside. Disrepresentation is what a manifesto looked like at a design conference. If they delivered it at a college it might be a prospectus with all the graphic conventions of colour and layout you'd expect. The point is that the manifesto isn't a Five-Year Plan. Equally Mieke Gerritzen's book *Everyone is a Designer! Manifesto for the Design Economy* isn't a programme for government or a programme to bring down government. It's a noisy collections of thoughts on design, communication and the internet. It touches on the notion of folk design raised by Letterbox and Philip Carter.

Gerritzen's work is unusual for a manifesto in that its mission statements are the product of a range of voices. The title is a reference to the utopian slogan of post-war German artist Joseph Beuys who declared that 'Everyone is an artist'. Beuys' art was inextricably bound up with politics, as he tried to makes sense of his own nationhood and the world-at-large after the horrors of Nazism. He saw art as revolutionary, at least in the sense that, as he believed, art opened up a space in a media-dominated world. Of course, his understanding of 'media' was the media of advertising and commerce. Gerritzen's work seems to suggest that there is a similar potential in individuals designing their own websites. The very idea of the web as a cacophony of voices is communicated in the manifesto itself. Unlike conventional manifestos, at the level of content, it doesn't have a unity of message. Not all contributions are as idealistic about the web. The text from Peter Lunenfeld from the Art Centre College of Design Pasadena bluntly states, 'Everyone is not a designer but the market would like them to think so. As the prices of visual communication tools drop and their learning curves flatten, people start to think they are, or will be, designers. But what does this mean? To me it's a commercial utopianism, a promise held out by salespeople pitching new product on the trade show floor.'

Banner politics

The colour Gerritzen provides for Lunenfeld's text is noisy and lurid. Designer and writer Max Bruinsma remarks in an article on Gerritzen's website design, that she is successful in translating a print aesthetic to the web by adhering to the fundamentals of graphic design – line and colour. It's remarkable how this style has become signature Gerritzen. Much of her website design that predates the Manifesto uses the same bold colour and blocks of words. And if Bruinsma is right about her style being rooted in print, the fact is that it was a style that fits the early web aesthetic of the 'banner'.

The 'banner' was an indigenous web-form modelled on print. Part headline, part advertising copy, part functional page turner, like cartoon heroes The X-Men, the banner soon became a strange all-powerful design mutation. But often it had to serve two masters: editorial and commercial. Its function became confused. If I click on a banner will it take me to a commercial affiliate or an in-depth article? As web tools became more sophisticated the banner soon got the reputation for being ugly and dysfunctional because no-one really clicked on it in anyway. So all you were left with was an aesthetic.

Gerritzen's manifesto exploits the noisy aesthetic of the banner and its capacity to shout a message in a very small space. One of the striking features of the manifesto is that each page seems to use every available smidgeon of space. Everything appears packed in, as the gaudy colour-clashes fight against each other. Gerritzen may have drawn on print media in the beginning, but it's clear that she has imported back a strong conception of space from webpage design. Each page is squeezed tight by a phantom screen. More than anything else Gerritzen is a web evangelist. It's a celebration of the medium of the internet as a democratic medium. This is illustrated by the fact that the manifesto is not uniform, but contains a variety of voices. And it's also a gesture towards the idea of the internet as a new technology of folk design.

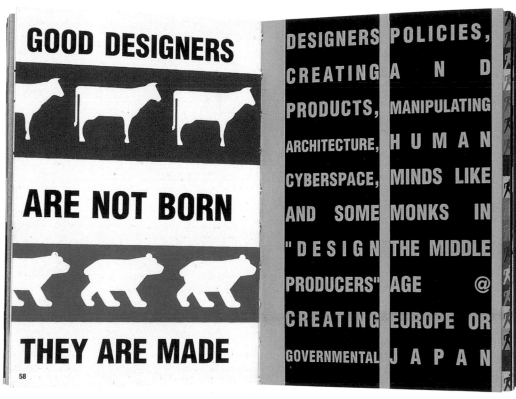

GOOD DESIGNERS

ARE NOT BORN

THEY ARE MADE

58

DESIGNERS POLICIES, CREATING A N D PRODUCTS, MANIPULATING ARCHITECTURE, H U M A N CYBERSPACE, MINDS LIKE AND SOME MONKS IN "DESIGN THE MIDDLE PRODUCERS" AGE @ CREATING EUROPE OR GOVERNMENTAL J A P A N

**Mieke Gerritzen
Netherlands, 2001
Pixel patterns and web wisdom highlight the
curious, vibrant and odd culture of the internet.
Corporate logos slide up and down the page
alongside Negroponte's snappy web aphorisms.**

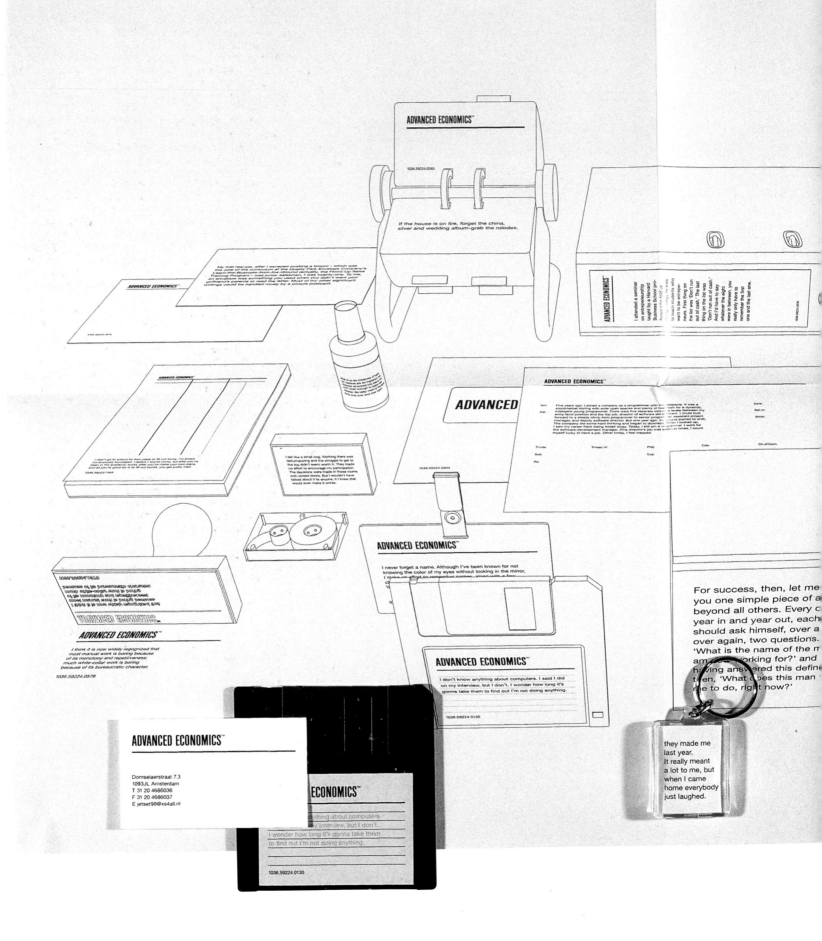

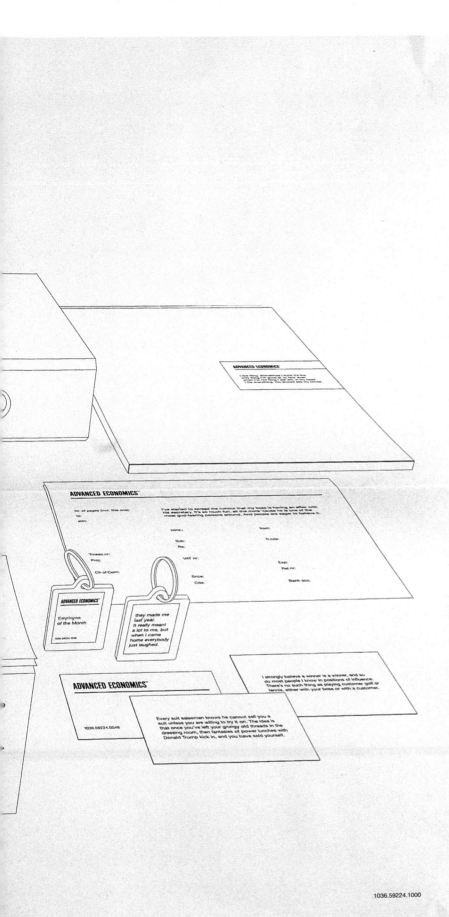

**Experimental Jetset
Netherlands, 1998
Inside the cardboard file folder of *Advanced
Economics* Experimental Jetset helpfully supply
office materials along with a poster narrating the
story of contemporary office life.**

→ **Office politics**

Advanced Economics by Experimental Jetset is a more anthropological work. It's one of the few cultural explorations of the phenomenon of office life with all its equipment, trappings and strange kinds of psychological states employees have to adopt.

What's also rare in graphic design is the fact that on many of the items in *Advanced Economics*, Experimental Jetset pen character sketches. These credible, fictional voices, that are both funny and pathetic, fill out the picture of the strange unspoken life of the office world. With *Advanced Economics* graphic design comes as close as you'll get to the same kind of pleasure in narrative and story-telling you'd get in a novel or a movie. It's packaged in a grey folder with a sticker on the front telling the story of an obsessive filer. 'I like filing. Sometimes I think it's the only thing I'm good at. In fact, even when I'm not filing I still am, in my head. I file everything. You should see my house.' The folder itself becomes the material icon of a psychological type.

Inside the folder, in sealed plastic, is the collection of office material. The 'Employee of the Month' key-ring, which continues its tale of pathos on the back: 'they made me last year. It really meant a lot to me, but when I came home everybody just laughed.' There's a floppy disc on which another employee writes, 'I don't know anything about computers. I said I did on my interview, but I don't. I wonder how long it's gonna take them to find out I'm not doing anything.' There's a postcard, a business card, an envelope and invoice slips. There's a poster displaying all the items in the bag and some more such as a rolodex, box-file, and a Tipp-ex bottle with a message that is signalled by the Tipp-ex itself. 'Most of us are creatures of habit, our mistakes are so ingrained, our character is so locked into place, we aren't smart enough to make new mistakes. We keep making the same dumb ones over and over again.'

You would think that the culture of work would be a huge resource for graphic designers. Designers are attuned to the minutiae of the office providing, for example, the look of office materials or the annual report. And as Experimental Jetset allude to in *Advanced Economics*, the world of work is saturated by theories of organisation, of personnel management. Work, certainly in Britain and America, has become inseparable from the idea of personal self-definition. Yet our lifestyle media rarely, if ever, address the phenomenon of work, which was the point behind the *Paranoia in the Workplace* spreads by Crash! for style magazine *Sleaze Nation*. Crash! is composed of Art Director Scott King and writer Matt Worley. King was art director at Terry Jones' *i-D* in the early '90s and is now Creative Director at *Sleaze Nation*. But in between Crash! (an acronym meaning 'creating resistance against society's haemorrhoids') became a personal project devoted to unpicking and mocking the splurge of processed youth, pop and lifestyle culture that exploded in the mid-1990s and the one-dimensional media that served it.

The humour depends on the difference between the abstract scientific graphics and the human stories that they in fact represent. In a way it's an example of what Experimental Jetset call Disrepresentationism. So, for example, 'figure three', which could be two circles picturing something like the optical wave frequencies of shades of pink and blue, is in fact a pictorial representation of office interaction. Perhaps they are models in some bizarre management theory. Malcolm is pink and Wendy is blue. As the accompanying text explains, 'So (Malcolm) attempting to make sexual advances towards 5a (Wendy) by making lurid suggestions and rubbing his crotch against the photocopy machine. 5a rebuffs 3b's advances, before remarking that even the photocopy machine finds him repulsive.'

→

→ Lifestyle politics

Scott King's graphics occasionally use the connotations of sociological information design, to give the Crash! text a vaguely academic and even nostalgically utopian feel. The utopianism partly has its source in the Situationist Theory of Guy Debord and Raoul Vanegeim. It's not that these thinkers offered a model of a utopian world but that their view of how 'political activity' itself might be conducted was utopian, which is why they inspired the generation of the late 1960s to 'take their desires for reality' as the slogan went. In fact, you could argue that Situationism is the political philosophy most suitable for graphic designers. Its writings are directed against the 'packaging' of everything in a consumer society; from commodities, to love, to sex, to politics and even revolution itself. Hence, the title of Debord's seminal book *The Society of the Spectacle* and Scott King's award-winning cover for *Sleaze Nation* of 'Cher Guevara'. As Malcolm McClaren – another inspired by Debord – once said, one of the things that Situationism taught him was how capitalism could even package and sell you back your own boredom. A strange idea until you think of reality TV shows like *Big Brother* whose spectacle lies entirely in watching people cope with the boredom of having nothing to do.

Hyperdrone, which is about the social and psychological parasite that is celebrity and lifestyle culture, displays text in a variety of boxes, linking them to create a kind of flow-chart. The black-and-white clip-art illustrations (by Anthony Smith) are typically Crash! in their blankness. The one continuous element in much of King's design is the paring down of signs and symbols to their most basic elements. It's cramped and stark. →

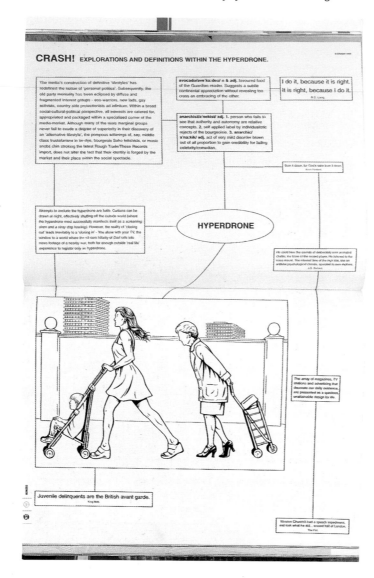

Crash!
UK, 1999
Explorations and Definitions with the Hyperdrone:
spreads from *Sleaze Nation.*

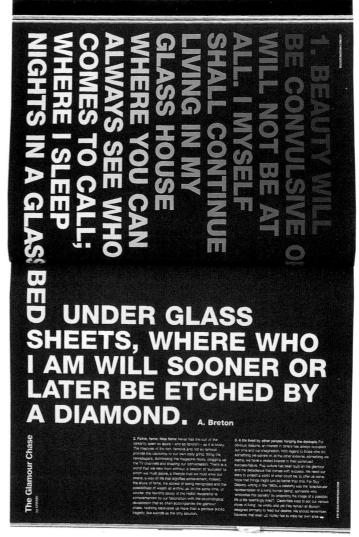

Crash!
UK, 2001
The Glamour Chase spreads from *Sleaze Nation.*

036.037

CRASH!

Crash!
UK, 1998
Exhibition catalogue for Crash! event at the
Institute of Contemporary Arts.

→ IIt's the voice of someone with political claustrophobia whose sanity is only preserved through cold, measured wrath.

One of the other features of Crash! is their facility for neologism. Hyperdrone is the smothering sound of exploitation in the 21st century. It's the mindless chatter of a culture with nothing to say and 24-hour media to say it on. 'The perpetrators [sic] of "audiovisual fog" will never cease, even though we all know that Tara Palmer-Tomkinson is brain dead; that Radio One is up the arse of the multi-national music industry; that *Hello!* embodies the backwardness of the English petit-bourgeoisie; that advertisers lie; that the tabloid media propagate the retarded opinion of its multi-billionaire leadership; that style magazines reflect the predilections and hang-ups of a handful of public-school boys and the advertising industry that funds their production.'

What's so refreshing about Crash! is both the sheer anger and how unpleasant it is. It's shocking simply because the kind of truths it communicates about things like our celebrity culture are so obvious, yet such observation is entirely absent or invisible in the media. The text is used as much as a visual element, the graphic sign of someone haranguing you, barracking you, trying to find ways to push your buttons. It is as likely to cite political agitator Rosa Luxemburg as soap-opera character Gail Tilsley – and also draws on the early 20th-century tradition of the political poster.

The first issue of Crash! was a manifesto/poster attacking the mid-1990s culture of the New Lad and its celebrity footsoldiers. Worley's analytic dissection and rhetorical prompting on one side opens out into a full poster. On the other side there's an image in pink of the religious temple, the sacred ground of the New Lad, the football pitch. Two teams made up of white dots face each other; Crash! heroes versus Crash! villains. Eleven villains, each dot carrying the name of a New Lad poster-boy, versus the massed ranks of dot-heroes, each dot named after a Crash! champion; Camus, Moon, Breton, Ryder, Warhol, Rotten, Genet. Musicians, artists, philosophers, lined up against New Lad flunkies. What's funny about the poster is not just the sheer number of heroes versus the 11 New Lads but that the fantasy steals the cherished New Lad culture of football and turns it against it in an entirely childish and innocent way. If *Fantasy Football* was a TV programme devoted to the culture of the New Lad, the Crash! fantasy football-match pictures what will be a crushing victory of the culturally righteous over the culturally damned.

Prada Meinhof is another angry manifesto/poster that, as the title suggests, rails against the emptying out of political heritage and its repackaging as style culture. The manifesto communicates its polemic through such sections as 'Pol Pot Noodle' and 'Carnaby Street Preachers' that picture a set of psycho-political character types and their consumption habits. The poster opens up on to two huge words →

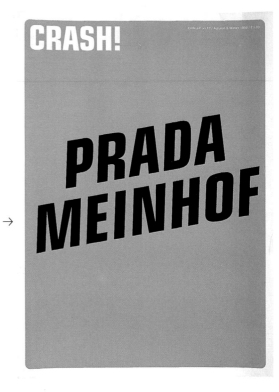

038.039

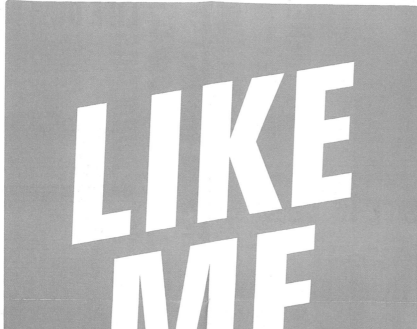

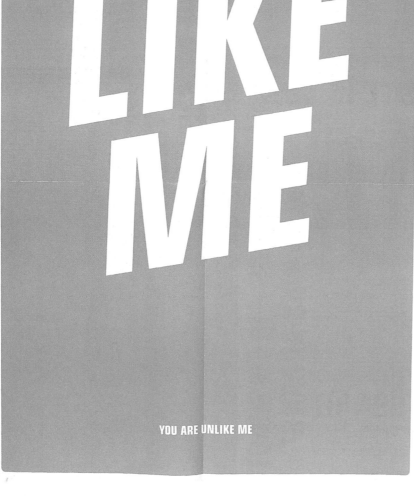

YOU ARE UNLIKE ME

Crash!
UK, 1999
The politics of neologism in Crash! pamphlet *Prada Meinhof*. A fundamental aspect of Crash! work is the invention of a vocabulary to describe new political and social groupings. The pamphlet opens out on to the *Like Me* poster. The tone is purposefully declamatory and confused, drunk even.

Crash!
UK, 1997
The *Death To The New* pamphlet opens out into a poster showing a one-sided football match between Crash! heroes and villains. Their use of dots signals the fact that sophisticated cultural and political analysis may be interesting, but political choice and action ultimately comes down to something simple: you are *for* or *against*.

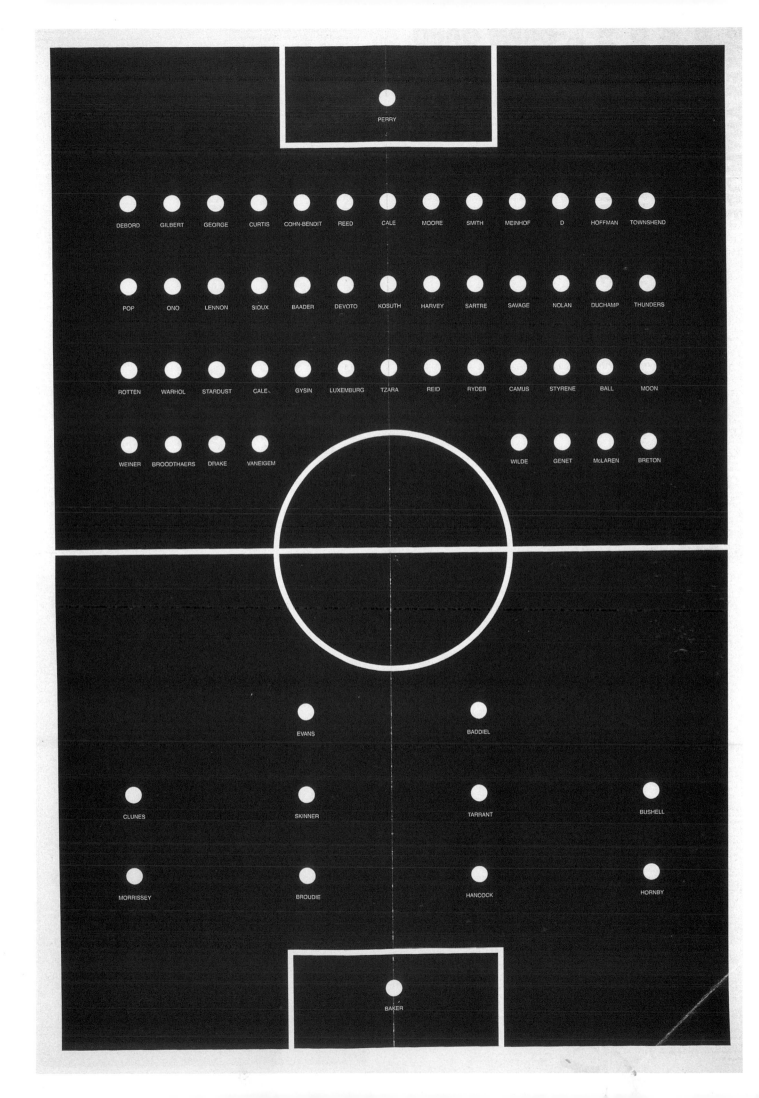

→ 'Like Me' and underneath in much smaller lettering 'You Are Unlike Me'. The slogan isn't a simple call-to-arms or proclamation, it's a strange dialogue. Its meaning is opaque, dumb. It's perhaps the mantra of the lifestyle victim who wants to be different and wants to be loved. But maybe it's more than that.

At the heart of Crash! there's an image of someone confused, messed up, brutalised, stupefied and scarred by the mindlessness of the consumer society we live in and contribute to – 'Like Me'; 'You Are Unlike Me!' It's the dialogue of the crazy voice in your head. That's what makes Crash! interesting. It's not just the anger and the wit, it's the ability to gesture towards an inarticulate Everyman rendered stupid; drunk on the crazy, insane world that rewards shallow celebrity to a mindless degree and promotes a sense of self built on choice of clothes, food, restaurant or music.

Crash! is polemical, as traditional political posters and manifestos are. But it also has a character of its own shaped by Worley's rage and King's mute blocks of type.

No recent political analysis has matched the humour and incandescent anger of the Crash! poster featuring a fictional dialogue between deceased German terrorist Ulrike Meinhof, and one of the UK society's 'IT' girls, upper-class women who have somehow carved out a niche for themselves in the media. The dialogue surrounds a comedy gameshow called *Shooting Stars* which is a parody of the gameshow genre itself. Aside from being blackly funny, the dialogue communicates a complete psychological and social mismatch. There's no shared language. It's a compelling, hilarious and frighteningly dystopian image of something ruptured. Jonathan Swift would have approved.

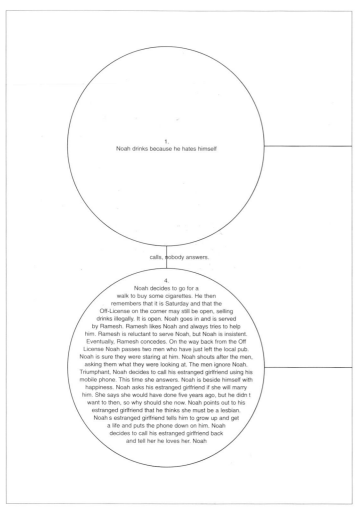

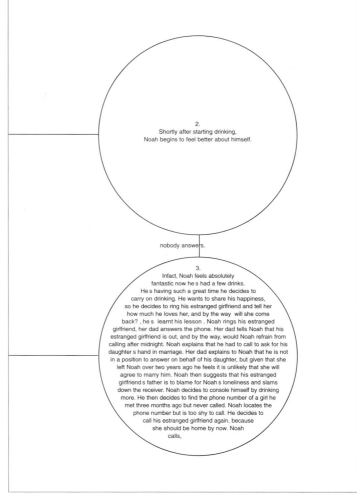

Scott King
UK, 2000
***Noah drinks because he hates himself* borrows from the graphics of a flow chart. It's a humorous graphic psychology.**

Crash!
UK, 1998
The rock extravaganza as an alienating spectacle. For the Rolling Stones, 20 years on, the song remains the same. Joy Division play in a more intimate setting.

Scott King
UK, 2000
Max Weber's model of bureaucracy and Malcolm and Wendy.

The Rolling Stones, 12 September 1969, Altamont Raceway

The Rolling Stones, 12 September 1969, Altamont Raceway

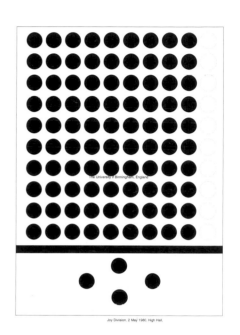

Joy Division, 2 May 1980, High Hall.

Figure 1
Max Weber's model of bureaucratic structure within in the modern workplace.

Numbers denote level of power/autonomy within particular organisation. Letters identify particular

```
              1
          2ᵃ    2ᵇ
       3ᵃ   3ᵇ   3ᶜ
     4ᵃ  4ᵇ  4ᶜ  4ᵈ
   5ᵃ  5ᵇ  5ᶜ  5ᵈ  5ᵉ
  6ᵃ 6ᵇ 6ᶜ 6ᵈ 6ᵉ 6ᶠ
 7ᵃ 7ᵇ 7ᶜ 7ᵈ 7ᵉ 7ᶠ 7ᵍ
8ᵃ 8ᵇ 8ᶜ 8ᵈ 8ᵉ 8ᶠ 8ᵍ 8ʰ
```

characters within organisation.

Figure 2
7d, 7e, 7f, 7g (Andy, Stu, Steve, Nick) threatening to topple Max Weber's model of bureaucratic structure within the modern workplace, by spending every afternoon drinking in the Red Lion.

```
              1
          2ᵃ    2ᵇ
       3ᵃ   3ᵇ   3ᶜ
     4ᵃ  4ᵇ  4ᶜ  4ᵈ
   5ᵃ  5ᵇ  5ᶜ  5ᵈ  5ᵉ
  6ᵃ 6ᵇ 6ᶜ 6ᵈ 6ᵉ 6ᶠ
    7ᵃ 7ᵇ 7ᶜ
8ᵃ 8ᵇ 8ᶜ 8ᵈ 8ᵉ 8ᶠ 8ᵍ 8ʰ
```

Figure 3
3b (Malcolm) attempting to make sexual advances towards 5a (Wendy) by making lurid suggestions and rubbing his crotch against the photocopy machine. 5a rebuffing 3b's advances, before remarking that even the photocopy machine finds him repulsive.

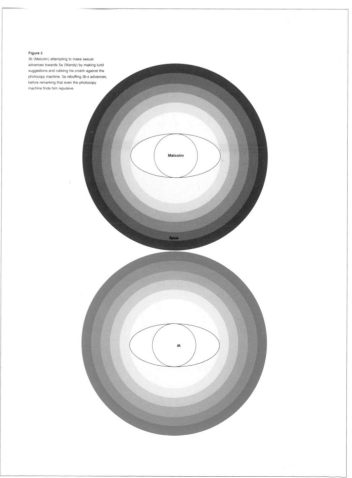

Meanwhile In A Large Central London Apartment The Telephone Is Ringing...

Tamara Beckwith: Hi, me speaking.

Ulrike Meinhof: Good afternoon. My name is Ulrike, I'm campaigning for the Red Army Faction.

Tamara: Sorry. Who?

Ulrike: I'm from the R.A.F.

Tamara: Cool. Great guys, bombed the Nazis.

Ulrike: That's correct. So, you will make a donation towards the struggle against bourgeois consumer capitalism?

Tamara: Look Ulrika, I'll happily make a donation, providing I get invited to do more 'Shooting Stars'.

Ulrike: That's perfect. Shooting stars is high on our agenda, along with bombing bureaucrats and killing cops. Do you have any further requirements?

Tamara: Well...I have to be on Mark's side.

Ulrike: Good. I too am on Marx's side.

Tamara: You are? So who's on the other side?

Ulrike: The whole might of Western Capitalism.

Tamara: Well, that's hardly fair.

Crash!
UK, 1999
Meanwhile in a large central-London apartment the telephone is ringing...Political crossed-wires.

Crash!
UK, 2000
The front and back of *Cher Guevara*, possibly the sharpest and saddest poster of our times, signalling our political and historical amnesia. It's what happens when lifestyle meets politics.

042.043

Meanwhile, In The Nelson Mandela Bar...

Jon: Che is still an icon, an inspiration to revolutionaries worldwide. A hero to those of us who understand that self empowerment only arises from direct action; and that direct action is the only viable weapon against capitalist oppression. Wouldn't you agree comrade?

Will: You're right...comrade...as a singular iconic force within the western world, Cher remains supreme. A true spiritual leader, whose vision has never been surpassed. Not even by Madonna.

Jon: The Lady Madonna is an archaic symbol of repression, a shrine to populist paranoia. People follow her in fear of expressing their own opinions. Worship as an attempt to suppress the collective will of the masses.

Will: Madonna is the ultimate symbol of manufactured mediocrity. Her vacuous reign over the hearts and minds of the weak has been achieved by what can only be understood as blatantly manufactured...corporate...fascism.

Jon: You're right. I can see that you truly understand how the modern icon is usually created comrade. However, I would argue that Che has now surpassed the simplistic status of a consumable icon. Comrade, I am thinking 'saint'.

Will: I am thinking 'angel'.

Jon: Absolutely. Remember what Che said? 'Man really attains the state of complete humanity when he produces, without being forced by physical need to sell himself as commodity'.

Will: Yes, and Cher has stuck by that maxim to the letter. Cher had achieved more than most of us ever will by the age of twenty five, but the will was strong, the message had to be spread. Of course you remember what Cher also said: 'I´m walking in Memphis walking, walking in Memphis. But do I really feel the way I feel?'

Jon: It's clear what the sub-text is there. One can only read that as Che subtly ridiculing the inherent moral poverty of American imperialism. 'Walking' being a metaphor for isolation, a hopeless yearning for purpose within the oppressive capitalist machine.

Will: At last, I have finally found a kindred spirit. Can I get you another drink...comrade?

CRASH!

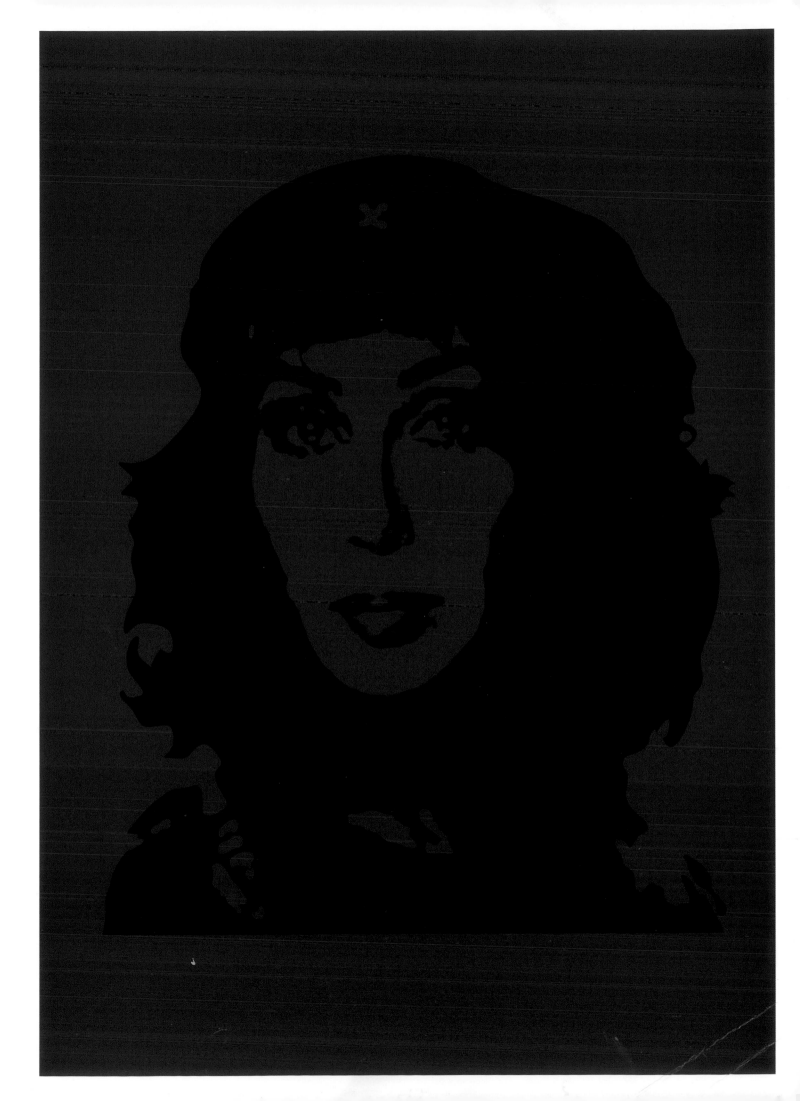

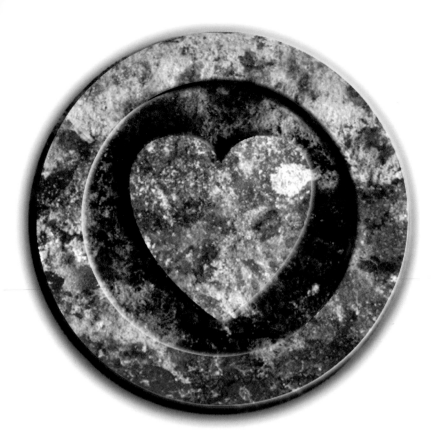

Gianni Bortolotti
Italy, 1997
Bortolotti describes *Untitled Without Image* as a kind of prevocational corrective to the graphic excess of contemporary design. It's a time-out from images of consumption. It's also an exploration of self-restraint, a kind of personal meditation that acts as a resource for his own work. Is it perhaps puritanical? In Borlotti's terms not really, because he argues that contemporary images prevent communication by their excess. His poster work is often an exercise in thinking through the concept and function of contemporary image making. As Bortolotti explains *Untitled Without Image* 'has purely provocative value, breaking from the usual, a contraposition from the vast array of complex images, which at present invade our lives in the name of communication. The absence of forms, message and meaning is obviously intentional and deliberate in its purpose. It is a reaction to the distraction of the needless exuberance of detail and frills which are inherent in most contemporary images.

This poster obviously does not communicate anything! There is no attempt to persuade, seduce or be spectacular.

My earnest endeavour is to achieve the maximum synthesis of forms. The absence of forms or in this case the "total void" is a consequence of my thinking in this area – a provocative statement. I feel a great compulsion to achieve a structural synthesis of the image which will have a significant influence in all my future graphic design production.'

Stefan Sagmeister Studio
US, 2001
The *Heart* is a pin commemorating the destruction of the Twin Towers. Sagmeister explains that it's 'made of a piece of the World Trade Centre that refused to be destroyed. All proceeds go to a major charity. The two-lobed heart shape was in use before the last ice age. Christians, Jews, Hindus, Buddhists and Muslims all use this symbol. One month after the WTC disaster 250,000 tons of rubble have been removed from the site and brought by truck and barge to the Fresh Kills landfill in Staten Island. It is estimated that there will be over 1,000,000 tons of rubble. For 300,000 pins less than two tons are needed.'

044.045

Experimental Jetset
Netherlands, 2000
Been There/Done That is a set of wristbands which can still be bought from the Purple stores in Paris and Tokyo. Like their manifesto it is partly about the issue of representation, partly about memory. As Experimental Jetset explain, 'We were inspired by these brightly coloured wristbands that serve as admission tickets when you visit a pop festival. Some kids keep wearing them the whole year through, to show which festivals they went to. Like trophies. The idea was that the people who wear our wristbands were all present at the same imaginary event. Like souvenirs from events that never happened.'

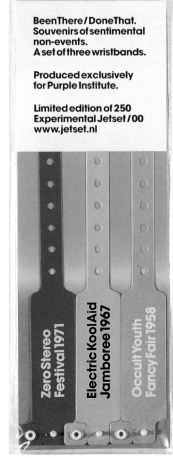

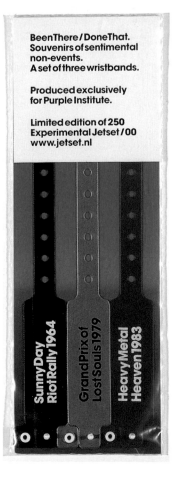

02

the exhibitionist

Exhibitionism and voyeurism: the pathologies of the designer. Like the instincts of love and hate, Freud tells us that looking and showing, voyeurism and exhibitionism are twins. Psychoanalytic generalisations are fun, and shouldn't be taken too seriously. But even psychoanalytic sceptics could admit that graphic design is about making people look, directing their perception and communicating in advertisements or magazines or posters the idea: 'I've got something you want.'

→

→ So you might think that designers let loose on self-promotion would come up with the design equivalent of those Hollywood Oscar-night dresses. The thespian skills which got people invited to the party are submerged by cleavage and bums. The collection of material here suggests that in fact designers, given a chance to promote themselves in some way, use the opportunity in more complex ways.

Many design agencies understand that contrary to popular assumption, their self-promotion work is not directed at clients or even potential clients. The best self-promotion isn't even a marketing tool. The ideal recipient of a piece of self-promotion is the agency itself. It's a love letter sent to themselves. Self-promotion is in fact an opportunity for self-definition.

A sense of collective purpose is critical in any successful business organisation. It's the reason why companies throw money at paintball fights, office parties and even company songs which are designed to bond employees and generate a sense of belonging. In contemporary business life, graphic design practices are an essential part in creating collective purpose, through designing marketing products, logos and even annual reports. All of these materials have an important function in how a company tells a story about itself, not just to others, but to its own employees.

Many people still believe that graphic designers are simply technicians providing a service, that designers are some sort of 'picture drones' slavishly producing images to order. But the fact is that designers spend most of their working lives interpreting clients' needs, demands and desires. Imagining the brief also involves imagining the clients in

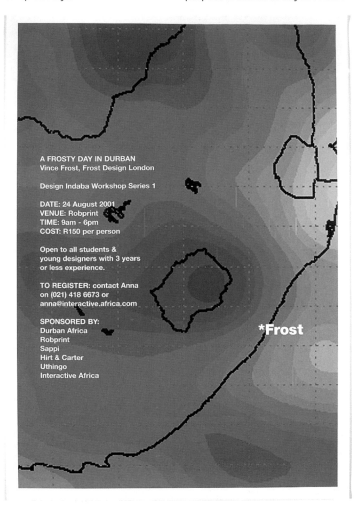

A FROSTY DAY IN DURBAN
Vince Frost, Frost Design London

Design Indaba Workshop Series 1

DATE: 24 August 2001
VENUE: Robprint
TIME: 9am - 6pm
COST: R150 per person

Open to all students &
young designers with 3 years
or less experience.

TO REGISTER: contact Anna
on (021) 418 6673 or
anna@interactive.africa.com

SPONSORED BY:
Durban Africa
Robprint
Sappi
Hirt & Carter
Uthingo
Interactive Africa

*Frost

Vince Frost
UK, 2001
Taking the temperature of contemporary design.
Vince Frost's poster for a lecture in Durban pictures
a weather map of South Africa.

048.049

Vince Frost
UK, 1999
Frost often exploits his name for visual puns, and
in this case it appears as the snow-white initial of
his surname.

VINCE FROST
MARCH 1999
CSD VOICEBOX LECTURES
2-CALEDONIAN UNIVERSITY,
GLASGOW.3-SALFORD.
UNIVERSITY,MANCHESTER.
4-FROST DESIGN LONDON.
TICKETS 0171 8319777 ADMISSION 7PM
MEMBERS£6NONMEMBERS£8STUDENTS£4-50
SPONSORED BY HOUSE OF NAYLOR, ARTOMATIC & PHOTONICA

Vince Frost
UK, 2001
This large Frost concertina portfolio can be read through each opening or by laying the whole work out. There is no explanatory text; the work for often well-known clients and Frost's layout are enough to tell the story.

some way. In short, a designer's work is about visualising others' fantasies. And of course a designer brings to the task their own aesthetic preferences and experiences. Even so, most designers occasionally need to do something 'creative'. This desire is a confession that they are missing something from their professional work.

They have lost what Paul Rand called the 'play instinct'. An instinct which is essential to all design. 'It is the instinct for order, the need for rules that, if broken,

spoil the game, create uncertainty and irresolution. "Play is tense," says Johan Huizinga. "It is the element of tension and solution that governs all solitary games of skill." ...Without play there is no experimentation. Experimentation is the quest for answers...There can be design without play, but that's design without ideas...Play takes time to make the rules. All rules are custom-made to make a special kind of game. In an environment in which time is money, one has no time to play. One must grasp at

every straw. One is inhibited, and there is little time to create the conditions of play.'

This dialectic between play and rules is at the heart of designer Tony Linkson's personal work in the art section. But as far as design companies are concerned, many instinctively follow Rand's belief in the importance of play. As we will see, Dublin's red dog, London's navyblue and Stefan Sagmeister all employ self-promotional activities as a kind of design therapy. →

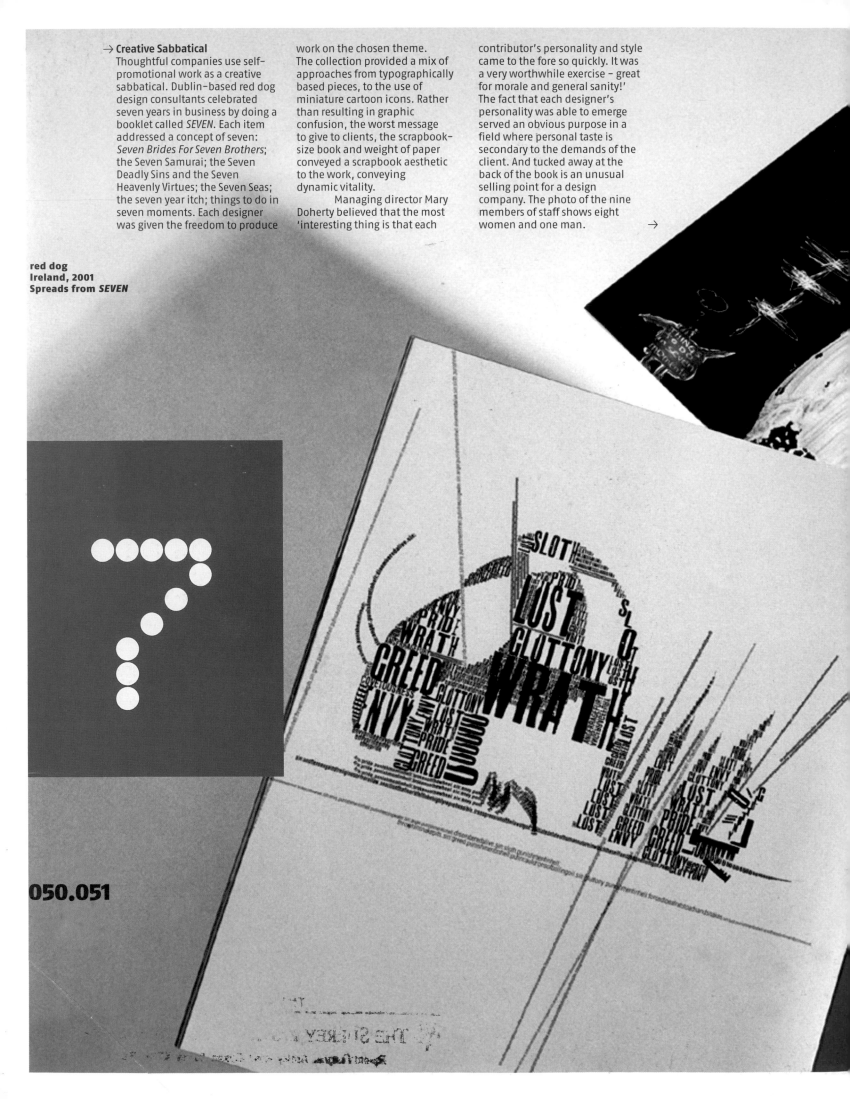

→ **Creative Sabbatical**
Thoughtful companies use self-promotional work as a creative sabbatical. Dublin-based red dog design consultants celebrated seven years in business by doing a booklet called *SEVEN*. Each item addressed a concept of seven: *Seven Brides For Seven Brothers*; the Seven Samurai; the Seven Deadly Sins and the Seven Heavenly Virtues; the Seven Seas; the seven year itch; things to do in seven moments. Each designer was given the freedom to produce work on the chosen theme. The collection provided a mix of approaches from typographically based pieces, to the use of miniature cartoon icons. Rather than resulting in graphic confusion, the worst message to give to clients, the scrapbook-size book and weight of paper conveyed a scrapbook aesthetic to the work, conveying dynamic vitality.

Managing director Mary Doherty believed that the most 'interesting thing is that each contributor's personality and style came to the fore so quickly. It was a very worthwhile exercise – great for morale and general sanity!' The fact that each designer's personality was able to emerge served an obvious purpose in a field where personal taste is secondary to the demands of the client. And tucked away at the back of the book is an unusual selling point for a design company. The photo of the nine members of staff shows eight women and one man. →

red dog
Ireland, 2001
Spreads from *SEVEN*

050.051

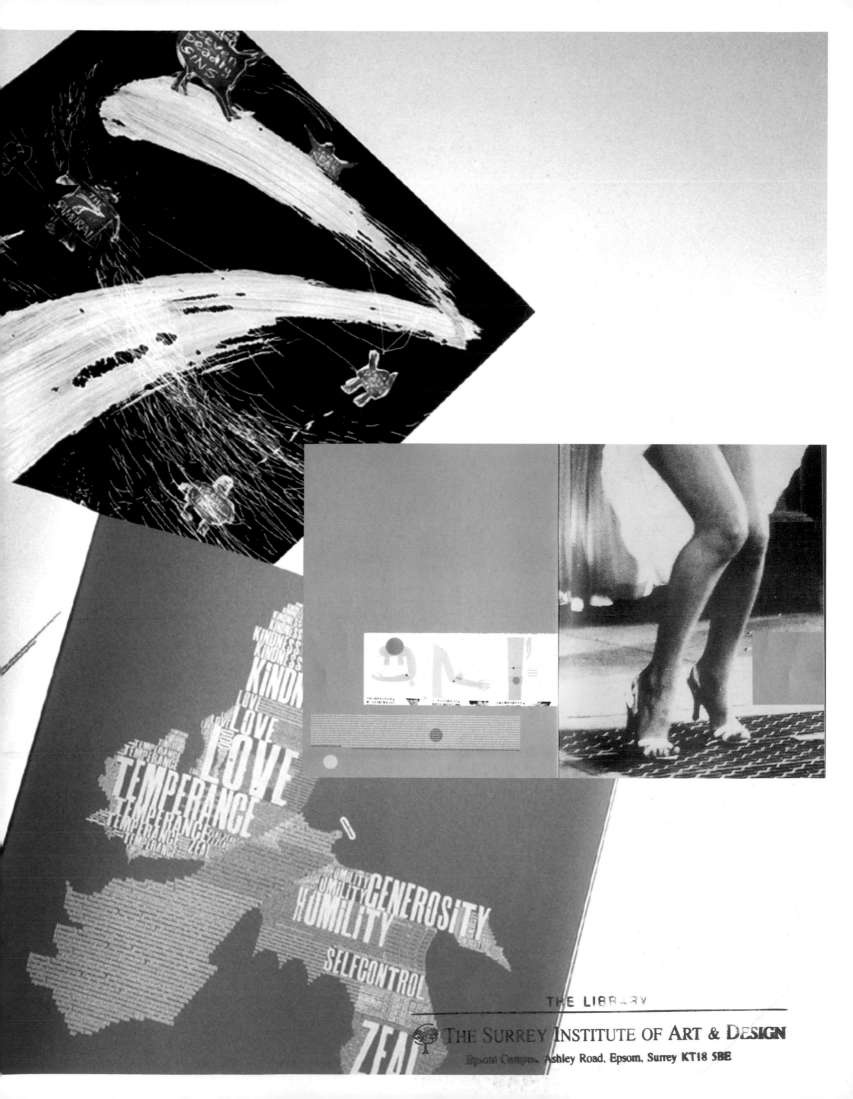

→ Another company to use self-promotional work as a means of taking stock are London agency navyblue. The work is called *thunk*. It's the sound of the booklet as it drops on your desk. It's a vulgar, lowercase version of the past tense of 'think'. As an object, it makes the reader work. It comes vacuum-sealed in plastic (can you think in a vacuum?) and as you open it you realise that you can only read the pages with copy. The pages with images have to be sliced open.

It comes with a poster of a duck floating in front of a tree-lined valley. But the valley is painted on a brick wall. It's a *trompe-l'oeil*. You 'thunk' it was real but it was something else. The theme is continued inside with photo-images using mannequins and models. Because you have to work to see the images, *thunk* highlights text by invited contributors. But in order to get the full picture you need to see the images. navyblue Development Manager and *thunk* editor Chris Bird explains the rationale of *thunk*, 'We wanted to acknowledge the part collaboration plays in the way we work. Because we wanted to put the words first, we used 'recessive' typography (Helvetica) and hid the colour imagery in the folds. The vacuum packing changed *thunk* – made it stiff and card-like. Puncturing it and releasing the 'softness' was part of the interaction.' You thunk it was hard but in fact it is soft.

For agencies who use self-promotion as a kind of creative sabbatical, the measure of success doesn't depend on whether people notice it or even like it. Self-promotion is an exercise in self-understanding. As Bird says 'It is easier to be objective about a client and create strategic solutions. But this was about us, and of course we were subjective, we did all the things we'd never do with a client (hopefully) from running over time to running away with the budget. And we argued. But it told us something about ourselves.' →

thunk

01.01
Editor
navyblue

thunk is for you: we invite you to take from it what you want.

navyblue
UK, 2000
Thunk package and spread.

untitled

01.08

Author
Greg Sheridan

I'm in a bit of a two 'n' eight. Actually a very big two 'n' eight. Granny Smith's finest. A place where hot means hot, where over hard means flipped and solid, and where the word sorry is anathema. Three days on the trot, literally, from 102 floors up to somewhere Downtown. Roads the size of Rhodes (well almost). 4 X 4s that really are about 16 times bigger than those over here, and club sandwiches that make you feel like you're eight months gone. It was my first time, so no points for guessing which airline I chose to whisk me off to Jaffa Cake, New York, New York, so good they named it. But even if they hadn't, I'd have still known exactly where I was. The buck starts here. So too does Starbucks, mind the ___ (they're everywhere), and urbanfetch.com, Urban Outfitters and urbanality. The weather was on its best behaviour, but you could have walked for/four miles before realising that the sun was actually shining. Breakfast at nine. 4 and 6, 46th St. Seventh heaven in Seventh Ave. Up to Blooming(hell)dales and MoMA. She's making eyes at me. Down to Gramercy for drinks. Greenwich Village for dinner. And SoHoHoHo to bed. Exhausting? You bet. Little wonder then that in the city that never sleeps we were out like a light. Until next time.

E greg@milkncsugar.com

2000
A year in the life of
Atelier Works

howdah

Atelier Works
UK, 2001
Howdah

054.055

Atelier Works
The graphic exploratory

Profile by Hugh Pearman,
design and architecture critic
for the *Sunday Times*

Smut the dog – a pure Jack Russell terrier and the embodiment of His Master's Voice – appears to be the office manager, or possibly the receptionist. Smut greets everyone who visits Atelier Works in the former piano showroom which is presently its base. The affable dog, attached to Atelier's co-founder Quentin Newark, is one of two slightly subversive devices encountered on arrival. The other, displayed just inside the door like an exhibit at the Design Museum, is a genuine, fully functional, ancient, oil-dripping Douglas motorcycle: property of the outfit's other co-founder, John Powner.

These living and mechanical creatures, both with illustrious pedigrees, tell you plenty about the character of Atelier Works. You are not, it is clear, engaging with any kind of bland corporate enterprise. The enthusiasms of people here are not separated from their work. Their studio, with its part-brick, part-panelled walls, lofty ceiling and cast-iron columns, echoes that character. In the meeting room, for instance, you find the original, sumptuously carved and decorated entrance doors of the erstwhile showroom. They have been brought inside for safe keeping, given a new function as sliding doors for a cupboard, but are actually there on the wall to look at. Makes sense: if you're inside a place, you can't normally see the architecture of the exterior. At Atelier Works, you can. It's part of the policy of owning these own premises, feeling a commitment to their workspace. But of course, being successful, Atelier needs to expand. At the time of our meeting, Atelier was thinking of finding a pub to convert, or even designing a new building. Which would involve other design disciplines. Which, in turn, is a long-term aim.

Pedigree – it's so important. Then again, if you have it, you can't escape it. Three of the four directors, for

Atelier Works 5

Smut

instance, originally came from the Pentagram stable. That's Quentin Newark, John Powner and Mette Heinz, wife of Quentin. The fourth, Ian Chilvers, started at publishers Faber and Faber – which has a strong connection with Pentagram, and is also an alma mater of Newark – before going on to a long stint at CDT, where he was made a director. Now if you know Pentagram and its history, you see its influence all over Atelier Works – not so much in style, but certainly in approach, and that desire for inclusiveness, pulling in and working with the other disciplines, even the desire to purpose-design the next premises. Pentagram was and still is in some senses an international training school for designers, a very English commercialised version of the Bauhaus, but it had its minus as well as its plus points. On the one hand, Newark and Powner have a reverence bordering on awe for their old masters there – in particular the éminence grise of British graphic design, Alan Fletcher. On the other hand, there was a downside to working for such a big practice, which was being, individually, small cogs

Alan Fletcher

Type faces

Christmas presence
As a treat for Christmas, rather than squander a lot of money on a bad meal, we squandered a lot of money on two days in Alan Kitching's TypoWorkshop in Clerkenwell. Using metal and wooden type, some of it 200 years old, we each made a self-portrait.

John Powner
John dismantles motorbikes. He lifts out the engine and takes every little bit apart, unscrews the frame, and lays all the elements out neatly until it doesn't resemble a bike at all. Then he cleans everything with wire brushes and lethal chemicals. (This takes weeks and weeks to do.) Then he puts it all back together. This ability to keep a picture of how everything comes together, combined with a fakir's patience, is how he steers his way through wildly complex design projects. This, and a withering hatred of meaningless flourishes and fandangles.
Written by Quentin

Ian Chilvers
Recently, I noticed a discreet ironed crease on the sleeve of Ian's cardigan. Carefully coordinated with a roll-neck sweater (also immaculate), I realised that this man thinks a lot about things. In his consultancy work for Volkswagen UK, he is known as the 'detailmeister' – though predictably perhaps, he refuses to wear the white lab coat. Ian's calm and wise demeanour sometimes belie his passion for creative work, his great sense of humour and astounding stamina for achieving the things he believes in.
Written by John

Quentin Newark
Any general will tell you that by establishing a position on the top of a hill he will have a strategic advantage. From here, he can control the ground his troops have already covered, while at the same time he is also in the ideal position to plan the campaign ahead. When you meet him for the first time you'll notice that he is tall. Very tall. It means that he can select those books from the shelves that other designers have no hope of reaching.
Written by Ian

Mette Heinz
Mette is a walking, talking Danish army knife! She has a certain magician's style as she whips items from her bag; tea pots, cakes, photography, illustrations, paper coats and denim skirts... "Where did you get that from Mette" I ask. "I made it" she replies.
Written by Natalie

Smut
Morning treat, sleep on a lap, bark, eat, sleep, sleep, bark at the couriers, sniff a client, jump, pull trouser legs, run round and round the park, chase a cat, drink water, sleep, sleep, when can I go home? bark!, bark!

→ **Typefaces**

At Atelier Works self-analysis takes a graphic form of body-mapping. The idea behind their work is that there is no single idea. Each project is approached as a particular set of problems, each one is designed individually – uniquely – without recourse to formulae or pet styles. How do I know this? It's what it says in the introduction to *howdah*, a portfolio of their work in 2000.

The immense difficulty in creating a narrative around self-promotional works is not to sound too vain, too self-congratulatory or too self-obsessed by picking up on the details that are really too personal, that no one is really interested in. Like sitting on a plane listening to a convivial stranger who suddenly decides to show you his collection of sex-toys. You don't really want to go there.

Self-promotional material that veers away from displaying or analysing the work made, to get into the personalities involved, can seem conceited. Like Pentagram's self-promotional book *Pentagram 5*, Atelier Works' *howdah*, whose introduction is by The *Sunday Times* architecture and design critic Hugh Pearman, comes close to getting a little too pally. Again, like *Pentagram 5* it's only true of the introduction where the text's interest in the personalities and working environment is distracting.

But there are two things that make *howdah* work. The first is the simple presentation of a varied body of work. The book format gives a formal unity to an assorted set of projects that you wouldn't necessarily get from a brochure. Bags, books and buildings are all featured with text simply documenting the client and design approach. However, what really makes *howdah* stand out is a section called 'typefaces' at the end. These typefaces were specially commissioned, 'as a treat for Christmas, rather than squander a lot of money on a bad meal, we squandered a lot of money on two days in Alan Kitching's TypoWorkshop in Clerkenwell. Using metal and wooden type, some of it 200 years old, we each made a self-portrait.'

It's certainly the most charming feature of *howdah* and makes the chummy introduction redundant. Each typeface has text underneath by a colleague. Though the introduction talks about the family atmosphere at the studio it's this section, conceived and designed by the designers themselves that makes an impression, that paints a picture of the professional life behind the work.

The title *howdah* itself stirs up mental associations with a kind of Texan or cowboy joviality 'Howdy!' In fact *howdah* was one of the words used on a carrier bag designed by Atelier for The Gilbert Collection. This is a decorative-arts collection held at Somerset House in London and the name *howdah* is the Urdu term for the seat and canopy on an elephant's back.

Throughout the catalogue each brief is clearly unpacked, and the decision-making behind the work is explained. By focusing on the personalities at the beginning and end of *howdah*, looking at studio life, Atelier Works gambled on the supposition that there was something to be gained by demystifying the idea of the design practice. In pitching for business potential clients can often feel threatened by the aura surrounding design or by the slick language used by advertising and marketing people. *Howdah* is aimed squarely at those fearful of the artiness of graphic design. →

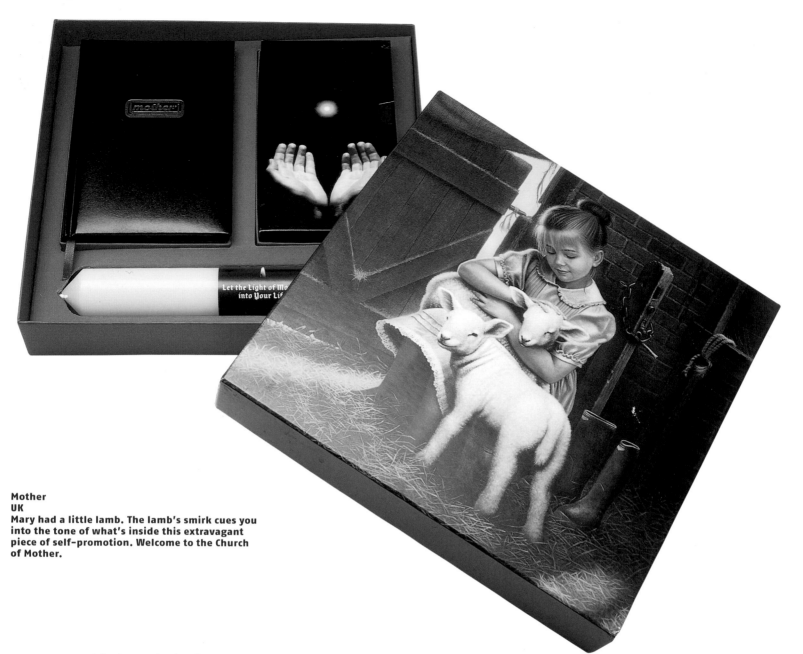

Mother
UK
Mary had a little lamb. The lamb's smirk cues you into the tone of what's inside this extravagant piece of self-promotion. Welcome to the Church of Mother.

→ **Designer priesthood**
London's design agency Mother on the other hand parodies the idea of the cliquish design group.

Their promotional material comes in a square box. On the cover is an illustration of a young girl sitting in a straw-covered barn, stroking a lamb. There's a soft golden glow radiating from outside.

There's one element of the illustration on the box that clues you in to the fact it's not borrowed from sentimental thrift-store art. It's the lamb smirking at you. It's queasy. It's a tone that's not unpleasant, just off centre.

By the end of the 1990s Mother were cleaning up award ceremonies. To grasp the idea and tone behind their work you have to look back to the change in British youth culture in the '90s. The style decade was dead and buried, and a loud, casual, freewheeling culture pushed its way to the front of the queue. It was the era of *Loaded* magazine, Damien Hirst, Oasis, Irving Welsh and The Prodigy.

It's the boisterous tone of this culture that Mother brought to the world of design and advertising.

And this is what they are selling with their self-promotional 'chocolate box'. But it's not really a chocolate box. Open it up and inside the video, the bible and the candle welcome you to the cult of Mother. Using biblical language the book begins with the creation myth of Mother, beginning with the four founders. The illustration used to picture each 'Prophet' makes them look like a waxwork from Tussaud's.

The plundering of design styles in the spreads conveys exactly the Mother creative ethos. It's highly ornamental, even baroque in a similar vein to Jeff Koons. The company philosophy appears on pages with simple black-and-white comic book illustrations. Mother clients are photographed in their office offering endorsements that hover between the kind of straplines for dog-food ads and cultish propaganda.

The Likeable
The staff, the 'brothers' and 'sisters', are pictured in passport-size mugshots, all wearing white shirts. The core of the cult of Mother's belief system is displayed in a comic-book illustration called 'The Shining Path of Mother. Chapter 3: New Populism'. A thought bubble floats above people on motorised ski-sledges. 'We produce communication, which involves the consumer. Whilst talking to a specific group it should be accessible to all. *The Simpsons* is written for teenagers and twenty-somethings. It appeals to everyone from five to 95. Why? Because it's brilliant. It pinpoints the highest common denominator, not the lowest, and then delivers against it brilliantly. Our work is likeable.'

You can see this in the showcase spreads of their poster work, such as the D&AD award-winning campaign for Britart.com. The copy on the poster uses the format of titling of an artwork in a gallery:

'*Car Park 1975
tarmac, oil, urine, cigarette packets, used condoms.
6000 x 8000cm
Monumental canvas stained with the droppings of iron sheep.*'

The slogan is 'art you can buy britart.com.' The dot in britart.com is red like the sticker that signifies that a painting has been sold. The poster samples a style, and is sure of the 'likeability' of its humour to parody the product, contemporary art, it is actually selling.

The video in the chocolate box displays a short showreel of their TV ads, from the Dr. Pepper's campaign 'what's the worst that can happen' to the parody of '70s fashion in adverts for Pimms. At times it seems as if the product merely plays the straight man to the ad's humour. The product is what Alfred Hitchcock called a 'Maguffin'. It's simply a device to get a story going. Because of this their straight-talking marketing approach is combined with design that is remarkably decorative and highly ornamental.

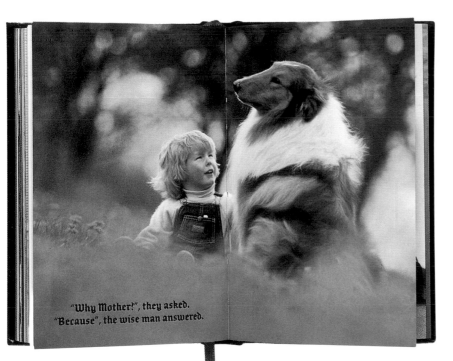

"Why Mother?", they asked.
"Because", the wise man answered.

The Book of Stef

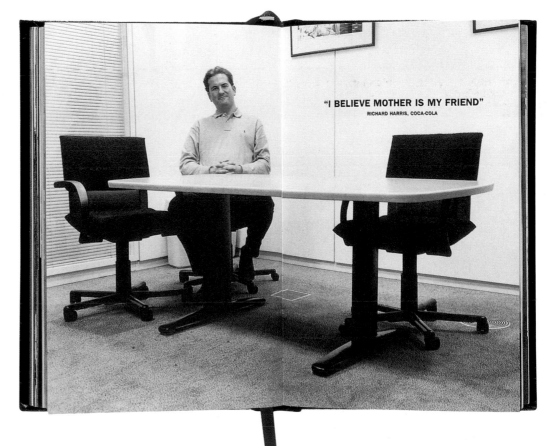

"I BELIEVE MOTHER IS MY FRIEND"

RICHARD HARRIS, COCA-COLA

The best reference point for this tone of work, a mixture of fun, genre parody and sampling, is the uniquely British mid-1990s music culture of Big Beat, of musicians like Fatboy Slim, The Chemical Brothers and The Propellerheads. Unlike the increasingly anal electronica and techno, Big Beat sold fun. As music theorist Simon Reynolds wrote, Big Beat was criticised as being rock'n'roll 'tarted up with ideas ripped off techno and house, or trad rockers dismissing it as inane party music without the redemptive resonance of your Verves and Radioheads. Guilty as charged on both counts, for sure – but so what? Big Beat's sole *raison d'être* is to generate excitement and intensity.'

And this is what Mother presents to a genre-wise, media-wise generation clued into marketing strategies, street-educated in design culture from the sleeves, flyers and T-shirts of club culture. In an age when overselling a product is the norm, simply being 'likeable' is an attention grabber.

→

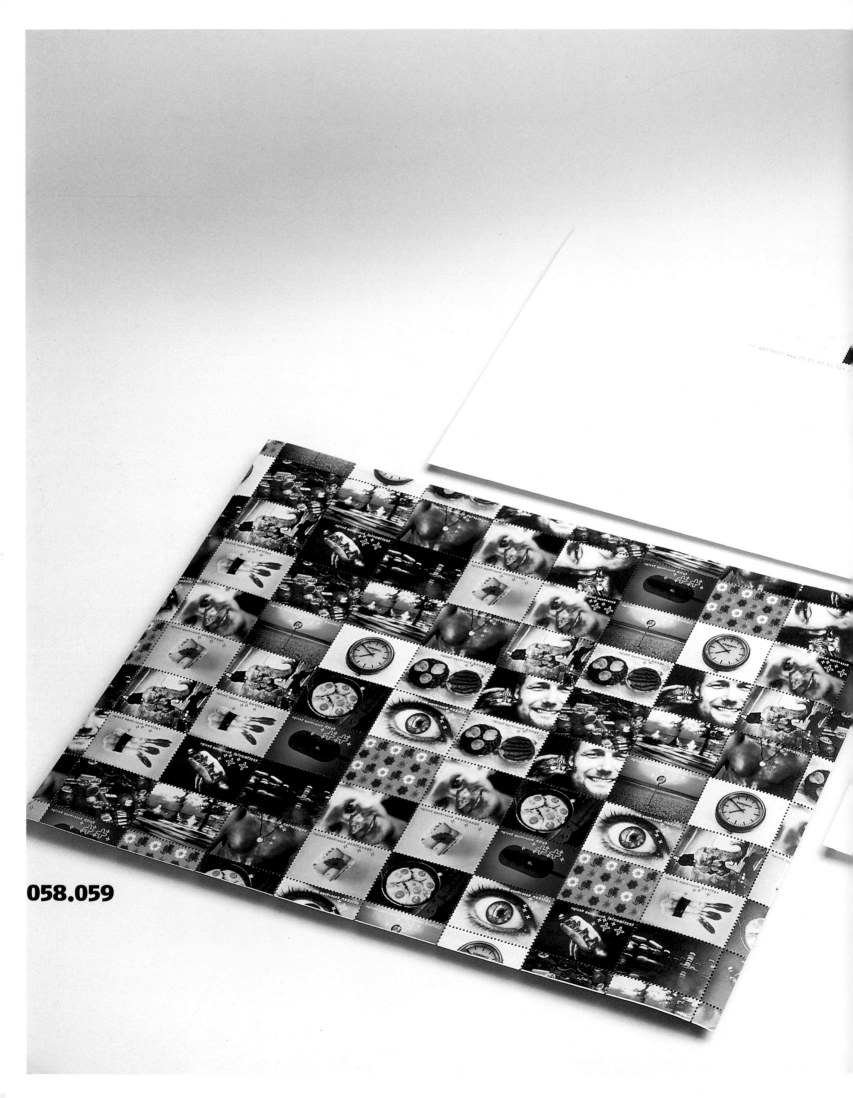

058.059

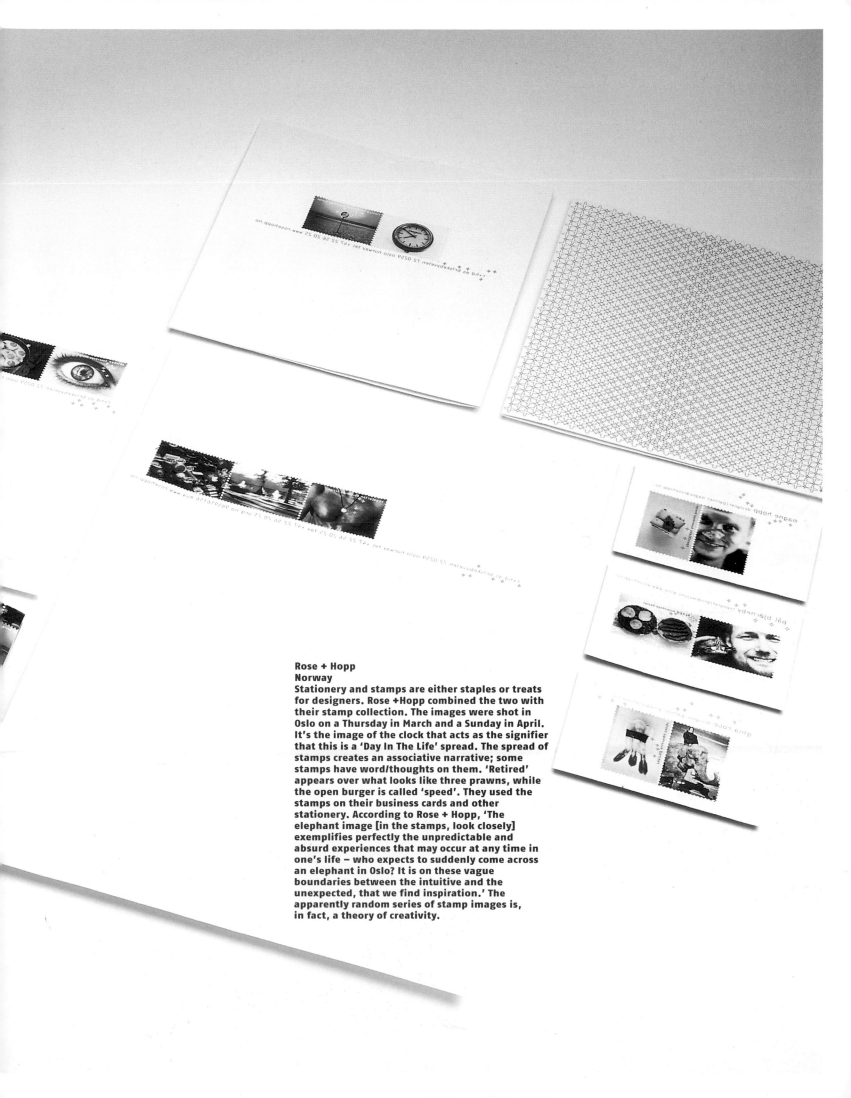

Rose + Hopp
Norway
Stationery and stamps are either staples or treats for designers. Rose +Hopp combined the two with their stamp collection. The images were shot in Oslo on a Thursday in March and a Sunday in April. It's the image of the clock that acts as the signifier that this is a 'Day In The Life' spread. The spread of stamps creates an associative narrative; some stamps have word/thoughts on them. 'Retired' appears over what looks like three prawns, while the open burger is called 'speed'. They used the stamps on their business cards and other stationery. According to Rose + Hopp, 'The elephant image [in the stamps, look closely] exemplifies perfectly the unpredictable and absurd experiences that may occur at any time in one's life – who expects to suddenly come across an elephant in Oslo? It is on these vague boundaries between the intuitive and the unexpected, that we find inspiration.' The apparently random series of stamp images is, in fact, a theory of creativity.

→ **Generic designers**

There's something appealingly generic about Browns. Their series of papers are called *Browns*. Unlike Atelier Works, they have adopted the personality of depersonalisation. It's not that their communications give the impression of being cold or haughty or distant. And if Mother are a priesthood, so are Browns, but the trappings (or lack of them) are different. There's a quiet humour to the covers of their annual newsletters. The first presents an image of the three partners, backs to the camera, facing a brown background. Newsletter 2, called *Paper 2*, has on the front a picture of 'Morritz', an award-winning braunvieh bull. 'Morritz' is brown. *Paper 3*'s cover is a class photo of a group of schoolgirls, wearing their brown uniform.

The newsletters feature the agency's work and the size of the pages allows for a mix of poster-size images along with an extensive display of spreads from catalogues, brochures and books they have done for clients or for themselves. What's clever about Browns is the way they have packaged themselves as the plain, starting with the name itself: 'Browns'. It's plain, brown. There's an aesthetic of the nondescript, of the self-effacing, which is communicated in their design and in their book publications. They are the Amish of graphic design. If you are in doubt just look at those covers again. A cow. A class photo. The elders who won't let their image be reproduced.

The editorial of their first newsletter is a mission statement describing the beliefs behind the new company: 'despite all the advantages of digital communications, the need for one thing was becoming increasingly clear – simplicity. Our world of fresh opportunities and new ways →

Browns, UK, 1999.
Paper 1. The London Bridge Amish stand backs to the camera.

060.061

Browns
UK, 2000
Paper 2
A cow (left)

Browns
UK, 2001
Paper 3
Brown nostalgia (above)

Browns
UK, 1999
Paper 1 opens up into a poster for a lecture given by one of the partners entitled 'make sense of it all'. (right)

make sense of it all
a browns perspective
jonathan ellery
falmouth college of arts
main lecture theatre
friday 21st may
2.00pm 1999

atelierbrownscdtdesign

houseergofarrowgra

phicthoughtfacilityhg

vimaginationjannuzzi

smithkaye(tony)lambi

enairnmufnorthomnifi

cpentagramquay(davi

d)randsastomatounav

incefrostwolffolinsxya

mamotozigguratmake

senseofitall★◉➜✳!@?

screen printed by artomatic 0181 896 6666 paper supplied by fedrigoni 0541 555 517 printed on sirio

→ to communicate was also suffering from information obfuscation. Annual reports full of meaningless graphic decoration and no real content, websites cluttered with layers of irrelevant detritus and identities with little or no thought to their potential longevity.' Just to make it clear and simple all of this is written in at least a point-20 typesize.

You could argue that this is the kind of vague sentiment that everyone could sign up to.

'Simplicity' is a feeling in search of a more rigorous aesthetic. It displays a kind of corporate inoffensiveness designed not to scare off clients. There's a tone of voice in corporate copy, pensions, banks; no matter how chatty and informal all have this tone that is so reassuring it becomes kind of creepy. Call it 'Stepford Copy'.

This language and its relationship to the design says either one of two things. That the scaled-down aesthetic of Browns

is a bit too polished. The Amish attitude is a bit too shiny. Alternatively the copy is a slightly more long-winded way of communicating the kinds of things they do with their design and in their books. What Browns is about is not 'simplicity' but 'dressing down'. It's as much an affectation as dressing up things, or as decorative, but it's a fascinating aesthetic that is communicated in the subject matter of the books they publish.

Minus Sixteen is a collection of photography by Robin Broadbent. The title comes from the temperature on one cold Scottish night, when Broadbent went out and shot images of the ice on the lock. In basic terms it's about the formal properties of ice. How cool is that? The black-and-white photos of the frozen lock sometimes resemble scientific plates of molecules, sometimes foliage. The crystalline ice textures float like stars in the cosmos.

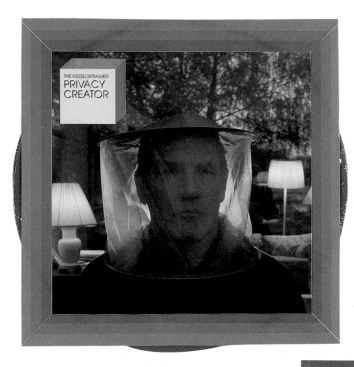

**KesselsKramer
Netherlands**
Privacy Creator. **Joke-shop design from the Dutch pranksters.**

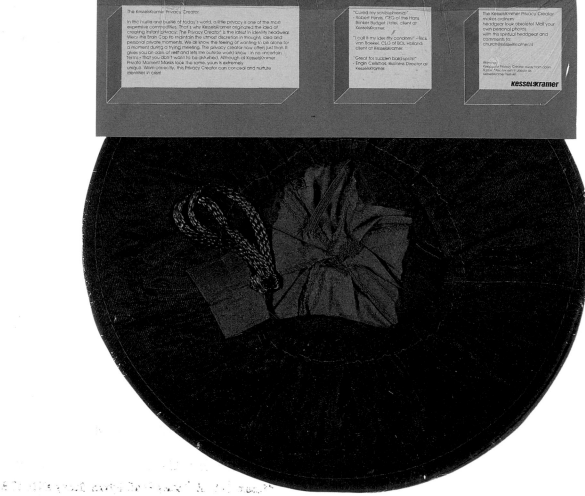

062.063

Minus Sixteen is an illustration of what happens when the simple becomes complex, revealing something richer and less fixed.

Broadbent is also the photographer of *Marmalade*, another set of black-and-white photos. The spreads show abstract details of buildings and landscapes from around the world. It's an abstract travelogue whose only slice of colour is the close-up of marmalade shot in Hoxton, London. The one, soft,

warm orange in the middle of the harsh monochromes suggest the simple comforts of home.

There's no questioning the quality of Broadbent's work but their most outstanding publication is *Notes from a Cold Climate*. It was published to coincide with the world premiere of Sir Peter Maxwell Davies' *Antarctic Symphony No. 8*. Davies was invited by the British Antarctic Survey and the Philharmonia orchestra to commemorate an

earlier work. In 1948, *Scott of the Antarctic*, starring John Mills, emerged out of Ealing Studios with a score by Vaughan Williams. *Notes from a Cold Climate* contains the diary of Maxwell Davies and some awe-inspiring photography by Peter Bucktrout, a member of the British Antarctic Survey. The spectacular photography is carefully paced throughout by considered design elements: changes in paper quality and colour; finely-lined images like a

note-pad, as if they were the photographic memory of the diarist; icescapes broken up by geometric panels on the image that give a sense of materiality and texture, that break up the dreaminess of this strange frozen place; a scribbled handwritten diary entry opposite an image of a frozen peak, giving a sense of human scale to set against the vast range of the ice-mountain.

What could so easily have been a coffee-table book is →

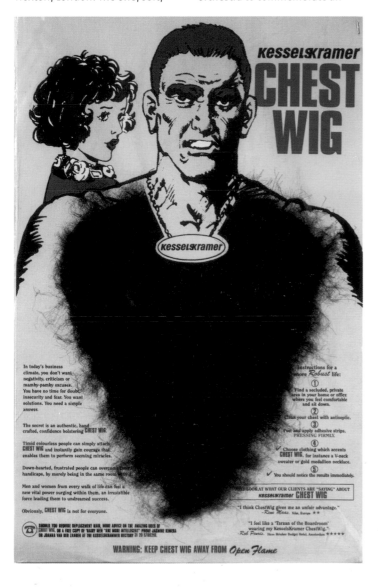

KesselsKramer
Netherlands
Travel back in time with this sexy chest-wig.

KesselsKramer
Netherlands
Tasteful badge from Kesselskramer.

Delikatessen
Germany, 1998
For this self-promotional mailing, 'An original
Action Man doll was newly dressed and equipped
with a small portfolio. The package was renewed
but the design and tonality parodies the original.'
'Good Agency Man' puts his credit card behind the
bar at Christmas parties. 'Bad Agency Man' wants
the client's annual report ready by 8 am the
morning after.

064.065

→ transformed by graphic design into an object of extraordinary beauty. There is real ambition behind this work that isn't simply due to the dramatic content. The self-effacing quietude of Browns' publications serves to draw attention to the underlying Amish aesthetic of their papers. It's as if in their work 'looking' itself becomes an act of modesty rather than a shameless act of voyeurism. And exhibitionism is not the behaviour of 'the elect'.

The design of suffering

Perhaps the designer who comes closest to seeing design as a quasi-religious act is Stefan Sagmeister. It's bound up with a vision of the 'suffering artist', an idea expressed by Thomas Mann in his story *Tristan*: 'But what is it, to be an artist? Nothing shows up the general human dislike of thinking, and man's innate craving to be comfortable, better than his attitude to this question. When these worthy people are affected by a work of art, they humbly say that that sort of thing is a "gift". And because in their innocence they assume beautiful and uplifting results must have beautiful and uplifting causes, they never dream that the "gift" in question is a very dubious affair and rests upon extremely sinister foundations.'

Nowadays, the romantic tradition of the suffering artist seems indulgent and even narcissistic. Why should an artist's suffering be any more profound than a bank manager's or teacher's? But despite the illogicality of it we are still in thrall to the idea of the suffering artist. Magazines and weekend newspaper supplements thrive on stories of actors, writers and artists bent out of shape by personal experience. The implication is that their art has in some way contributed to their suffering. In these stories, therapy of one kind or another provides the happy ending, allowing you to chew happily on your muesli. But what about the suffering designer?

This is the question posed by Stefan Sagmeister in two works: his famous sacrificial poster for an AIGA talk he was giving in 1999, and the spread for the *WhereIsHere* book, designed by Laurie and Scott Makela.

The AIGA poster materialised from the idea of a 'body of work'. Part self-mutilation, self-flagellation and catharsis, Sagmeister art directed a work where, over a period of eight hours, the intern at his studio carved and cut out a design on Sagmeister's torso.

According to Sagmeister the concept was to literalise the idea of the suffering artist, to communicate the anxiety and despair designers go through: 'We tried to visualise the pain that seems to accompany most of our design projects.' Extreme? Ironic? Serious? In Sagmeister's terms it's about communicating the human effort and will involved in graphic design which, on the surface is simply a commercial transaction.

Sagmeister's act is given as some sort of evidence. It's extreme nature is proof of something. But proof of what? Is it the design equivalent of the missing Manic Street Preachers' guitarist Richey Edwards' self-mutilation. When confronted by a journalist who questioned the authenticity of

Stefan Sagmeister
US, 2001
WhereIsHere spreads. Art and design slug it out
over Sagmeister's body.

'But what is it, to be an artist?'

Thomas Mann

the band's attitude, Edwards responded by cutting the words '4-real' into his own arm. How real is a designer's suffering? Why shouldn't designers have access to the same psychological vocabulary as artists? Is suffering Sagmeister's equivalent of Paul Rand's play? In some ways Sagmeister's explanation that it's about creative suffering, draws you away from what's really going on. It's too easy. Perhaps frightened by the act itself, it's as if he daren't look too deeply for the motivation.

Image bleed

In *Made You Look*, the monograph on Sagmeister, it is suggested that the image made an impact, not just because it looks painful, but because in some respects it was the revenge of the designer in the age of computer-generated design. The poster 'signalled a turning point for the design profession, away from aspirations of digital perfection toward a higher appreciation for a designer's personal mark. Twelve years of computer-driven design had initiated a backlash in favour [sic] of the tactile and hand-hewn – anything that showed physical evidence of a creator and evoked an equally physical response, even repulsion.'

It's an interesting and persuasive argument. But human flesh, raw, cut, ripped, is provocative at any time. It is manipulative (which is no surprise. The title of his monograph is *Made You Look*). It creates a chain of possible meanings: it's a visual metaphor of the concept of 'cutting edge'; it's a challenge. What are you →

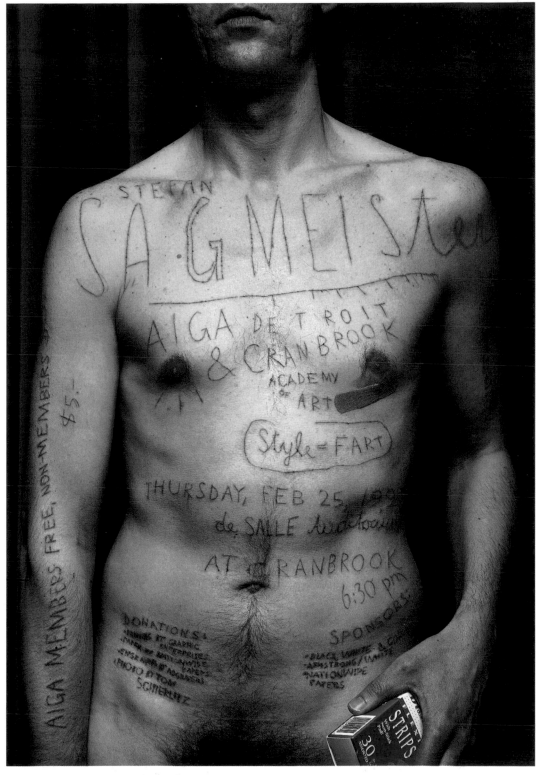

Stefan Sagmeister
US, 2001
You know the feeling when you go looking for a plaster and the box is always empty? Sagmeister's AIGA Detroit poster.

→ prepared to do? How far will you go for your work?; it's just fetishism; it's the work of a body architect; it's a fantasy of permanence in the age of the throwaway and transient. In an age of complete and total commodification, where everything can be bought and sold and has a price, our own bodies are the last refuge of the powerless. The poster says all these things. And what's more, like the blood seeping from Sagmeister's wounds, the meaning drips away.

The meaning of the image finally pours through the top of the poster, where the brief glimpse of the face acts as an invitation, almost giving us a picture of the man who would mutilate himself, who would own this act, then give it meaning. But in an act of complete abjection, the image of the face is severed, cut, and the whole poster is an image of incompleteness. Despite the queasy fascination of the body cutting, everything in the image is drawn upwards towards its disappearance. It's not that Sagmeister disowns the image by not showing his face, it's just that it's an extreme image of self-alienation.

Sagmeister produced an equally disturbing body image for the *WhereIsHere* book designed by Laurie and Scott Makela. Called *Art vs Design*, the arms and legs form an 'X', while two extra arms appearing from the top of the torso and the crotch confront each other. It's an angry image, a picture of mutual animosity, a war taking place over the designer's body which is in a kind of freeform crucifixion. There's obviously a sense in which this conflict between work and play is being played out in Sagmeister. It culminated in a decision to take a year out in 2000, 'a year without clients', doing his own work. Even the title page of his monograph

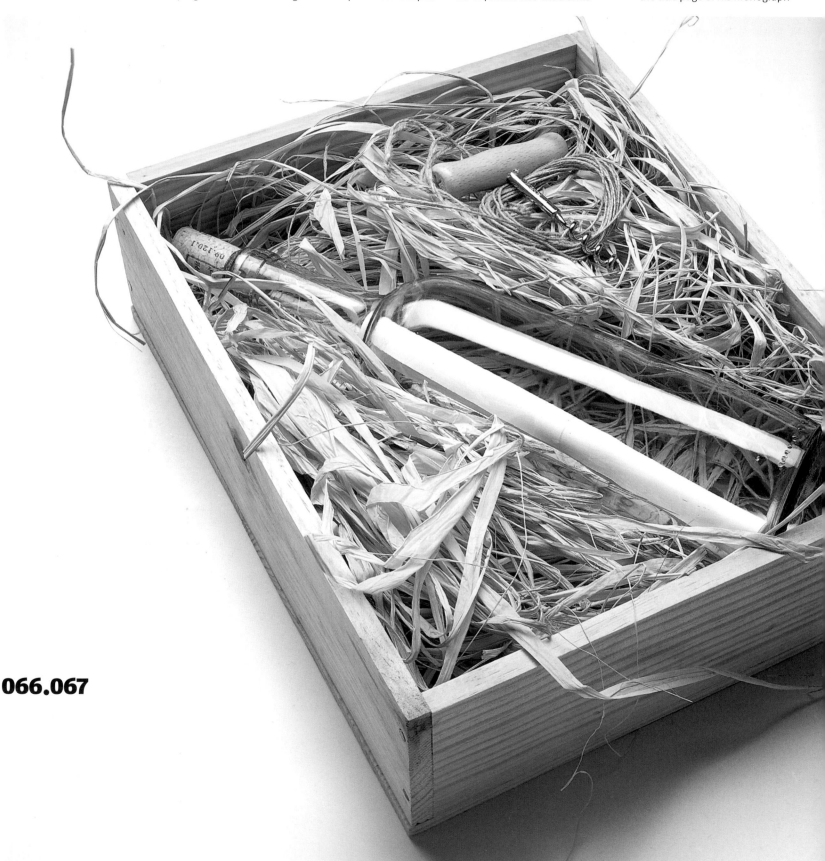

has a handwritten subtitle: 'another self-indulgent design monograph'.

It's not that Sagmeister is a tortured soul or anything. His work is often just very funny, and has a lightness of touch. But his non-commissioned work has an ongoing 'auto-bio-graphical' quality to it. An invitation to a party for his 26th birthday was a simple line drawing of a man in a party hat, with a tumescent penis made out of a small black chain.

Shake the card and the penis would go flaccid. The text at the bottom of the card says 'Getting 26 and all excited'. His 30th-birthday invitation shows a series of photos of Sagmeister from each year since he was born.

Over the last decade, many have been critical of the cult of personality surrounding graphic design 'superstars'. But Sagmeister puts himself on stage as a design work, not as a design celebrity. His AIGA poster and *Art*

vs Design are some sort of benchmarks in the evolution of graphic-design history. They mark the eruption of the psychotic into graphic design. They are about a designer exploring the dislocation of mind and body, turning his body into something alien. Sagmeister wants to lay claim to the status of art for graphic design. Most importantly he knows that to do that he must do it within the terms of graphic design.

Message in a bottle…

Propeller
Germany, 2001
Will your message get through to your customers? This is the question asked and answered by this mailer from Propeller. The box was sent to marketing directors in the wine trade. The message in the bottle contains a fax.

Drop into Bath*
and see how we've grown.
Mytton Williams' new design studio:
15 St James's Parade Bath BA1 1UL
T 01225 442634 F 01225 442639

*a bowl of water will do

Mytton Williams
UK, 1996
**This early promotional piece establishes the style
of punning that is carried through in their later
work. The sponge was compressed, and printed on
top was an invitation to drop into Bath, where the
company, of course, is based.**

068.069

Mytton Williams
UK, 1999
This acrylic block called *Millennium Mailer* exploits the transparency of the material to create a visual pun. 'We printed the acrylic block on both sides, leaving one of the 'M's clear – linking the MM of millennium with the MW of the company's name when the block is turned over. The wording on the back refers recipients to the website where the concept is followed up as an animated gif.'

Mytton Williams
UK, 2001
Commemorating five years as a company, this poster, like the acrylic block, aligns the letters of the company with the roman numeral for the number five.

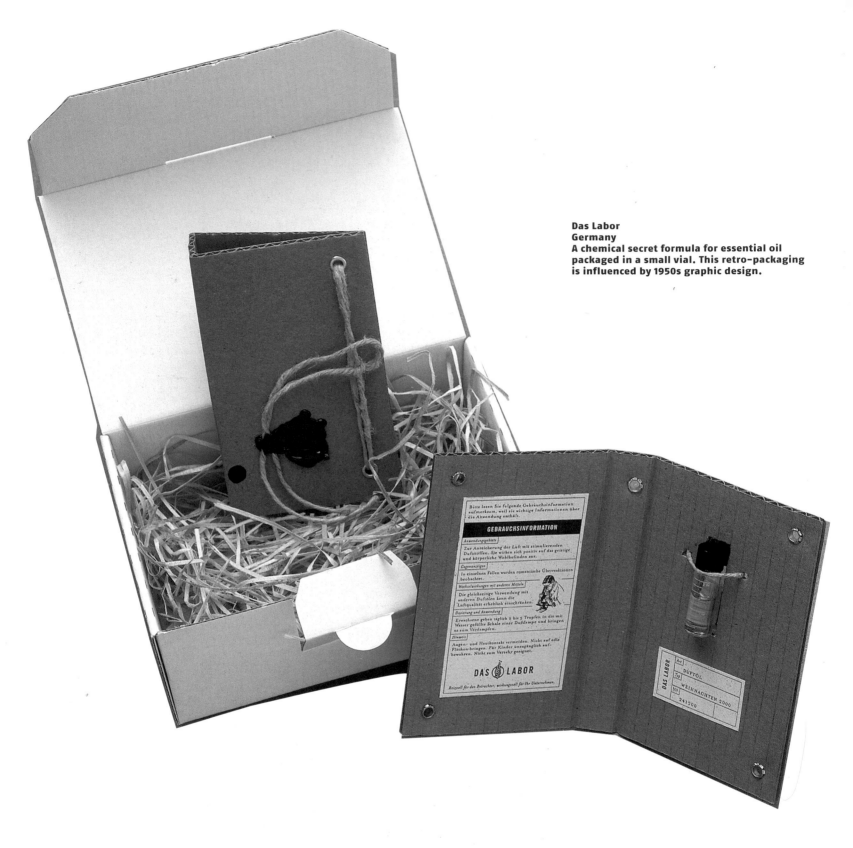

Das Labor
Germany
A chemical secret formula for essential oil
packaged in a small vial. This retro-packaging
is influenced by 1950s graphic design.

070.071

Alessandri Design
Austria, 2001
The portfolio as standard office equipment. The rolodex form was enlarged to fit bigger cards. Each piece of design fits into a category and you can see from the cards that the layout conforms to the bureaucratic structure of the rolodex system itself.

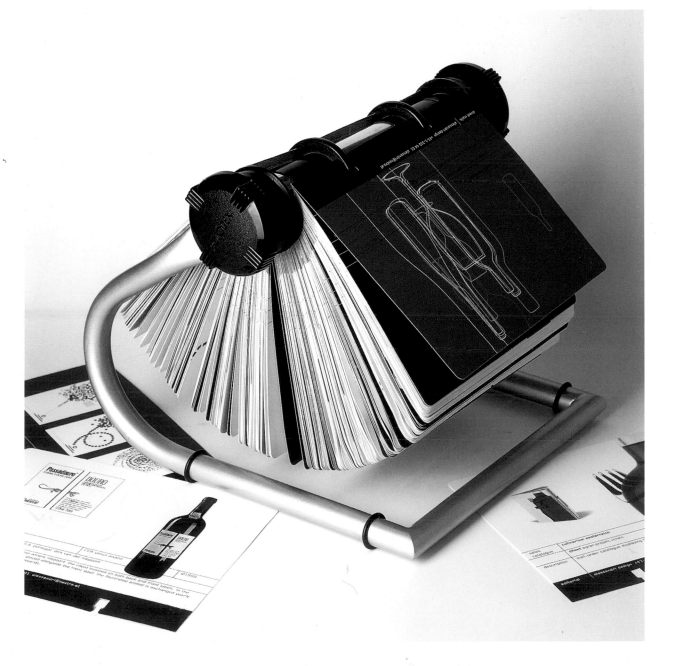

Form
UK, 1997
This filofax brochure contains a survey of Form's work. The cover is made from polypropylene screen-printed with silver, and their logo is die cut. The binder, which can be opened, allows Form to send updates of new work. What seems to be an act of optimism, that someone would keep and update the material, is offset by the fact that as an object it looks good enough to be a kind of shelf accessory.

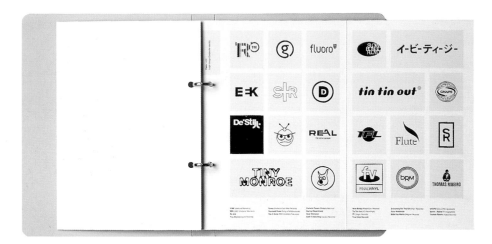

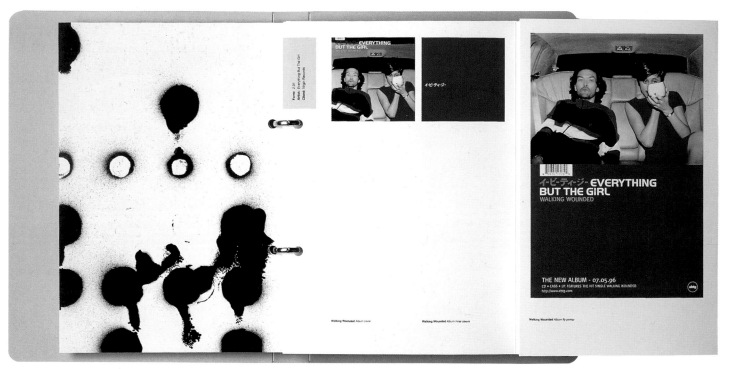

072.073

NB: Studios
UK, 2001
According to NB: Studios, choosing a pack of cards to display their portfolio was because 'it solved all the usual criteria of an agency portfolio – portable, expandable and updateable – but also enabled us to include a greater number of projects than might have been possible in a brochure.' It is an elegant solution but what really makes it work is its tactility. There's something about the nature of a pack of cards that makes you want to shuffle and fiddle with them.

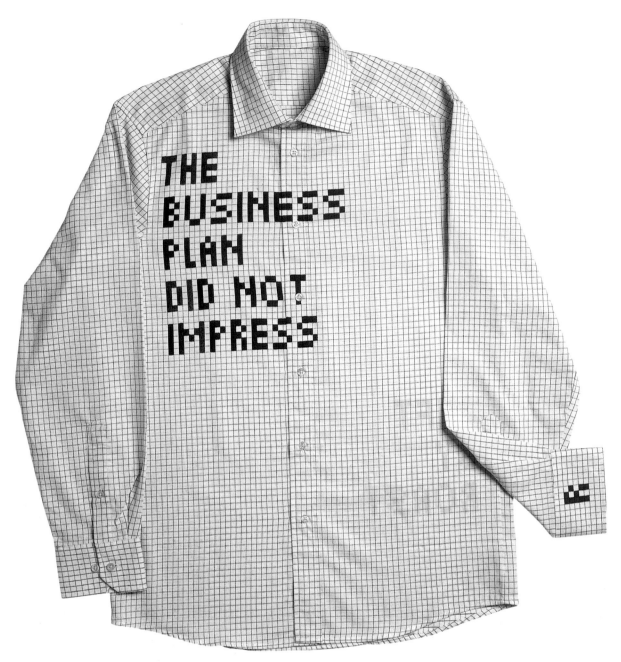

THE
BUSINESS
PLAN
DID NOT
IMPRESS

Roast
Norway, 2001
This *Business Shirt* comes sealed in newspaper
packaging made from the *Financial Times*. The
logo is a badge of honour for the underachiever.
It's hand-finished and comes in a variety of
colours and grid sizes. (See page 136.)

074.075

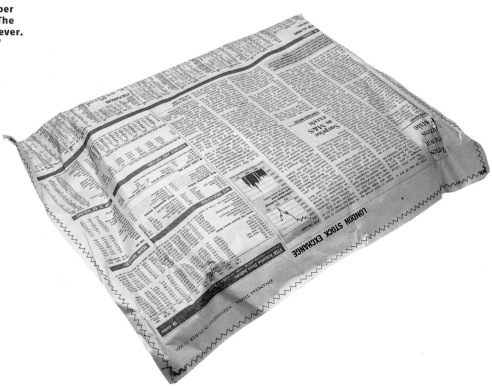

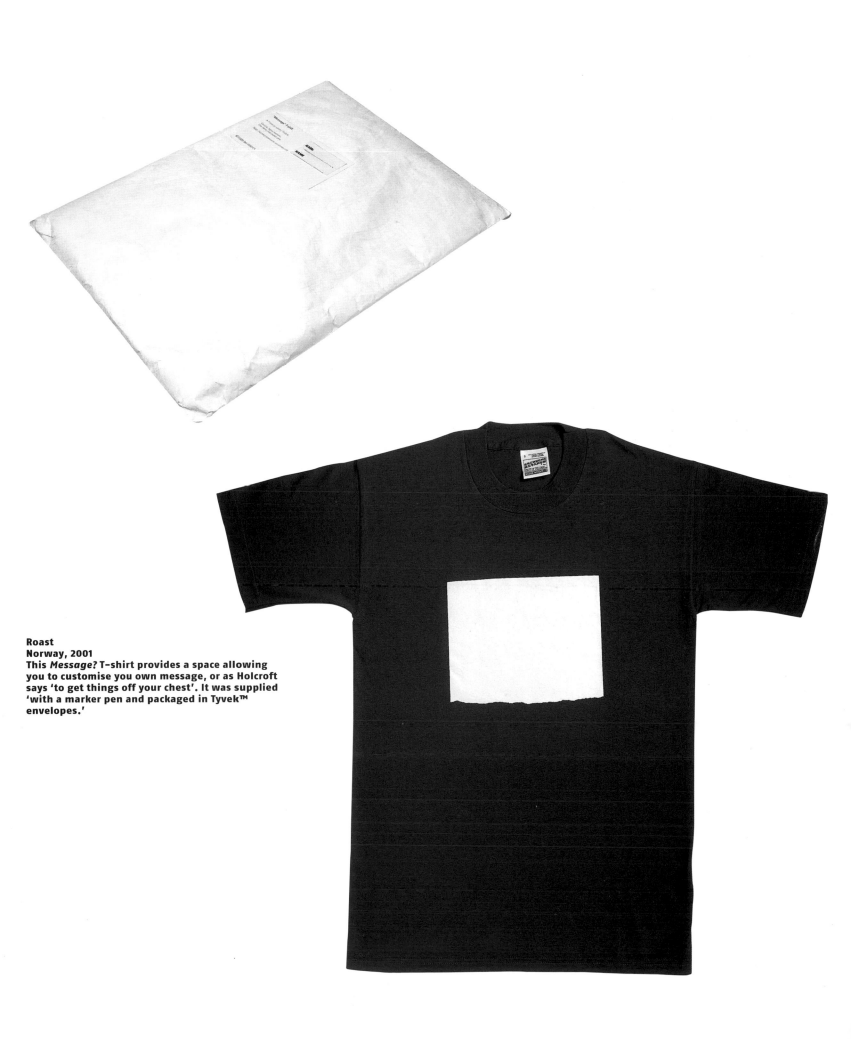

Roast
Norway, 2001
This *Message?* T-shirt provides a space allowing you to customise you own message, or as Holcroft says 'to get things off your chest'. It was supplied 'with a marker pen and packaged in Tyvek™ envelopes.'

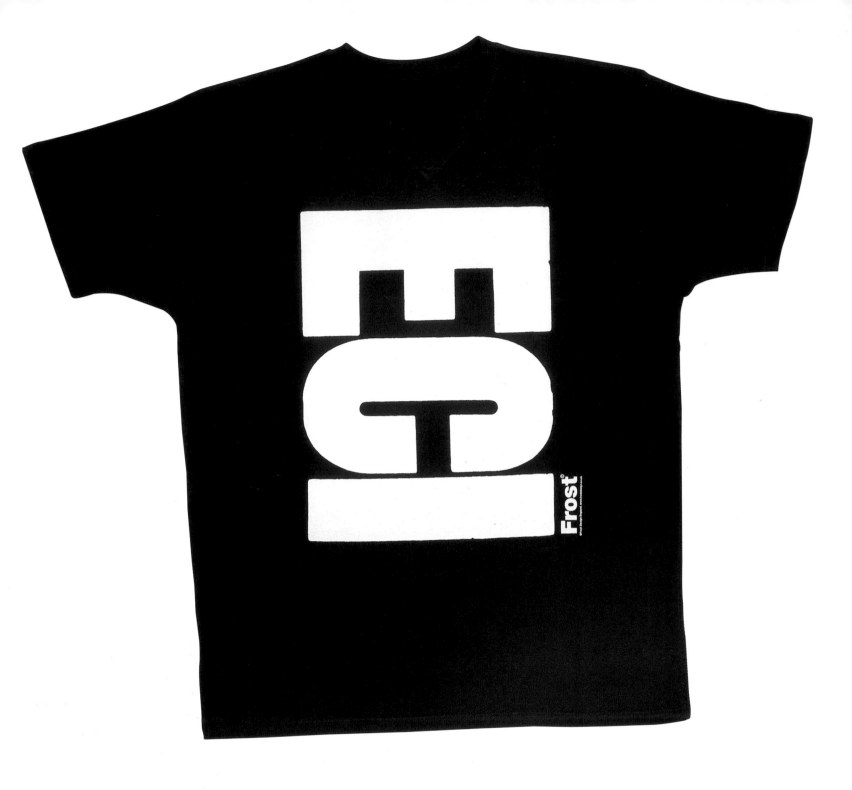

076.077

Vince Frost
UK, 2001
T-shirts from Vince Frost. Place, exclamation and
the pound sign turned into a T-shirt icon.

Form
UK, 2000
For the launch of a new range of T-shirts and to accompany the card mailer (see Messenger), Form created this T-shirt. The design on the front is like the computer information revealed on the card when you scratch the strip.

Intro
UK, 2001
It's easy to forget the unparalleled optimism of the so-called dotcom revolution. The dotcoms were like 'business ecstasy', inducing a mindless glee for new technology. This T-shirt inks over the word 'technology' while its graffiti script evokes the late '60s situationist sloganeering.

078.079

The misspelling of 'enivoroment' (which is difficult not to read as environment) bursts the bubble-headed bombast of the web evangelists.

Intro
UK, 2001
Utopianism from Intro? There can be few T-shirts that require close interpretation, but 'space. enivoroment utopia' were upbeat buzz words associated with the internet at the end of the century. This blind faith in the web is undermined by the black squares which spell out the word 'saad'. The misspelling of 'enivoroment' (which is difficult not to read as environment) bursts the bubble-headed bombast of the web evangelists.

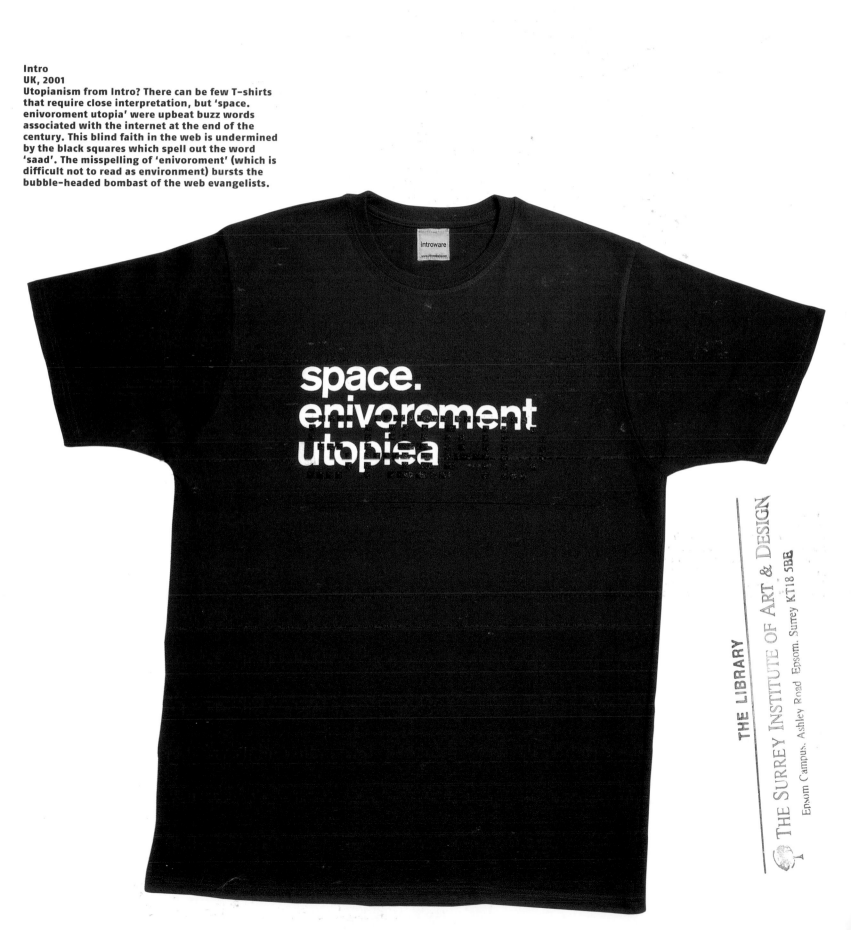

080 881

KesselsKramer,
Netherlands
'Do' T-Shirt project

03
the messenger

In Greek mythology Hermes was the messenger god. He was the postie who carried the messages of the gods to ordinary mortals. But he wasn't really a postie. He didn't just carry messages to mortals, he translated the message and he shaped it so it could be understood. Hermes was a designer. →

NB: Studio
UK, 1999
The DIY ethic of NB: Studio's Christmas card was so successful as a promotional material that they employed the same format for other occasions such as Valentine's Day and Mother's Day. The NB Studio's cards are a humorous deconstruction of the sentimentality of the traditional greetings card.

As media messages get more sophisticated the classic greetings card belongs to another age. It's a cliché that has somehow bypassed our age of cynicism. The mythology of the greetings card message is that the sentiment is from the heart, as if it has come from the sender. In fact, the message arises out of an industrial process. Pat Cadigan, the 'Queen of Cyberpunk Fiction' told me in an interview that she had worked in Hallmark cards for ten years. Each emotion, each area of feeling expressed in a card, had been assigned a four-digit serial number on an index card. She explained that she would get a request such as, 'we need a six-line verse; the main theme has to be "how much you mean" (HMYM) with a "wish for day" (WFD). There's wish for day, wish for life, wish for emotion. And they might add "Oh, and by the way, we have too many rhymes that end 'oo' or 'a' so none of those."'

The NB: Studio cards deconstruct the vocabulary of the 'greeting'. And it's not the case that putting the message together yourself makes it any more meaningful. The very act of taking apart the vocabulary of the greeting and making the sender 'stick' the pre-ordained sentiment together highlights the illusion at the heart of all greetings cards. The humour is in exposing and puncturing the myth.

084.085

→ The contemporary graphic designer shapes and forms the client's messages, translating the brutal 'buy this' into something more palatable. (Mercury, the Roman equivalent of Hermes, was also the god of merchants). But designers haven't just become an intermediary between business and the consumer. They are also our graphic chronologists. Designers mark time. Diaries, calendars and cards are all means of punctuating time. Designers are messengers of time and in this section we look at some examples of graphic design's most universal activity.

What's particularly interesting about the work created to mark time is the extent to which it is the result of a process, or system. The designer will have decided on a formula or set of rules, or will have let the rules be imposed by the material or circumstances. So, for example, Cartlidge Levene's Christmas card in 1998 substituted common signifiers of Christmas (Santa, Rudolph, baby Jesus and manger) with the postcodes of their entire Christmas-card list. The recipient of each card had their own postcard marked, which both personalised and customised the system. In 1999 the Christmas card collated the addresses of everyone at the company, listing where each employee spent Christmas Day since they were born.

The NB: Studio cards break up conventional messages and greetings into a set of stickers. You can paste your own greeting for Christmas, Mother's Day, passing your driving test, for any occasion whatsoever. It's as if the traditional form of greeting has broken down, buried under the weight of its own sentiment and cliché. In the absence of sentiment you get systems and lists.

→

The NB: Studio cards deconstruct the vocabulary of the 'greeting'.

Good Luck Sticker Set

exams · good · you · pass · flying colours · move · test · hope · love · with · new · fingers crossed · future · luck · job · thinking · wishes · best · better · of · for · the · your · charm

Marriage Sticker Set

great · happiest · rings · knot · shotgun · your · white · aisle · day · wish · marry · you · church · husband · wedding · you may · groom · bride · wife · best · the · have a · forever · kiss

Mother's/Father's Day Sticker Set

mother · are · thanks · best · parent · father · love · the · your · you · son · top · have a · ultimate · greatest · day · thinking · special · without · after · looking · most · daughter · years

No Thanks Sticker Set

you · over · being · f*** · nothing · bitch · waster · ass · the end · idiot · halfwit · no thanks · loser · are · son of a · numbskull · dumb · never · muppet · fool · twit · lazy · your · imbecile

Valentine's Sticker Set

valentine's · kitten · love · I · sexy · hate · fancy · kiss · x x x · forever · new · fingers crossed · be my · you · lick · desire · anonymous · lust · you're · want · my · I am · suck · it's

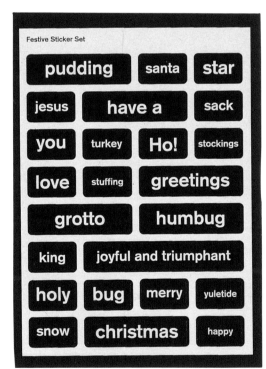

Festive Sticker Set

pudding · santa · star · jesus · have a · sack · you · turkey · Ho! · stockings · love · stuffing · greetings · grotto · humbug · king · joyful and triumphant · holy · bug · merry · yuletide · snow · christmas · happy

086.087

Have fun at Christmas with NB: Studio

5 縦書印字　8サ　40 字変換漢字変換　150×150mm

字※換漢字変換
FESTIVE ORIGAMI SET

throw
it™
かくすらてにか

MASTER THE ANCIENT JAPANESE ART OF PAPERFOLDING WITH
THE NB: STUDIO CHRISTMAS FESTIVE ORIGAMI SET

NB: Studio
UK, 2000
Taking their deconstructive technique a stage
further, the *Christmas Card 2000* was an origami
set including illustrated instructions on how to
make your own set of origami snowballs. It also
contained a Japanese translation for those who
couldn't calculate the trajectory to the bin.

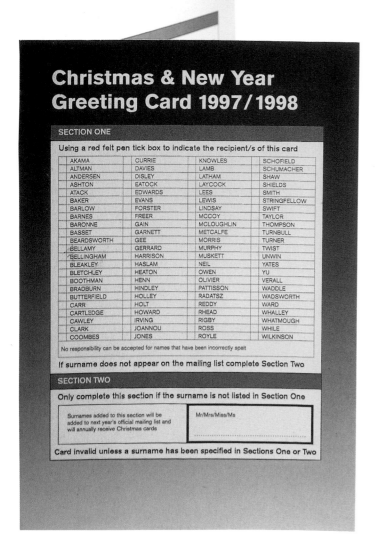

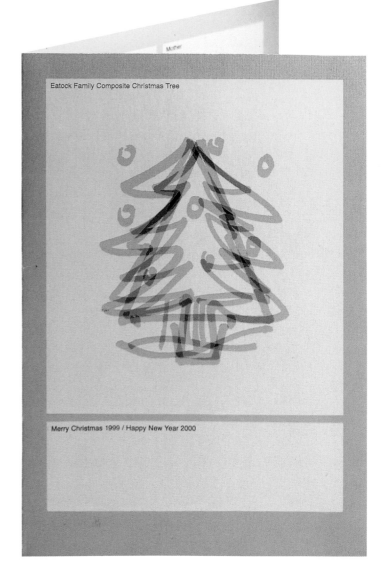

Foundation 33
UK, 1998
One of their *Utilitarian Greetings Cards*.

Foundation 33
UK, 1999
This *Composite Christmas-Tree Card* by Daniel
Eatock contains the four drawings of a Christmas
tree on the inside by his family, while the cover
merges each image.

088.089

'Say YES to fun and function and NO to seductive
imagery and colour!'

(Foundation 33)

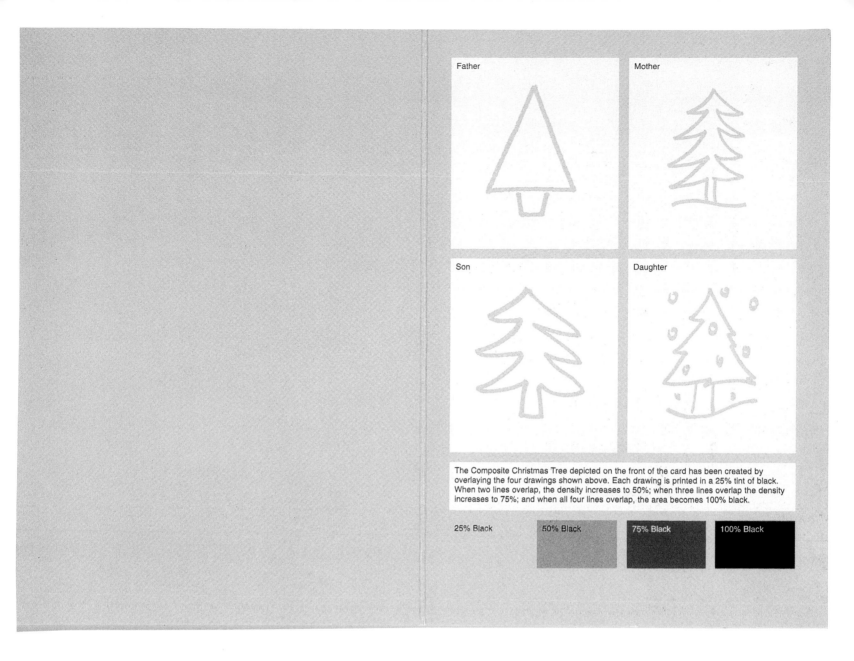

Father

Mother

Son

Daughter

The Composite Christmas Tree depicted on the front of the card has been created by overlaying the four drawings shown above. Each drawing is printed in a 25% tint of black. When two lines overlap, the density increases to 50%; when three lines overlap the density increases to 75%; and when all four lines overlap, the area becomes 100% black.

25% Black | 50% Black | 75% Black | 100% Black

→ Lists

Graphic designers are doing with cards what novelists and film-makers have done with narrative and storytelling. Take, for example, JG Ballard's emblematic extract from 1970 in his work *The Atrocity Exhibition*: 'Conceptual Games. Dr Nathan pondered the list on his desk-pad: (1) the catalogue of an exhibition of tropical diseases at the Wellcome Museum; (2) chemical and topographical analyses of a young woman's excrement; (3) diagrams of female orifices: buccal, orbital, anal, urethral, some showing wound areas; (4) the results of a questionnaire in which a volunteer panel of parents were asked to devise ways of killing their own children; (5) an item entitled 'self-disgust' – someone's morbid and hate-filled list of his faults. Dr Nathan inhaled carefully on his gold-tipped cigarette. Were these items in some conceptual game?'

Rather than the list being an item of content, one part of a narrative, it becomes the glue for the whole work, the means by which the whole work functions. In the case of Ballard the emergence of the system or list as an instrument of storytelling is a sign of what he calls (in *The Atrocity Exhibition*) the 'death of affect', a breakdown of the social ability to empathise, to connect with each other. The death of affect is what happens when all stories seem to have been played out, when we seem to have heard them before. In a world of 'spin doctors', one story is a credible as another. The list is both a symptom of cultural and social exhaustion, and an instrument for finding a way out of this. It's not just a popular device in literature. It is also found in cinema, most obviously in the work of Peter Greenaway, and also in more popular work such as Tarantino's *Pulp Fiction*, whose patchwork of overlapping stories is held together by a descriptive list. It's popular in art, where process has been a device to make work at least since Sol Le Witt, and most recently, it is the tool of 2002 Turner Prize-winner Martin Creed.

Perhaps the most extreme example of this in graphic design is in the work of Foundation 33. For Foundation 33 the list is like an anti-manifesto. Just as the manifesto is traditionally about a set of beliefs and principles, the list in the work of Foundation 33 is a sign of the absence of belief.

Design group Letterbox say 'modernists make design look like a job'. Foundation 33 makes design look like instruction-manual heaven. In their own creative work graphic design has been purged, cleaned out, given an enema by the idea of pure utility. 'Form follows function' wasn't just a slogan but the practical engine of modernism. Foundation 33 switches on this engine and presses their foot on the accelerator to see where this baby will take them. By pushing this modernist motif to the kind of limits unimagined by the early modernists, Foundation 33's work transforms the functional and the useful into the ornamental and the decorative.

What's also interesting about Foundation 33 is the extent to which the modernist aesthetic of impersonality is recreated as the personality of impersonality. Take, for example, their *Utilitarian Greetings Cards*. In terms of the sheer austerity of their look you'd have to call the colour of the cards something like 'post-war-rationing grey.' It's basically cardboard. There's a series of eight cards, each with a different purpose. The text on the cover of the multi-purpose *Occasion Card* reads, 'Before giving card, tick the box relevant to the occasion being celebrated.' Below the boxes a dotted line is provided just in case you ticked the 'Other' box and need to specify the occasion that falls outside the average list. There's also a note suggesting 'A message of no more than 50 words should be hand-written inside this card.'

What are utility and functionalism at their root? They are rules. Procedures. The *Cash Card*, which presents various amounts of money alongside circles to tick, provides an arrow at the bottom of the card pointing upwards with the message 'place this way up on mantelpiece'.

→

→ Foundation 33 have also created their own card information icons, like the kinds of things you get on clothes tags. An umbrella with snow on it? A 'deliver-by-hand' sign? It's not clear. On the back, each card displays its number in the limited edition of 500 and is signed. Underneath at the very bottom is a sentence offering the philosophy of Foundation 33, 'Say YES to fun and function and NO to seductive imagery and colour!'

Are these cards meant to be used? Are they actually meant to function as cards? Have Foundation 33 turned the utilitarian, the instrumental and the functional inside-out and made it an aesthetic? It would be easy to argue this. But the work of Foundation 33 shouldn't really be considered in terms of an aesthetic, assessing it in such terms as beauty and composition. What's really interesting about Foundation 33's self-initiated work is that they are pulling, stretching and extending the most fundamental purpose of graphic design – information communication.

This becomes clear in their *Utilitarian Poster*. At the top of this silkscreened poster instructions tell the user to fill in the blank information blocks where necessary, which would include such details as the type of event. There's space for a picture of some sort and they list the possible uses, 'Diagram/Doodle/Drawing/ Image/Painting/Photograph/ Scribble/Etcetera.' This list is absurd; the fact that it is all-encompassing makes it redundant. It's a taxonomy of everything. It's like Jorge Luis Borge's reference to a Chinese encyclopedia where animals are classified as '(a) belonging to the Emperor, (b) embalmed, (c) tame, (d) sucking pigs, (e) sirens, (f) fabulous, (g) stray dogs, (h) included in the present classification, (i) frenzied, (j) innumerable, (k) drawn with a fine camel-hair brush, (l) et cetera, (m) having just broken the water pitcher, (n) that from a long way off look like flies.'

The Foundation 33 poster is a classification of the whole of graphic design. And they make the point that the poster is only complete when filled in by the user. It's not just that the user is part of creating the meaning of the work, in interpreting it. 'The work is wholly dependent upon viewer response, the absence of which denies the piece its essential content.' The work is only complete when the blanks are filled in. That said, a completed version is likely to be worth less than a virgin, unused, uncompleted one.

There's a kind of self-reflexive feedback loop operating in their work, in pieces such as *Fifteen colour photocopies of a Polaroid photograph developing the image of the photocopier and the polaroid photograph of the photocopier once developed*. Or the *Rubber Stamp Postcard* whose image on the front of the rubber stamp is the stamp that made the imprint of the stamp on the back. Or the *Neckclasp Postcard* with the image of a necklace wholly made out of the clasps that normally link a necklace together. This self-reflexivity is also communicated in their list of interests, an A–Z of words beginning, of course, with A for 'Alphabetising'. The bottom line is this. The work of Foundation 33 is documenting the work of Foundation 33.

090.091

Foundation 33
UK, 1999
Utilitarian Greetings Cards.

Graphic Science Fiction

What's interesting about Foundation 33 and other designers' uses of lists and systems is that it's a kind of Ballardian science fiction. The aesthetic of listing and documenting apes the scientific method of documenting procedures and observations. They have a kind of bureaucratic beauty. Perhaps it's no accident. Graphic design is a child of modernism. The paradox of modernism's obsession with the new, its lovesickness for the new, meant that it would always be an aesthetic, a philosophy, of the future. And the way these cards and calendars picture their audience is also futuristic. When cards and calendars are no longer burdened by sentiment or stereotyped receivers, they become something else. The receiver is almost post-human. The receiver of the cards and calendars of Foundation 33 or Cartlidge Levene or NB: Studios are post-human. They could be machines, simply filling in the spaces like a computer. This is why this work is a kind of graphic science fiction. It's the result of graphic designers contemplating the exhausted forms and clichés of picturing time.

Area
UK, 1997
This Christmas card was part of a series of personal projects called *Code*. The lettering through which you view the blurred image was a 'found object'. John Dowling of Area explains, 'We had collected this type over the years. The Christmas card was loosely based on the fact we had already created an umbrella name *Code*. *Code* involved a series of experiments with cards, and it so happened that the Christmas card was the fourth in the project so it became *Code* 4. The Christmas card was a play on the word 'code'. It so happened when we found it you could already see the words 'code' and 'area' in it. The lettering was suspended with chicken wire from the ceiling and walls, then photographed. We removed the wire so it looks like it's floating. The studio was in the background which gave it a personal touch.'

The lettering becomes the graphic equivalent of a stained-glass window. The first name of the designers in Area, Cara Galliado, John Dowling and Richard Smith are marked out, along with the year of the card. Dowling says that the card generated all sorts of interpretation. And it's not simply that any work is open to interpretation. This work is about the act of interpretation itself.

Given that it was part of a project called *Code*, the serial lettering materialises the idea of the recipients putting letters together themselves in order to interpret the work. In some respects this Area work is a 'meta-card', a message about messages. Hermes, as mentioned in the introduction, isn't just the Greek messenger God, it is also the origin of the word Hermeneutics. It means interpretation (*hermeneus*), and is the name given to a Judaic discipline of Biblical interpretation, and more recently a philosophical school of thinking. The reader interprets a work according to their cultural baggage, but the very act of reading also changes them. Area's Christmas card is a kind of graphic hermeneutics. Area use the basic element of graphics, the letter, to make the reader think about the nature of the graphic.

092.093

Area
UK, 1995
Another Christmas 'meta-card'; this simple
graphic uses 'postage' icons on a posted object.

Area
UK, 1996
Using building signage this card announced the
addition of two architects to the company.

The lettering becomes the graphic equivalent
of a stained glass window.

Cartlidge Levene are doing the graphic equivalent
of Harry Caul's information gathering in Coppola's
The Conversation.

094.095

Cartlidge Levene
UK, 1995
Cartlidge Levene's Christmas cards recontextualise
time. They employ different measurements to
picture the event. Christmas Day on this occasion
is graphically represented by a series of satellite
images of their office on the 25th of December.
No doubt unconsciously, all of Cartlidge Levene's
Christmas cards are about monitoring. It's not
sinister or anything but Cartlidge Levene are doing
the graphic equivalent of Harry Caul's information
gathering in Coppola's *The Conversation.*
Christmas Day is transformed from tinsel and
turkey into information mapping.

Cartlidge Levene
UK, 1997
Each tinted box represents a half-hour of time on
Christmas Day 1996. It is a graphic interpretation
showing the varying degrees of electricity
consumption throughout the day. Unlike other
countries, Christmas Day is unusually dominated
in the UK by TV events such as the Queen's Speech
and dramatic soap-opera specials. The one box
highlighted is *The Morecambe and Wise Show.*

Cartlidge Levene
UK, 1998
**A concertina Christmas card displaying the
company's entire Christmas-card list. Each card
was personalised by being marked by the postcode
of the recipient.**

Cartlidge Levene
UK, 1999
**This card lists where each employee has spent
Christmas Day since birth.**

'Me, me, me, me, me...'
Stefan Sagmeister

096.097

HGV
UK, 2001
**This technological and graphic pun was created
to launch HGV's new website. The image of a
baby being born was generated from letterform
software originally used by programmers to
draw images on email.**

Ruedi Baur et Associés
France, 1997
This card announces the birth of Ruedi Baur's daughter through a cartoon image of a face constructed from three stamp marks and a dummy.

Stefan Sagmeister
US, 1992
'Me, me, me, me, me...' Stefan Sagmeister's 30th birthday invite shows an image of himself every year since his birth.

Octavius Murray
UK, 2000
The Christmas card as concertina paper sculpture.

098.099

This work is a kind of graphic science fiction. It's the result of graphic designers contemplating the exhausted forms and clichés of picturing time.

Fibre
UK, 2000
**This recycled charity card is shredded into fibres
and sealed in a vacuum bag of the type normally
containing fresh produce. The sticker on the bag
details the ingredients.**

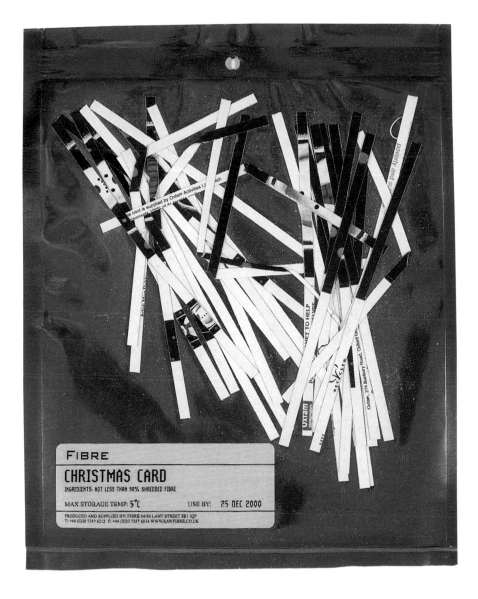

Jekyll and Hyde
Italy, 2000
**This is an interactive change-of-address card.
Inspired by old computer punch cards, you can
shift the card along from the old address to
reveal the new one.**

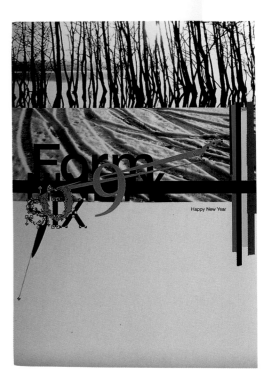

Form
UK, 2000
To coincide with the launch of a range of T-shirts for their very successful sister website UniForm, Form combined a New Year's greeting with this scratch card sent out in a silver bag.

Form
UK, 1996
Two different images are brought together in this card. Instead of contributing to the glut of Christmas cards which are binned by the beginning of January, Form distinguish themselves by delivering cards in the New Year.

Form
UK, 1994
The phonetic play of this textured, letterpress card announces the year of 4orm.

Form
UK, 2001
A message written in snow on the previous New Year's Day.

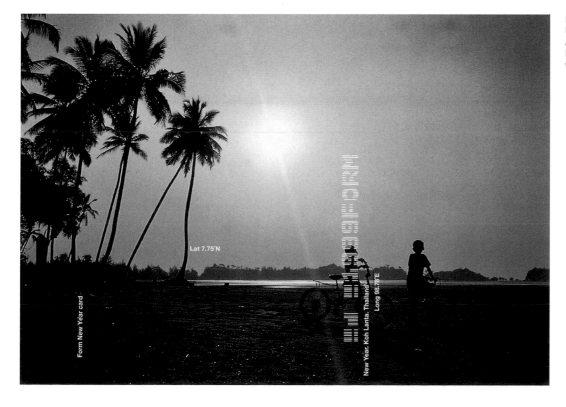

Form
UK, 1999
A visit to Thailand on the previous New Year's Day provides an enviable image for winterbound clients.

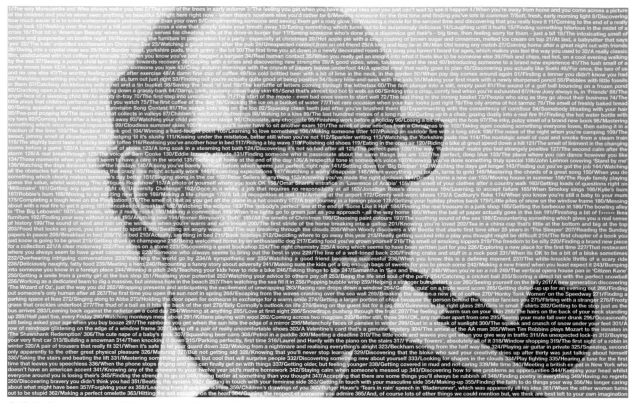

365 days of joy

www.thompsondesign.co.uk
0113 232 9222

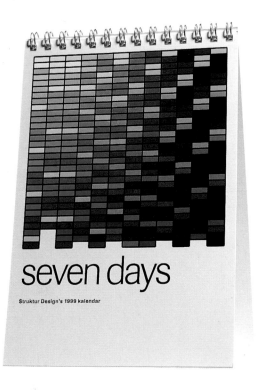

seven days

Struktur Design's 1999 kalendar

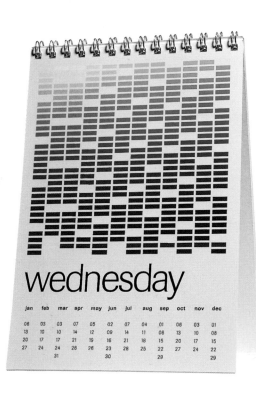

wednesday

jan	feb	mar	apr	may	jun	jul	aug	sep	oct	nov	dec
06	03	03	07	05	02	07	04	01	06	03	01
13	10	10	14	12	09	14	11	08	13	10	08
20	17	17	21	19	16	21	18	15	20	17	15
27	24	24	28	26	23	28	25	22	27	24	22
		31			30			29			29

Struktur
UK, 1999
Time becomes data in this calendar by Struktur.
Seven Days **delivers each day of the week for a year**
on a single opening. The gaps in the colour–coded
chart signal the relevant day. If Foundation 33's
lists owe something to Ballard, Struktur's
translation of time into information has the
icy futurism of Kubrick.

102.103

Struktur's translation of time into
information has the icy futurism of Kubrick.

Thompson Design
UK, 2002
This A2 Christmas poster, delivered in a
transparent tube, lists 365 things that make you
happy – from making a perfect omelette to finding
a perfect fit. The image on the poster is that of Eric
Morecambe, co-star of saintly UK comedy duo
Morecambe and Wise, who in the 1970s were a
national institution. Morecambe was the dimwit
who was actually smart, while Wise thought he
was sophisticated but was actually stupid,
writing awful plays and playing the tall guy to
Morecambe's barbed putdowns. So number one
in the 365 things that make you happy is 'The
way Morecambe and Wise always make you feel.'

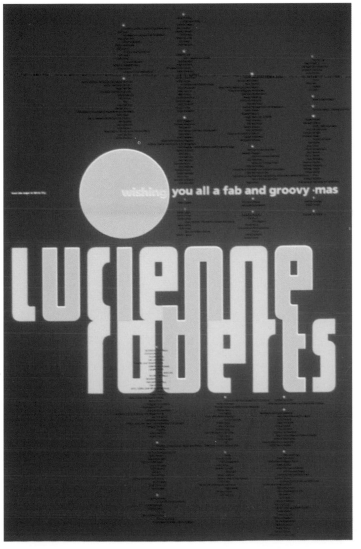

Lucienne Roberts
sans+baum
UK, date unknown
For her Christmas card, Lucienne Roberts displayed
posters in London Underground stations. Roberts
explains this extravagant ambient greeting,
'Having always been keen on older London
Transport posters I approached London Transport
Advertising about my Christmas poster. They very
kindly agreed to give me a series of cheap sites to
display my Christmas greeting, mainly because
they thought using the tube in this way was
funny! All my family, friends and colleagues were
listed alphabetically on the Christmas poster.
Various people were not only pleased to spot it,
and see their names, but were also bemused to
find that we had friends in common but had never
realised. Posters were shown at several central
London stations including Leicester Square, Covent
Garden and Farringdon.'

Thompson Design
UK, 1998
Called *Small Stories*, this diary presents a year of thoughts linked to photos and images of people who demonstrate in some aspect of their lives qualities such as 'perseverance' or 'loyalty'. It's a graphic version of BBC Radio 4's *Thought For the Day*.

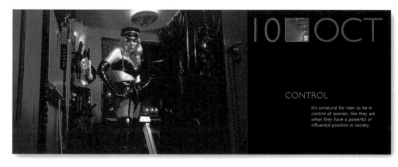

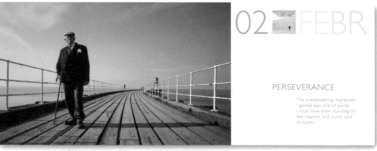

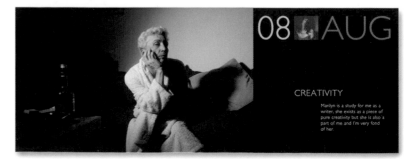

104.105

UNA
Netherlands/UK, 2002

For clients and fellow designers, the arrival of the UNA desk diary is met with the expectancy of readers awaiting a new novel by their favourite author, or gamers anticipating the launch of a new console. Indeed, like a computer game, each year the chosen theme of the UNA diary sets up a scenario of time. There can be very few diaries which carry an editorial and for 2002, the editorial introduces the idea of marking time. The modest but sumptuous design of the diaries make them a 'Book of Time', and the narrative device for 2002 is the anniversaries, holidays and national feasts by which nations represent themselves.

The editorial for 2002 explains, 'There is no other device in the political repertoire of a culture or nation that unites people as effectively as a shared calendar, which in many ways represents the collective conscience...[this calendar] represents the manifold ways the past has been experienced, interpreted – sometimes re-interpreted – and, ultimately, memorialised in an effort to legitimise the politics of culture.' Each day comes with a global list of celebrations during the year, from Hong Kong Special Administrative Region Establishment Day (1st July) to Bob Marley Day in Jamaica (11th May). The beginning of each week examines the mythology and legend surrounding a particular day.

The architecture of their diaries is built around the mechanics and concept of 'the fold'. Each week is a spread. The light paper reveals an image contained within the fold of each page that can be opened by cutting along the serrated edge. Opening it up reveals an image or text. It signals the idea of layers of time and folds of time. The material inside the fold reveals a text or graphic perspective on one of the anniversaries of the week. And the all-black cover with a list of anniversaries set in relief also communicates the idea of the texture of time. Though this particular diary is called *Marking Time*, all of the UNA diaries reflect on ways of sequencing time.

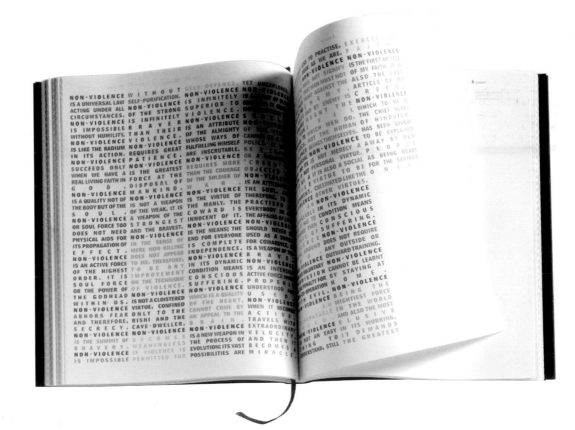

04
the publisher

A well-known international florists used to sell their product to the public with the slogan 'say it with flowers'. 'It' meant something special, personal, intimate like 'I love you'. When designers want to say something special and intimate they 'say it with books'. Books still have a cultural aura, perhaps more so in our digital age. →

→ One of the most lavish promotional book projects of recent years was created by UK design company Intro. They were commissioned by a company called the 'colour of white', a new division of online art sellers eyestorm.com, to create something to launch the company to potential clients. The audience were Creative Directors. Foregoing conventional promotional gimmicks Intro gambled on the prestige of the book. Three hundred copies were made of an extraordinary, extravagant book. The mix of paper stocks communicated a richness of texture. The panoply of printing techniques, including screenprinting, debossing and varnished text, invited the user to experience the book as a tactile object. And it was all white. White text on white paper. It was a vision of pure space. The book was put together using traditional binding methods. Like a bouquet of flowers, it was hand-delivered. The book, at least the idea of the book, still remains an object of reverence.

Designers who create non-commissioned books do so for a variety of reasons. Sometimes simply out of love for the book as an object, sometimes because it's a suitable medium for their work. Valeria Brancaforte uses the book as a means of sequencing her illustrations into a story-form. Her style of lithographic prints makes the book a fairytale object.

With their *Book of Thoughts* London-based Graça Abreu Design literalise the idea of self-expression as a secret diary. The hardback cover is tied together by a leather ribbon. The cover dimensions of the *Book Of Thoughts* are roughly 160mm long by 109mm wide. Size is important not just because it can be grasped in one hand like a diary, but because on the front page you read '1,041,600mm² For Memories'. This is the available space for thinking. Most of the pages inside are there to be filled, like an imaginary Jane Austen character, who jots things down for self-improvement, logging events in order to learn from them.

Inside there is a spread of a photocopied book – a guide to etiquette. There's an image of a very old typewriter underneath texts in type that looks as if it has been hammered out by the typewriter keys themselves. Another page displays a prayer, a thought for the day: 'God grant me the courage to change the things I can change; the Serenity to accept those I cannot change; and the Wisdom to know the difference.' Even old Italian nuns knew the value of copywriting's third beat.

The *Book of Thoughts* is a quaint, precious object. The leather ribbon both literally and metaphorically ties the book together. Knotting the book actually makes you feel like an old Italian nun, carefully preserving the events of the day, for reflection, to meditate on lessons learned and feed the soul.

But the two most ambitious book projects in graphic design are by Pentagram and KesselsKramer. Their ongoing output is more than just self-publicity. They demonstrate the practical and intellectual versatility of just what books can do. Their publications construct an image not just for others but, more importantly, for their own organisations. And both companies use their books to interrogate the assumptions and values of their respective disciplines. →

108.109

Graça Abreu Design
UK, 2000
The *Book of Thoughts*. Hand-size and available for immediate reflections.

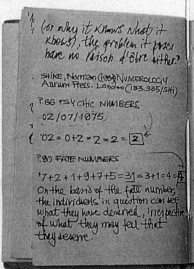

Once we can instantly relate to something or someone, the feeling of loneliness is replaced by serene satisfaction.

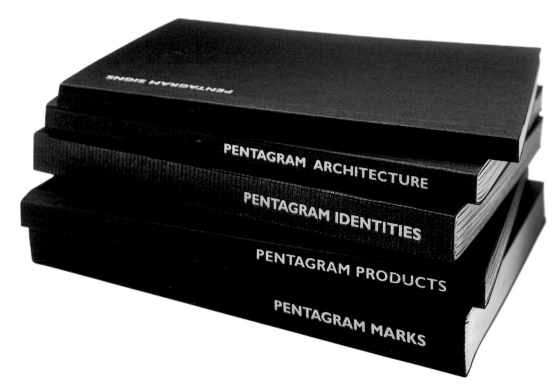

Pentagram
UK, 2002
The palm-size Pentagram *Black Books* (*Identities, Marks, Signs, Products, Architecture*) which showcase their work, are updated and reprinted on a regular basis.

→ Pentagram

Say you're a design company made up of 19 semi-autonomous practices. Each individual who is asked to join and become a partner is already well known, and is not only commercially thriving, but has made their mark in the design world through accomplished work. These newcomers to the company not only bring a list of potential clients and a set of skills, but also the psychology of someone who is already successful. How does such a company foster a sense of community and communicate to clients the idea of a group practice, of a Pentagram identity that they can buy into? This is the challenge faced by Pentagram design. And it's what makes Pentagram and the aesthetic that surrounds their company so fascinating.

Paradoxically, if there is an image of Pentagram among designers, the very nature of their structure as a kind of design supergroup means that occasionally there is the perception that the company is a clique, that they are so big they are intent on 'world domination'. When Steven Heller put this perception to Pentagram partner Michael Bierut in *Eye* magazine (no 24, vol. 6 Spring 1997) Bierut responded, 'you don't get chosen to be a partner here completely at random. There has to be a certain affinity with existing partners. So like any group that votes in its future members, it proceeds from a certain point of view. Just like in a school faculty, the challenge is to try and bring in people who are compatible without being identical. The basic premise of Pentagram, founded by five guys, has never been as single-minded as, say, an office that was founded by one person whose point of view permeates everything.'

Community of taste

Some people are suspicious of Pentagram's size, the fact that they appear to be a corporate monolith. Bierut articulates the obvious fact that, to the contrary, the difficulty for Pentagram if there is one, is not that as a company it is single-minded, but that there is a diversity of opinion. The online business magazine Inc.com noted this in the wry headline of their Pentagram profile 'Meet the most smoothly functioning collection of prima donnas on the planet.' What holds everything together, and is underlined by their own self-initiated publications, is the fact that Pentagram doesn't have a corporate style but are a 'community of Taste'.

At a very basic level this simply means that in a commercial world where design is often seen merely as a matter of styling, of decoration, at the heart of Pentagram there is a genuine philosophy. Even the business structure of Pentagram means that being chosen to be a partner in the firm is already a kind of peer recognition, a judgement of taste on the work of potential partners. This is why Pentagram is different from other design groups. And the very nature of this difference means that when clients buy into Pentagram, they are not only buying a job of quality work, they are buying into their cachet. They are also buying an interrogation of the idea of taste.

What it boils down to is this: while art has a canon of great works and a critical vocabulary for assessment and judgement, Pentagram through their publications is inventing a tradition and history of the beautiful in graphic design, a tradition not limited to the great figures of the medium.

Design Curators

The *Pentagram Papers*, launched in 1975, are sent to clients. On the back fly-leaf of each publication they set out the idea behind the papers: '*Pentagram Papers* will publish examples of curious, entertaining, stimulating, provocative and occasionally controversial points of view that have come to the attention of, or in some cases are actually originated by, Pentagram.' In this way the *Pentagram Papers* can be viewed as a kind of curatorial project.

The papers are black, covered with a thin white border. To those suspicious of Pentagram's gigantism they do conjure up the appearance of a black monolith. The number of each edition appears on the top. But, more significantly, the border acts as kind of frame as if the cover of the book was a window on a painting. The border is a gesture at least to the idea of art.

The first impression when you look at the contents of the Christmas booklets with titles such as *The Pressman's Hat*, *Six Tunes for Eight Wine Bottles*, and *Crossword* is that these are perhaps graphic design's equivalent of expensive executive toys; that these booklets are interesting, but ultimately whimsical treats for rich clients to browse through over a cigar and brandy. And indeed their *Feedback* book might confirm this view.

Feedback is a collection of reviews of places to visit – restaurants, bars and shops from around the world. The reviewers are designers, artists, writers, artists and photographers. You could argue that it promotes the idea of Pentagram as a kind of exclusive club which offers the rich businessman an entry to places frequented by the artistic and the bohemian – a window on a world outside the five-star hotel, club-class, all-expenses-paid world of the business traveller. There is no question that there is an element of truth in this. It's a very functional and literal promotion of the idea of Pentagram offering a model of taste that clients can buy into. It's a kind of 20th-century guide to a 20th-century version of the Grand Tour.

The Grand Tour has its origins in the 18th century when young wealthy Englishmen travelled the world in search of exotic experience. By the 19th century it had become an American phenomenon, when young Americans travelled to Europe to explore and pay homage to the tradition of European culture of which they considered themselves the heirs. It wasn't a 'holiday', it was an education in taste most famously depicted by Henry James in *A Portrait of a Lady*. In a contemporary world where travellers don't have a way 'in' to a local culture via an extended family of the well-to-do, *Feedback* is the closest you will get →

Pentagram
UK, 1998
Pentagram Papers No 27, Nifty Places –
The Australian Rural Mailbox.

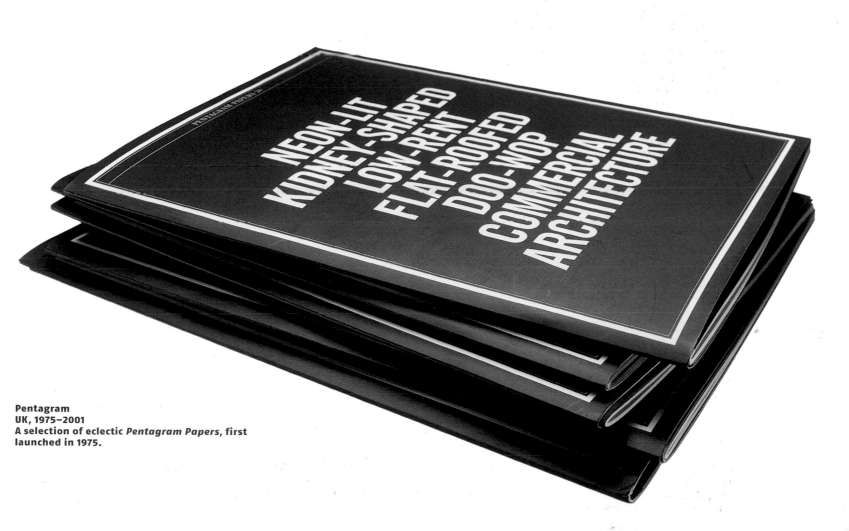

Pentagram
UK, 1975–2001
A selection of eclectic *Pentagram Papers*, first
launched in 1975.

Pentagram…is inventing a tradition and history of the beautiful in graphic design.

Pentagram
UK, 2000
Cover and spread from *All The King's Horses*,
Pentagram's Christmas card booklet.

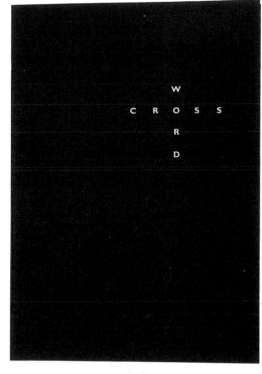

Pentagram
UK, 1999
Cover and spread from *Crossword*, **Pentagram's**
Christmas card booklet.

→ to an intimate and trusted recommendation of places you must visit and culture to consume.

From a commercial and marketing point of view it is a fascinating example of how Pentagram sells itself without seeming to. And indeed it is a feature of Pentagram design that it is marked by restraint. Perhaps this restraint and self-control is an organisational reflex reaction to a company made up of already independently successful indidividuals, or in Inc.com's words, 'prima donnas'.

But the fact is, *Feedback* wouldn't work, wouldn't have its appeal, if Pentagram hadn't already been perceived as arbiters of taste through things like their *Pentagram Papers*. 'Arbiters of taste' isn't quite correct. If they were merely this, the *Pentagram Papers* would be no more than graphic design's equivalent of a lifestyle magazine. And there is a degree of this. The *Pentagram Papers* have the aura of the George Lois-designed *Esquire*, sophisticated treats for a wordly clientele.

Design Thinking Design
But what the seemingly quirky editions of the *Pentagram Papers* are doing is in fact highlighting transient objects or trivial images as something worthy of attention. It's about using design to reflect on design. *Nifty Places*, for example, is a study by Cal Swann, Professor of Design at Curtain University of Technology in Perth, Western Australia, of the Australian rural mailbox. Like Philip Carter's *1057* it's a collection of folk design. The mailboxes are constructed from milk churns, petrol cans, oil drums and even fridges. The creators of these mailboxes form a taste community themselves, each trying to outdo the other in decoration, size and materials. As Professor Swann writes, 'Whatever the original motive may have been for the early settlers to recycle a ready-to-hand artefact in the performance of the mailbox duty, a cult has developed throughout Australia for the bizarre and often outrageous objects such as mailboxes. It now has less to do with practicalities and recycling;

competition is rife and efforts to make mailboxes that demonstrate individuality and humour are found in many localities.'

A more upmarket version of Cal Swann's Australian folk art is their paper called *Savoy Lights*. The fact that the lighting in the Savoy Hotel was provided by electricity guaranteed a degree of attention when the hotel was opened in 1889. But it was as much the visual impact of the lighting's aesthetics that proved a talking point. The creative force behind the lighting design was Richard D'Oyly Carte who created the hotel as a recreational companion to the Savoy Theatre. If *Nifty Places* offers a picture of rural sculpture, *Savoy Lights* is about cosmopolitan luxury. The images of the lights in the photos suggest something of D'Oyly Carte's theatrical background, as providing a dramatic and extravagant background to the luxuriously fitted hotel. The subject matter fits the concept of opening the canon of art to the world of commercial design, while also flattering, by association, the

worldly business traveller staying in opulent hotels that such surroundings are worthy of study and reflection.

But there are two papers that give explicit definition to the curatorial philosophy behind the *Pentagram Papers*, and explicitly address the issue of taste: the Tom Wolfe-inspired mouthful of *Neon-Lit Kidney-Shaped Low-Rent Flat-Roofed Doo-Wop Commercial Architecture* by Jonathan van Meter; and an Ernst Gombrich lecture called *On Pride and Prejudice in the Arts*.

Learning From Wildwood New Jersey
Jonathan van Meter's work is about the motel architecture of Wildwood, New Jersey. A clue to its other inspiration is the subtitle on the inside page: 'Or, Learning From Wildwood New Jersey'. This is an allusion to one of the founding texts of postmodernism by Robert Venturi, Denise Scott Brown and Steven Izenhour called *Learning From Las Vegas*. In itself, architect Venturi's book was a celebration of American vernacular →

→ architecture, but it would become a manifesto of postmodernism in its affirmation of popular architecture and rejection of the tradition of the International Style. As van Meter writes, 'The result was a carnival of excessiveness, a new architectural idiom borrowing the vocabulary of modernism, but with the volume turned way up through the application of brightly coloured paint, huge signs, neon lights and, of course, plastic palm trees.' The motel resort wasn't just a playground for the middle-class but a cathedral to the new age of the automobile.

Whereas the images of the mailboxes in *Nifty Places* are full-bleed, documentary-style, the photos in *Learning From Wildwood* by Dorothy Kresz are given a frame by a white border. Rather than seeing these signs as ugly, commercial and tacky, we are meant to recognise their idiomatic beauty rooted in history and society. And this is where graphic design, as a discipline born out of art and commerce, has a key role in shaping a taste culture.

Postmodern critics and commentators were often actually patronising about popular culture, barely concealing their critical anchoring in classical standards, enthusing about kitsch, about culture that was 'so bad it's good'. And classical arbiters of taste would indeed see the Wildwood architecture as simply vulgar. But from a graphic design perspective there is no questioning the flashy, totemic beauty of these signages.

The point is that the graphic language of the motel resort shouldn't either be dismissed or merely be of interest to sociologists, historians or nostalgia nuts. There is a graphic aesthetic at work. Van Peters cites Tom Wolfe writing about Las Vegas in *The Kandy-Coloured Tangerine-Flake Streamline Baby*, but as he says, it could equally apply to Wildwood's signage: 'They soar in shapes before which the existing vocabulary of art history is helpless. I can only attempt to supply names — Boomerang Modern, Palette Curvilinear, Flash Gordon Ming-Alert Spiral, McDonald's Hamburger Parabola,

Mint Casino Elliptical, Miami Beach Kidney.' The challenge when the universal criteria of taste breaks down is to invent a new critical language, a new hierarchy of values, of the good and the bad in assessing graphic design. This is the agenda behind the *Pentagram Papers*.

The Avant-Garde and the Artisan
This is implicitly spelled out in the lecture *On Pride and Prejudice in the Arts*. It was given to the Art and Architecture Group in Leighton House in 1992. On the fly-leaf Gombrich's argument is condensed by the editor: 'With persuasive learning and good sense he warns against indulging the vanities of artists, and asks for renewed respect for the intrinsic humility and humanity of artisans. 'It's a fascinating choice, some ruminations from the grand old man of art history, and it would be easy to see the choice of subject matter as merely an exquisite delectation offered to clients. The front page of the lecture has a passport-size sketch portrait of the great man. →

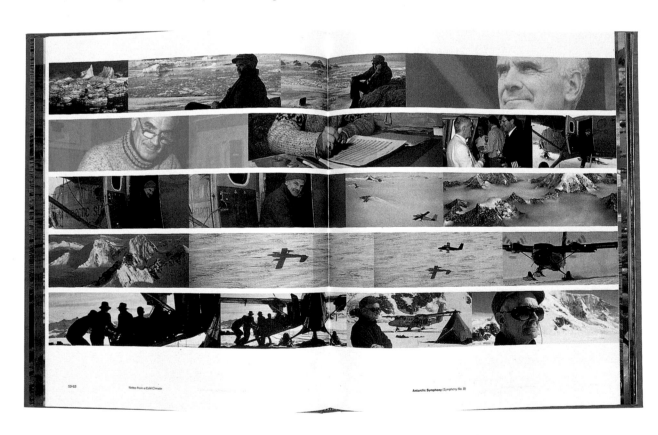

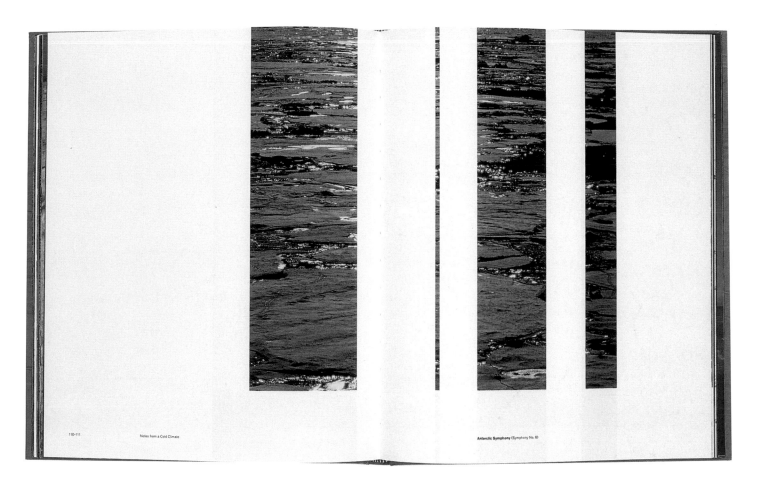

**Browns,
UK, 2001**
While the *Pentagram Papers* are content driven,
the recently established Browns have tended to
publish more abstract work of photography. *Notes
From A Cold Climate: Antarctic Symphony* is a
photographic and written account of composer Sir
Peter Maxwell Davies' trip to the Antarctic. The
extraordinary photography by a member of The
British Antarctic Survey is complemented by
occasional changes in paper textures. Maxwell
Davies' diary notes are on thin, leafy paper.

 The design features in the images are quiet
reminders of the purpose of Maxwell Davies' trip,
to do research for a symphonic sequel to Vaughan
Williams' score for the 1948 film, *Scott of the
Antarctic*. Occasionally the photography is 'scored'
by barely perceptible thin white lines. In some
spreads the photos of this beautiful alien icescape
are broken up with white strips, like ice cracking.

 Maxwell Davies writes in his diary that 'In
Antarctica one is unaccustomedly hypersensitive to
the act of Creation itself as never before.' And even
though Browns' design elements are discreet, they
also call attention to the graphic qualities of the
icescapes, the jagged shards, the shadows of the
icebergs, the criss–cross snow ravines. It's a
picture of the Creator as the great cosmic
graphic designer.

EVEN
THE
UNFROZEN
SEA-WATER
WAS
LIKE
OIL,
THICKLY
VISCOUS

Gombrich himself was one of the founders of the discipline of art history. The lecture is fascinating not least perhaps because of Gombrich's own prejudices about the avant-garde. But it's because of this that Gombrich is able to oppose the pride of the artist with the humility of the artisan. An unwary artist can get locked into the myth of the heroic outsider, and this psychology is also often played out in art criticism, in making taste judgements about what's good and what's bad. The avant-garde artist, and the positive critical opinion surrounding him, will always be a minority opinion, or taste.

The artisan, on the other hand, not only has to respond to the demands of the client, but the commercial nature of the artisanal work will by definition have a wider audience. Gombrich argues that the prejudice against artisanal work stems from a prejudice in fine art against immediate sensual pleasure.

The artisan, for which you could read 'designer', has no disposition towards producing difficult or obscure work. Gombrich argues, 'Think for a moment of the glories of oriental rugs, of Chinese ceramics, of English silver; where would we be if these masters had worried about making concessions to the taste of their customers.'

The accessibility of a work doesn't disqualify it from being an artwork. This taste for accessibility also reflects Pentagram partner Michael Bierut's design strategy as outlined to Steven Heller in the *Eye* interview, 'I would say that I like my graphic design to be accessible, understandable in some way to the greatest number of people, all of whom can put their own personal interpretation on it. Layering in a bunch of coded references for the edification of other trained designers always seemed to be a little mean to me; mean to the people who weren't trained as members of the design elite.'

Accessibility is a constraint that may actually become a condition of quality. Obscure work in any field is not a sign of meaningful complexity. It's often the sign of a lack of skill. A work can be difficult without being obscure. Accessibility is another way of describing an open work, a work available for re-interpretation. The meaning of a work then becomes a dialogue between creator and user. Which is what Pentagram are doing in constructing this parallel history of popular graphic design.

A design agency is about making money, so at a mundane level the taste shown by Pentagram in their choice of material for the *Papers* flatters the client's own sense of the aesthetic. It flatters the client for having the taste to commission Pentagram. But the pedagogical aspect of the *Pentagram Papers* is an expression of a belief that the primary condition of a good design business is an understanding of a wider culture. And it's not just about having a stake in that culture, but having a stake in creating it. →

116.117

Browns
UK, 1998
The world is a deserted, barren landscape in Robin Broadbent's *Marmalade*. A collection of stark black-and-white photos depicts an alien, desolate environment except for one comforting colour image of marmalade.

Browns
UK, 1999
Crystal flowers and ice veins are just two of the
images that come to mind to describe the photos
in *Minus Sixteen*. This collection of photography by
Robin Broadbent was taken on one cold Scottish
night. The shots of the ice on the lock sometimes
look like scientific plates. But the colour tone of
the images give them a peculiarly Gothic feel.

→ KesselsKramer

Love them or loathe them, brands are the grammar of everyday life. Brands like McDonald's or Starbucks punctuate our towns, structuring our experience of the city and offering a reassuring degree of sameness and security in an increasingly chaotic world. If brands are our grammar, some advertising and design agencies are like children who have learned the rules of language and discover a pleasure in playing with the rules of branding. KesselsKramer are such an agency.

Their advertising work from the famous Hans Brinker budget hotel in Amsterdam to the launch of Channel 5 TV in the UK resulted in memorable campaigns. In these campaigns brand recognition and trust haven't been created from soothing voiceovers or human stereotypes, but from text and images that are both bizarre and eccentric. This odd company has forged strong brand identities while simultaneously interrogating and stretching the very idea of 'branding' itself. They produce curious and successful work by turning branding conventions inside out.

KesselsKramer have not only made a name for themselves producing eccentric client-led work but they have documented many of their projects in self-published books. The idea of an agency documenting their own campaigns then publishing books about them, which is what they do, seems like the height of '80s hubris, when large advertising agencies imagined and presented themselves as masters of the universe. One book is called *365 days of e-mail @kesselskramer.nl*. How self-absorbed is that? There is an element of conceit in doing that, but even the most ordinary case studies are an opportunity for self-interrogation, for learning lessons about a project. Above all else KesselsKramer are possibly the most inventive self-mythologisers around.

Do read

They have also produced a large amount of extra-curricular projects. One such project was their do brand. 'Do' was a brand without content. A kind of brand after the fact. We'll supply the brand, you supply the product. Like the worldwide TV phenomenon of *Pop Idol* where the concept was in search of content. ('We've got the stardom, you find the star.') As much as anything else 'do' became a branding laboratory project.

What is 'do'? On their website the company explains 'Through 'do', the old-fashioned marketing process was deliberately turned around. First, a brand was established, then the ever-changing products and services follow. The mentality of the brand is especially important: do wants to constantly provoke action. 'Do' might be an XXXL t-shirt (it's usefulness depends on what you make with it: a tablecloth? A turban?), or a chair with only three legs where you have to prop something under it yourself for the chair to function.' Like Kevin Costner in *Field Of Dreams* the do principle is based on the pioneering idea of 'build it and they will come'. Create the brand and product will follow.

On the one hand, the concept behind the 'do' brand is the idea of getting your audience to interact with a brand, thereby bringing the brand to life. In the language du jour it's a 'lean-forward' brand. On the web it's called viral marketing, but let's call it 'Pinocchio marketing' where an inanimate product is brought to life through word-of-mouth. But this aspect of 'do' isn't the most interesting feature.

It's the fact that 'do' is what happens when you push the idea of the 'brand' to its limit; it becomes a pure brand, emptied of everything. 'Do' takes the magnificent emptiness of Nike's 'Just Do It', it's vacuousness of meaning that allows it to mean everything and nothing, and strips this minimal slogan down, takes out the grammar and makes the declaration intransitive. No 'it'. Nothing. Nada. 'Do.'

The perfect commodity that's beyond commodity. What's its logo? A thumbprint. It's the supreme interactivity of the personal and impersonal (remember it's not your thumbprint, it's anybody's, everybody's). 'Do' is a metabrand. The brand of brands. As they write in their second 'do' book, *do future*: 'Maybe you wonder why KesselsKramer are doing this? Maybe you wonder why we aren't living on the moon?...That's why we had the thought of developing a brand that is open to ideas from anyone and anywhere. A brand that can change overnight. A brand that can be a new software or small hotel chain that specialises in soaps...A brand that develops a new sport like the skyscraper marathon...A brand that discovers a new use for lawnmowers...A brand that listens to inventors others would dismiss as being insane.'

There's no question that there's a certain romanticism here, of outsiderism, that Oliviero Toscani, for example, fostered with the ads for the Fabrica college at Benetton. It has always been the blind-spot of creatively ambitious, driven creatives who earn a living through advertising, to associate imagination with the socially unacceptable, as being deviant in some way. Shocking the bourgeoisie. They identify with outsiders who are rejected by a public who don't recognise what's at stake in their work. It's not so much egotism or megalomania as an element of their own self-mythologising. If there's one thing that KesselsKramer do with all their publications (they've even produced a book about the Church premises in which they work) it is to self-mythologise themselves in grand style. Which must be a basic attraction for any potential client because if you can't invent yourself, you won't be able to invent a myth for anyone else.

KesselsKramer
Netherlands, 1999
The Face of the Century

ANNIE BATTY

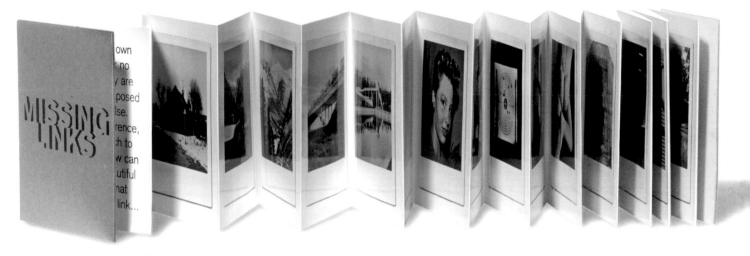

→ Tantric Marketing

Rick Poyner commented in his book *Obey the Giant* on the apparent lack of satire in KesselsKramer's general conception of 'do'. And though there is humour in much of their work, and the unfolding of 'do' is occasionally very funny, it's not satire in the sense of poking fun at the idea of the brand. Indeed, in their own peculiar way they are committed to the idea of branding, communicated in such books as *Brand Reincarnation* where the idea of 'Brand Karma' is invoked: 'Inject your brand with positive, fulfilling karma and you can be sure that what goes around will come around.' Economists, if they bothered to consider this at all, might call this 'supply-side eastern mysticism'. Is the idea of Brand Karma daft, half-witted, interesting or creative? Yes. To all of those. It's Bill and Ted's Excellent Marketing Adventure.

One shorthand definition of professionalism in advertising and design is disguising fantasy, presenting it as normal desire. KesselsKramer re-invest advertising with the surreal. Marketing philosophies fail when they bow to corporate convention and common sense, when they become anal. KesselsKramer take marketing theory and make friends with its essential stupidity. Their ad campaign for the Hans Brinker budget hotel highlighted the 'dangers' of spending time at the hotel, showing 'before' and 'after' pictures of dishevelled, wasted youth. It gambled on the good humour of the hotel's potential clients (one spread from the brochure showed doctors rushing a patient on a trolley through a corridor with the strapline 'Close to the best hospitals in Amsterdam').

And you could apply the idea of 'Brand Karma' to understanding the good-will KesselsKramer generate through their own publications and self-promotions. By selling themselves with humour and imagination they are able to sell others. They are like Bill and Ted, who by simply goofing around with geniality and generosity, actually get the project done.

And like these two characters who are not quite all there, KesselsKramer's best work uses the strategy of leaving something out, taking something away. It's a shorthand definition of the surreal. Like the surrealists KesselsKramer create a world but there's always something missing. This creative technique distinguishes them from Mother, another agency who put a premium on the use of humour. The signature of Mother is about adding things on through their raiding of genres and through pastiche. Mother's work is about magnifying things, exaggeration. KesselsKramer often use similar material but strip things away to produce the opposite effect.

KesselsKramer
Netherlands, 1997
Missing Links

→

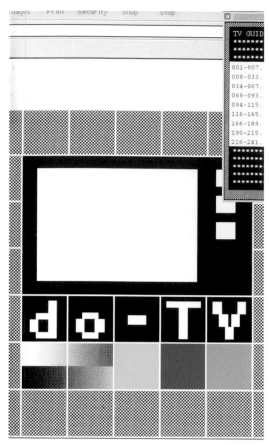

coming up after the commercial break...24 hrs of do-tv

KesselsKramer
Netherlands
Do TV

→ **Re-branding History**
Compare KesselsKramer's *Useful Photography #001* magazine with Mother's advert for Pimms. The Mother advert exploits the nostalgia and the retro appeal for a (funny) joke at the expense of the '70s. It's not just the clothes, or the music and bad wine, but an innocent awkwardness before the camera which evokes an age before reality TV, when anyone could be a 'personality' in front of the camera. It's also fascinating how a whole historical period, the '70s (a decade is a completely arbitrary demarcation of history in any case), is mocked for poor production values. It's funny, it works.

But for KesselsKramer history, the past, is something strange and peculiar. Whereas Mother decontextualise the past through their pastiche of genres, presenting it through the wry perspective of the present, KesselsKramer's take on the past is that it's something we are exiled from, that we can't get a purchase on. If the past is a foreign land, KesselsKramer make the past another planet. In this respect it's like a lot of their commercial work which is able to convey an authentic but uncanny sense of time and place.

Useful Photography #001 is a collection of photo-images, both colour and black-and-white. They're taken from old shopping catalogues, porn mags, football-team photos, second-hand car catalogues, 'innovations' catalogues with gimmicky kitchen utensils, dog-shows, old wedding photos. The photos are arranged with a thick white border, unusual only in that the same border frames images of different sizes.

In one respect *Useful Photography #001* is about that thick white border, the frame. It belongs to the tradition of working with found objects that stretches back to Duchamp, and putting a frame around them. There are no clues to the origin of these photos, one can only guess. One of the panels on the back cover delivers text that's as blank as the images inside. '*Useful Photography #001* is an ode to the photographers we don't know by name, but whose work we all know by looking at it daily.' Perhaps this is stock-photography that has fallen off the edge of history, that had no history in the first place precisely because stock photography is never about particular people with their own stories and context but aims to represent universal types to be used in any context. →

14 Amsterdam, November 12, 1998, 22.15 p.m.

4 Amsterdam, March 29, 1998, 23.10 p.m.

KesselsKramer
Netherlands, 1997
The Instant Men

KesselsKramer are possibly the most inventive
self-mythologisers around.

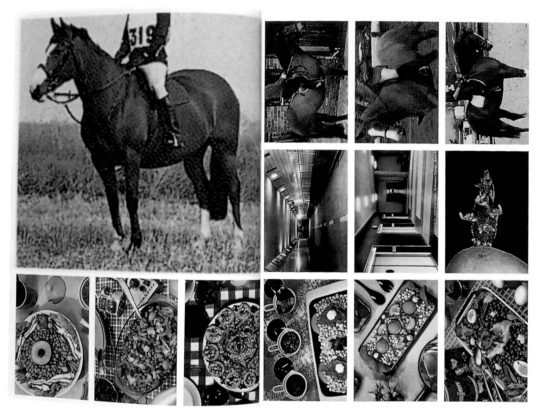

→ **Appliances and Bras in the Twilight Zone**

The choice of images and the layout is designed to draw your attention to this complete absence of world. Two landscape panels across a spread feature what could be an image from an Ideal Homes exhibition. The top image pictures the empty kitchen with its white and chrome surfaces and along the bottom of the photo, like some consumerist baroque, is a long line of food and utensils. The photo below is exactly the same except the food and utensils have been packed away and the doors have been taken off the cupboards. You begin to see the strange distortion of perspective that the food presented. It could be an artwork, a Diptych called Poltergeist. Who would know? At the bottom of the page runs a series of lingerie photos from a shopping catalogue. Removed from the context and visual language of browsing, shopping and selling, these images of women with bra-revealing open-

shirts, eyes looking at the camera, become purely odd.

Without the context of the shopping catalogue the conventions of catalogue photography become accentuated. The casualness of the way their shirts open is mannered. There is something a little psychotic about the images, as if these women have lost touch with reality, baring their bras in such a nondescript and studied way. You begin to recognise the curious mechanics of the lingerie photo where the woman is pictured in a curious space, both self-conscious and unself-conscious of herself and her body. The images have simply lost touch with the visual vocabulary of shopping catalogue. You could call them 'abstract'. What this means is that these functional, utilitarian photos originally meant to sell bras are no longer representational. They no longer represent a fantasy of womanhood. The images are blank, emptied of meaning.

They've lost their frame of reference and the skill of *Useful Photography #001* is in creating a pure design space devoid of visual spin. It is the polar opposite of the way images are framed in our advertising-saturated culture. And in a way that's why the images are so hard to process, so difficult to make sense of.

The *Missing Links* book employs a similar concept, with its collection of polaroids taken over a period of ten years. Gathered together in a miniature, almost polaroid-size book, with a cardboard cover, this selection of 18 photos opens out in concertina style. The first opening tells the reader, 'Elements on their own often have little or no relevance until they are put together or juxtaposed with something else. Then there is a visual foil in which to feel context. For how can you tell what is beautiful until you know what not beautiful is? Do link...' So what's the story of *Missing Links*? Is there some Darwinian theme at work? Or

perhaps it's the missing link in a chain of meaning which is the ploy they use in much of their work.

Faces of the Century is a book of photos with an image of someone born in each year of the 20th century. The only link between each individual is the arbitrary fact that they were born one year before or after another. And *Instant Men* turns the camera on the street photographers who snap polaroids of couples in the evenings while strolling or in restaurants and bars. It's a surreal postmodern moment.

The commercial work that KesselsKramer do is fuelled by their own mythmaking. But this mythmaking isn't just bragging. It's a way of exploring the tone and aesthetic that drives their design business.

Perhaps this is stock-photography that has fallen off the edge of history.

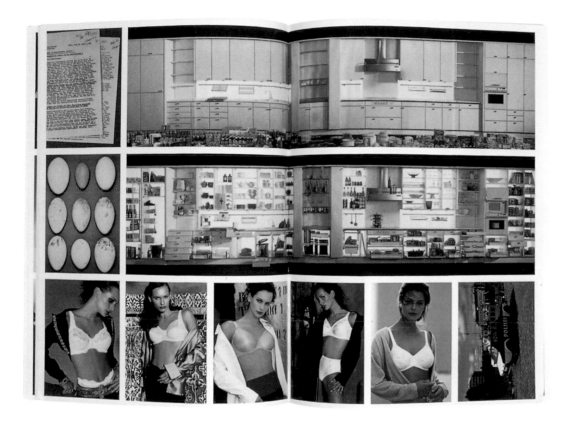

KesselsKramer
Netherlands
Useful Photography #001

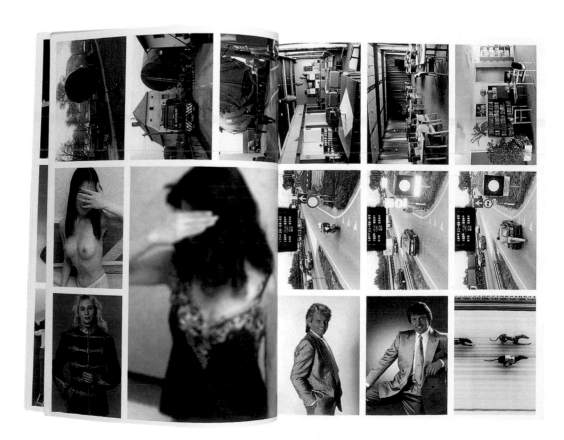

Valeria Brancaforte
Italy, 2001
The lineout drawings of *Chinese Proverbs* illustrate Brancaforte's typographic dreamworld. The text doesn't just tell a straightforward narrative. It pictures the image as a slice in time, lending each page a surreal quality. Hence the choice of Chinese Proverb as a concept.

124.125

Valeria Brancaforte
Italy, 2000
By conventional standards of self-promotion
illustrator Valeria Brancaforte's calling card is
profoundly eerie. Her address and phone number
unfolds over several spreads of this mini-booklet,
the paper coming from her mind and spoken via
her tongue. It's a kind of lithographic Dali. The
literal message here is that she has heart and an
eye for images. Its tone is uncannily ambiguous
because the raw lineouts simultaneously soften
and intensify the highly ritualised images.

05

the artist

The Artist section includes works that couldn't fit anywhere else in the book. It wasn't simply because the work couldn't find a place and so it was dumped in here for lack of anywhere else. It was because the work seemed to match the definitions of art suggested by philosophers such as Gilles Deleuze and Jean-François Lyotard. Artworks invent their own concepts, they change in some way the rules of the game. Conventional means of classifying them and addressing them can't really be applied. What all these works have in common is that they create their own unique tools of perception for the viewer. They set up their own form of engagement.

\rightarrow

→Design has always been regarded by many as art's cousin from the wrong side of the tracks. Tainted by commerce, it has to earn its way in the world in the way that aristocratic art supposedly doesn't. The tradition of art is a cultural inheritance from which any artist can draw. Whether their work is good or poor, whether it's good art or bad art, it is still validated by the stamp of art. Designers don't have this luxury.

In any case, in very practical ways this crude distinction between art and design is increasingly untenable. Many contemporary artists actually rely on designers' work as a crucial feature for their artworks. Jeff Koons used to farm out work to craftsmen and recently Damien Hirst has relied heavily on input from Jonathan Barnbrook. Barnbrook described his role for Hirst's pharmaceutical series *The Last Supper* as being that of an art director. (This relationship between artist and designer is discussed in more detail on pages 142–144.)

Often artists and designers play out the same topic. The nature of Englishness has been a driving force in the recent work of artists such as Tracy Emin and Jeremy Deller, and the photographer Martin Parr. Crash! and designer Ian Holcroft who feature in this section also make work that explores a particular vein of Englishness.

In their different ways Experimental Jetset, Peter Davenport and Tony Linkson have all created work relating to the nature of time.

The editorial format of this section is different to the rest of the book. In the rest of the sections we chose to let the work speak for itself, in the sense that very few interviews were conducted. This was also because the work mostly had a clearly defined purpose, whether that was self-promotion, or to simply be read, as in the books in the publishing section.

The work displayed in this art section has a less clearly defined purpose. So, aside from some brief introductions, we let the highlighted designers speak for themselves. You can decide for yourself whether each designer's testimony is convincing. You can decide whether these designers are uppity urchins from the wrong side of the tracks or whether this work can lay claim to the inheritance of art.

LUST
Netherlands, 1995
The idea and practice of 'process' in graphic design has never been more popular. One consequence of process – minimising the design decisions and intrusions into creating work – is the elimination of self in the work. You could argue that it's a reaction to the design celebrity of the last decade, or a reaction to slick, corporate design, or even a reaction to computer-dominated design, because in some respects the listing of procedures and instructions resembles nothing more than software code. LUST, like Foundation 33, work with the concept of process. And the work here is partly about leaving in the entropic elements of creation. The entropic elements mean that everything is included in the final work. There have been interesting commentaries recently about how designers use mistakes to create work, but LUST do more than this. They don't resolve the accident into a final form. They leave stuff hanging, unresolved. According to LUST *Stad* is a book which 'examines the role of coincidence in graphic design and the implementation of these concepts into architecture and urban structure'. The spread shows a map of an urban environment that appears to have been degraded in the production process.

128.129

LUST
Netherlands, 1995
The front cover of this book has the word LUST censored in black. On the back a picture of a pin-up has also been obscured. The booklet opens out into a map of LUST's psychic organisation. They explain, 'This map functions as a conceptual guide to the inner workings of LUST. It was designed as a map to accompany two separate projects: one being a study of the role of coincidence and association in graphic design; and the other being the implementation of these concepts into architecture and urban structures. The key elements of the map which directly relate to the LUST design philosophy and methodology include: an associative collection of words; a ratio of magnification; a virtual legend; a relative scale; an index of self-defined words and images; coincidental spaces; architectural and urban structures; the Golden Section; Fibonacci's numbers; an intentionally broken piece of glass; a black square; and a pin-up girl.'

Tony Linkson
UK, 1999
Striptease

→ **STRIPTEASE AND FIGURINE**
Tony Linkson's pieces *Striptease* and *Figurine* were originally private video-based projects that ended up being placed, in different versions, in the UK's *Tank* magazine. The visual form of *Striptease*, a large frame broken down into blocks, has some resonance with Linkson's client-led work for the giant screen displays for Times Square in New York on New Year's Eve 2000. It was highly praised for its choreography, the way simple body movements unfolded over time (in a massive celebration of time) over multi-screens.

At the heart of *Striptease* and *Figurine* is an exploration of different dimensions of time — in-between time, duration, the shape of time. It's also about lost time. The model in *Figurine* is captured at the moment she's lost control.

Such a moment remains mysterious, which is why the figure of the epileptic, oscillating between violence and extreme calm, exerts such fear and fascination. The epileptic suffers a break in time. It's suspended. As Linkson remarks about the carefully constructed still images of the model from *Figurine*, 'It looked as if she had been removed from the space. It looked as if she

didn't belong standing in it, or falling over in it. It was almost some magical space in between. Could almost be as if someone had cut her out, Photoshopped her, and stuck her somewhere else.'

The epileptic moment is an in-between time, neither here nor there, which is why Joy Division's Ian Curtis sang in the autobiographical *She's Lost Control*: 'I could live a little in a wider line.' The image of the epileptic is perhaps a little strong in conveying the impact of Linkson's piece. More than anything else there is something delicate and fragile about it.

Striptease and *Figurine* are also about 'spending' time. They are about the relationship between time spent on your own work and the time spent on clients.

TONY LINKSON
'Both *Striptease* and *Figurine* are personal projects that came out of nowhere, from messing about when I learned to use After Effects. While learning this time-based software I imagined myself working with down-time.

The first one, *Striptease*, came out of being asked to contribute to *Tank* magazine at a point when I hadn't done anything that wasn't on-screen,

that wasn't time-based, for at least two years. It just starts with an image, one huge image made of time-based images moving diagonally across the page. One colour fades into another. I saw it as being a really beautiful diagram of the way time elapses. It was kind of almost being able to take a step back and have a grand view of a potentially huge period of time. I got really intrigued by this ability to show not just one shape, one moment in time but a shape of a period of time, to see a pattern of behaviour. It's literally a 'pattern of time'.

Sensual Time
I decided to do a striptease because of the whole idea of trying to reveal something sensual about the way things happen in time. The striptease has to work over time. When I think of striptease I think of people that are enjoying being in some kind of perpetual anticipation.

I was thinking a lot at that time about the way people transform themselves, and about snakes shedding their skins. This thought helped me work out that it was going to work diagonally in a grid. It actually works in a snake pattern starting in one square then going forward and back. →

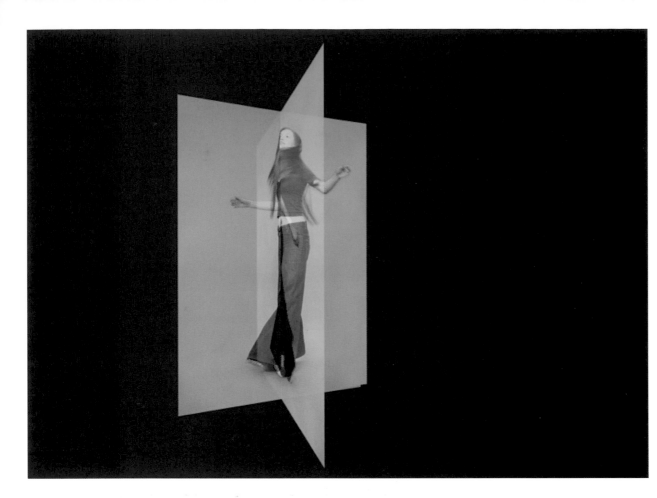

Tony Linkson
UK, 2001
Figurine

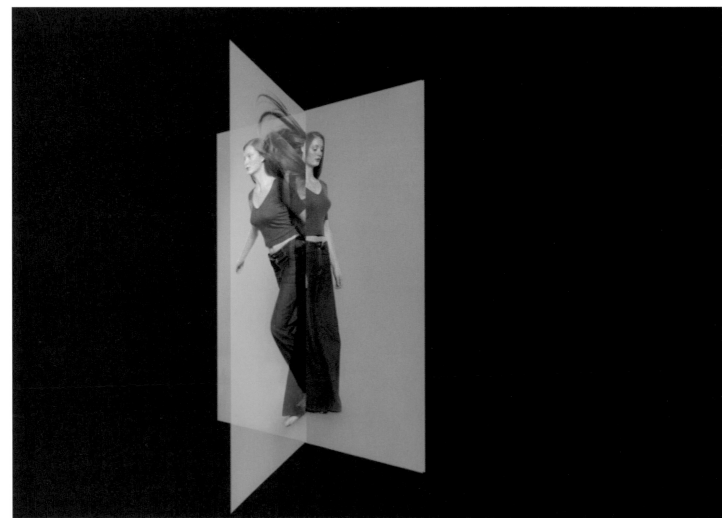

132.133

→ You are zig-zagging across the screen. The snake shedding skin is connected to the layers of clothes coming off.

So I shot stuff on a handheld video. It was very free, very intuitive. Without anyone else there doing anything technical. Then taking that footage and getting really mathematical about it, using this grid. *Striptease* has blocks of time which all lock together.

Then I started doing the audio. Each box contains everything. Every box was its own stage, had its own soundtrack. You create as many films as you want by offsetting and by different degrees, because you are not only changing the shape of it visually, you are changing the shape of it audibly as well.

Aggressive Time

Figurine was originally constructed out of aggressive little slices of time. It was about analysing really intense moments which is why violence comes into it. In the beginning I used my partner Jo as she was shouting at someone running past her. I pulled off key frames and flattened them, removing them from the chronological sequence – stopped them being part of the living thing. Then I used the most basic 3D-animation technology where you can only tilt or swivel, the objects are only going up or down. It's cheat 3D.

Making the piece was a circular process. Reanimating these things you have made static, taking them from a moving thing, making them static and then making them move again. The spreads are like a real 3D-environment where you have

self-illuminated panels. It's really an explosive, intense moment you can walk around. You can have 15–20 frames, one frame after another. That was actually shot on large-format transparency.

Freedom versus Constraint

In front of a one-colour backdrop I got this girl to relax and then got her to tilt forward and forward and forward, very, very slowly. She's looking very cool, very calm, collected and beautiful, and then there's only a very tiny moment before she falls – then her arms and legs are just going to go out, and she's going to look really stupid. It's getting that moment in between. The photographs are taken at the point she loses control. I got her to fall backwards, fall forwards and jump.

Part of it is extremely violent and part of it becomes benign again. But you don't know which bit came first. Was it cool, then it became violent? Or was it violent, then it subsided? In some ways it's like a reconstruction.

One thing that *Figurine* and *Striptease* have in common is that they are kind of throwing back and forth the idea of freedom versus constraint. With *Striptease* it was a case of 'I'm doing this in print but why don't I obey the rules of what I'm doing already.' Which was doing something time-based.

And of course the whole issue of freedom and constraint has a connection with the difference between working as an artist as opposed to a designer It's about being independent versus client-led and the way that one can feed into another.'

'...freedom and constraint has a connection with the difference between working as an artist as opposed to a designer.'

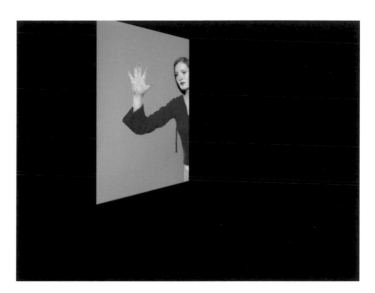

Anker and Strybos
Netherlands, 2000
This highly elaborate work, *Tastable*, is a comment on our current 19th-century workhouse/plantation ethic where we are on call 24/7. As Marx said, history occurs first as tragedy and is repeated as farce. It's certainly true of the *Tastable LR 406®* which is as tasteful as coffee in a can. The marketing rationale attached to the product is typical of our contemporary Catch 22 lifestyle economics. Overworking just to stay still requires more money. Working too hard causing marital problems? Shell out for £60-an-hour therapy. Or better still how about a £250-an-hour divorce lawyer? The creepy realism of the amiable marketing copy is enhanced by the rhetorical smile at the end. 'Recent research conducted by our Consumer Trends & Development division has pointed to a rapid expansion of the carry & care market, especially for products linked directly to business and lifestyle. It is against this backdrop that Axsellent Europe Inc. developed the *Tastable LR 406®*, an ecologically sustainable product that fully meets today's 21st-century consumer standards.

　　Our aim in designing the *Tastable LR 406®* was to build on two important international trends. First, consumers are becoming increasingly mobile. Second, labour productivity is advancing rapidly. Both trends, however, are in conflict with basic human needs for peace and contemplation. These problems are now solved by the *LR 406®*: this innovative product enables you to take a meal at any location, wherever you like, 24/7. To enable you to put good taste first. Always.'

134.135

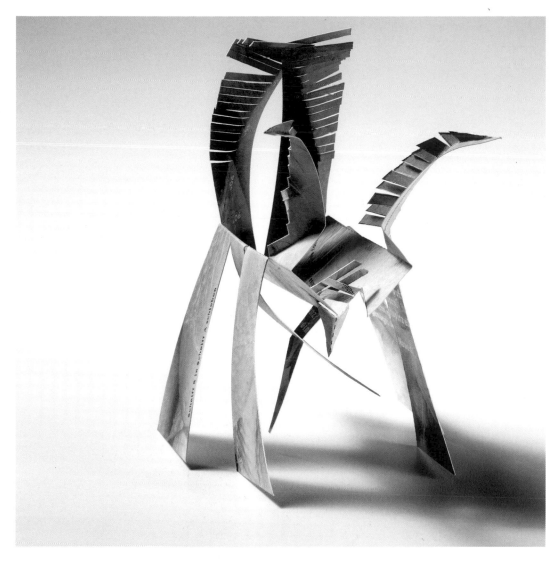

Sandra Kunz
Switzerland, 1995–2001
Card sculpture from Sandra Kunz. Her business
cards have a set of instructions on them with lines
showing where to cut and the angle of fold.

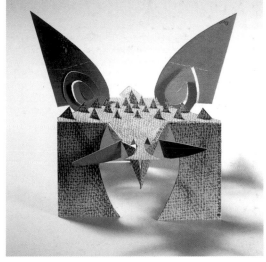

→ ROAST

The most important element of promotional material is striking the right tone. Though you are selling, you don't want to sound as if you are. And if a freebie of some sort is part of the package, you've got to do it with taste. Alternatively you could try the approach of Ian Holcroft who wrote to a design magazine saying, 'Hello…I am a designer who has sent you gifts. I hope you like my stainless-steel chip fork and promotional material. I think this fork is a design icon and the chip shop a national identity.' Sometimes wit is the best tactic.

Ian Holcroft's work is remarkably varied. There is no question that it's unbriefed, because Holcroft is currently a 'stay-at-home dad.' It's not just the content of his work that is peculiarly British, but also the humour and the name under which everything is named – Roast, conjuring up the cosy image of Sunday dinners, throwing peas at your siblings.

For someone who is a full-time dad, the work he makes has extraordinarily high production values. His *A1/A1 stainless-steel ruler* and *Business shirt* complete with *Financial Times* packaging look like high quality manufacturing.

Alongside conceptual ambition and craft, there's one talent that Holcroft has that can't be taught and that's a highly subtle sense of tone. You can see it in the way he documents his work which seems as significant as the work itself. So alongside the interview we have reproduced some of the CV that Holcroft sent.

136.137

IAN HOLCROFT

'I'm a full-time 'stay-at-home dad' and this work is a way of 'keeping my finger in'. Its variety is partly due to my time studying in London, soaking up the whole atmosphere in design and art. I was at Central Saint Martin's and I was interested in a broad range of things from furniture to art, I had to keep finding solutions and ideas in these mediums. I also got interested in processes, trying to find the cheapest way of doing things, ways of getting things out.

At the moment GTF are quite an influence as are colleagues I have worked with in London like Alex Rich. We both had similar ideas about things like 'making the object', and the idea that the act of doing it was as important as the result. In order to do the work I try and save bits of money here and there. It's all off my own back really. I sacrifice other things in a way. I do most of the things myself. I didn't make the ruler but I made the packaging for the business shirt and sewed it together.

I think the interest in the idea of Englishness is partly a result of living in another country. I find myself more attached to England when I'm absent. I think it comes from that. It's not terribly conscious but it's there, like in the A1 Road. I've been designing a few tables, which are still waiting to be produced; they are just mounting up through trying to find time. I've not made any money but I'm not in it for the money. It's about trying to get started on a vision of what I want to do with my life.

Roast
Norway, 2001
A1/A1 Ruler

Business shirts

The business shirt is the symbol of capitalistic progress, a necessary and precise garment, part of the prescribed uniform embedded with cultural undertones of doing (the) business, making deals, making money, forcing the goal of bigger success and financial achievement.

Roast brings this epitome of successful business crashing down to earth. The *Business Shirt* grid is now (dis)graced with the babbling of the under-achiever, the failing man and the corrupt. The *Business Shirts* come in a variety of colours and grid sizes, hand-finished with one of five different messages. They are sealed in newspaper packaging made from the *Financial Times*.

A1/A1 ruler (An executive gift by ROAST 2001)

The A1 north road, from London to Edinburgh, becomes a measure of sorts for the length of England. I presented this road and the main cities along its path as an aluminium ruler. The ruler length is that of the A1 road's similarly named paper-format A1 (length 840mm). By combining these corresponding scales, it is then possible to calculate distances between the destinations along the road. →

Enjoy
A piece of white.
in our chaotic, overstimulated world
we need space to think, to breathe, to enjoy

→ **A piece of white**
A clean/unused sheet of white paper is presented and appreciated for revealing nothing more than a blank space. Through its lack of information and application, it shows itself against the constant influx and pervasive aggression of information, colour and form, which bombards our visual landscape. In our chaotic, overstimulated world we need space to think, to breathe, to enjoy.

A sheet of paper is no longer considered just that; it is regarded as much more.

Roast
Norway, 2001
A piece of white

Stainless-steel chip fork

The idea for this work was to represent our national identity with food. The chip shop is part of our Britishness, a well-known identity. I have reappropriated the chip shop disposable fork and celebrated its associations with our most famous British food. I realised that the chip fork, a tool picked up at the chip shop and discarded without a thought after a night on the town, was a cultural icon for the nation's passion for fish and chips. My stainless-steel chip fork is a design icon for fish and chips, and for a British habit.

The familiar and mundane quality of the wooden fork is now explored in a reusable form, with the beauty of stainless steel adding function while retaining the simplicity of the original.

The fork is flow-wrapped by hand in protective and transparent glass-line paper, the paper becoming the disposable part of the idea. The two accompanying posters represent the chip shop and its national association. Two sheets of chip paper (as when wrapping chips in the chip shop): one poster has the fork screen-printed on one side and the British Isles printed on the reverse, so it shows through the right way when the paper becomes translucent with chip fat; the other chip paper has the illustrated folding process of making a chip cone, for that authentic 'open wrapped' chip serving preference.

Chip fork 'campaign edition'

The local fish and chip shop, and consequently our national identity, is being subdued. Noodle & Sushi bars and other trendy fast-food establishments are spreading throughout the country, even threatening to reach as far West as the valleys. The local chip shop must remain an integral part of our British life. In response my 'campaign edition' chip fork is launched. As 2001 seemed to be the year of the slogan, I thought "fuck sushi" was appropriate here.'

'As 2001 seems to be the year of the slogan, I thought "fuck sushi" was appropriate here.'

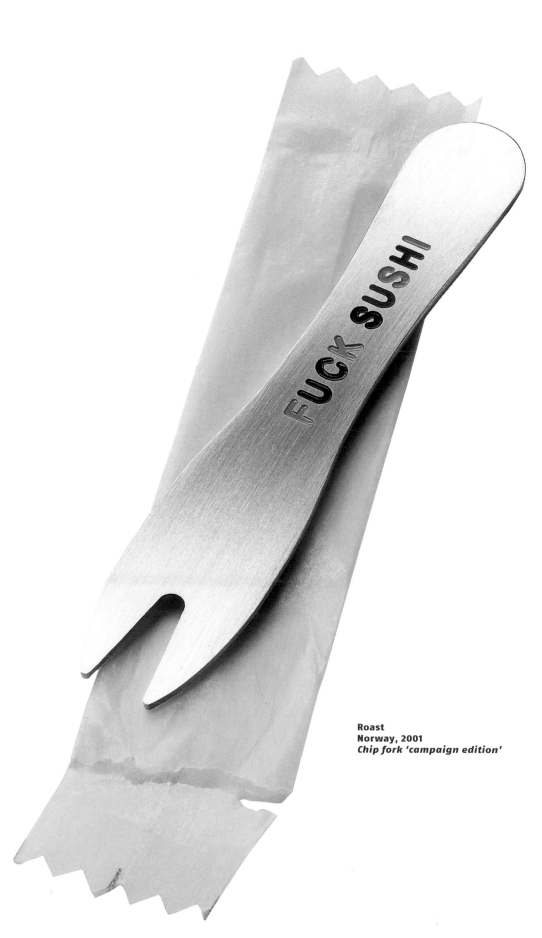

Roast
Norway, 2001
Chip fork 'campaign edition'

Au_ra Lisauskienë
Lithuania, 2000
This textured, ethereal poster called *Time* is the
second in a series (the other is called *Space*). The
purpose of the work according to Lisauskiene
was to show a 'two-dimensional plane's optical
transformation to a three-dimensional view and
show the kinetic motion inside.'

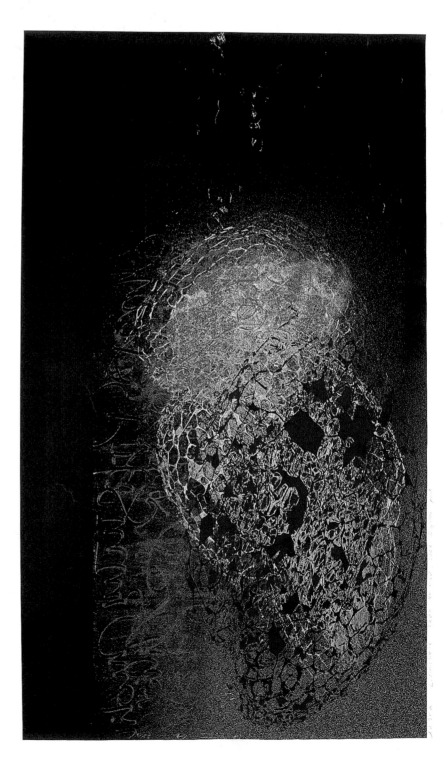

Au_ra Lisauskienë
Lithuania, 2001
Again there is a painterly quality to this poster.
Calligraphy, drawing and colour in digital graphics
render an image of the creative brain
at work.

140.141

Gianni Bortolotti
Italy, 1984
'The four colours of the four letters which make
up the word 'Love' represent the four human
races and are only virtual since universal love
does not exist. The tri-dimensional form of the
four characters expresses the great value, urgency
and the necessity for peace through tolerance and
solidarity. The ubiquitous value of this message
is expressed by using the whole of the space with
the diagonal form.'

Gianni Bortolotti
Italy, 1999
Gianni Bortolotti's posters have been shown in
exhibitions worldwide. They are also kept in the
permanent collection of galleries such as New
York's Museum Of Modern Art, Washington's
Library of Congress and Musée de la Publicité at
the Louvre in Paris. His work is influenced by
aesthetics as much as graphic design, partly no
doubt because posters such as those shown here
are not driven by the demands of information
communication. He is the thinker of the poster
form, and the idiom in which he thinks is very
much Italian. Like his fellow countrymen – writer
Umberto Eco and philosopher Gianni Vattimo – he
has an easy facility for addressing contemporary
issues of communication in terms of classical
metaphyiscs. It's worth comparing his take on
'nothingness' with Davenport Associates Images
of The Century. Like other examples of Bortolotti's
poster work, shape, geometry and space are
vehicles for political and social ideas. As he
explains about *Sitting Nude*, 'My aim is to make
a choice which will make a difference, will alter
the course of things, will start a chain of events
which could be irreversible. It's about the freedom
of going against the flow of decadence...in which
the communicating values of the image have been
slowly undermined. This is a move, then, towards
"nothingness", as a principle of transformation in
the context of subtraction – acquisition, through
the power of the concept of "nothingness" has to
evoke images.'

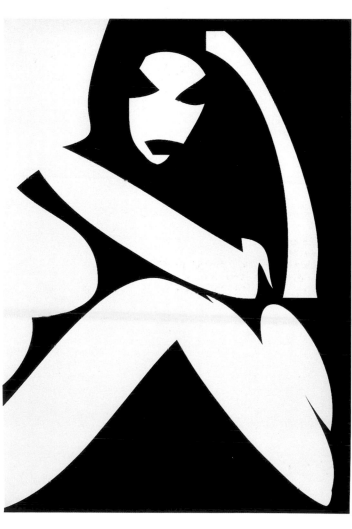

In the English speaking world the graphic novel has had an explosion of interest in the last 20 years. Frank Miller's *Batman* series, Art Spiegelman's *Maus* and Alan Moore's/Dave Gibbons's *Watchmen* are just a few examples of graphic novels entering the mainstream. (*From Hell*, Moore's collaborative work with Eddie Campbell, was recently made into a Hollywood movie.) But mainland Europeans have always been relaxed about the inherent quality of the comic book or graphic novel. Reading graphic novels has always been a grown-up, adult activity.

The graphic novel has always been the cultural expression of the designer and illustrator, but like design work in general, its aspiration to stand alongside art has always been hampered in the eyes of many by the fact that graphic novels are commercial products. The graphic novel of Finnish designer and illustrator Ville Tietäväinen (whose spreads are shown here) isn't tainted by commerce yet. Though intended for publication, it is currently a labour of love. You can judge for yourself its artistic merit, in the beautiful and epic nature of his illustration, in its evocative use of tone and hues to create an enthralling atmosphere.

In any case, there is still a large degree of snobbery in the artworld about design, illustration and graphic novels. A case in point was the nomination of artist Glenn Brown for the UK's Turner Prize. Brown's work consists of exact copies of illustrations from the covers of science-fiction works. Brown's copy of Anthony Roberts' cover for Robert Heinlein's book *Double Star* cost £30,000. Rian Hughes, a London-based illustrator, took issue with this profitable snobbery in an article for *Eye* Magazine (no.39 Vol.10 Spring 2001). She argued that Brown's work 'relies upon a two-tier system that holds certain kinds of work as raw material, mere cultural clip-art.' She also interviewed artist Dave Gibbons who asserted, 'I detest the arrogant notion that commercial work just happens to exist and is therefore devoid of creativity or intellectual process...Many of the "art" copies of commercial work lack even the basic craftsmanship of the original...Roy Lichtenstein's copies of Irv Novick and Russ Heath are flat, uncomplicated tracings of quite sophisticated images...the original artists have translated reality into clear, effective compositions, using economical and spirited linework.'

Perhaps in years to come the work of Ville Tietäväinen may find itself reproduced faithfully by an artist in London's Tate Gallery or the Guggenheim in New York. In the meantime it can be enjoyed for what it is. Artworks are like people. It's not important where you come from. What's important is where you are now.

Ville Tietäväinen

'I'm a 31-year-old self-trained graphic designer, graphic novel artist and illustrator from the city of Espoo, Finland. I actually graduated as an architect, but I found that I needed to get in a field of business where I could express myself more. I have been running my own design firm, Studio Tietäväinen Oy since 1998. Beside my work as an illustrator and graphic designer, I have been doing a 112-page-long graphic novel album for two years.

The title of the work is *Birds and Oceans*. It comes from an old Chinese fairytale which tells of a battle between a little bird and a vast ocean that drowns the bird's lover. It consists of two intertwined stories that are situated in Hong Kong in year 1996, just before the 'handover' to China. The story is fictitious. But my intention is to depict quite realistically the plight of a young Hong Kong couple and a Vietnamese refugee family. The story deals with themes of hope and despair. The tragic destinies of the individuals are metaphors for the uncertain future of the whole society. Both stories handle the need of becoming free in order to decide one's own life. It's also a telling metaphor for the author.

Ville Tietäväinen
Finland, 2002
Birds and Oceans

→ Inspirations

In the field of graphic novels I have enjoyed the work of Alan Moore, Art Spiegelmann, Hugo Pratt, Miguelangelo Prado, Enki Bilal/Pierre Christin and the collaboration of Neil Gaiman and Dave McKean. Oh, and a Finnish colleague of mine, Tarmo Koivisto, who has created Mämmilä. This massive ten-album saga is a larger-than-life, semi-fictional world of a Finnish village and society. Other than that I'm actually not a huge fan of contemporary graphic novels. I get my inspiration mainly from books and movies. It has been liberating not to have an exemplary figure in the field of graphic novel.

 The content has evolved dramatically since 1997, when I first had some kind of an idea about it. I had a grant to go to Hong Kong to photograph sites and study the culture. I stayed in Hong Kong for three months and had local friends correct the flaws in authenticity and add spice to the synopsis. When seeing the mercilessness of the city, the story became more frantic than I ever would have imagined in my mind.

 Compared to my work as an illustrator, composing a graphic novel is far more challenging. Nearly 700 pictures have to be placed in relationship with each other. The preserving of consistency of the technique and the story flow are things I don't have to give thought to in my usual illustration work. The basic layout of this album is quite conventional. I deliberately avoid over-dynamic 'comics-like' page compositions and try to give a more epic touch to the whole.　　　→

The overall narrative form of the work is in itself tricky. The album begins and ends at a point where the story is chronologically in the middle. And so the chronological end is in the middle of the album. Hence, after passing the chronological end the reader knows what's going to happen in the rest of the book. This gives another perspective to the events which follow. Phew, I hope I made myself at least partially clear!

In the album there are frequently simultaneous scenes and, on the other hand, month-long leaps. I try to create a feeling of the story's chronological time-span of approximately one year. I try to avoid narrative text as much as possible and tell things visually. For example I alter people's appearance and take advantage of day and night both atmospherically, and in depicting passing time.

In the first story the protagonists are a young Hong Kong girl and her loved one, a somewhat older boy who is an illegal Cantonese immigrant. These two experience the most noticeable psychological changes in becoming independent of their communal and family chains. The second story is in the middle of the album, dividing the first story in half. It is about a Vietnamese refugee who tries to escape from Hong Kong's Whitehead refugee camp during a riot in 1996. In a way they are all heroes, in spite of their fated destinies.

The sketching and final drawing/painting are done with aquarell-pencils and gouache on a grey cardboard to get the lights and shadows. The final quadtone-hues and blue aerial perspective are done with computer. The hues are limited to give atmosphere and depict the passing of time and place, so that the colours help the reader to comprehend the unlinear progression of the two intertwined stories.

It will be ready to be published sometime in 2002. I haven't looked for a publisher yet, because I'm so passionate about the project that I'm going to get it ready anyway, and it is easier to show the finished work.'

144.145

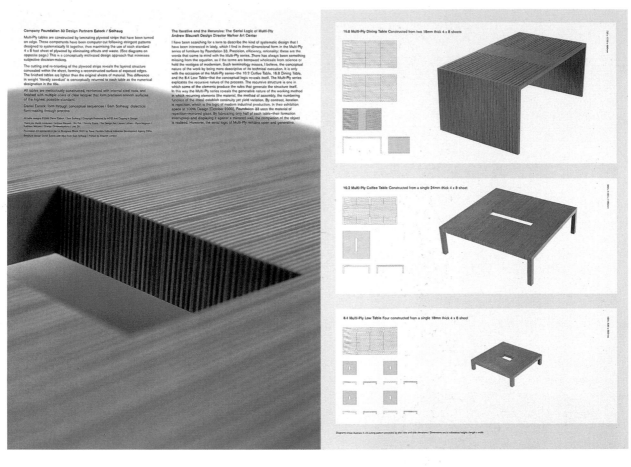

Foundation 33
UK, 2000/2001
Promotional leaflet for eco-friendly process furniture from the group who designed the UK's *Big Brother* identity in 2001. 'Multi-ply tables are constructed by laminating plywood strips that have been turned on edge. These components have been computer-cut following stringent patterns designed to systematically fit together, thus maximising the use of each standard 4x8-foot sheet of plywood by eliminating offcuts and waste...This is a conceptually motivated design approach that minimises subjective decision making.

The cutting and re-orienting of the plywood strips reveals the layered structure concealed within the sheet, forming a reconstructed surface of exposed edges. The finished tables are lighter than the original sheets of material. This difference in weight which is "literally sawdust" is conceptually returned to each table as the numerical designation in the title.'

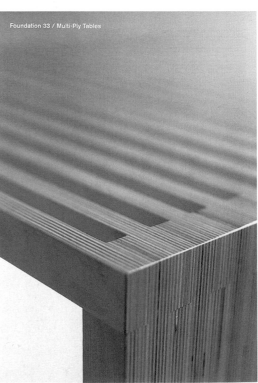

UTILITARIAN (DELETE AS NECESSARY) ADVERTISEMENT/ANNOUNCEMENT/BULLETIN/DECLARATION/PROCLAMATION

THIS POSTER PROVIDES A FRAME & STRUCTURE FOR THE INFORMATION & DETAILS FOR ANY EVENT/HAPPENING
COMPLETE THE EIGHT SECTIONS BELOW USING ANY METHOD OR MEDIUM
CONCEPT & DESIGN COPYRIGHT DANIEL EATOCK 1998 SAY YES TO FUN & FUNCTION & NO TO SEDUCTIVE IMAGERY & COLOUR!

TITLE

DESCRIPTION OF EVENT/HAPPENING

DATE

TIME

DIAGRAM/DOODLE/DRAWING/IMAGE/PAINTING/PHOTOGRAPH/SCRIBBLE/ETCETERA

LOCATION/ADDRESS

DIRECTIONS/MAP

FURTHER INFORMATION

IF YOU WOULD LIKE COPIES OF THE UTILITARIAN POSTER FOR ANY FORTHCOMING EVENT/HAPPENING CONTACT:
DANIEL EATOCK/SCHOOL OF COMMUNICATION DESIGN/ROYAL COLLEGE OF ART/KENSINGTON GORE/LONDON/SW7 2EU/UNITED KINGDOM
TELEPHONE + 44 171 590 4444 EXTENSION 4311/FACSIMILE + 44 171 590 4300

POSTER COMPLETED BY

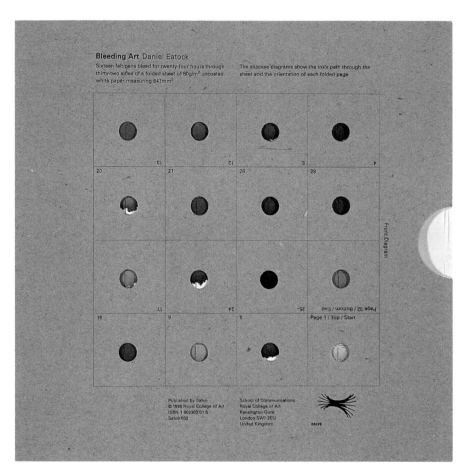

Foundation 33
UK, 1998
This *Bleeding Art* publication was created by
'Sixteen felt pens bleeding for 24 hours through 32
sides of a folded sheet of 80g/m² uncoated white
paper measuring 841mm². The slipcase diagrams
stop the ink's path through the sheet and the
orientation of each folded page. Published in
an edition of 300 copies.'

146.147

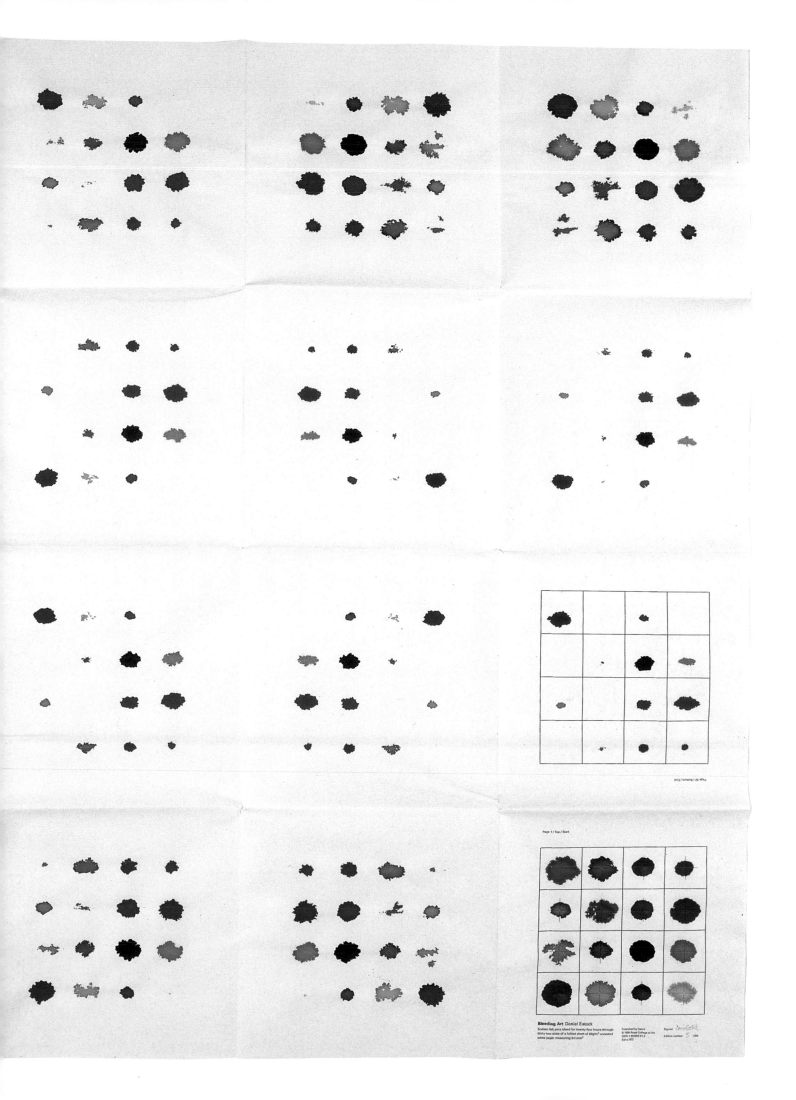

Bleeding Art Daniel Eatock

Sixteen felt pens bleed for twenty four hours through thirty two sides of a folded sheet of 80g/m² uncoated white paper measuring 84 (mm²)

Published by Salvo
© 1999 Royal College of Art
ISBN 1 902303 01 4
Salvo 002

Signed *Daniel Eatock*

Edition number 5 / 200

ART CRASH!

In the summer of 2001 Scott King and Matt Worley's Crash! were asked to participate in an art and politics event at the Austrian Cultural Institute in London. The opening night was hosted by two artists, Alexander Brener and Barbara Schurz, under the title of Brener & Schurz Summer School of Bukaka: Resistance, Insurrection, Constituent Power.

By the mid 1990s Alexander Brener had attracted a certain degree of notoriety. In 1997, at the Stedelijk Museum in Amsterdam, he had sprayed a green dollar sign on the Malevich painting White Suprematism 1922–1927. This was an evolution in Brener's anti-art 'action art.' According to a letter of support (posted on the net by a group of Slovenians who defended the artistic merit of defacing the Malevich), in 1994 Brener performed an 'action' at the Fine Art Museum in Moscow. He defecated in his pants in front of one of Van Gogh's paintings while repeating 'Vincent, Vincent'.

This defecation was explained as having a twofold meaning. It was an expression of pleasure at the work of art and the manifestation 'of the monolithic ideology that Van Gogh was placed in as its founder.' Depending on your point of view it's either following a glorious tradition of 'anti-art' art, or misplaced navel gazing.

There were two parts to the Crash! contribution to the event. The first was a looped text display over the stage, which included the character of Gail Tilsley who appears in a hugely popular UK soap opera, Coronation Street. The text has four parts, each displayed separately, one after the other.' Jeremy would masturbate endlessly over the thought of Gail Tilsley from Coronation Street...He had a perfectly good reason for this...Janice had only let Jeremy

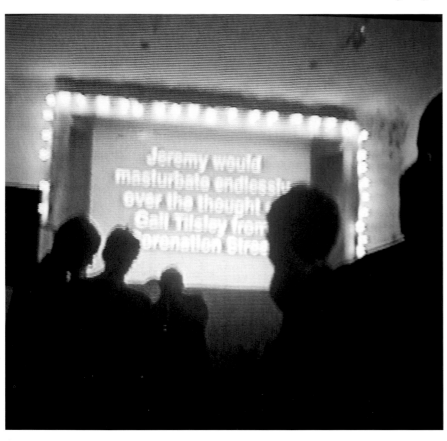

Crash!
UK, 2001
Art chaos at the Austrian Cultural Institute.
Stills taken from video by John Madden.

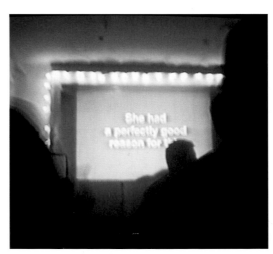

148.149

'The atmosphere was what we imagined punk was like.'

touch her once in the twenty-first century...she had a perfectly good reason for this...Jeremy would masturbate endlessly over the thought of Gail Tilsley from *Coronation Street...*', and so on.

Crash! explain the formal inspiration for this text in their account which follows. They also invited the band Earl Brutus to perform. The relationship between Crash! and the band goes back at least as far their album *Tonight You Are The Special One*,

which Crash! provided the concept for. Scott King (who has recently designed the Pet Shop Boys' singles sleeves) did the art direction and design. King's sleeve has a picture of a Jeep and a BMW side-by-side. Each car has a hose going from its exhaust pipe into the window of the other. The cover is called 'I've got a window Wednesday.' It's also been described as a 'yuppie suicide pact.'

Thwarted Englishness
What's notable about the Crash! relationship with Earl Brutus is the fact that both explore a specifically English terrain of failure. Earl Brutus is like a fantasy pub band. They used to drink in the Earl Percy in Ladbroke Grove. The idea is that they are the ultimate non-band. The singer once fruitily described the band as 'Kraftwerk with a loss of dignity. Kraftwerk after 16 pints. Kraftwerk caught wanking by their dad.'

Just as the raw materials of Crash! are the signs and symbols of British culture, Earl Brutus are a band conceived around the idea of the existentially thwarted. Their songs explore this neglected sliver of English life. And Earl Brutus' sound of low-end pulsing bass and high-end guitar feedback has its mirror in how Crash! handle high and popular culture. The impact and pleasure of their work comes out of the dissonance they create, in the easy slippage from →

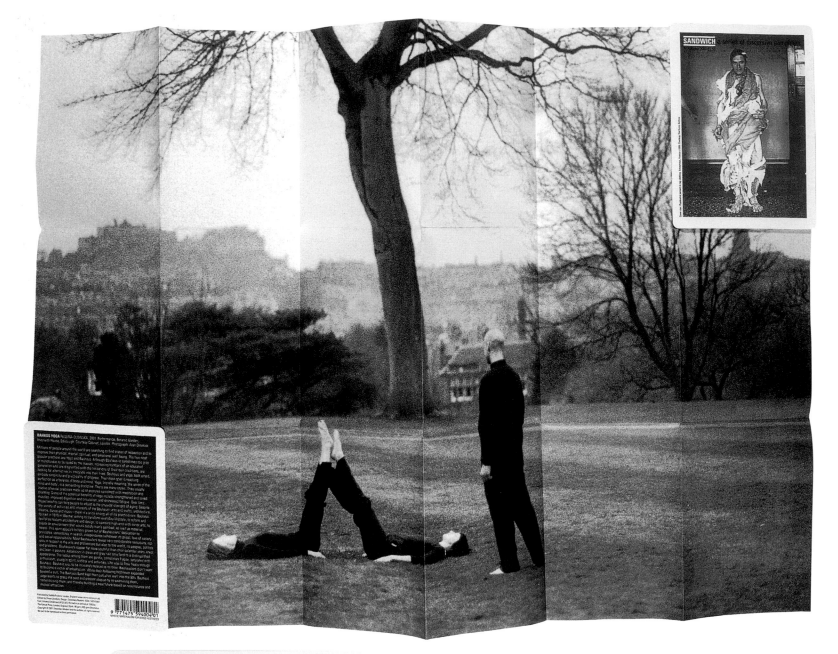

BAHAUS YOGA PAULINA OLOWSKA. 2001. Performance, Botanic Garden, Inverleith House, Edinburgh. Courtesy Cabinet, London. Photograph Alan Dimmick.

Millions of people around the world are searching to find states of relaxation and to improve their physical, mental, spiritual, and emotional well-being. This two-roof popular practises are Yogri and Bauhaus. Although Bauhaus is sometimes too joy or misattributed to be loved by the masses, increasing numbers of an educated generation who are disgruntled with the niceties of their own traditions, are looking for alternative to integrate into their lives. Bauhaus and yoga, both smart, embody simplicity and practicality of progress. Their major goal is reaching perfection as a harmony of body and mind. Yoga, literally meaning 'the union of the mind and body', it a demanding discipline. There are many styles. They usually involve physical exercises made up of postures combined with movement and chanting. Some of the potential benefits of yoga include strengthened and toned muscles, improved digestion and circulation, and increased flexibility. Over time, these benefits can help people to adjust to the physical changes of aging. Despite the variety of activities and interests of the Bauhaus—arts and crafts, architecture, theatre, dance and music—there is a unity among all of its practitioners. Bauhaus formed in 1919 in Weimar aiming to transform everyday lifestyle, to reform and revitalise modern architecture and design. To combine high arts with exotic arts, to create an environment that would satisfy man's spiritual, as well as material, needs. His spirit appears to have grown out of Bauhaulders' dedication to principles consistency in search, indispensable enthusiasm in good, love of variety and social responsibility. Most Bauhaulders reveal very comparable sensitivity, not only in respect to the arts and professions but also to the world, its systems, politics and problems. Bauhaulders looked far more youthful than their calendar years, erect and lean in posture. Asceticism in dress and gray hair only lend to a distinguished appearance. The ladies among them are gentle, conscious if quite, saturated with enthusiasm, young in spirit, radical and selfless. Life was to flow freely through the Bauhaus, Bauhaus was to be minutely realized as its time. Bauhaulders didn't want to become a victim of schematism. While their following had never expanded yoga wants to grasp the past and present steps as far re-examining them mnemonic origins and thereby building a new future based on resentments and neutral attitudes.

150.151

SANDWICH a series of discursive pamphlets.
A, Autumn 2001 £2.50

Cover star: Psychiatric patient in rag clothing. Anonymous, France c.1899. Courtesy The Burns Archive.

→ the highbrow to the lowbrow in, for example, the transposition of Cher and Che Guevara.

So it was ironic when on the evening of Thursday 30th August 2001, the organisers of the event performed their work, reading a manifesto decrying among other things Britart, Tony Blair and the evening's 'light entertainment,' because Crash! more than anyone else in recent years have created a populist, sophisticated, design–led critique of British society. It is even more ironic that Brener who may have aimed his project at the 'spectacle' that commerce has made of art, devaluing art of any real impact, is someone clearly adept at manufacturing contrived situations himself. Here is the Crash! account of that night.

CRASH!

'We got invited by Alexander Brener to do this show. They came from abroad and we didn't know anything about them. We offered to do the piece of work that we eventually showed onscreen above the stage. We showed a video projection above the band where the text is interlocked. It's inspired by the RD Laing book *Knots*. It's like a relationship where you are locked into blaming the other partner.

They asked could we have sound with it? We said we could get the England Sandwich track from Earl Brutus. Then we suggested we could even get the band. Something we wanted to do for a long time was put Earl Brutus on in an Art Gallery.

Secondary Modern
UK, 2001
This art pamphlet *Sandwich* opens up to a full
poster. On one side there's an image of a work by
Pauline Olowska called *Bauhaus Yoga*, with an
essay by her in the bottom-left-hand corner which
is the back of the pamphlet. The cardboard cover is
in the top-right-hand corner, hence the title
Sandwich. The other side contains among other
items, an essay called 'Metaphysics' by artist Jake
Chapman. This is the first issue of *Sandwich* and is
as much an object in itself as a forum for artists
and writers. Designer Simon Josebury's work for
London's Cabinet Gallery (home of Martin Creed
and Jeremy Deller among others) has meant that
this pamphlet has a unique perspective that is
both highly intellectual and raw.

Christoph Steinegger
Germany, 1998–2001
Promotional lighter for Sabotage called
Hype/Learning By Burning. It's a reflection on
the vampiristic tendencies of business's attitude
towards culture. So the Hype lighter comes in a
plastic bag with the warning 'Don't burn your
fingers. The content can become dangerous. To
avoid general danger of suffocation, this plastic
bag has to be kept away from so-called trend-
scouts and hangers-on.'

Watermelon Art
When we got down there we
found out that in some ways we
had been set up. And that these
artists were armed with eggs and
watermelon and had some
intention of pulling down the
edifice of British Art. We were the
fall guys for some reason. They
read out a manifesto on stage.

As soon as we started up
to get the band on, this guy began
turning over tables and
dismantling the exhibition,
shouting 'you're all going to die'
and that kind of stuff. The
atmosphere was what we
imagined punk was like. It was
really tense. There were bottles
and eggs being thrown and it was
so dark you couldn't see anything,
but you could hear the bottles
breaking. It wasn't scary. All this
stuff just heightened the tension.

Beforehand everyone was
just standing around sipping
wine. Though Brener started by
being provocative I think he
thought we would just fold up and
not react. It was dangerous,
people were running outside,
there were bottles smashing.
Brener was tearing down his own
work, he turned over tables and
tried to turn over the bar. He
started pushing people around,
Scott stepped in to intervene and
then a fight broke out. Punches
were thrown. The whole premise
of it seemed to be that what
Brener was doing was an
authentic anti-capitalist gesture,
and what we were doing was
providing light entertainment,
which we were! That's how Brener
saw it. It was basically a set up.

Capitalism Unplugged
Then Earl Brutus cranked up really
loud and got going. The band
were so loud, in this tiny room.
They really stoked-up the
atmosphere. We had come in
good faith to do a piece of work
and put the band on for no
money. They were trying to stop
that or use us or make us look
ridiculous. We were just like
stooges. We were just to appear
and they would unplug us, throw
stuff and we would walk off
crying. But the opposite happened.

It was just petty, which
Crash! never was. Crash! was
always meant to be a critique of
that level of political art. Clearly
that kind of political art is quite
hopeless. It fails. Crash! to us was
always more realistic about that,

trying to make a serious point but
simultaneously accepting the
position that it's only art, it's only
publishing or it's only effective to
a certain extent. Whereas Brener
and his colleagues, rightly or
wrongly, held the belief that doing
wax crayon drawings on the wall
would somehow end the art
establishment. That's what we
were pissed off about. The idiocy
of it. A lot of Crash! is about the
signs of radical gestures. It's about
attempting to question these signs
and gestures. Not to completely
deny them or to say they are
meaningless, but not to confuse
them for truth.'

152.153

Richard Smith
US, 2001
The work of artist Lawrence Weiner has proved
attractive to graphic designers exploring the
impact of stark, isolated text. But whereas Weiner
chose typography (such as Franklin Gothic
Condensed) that wouldn't editorialise the text or
inflect it, Smith's *Victoria I* and *Bye Buy* uses the
found typography of Scrabble letters. One can only
assume from the game of *Victoria I* that it is
Beckham rather than her majesty that Smith is
referring to. Or perhaps it's a reference to a
personal relationship. *Bye Buy* and *Rich and Heel*
have a kind of duplicity and confusion. The only
certainly with *Bye Buy* is that you get the same
points for each word. Whereas, as the tone of
Weiner's text is flat and gnomic, Smith's work is
a kind of Scrabble/*Sex in the City*. The words of
Victoria I are signifiers of attraction with which
we invest and imagine our lover to have/be.

RICH HEEL

Orgdot.com
Norway, 1999
Orgdot.com created this spooky installation called *Dead At Night* for an electronics arts exhibition called Detox. Orgdot.com describe *Dead At Night* as 'a meta-game dealing with the internet and the dawning of an artificial intelligence with no trace of human values trying to deal with its sudden existence.

The physical representation of the game at the exhibition consisted of three futuristic office cells connected to each other. These cells provided players with a private atmosphere – a one-to-one feeling with the representation of the net that was the platform of the game. The game itself was never online. That way we could allow ourselves to deal with broader than broadband media.'

Audio Cassette

Lost
Formats
Preservation
Society

Lost
Formats
Preservation
Society

Lost
Emigre57
Preservation
Society

Lost
Formats
Preservation
Society

Lost
Formats
Preservation
Society

Lost
Formats
Preservation
Society

Lost
Formats
Preservation
Society

Lost
Formats
Preservation
Society

Video Cassette

Lost
Formats
Preservation
Society

Lost
Formats
Preservation
Society

Lost
Formats
Preservation
Society

Lost
Formats
Preservation
Society

Lost
Formats
Preservation
Society

Lost
Formats
Preservation
Society

Lost
Formats
Preservation
Society

Lost
Formats
Preservation
Society

Floppy Disc

Lost
Formats
Preservation
Society

Lost
Formats
Preservation
Society

Lost
Formats
Preservation
Society

Lost
Formats
Preservation
Society

Lost
Formats
Preservation
Society

Lost
Formats
Preservation
Society

Lost
Formats
Preservation
Society

Lost
Formats
Preservation
Society

'Q: How many support technicians does it take to change a lightbulb?
A: Please hold and someone will be with you shortly...'

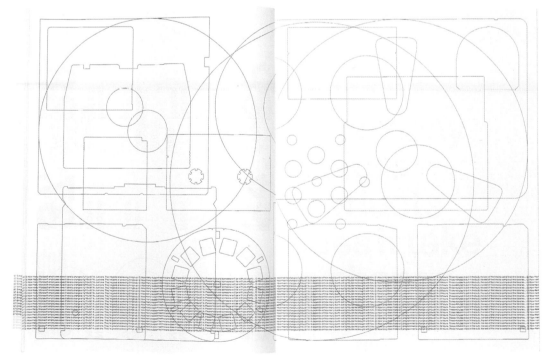

Experimental Jetset
Netherlands, 2000–2001
**Experimental Jetset designed and edited issue 57
of *Émigré*. Their theme, 'Lost Formats Preservation
Society', was signalled by an eight-page cover
with eight different 'cover stars' (floppy disc,
video cassette, eight-track, etc). The other spread
shows drawings of formats, displayed, as they say
'in the middle of the magazine like sewing
patterns'. The lines of text at the bottom of the
page are, literally, a running joke throughout the
magazine. It's the light-bulb joke told with
various technologists as the butt. One at the
bottom of this spread says, 'Q: How many support
technicians does it take to change a lightbulb?
A: Please hold and someone will be with
you shortly...'**

Images of the Century

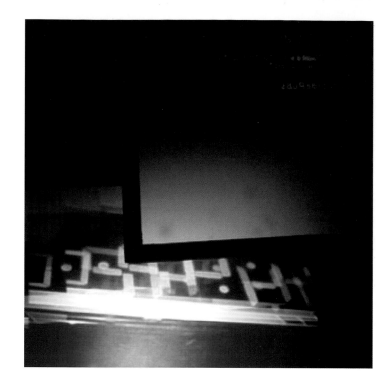

Kennedy assassination
Abraham Zapruder

1963

Lee Harvey Oswald murdered
Robert Jackson

1963

**Davenport Associates
UK, 1999**
The Greatest Televison Show on Earth is a short story by Ballard about a TV Time Travel show. It's kind of like *Big Brother*, but set on the Somme or Guadalcanal. The show's concept is nearly scuppered at the very start when a Japanese businessman tries to copyright history. Copyrighting history!? Funny but unimaginable you may think but this idea is addressed in the remarkable *Images of the Century*.

A memorable image from each year of the 20th century is represented by a blank page and a caption at the bottom: 'Kennedy Assassination, Abraham Zapruder, 1963'; 'Apple Computer trademark, Regis McKenna, 1977'; 'Car Crash, Paris, 1997'. It's a simple and powerful account of our collective memory as told through images. But it's not just about the power of visual memory. Many of these images are privately owned, such as the death of Kennedy or the overlapping circles of Mickey Mouse's face. Copyright owners can place a high price on the use of such images or even not allow them to be used at all.

Ballard's story wasn't prophetic. History isn't an open source, it's proprietary. As Peter Davenport wrote at the time, 'Copyright makes it illegal to store or retrieve the images named in this book by any means whatsoever. As the reader of *Images of the Century* will rapidly understand, those means are fundamental to the condition of being human and aware in our culture and we can no more disown them than we can resolve not to think of the number twelve. But in order not to infringe copyright, that is exactly what we must undertake not to do when we think of – but must refrain from visualising, the South Vietnamese girl burned by napalm, Smiley, Myra Hindley, The Pompidou Centre....'

156.157

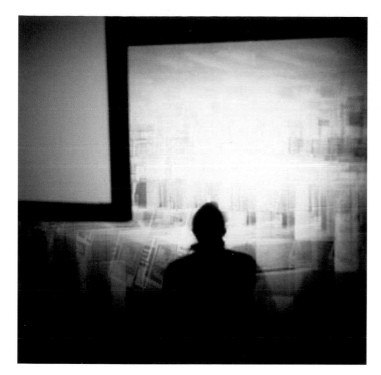
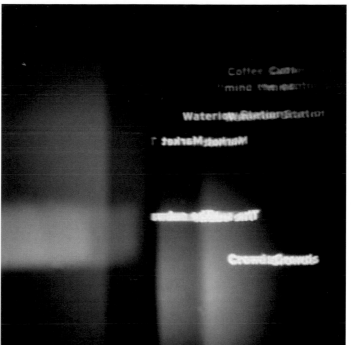

**Paul Farrington,
London**
Tonne's sound polaroids. These interactive sound-based images were part of a work with Scanner in a performance at the ICA, London.

**André Stauffer
Switzerland, 2001**
The simple four-sided shape of *The Pragmatic Square* is a master of disguise, telling a different story each time.

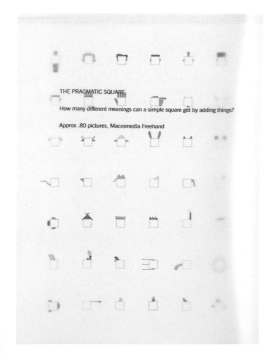
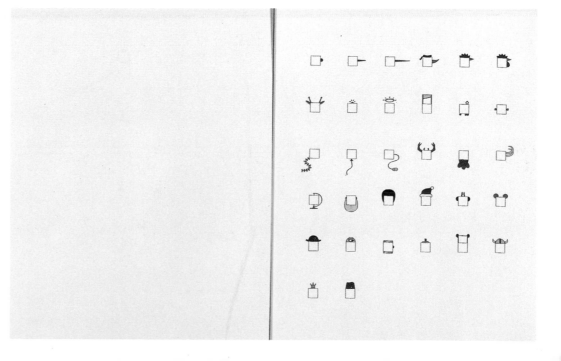

| audio | 01 | **Tonne** | **Uncoated** 07.19 |
| | | | Music by Tonne, published by Studio Tonne Editions 2002 |

02 Jake Tilson

New Delhi (music from afar) 01.06
Band, wedding reception, Market Road, 26th November 1992
Extract from *music from afar*, which comprised ten overlapping parts. Each part is a one-take continuous recording made of live music in a public space recorded from a distance. No other sounds have been added. Published by Atlas 1996

03 Tonne

Stainless 06.25
Music by Tonne, published by Studio Tonne Editions 2002

04 Jake Tilson

New York (parisnewyorklondon) 04.23
The Metropolitan Museum of Art, Great Hall, Thursday 17th November 1994, 2.00pm
Extract from *parisnew yorklondon* which comprised three overlapping parts. Each part is a one-take continuous recording made of background sounds in three international museums. No other sounds have been added. Published by Atlas 1996

05 Jake Tilson

New York (music from afar) 01.50
Harmonica, E Train, 8th Ave Local, 18th November, 1995
Extract from *music from afar*, which comprised ten overlapping parts. Each part is a one-take continuous recording made of live music in a public space recorded from a distance. No other sounds have been added. Published by Atlas 1996

06 Foundation 33

Numerical time-based sound composition 05.00
Composer: Daniel Eatock; musician: Timothy Evans
Five minute extract from the above composition. A digital time display counts to one hour using four units: seconds, tens of seconds, minutes, tens of minutes. A numerical sound composition has been constructed using the ten sequential digits: 0, 1, 2, 3, 4, 5, 6, 7, 8, 9. Each digit has been assigned a tone. The tones are mathematically selected from the range of 20Hz to 20,000Hz; the two extremes audible to the human ear. The tones are logarithmically divided between the ten digits providing tonal increments that produce a musical scale. Every second a different combination of four tones is defined by the time counter. Copyright Eatock/Evans 2001

07 Experimental Jetset

31 flavours of doom 02.00
A naive melody generated using Eperimental Jetset's Vibraphone™ instrument.

06

the musician

Good Housekeeping

STEP-BY-STEP
NEEDLECRAFT

LIMITED EDITIONS BOOKTITLES

Good Housekeeping Step-by-Step Needlecraft
was created and produced by
CARROLL & BROWN LTD
5 Lonsdale Road, London NW6 6RA

Editor Madeline Weston
Contributing Editor Kate Pountney
Assistant Editor Patricia Shine

Art Director Denise Brown
Art Editor Lisa V. Webb
Designer James Arnold
Design Assistant André-Scott Bamforth

First published 1994
This edition published 1994 by Limited Editions

1 3 5 7 9 10 8 6 4 2

First published in United Kingdom in 1994 by Ebury Press,
Random House, 20 Vauxhall Bridge Road, London SW1V 2SA

Random House Australia (Pty) Ltd,
20 Alfred Street, Milsons Point, Sydney,
New South Wales 2061, Australia

Random House New Zealand Limited,
18 Poland Road, Glenfield,
Auckland 10, New Zealand

Random House South Africa (Pty) Limited,
PO Box 337, Bergvlei, South Africa

Random House UK Limited Reg. No. 954009

A CIP catalogue record for this book
is available from the British Library

ISBN 0 09 178201 5

Printed and bound by New Interlitho SpA, Milan

CONTENTS

INTRODUCTION

*T*here is something especially satisfying about making an article by hand, and we hope this book will provide you with hours of inspiration and enjoyment. From the moment you embark on a new project, you will find tremendous pleasure in selecting quality materials, choosing a design that reflects your taste, and creating a piece that is uniquely yours.

In this book, we provide step-by-step instructions for learning how to knit, crochet, embroider, do needlepoint, quilting, and rug making. Each of these crafts has been around for generations, but all find honest uses on the contemporary scene. The techniques and patterns offered in the following pages represent the ingenuity of early needlecrafters, but the garments, accessories, and household items you'll see featured in the book are far from old-fashioned. The crafts may be ancient, but the effects you can achieve after learning a few basics are timeless. All it takes is a little time and a little imagination.

For each craft, **Good Housekeeping Step-by-Step Needlecraft** describes and illustrates the necessary materials and equipment, how-to-techniques, and provides extensive stitch and pattern glossaries. In addition, the book offers an enticing selection of beautifully designed garments and accessories for you to make for yourself and your family.

After you've entered the world of needlecrafts, you will find that the natural world around you – leaves, flowers, colours – will jump out as inspiration for your next project. After you've knitted your first sweater, stitched your first patchwork quilt or hooked your first rug, patterns, fabrics, and textures will strike you in completely new ways. For instance, you may

glance at a pale green leaf, and suddenly see it as the perfect pattern for a knitted sweater or the border for a rug. Someone once described needlework as painting with a needle and we couldn't agree more!

Good Housekeeping Step-by-Step Needlecraft gives each reader the confidence to create new items or to personalise the projects that appear in its pages. You will find items that can be worn, used in your home, or given as gifts, and the illustrated, step-by-step instructions and techniques give you all the information you need to start and, more importantly, finish these projects. Sweaters, hats, and mittens; cushions, quilts, and rugs; scarves, bags, and boxes – the book contains over 60 fabulous items to show off your skills.

Each technique in **Good Housekeeping Step-by-Step Needlecraft** is presented in full colour photographs that let you follow the action every step of the way. And the photos are so vivid, you can almost feel the texture of the yarn. It's like having an expert at your elbow. In the stitch and pattern glossaries, the large-size colour samples are so bold that it is easy to see each individual stitch – a boon for beginners as well as experienced needleworkers.

In addition to the satisfaction of learning new skills, it is our wish that **Good Housekeeping Step-by-Step Needlecraft** will open your eyes to appreciate the skill involved in the making of the needlecrafts found in stately homes and museums. We sincerely hope that you will use this book as a stepping stone to new skills and new interests – and to create heirlooms for the future.

KNITTING

Hand knitting offers a lovely way of creating individual clothes and accessories for yourself and your family. Today's knitters have a wide choice of colours and fibres, ranging from soft-coloured wools, to jewel-toned silks, and versatile cottons and acrylics. In addition, knitting is quickly mastered, giving people of all ages creative satisfaction. Knitting was around long before Irish or Fair Isle fishermen were bundling up in warm, hardwearing sweaters; it was practised as far back as Biblical times. Over the years, the basic stitches have been combined into complicated texture and colour patterns, many of which have been used to identify a particular village or area. Knitters would produce socks and sweaters for their family, as well as for the thriving cottage industry that bought their handiwork.

Each generation seems to rediscover the satisfaction of creating hand-knitted garments and accessories. And today, with the wide range of exciting yarns and the availability of fashionable patterns, like those that appear in Good Housekeeping, there's even more reason to become adept at this exciting art.

EQUIPMENT & YARNS

STARTING A KNITTING project requires little more than enthusiasm, yarn, and a pair of standard straight knitting needles. These are made of aluminium, plastic, wood, or bamboo and come in a range of sizes. For large pieces, and for knitting in the round, circular needles are useful, while gloves call for double-pointed needles. A few simple accessories are helpful.

TYPES OF NEEDLES

Special needles are used for cables, or for knitting in the round.

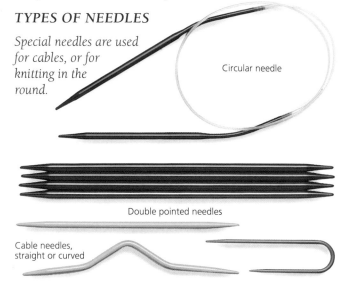

Circular needle

Double pointed needles

Cable needles,
straight or curved

OTHER USEFUL EQUIPMENT

These will help you hold or count your stitches, mark your place, or handle colours separately. Long pins and a blunt-pointed tapestry needle are needed for seams.

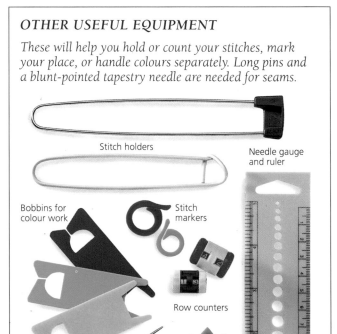

Stitch holders

Needle gauge
and ruler

Bobbins for
colour work

Stitch
markers

Row counters

Blunt-pointed
tapestry needle

Needle
stops

Long pins

KNITTING NEEDLE SIZES

Equivalent knitting needle sizes:

US	Metric (mm)
14	2
13	2¼
12	2¾
11	3
10	3¼
9	3¾
8	4
7	4½
6	5
5	5½
4	6
3	6½
2	7
1	7½
0	8
00	9
000	10

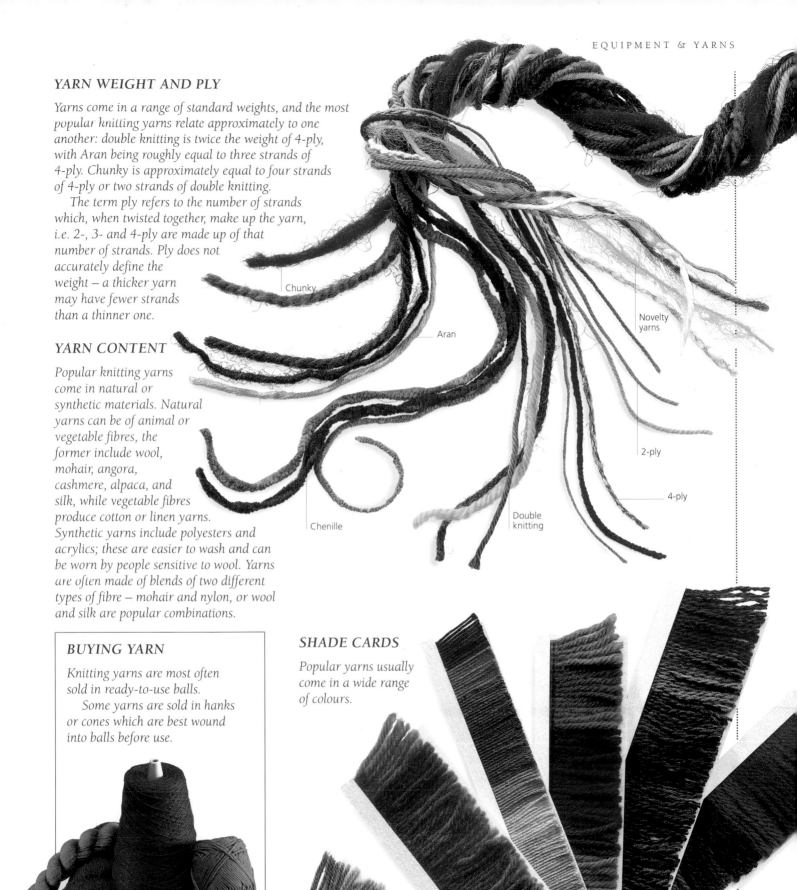

YARN WEIGHT AND PLY

Yarns come in a range of standard weights, and the most popular knitting yarns relate approximately to one another: double knitting is twice the weight of 4-ply, with Aran being roughly equal to three strands of 4-ply. Chunky is approximately equal to four strands of 4-ply or two strands of double knitting.

The term ply refers to the number of strands which, when twisted together, make up the yarn, i.e. 2-, 3- and 4-ply are made up of that number of strands. Ply does not accurately define the weight – a thicker yarn may have fewer strands than a thinner one.

YARN CONTENT

Popular knitting yarns come in natural or synthetic materials. Natural yarns can be of animal or vegetable fibres, the former include wool, mohair, angora, cashmere, alpaca, and silk, while vegetable fibres produce cotton or linen yarns. Synthetic yarns include polyesters and acrylics; these are easier to wash and can be worn by people sensitive to wool. Yarns are often made of blends of two different types of fibre – mohair and nylon, or wool and silk are popular combinations.

Chunky

Aran

Novelty yarns

2-ply

4-ply

Double knitting

Chenille

BUYING YARN

Knitting yarns are most often sold in ready-to-use balls.

Some yarns are sold in hanks or cones which are best wound into balls before use.

SHADE CARDS

Popular yarns usually come in a wide range of colours.

CASTING ON

THE FIRST STEP in knitting any article is to place the required number of stitches on the needles – this is called casting on. These stitches will form one edge of the finished article, usually the bottom. If you want the edge to be even, it is important that the stitches all be the same size. It is also necessary for the stitches to be moderately loose so you can easily work them off the needle. We recommend the one-needle cast on method for beginners, as it is easy to master, but if your resulting stitches are too snug on the needle, try the two-needle cast on. The first stitch in both methods is formed by making a slip knot.

Making a slip knot

About 15cm (6 in) from the yarn end, make a loop and insert needle under the short length (*left*). Draw thread through loop and pull both ends to tighten the knot on the needle (*right*).

ONE-NEEDLE CAST-ON EDGE

This should be made at a measured distance from the end of the yarn. Allow 2.5cm (1 in) per stitch for heavyweight yarn and 12mm (¹/₂ in) per stitch for lightweight. For example, start 25cm (10 in) from the slip knot to cast on 10 stitches in double knitting. The cast-on stitches will form a firm, yet elastic, foundation for all subsequent stitches, which is suitable for all patterns except those with a delicate edge.

TWO-NEEDLE CAST-ON EDGE

With this method, each new stitch is formed as a knit stitch (see page 14) and transferred to the left needle. If you work through the loop fronts on the first row, it produces a soft, loose edge, suitable for fine lace stitches. If you work through the loop backs on the first row, a firmer edge will be produced. Casting on with this method is useful when increasing stitches at one side (see page 18) or when completing a buttonhole (see page 62).

(see page 14)

One-needle cast on

Hold the yarn in the fingers of your left hand

1 Allowing sufficient yarn for the number of stitches you want to cast on, form the slip knot; hold the needle in the right hand. Using the ring and little fingers of your left hand, hold the strands of yarn securely.

2 Slip your left forefinger and thumb between the strands so that the strand from the skein is at the back, and the working yarn is at the front.

Keep the yarn taught with your left thumb

3 Bring your left thumb up and spread your other fingers still holding on to the yarn ends.

4 Take the needle under the yarn held across your thumb (*left*) and then up to the yarn on your left forefinger (*right*).

5 Putting the point of the needle behind the yarn on your left forefinger (*left*), draw the needle and yarn through the loop on your thumb to make the stitch (*right*).

6 Let the loop slip from your thumb and pull both ends to secure the new stitch. Repeat steps 1 to 6 for each required stitch.

Two-needle cast on

1 Make the slip knot and hold the needle in your left hand. Insert right needle through front of loop and pass the working yarn under and over its tip.

2 Draw yarn through the slip knot to form a new stitch.

3 Leaving the slip knot on the left needle, place the new stitch next to it.

4 Insert needle through front of loop of new stitch and pass the working yarn under and over its tip. Continue to form a new stitch as in steps 2 and 3 above.

Soft edge
Knit through the front of the stitch on the first row.

Soft edge

Firm edge
Knit through the back of the stitch, crossing the yarn.

Firm edge

KNIT & PURL STITCHES

KNIT AND PURL are the two fundamental stitches which most people recognize as plain knitting. Although these stitches are basic, they can be used in endless combinations to create any desired effect, whether you are knitting the simplest scarf or the most elaborate sweater. The knit stitch forms a flat, vertical loop on the fabric face; the purl stitch forms a horizontal semicircle. The simplest knitted pieces are worked in garter stitch, where every row is knitted; both sides look identical. Knitting and purling alternate rows produces stocking stitch – with a smooth knitted side and pebbly purled one.

The knit side of stocking stitch is smooth and flat

The reverse shows all the ridges of the purl stitches

STOCKING STITCH

This basic and versatile knitting pattern produces work that tends to curl if not blocked (see page 64). It stretches more widthwise than from top to bottom. The knit side is generally used as the right side.

REVERSE STOCKING STITCH

This is knitted in the same way as stocking stitch, but with the purl side used as the right side. It is often used as a background for cables and other raised patterns.

Reverse stocking stitch, with its purl stitches, can be used as a right side

The back shows the plain, smooth texture of the knit stitches

GARTER STITCH

This stitch is most commonly formed by knitting every row, but the same effect is achieved by purling every row. The work formed stays flat and firm, resists curling, and is good for borders, buttonhole bands, and edgings. It has a loose structure with "give" in both directions.

Knitting every row produces work that is identical on both sides, with ridges and furrows

KNIT STITCH USING RIGHT HAND

In this method, use your right hand to draw the yarn around the right needle. The amount of yarn released with each stitch is controlled by wrapping the working yarn between your two end fingers. Your left hand propels the knitting forward while your right hand makes the stitch – raising the thread, placing it over the needle, and pulling it through the loop.

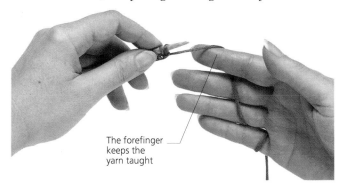

The forefinger keeps the yarn taught

1 Hold the needle with cast-on stitches in your left hand. Take yarn around the little finger of your right hand, under the next 2 fingers, and over the top of your forefinger.

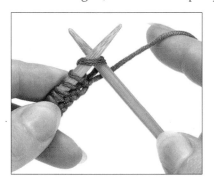

2 Keeping the yarn behind the work, hold the 2nd needle in your right hand and insert it into the front of the first stitch.

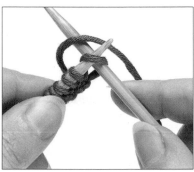

3 With your right forefinger, take the yarn forward under and over the point of the right needle.

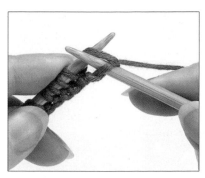

4 Draw yarn through the loop and push the resulting stitch toward the tip of the left needle so you can slip it onto your right needle.

KNIT STITCH USING LEFT HAND

In this method, often found to be faster than holding yarn in your right hand, you use the forefinger of your left hand to keep the yarn under tension and to scoop the yarn onto the right needle. The amount of yarn released is controlled partly by your last two fingers, and partly by your forefinger. Hold your left hand up slightly to help keep the yarn taut.

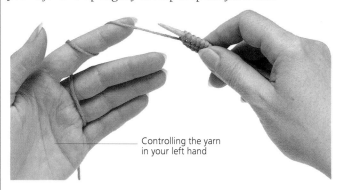

Controlling the yarn in your left hand

1 Hold the needle with the cast-on stitches in your right hand. Wrap the yarn over your left forefinger, let it fall across the palm and take up the slack between the last 2 fingers.

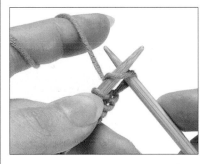

2 With work in left hand, extend your forefinger, pulling the yarn behind the needle. Using your thumb and middle finger, push the first stitch toward tip and insert right needle into front of stitch.

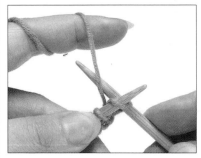

3 Twist the right needle and pull the tip under the working yarn to draw loop onto the right needle.

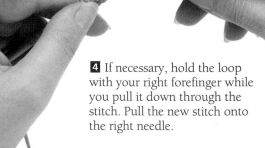

The first stitch is formed on the right needle

4 If necessary, hold the loop with your right forefinger while you pull it down through the stitch. Pull the new stitch onto the right needle.

PURL STITCH USING RIGHT HAND

The movements here are opposite those for knit stitch. The needle is put into the front of the stitch, then the yarn, which is held in the front, is thrown over the back of the needle. Purl stitches tend to be looser than knit ones, so keep your forefinger closer to the work to help make the stitches even.

Hold the
yarn in your
right hand

1 Hold the needle with stitches (cast-on or knit) in your left hand. Wrap yarn around your little finger, under your next two fingers, and over the forefinger of your right hand.

Right needle
is in front
of the left

2 Keeping the yarn in front of the work, pick up the needle in your right hand and insert the point into the front of the first stitch on the left needle.

3 With your right forefinger, take the yarn over the point of the right needle, and then under it.

4 Draw the loop on the right needle through the stitch and push the new stitch toward the tip of the left needle so you can slip it onto your right needle.

PURL STITCH USING LEFT HAND

With this method, your left forefinger holds the working yarn taut while you scoop up a new loop with your right needle. This action is helped by twisting your left wrist forward to release the yarn and using your middle finger to push the yarn towards the tip of the needle.

Hold the
yarn in your
left hand

1 Hold the needle with the stitches in your right hand. Wrap the yarn over your left forefinger, let it fall across your palm, and take up the slack between your last 2 fingers.

Right needle
is in front
of the left

2 With the work in your left hand, extend your forefinger slightly, pulling the working yarn in front of the needle. With your thumb and middle finger, push the first stitch toward the tip and insert the right needle into the front of the stitch. Hold stitch with your right forefinger.

3 Twisting your left wrist back slightly, use the forefinger of your left hand to wrap yarn around the right needle.

4 Push down and back with the right needle to draw the loop through the stitch and slip the new stitch onto the right needle. Straighten your left forefinger to tighten new stitch.

CORRECTING MISTAKES

THE SOONER YOU notice an error in your knitting the easier it is to correct. If a stitch has fallen off the needle one row down, you can retrieve it using your knitting needles. If you don't, it will unravel and form a run, and you will need a crochet hook to pick it up. If you knit a stitch incorrectly one or two rows down, you can unpick it and then correct it in the same way. If a mistake has occurred near the start of your piece, you will have to unravel your work to get close to it. If you are working in stocking stitch or ribbing, always pick up stitches with the knit side toward you, as this is easiest. Be careful not to twist any of the stitches.

Retrieving a dropped knit stitch

1 Insert your right needle into the front of the dropped stitch, picking up the loose yarn behind it.

2 Take your left needle into the back of the stitch and gently lift the stitch up and over the loose yarn and off the right needle.

3 To transfer the new stitch, insert the left needle into the front so that the stitch slips onto it in the correct working position.

Retrieving a dropped purl stitch

1 Insert your right needle into the back of the dropped stitch, picking up the loose yarn in front.

2 Take your left needle into the front of the stitch and gently lift the stitch up and over the loose yarn and off the needle.

3 Insert the left needle into the new stitch on the right needle and slip the new stitch onto it in the correct working position.

Correcting a run of dropped stitches

With knit side of work facing you, insert crochet hook into front of fallen stitch and pick up loose yarn behind. Draw yarn through stitch, forming a new stitch. Continue until you reach top of run. To work on purl side, insert hook into back of stitch and pick up yarn in front.

UNRAVELLING YOUR WORK

Mark the row in which your error occurred. Take the work off the needles and carefully pull the working thread, until you are **one row** *above the error.*

To replace stitches on needle, hold yarn at back, and insert your left needle into front of first stitch below unpicked row. Pull on working yarn to remove top stitch.

INCREASING

IT IS NECESSARY to increase (add stitches), when you are shaping a garment. Increases are also necessary in creating certain stitch patterns, such as bobbles and laces (see pages 38 and 42). Where increases are made in garment shaping, they are often worked in pairs so that the item widens equally on both sides. Where increases are made in stitch patterns, they are combined with decreases (see page 21) so the total number of stitches remains constant.

There are several methods of producing increases. The yarn-over method (see page 20) is visible and is used for lace patterns. The other methods are called invisible. In reality, all increases can be seen but some are more obvious than others and different methods are used at different times.

Bar, raised, and lifted increases are all invisible increases, and are typically used in garment shaping. When you are creating a gradual shape, such as a sleeve, it is neater to make the increases two or three stitches in from the sides and to use one of the invisible increases. With a complicated pattern, you will find it easier to add the stitches at the edges.

BAR METHOD

This frequently used technique produces a small bump on the right side of the work, hence its name. It is commonly abbreviated as Inc 1. You knit (or purl) into the front and back of a stitch to make two stitches. This increase can be used near the edge of the work when shaping garments or when making bobbles, where the bump will not matter.

1 Knit a stitch in the usual way but do not remove it from the left-hand needle.

2 Insert right-hand needle into back of the same stitch and knit again.

3 Remove the stitch from the needle. The extra stitch formed by this method produces a small bump on the right side. This will not be noticeable at the edge of the work.

RAISED METHOD

Here, you pick up the horizontal strand between two stitches and knit (or purl) it to make a new stitch. To make it virtually invisible, you have to work into the back of the strand so that it twists. It is effective for shaping darts on mitten or glove thumbs, and is commonly abbreviated make one (M1).

1 Insert your left-hand needle from front to back under the horizontal strand between 2 stitches.

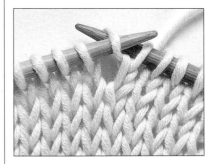

2 Knit (or purl) into the back of the strand on your left-hand needle.

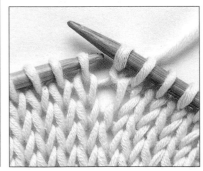

3 Remove stitch from the needle; the twist in the stitch prevents a gap from appearing.

LIFTED METHOD

This increase forms a slant, which needs to be paired with another to balance the work. You have to work both left-side and right-side increases from the centre. This method is particularly suitable for raglan sleeves as the resulting arrows create a fully fashioned appearance. Knit it with a loose tension since this method tends to tighten the work. The increase is made by knitting (or purling) into the horizontal strand below the next stitch to be worked. It is abbreviated as K (or P) up 1.

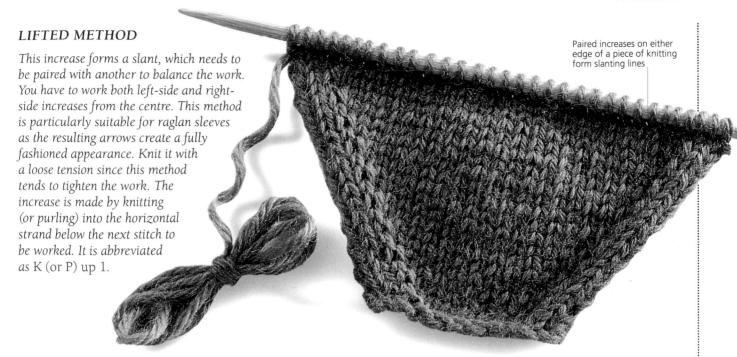

Paired increases on either edge of a piece of knitting form slanting lines

Right-side increase

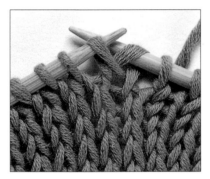

1 Insert your right-hand needle from front to back into the top of stitch below the next one to be knitted.

2 Knit the loop you have just picked up in the usual way.

3 Then knit the following stitch normally.

Left-side increase

1 Insert your left-hand needle from back to front into the top of stitch below the last completed stitch.

2 Pull stitch back gently and knit into the front of the loop.

DOUBLE AND MULTIPLE INCREASES

To make two increases in the same stitch (M2), knit, purl, and knit into the front of the stitch. To make more than two stitches, as in bobble and embossed patterns (see page 38), continue to knit and purl in the same stitch for the number of stitches that must be made. An increase of, say, five stitches is used to form a large bobble.

YARN OVER VISIBLE INCREASE

This is used for lace and other fancy patterns. This increase method produces a hole, which forms an openwork pattern. The basic technique is to wind the yarn once around the needle to form a loop, which is knitted or purled on the next row. The yarn is wound in different ways depending on where the new stitch falls (see below). This yarn over increase method is abbreviated as yo.

Yarn over in stocking stitch

1 To make a yarn over in stocking stitch, bring the yarn forward to the front of the work, loop it over your right-hand needle (*left*) and knit the next stitch (*right*).

2 The loop and new stitch are on the right-hand needle; knit to the end of the row.

3 On the following row, and with the rest of the stitches, purl the loop in the usual way.

Between purl stitches in reverse stocking stitch

Purl stitch, then take yarn back over right needle then forward under it.

Between two knit stitches in garter stitch

Bring the yarn forward over the right-hand needle, then back under it again.

Between two purl stitches in garter stitch

Take yarn back over right needle, then forward under it.

Between knit and purl stitches in ribbing

After knitting a stitch, bring yarn forward between needles, then back over right-hand needle and forward under it.

Between purl and knit stitches in ribbing

After purling, take the yarn over the right-hand needle from front to back.

DOUBLE AND MULTIPLE INCREASES

Several stitches may be made by the yarn-over method. In stocking stitch, to make a double increase, yo2, on a knit row, bring the yarn forward as for single yarn over but wrap it twice around the right needle before knitting the next stitch. On the next row, purl the first of the new stitches and knit the second.

When making multiple increases, yo3 (4, etc.), bring the yarn forward and then 3, (4, etc.) times around the needle. On the next row, purl and knit the new stitches alternately, always knitting the last new stitch.

DECREASING

CASTING OFF (see page 23) is the preferred method of decreasing when three or more stitches have to be lost, for example, at an underarm. However, if only one or two stitches have to be decreased, as when shaping a garment, any of the three methods described below may be used. Each method is visible and pulls stitches on a diagonal to the right or left. If you are decreasing randomly, or at the edge of the work, the direction of the slant is not important. In symmetrical shaping, however, such as with a raglan sleeve or V-neck, the decreases must be paired, to the right and left of the centre, so that the decreases balance one another. Right and left slants are made by knitting (or purling) two stitches together in their fronts or backs.

Slip-stitch decreases slant in only one direction, so in the same row they are generally used in combination with knitting two stitches together.

KNITTING TWO STITCHES TOGETHER

Decreasing by knitting two stitches together creates a slightly tighter decrease than the slip-stitch method. It is abbreviated K2tog for a right slant; K2tog tbl for a left slant.

Right slant

Knit 2 stitches together through the front of both loops. A slant to the right is used at the left edge of the work.

Left slant

Knit 2 stitches together through the back of both loops. A slant to the left is used at the right edge of the work.

PURLING TWO STITCHES TOGETHER

Decreases to the right are made by purling two stitches together through the front of both loops. This is abbreviated P2tog. For a decrease which slants to the left, purl two stitches together through the back of both loops. This method is abbreviated P2tog tbl.

THE SLIP-STITCH DECREASE

This results in a slightly looser decrease than knitting two stitches together. When made on a knit row, it slants from right to left, and is abbreviated Sl 1, k1, psso. A similar decrease can be made on a purl row, when it slants from left to right. It is abbreviated Sl 1, p1, psso.

On a knit row

1 Slip one stitch knitwise from your left needle onto the right needle then knit the next stitch.

2 Insert your left needle into the front of the slipped stitch and pull it over the knitted one.

3 The right-to-left slant is used on the right side of the centre of the work.

SELVEDGES

THE CAST-ON and cast-off (see page 23) stitches usually form the top and bottom ends of the work, and often have another finish applied to them, such as a fringe or neckband. The sides, known as selvedges, may be sewed into a seam or left exposed. If the sides are to be joined, use one of the simple edges since they are easier to sew. If you are knitting something with exposed edges, such as a scarf, tie, or blanket, use a border. This will be more attractive and help the finished piece lie flat.

Use the slip-stitch edge where there will be an edge-to-edge seam

SIMPLE SELVEDGE

The edge in stocking stitch, is formed by the work's alternate knit and purl rows. Beginning knitters often have trouble keeping this edge tight. Two variations can make this a more stable edge and one more suitable for seams. The slip-stitch edge is suitable when you will be seaming edge-to-edge, the garter-stitch edge is effective for backstitched and oversewn seams.

Slip-stitch selvedge
On all right sides of work (knit rows): slip the first stitch knitwise then knit the last stitch.
On all wrong sides of work (purl rows): slip the first stitch purlwise then purl the last stitch.

Garter-stitch selvedge
Knit the right-side rows as usual, and knit the first and last stitches of every wrong-side (purl) row.

A garter-stitch edge can be used when there will be a back-stitched seam

The double garter-stitch edge is firm and even

BORDERS

Most pattern instructions do not take special edges into account, so you may have to add two additional stitches on each side. The double garter-stitch edge is firm and even, and will not curl. The double chain edge is decorative as well as firm.

A double chain edge is a more decorative edge

Double garter-stitch edge
On every row: slip the first stitch knitwise and knit the 2nd stitch; knit the last 2 stitches.

Double chain edge
On all right sides of work (knit rows): slip the first stitch knitwise, purl the 2nd stitch. Knit to the last 2 stitches, then purl 1 and slip last stitch knitwise.

CASTING OFF

CASTING OFF PROVIDES a selvedge (finished edge) at the end of your work. This technique is also used in armhole and buttonhole shaping. Plain casting off is the most common and easiest method.

Usually you cast off on the right side of the work and work the stitches in the same way as they were formed, knitting knit stitches and purling purl stitches. It is important that you cast off somewhat loosely, otherwise the edge may pull in and become distorted. If your stitches are too tight, try casting off with a needle one size larger than used for the work, or use the suspended cast off.

PLAIN CAST OFF

This produces a firm, plain edge that is suitable for seaming and armhole and buttonhole shaping.

1 Work your first 2 stitches in pattern. *Keeping the yarn at the back, insert the tip of your left-hand needle through the first stitch.

2 Lift the first stitch over the 2nd stitch and off your needle.

3 Work the next stitch in pattern.* Repeat sequence set out between the asterisks until the desired number of stitches are cast off. Secure yarn at end (see box below).

SUSPENDED CAST OFF

More flexible than the plain cast off, this method produces a looser edge and is preferable if your selvedges tend to be tight.

1 Work first 2 stitches in pattern. *Keeping yarn at the back, insert the tip of your left needle through the first stitch. Lift the first stitch over the 2nd stitch off the right needle, and retain on left needle.

2 Work the next stitch and drop the held stitch when you complete a new stitch.*

3 Repeat the instructions between the asterisks until 2 stitches are left. Knit these 2 together. Secure yarn at end, (see box below).

SECURING THE YARN END

After casting off with either of the two methods above, you will have a single stitch left on your needle. Slip this off your needle, take the yarn end and slip it through the last stitch and pull firmly to tighten the loop. Then, using a tapestry needle, weave the secured yarn end into the seam edge to a depth of 5cm (2 in) to 8cm (3 in).

Alternatively, if appropriate, fasten off securely by pulling the yarn through the last loop and leave a length of yarn which can be used for joining seams.

TENSION

AT THE BEGINNING of every knitting pattern you will find the tension – the number of stitches and rows to a given measure that should be obtained using the specfied needles and yarn. This tension is very important to the size and fit of your garment. Before beginning a new project, make a swatch about 10cm (4 inches) square and compare the number of stitches and rows over a given measure to the tension given in the pattern.

CHECKING THE TENSION

Using the given tension as a guide, and the needles and yarn designated, cast on four times the number of stitches that equal 2.5cm (1 in).
Then take your sample and pin it to a flat surface; do not stretch it. Use a ruler, plastic tape measure, or stitch gauge to measure both horizontally and vertically.

Use a tape measure to check the distance between the pins

MAKING ADJUSTMENTS

If your tension does not exactly equal that given, change needle size and knit another sample. One needle size makes a difference of about one stitch over 5cm (2 in). If you have more stitches to the centimetre, your tension is too tight and you should change to larger needles. If you have fewer stitches, your tension is too loose so use smaller needles.

Measuring horizontally

In stocking stitch, it is easier to measure on the knit side, where each loop represents one stitch. In garter stitch, count the loops in one row only. Place 2 pins 2.5cm (1 in) apart and count the stitches between them.

Measuring vertically

In stocking stitch, it is easier to measure on the purl side (2 ridges equals one row). In garter stitch, a ridge is one row and a valley another. Place 2 pins 2.5cm (1 in) apart and count the number of rows between them.

THE EFFECT OF YARNS AND PATTERNS

Yarn and pattern also affect tension, so it is especially important to make a sample if you are changing either one from those called for in the instructions. Loosely spun or thick yarns, such as double knitting, will knit up with many fewer stitches and rows than firmly spun yarns, such as silk. Rib and other textured patterns produce much tighter work than do lacy patterns.

4-ply is the finest of the three yarns and produces the smallest square

Double knitting, worked to the same number of stitches, makes a larger piece than 4-ply

Aran yarn is the bulkiest yarn of the three and has fewest stitches to the inch

KNITTING TERMINOLOGY

A SET OF standard abbreviations, terms, and symbols have been devised in order to reduce knitting instructions to their shortest possible length. Otherwise, the row-by-row instructions for even a simple garment could take several pages. Multiples and repeats are commonly found in patterns and a fuller explanation is offered below.

Pattern abbreviations

alt	alternate
beg	beginning
CC	contrasting colour
cn	cable needle
dec(s)	decrease(s), (see page 21)
dp	double pointed
k	knit
k2tog	knit 2 stitches together
k-wise	insert needle as though to knit
inc(s)	increase(s), (see page 18)
lp	loop
M1	make 1, (see page 18)
MC	main colour
p	purl
patt	pattern
psso	pass slipped stitch over the knitted one, (see page 21)
p2tog	purl 2 stitches together
p-wise	insert needle as though to purl
RS	right side
rem	remaining
rep	repeat
rnd(s)	rounds
sk	skip
sl	slip (always slip sts purlwise unless otherwise instructed)
sl st	slip stitch, (see page 21)
ssk	slip, slip, knit decrease (see page 43)
st(s)	stitch(es)
tbl	through back of loop (work into back of stitch)
tog	together
WS	wrong side
yb	yarn behind
yf	yarn forward
yo	yarn over needle, (see page 20)
*	Work instructions immediately following *, then repeat as directed, (see Repeats)
[]	Work or repeat all instructions enclosed in brackets as directed immediately after, (see Repeats)
–	The number of sts that should be on your needles or across a row is given after a dash at the end of the row. This serves as a check point, especially after a section of increasing or decreasing.

Repeats

Because a knitting pattern usually consists of sequences of stitches, two devices are used to express this in the shortest possible space. One is the asterisk*, which is placed before the instruction it relates to. For example, *P2, *k2, p2; rep from *, end k2,* means you purl the first two stitches, then for the rest of the row until you are two stitches from the end, you knit two, purl two. The last two stitches are knitted.

Brackets are also used to indicate repeats. For example, *P2 [k2, p2] ten times, k3* means that after purling your first two stitches you repeat the sequence of knitting two and purling two ten times (a total of 40 stitches) before knitting the last three.

Multiples

Preceding each stitch pattern is an instruction about the number of stitches required to complete the pattern across the row. This is expressed as a multiple of a number of stitches, for example, *multiple of 6 sts*. It may also include an additional number to balance the pattern or account for a diagonal, for example, *multiple of 6 sts plus 3*. The number of stitches on the needle must be divisible by the multiple, so for a multiple of 5 sts plus 2, you would need to cast on 5 + 2, 10 + 2, 15 + 2,.... 100 + 2, etc. In the pattern instructions, the multiple is expressed in the following ways:

Multiple of 8 sts plus 2
Row 1: *K4, p4*, k2
Row 2: *P4, k4*, p2
or
Row 1: *K4, p4, rep from *, end k2
Row 2: *P4, k4, rep from *, end p2

TEXTURED PATTERNS

WITH ONLY THE two basic stitches, a wide variety of patterns can be created. Though the techniques are simple, the results are often sophisticated, and lend themselves to use on a wide variety of garments. In combination, knit and purl stitches accentuate each other, creating texture. When they are worked vertically, the knit rows tend to stand out from the purl ones. When they are worked horizontally, in welt or ridge patterns, the purl rows stand away from the knit rows. In textured patterns, the stitches form subtle designs that alter the surface of the fabric.

Vertical rows of knit and purl are known as ribbing, and will stretch in a crosswise direction. This quality is ideal for use on garment edges, and for children's clothes because the garment will expand to accommodate the child. To be sure cuffs and waistbands are snug fitting, use smaller needles than those used for the body of the garment.

KNIT AND PURL CUSHIONS

Use up scrap yarn by working small squares or rectangles in some of your favourite textured stitches; then sew them together for these patchwork cushions. They will serve as records of different knitting stitches. (See page 225.)

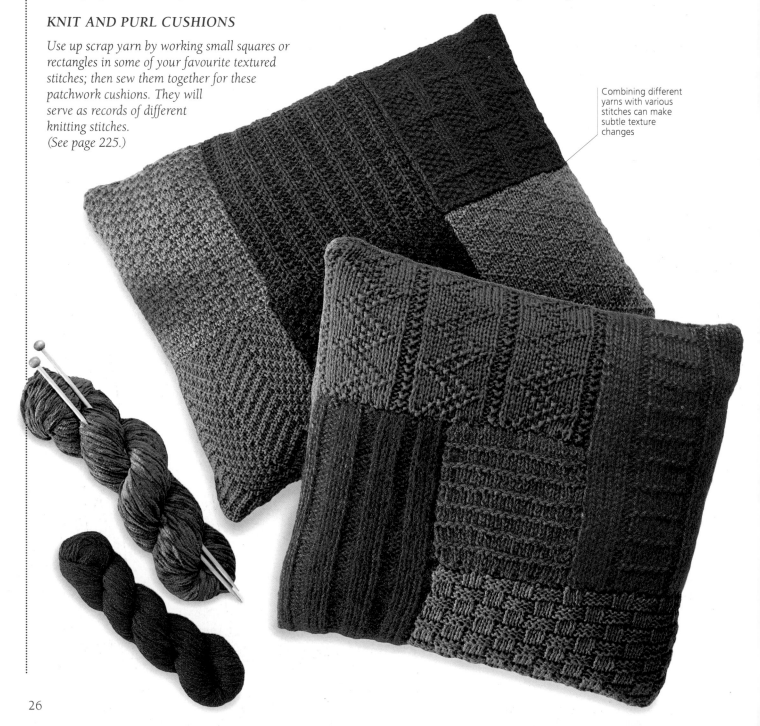

Combining different yarns with various stitches can make subtle texture changes

A three by three rib can be knitted in two colour stripes

Ladder stitch panels are interspersed with plain panels of stocking stitch

LADDER ▲

Worked over 11 sts on a background of st st

Row 1 (right side): P2, k7, p2.
Row 2: K2, p7, k2.
Rows 3 and 4: as rows 1 and 2.
Row 5: P.
Row 6: as row 2.
Row 7: as row 1.
Rows 8 and 9: As rows 6 and 7.
Row 10: K.
Rows 1 to 10 form the pattern.

◄ THREE BY THREE RIB

Multiple of 6 sts plus 3

Row 1: *K3, p3; rep from * to last 3 sts, k3.
Row 2: P3, *k3, p3; rep from * to end.
Rows 1 to 2 form the pattern.

MOSS STITCH RIB ▼

Multiple of 11 sts plus 5

Row 1: K5, *[k1, p1] 3 times, k5; rep from * to end.
Row 2: *P5, [p1, k1] 3 times; rep from * to last 5 sts, p5.
Rows 1 to 2 form the pattern.

BROKEN RIB ▲

Multiple of 2 sts plus 1

Row 1 (right side): K.
Row 2: P1, *k1, p1; rep from * to end.
Rows 1 to 2 form the pattern.

MOCK FISHERMAN'S RIB ▶

Multiple of 4 sts plus 3.

All rows: *K2, p2; rep from * to last 3 sts, k2, p1.

DIAMOND BROCADE ▲
Multiple of 8 sts plus 1

Row 1 (right side): K4, *p1, k7;
rep from * to last 5 sts, p1, k4.
Row 2: P3, *k1, p1, k1, p5; rep
from * to last 6 sts, k1, p1, k1, p3.
Row 3: K2, *p1, k3; rep from * to
last 3 sts, p1, k2.
Row 4: P1, *k1, p5, k1, p1; rep
from * to end.
Row 5: *P1, k7; rep from * to last
st, p1.
Row 6: as row 4.
Row 7: as row 3.
Row 8: as row 2.
Rows 1 to 8 form the pattern.

SEED STITCH ▲
Multiple of 4 sts

Row 1: *K3, p1; rep from * to end.
Row 2: P.
Row 3: K.
Row 4: P.
Row 5: K1, *p1, k3;* rep from * to last 3 sts,
p1, k2.
Row 6: P.
Row 7: K.
Rows 1 to 7 form the pattern.

SEEDED TEXTURE ▲
Multiple of 5 sts plus 2

Row 1 (right side): K2, *p3, k2; rep from
* to end.
Row 2: P.
Row 3: *P3, k2; rep from * to last 2 sts, p2.
Row 4: P.
Rows 1 to 4 form the pattern.

DOUBLE MOSS STITCH ▶
Multiple of 4 sts plus 2

Row 1: K2, *p2, k2; rep from * to end.
Row 2: P2, *k2, p2; rep from * to end.
Row 3: as row 2.
Row 4: as row 1.
Rows 1 to 4 form the pattern.

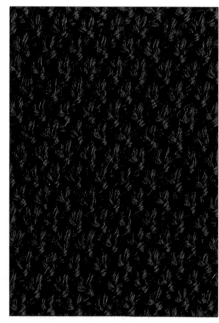

CHEVRON RIB ▲
Multiple of 18 sts plus 1

Row 1 (right side): P1, *k1, p2, k2,
p2, k1, p1; rep from * to end.
Row 2: *K3, p2, k2, p2, k1,
[p2, k2] twice; rep from *
to last st, k1.
Row 3: *[P2, k2] twice, p3, k2,
p2, k2, p1; rep from * to
last st, p1.
Row 4: *K1, p2, k2, p2, k5, p2,
k2, p2; rep from * to last st, k1.
Rows 1 to 4 form the pattern.

◀ **MOSS STITCH**
Multiple of 2 sts plus 1
All rows: K1, * p1, k1, rep from * to end.

MARRIAGE LINES ▶

Worked over 17sts on a
background of st st

Row 1 (right side): P3, k6, p1,
k2, p1, k1, p3.
Row 2: K1, p1, [k1, p2] twice,
k1, p5, k1, p1, k1.
Row 3: P3, k4, p1, k2, p1, k3, p3.
Row 4: K1, p1, k1, p4, k1, p2,
k1, p3, k1, p1, k1.
Row 5: P3, [k2, p1] twice, k5, p3.
Row 6: K1, p1, k1, p6, k1, p2,
[k1, p1] twice, k1.
Row 7: as row 5.

Row 8: as row 4.
Row 9: as row 3.
Row 10: as row 2.
Rows 1 to 10 form the pattern.

RIPPLE STRIPE ◀

Multiple of 8 sts plus 1

Row 1 (right side): K4, *p1, k7;
rep from * to last 5 sts, p1, k4.
Row 2: P3, *k3, p5; rep from
* to last 6 sts, k3, p3.
Row 3: K2, *p2, k1, p2, k3;
rep from * to last 2 sts, k2.
Row 4: P1, *k2, p3, k2, p1;
rep from * to end.
Row 5: K1, *p1, k5, p1, k1;
rep from * to end.
Row 6: P.
Rows 1 to 6 form the pattern.

BASKETWEAVE ▲

Multiple of 8 sts plus 3

Row 1 (right side): K.
Row 2: K4, p3, *k5, p3; rep
from * to last 4 sts, k4.
Row 3: P4, k3, * p5, k3; rep
from * to last 4 sts, p4.
Row 4: as row 2.
Row 5: K.
Row 6: P3, *k5, p3; rep from
* to end.
Row 7: K3, *p5, k3; rep from
* to end.
Row 8: as row 6.
Rows 1 to 8 form the pattern.

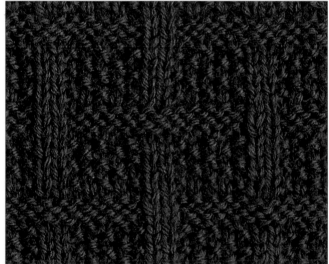

SQUARE LATTICE ◀

Multiple of 14 sts plus 2

Row 1 (right side): K.
Rows 2, 4 and 6: P2, *[k1, p1]
twice, k1, p2; rep from * to end.
Rows 3, 5, and 7: K3, *p1, k1, P1,
k4; rep from * to last 3 sts, k3.
Row 8: P2, *k12, p2; rep from
* to end.
Row 9: K2, *p12; rep from
* to end.
Row 10: P.
Rows 11, 13, and 15: K2,
*[p1, k1] twice, p1, k2; rep from
* to end.
Rows 12, 14, and 16: P3, *k1, p1,
k1, p4; rep from * to last 3 sts, p3.
Row 17: P7, *k2, p12; rep from
* to last 9 sts, k2, p7.
Row 18: K7, *p2, k12; rep from
* to last 9 sts, p2, k7.
Rows 1 to 18 form the pattern.

GARTER STITCH RIDGES ◀

Any number of stitches

Row 1 (right side): K.
Row 2: P.
Rows 3 and 4: as rows 1 and 2.
Rows 5 to 10: P.
Rows 1 to 10 form the pattern.

29

CABLE KNITTING

CABLES CAN TRANSFORM an otherwise simple knitted garment into something really special. They can be used as single panels or combined into an all-over pattern. Originally, fishermen's sweaters were often decorated with cables and patterns that served to identify a man's parish. Heavily textured patterns add to a sweater's warmth and durability. Learning to make cables is within the abilities of every knitter. If you are adding cable panels to a plain sweater pattern, you must remember that cables tend to decrease the overall width, so plan the pattern and yarn requirements accordingly.

HONEYCOMB ARAN SWEATER

This round-necked cable sweater uses many of the traditional Aran Islands patterns, including a special feature of cable ribbing. The raglan style sleeve makes this ideal for men and women (see page 226).

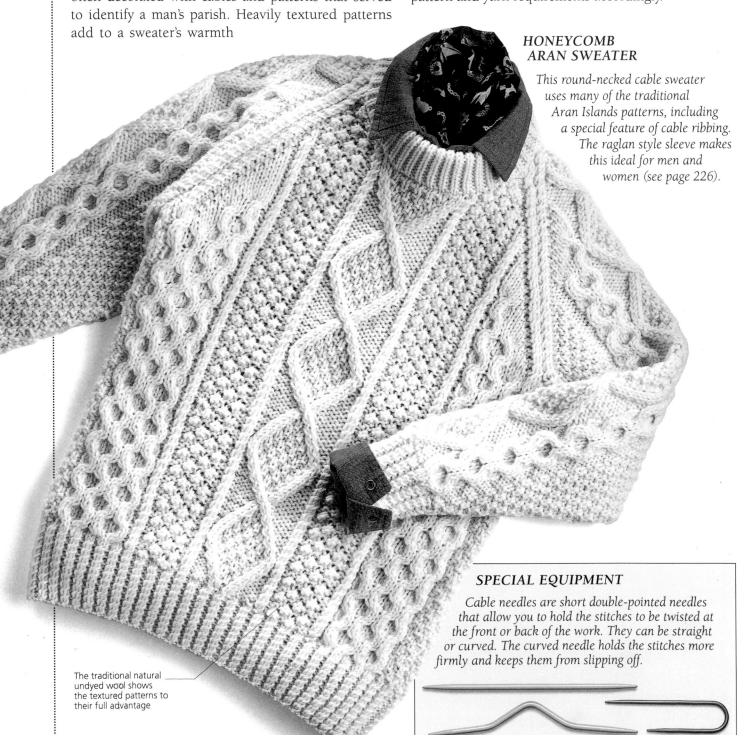

The traditional natural undyed wool shows the textured patterns to their full advantage

SPECIAL EQUIPMENT

Cable needles are short double-pointed needles that allow you to hold the stitches to be twisted at the front or back of the work. They can be straight or curved. The curved needle holds the stitches more firmly and keeps them from slipping off.

CABLING BASICS

The basis of all cable patterns is a simple technique whereby stitches are crossed over another group of stitches in the same row. Some of the stitches making up the cable are held at the back (or front) of the work on a special cable needle, while the other stitches are knitted. Then the stitches on the cable needle are knitted, thereby creating a twist.

MAKING CABLES

The cables shown below are 6 stitches wide; these 6 stitches are knitted on the right side and purled on the wrong side.
The stitches on either side are purled on the right side and knitted on the wrong side, i.e. reverse stocking stitch. The length between the twists can be changed as desired; commonly they are crossed every sixth or eighth row. The cables shown here are crossed at the eighth row, having started with a wrong-side row.

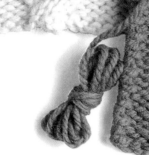

Left-hand cable

Right-hand cable

Left-hand cable
Holding the stitches at the back of the work always produces a left-over-right cable.

1 Slip the first 3 stitches onto a cable needle and hold at the back of the work.

2 Then knit the next 3 stitches on the main needle.

3 Finally, knit the 3 stitches held on the cable needle.

Right-hand cable
Holding the stitches at the front of the work always produces a right-over-left cable.

1 Slip the first 3 stitches onto a cable needle and hold at the front of the work.

2 Then knit the next 3 stitches on the main needle.

3 Finally, knit the 3 stitches held on the cable needle.

CABLE INSTRUCTIONS

For the pattern instruction C4B (Cable 4 Back), C6B (Cable 6 Back), C4F (Cable 4 Front), C6F (Cable 6 Front) etc, where the number is even, work cables as follows: Slip two (or three etc) sts onto cable needle and hold at back or front of work, knit two (or three etc) sts from left needle then knit sts from cable needle.

◄ LARGE DOUBLE CABLE

Worked over 20 sts on a background of reverse st st

Row 1 (right side): K.
Row 2: P.
Row 3: C10B, C10F.
 Row 4: P.
 Rows 5 to 12: Rep rows 1 and 2 four times.
Rows 1 to 12 form the pattern.

MEDALLION MOSS CABLE ▲

Worked over 13 sts on a background of reverse st st

Row 1 (right side): K4, [p1, k1] 3 times, k3.
Row 2: P3, [k1, p1] 4 times, p2.
Rows 3 and 4: as rows 1 and 2.
Row 5: C6F, k1, C6B.
Row 6: P.
Row 7: K.
Rows 8 to 11: rep rows 6 and 7 twice.
Row 12: P.
Row 13: C6B, k1, C6F.
Row 14: as row 2.
Row 15: as row 1.
Row 16: as row 2.
Rows 1 to 16 form the pattern.

LITTLE WAVE ▲

Multiple of 7 sts plus 4

Row 1 (right side): K.
Row 2: P4, *k2, p5; rep from * to end.
Row 3: K4, *C2F, k5; rep from * to end.
Row 4: P4, *k1, p1, k1, p4; rep from * to end.

Row 5: *K5, C2F; rep from * to last 4 sts, k4.
Row 6: *P5, k2; rep from * to last 4 sts, p4.
Row 7: K.
Row 8: as row 6.
Row 9: *K5, C2B; rep from * to last 4 sts, k4.
Row 10: as row 4. .
Row 11: K4, *C2B, k5; rep from * to end.
Row 12: as row 2.
Rows 1 to 12 form the pattern.

◄ TELESCOPE LATTICE

Worked over 12 sts on a background of st st

Row 1 and every alt row (wrong side): P.
Row 2: K.
Row 4: *C4B, k4, C4F; rep from * to end.
Row 6: K.
Row 8: *K2, C4F, C4B, k2; rep from * to end.
Rows 1 to 8 form the pattern.

◄ CROSS RIB CABLE

Multiple of 11 sts

Row 1 (wrong side): K2, [p1, k1] 4 times, k1.
Row 2: P2, [k1 tbl, p1] 4 times, p1.
Rows 3 to 6: rep rows 1 and 2 twice.
Row 7: as row 1.
Row 8: P2, slip next 4 sts to front on cable needle, [k1tbl, p1] twice from main needle, [k1tbl, p1] twice from cable needle, p1.
Rows 9 to 12: rep rows 1 and 2 twice.
Rows 1 to 12 form the pattern.

SMALL TWIST STITCH CABLE ▲

Multiple of 8 sts plus 3

Row 1 (right side): *K3, p1, k1tbl, p1, k1tbl, p1; rep from * to last 3 sts, k3.
Row 2: P3, *k1, p1tbl, k1, p1tbl, k1, p3; rep from * to end.
Rows 3 to 6: rep rows 1 and 2 twice.

Row 7: *K3, p1, slip next 2 sts to front on cn, k1tbl, p1, k1tbl from cn, p1; rep from * to last 3 sts, k3.
Row 8: as row 2.
Rows 1 to 8 form the pattern.

OPENWORK AND TWIST ▶

Multiple of 15 sts plus 12

Special abbreviation

T4LR (Twist 4 Left and Right): Slip next 3 sts onto cn and hold at back of work, knit next st from left needle then slip the first st on cn back to left needle, p2 from cn then k1 from left needle.

Row 1 (right side): P1, T4LR, p2, T4LR, p1, *k1, yo, sl 1, k1, psso, p1, T4LR, p2, T4LR, p1; rep from * to end.

Row 2: K1, p1, [k2, p1] 3 times, k1, *p3, k1, p1, [k2, p1] 3 times, k1; rep from * to end.

Row 3: P1, k1, p2, T4LR, p2, k1, p1, *k2tog, yo, k1, p1, k1, p2, T4LR, p2, k1, p1; rep from * to end.

Row 4: as row 2.

Rows 1 to 4 form the pattern.

BRAID CABLE ▲

Multiple of 8 (min. 16 sts) worked on a background of reverse st st. Shown worked over 24 sts

Row 1 (right side): K.
Row 2 and every alt row: P.
Row 3: K.
Row 5: *C8B; rep from * to end of panel.
Row 7: K.
Row 9: K.
Row 11: *C8F; rep from * to end of panel.
Row 12: P.
Rows 1 to 12 form the pattern.

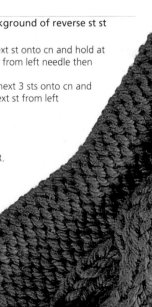

◀ 9 STITCH PLAIT

Worked over 9 sts on a background of reverse st st.

Downward plait
Row 1 (right side): K.
Row 2 and every alt row: P.
Row 3: C6F, k3.
Row 5: K.
Row 7: K3, C6B.
Row 8: P.
Upward plait
Row 1 (right side): K.
Row 2 and every alt row: P.
Row 3: C6B, k3.
Row 5: K.
Row 7: K3, C6F.
Row 8: P.
Rows 1 to 8 form each pattern.

Up Down

Up Down

◀ CLAW PATTERN

Worked over 9 sts on a background of reverse st st

Special abbreviations

Cross 4L (Cross 4 Left): Slip next st onto cn and hold at front of work, knit next 3 sts from left needle then knit st from cn.

Cross 4R (Cross 4 Right): Slip next 3 sts onto cn and hold at back of work, knit next st from left needle then knit sts from cn.

Downward claw
Row 1 (right side): K.
Row 2: P.
Row 3: Cross 4L, k1, Cross 4R.
Row 4: P.
Rows 1 to 4 form the pattern.

Upward claw
Row 1 (right side): K.
Row 2: P.
Row 3: Cross 4R, k1, Cross 4L.
Row 4: P.
Rows 1 to 4 form the pattern.

Medallion moss cable

STRIPED MEDALLION CABLE ▶

Worked over 16 sts on a background of reverse st st

Special abbreviations

T8B rib (Twist 8 Back rib): Slip next 4 sts onto cn and hold at back of work, k1, p2, k1 from left-hand needle, then k1, p2, k1 from cn.

T8F rib (Twist 8 Front rib): Slip next 4 sts onto cn and hold at front of work, k1, p2, k1 from left-hand needle, then k1, p2, k1 from cn.

Row 1 (right side): K1, p2, [k2, p2] 3 times, k1.

Row 2: P1, k2, [p2, k2] 3 times, p1.

Row 3: T8B rib, T8F rib.

Row 4: as row 2.

Rows 5 to 14: Rep rows 1 and 2 five times.

Row 15: T8F rib, T8B rib.

Row 16: as row 2.

Rows 17 to 24: Rep rows 1 and 2 four times.

Rows 1 to 24 form the pattern.

▼ ALTERNATING BRAID CABLE

Worked over 6 sts on a background of reverse st st

Row 1 (wrong side): P.

Row 2: K.

Row 3: P.

Row 4: C4B, k2.

Row 5: P.

Row 6: K2, C4F.

Rows 3 to 6 form the pattern.

◀ CELTIC PLAIT

Multiple of 10 sts plus 5 (min. 25 sts) on a background of reverse st st. Shown worked over 25 sts

Special abbreviations

T5B (Twist 5 Back): Slip next 2 sts onto cn and hold at back of work, knit next 3 sts from left needle, then purl sts from cn.

T5F (Twist 5 Front): Slip next 3 sts onto cn and hold at front of work, purl next 2 sts from left needle, then knit sts from cn.

Row 1 (right side): K3, *p4, k6, rep from * to last 2 sts, p2.

Row 2: K2, *p6, k4; rep from * to last 3 sts, p3.

Row 3: K3, *p4, C6F; rep from * to last 2 sts, p2.

Row 4: K2, *p6, k4; rep from * to last 3 sts, p 3.

Row 5: *T5F, T5B; rep from * to last 5 sts, T5F.

Row 6: P3, *k4, p6; rep from * to last 2 sts, k2.

Row 7: P2, *C6B, p4; rep from * to last 3 sts, k3.

Row 8: as row 6.

Row 9: *T5B, T5F; rep from * to last 5 sts, T5B.

Row 10: as row 4.

Rows 3 to 10 form the pattern.

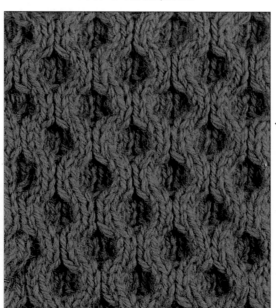

DOUBLE CROSSOVER ▼

Worked over 16 sts on a background of reverse st st

Special abbreviations

T3B (Twist 3 Back): Slip next st onto cn and hold at back, k next 2 sts from left needle, then p st from cn.

T3F (Twist 3 Front): Slip next 2 sts onto cn and hold at front of work, purl next st from left needle, then knit sts from cn.

Row 1 (right side): K2, p4, k4, p4, k2.

Row 2: P2, k4, p4, k4, p2.

Row 3: K2, p4, C4B, p4, k2.

Row 4: as row 2.

Row 5: [T3F, p2, T3B] twice.

Row 6: K1, p2, [k2, p2] 3 times, k1.

Row 7: P1, T3F, T3B, p2, T3F, T3B, p1.

Row 8: K2, p4, k4, p4, k2.

Row 9: P2, C4B, p4, C4B, p2.

Row 10: as row 8.

Row 11: P2, k4, p4, k4, p2.

Rows 12 and 13: as rows 8 and 9.

Row 14: as row 8.

Row 15: P1, T3B, T3F, p2, T3B, T3F, p1.

Row 16: as row 6.

Row 17: [T3B, p2, T3F] twice.

Rows 18 and 19: as rows 2 and 3.

Row 20: as row 2.

Rows 1 to 20 form the pattern.

◀ HONEYCOMB

Multiple of 8 sts

Row 1 (right side): *C4B, C4F; rep from * to end of panel.

Row 2: P.

Row 3: K.

Row 4: P.

Row 5: *C4F, C4B; rep from * to end of panel.

Row 6: P.

Row 7: K.

Row 8: P.

Rows 1 to 8 form the pattern.

ALTERNATED CABLE

Worked over 10 sts on a background of reverse st st

Special abbreviations

T3B (Twist 3 Back): Slip next st onto cn and hold at back of work, knit next 2 sts from left needle, then purl st from cn.

T3F (Twist 3 Front): Slip next 2 sts onto cn and hold at front of work, purl next st from left needle, then knit sts from cn.

Row 1 (right side): P1, k8, p1.
Row 2: K1, p8, k1.
Row 3: P1, C4B, C4F, p1.
Row 4: K1, p2, k4, p2, k1.
Row 5: T3B, p4, T3F.
Row 6: P2, k6, p2.
Row 7: K2, p6, k2.
Rows 8 and 9: as rows 6 and 7.
Row 10: as row 6.
Row 11: T3F, p4, T3B.
Row 12: as row 4.
Row 13: P1, C4F, C4B, p1.
Row 14: K1, p8, k1.
Row 15: P1, C4B, C4F, p1.
Row 16: K1, p8, k1.
Row 17: P1, k8, p1.
Rows 18 and 19: as rows 14 and 15.
Row 20: as row 16.
Rows 1 to 20 form the pattern.

CHAIN CABLE ▶

Worked over 8 sts on a background of reverse st st

Row 1 (right side): K.
Row 2: P.
Row 3: C4B, C4F.
Row 4: P.
Rows 5 and 6: as rows 1 and 2.
Row 7: C4F, C4B.
Row 8: P.
Rows 1 to 8 form the pattern.

SNAKE CABLE ▲

Worked over 8 sts on a background of reverse st st

Row 1 (right side): K8.
Row 2: P8.
Row 3: C8B.
Row 4: P8.
Rows 5 to 10: Rep rows 1 and 2 three times.
Row 11: C8F.
Row 12: P8.
Rows 13 to 16: Rep rows 1 and 2 twice.
Rows 1 to 16 form the pattern.

INTERLACED CABLES ▼

Multiple of 8 sts plus 10

Special abbreviations

T4B (Twist 4 Back): Slip next 2 sts onto cn and hold at back of work, knit next 2 sts from left needle, then purl sts from cn.

T4F (Twist 4 Front): Slip next 2 sts onto cn and hold at front of work, purl next 2 sts from left needle, then knit sts from cn.

Row 1 (right side): P3, k4, *p4, k4; rep from * to last 3 sts, p3.
Row 2: K3, p4, *k4, p4; rep from * to last 3 sts, k3.
Row 3: P3, C4B, *p4, C4B; rep from * to last 3 sts, p3.
Row 4: as row 2.
Rows 5 to 8: as rows 1 to 4.
Row 9: P1, *T4B, T4F; rep from * to last st, p1.
Row 10: K1, p2, k4, *p4, k4; rep from * to last 3 sts, p2, k1.
Row 11: P1, k2, p4, *C4F, p4; rep from * to last 3 sts, k2, p1.
Row 12: as row 10.
Row 13: P1, *T4F, T4B; rep from * to last st, p1.
Rows 14 and 15: as rows 2 and 3.
Row 16: as row 2.
Rows 1 to 16 form the pattern.

WOVEN TRELLIS ▼

Multiple of 12 sts plus 14

Special abbreviations

T4B (Twist 4 Back): Slip next 2 sts onto cn and hold at back of work, knit next 2 sts from left needle, then purl sts from cn.

T4F (Twist 4 Front): Slip next 2 sts onto cn and hold at front of work, purl next 2 sts from left needle, then knit sts from cn.

Row 1 (right side): P3, T4B, T4F, *p4, T4B, T4F; rep from * to last 3 sts, p3.
Row 2: K3, p2, *k4, p2; rep from * to last 3 sts, k3.
Row 3: P1, *T4B, p4, T4F; rep from * to last st, p1.
Row 4: K1, p2, k8, *p4, k8; rep from * to last 3 sts, p2, k1.
Row 5: P1, k2, p8, *C4B, p8; rep from * to last 3 sts, k2, p1.
Row 6: as row 4.
Row 7: P1, *T4F, p4, T4B; rep from * to last st, p1.
Row 8: as row 2.
Row 9: P3, T4F, T4B, *p4, T4F, T4B; rep from * to last 3 sts, p3.
Row 10: K5, p4, *k8, p4; rep from * to last 5 sts, k5.
Row 11: P5, C4F, *p8, C4F; rep from * to last 5 sts, p5.
Row 12: as row 10.
Rows 1 to 12 form the pattern.

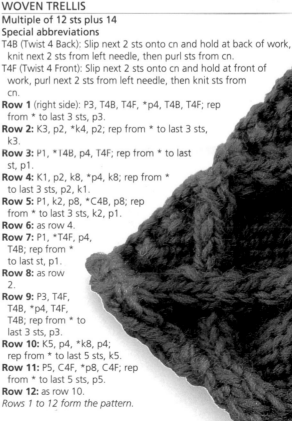

SIMPLE PROJECTS

ONE COLOUR PROJECTS are a good choice for beginners, but they need not be ordinary. The use of texture stitches can transform a simple garment into something special.

EMERALD ISLE VEST

This waistcoat is worked in Donegal tweed yarn, which enhances the cable pattern borrowed from Aran sweaters. Because the back is plain, the waistcoat knits up quickly. (See page 227.)

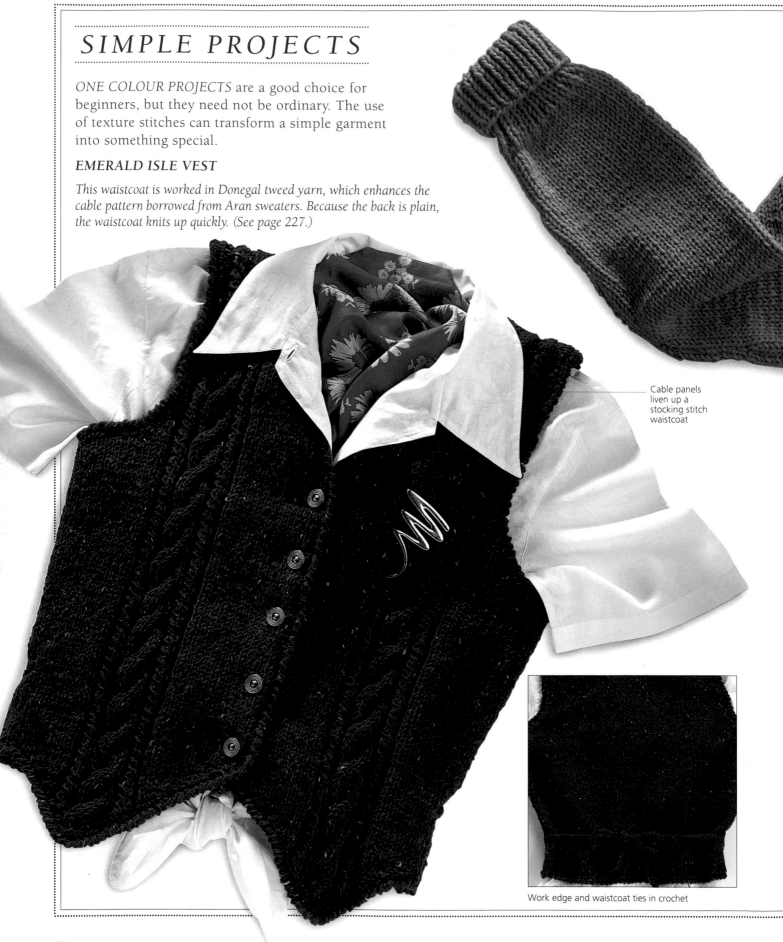

Cable panels liven up a stocking stitch waistcoat

Work edge and waistcoat ties in crochet

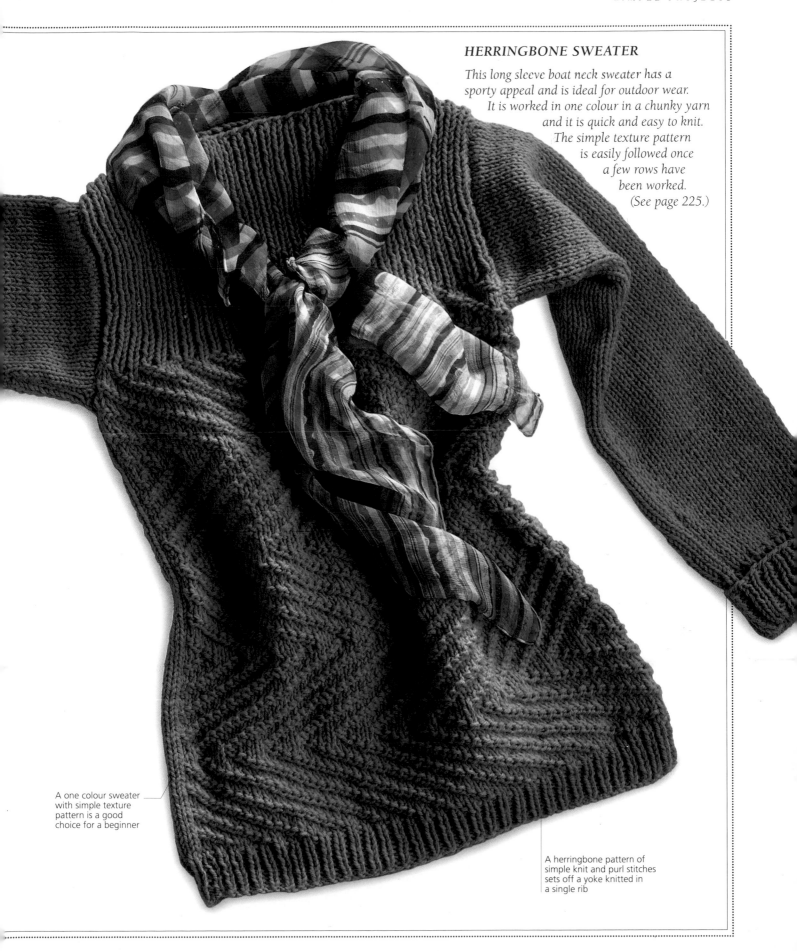

HERRINGBONE SWEATER

*This long sleeve boat neck sweater has a
sporty appeal and is ideal for outdoor wear.
It is worked in one colour in a chunky yarn
and it is quick and easy to knit.
The simple texture pattern
is easily followed once
a few rows have
been worked.*
(See page 225.)

A one colour sweater
with simple texture
pattern is a good
choice for a beginner

A herringbone pattern of
simple knit and purl stitches
sets off a yoke knitted in
a single rib

RAISED PATTERNS

A VARIETY OF dramatic effects can be achieved by using stitches to create patterns that stand out from a ground fabric. These stitches are produced by increasing and decreasing techniques, sometimes combined with twist or cable stitches.

Raised stitches come in all sizes, and can be worked in rows or panels, or as all over textures. They can also be combined with lace patterns and cables. Bobbles, popcorns, buds, and clusters are some of the most common patterns. A garment that has many motifs will be much thicker and heavier than a plainly knitted one, and will use more yarn. For this reason traditional outdoor wear, such as fishermen's sweaters, is often heavily patterned. To make these stitches, you need only to master the technique of multiple increases in a single stitch. For an easy-to-work pattern that has a strong texture, Popcorn stitch is a popular choice. Instructions are on page 57.

BOBBLES

A bobble is a large cluster of stitches that is independent of the knitted ground; it can be worked in stocking stitch or reverse stocking stitch. It is formed by increasing into a single stitch so that three, (four, or five) additional stitches for a small, (medium, or large) bobble are made. Work backwards and forwards on these stitches only. Finally, decrease these extra stitches to the original one. The increases can be made in two ways – using the yarn-over method or working into the front and back of a stitch. The stitches on either side must be worked firmly. Bobbles will make the edge uneven, so start a few stitches in to make the sewing up easier.

Small, medium, and large bobbles

Yarn-over increases

Knit up to your chosen stitch then make a yarn over – insert your right-hand needle into the stitch and knit as usual but do not discard. To make 5 new stitches (a total of 6 stitches), yarn over and knit into the same stitch 3 more times; slip last stitch onto right needle. This may be abbreviated as *yo, k1; rep from * twice (3, 4 times, etc.).*

Working into front and back of stitch

Knit up to your chosen stitch then insert your right-hand needle into it. Leave the stitch on the needle as you knit first into the front and then the back the appropriate number of times. To increase 4 times, making 4 new stitches (a total of 5 stitches), knit into the front and back of the stitch twice and then knit into the front again. Occasionally, an instruction will ask you to increase by alternately knitting and purling into the stitch.

1 For a medium bobble, work up to the chosen stitch. Then increase 3 times into the stitch (4 sts altogether). [We've used the yarn-over method.]

2 Turn work and knit 4 stitches; turn work and purl 4 stitches; turn work and knit 4 stitches; turn work (3 rows of reverse stocking stitch made).

3 Decrease 3 stitches in the row: Sl 2, k2tog, p2sso. Continue in pattern.

4 The completed bobble on a stocking stitch ground.

BUBBLE STITCH AND REVERSE BUBBLE STITCH ▶

Multiple of 8 sts plus 4

Note: Slip all sts p-wise.

Row 1 (right side): K.

Row 2: P.

Row 3: P1, yb, sl 2, yf, *p6, yb, sl 2, yf; rep from * to last st, p1.

Row 4: K1, yf, sl 2, yb, *k6, yf, sl 2, yb; rep from * to last st, k1.

Rows 5 to 8: rep rows 3 and 4 twice.

Row 9: K.

Row 10: P.

Row 11: P5, yb, sl 2, yf, *p6, yb, sl 2, yf; rep from * to last 5 sts, p5.

Row 12: K5, yf, sl 2, yb, *k6, yf, sl 2, yb; rep from * to last 5 sts, k5.

Rows 13 to 16: rep rows 11 and 12 twice.

Rows 1 to 16 form the pattern.

Bubble stitch

Use the reverse side of the bubble stitch as the right side

ORCHARD PATTERN ▲

Multiple of 6 sts plus 5

Note: Sts should only be counted after rows 6 or 12.

Row 1 (right side): P2, *k into front, back, front and back of next st, p2, k1, p2; rep from * to last 3 sts, k into front, back, front and back of next st, p2.

Row 2: *K2, [k1 winding yarn round needle twice] 4 times, k2, p1; rep from * to last 8 sts, k2, [k1 winding yarn round needle twice] 4 times, k2.

Row 3: P2, *k4 (dropping extra loops), p2, k1, p2; rep from * to last 6 sts, k4 (dropping extra loops), p2.

Rows 4 and 5: as rows 2 and 3.

Row 6: *K2, p4 tog, k2, p1; rep from * to last 8 sts, k2, p4tog, k2.

Row 7: P2, *k1, p2, k into front, back, front and back of next st, p2; rep from * to last 3 sts, k1, p2.

Row 8: *K2, p1, k2 [k1 winding yarn round needle twice] 4 times; rep from * to last 5 sts, k2, p1, k2.

Row 9: *P2, k1, p2, k4 (dropping extra loops); rep from * to last 5 sts, p2, k1, p2.

Rows 10 and 11: as rows 8 and 9.

Row 12: *K2, p1, k2, p4tog; rep from * to last 5 sts, k2, p1, k2.

Rows 1 to 12 form the pattern.

HONEYCOMB STITCH ▼

Multiple of 4 sts

Special abbreviation

C2B or C2F (Cross 2 Back or Front): K into back (or front) of 2nd st on needle, then k first st, slipping both sts off needle at same time.

Row 1 (right side): *C2F, C2B; rep from * to end.

Row 2: P.

Row 3: *C2B, C2F; rep from * to end.

Row 4: P.

Rows 1 to 4 form the pattern.

HAZEL NUT ▲

Multiple of 4 sts plus 3

Special abbreviation

HN (Make 1 Hazel Nut): K1 without slipping st off left needle, yo, then k1 once more into same st.

Note: Sts should only be counted after rows 4, 5, 6, 10, 11, or 12.

Row 1 (right side): P3, *HN, p3; rep from * to end.

Row 2: K3, *p3, k3; rep from * to end.

Row 3: P3, *k3, p3; rep from * to end.

Row 4: K3, *p3tog, k3; rep from * to end.

Row 5: P.

Row 6: K.

Row 7: P1, *HN, p3; rep from * to last 2 sts, HN, p1.

Row 8: K1, *p3, k3; rep from * to last 4 sts, p3, k1.

Row 9: P1, *k3, p3; rep from * to last 4 sts, k3, p1.

Row 10: K1, *p3tog, k3; rep from * to last 4 sts, p3tog, k1.

Row 11: P.

Row 12: K.

Rows 1 to 12 form the pattern.

39

GARTER STITCH CHEVRON ▶

Multiple of 11

Rows 1 to 5: K.
Row 6 (right side): *k2tog, k2, knit into front and back of each of the next 2 sts, k3, ssk; rep from * to end.
Row 7: P.
Rows 8 to 11: rep rows 6 and 7 twice.
Row 12: as row 6.
Rows 1 to 12 rows form the pattern.

◀ VERTICAL BOBBLE AND STRIPE

Multiple of 10 sts plus 5

Special abbreviation
MB (Make Bobble): Work [k1, p1, k1, p1, k1] into the next st, turn and k5, turn and k5tog.
Row 1 (right side): P2, k1, *p4, k1; rep from * to last 2 sts, p2.
Row 2: K2, p1, *k4, p1; rep from * to last 2 sts, k2.
Row 3: P2, *MB, p4, k1, p4; rep from * to last 3 sts, MB, p2.
Row 4: as row 2.
Rows 5 to 20: rep rows 1 to 4 four times.
Row 21: as row 1.
Row 22: as row 2.
Row 23: P2, *k1, p4, MB, p4; rep from * to last 3 sts, k1, p2.
Row 24: as row 2.
Rows 25 to 40: rep rows 21 to 24 four times.
Rows 1 to 40 form the pattern.

BOBBLE FANS ▲

Worked over 11 sts on a background of reverse st st

Special abbreviations
MB (Make Bobble): [K1, p1] twice all into next st, turn and p4, turn and k4, turn and p4, turn and sl 2, k2tog, p2sso.
T2F (Twist 2 Front): Slip next st onto cn and hold at front of work, purl next st from left needle, then knit st from cn.
T2B (Twist 2 Back): Slip next st onto cn and hold at back of work, knit next st from left needle, then purl st from cn.
T2FW (Twist 2 Front on Wrong side): Slip next st onto cn and hold at front (wrong side) of work, purl next st from left needle, then knit st from cn.
T2BW (Twist 2 Back on Wrong side): Slip next st onto cn and hold at back (right side) of work, knit next st from left needle, then purl st from cn.
Row 1 (right side): P.
Row 2: K.
Row 3: P5, MB, p5.
Row 4: K5, p1tbl, k5.
Row 5: P2, MB, p2, k1tbl, p2, MB, p2.
Row 6: K2, [p1tbl, k2] 3 times.
Row 7: MB, p1, T2F, p1, k1tbl, p1, T2B, p1, MB.
Row 8: p1tbl, k2, p1tbl, [k1, p1tbl] twice, k2, p1tbl.
Row 9: T2F, p1, T2F, k1tbl, T2B, p1, T2B.
Row 10: K1, T2BW, k1, [p1tbl] 3 times, k1, T2FW, k1.
Row 11: P2, T2F, M1 p-wise, sl 1, k2tog, psso, M1 p-wise, T2B, p2.
Row 12: K3, T2BW, p1tbl, T2FW, k3.
Row 13: P4, M1 p-wise, sl 1, k2tog, psso, M1 p-wise, p4.
Row 14: K5, p1tbl, k5.
Row 15: P.
Row 16: K.
Rows 1 to 16 form the pattern.

SCATTERED BOBBLES ▼

Multiple of 10 sts plus 5 worked on a background of st st

Special abbreviation
MB (Make Bobble): Knit into front, back and front of next st, turn and p3, turn and k3, turn and p3, turn and sl 1, k2tog, psso.
Rows 1 and 3: K.
Rows 2 and 4: P.
Row 5: K7, *MB, k9; rep from * to last 8 sts, MB, k7.
Rows 6, 8 and 10: P.
Rows 7 and 9: K.
Row 11: K2, *MB, k9; rep from * to last 3 sts, MB, k2.
Row 12: P.
Rows 1 to 12 form the pattern.

BUD STITCH ▲

Multiple of 6 sts plus 5

Note: Sts should only be counted after row 6 or 12.
Row 1 (right side): P5, *k1, yo, p5; rep from * to end.
Row 2: K5, *p2, k5; rep from * to end.
Row 3: P5, *k2, p5; rep from * to end.
Rows 4 and 5: as rows 2 and 3.
Row 6: K5, *p2tog, k5; rep from * to end.
Row 7: P2, *k1, yo, p5; rep from * to last 3 sts, k1, yo, p2.
Row 8: K2, *p2, k5; rep from * to last 4 sts, p2, k2.
Row 9: P2, *k2, p5; rep from * to last 4 sts, k2, p2.
Rows 10 and 11: as rows 8 and 9.
Row 12: K2, *p2tog, k5; rep from * to last 4 sts, p2tog, k2.
Rows 1 to 12 form the pattern.

TRINITY STITCH ▼
Multiple of 4 sts plus 2

Special abbreviation
M2 (Make 2 sts): K1, p1, k1 all into next st.
Row 1 (right side): P.
Row 2: K1, *M2, p3tog; rep from * to last st, k1.
Row 3: P.
Row 4: K1, *p3tog, M2; rep from * to last st, k1.
Rows 1 to 4 form the pattern.

MOCK CABLE ▲
Multiple of 5 sts plus 2

Row 1 (right side): P2, *sl 1, k2, psso, p2; rep from * to end.
Row 2: K2, *p1, yo, p1, k2; rep from * to end.
Row 3: P2, *k3, p2; rep from * to end.
Row 4: K2, *p3, k2; rep from * to end.
Rows 1 to 4 form the pattern.

SINGLE BELL EDGING ▲
Cast on multiple of 12 sts plus 3

Note: Sts should only be counted after rows 1 and 2.
Row 1 (right side): P3, *k9, p3; rep from * to end.
Row 2: K3, *p9, k3; rep from * to end.
Row 3: P3, *yb, ssk, k5, k2tog, p3; rep from * to end.
Row 4: K3, *p7, k3; rep from * to end.
Row 5: P3, *yb, ssk, k3, k2tog, p3; rep from * to end.
Row 6: K3, *p5, k3; rep from * to end.
Row 7: P3, *yb, ssk, k1, k2tog, p3; rep from * to end.
Row 8: K3, *p3, k3; rep from * to end.
Row 9: P3, *yb, sl 1, k2tog, psso, p3; rep from * to end.
Row 10: K3, *p1, k3; rep from * to end.
Row 11: P3, *k1, p3; rep from * to end.
Row 12: as row 10.
Rows 1 to 12 form the edging.

BOBBLE AND RIDGE ▲
Multiple of 6 sts plus 5

Special abbreviation
MB (Make Bobble): Knit into front, back and front of next st, turn and p3, turn and k3, turn and p3, turn and sl 1, k2tog, psso.
Row 1 (right side): K.
Row 2: P.
Row 3: K5, *MB, k5; rep from * to end.
Row 4: P.
Row 5: K2, MB, *k5, MB; rep from * to last 2 sts, k2.
Rows 6, 7 and 8: as rows 2, 3 and 4.
Row 9: P.
Row 10: K.
Rows 1 to 10 form the pattern.

PUFF BALL EDGING ▶
Cast on 13 sts

Row 1 (right side): K2, k2tog, yo2, k2tog, k7.
Row 2: K9, p1, k3.
Rows 3 and 4: K.
Row 5: K2, k2tog, yo2, k2tog, k2, [yo2, k1] 3 times, yo2, k2 – 21 sts.
Row 6: K3, [p1, k2] 3 times, p1, k4, p1, k3.
Rows 7 and 8: K.
Row 9: K2, k2tog, yo2, k2tog, k15.
Row 10: K 12 sts wrapping yarn twice around needle for each st, yo2, k5, p1, k3 – 23 sts (each double wrapped st counts as 1 st).
Row 11: K10, [p1, k1] into next st, slip next 12 sts to right needle, dropping extra loops. Return sts to left needle then k12tog –13 sts.
Row 12: K.
Rows 1 to 12 form the pattern.

41

OPENWORK PATTERNS

YARN-OVER INCREASES form some of the loveliest and most delicate stitches a knitter can create. Made with fine yarns and needles, openwork patterns are ideal for gossamer shawls, lacy sweaters, or dressy scarves. Where a more robust appearance, or a warmer fabric, is required, use medium-weight yarn to knit patterns with smaller openings.

There are two major categories of openwork pattern – lace and eyelet. Lace is truly openwork, unlike eyelet which is solid work punctuated by small openings. Lace, when combined with other stitches, lends itself to being used as panels. Knit the panels in or near the centre and away from the sides, where they are difficult to shape.

Wool, cottons, silks, and cashmere are among the many yarns that knit up beautifully in lace patterns. Cotton lace is often used for trimming curtains, place mats, bed linens, as well as clothes.

OPENWORK BASICS

Openings are formed by yarn-over increases, which are later offset by the same number of decreases so that the number of stitches remains constant. It is important that you work to the correct tension, and with appropriate needles and yarn. Openwork needs stretching before it is fully effective. Therefore, when you are substituting a lace pattern for stocking stitch, cast on less stitches than the width requirement – about three-quarters the number should suffice.

The shawl shown here is worked in a simple openwork pattern with a knitted border worked separately and then sewn onto the main piece.
(To make, see page 228.)

This triangular shawl features an attractive leaf pattern and a decorative border

LACE EDGINGS

These are marvellous for trimming bed and table linens. Use fine crochet cotton and sew finished edging to the cloth. When trimming knitting with a lace edge, first complete the main piece then pick up the required number of stitches for the lace edge (below).

Picking up stitches for an edge

Hold the working yarn behind the completed piece and insert your knitting needle through it, between the rows and between the last 2 stitches of each row, from front to back. Take the yarn over the needle as if knitting and draw a loop of the yarn through to form a stitch. Continue until the correct number of stitches have been formed.

EYELETS

There are two main types of eyelet: the chain and open. Made singly, eyelets can be used as tiny buttonholes or formed into a line for threading ribbon through. Used in combination, with plain rows between, eyelets can be placed vertically, horizontally, or diagonally to form decorative motifs. Do not make eyelets at the beginning or end of a row; work them at least two stitches in from the edge.

A row of open eyelets

Chain eyelet

This is the simplest and most common type of eyelet. It can be combined with the open eyelet in more intricate stitches. It is abbreviated as *yo, k2tog.*

1 Make a yarn-over by bringing your yarn to the front, and then knitting the next 2 stitches together.

2 The yarn-over adds one stitch, but knitting 2 together reduces the stitches to the original number.

3 A chain eyelet has been made in the knitted work.

Open eyelet

To work a slightly larger opening, use this method. This is more suitable for threading ribbon. It is abbreviated as *yo, sl 1 k-wise, k1, psso.*

1 Make a yarn-over by bringing the yarn forward around the front of the needle. Slip the next stitch knitwise, knit the next stitch, and then pass the slipped stitch over.

2 The increase made by the yarn-over has been replaced by the slip-stitch decrease. The number of stitches remains the same.

3 A finished open eyelet.

SLIP, SLIP, KNIT DECREASE

This decrease is especially useful for lace and openwork and leaves a smooth finish, abbreviated as ssk.

1 Slip the first and 2nd stitches knitwise, one at a time, onto the right needle.

2 Insert the left needle into the fronts of these 2 stitches from the left, and knit them together from this position.

3 The completed slip, slip, knit decrease is made.

DIAMOND AND WAVE EDGE ▶
Worked over 13 sts

Note: Sts should only be counted after rows 1 and 20.

Row 1 and every alt row (wrong side): K2, p to last 2 sts, k2.

Row 2: K7, yo, ssk, yo, k4.

Row 4: K6, [yo, ssk] twice, yo, k4.

Row 6: K5, [yo, ssk] 3 times, yo, k4.

Row 8: K4, [yo, ssk] 4 times, yo, k4.

Row 10: K3, [yo, ssk] 5 times, yo, k4.

Row 12: K4, [yo, ssk] 5 times, k2tog, k2.

Row 14: K5, [yo, ssk] 4 times, k2tog, k2.

Row 16: K6, [yo, ssk] 3 times, k2tog, k2.

Row 18: K7, [yo, ssk] twice, k2tog, k2.

Row 20: K8, yo, ssk, k2tog, k2.

Rows 1 to 20 form the pattern.

LEAF PATTERN ▲
Multiple of 10 sts plus 1

Row 1 and every alt row (wrong side): P.

Row 2: K3, *k2tog, yo, k1, yo, ssk, k5; rep from *, ending last rep k3.

Row 4: K2, *k2tog, [k1, yo] twice, k1, ssk, k3; rep from *, ending last rep k2.

Row 6: K1, *k2tog, k2, yo, k1, yo, k2, ssk, k1; rep from * to end.

Row 8: K2tog, *k3, yo, k1, yo, k3, sl 1, k2tog, psso; rep from * to last 9 sts, k3, yo, k1, yo, k3, ssk.

Row 10: K1, *yo, ssk, k5, k2tog, yo, k1; rep from * to end.

Row 12: K1, *yo, k1, ssk, k3, k2tog, k1, yo, k1; rep from * to end.

Row 14: K1, *yo, k2, ssk, k1, k2tog, k2, yo, k1; rep from * to end.

Row 16: K1, *yo, k3, sl 1, k2tog, psso, k3, yo, k1; rep from * to end.

Rows 1 to 16 form the pattern.

◀ ENGLISH LACE
Multiple of 6 sts plus 1

Row 1 and every alt row (wrong side): P.

Row 2: K1, *yo, ssk, k1, k2tog, yo, k1; rep from * to end.

Row 4: K1, *yo, k1 sl 1, k2tog, psso, k1, yo, k1; rep from * to end.

Row 6: K1, *k2tog, yo, k1, yo, ssk, k1; rep from * to end.

Row 8: K2tog, *[k1, yo] twice, k1, sl 1, k2tog, psso; rep from * to last 5 sts, [k1, yo] twice, k1, ssk.

Rows 1 to 8 form the pattern.

FEATHER PANEL ▶
Worked over 13 sts on a background of reverse st st

Special abbreviation

S4K (Slip 4 knit): Slip next 4 sts knitwise, one at a time, onto right needle, then insert left needle into fronts of these 4 sts from left, and knit them together from this position.

Row 1 (right side): K.

Row 2: P.

Row 3: K4tog, [yo, k1] 5 times, yo, S4K.

Row 4: P.

Rows 1 to 4 form the pattern.

FLEURETTE ▶
Multiple of 6 sts plus 5

Note: Sts should only be counted after rows 1-3, 6-9, and 12.

Row 1 and every alt row (wrong side): P.

Row 2: K2, *k1, yo, ssk, k1, k2tog, yo; rep from *, ending k3.

Row 4: K4, *yo, k3; rep from *, ending k1.

Row 6: K2, k2tog, *yo, ssk, k1, k2tog, yo, sl 2 k-wise, k1, p2sso; rep from *, ending yo, ssk, k2.

Row 8: K2, *k1, k2tog, yo, k1, yo, ssk; rep from *, ending k3.

Row 10: as row 4.

Row 12: K2, *k1, k2tog, yo, sl 2 k-wise, k1, p2sso, yo, ssk; rep from *, ending k3.

Rows 1 to 12 form the pattern.

CAT'S PAW ▶

Multiple of 16 sts plus 9

Row 1 and every alt row (wrong side): P.
Row 2: K10, *k2tog, yo, k1, yo, ssk, k11; rep
from *, ending last rep k10 instead of k11.
Row 4: K9, *k2tog, yo, k3, yo, ssk, k9; rep from
* to end.
Row 6: K10, *yo, ssk, yo, k3tog, yo, k11; rep
from *, ending last rep k10 instead of k11.
Row 8: K11, *yo, sl 1, k2tog, psso, yo, k13; rep
from *, ending last rep k11 instead of k13.
Row 10: K2, *k2tog, yo, k1, yo, ssk, k11; rep
from *, ending last rep k2 instead of k11.
Row 12: K1, *k2tog, yo, k3, yo, ssk, k9; rep
from *, ending last rep k1 instead of k9.
Row 14: K2, *yo, ssk, yo, k3tog, yo, k11; rep
from *, ending last rep k2 instead of k11.
Row 16: K3, *yo, sl 1, k2tog, psso, yo, k13; rep
from *, ending last rep k3 instead of k13.
Rows 1 to 16 form the pattern.

LATTICE STITCH ▼

Multiple of 6 sts plus 1

Row 1 (right side): K1, *yo, p1,
p3tog, p1, yo, k1; rep from * to end.
Row 2 and every alt row: P.
Row 3: K2, yo, sl 1, k2tog, psso, yo, *k3, yo, sl 1,
k2tog, psso, yo; rep from * to last 2 sts, k2.
Row 5: P2tog, p1, yo, k1, yo, p1, *p3tog, p1, yo, k1, yo,
p1; rep from * to last 2 sts, p2tog.
Row 7: K2tog, yo, k3, yo, *sl 1, k2tog, psso, yo, k3, yf; rep
from * to last 2 sts, ssk.
Row 8: P.
Rows 1 to 8 form the pattern.

OPENWORK EYELETS ▲

Multiple of 4 sts plus 3

Row 1 (right side): K.
Row 2: P.
Row 3: *K2, k2tog, yo; rep from * to last
3 sts, k3.
Row 4: P.
Row 5: K.
Row 6: P.
Row 7: *K2tog, yo, k2; rep from * to last
3 sts, k2tog, yf, k1.
Row 8: P.
Rows 1 to 8 form the pattern.

WAVE EDGE ▶

Worked over 13 sts

Note: Sts should only be counted after rows
1, 4, 5 or 14.

Row 1 and every alt row (wrong side): K2,
p to last 2 sts, k2.
Row 2: Sl 1, k3, yo, k5, yo, k2tog, yo, k2.
Row 4: Sl 1, k4, sl 1, k2tog, psso, k2,
[yo, k2tog] twice, k1.
Row 6: Sl 1, k3, ssk, k2, [yo, k2tog] twice, k1.
Row 8: Sl 1, k2, ssk, k2, [yo, k2tog] twice, k1.
Row 10: Sl 1, k1, ssk, k2, [yo, k2tog] twice, k1.
Row 12: K1, ssk, k2, yo, k1, yo, k2tog, yo, k2.
Row 14: Sl 1, [k3, yo] twice, k2tog, yo, k2.
Rows 1 to 14 form the pattern.

◀ FALLING LEAVES

Worked over 16 sts on a background of
reverse st st

Row 1 (right side): P1, k3, k2tog, k1, yo, p2, yo,
k1, ssk, k3, p1.
Row 2 and every alt row: K1, p6, k2, p6, k1.
Row 3: P1, k2, k2tog, k1, yf, k1, p2, k1, yo,
k1, ssk, k2, p1.
Row 5: P1, k1, k2tog, k1, yo, k2, p2, k2,
yo, k1, ssk, k1, p1.
Row 7: P1, k2tog, k1, yo, k3, p2, k3,
yo, k1, ssk, p1.
Row 8: K1, p6, k2, p6, k1.
Rows 1 to 8 form the pattern.

USING COLOUR

COLOUR IS ANOTHER way of transforming simple shapes. Its use may be subtle or dramatic, providing a mosaic of shades in a complex arrangement.

The simplest way of using colour is to make horizontal stripes. Here, you introduce a new shade at the beginning of a row. To make vertical stripes, use a separate ball of yarn for each colour and, when you get to the end of each block, pick up the new yarn in a way that prevents a hole from appearing. Another effective but easy way of adding colour is to combine two different yarns, working them as one strand. Colour also may be embroidered onto a stocking stitch background using Swiss darning (see page 58).

Simple colour patterns are often shown in chart form. Charts can be coloured or printed in black and white with symbols representing the different colours.

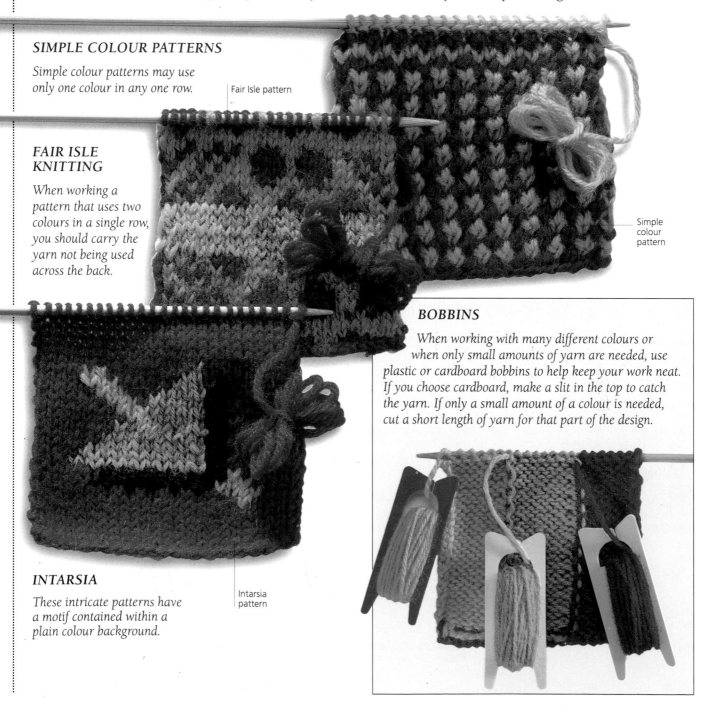

SIMPLE COLOUR PATTERNS

Simple colour patterns may use only one colour in any one row.

Fair Isle pattern

FAIR ISLE KNITTING

When working a pattern that uses two colours in a single row, you should carry the yarn not being used across the back.

Simple colour pattern

INTARSIA

These intricate patterns have a motif contained within a plain colour background.

Intarsia pattern

BOBBINS

When working with many different colours or when only small amounts of yarn are needed, use plastic or cardboard bobbins to help keep your work neat. If you choose cardboard, make a slit in the top to catch the yarn. If only a small amount of a colour is needed, cut a short length of yarn for that part of the design.

ADDING NEW YARN AT START OF ROW

Use this method when knitting horizontal stripes. If you will be using the old colour again, leave it at the side. Make sure any ends are woven neatly into the edge or back of the work.

1 Insert your right needle into the first stitch on the left needle and wrap both the old and new yarns over it. Knit the stitch with both yarns.

2 Drop the old yarn and knit the next 2 stitches with the doubled length of the new yarn.

3 Drop the short end of the new yarn and continue knitting in pattern. On the subsequent row, knit the 3 double stitches in the ordinary way.

ADDING NEW YARN AND WEAVING IN

When joining a colour at the start of a row, use this method to weave in the ends of yarns on the wrong side of the work.

1 Cut the old colour, leaving about 3 inches. With the new yarn, purl the first 2 stitches. Lay the short ends of both the old and new yarns over the top of the needle and purl the next stitch under the short ends.

2 Leave the short ends hanging and purl the next stitch over them. Continue until the short ends are woven in.

ADDING NEW YARN WITHIN THE ROW

Use this method when you will be working the original yarn again in the same row. See page 48 for instructions for carrying the yarn along the back.

1 Leaving the old yarn in the back of the work, insert your right-hand needle into the stitch. Wrap the new yarn over the needle and use this to knit the stitch.

2 Knit the next 2 stitches with the doubled length of new yarn.

3 Drop the short end and continue knitting with the new yarn while carrying the old yarn across the back. On subsequent rows, knit the double stitches normally.

MAKING VERTICAL STRIPES OR DESIGNS

This method is known as intarsia and is suitable for knitting motifs. The pattern instructions are always in chart form.

To make vertical stripes or independent blocks of colour, use a separate ball or bobbin of yarn for each colour. Drop the old yarn and pick up the next one from underneath it so the yarns cross. By twisting the yarns in this way, you will prevent a gap appearing in the work. *(Top left.)* Work in the same way for the purl row *(bottom left).*

CARRYING COLOURS ACROSS THE BACK

When working multicolour patterns, you must alternate between two or more balls of yarn. The yarn not in use has to be carried along the back until needed. There are two main methods, stranding and weaving. Stranding is suitable for short distances (5 stitches or less); weaving is better when the yarn is carried 6 stitches or more.

STRANDING

The strands, known as floats, can make knitting more difficult. Floats have to be carried along the back at the correct tension – not too loosely or tightly. With more than two yarns, you will have to drop and pick them up as needed.

If you have only 2 colors in a knit row, hold one in each hand using the methods shown on page 15. *(See above left).* For the purl row *(below left),* follow the instructions for holding the yarn given on page 16.

Do not make your floats longer than 5 stitches, and take care that your strands are the same tension as the knitting.

WEAVING

In this method, the carried yarn is brought alternately above and below each stitch made so that it is woven in. It is best worked using both hands. You can also use it in combination with stranding; for example, weaving in at every third stitch and stranding in between will create a more elastic fabric, which will have a smoother finish.

Yarn above the stitch

Holding one yarn in each hand, knit 1 *(left)* or purl 1 *(right)* with the first colour, and, at the same time, bring the 2nd colour over the tip of the right needle.

Yarn below the stitch

With one yarn in each hand, knit 1 *(left)* or purl 1 *(right)* with the first colour, holding the 2nd colour below the first.

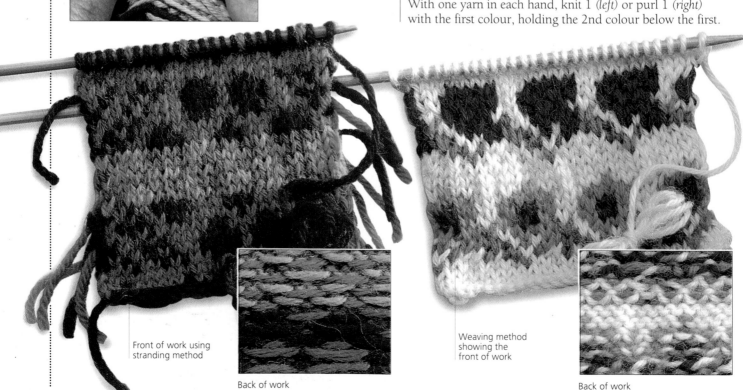

Front of work using stranding method

Back of work

Weaving method showing the front of work

Back of work

WORKING FROM A CHART

COLOUR PATTERNS ARE often charted on graph paper. Each square represents a stitch and each horizontal line of squares is a row of stitches. A coloured-in chart, where the indicated colours fill the graphed squares, is the easiest to follow and has the added advantage of giving you a preview of what the finished work will look like.

Many knitting charts are printed in black and white, and different symbols are used to indicate the different colours. These charts usually come with a colour key, and show only one pattern repeat. In the case of a large multicoloured sweater, the chart may represent the whole garment.

Charts are read from bottom to top; they are usually based on stocking stitch where the first and all odd-numbered rows are knitted from right to left and all even-numbered rows are purled from left to right. Therefore, the first stitch of a chart is the bottom one on the right. You may find placing a ruler under each row will help you keep track of where you are. When knitting in the round (see page 60), the right side always faces you so that, for every row, you always read every row of the chart from right to left.

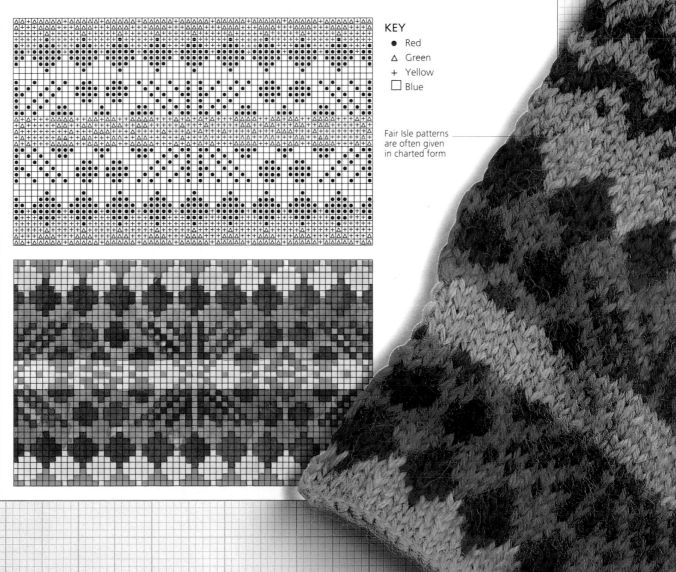

KEY

- ● Red
- △ Green
- + Yellow
- □ Blue

Fair Isle patterns are often given in charted form

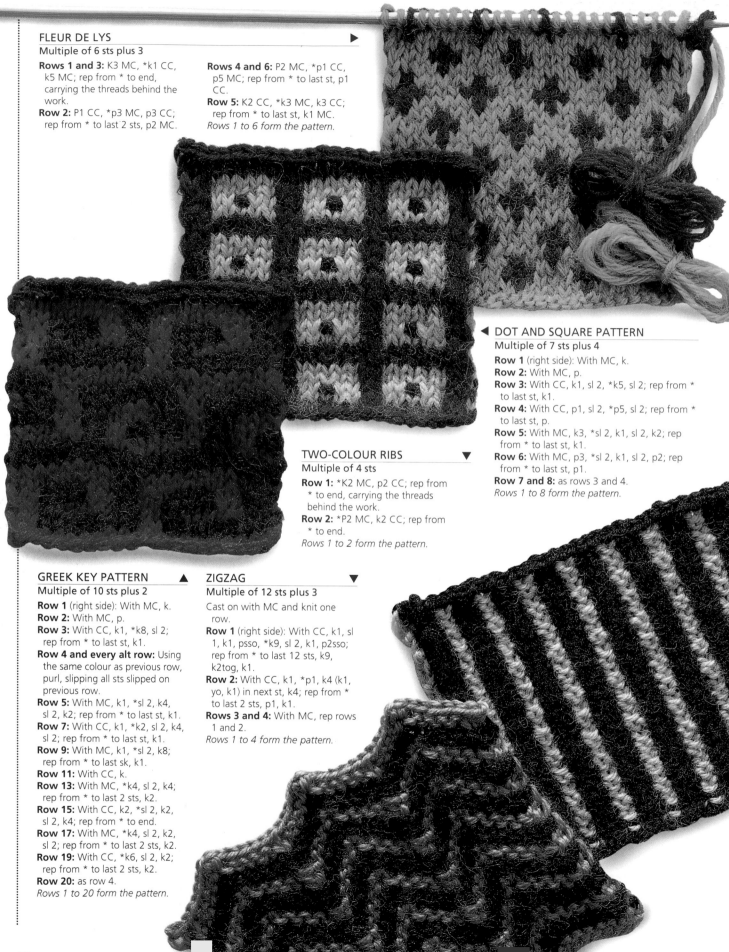

FLEUR DE LYS ▶
Multiple of 6 sts plus 3

Rows 1 and 3: K3 MC, *k1 CC, k5 MC; rep from * to end, carrying the threads behind the work.
Row 2: P1 CC, *p3 MC, p3 CC; rep from * to last 2 sts, p2 MC.

Rows 4 and 6: P2 MC, *p1 CC, p5 MC; rep from * to last st, p1 CC.
Row 5: K2 CC, *k3 MC, k3 CC; rep from * to last st, k1 MC.
Rows 1 to 6 form the pattern.

◀ DOT AND SQUARE PATTERN
Multiple of 7 sts plus 4

Row 1 (right side): With MC, k.
Row 2: With MC, p.
Row 3: With CC, k1, sl 2, *k5, sl 2; rep from * to last st, k1.
Row 4: With CC, p1, sl 2, *p5, sl 2; rep from * to last st, p.
Row 5: With MC, k3, *sl 2, k1, sl 2, k2; rep from * to last st, k1.
Row 6: With MC, p3, *sl 2, k1, sl 2, p2; rep from * to last st, p1.
Row 7 and 8: as rows 3 and 4.
Rows 1 to 8 form the pattern.

TWO-COLOUR RIBS ▼
Multiple of 4 sts

Row 1: *K2 MC, p2 CC; rep from * to end, carrying the threads behind the work.
Row 2: *P2 MC, k2 CC; rep from * to end.
Rows 1 to 2 form the pattern.

GREEK KEY PATTERN ▲
Multiple of 10 sts plus 2

Row 1 (right side): With MC, k.
Row 2: With MC, p.
Row 3: With CC, k1, *k8, sl 2; rep from * to last st, k1.
Row 4 and every alt row: Using the same colour as previous row, purl, slipping all sts slipped on previous row.
Row 5: With MC, k1, *sl 2, k4, sl 2, k2; rep from * to last st, k1.
Row 7: With CC, k1, *k2, sl 2, k4, sl 2; rep from * to last st, k1.
Row 9: With MC, k1, *sl 2, k8; rep from * to last sk, k1.
Row 11: With CC, k.
Row 13: With MC, *k4, sl 2, k4; rep from * to last 2 sts, k2.
Row 15: With CC, k2, *sl 2, k2, sl 2, k4; rep from * to end.
Row 17: With MC, *k4, sl 2, k2, sl 2; rep from * to last 2 sts, k2.
Row 19: With CC, *k6, sl 2, k2; rep from * to last 2 sts, k2.
Row 20: as row 4.
Rows 1 to 20 form the pattern.

ZIGZAG ▼
Multiple of 12 sts plus 3

Cast on with MC and knit one row.

Row 1 (right side): With CC, k1, sl 1, k1, psso, *k9, sl 2, k1, p2sso; rep from * to last 12 sts, k9, k2tog, k1.
Row 2: With CC, k1, *p1, k4 (k1, yo, k1) in next st, k4; rep from * to last 2 sts, p1, k1.
Rows 3 and 4: With MC, rep rows 1 and 2.
Rows 1 to 4 form the pattern.

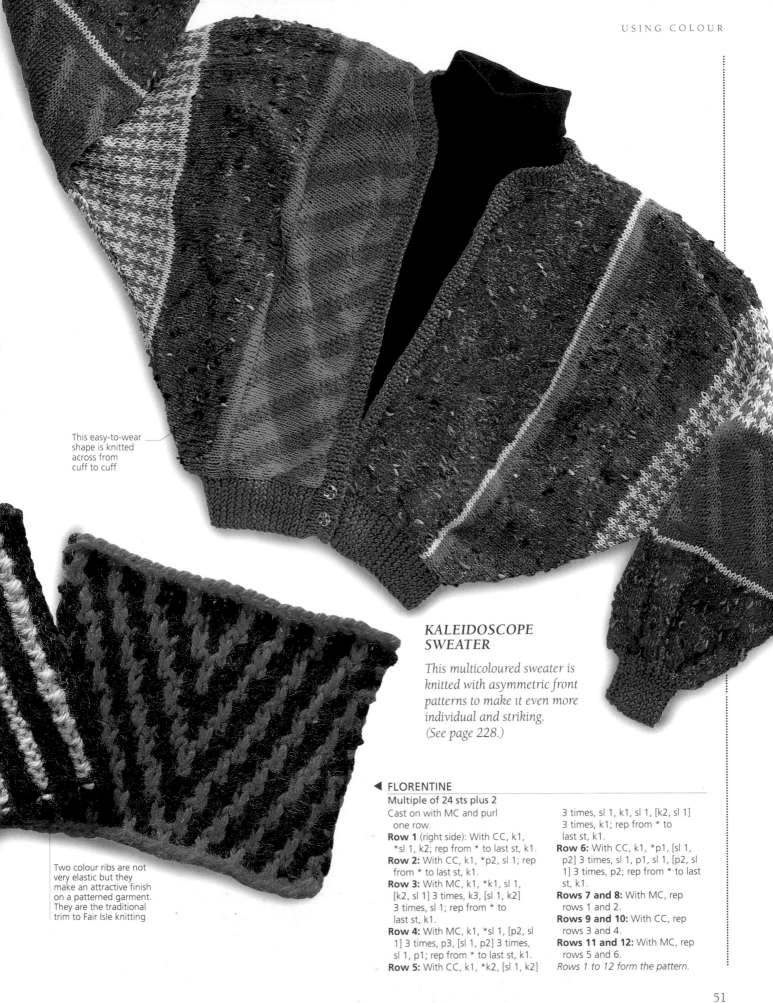

This easy-to-wear shape is knitted across from cuff to cuff

Two colour ribs are not very elastic but they make an attractive finish on a patterned garment. They are the traditional trim to Fair Isle knitting

KALEIDOSCOPE SWEATER

This multicoloured sweater is knitted with asymmetric front patterns to make it even more individual and striking. (See page 228.)

◀ FLORENTINE

Multiple of 24 sts plus 2

Cast on with MC and purl one row.

Row 1 (right side): With CC, k1, *sl 1, k2; rep from * to last st, k1.

Row 2: With CC, k1, *p2, sl 1; rep from * to last st, k1.

Row 3: With MC, k1, *k1, sl 1, [k2, sl 1] 3 times, k3, [sl 1, k2] 3 times, sl 1; rep from * to last st, k1.

Row 4: With MC, k1, *sl 1, [p2, sl 1] 3 times, p3, [sl 1, p2] 3 times, sl 1, p1; rep from * to last st, k1.

Row 5: With CC, k1, *k2, [sl 1, k2] 3 times, sl 1, k1, sl 1, [k2, sl 1] 3 times, k1; rep from * to last st, k1.

Row 6: With CC, k1, *p1, [sl 1, p2] 3 times, sl 1, p1, sl 1, [p2, sl 1] 3 times, p2; rep from * to last st, k1.

Rows 7 and 8: With MC, rep rows 1 and 2.

Rows 9 and 10: With CC, rep rows 3 and 4.

Rows 11 and 12: With MC, rep rows 5 and 6.

Rows 1 to 12 form the pattern.

51

COLOUR MOTIFS

COLOUR KNITTING CAN be as simple or as intricate as you wish. In theory, any pattern that can be drawn out on graph paper can be transferred to knitting, but the more colours you have in any one row, the more practice you will need to master the techniques of picking up and joining the new colour, and carrying the unused colour behind the work. In more complicated colour patterns, stranding and weaving can be combined with intarsia. An example of this is found in the Old Rose motif shown on page 55.

You can use most of these patterns to stand as single motifs, or arrange them in repeats in rows or diagonals. Plot them out on graph paper to fit the shape of the garment pieces you are knitting.

Big Bow
You can use a large single motif to work on a pocket, or a border round the hem of a sweater. Space the motifs as close or as far apart as you like. The colours you choose will affect the look of the pattern; avoid using too strong a background.

Little Bows
A row of small bows can be knitted in the same colour, alternating colours, or a string of different colours, according to your mood. Use a small border like this around the sleeves and hem of a cardigan.

Harlequin

Interlaced black and white grid lines provide a framework for multicoloured diamonds in this all-over pattern. Use it on waistcoats, cardigans, and sweaters in bright or subdued tones – and create a garment that will be a modern classic. Note how the knitting broadens the pattern shape.

Big Arrow

A bold geometric shape (*right*) can be used as a scatter pattern – combine the big and small arrows together in one pattern, or use motifs of all one size.

Small Arrow

Bright, paintbox colours make this pattern (*left*) fine for children's sweaters. Use it with the Big Arrow or on its own.

Houndstooth

A traditional pattern (*above*) used in tweeds is easily adapted to knitting. Use more heathery colours for classic men's waistcoats and sweaters.

Bavarian Flowers
Small, neat rows of this flower repeat (*left*) would make an all-over pattern. Notice that the dark and light colourways create a completely different effect.

Welsh Poppies
For a hotter colour variation, knit the flowers in bright reds. This motif (*below, left*) could be spaced wide apart on jackets or cardigans.

Purple Flower
The simple shape of this pretty flower (*above*) takes on a richness by the use of six colours.

Old Rose

A classic old rose pattern *(right)* reminiscent of upholstery chintzes, with carefully shaded petals and leaves. Use this as a single motif on a dressy cardigan.

Single Anemone

This flower and leaf motif *(below)* could be spaced over the background and set into diagonal lines. The edge of the motif must be carefully knitted.

Anemone border

A flower border *(right)* with overlapping petals can be adapted into many different colorways; use it to set off the Single Anemone pattern as a border trim on a cardigan.

COLOURFUL WINTER WEAR

MULTICOLOUR KNITTING IS popular for scarves and sweaters, and can be done in a variety of ways. Here we show a sweater, cardigan, and scarf that all use different techniques. The Log Cabin pattern sweater consists of blocks of colour, and uses the technique of intarsia. The cardigan is knitted in one background colour with a contrasting dot, and the colourful embroidery added at the end. This scarf makes an excellent project for a beginner – it features Popcorn stitch on every other stripe, and is knitted in vivid bands of colour.

LOG CABIN SWEATER

This turtle neck sweater in a tweed Aran weight will keep you warm and cosy in winter weather. The flecked tweed adds a dimension to the simple back and sleeves – and it is surprisingly fast and easy to make. (See page 230.)

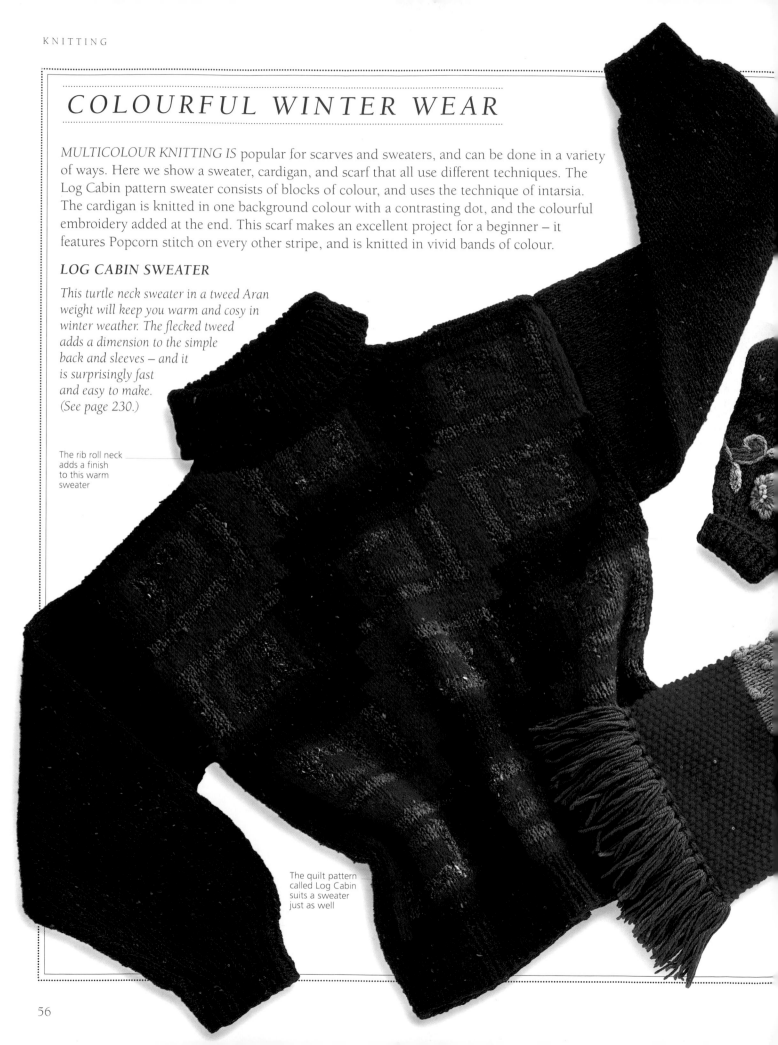

The rib roll neck adds a finish to this warm sweater

The quilt pattern called Log Cabin suits a sweater just as well

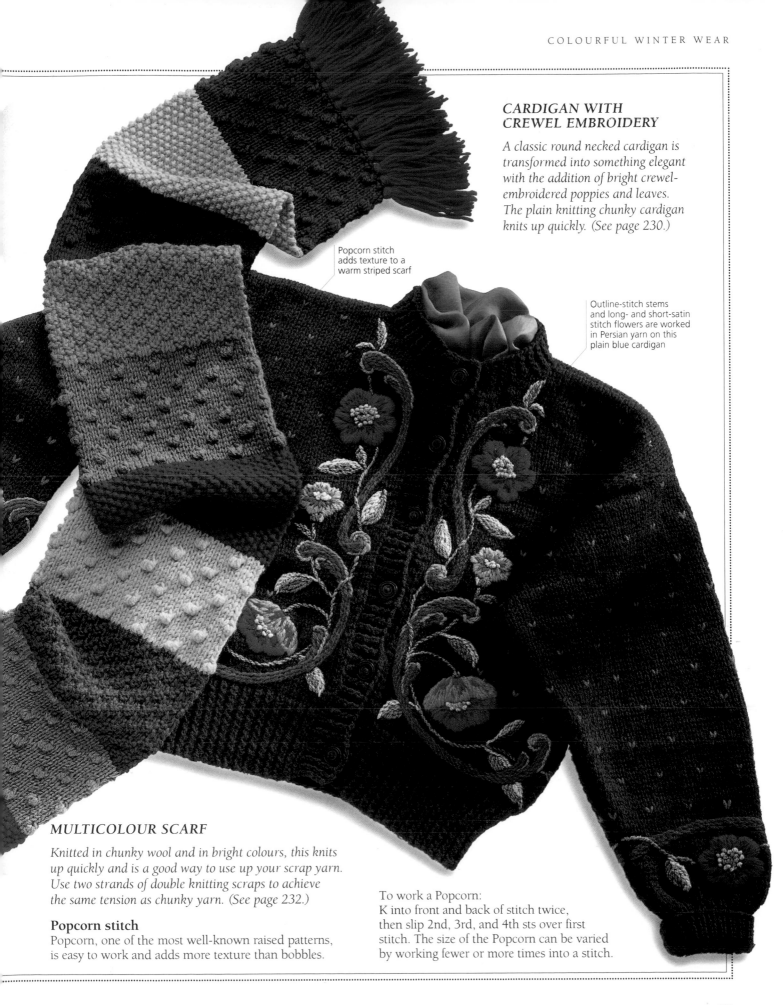

CARDIGAN WITH CREWEL EMBROIDERY

A classic round necked cardigan is transformed into something elegant with the addition of bright crewel-embroidered poppies and leaves. The plain knitting chunky cardigan knits up quickly. (See page 230.)

Popcorn stitch adds texture to a warm striped scarf

Outline-stitch stems and long- and short-satin stitch flowers are worked in Persian yarn on this plain blue cardigan

MULTICOLOUR SCARF

Knitted in chunky wool and in bright colours, this knits up quickly and is a good way to use up your scrap yarn. Use two strands of double knitting scraps to achieve the same tension as chunky yarn. (See page 232.)

Popcorn stitch

Popcorn, one of the most well-known raised patterns, is easy to work and adds more texture than bobbles.

To work a Popcorn:
K into front and back of stitch twice, then slip 2nd, 3rd, and 4th sts over first stitch. The size of the Popcorn can be varied by working fewer or more times into a stitch.

EMBROIDERING KNITTING

SIMPLE EMBROIDERY STITCHES enrich any knitted garment by adding extra colour and texture. Four of the most popular stitches are shown here – Swiss darning, cross stitch, long and short, and bullion knot. Swiss darning follows the same stitch pattern as the knitting, and can be used instead of colour knitting (see page 46) to work motifs, or in combination with colour knitting to add areas of colour. Cross stitch is a quick and easy pattern stitch; bullion knots provide interesting texture. Long and short stitch is useful for filling solid shapes in free-form embroidery. You can also experiment with other common stitches – including chain stitch, daisy stitch, and running stitch.

EMBROIDERY BASICS

It is often easier to embroider on knitting before the garment has been assembled, but after it has been blocked (see page 64). The golden rule is to work with the knitted fabric and not against it. Do not pull the embroidery stitches too tight or the knitting will pucker, and always work with a blunt-ended tapestry needle or yarn needle to avoid splitting the knitted stitches. Embroider with a yarn of the same type and thickness as the knitting – if the embroidery yarn is too thin it will sink into the knitted stitches, and if it is too thick it will stretch the knitting and look lumpy. You can also use embroidery floss or tapestry wool instead of knitting yarn. These products are sold in small, economical amounts and come in a wide range of beautiful colours. Bear in mind that you may need to work with several strands to match the thickness of the knitting yarn.

Swiss darning worked on a knitted pocket can form a striking initial or monogram

Swiss darning in vertical rows on stocking stitch

1 Bring needle out on right side of knitting under strand at the bottom of a knit stitch (base of V-shape). Insert needle from right to left behind knit stitch directly above and pull the yarn snug.

2 Insert needle under same strand where the thread emerged for first half-stitch. Bring needle out under the connecting strand of the knit stitch directly above it.

Swiss darning in horizontal rows on stocking stitch

1 Bring the needle up on the right side under the connecting thread at the bottom of a knit stitch. Insert needle from right to left behind the knit stitch above, and pull the yarn snug.

2 Insert needle under the same strand where thread emerged for the first half stitch. Bring needle up again under the connecting strand of the stitch to the left of it.

Cross stitch

1 Bring yarn out at the front of the work at the bottom of a knit stitch, and take a diagonal stitch up to right. Bring the needle out directly below, and pull the yarn snug.

2 To complete the cross, insert the needle directly above where it first emerged. If making a 2nd cross stitch, bring it out at bottom to left and continue as in step 1.

Stem stitch

Work from left to right, taking regular, slanted backstitches. The thread should always emerge on the left of the previous stitch.

Long and short stitch

1 Baste the outline shape with contrasting thread (this is removed afterwards). Count down the knitted rows vertically, and bring needle out at front of work about 2 knit stitches inside outline.

2 Insert needle at outline, and bring it out at left of previous stitch and one knit stitch down. Repeat using long and short stitches alternately, closely following the outline. Work stitches in following rows to fill shape.

Bullion knot

1 Similar to a French knot (see page 135), this stitch may be worked singly or in clusters. Bring yarn out at front of work at the position for the knot. Make a backstitch the size of the knot(s) required, bringing needle out at front next to first stitch. Twist yarn around needle point as many times as required to equal the backstitch length.

2 Hold your left thumb on the coiled yarn and pull needle through the coils. Then turn needle back to where it was first inserted, and pull yarn through to the back of the work so that the bullion knot lies flat.

A combination of different embroidery stitches can be used very effectively

Knots form the centres of the flowers, which are worked in long and short stitch

KNITTING IN THE ROUND

KNITTING IN THE round is a more ancient art than flat knitting, and many of the antique pieces and traditional garments you will see in museums have been knitted in this way. Since the knitting is worked as a continuous spiral there are no seams to sew up, and a stronger garment is produced. Another advantage is that the right side of the knitting is always facing you, so if you are working a colour pattern you can see it clearly at all times. Knitting stocking stitch is simplified because you knit every row or round. Purling every row produces reverse stocking stitch.

There are two main ways of working in the round: with a flexible circular needle or with four or more double-pointed straight needles. A circular needle can hold three times as many stitches as a straight needle so it is the best way of knitting large items such as skirts. Small items, such as socks, collars, and mittens are usually produced with four or more straight needles rather than a circular needle.

FAIR ISLE HAT AND MITTENS

Traditional Fair Isle patterns are popular decorations for warm hats and mittens. When knitting in the round the pattern will always be facing you.
(See page 232.)

Double knitting mittens are decorated on the back and front

A Fair Isle ski hat is decorated with a pompom

SPECIAL EQUIPMENT

Circular needles come in a range of lengths. The shortest are best for knitting collars or neckbands; long ones can be used for knitting large straight pieces. To mark the end of a round, coloured markers are useful. Double-pointed needles come in sets of four or more, and in different lengths.

Coloured markers

Circular needle

Set of double-pointed needles

KNITTING WITH A CIRCULAR NEEDLE

Choose a circular needle about 5cm (2 in) smaller than the circumference of the knitting to avoid stretching the stitches. If you haven't used this type of needle before, just work as if each pointed end is a separate needle.

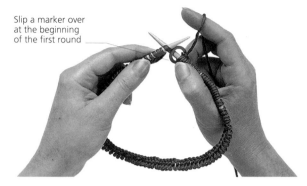

Slip a marker over at the beginning of the first round

1 Cast on the number of stitches needed, then slip a marker between the first and last stitches so that you can see where the first round starts. Hold the needle tip with the last cast-on stitch in your right hand, and the tip with the first cast-on stitch in your left hand. At this point it is crucial to check for any twisted stitches by making sure the cast-on edge is facing in toward the centre of the needle. When knitting the first stitch of the round, pull the yarn firmly to avoid a gap.

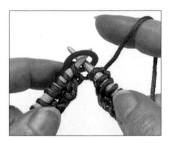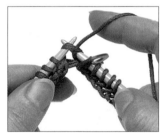

2 Knit until you reach the marker, then slip the marker over. You are now ready to start the second round. Check again to see if any stitches are twisted. If so, unravel the first row – twisted stitches cannot be corrected in any other way.

To knit flat work on a circular needle

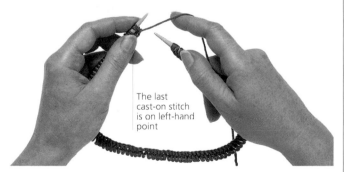

The last cast-on stitch is on left-hand point

A circular needle is ideal for knitting large flat pieces. Hold the needle tip with the last cast-on stitch in your left hand and the needle tip with the first cast-on stitch in your right hand. Knit as with ordinary needles across the row, ending with the last stitch, then turn your work around so that the wrong side is facing you. Purl across the row. Continue to work back and forth, knitting and purling.

KNITTING WITH DOUBLE-POINTED NEEDLES

Double-pointed needles usually come in sets of four, but sometimes as many as six needles can be used. The working method is always the same: one needle is used to knit off the stitches that are equally divided between the other needles.

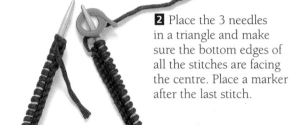

1 To knit with 4 needles, cast on one third of the stitches onto each of 3 needles. When you complete the stitches on one needle, hold the next one parallel and above it with the point a little bit further forward than the lower one. (Alternatively, cast on all the stitches on one needle and then divide them between the other needles.)

2 Place the 3 needles in a triangle and make sure the bottom edges of all the stitches are facing the centre. Place a marker after the last stitch.

3 Use the 4th needle to knit into the first cast-on stitch. Pull the yarn extra firmly on this stitch to avoid a gap in the work. When you have knitted all the stitches off the first needle, use it as the working needle to knit the stitches off the 2nd needle, then use this needle to work the stitches off the 3rd needle.

The marker will show you where each new round starts

4 Continue knitting in this way, holding the 2 working needles as you would normally, and dropping the needles not in use to the back of the work. When you reach the marker, slip it and start the next round.

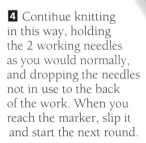

BUTTONHOLES

THERE ARE FOUR basic types of buttonholes – horizontal, vertical, round, and loop. The horizontal is hardwearing and is the most commonly used. It is suitable for light and medium weight garments. The vertical type is better when the knitting will have a vertical pull, such as on pocket flaps. Round buttonholes are worked for small buttons on baby

clothes, (see eyelets page 43). Loops are suitable for thick jackets, and are sewn to the edge of the knitting.

It is essential that the size and position of the buttonhole match the button to be used. In general, a horizontal buttonhole extends one stitch beyond the button, a vertical hole extends one row above it, and a round hole or loop aligns exactly with the button.

Horizontal buttonhole

Knit up to buttonhole position. On a right-side row, cast off number of stitches required for size of button and then knit to end of row. On next row, work up to stitch before buttonhole and knit into front and back of this stitch. Cast on one stitch less than number cast off. Knit to end of row.

Vertical buttonhole

Turn work at base of buttonhole, holding unused stitches on spare needle. Work on first set of stitches to the depth needed, ending on a right-side row. Join new yarn, and work one less than this number of rows on 2nd set of stitches. Slip these back onto original needle and knit across.

Loop

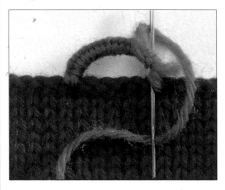

Mark 2 fixing points on wrong side. With a blunt-ended needle, secure yarn firmly to one point, then loop it over to the 2nd fixing point and take a small stitch. Continue looping and securing yarn until the required thickness has been achieved. Then buttonhole stitch over the loops.

Buttonhole stitch

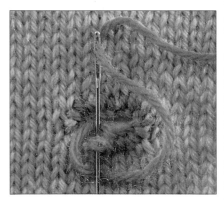

This stitch is used to cover loops *(above)* and to neaten other buttonholes. Work from right, using a blunt-ended needle. Bring yarn out on right side just below edge. Take a straight downwards stitch with thread under needle, pull up stitch to form a loop knot at buttonhole edge and repeat. Work stitches close together.

Buttonstand

With some patterns you may need to knit a buttonstand – an extra area of fabric onto which buttons are sewn. To knit a buttonstand, simply cast on the extra number of stitches required at the end of a row, then work across these and the rest of the stitches until you reach the required depth. Cast off the extra stitches.

Knitted buttons

With scrap yarn, cast on 14 stitches. With yarn for button, knit 5 rows; leaving about 8 inches, cut yarn. With this yarn, sew through stitches in last row. Unpick scrap yarn; with another length of yarn, sew through loops. Draw both ends tight and fasten. Stuff button with yarn, and sew up. Use threads to sew on.

TRIMMINGS

THE RIGHT TRIMMING can add that special finishing touch to your knitted garment. Pompoms are fun on children's hats, a fringe is the perfect edging for a scarf, and tassels make a jacket look smart or home furnishings more professionally finished. All can be made in the same or contrasting yarn.

Pompoms

1 Cut 2 cardboard circles to desired size. In centres, cut a hole about one third of total diameter. Place circles together and wrap yarn as shown.

2 Continue wrapping yarn until the centre holes are completely filled. If you run out of yarn, wrap a new length in and leave the ends dangling at the outer edge.

Tie a length of yarn between cardboard circles

3 Cut through yarn around edges. Ease circles slightly apart and wrap a length of yarn tightly around strands a few times, and secure with a firm knot. Pull off cardboard. Fluff out pompom, and trim with sharp scissors.

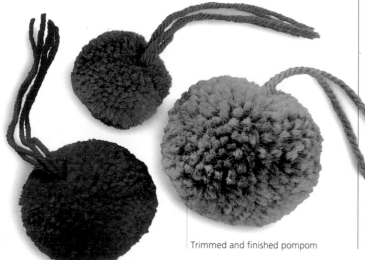

Trimmed and finished pompom

Fringe

1 Wrap yarn around a cardboard rectangle slightly deeper than desired length of fringe. Cut along one edge to make the strands. Take several strands and fold.

2 With a crochet hook, draw loop of strands through edge stitch, then pull cut ends through loop to form a loose knot. Adjust and trim.

Tassels

1 Wrap yarn around cardboard cut to desired length. Thread length of yarn under top loops, and tie tightly; leave one end long. Cut through yarn at lower edge.

2 Hide knot and short end of yarn under tassel strands. Wind long end tightly around strands to form a neat top. Thread needle with long end of yarn and push under binding and out through top of tassel. Trim ends if necessary.

BLOCKING & PRESSING

BEFORE A KNITTED garment is sewn together it must be blocked. This means that each knitted piece is shaped to the measurements given in the pattern. The process also helps smooth out any stitch irregularities and flattens curling edges. Before blocking, weave in all the loose ends. The beauty of the garment is in its hand knitted appearance – be careful not to over-press and obliterate this look.

BLOCKING

You will need a large, flat, padded surface. A table covered with a folded blanket and topped with a clean white sheet works well. Place each knitted piece wrong side up on the padding, smooth it out, and pin the corners to the padding with straight steel pins. Take care not to stretch or distort the basic shape, and make sure the knit rows run in straight lines. Then take a tape measure and check the length and width of each piece against those given in the pattern. Stretch or shrink the piece as necessary, and continue pinning at fairly close intervals all around the edges. The edges should be quite smooth: if each pin draws out a point of the knitting, you are either stretching it too much or are not using enough pins.

Block the piece to the
measure given in the
pattern instructions

PRESSING

After pinning cotton and wool, press very lightly under a damp cloth with a warm iron. Alternatively, hold a steaming iron very close to, but not touching, the knitting. Leave until completely dry. For synthetic yarn, check label instructions.

Stocking and garter stitch

Press or steam each part of the knitting. If pressing, lift up and re-apply the iron since moving it over the surface of the cloth will distort the stitches.

Embossed patterns

Hold a steaming iron or steamer just above the knitting. If you press, use a damp cloth and unpin the piece immediately and lightly pat it into shape so that the texture doesn't become flattened.

Ribbing

If the garment is all ribbing, use minimum pinning so that the ribbing isn't under any tension. If the ribbing is attached to stocking stitch, omit the pins on the ribbing section altogether. After pressing or steaming, immediately unpin the piece and ease the ribbing into its correct shape.

SEAMS

ONCE YOU'VE FINISHED knitting all the pieces of a garment, you have to sew them together. Don't be tempted to rush this process because clumsy seaming can completely ruin beautiful knitting. Seams should be sewn with a blunt-ended tapestry needle and matching yarn. If the garment yarn is not smooth, use plain yarn in a matching or slightly darker colour, making sure the washing instructions are compatible. A ladder-stitch seam is best for straight edges, and can be almost invisible. Backstitch seams make a small ridge inside the garment. If you are joining two pieces of horizontal knitting, use the grafting method.

ORDER OF SEAMING

If given, always follow the assembling instructions included with the pattern. Due to special design features, your pattern instructions may vary slightly from the basic steps listed below:

1 Shoulder seams
2 Set in sleeves (see below)
3 Side and sleeve seams: seam in one continuous line of stitching
4 Collar: sew right side of collar to wrong side of neckline, matching centre back of both pieces
5 Buttonbands
6 Pockets
7 Hems

Backstitch seam

Place the pieces to be joined, right side to right side, carefully matching up the rows of knitting stitch for stitch. Baste together with contrasting yarn. Work backstitch along the seam about 6mm (¼ in) in from edges, sewing into the centre of each stitch and checking that the stitches correspond on both pieces. To work backstitch: bring needle one stitch ahead at starting edge, insert it one stitch back and bring it out one stitch ahead of emerging thread. Repeat to end and remove basting thread.

Ladder-stitch seam

Place the 2 pieces in your left hand, edge to edge, and with the 2 right sides facing you. Match the knitting row by row. Pick up the strand between the first and 2nd stitches on one edge, and then the strand between first and 2nd stitches on the other edge. Take care to match the tension of the knitting.

To set in sleeves

The sleeve cap is often slightly larger than the armhole. The following steps will ensure a good fit. Fold the sleeve in half lengthways and mark the centre cap. Match it to the shoulder seam on the garment and pin in position. Then pin the 2 pieces together at intervals, easing in the sleeve fullness. Sew the sleeve into the armhole.

Grafting

Slip the stitches off the needles; in order to prevent your work from unravelling, press lightly with a steam iron or thread a piece of yarn through the stitches. Place the 2 pieces face up on a padded surface, with the 2 edges to be joined abutting. Thread a tapestry needle with matching yarn; you will need about 3 times the length of the seam to be joined.

Insert needle from back to front through first loop on lower piece. *Insert needle from front to back through first loop on upper piece; then from back to front on 2nd upper loop.

Insert needle from front to back in first lower loop, then from back to front in 2nd lower loop. Repeat from *, always going from front to back through a loop you have already gone through from back to front.

MEASURING UP

IF YOU WANT a new pattern to fit perfectly or if you wish to alter an existing pattern, you will need to take accurate measurements. Then, compare these to the measurements of the garment given at the beginning of the pattern. Most patterns give a body measurement, and a finished measurement of the knitted garment which allows for ease of fit. Compare your own measurements with those given on the pattern. After knitting up a tension sample (page 24), you will have all the information you need to vary the amount of ease, alter measurements, or knit up a pattern in a different stitch.

TAKING MEASUREMENTS

For greatest accuracy, measurements should be taken over underclothes. If you are taking your own measurements, ask somebody else to help you hold the tape measure straight.

Basic body measurements

Armhole: From tip of shoulder bone, down to 2.5cm (1 in) below armpit.
Shoulder length: From base of neck to tip of one shoulder.

Underarm to waist: Measure from 2.5cm (1 in) below armpit to waist.
Sleeve: From 2.5cm (1 in) below armpit to wrist with arm bent. Outer arm, from shoulder tip to wrist.
Overall back length: From base of neck to the required length.

Wrist: Measure around the wristbone.

For a hat

1 Circumference: Measure straight around the head at mid-forehead level.
2 Diameter: Measure across top of head from ear tip to ear tip and then from mid-forehead across top of head to base of skull.

Shoulder width: Measure across back from shoulder tip to shoulder tip (7.5cm (3 in) below base of neck for a child, 12.5cm (5 in) on a woman, 15cm (6 in) on a man).

Chest or bust: Measure straight across the back, under the arms and across the fullest part at front.
Waist: Measure not too tightly around the narrowest part.
Hips: Measure around the broadest part about 22.5cm (9 in) below the waist.

TO ALTER A PATTERN

Knit a sample square to the required tension and count the stitches per 2.5cm (1 in). To make the garment larger across the bust, for example, calculate how many extra centimetres you need. Then, add extra stitches across the width of the front and back to obtain the measurement required. Remember you must allow for complete pattern repeats. If you want to knit up a favorite garment in a different stitch, you need to check that your tension matches that originally given. If it doesn't match, you must either change your needle or make adjustments to the width and length as necessary.

CARING FOR YOUR KNITS

KNITTED GARMENTS CAN be pulled out of shape all too easily during washing and drying. Handle garments gently, particularly when they are wet. Some specially treated wool yarns and many acrylic yarns are machine washable, and most yarns will benefit from a short, fast spin before being laid out flat to dry. Check the instructions on the yarn label first, and, if you are in any doubt, use the method given below.

TROUBLE-SHOOTING

Here are some tips for keeping your knitted garments in great condition:

- Snags should never be cut. Ease the yarn back in position with a blunt tapestry needle, and, if necessary, catch with a few small stitches on the wrong side.
- Some yarns are prone to pilling (tiny balls of fluff caused by rubbing). Lay the garment flat and pick off the balls gently by hand. They may also be removed by brushing lengthways with the edge of a stiff, dry synthetic sponge. A small shaver can also be bought from stores for this purpose.
- The texture of mohair can be improved by brushing very gently with a metal 'teazel'.
- Stains require immediate action. Most will respond to cold water. Dab or soak the area – don't rub. Oil-based stains should be treated with an appropriate solvent on the wrong side, following the manufacturer's instructions. Rinse afterward.

MACHINE WASHING

Use only when indicated on the yarn label. Turn the garment inside out and wash on the appropriate cycle. To avoid stretching, place garment in a loosely tied pillowcase before washing. Then, wash it on the woollen programme. Remove the garment when damp, lay it on a flat surface away from direct heat or sunlight, and pat it into its original shape. Leave until completely dry.

The pillowcase prevents the garment stretching in the machine's drum

HAND WASHING

Large items should be washed separately in lukewarm water, using a mild detergent made especially for knitwear. If you think strong colours will run, wet a corner of the garment and press it on a white cloth. If it makes a stain, use cold water for a few washes.

1 Work in lather by gently squeezing and pressing the knitting up and down. Never rub or twist. Rinse thoroughly with several changes of lukewarm water.

2 Do not wring; squeeze out excess moisture. Then roll in a clean towel to soak up as much moisture as possible; repeat with a second towel if necessary.

3 Spread the article out on a flat surface, away from direct heat, and ease it into its original shape. Leave until completely dry.

STORAGE

Dust can damage knitted garments. To prevent this, store knitwear flat in a cupboard, drawer, or in a container under the bed, not on an open shelf. Always wash your knits before storage. Never hang up knitted garments as their weight will cause them to stretch out of shape.

CROCHET

*B*ig and bold or light and lacy, crochet is a versatile
craft that lends itself to a variety of uses. As tools
and materials are minimal – a single hook and a ball of yarn –
crochet is extremely portable. Like knitting, it is formed from
a continuous length of yarn but only one stitch at a time is
made. By using a large hook and thick yarn, you can create
chunky hats and sweaters. If you choose a thin hook and
fine yarn, a combination of stitches will result in patterns
that rival lace in their delicacy. These patterns work well on
household items, such as bedspreads or to decorate garments.
Easy to work in rows or rings, well-loved patterns include
multicoloured granny squares, which are ideal for using
up scraps of different yarns, and delicate lace medallions,
most often created from finer cotton.
Crochet is an old craft and is practised all around the world.
New stitch patterns are regularly created and each year another
generation of designers rediscovers crochet's appeal. With the
wealth of attractive patterns and yarns available it is not
surprising that crochet has remained such a popular pastime.

HOOKS & YARNS

CROCHET HOOKS COME in different sizes and materials. There are fine steel hooks and larger ones of aluminium, plastic, or wood. Avoid the cheaper plastic versions that may have rough edges. Yarns are sold by weight and/or length. Beginners will find it helpful to choose a smooth yarn in a heavy weight that is not likely to untwist while you work. Generally, the coarser the yarn, the larger the hook needed. Sometimes a hook size is given on the label: use this as a starting point, but it is essential to obtain the tension stated in a pattern (see page 83). Fancy yarns can be worked with a larger hook than a smooth yarn of similar weight. If you are mixing more than one yarn in a garment, check that they share the same care instruction.

YARNS

There are basic standard terms which describe the most popular weights of yarns and some of their suitable uses. These yarns may be made of different numbers of strands spun together, 2-, 3- and 4-ply are all common. There is often an overlap within these terms so the following is a guide:

Fine weight or 2-ply is usually used for lace work and edgings. It is approximately half the thickness of 3-ply, or finer. 3-ply is used for delicate garments and baby wear. Four-ply is middle of the weight range, for sweaters, cardigans, or shawls, and is the standard on which other yarn weights are based.

Double knitting suits chunkier jackets and sweaters, and is equivalent to two strands of 4-ply. Aran weight is equivalent to three strands of 4-ply, and is used for heavy afghans or jackets. Chunky, for warm outdoor garments, is equivalent to four strands of 4-ply or two strands of double knitting.

Fine weight

3-ply

4-ply

Double knitting

Aran

Chunky

HOOKS

Steel and aluminium hooks come in a large range of sizes, but wooden hooks are also popular. Tunisian crochet needs the very long hook shown on the right.

CROCHET HOOK SIZES

Aluminium and plastic hooks

Size	mm
2	7.00
3	6.50
4	6.00
5	5.50
6	5.00
7	4.50
8	4.00
9	3.50
10	3.25
11	3.00
12	2.50
13	2.25
14	2.00

Steel hooks

Size	mm
000	3.00
00	2.50
0	–
1	2.00
1 1/2	1.75
2 1/2	1.50
3	1.25
4	1.00
5	1.00
5 1/2	0.75
6	0.75
6 1/2	0.60
7	0.60

BEGINNING TO CROCHET

CROCHET WORK, like knitting, is created from a continuous length of yarn. However, in crochet a single hook is used to work one stitch at a time. To begin crocheting, you start with a slip knot then continue to make loops (called chains) to form your foundation chain, from which you make your first row. You can hold the hook and yarn as you like, but we show the two most common ways or you can devise a method to suit yourself. The tension of the yarn is controlled with either your middle or forefinger. With practice, you will learn to control the yarn evenly and develop uniform chains.

LEFT-HANDED CROCHETERS

Illustrations show hook and yarn positions of a right-handed person. If you are left-handed, hold the working yarn in your right hand and hold the hook exactly as shown, but in the left hand. If it helps, hold this book in front of a mirror to follow the correct working positions.

Making a slip knot

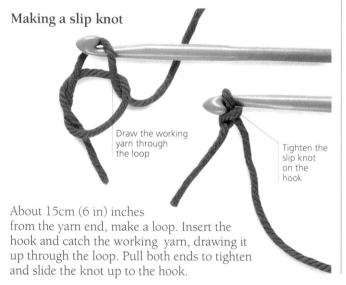

Draw the working yarn through the loop

Tighten the slip knot on the hook

About 15cm (6 in) inches from the yarn end, make a loop. Insert the hook and catch the working yarn, drawing it up through the loop. Pull both ends to tighten and slide the knot up to the hook.

HOLDING THE HOOK

Both methods are equally good, so use whichever feels most comfortable.

Pencil position
Grasp the flat part of the hook between thumb and forefinger as if it were a pencil with the stem above your hand.

Hold the hook as if it were a pencil

Knife position
With the stem against your palm and your thumb on the flat part, grasp the hook between thumb and fingers.

Hold the hook in the knife position

CONTROLLING THE YARN

The way you hold the yarn allows it to flow easily with the right tension. You can wrap the yarn around your little finger, over the next two fingers, and catch it with your forefinger – when your middle finger will control the yarn. Or you can wrap the yarn around your little finger, then under your next two fingers and over your forefinger – when your forefinger will control the yarn. With thick yarn, you can catch it between your fourth and fifth fingers. Use the method that you feel comfortable with.

Forefinger method
Pass working yarn around little finger, under next 2 fingers and over forefinger. With hook through slip loop, and holding slip knot between thumb and middle finger, prepare to make first chain by raising your forefinger.

Middle finger method
Pass working yarn around little finger, and over other fingers. With hook through slip loop, and holding slip knot between thumb and forefinger of your left hand, prepare to make first chain by raising your middle finger.

CHAIN STITCH (CH)

Chain stitch is usually used to form the foundation for the first row in crochet. It is also used as part of a pattern stitch, to make spaces between stitches, for bars in openwork (see page 105), and for the turning chains at the beginnings of rows/rounds (see page 76).

Foundation chain

The foundation chain should be worked loosely and evenly to ensure that the hook can enter each loop easily on the first row. The hook and your tension will determine the size of the chains. Do not try to make them loose by pulling them as you make them, since this tightens up previously made chains. If the chains are too tight, ensure that the yarn is flowing through your fingers easily, or use a larger hook than you will use for the rest of your work. The length of the foundation chain will be specified in the pattern instruction.

Making a chain stitch

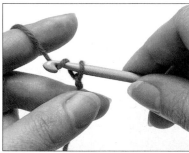

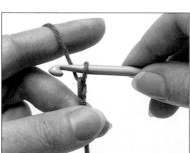

1 Hold hook in your right hand. Keeping working yarn taut, grasp slip knot with thumb and middle finger of your left hand. Push hook forward and take hook under (anti-clockwise), behind and then over yarn, so that yarn passes round hook and is caught in it. This is called yarn round hook – or *yrh*.

2 Draw hook and yarn back through the slip loop to form the first chain stitch.

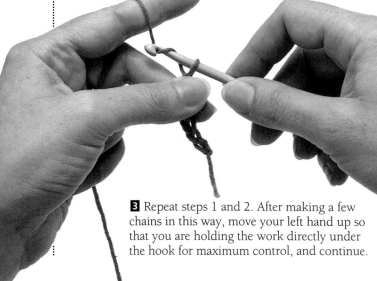

3 Repeat steps 1 and 2. After making a few chains in this way, move your left hand up so that you are holding the work directly under the hook for maximum control, and continue.

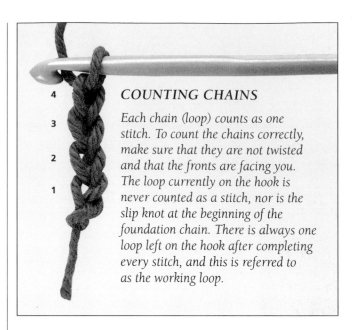

COUNTING CHAINS

Each chain (loop) counts as one stitch. To count the chains correctly, make sure that they are not twisted and that the fronts are facing you. The loop currently on the hook is never counted as a stitch, nor is the slip knot at the beginning of the foundation chain. There is always one loop left on the hook after completing every stitch, and this is referred to as the working loop.

SLIP STITCH (SL ST)

Some of the earliest crochet work found was done in continuous slip stitch or single crochet. However, this stitch is now only used to join a row into a round (see page 98), to decrease (see page 85), and for joining seams (see page 117).

1 Make a length of evenly worked foundation chain.

2 Insert the hook from front to back under the top of the 2nd chain (*ch*) from the hook. Wrap the yarn around the hook (*yrh*).

3 Draw yarn through the 2 loops now on the hook, making a slip stitch. To continue working slip stitch, insert the hook into the next and each chain, and repeat step 2 as required.

BASIC CROCHET STITCHES

IT IS EASY to learn crochet stitches because they are all made in the same way. Apart from the chain and the slip stitch, there are five basic crochet stitches, which vary in height (there are others, but these are used infrequently). The difference in the height or length of these stitches is determined by the number of times the yarn is wrapped around the hook. As each stitch has a flatter appearance on the front than on the back, the crocheted piece has more texture when worked in rows and turned because you see both the fronts and the backs of the stitches. The surface has a smoother, flatter look when worked in rows/rounds without turning, as it always shows the front of the stitches.

DOUBLE CROCHET

This is a simple compact stitch. It is found in many pattern designs and forms a firm, smooth surface.

HALF TREBLE CROCHET

Between double and treble crochet in size, this stitch produces a slightly looser surface with an attractive ridge.

Treble crochet

Half treble crochet

Double crochet

TREBLE CROCHET

Twice as high as double crochet, this stitch works up quickly. It is the most commonly used stitch.

DOUBLE TREBLE CROCHET

Three times as high as double crochet, this stitch forms a looser texture.

Double treble crochet

Triple treble crochet

TRIPLE TREBLE CROCHET

This extremely long stitch is commonly used in fancy stitch patterns, but is not generally used continuously to make a whole piece, except where it is linked (see page 78).

MAKING THE BASIC STITCHES

WHEN YOU ARE working the basic stitches onto the foundation chains, insert the hook from front to back under the top loop of each chain. On subsequent rows, unless instructed otherwise, insert your hook from front to back under the top two loops of each stitch. Turn the work at the end of each row, then make extra chains, called turning chains, to bring the hook level with the height of the stitches in the new row (see page 76). The turning chains may or may not count as stitches at the beginning of a row, according to the pattern. They do count as a stitch in the basic stitch patterns below.

Double crochet (dc)

1 Make a foundation chain. Skip 2 ch and insert hook under top loop of 3rd ch (*right*). Yrh and draw yarn through chain loop only (*far right*).

2 There are 2 loops on the hook. Yrh and draw through both loops.

3 Double crochet made. Continue working dc into the next and all following chains to the end of the row.

4 Turn work and ch 1. This is called the turning chain (t-ch). Skip first st, at base of t-ch, work 1 dc into top 2 loops of 2nd st in previous row. Work 1 dc into next and each st to end, including top of t-ch.

Half treble crochet (htr)

1 Make a length of foundation chain. Skip 2 ch, yrh and insert the hook under top loop of 3rd ch. Yrh.

2 Draw the yarn through the chain loop only; (there are now 3 loops on hook). Yrh.

3 Draw yarn through all 3 loops. Half treble crochet made. Continue working htr into next and all following chs to end of row.

4 To make the next and following rows of htr, turn work and ch 2. This turning chain counts as first htr in new row. Skip first st, which is at base of t-ch. Work 1 htr, inserting hook under top 2 loops of 2nd st in previous row. Work 1 htr into next and each st to end, including into top of t-ch.

Treble crochet (tr)

1 Make a length of foundation chain. Skip 3 ch, yrh and insert the hook under the top loop of the 4th ch. Yrh.

2 Draw yarn through ch loop only (there are now 3 loops on hook). Yrh.

3 Draw yarn through 2 loops only (2 loops on hook). Yrh.

4 Draw yarn through these 2 loops. Treble crochet made. Continue working tr into the next and all following chains to the end of the row.

5 To make next and following rows of tr, turn work and ch 3. This t-ch counts as first tr in new row. Skip first st which is at base of t-ch. Work 1 tr inserting hook under top 2 loops of 2nd st in previous row. Work 1 tr into next and each st to end, including into top of t-ch.

Double treble crochet (dtr)

1 Make a length of foundation chain. Skip 4 ch, yrh twice and insert hook under the top loop of the 5th ch. Yrh.

2 Draw yarn through ch loop only; (there are now 4 loops on hook). Yrh.

3 Draw yarn through 2 loops only; (3 loops on the hook). Yrh.

4 Draw yarn through 2 loops only, yrh again. Draw yarn through remaining 2 loops. Double treble made. Continue working dtr into the next and all following chains to the end of the row.

5 To make next row of dtr, turn work and ch 4. This t-ch counts as first dtr in new row. Skip first st which is at base of t-ch. Work 1 dtr, inserting hook under top 2 loops of 2nd st in previous row. Work 1 dtr into next and each st to end of row, including into t-ch.

Triple treble (ttr)

1 Make a length of foundation chain. Skip 5 ch, yrh 3 times and insert hook under top of the 6th ch, yrh and draw it through the ch loop only; (there are now 5 loops on the hook). *Yrh.

2 Draw yarn through 2 loops only.

3 Repeat from * three times more.

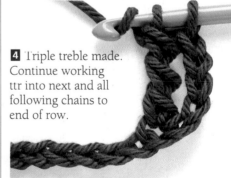

4 Triple treble made. Continue working ttr into next and all following chains to end of row.

5 To make the next and following rows of ttr, turn the work and ch 5. This t-ch counts as the first ttr in the new row. Skip the first st, which is at the base of the t-ch. Work 1 ttr, inserting the hook under the top 2 loops of the 2nd st in the previous row. Work 1 ttr into next and each st to the end of row, including into top of t-ch.

TURNING CHAINS (T-CH)

*To bring the hook up to the height of the stitches, you must add turning chains at the beginning of each row. Each stitch has its own number of chains: the table gives the numbers when the t-ch counts as the first stitch. Sometimes the t-ch may **not** be counted as a stitch (see Straight Edges). Some instructions say ch 2 and turn.*

Stitch	Add to foundation chain	Skip at beginning of foundation row (counts as first st)	For turning chain counts as first st
Double crochet	1	2	1
Half treble	1	2	2
Treble	2	3	3
Double treble	3	4	4
Triple treble	4	5	5
Quad treble	5	6	6

STRAIGHT EDGES

To obtain straight edges and keep the number of stitches constant, you need to make the turning chains in one of two ways. The first is most common, but the second is used with very short stitches, or to avoid the gap created by using the turning chain as a stitch. However, the second method creates slightly uneven edges. The instruction to work "even" in a pattern means to work without any increasing or decreasing.

Turning chain counts as first stitch

Skip the first stitch of the previous row at the base of the turning chain. When you reach the end of the row, work a stitch into the top of the turning chain of the previous row.

Turning chain does not count as stitch

Work into the first stitch at the base of the turning chain. When you reach the end of the row, do not work into the top of the previous turning chain.

WORKING IN ROWS

Crochet is normally worked in rows to produce the desired width, and the work is turned between each row: the right side of the work will not always be facing you.

The first row is made by working across the foundation chain from right to left (if you are left-handed, work from left to right).

At the end of the foundation chain or row, turn the work so that the yarn is behind the hook and the new stitches can be worked into the tops of those in the previous row.

FASTENING OFF

To prevent the work from unravelling when you have finished, it is necessary to fasten the end.

Complete the final stitch, then cut the working yarn and pull it through the last loop on the hook. Pull the yarn tight to close the loop. Thread the working end of the yarn into a tapestry or yarn needle and weave it into the back of the work.

COUNTING STITCHES

To count short stitches, such as double crochet (as shown), it is easier to look at the tops. For longer stitches, count the upright stems – each is counted as a single stitch.

BASIC STITCH VARIATIONS

YOU CAN ACHIEVE interesting textural effects by working the basic stitches, but then inserting the hook into a different part of the work instead of into the top two loops of each stitch. For example, you can work under one top loop at a time, between the stitches, or around the stem of the stitch. All crochet stitches can be worked with these variations, but some produce more interesting effects than others. As well as adding surface texture, these stitches will make a garment thicker and warmer. To begin any of these stitch variations, first make a length of foundation chain and work one row in your chosen stitch.

WORKING UNDER ONE LOOP

By continually working into only the back loop (abbreviated as bl as in bldc), you can create a pattern with a ridged effect. Working into only the front loop (fl) makes a less pronounced ridge with a horizontal line. This technique works well with the shorter stitches, for example double crochet and half treble crochet.

To work into the back loop

From the 2nd row onwards work your chosen crochet stitch normally (for example, htr as shown here), but insert the hook into the back loop of each stitch.

To work into the front loop

From the 2nd row onwards work your chosen crochet stitch normally (for example, dc as shown here), but insert the hook into the front loop only of each stitch.

Stitch worked into back loop

Stitch worked into front loop

WORKING BETWEEN TWO STITCHES

This technique of working between the stitches of the previous row is quick and easy, and produces a slightly thicker fabric with a more open look.

To work between two stitches

From the 2nd row onwards work your chosen crochet stitch normally (for example, tr as shown here), but insert hook between stems and below all horizontal threads connecting stitches.

WORKING SPIKES

Spikes are arrow-shaped loops of yarn on the surface of the work. They are made by inserting the hook lower down than usual, for example, into one or more rows below the previous one (pattern instructions will always specify where).

To make a simple dc spike

Insert hook into base of next stitch (*left*), yrh and draw it through up to height of a dc in this row, (2 loops on hook) (*right*). Yrh and draw it through both loops. Dc spike made.

WORKING AROUND THE STEM (RAISED STITCHES)

A raised effect can be achieved by working around the stems of the stitches in the previous row, either in the front (raised front, abbreviated rf), or in the back (raised back, abbreviated rb). Rows can be worked all in front or all in back, or alternatively one or more stitches around the back then one or more stitches around the front, to produce a large variety of stitch patterns.

To work raised stitches around the front

First work a row of your basic stitch, such as the tr shown here. From 2nd row onwards, make each stitch normally, but insert hook in front and from right to left around stem of stitch below *(right)*.

 A raised stitch worked around the front

To work raised stitches around the back

Work exactly the same as for raised stitches to the front, except insert the hook in back and from right to left around stem of stitch below *(right)*.

The finished stitch worked around the back

WORKING LINKED STITCHES

Longer stitches can be linked to each other down their sides to eliminate the space between the stems of the stitches. This creates an effect as if several rows of shorter stitches had been worked in the same direction at the same time.

To work a linked double treble

1 Insert the hook down through the upper of the 2 horizontal loops around the stem of the last stitch made; yarn round hook.

2 Draw a loop through, insert the hook down through the lower horizontal loop of the same stitch, yrh, draw a loop through. (There are now 3 loops on hook.)

3 Insert hook for next stitch, yrh, draw it through stitch only, [yrh and draw it through 2 loops only] 3 times. Linked dtr made.

To start a row with a linked double treble, treat 2nd *(left)* and 4th chains from the hook as the upper and lower horizontal loops of last stitch made.

FOLLOWING PATTERNS

CROCHET PATTERN INSTRUCTIONS indicate, in abbreviated form, how many and what kind of stitches to work and where to insert the hook. They assume you are familiar with the basic stitches and other procedures and that you understand these abbreviations.

Pattern abbreviations

across	to the end of the row
alt	alternate
approx	approximate(ly)
beg	beginning
bet	between
bl	insert hook under back loop only. Eg. bldc – back loop double crochet
ch(s)	chain or chain stitch(es)
ch sp(s)	chain space(s)
cl	cluster
cont	continue
dc	double crochet
dc2tog	work 2 dc together
dec	decrease
dtr	double treble crochet
dtr2tog	work 2 dtr together
fl	insert hook under front loop only. Eg. fldc – front loop double crochet
foll	following
gr	group
htr	half treble crochet
htr2tog	work 2 htr together
in	inches
in next	sts to be worked into same stitch
inc	increase
lp(s)	loop(s)
nc	not closed (see Clusters, page 102)
patt	pattern
p or pc	picot
rf	raised front. Eg. rfdc – raised front double crochet
rb	raised back. Eg. rbdc – raised back double crochet
rem	remaining
rep	repeat
rnd	round
sk	skip
sl st	slip stitch
sp(s)	space(s)
st(s)	stitch(es)
t-ch(s)	turning chain(s)
tog	together
tr	treble crochet
tr2tog	work 2 tr together
ttr	triple treble crochet
ttr2tog	work 2 ttr together
yrh	yarn round hook
*	Work instructions immediately following *, then repeat as directed, (see Repeats)
[]	Work or repeat all instructions enclosed in brackets as directed immediately after, (see Repeats)

Unless otherwise specified:
• Do not turn the work at the end of a row/round.
• Always count the turning chain as a stitch (see page 76).
• Work into the next available stitch in the previous row.
• Always insert the hook under both top loops of a stitch, unless it is a chain space or loop.
• The instruction, *1 dc*, means work one double crochet into next sitch, and *5 tr,* work 1 tr into each of next 5 sts.
• For a cluster, the instruction *tr3tog*, or *dtr5tog*, means that each stitch is worked into a separate stitch, before joining.
• If all parts of the cluster are to be worked into the next stitch, the instruction would say *tr5tog in next*.

Multiples
In the stitch glossaries the pattern gives the number of stitches required in the row and the number of chains to work for the foundation chain in this way: *Multiple of 5 sts plus 2, plus 2 for foundation ch*. This means make 9, 14, 19, etc, chains in order to work with 7, 12, 17, etc. stitches.

Brackets [] or parentheses ()
These are used in three distinct ways:
• To simplify repetition – see Repeats.
• To indicate at the end of a row/round the total number of stitches that have been worked in that row/round. For example, *(24 dc)* means that the row/round counts as 24 double crochet stitches.
• To give information about different sizes.

Right side/wrong side (RS/WS)
Even if a crochet pattern is reversible it is usual to define a right side. When working in the round, the right side is normally facing you. Where the work is turned between rows, instructions specify the first right side row. If you are directed to keep the right side facing you when working rows, fasten off at the end of each row and rejoin the yarn.

Repeats
Instructions within brackets are worked the number of times stated, for example *[ch 1, skip 1 ch, 1 tr] 5 times*. A single asterisk marks the beginning of a pattern repeat sequence. For example **ch 1, skip 1 ch, 1 dc; rep from * across*. A double asterisk indicates a smaller repeat in the main repeat sequence. The instruction: *rep from * to last st* means work complete repeats until only one stitch remains.

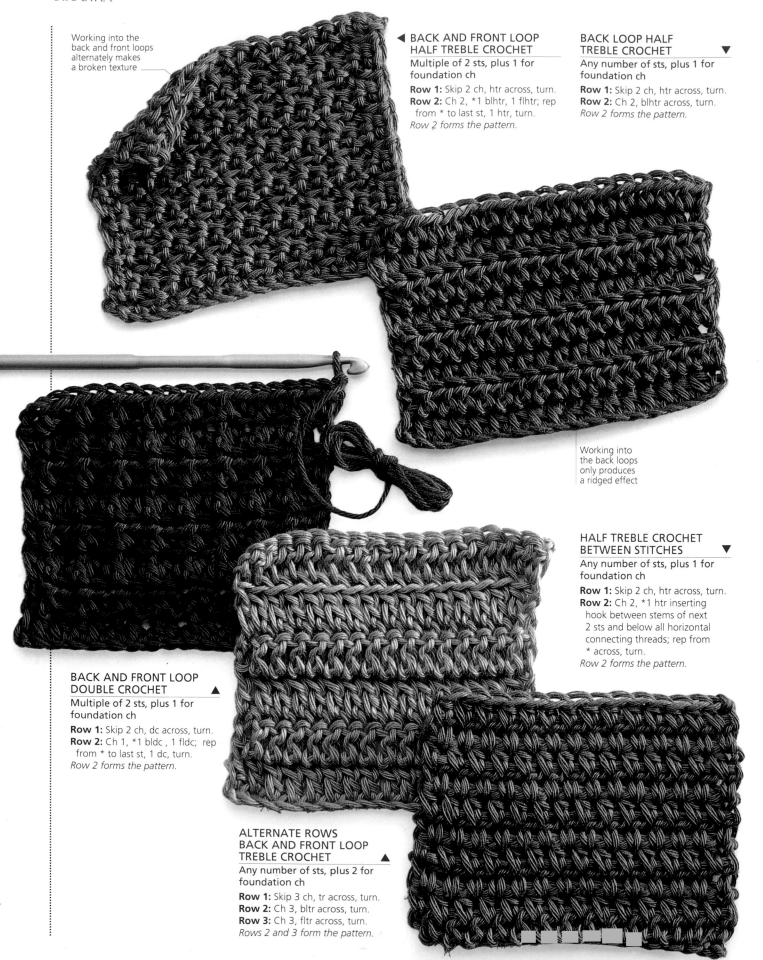

Working into the back and front loops alternately makes a broken texture

◄ BACK AND FRONT LOOP HALF TREBLE CROCHET

Multiple of 2 sts, plus 1 for foundation ch

Row 1: Skip 2 ch, htr across, turn.
Row 2: Ch 2, *1 blhtr, 1 flhtr; rep from * to last st, 1 htr, turn.
Row 2 forms the pattern.

BACK LOOP HALF TREBLE CROCHET ▼

Any number of sts, plus 1 for foundation ch

Row 1: Skip 2 ch, htr across, turn.
Row 2: Ch 2, blhtr across, turn.
Row 2 forms the pattern.

Working into the back loops only produces a ridged effect

HALF TREBLE CROCHET BETWEEN STITCHES ▼

Any number of sts, plus 1 for foundation ch

Row 1: Skip 2 ch, htr across, turn.
Row 2: Ch 2, *1 htr inserting hook between stems of next 2 sts and below all horizontal connecting threads; rep from * across, turn.
Row 2 forms the pattern.

BACK AND FRONT LOOP DOUBLE CROCHET ▲

Multiple of 2 sts, plus 1 for foundation ch

Row 1: Skip 2 ch, dc across, turn.
Row 2: Ch 1, *1 bldc , 1 fldc; rep from * to last st, 1 dc, turn.
Row 2 forms the pattern.

ALTERNATE ROWS BACK AND FRONT LOOP TREBLE CROCHET ▲

Any number of sts, plus 2 for foundation ch

Row 1: Skip 3 ch, tr across, turn.
Row 2: Ch 3, bltr across, turn.
Row 3: Ch 3, fltr across, turn.
Rows 2 and 3 form the pattern.

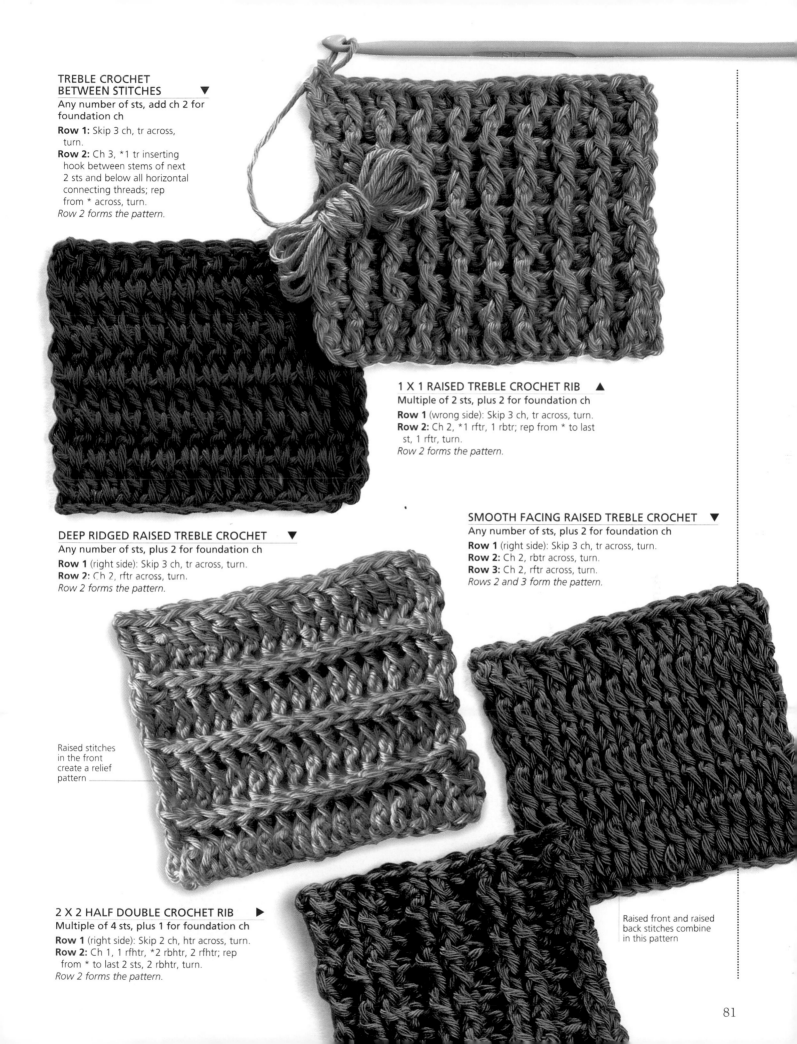

TREBLE CROCHET BETWEEN STITCHES ▼

Any number of sts, add ch 2 for foundation ch

Row 1: Skip 3 ch, tr across, turn.

Row 2: Ch 3, *1 tr inserting hook between stems of next 2 sts and below all horizontal connecting threads; rep from * across, turn.

Row 2 forms the pattern.

1 X 1 RAISED TREBLE CROCHET RIB ▲

Multiple of 2 sts, plus 2 for foundation ch

Row 1 (wrong side): Skip 3 ch, tr across, turn.

Row 2: Ch 2, *1 rftr, 1 rbtr; rep from * to last st, 1 rftr, turn.

Row 2 forms the pattern.

DEEP RIDGED RAISED TREBLE CROCHET ▼

Any number of sts, plus 2 for foundation ch

Row 1 (right side): Skip 3 ch, tr across, turn.

Row 2: Ch 2, rftr across, turn.

Row 2 forms the pattern.

Raised stitches in the front create a relief pattern

SMOOTH FACING RAISED TREBLE CROCHET ▼

Any number of sts, plus 2 for foundation ch

Row 1 (right side): Skip 3 ch, tr across, turn.

Row 2: Ch 2, rbtr across, turn.

Row 3: Ch 2, rftr across, turn.

Rows 2 and 3 form the pattern.

2 X 2 HALF DOUBLE CROCHET RIB ▶

Multiple of 4 sts, plus 1 for foundation ch

Row 1 (right side): Skip 2 ch, htr across, turn.

Row 2: Ch 1, 1 rfhtr, *2 rbhtr, 2 rfhtr; rep from * to last 2 sts, 2 rbhtr, turn.

Row 2 forms the pattern.

Raised front and raised back stitches combine in this pattern

81

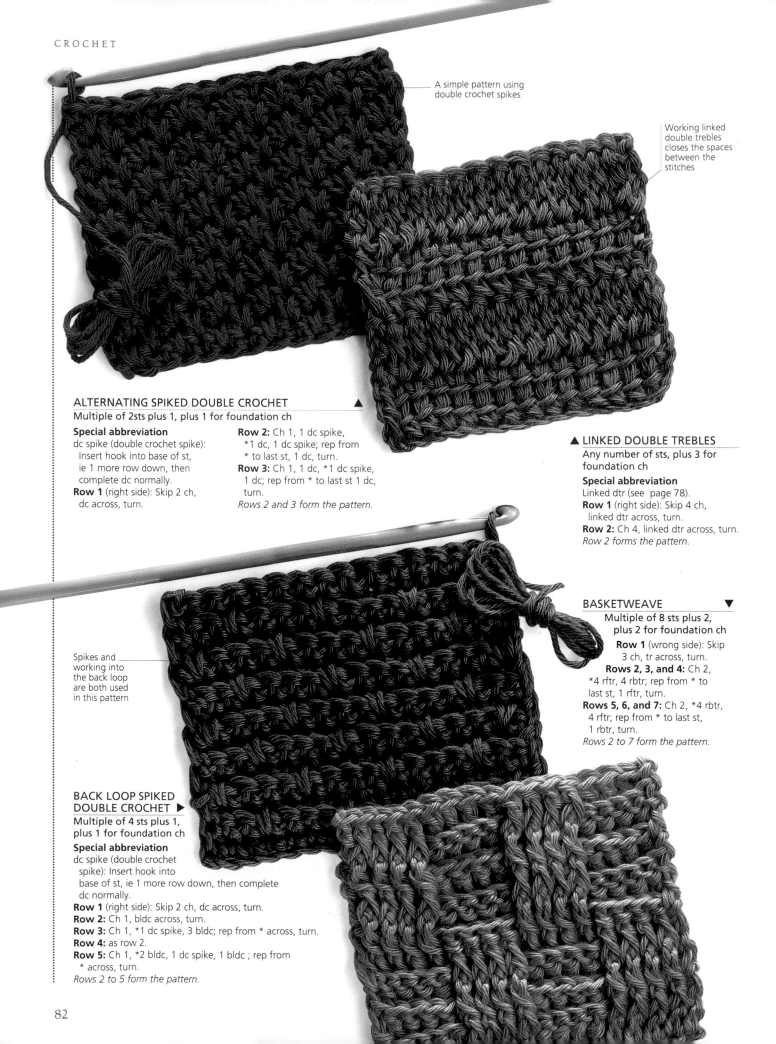

A simple pattern using double crochet spikes

Working linked double trebles closes the spaces between the stitches

ALTERNATING SPIKED DOUBLE CROCHET ▲
Multiple of 2sts plus 1, plus 1 for foundation ch

Special abbreviation
dc spike (double crochet spike): Insert hook into base of st, ie 1 more row down, then complete dc normally.
Row 1 (right side): Skip 2 ch, dc across, turn.

Row 2: Ch 1, 1 dc spike, *1 dc, 1 dc spike; rep from * to last st, 1 dc, turn.
Row 3: Ch 1, 1 dc, *1 dc spike, 1 dc; rep from * to last st 1 dc, turn.
Rows 2 and 3 form the pattern.

▲ LINKED DOUBLE TREBLES
Any number of sts, plus 3 for foundation ch
Special abbreviation
Linked dtr (see page 78).
Row 1 (right side): Skip 4 ch, linked dtr across, turn.
Row 2: Ch 4, linked dtr across, turn.
Row 2 forms the pattern.

BASKETWEAVE ▼
Multiple of 8 sts plus 2, plus 2 for foundation ch
Row 1 (wrong side): Skip 3 ch, tr across, turn.
Rows 2, 3, and 4: Ch 2, *4 rftr, 4 rbtr; rep from * to last st, 1 rftr, turn.
Rows 5, 6, and 7: Ch 2, *4 rbtr, 4 rftr; rep from * to last st, 1 rbtr, turn.
Rows 2 to 7 form the pattern.

Spikes and working into the back loop are both used in this pattern

BACK LOOP SPIKED DOUBLE CROCHET ▶
Multiple of 4 sts plus 1, plus 1 for foundation ch

Special abbreviation
dc spike (double crochet spike): Insert hook into base of st, ie 1 more row down, then complete dc normally.
Row 1 (right side): Skip 2 ch, dc across, turn.
Row 2: Ch 1, bldc across, turn.
Row 3: Ch 1, *1 dc spike, 3 bldc; rep from * across, turn.
Row 4: as row 2.
Row 5: Ch 1, *2 bldc, 1 dc spike, 1 bldc ; rep from * across, turn.
Rows 2 to 5 form the pattern.

TENSION

THE NUMBER OF stitches and rows required to make a piece of crochet of a specific size depends upon four things: the yarn, the hook size, the stitch pattern, and the individual crocheter. The tension is given at the beginning of every crochet pattern. This indicates the number of stitches and rows in a particular measure, and the entire design is based around this. To achieve the best results, you **must** follow the tension. But since crochet is a true hand craft, each person's work will be slightly different. Before beginning a project, make a swatch to ensure that your tension matches that given. If you want to change the yarn or the stitch pattern, you can usually do so as long as you make sure you can still match the tension.

CHECKING THE TENSION

Using the weight of yarn, hook size, and stitch pattern given with the instructions, crochet a sample at least 10cm (4 in) square. Place the finished sample right side up on a flat surface, taking care not to stretch it out of shape.

Measuring stitches

Lay your ruler across the sample at the bottom of a row of stitches. Insert 2 pins vertically 2.5cm (1 in) apart. Count the number of stitches between the pins. If a pin falls in the middle of a stitch, measure 5cm (2 in).

Measuring rows
Now turn your ruler vertically and lay it along one side of a column of stitches. Avoiding the edges, place pins horizontally 10cm (4 in) apart. Count the rows between the pins. If a pin falls in the middle of a row, measure 5cm (2 in).

MAKING ADJUSTMENTS

If your tension does not correspond with that given in the instructions, change to a bigger or smaller hook and crochet another sample. Fewer stitches and rows than indicated means your work is too loose and you should try a smaller hook. More stitches and rows than shown means it is too tight and you should try a larger hook. Occasionally you may find it impossible to match the tension of both stitches and rows at the same time, in which case you should match the tension and compensate by working more or fewer rows.

THE EFFECT OF YARNS AND PATTERNS

Weight of yarn and stitch pattern affect tension, so always work a sample before altering written instructions. Fine yarn will work with more stitches to the inch than heavier yarn, as will yarn worked with a smaller hook.

A thick yarn and a finer yarn worked on the same hook size will result in different numbers of stitches per cm

The same yarn and stitch worked on different size hooks will work up to a different tension

Different stitch patterns worked with the same hook and yarn will also produce different numbers of stitches per cm

INCREASING

MANY CROCHET ITEMS are made of rectangles worked evenly throughout (see page 76). There are times, however, when it is necessary to shape your work. To widen the fabric, you increase or add stitches. This may be done at the beginning and/or the end of a row, or at one or more places within a row.

WORKING SINGLE INCREASES

When it is necessary to increase by a single stitch, the simplest way is to work twice into the same stitch.

At the beginning of a row

When the turning chain counts as a stitch (*see page 76*), use one of these methods. Skip the first st as usual and work 2 sts into the 2nd st, or work 1 st into the first st that you usually skip.

At the end of a row

Work 2 sts into the last st (this will be the turning chain, if it counts as a st).

REPEATED SINGLE INCREASES

When you are making single increases one above another, work each subsequent pair into either the first or second of the previous pair consistently, so as to maintain vertical lines of increase. To slant them to the right on a right side row, work each increase pair into the first of the previous pair; to slant them to the left, work them into the second.

Across a row

Mark the position for each increase. Pattern instructions usually tell you exactly where to place these, but if not, spread them evenly. Work 2 stitches into each marked stitch.

MULTIPLE INCREASES

To increase by more than two stitches at the edge, make additional chain sts. The method is the same for all the basic stitches. Here the turning-chain counts as a st. When several stitches at once are made at an edge, a sharp angle is created.

At the beginning of a row

Add the the number of increases needed to the number of turning-chains being used. For example, if you are working trebles (tr), which need 2 t-ch, and want to add 5 sts, you will need to work 7 ch. Skip 3 ch (counts as 1 tr) and work 1 tr into each of the remaining 4 new ch sts, making 5 new sts, including turning-chain.

At the end of a row

To make the first additional stitch, insert the hook through the lower part of the last stitch made, picking up the single, vertical thread on its left-hand side. Continue inserting the hook into the base of the stitch just completed to work the required number of additional stitches.

DECREASING

IT MAY BE necessary to shape your crochet work by subtracting stitches; these decreases may be made at the beginning and/or the end of a row, or at set at various places within the row. You can also narrow your work by skipping one or more stitches, but this method may leave holes. Unless you want to create holes as a decorative effect, it is preferable to decrease by crocheting two or more stitches together.

REPEATED SINGLE DECREASES

When working single decreases one above another in mid row, work consistently either the first or the second part of the decrease cluster into the top of the previous cluster so as to maintain vertical lines of decrease. (See Repeated Single Increases, page 84.)

MULTIPLE DECREASES

To decrease more than two or three stitches, work multiple decreases at the ends of rows. The t-ch counts as a stitch. This method creates a sharp angle. Treble crochet (tr) is shown here, but the method is the same for all basic stitches

At the beginning of a row

Work slip st over each st to be subtracted. Then, make the required number of turning chains to form a new edge st and continue the row in pattern from there.

At the end of a row

Work in pattern until you reach the stitches to be decreased. Leave these sts unworked, turn and make the t-ch for the first st of the next row.

WORKING STITCHES TOGETHER AS ONE (STITCH CLUSTER)

To decrease 1, 2, 3, sts. etc. work 2, 3, 4, sts. etc. together. At the beginning of a row, when the t-ch counts as first st, work the 2nd and 3rd sts together to make a single decrease and the 2nd, 3rd, and 4th together to make a double decrease.

At the end of a row

Work the last 2, 3, or 4 sts together. In mid row work 1, 2, or 3 consecutive sts together in the appropriate positions (*see also Increasing and Repeated Single Decreases*).

At the beginning of a row
Double crochet

Single decrease (dc2tog): Make 1 ch (counts as 1 dc), skip first st, *insert hook into 2nd st, yrh and draw through**; rep from *once more into 3rd st (3 loops on hook), ending yrh and draw through all loops – single decrease made. Double decrease (dc3tog): Work as for single decrease from *, but rep from * to ** once more into 4th st (4 loops on hook) before ending.

Half treble crochet

Single decrease (htr2tog): Make 2 ch (counts as 1 htr), skip first st, *yrh, insert hook into next (2nd) st, yrh and draw through**; rep from * once more into next (3rd) st (5 loops on hook), ending yrh and draw through all loops – single decrease made. Double decrease (htr3tog): Work as for single decrease from *, but rep from * to ** once more into next (4th) st (7 loops on hook) before ending.

Treble crochet

Single decrease (tr2tog): Make 3 ch (counts as 1 tr), skip first st, *yrh, insert hook into next (2nd) st, yrh and draw through, yrh and draw through 2 loops only**; rep from * once more into next (3rd) st (3 loops on hook), ending yrh and draw through all loops – single decrease made. Double decrease (tr3tog): Work as for single decrease from *, but rep from * to ** once more into next (4th) st (4 loops on hook) before ending.

Double treble crochet

The method is the same for longer crochet stitches, such as double treble crochet.

Making a single decrease in double treble crochet

WORKING WITH COLOUR

COLOURED YARNS ARE used to create stripes, geometric patterns, and simple pictures in sharp contrasts or subtle gradations. Crochet stitches are generally larger and more varied than knitted ones and are perfect for overlapped and relief effects as well as variegated row structures. These stitches are best used for their own unique character, boldly and with imagination. Single yarns may be used, or strands of more than one giving both variegated colour and additional warmth. Yarns may be plain colour, two-tone, or patterned in different ways – heather mixtures, mottled or multicoloured yarns.

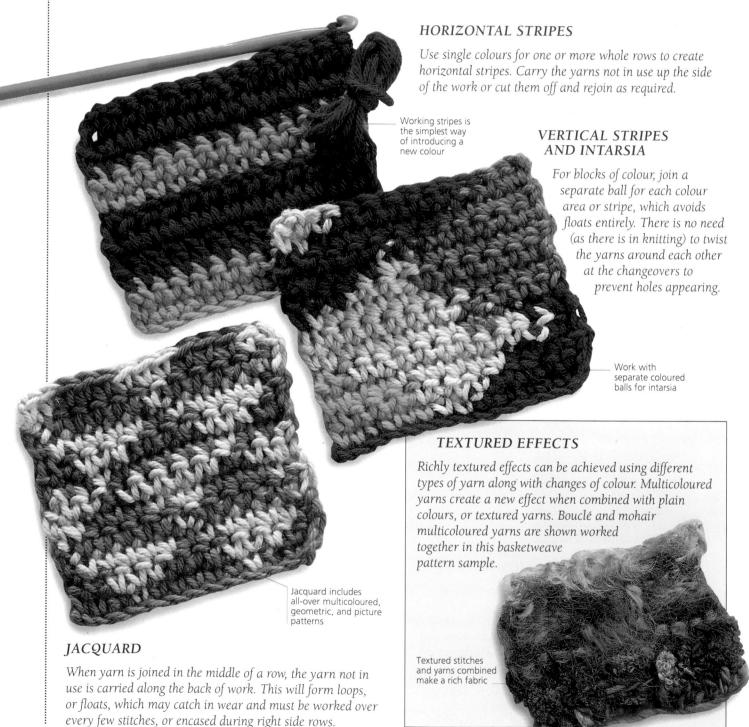

HORIZONTAL STRIPES

Use single colours for one or more whole rows to create horizontal stripes. Carry the yarns not in use up the side of the work or cut them off and rejoin as required.

Working stripes is the simplest way of introducing a new colour

VERTICAL STRIPES AND INTARSIA

For blocks of colour, join a separate ball for each colour area or stripe, which avoids floats entirely. There is no need (as there is in knitting) to twist the yarns around each other at the changeovers to prevent holes appearing.

Work with separate coloured balls for intarsia

TEXTURED EFFECTS

Richly textured effects can be achieved using different types of yarn along with changes of colour. Multicoloured yarns create a new effect when combined with plain colours, or textured yarns. Bouclé and mohair multicoloured yarns are shown worked together in this basketweave pattern sample.

Jacquard includes all-over multicoloured, geometric, and picture patterns

Textured stitches and yarns combined make a rich fabric

JACQUARD

When yarn is joined in the middle of a row, the yarn not in use is carried along the back of work. This will form loops, or floats, which may catch in wear and must be worked over every few stitches, or encased during right side rows.

YARN ENDS

Provided you can do so without interfering with the visual effect, it is advisable to work over yarn ends whenever possible. Remember that all stray ends must finally be woven into the wrong side.

CHARTS

Most multicolour patterns are presented in the form of graphs, in which each square corresponds to one stitch – normally double crochet, since it is the smallest, squarest stitch. There are two main rules for following colour chart grids: always change to next colour required just before you complete the previous stitch and follow odd-numbered rows from right to left and even-numbered from left to right (chart always represents right side of the work).

JOINING NEW YARN

When working horizontal stripes, change to the new yarn at the end of the row just before completing the last stitch. This way, the new colour is ready to work the turning chain. When working in the round, work the last stitch with the old colour and use the new colour to make the joining slip stitch.

1 Just before you pick up for the last time to make the last stitch with the old colour, drop the old yarn and pick up the new yarn.

2 Draw new yarn through to complete the old stitch – the working loop is now ready in the new colour. This sample is in tr, but the same principle applies to all other stitches.

Before working the next stitch, make sure old yarn is kept to the wrong side of the work, or carried along the tops of the next few stitches so that it will become encased.

CHANGING YARN

Change the yarns as for joining, just before you complete the last stitch with the old colour. Draw up the float in the new colour evenly, making sure the old yarn is appropriately positioned. Double crochet is illustrated here, but the same principle applies to all other basic stitches.

RE-JOINING YARN

Occasionally you will need to join yarn into a piece of crochet that has been fastened off, in order to make a fresh start.

Insert the hook into the appropriate place. Start with a slip knot (or a simple loop, if you prefer) and draw this through. Make the appropriate turning chain for the first new stitch (ch 3 for 1 tr shown here).

FLOATS

To help the tension of floats be more even, catch them into the work every few stitches. When finished, cut in half any unacceptably long float threads and weave them in.

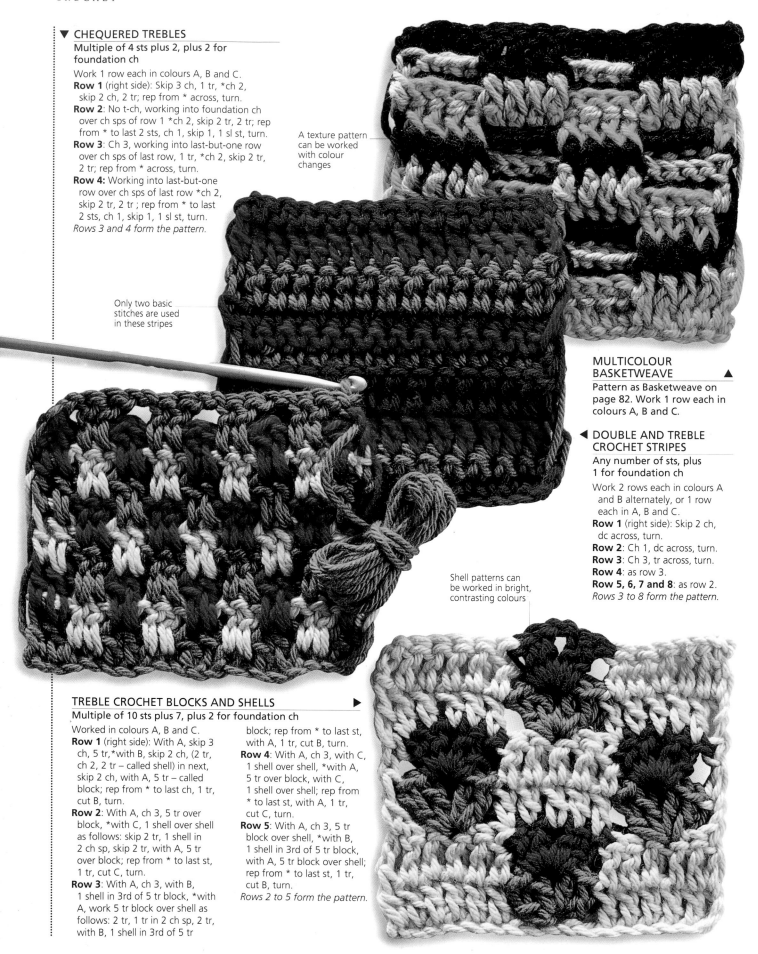

▼ CHEQUERED TREBLES

Multiple of 4 sts plus 2, plus 2 for foundation ch

Work 1 row each in colours A, B and C.

Row 1 (right side): Skip 3 ch, 1 tr, *ch 2, skip 2 ch, 2 tr; rep from * across, turn.

Row 2: No t-ch, working into foundation ch over ch sps of row 1 *ch 2, skip 2 tr, 2 tr; rep from * to last 2 sts, ch 1, skip 1, 1 sl st, turn.

Row 3: Ch 3, working into last-but-one row over ch sps of last row, 1 tr, *ch 2, skip 2 tr, 2 tr; rep from * across, turn.

Row 4: Working into last-but-one row over ch sps of last row *ch 2, skip 2 tr, 2 tr ; rep from * to last 2 sts, ch 1, skip 1, 1 sl st, turn.

Rows 3 and 4 form the pattern.

A texture pattern can be worked with colour changes

Only two basic stitches are used in these stripes

MULTICOLOUR BASKETWEAVE ▲

Pattern as Basketweave on page 82. Work 1 row each in colours A, B and C.

◄ DOUBLE AND TREBLE CROCHET STRIPES

Any number of sts, plus 1 for foundation ch

Work 2 rows each in colours A and B alternately, or 1 row each in A, B and C.

Row 1 (right side): Skip 2 ch, dc across, turn.

Row 2: Ch 1, dc across, turn.

Row 3: Ch 3, tr across, turn.

Row 4: as row 3.

Row 5, 6, 7 and 8: as row 2.

Rows 3 to 8 form the pattern.

Shell patterns can be worked in bright, contrasting colours

TREBLE CROCHET BLOCKS AND SHELLS ▶

Multiple of 10 sts plus 7, plus 2 for foundation ch

Worked in colours A, B and C.

Row 1 (right side): With A, skip 3 ch, 5 tr,*with B, skip 2 ch, (2 tr, ch 2, 2 tr – called shell) in next, skip 2 ch, with A, 5 tr – called block; rep from * to last ch, 1 tr, cut B, turn.

Row 2: With A, ch 3, 5 tr over block, *with C, 1 shell over shell as follows: skip 2 tr, 1 shell in 2 ch sp, skip 2 tr, with A, 5 tr over block; rep from * to last st, 1 tr, cut C, turn.

Row 3: With A, ch 3, with B, 1 shell in 3rd of 5 tr block, *with A, work 5 tr block over shell as follows: 2 tr, 1 tr in 2 ch sp, 2 tr, with B, 1 shell in 3rd of 5 tr block; rep from * to last st, with A, 1 tr, cut B, turn.

Row 4: With A, ch 3, with C, 1 shell over shell, *with A, 5 tr over block, with C, 1 shell over shell; rep from * to last st, with A, 1 tr, cut C, turn.

Row 5: With A, ch 3, 5 tr block over shell, *with B, 1 shell in 3rd of 5 tr block, with A, 5 tr block over shell; rep from * to last st, 1 tr, cut B, turn.

Rows 2 to 5 form the pattern.

DOUBLE CROCHET AND SPIKE CLUSTERS ▼

Multiple of 8 sts plus 5, plus 1 for foundation ch

Special Abbreviation

spcl (spike cluster): Over next st pick up 5 spike loops by inserting hook as follows: 2 sts to right and 1 row down; 1 st to right and 2 rows down; directly over next st and 3 rows down; 1st to left and 2 rows down; 2 sts to left and 1 row down, (6 loops on hook); insert hook into top of next st in current row itself, yrh, draw loop through, yrh drawn through all 7 loops on hook.

Work 4 rows each in colours A, B and C throughout.

Note: T-ch does not count as a stitch.

Row 1 (right side): Skip 1 ch, dc across, turn.

Row 2: Ch 1, dc across, turn.

Rows 3 and 4: as row 2.

Row 5: Ch 1, 4 dc, *1 spcl, 7 dc; rep from * to last st, 1 dc, turn.

Rows 6 to 8: as row 2.

Rows 5 to 8 form the pattern.

INTERLOCKING TREBLE SHELLS ▼

Multiple of 6 sts plus 1, plus 1 for foundation ch

Work 1 row each in colours A, B and C.

Row 1 (right side): Skip 1 ch, 1 dc, *skip 2 ch, 5 tr in next – called shell, skip 2 ch, 1 dc; rep from * across, turn.

Row 2: Ch 3, 2 tr in first st, *1 dc in 3rd tr of shell, 1 shell in dc; rep from * to last shell, 1 dc in 3rd tr of shell, 3 tr in dc, turn.

Row 3: Ch 1, *1 shell in dc, 1 dc in 3rd tr of shell; rep from * across with last dc in t-ch, turn.

Rows 2 and 3 form the pattern.

ALTERNATING RELIEF STITCH ▲

Multiple of 2 sts plus 1, plus 2 for foundation ch

Work 1 row each in colours A, B and C.

Row 1 (right side): Skip 3 ch, tr across, turn.

Row 2: Ch 3, *1 rfdtr, 1 tr; rep from * across, turn.

Row 2 forms the pattern.

Shells in stripes of colours make an attractive pattern

The reverse of this pattern also makes an interesting right side

INSET FLOWER BUDS ▶

Multiple of 10 sts plus 3, plus 2 for foundation ch

Worked with colour A and with B and C for the flower buds.

Row 1 (right side): With A, skip 3 ch, 2 tr, *ch 3, skip 3 ch, 1 dc, ch 3, skip 3 ch, 3 tr; rep from * across, turn.

Row 2: Ch 2, 2rbtr, *ch 3, skip 3 ch, 1 dc in dc, ch 3, skip 3 ch, 3 rbtr; rep from * across, turn.

Row 3: Ch 2, 2 rftr, *ch 1, skip 3 ch, 5 tr in dc, ch 1, skip 3 ch, 3 rftr; rep from * across. Do not turn but work flower buds in B and C alternately over each group of 5 tr thus: ch 3, tr4tog, ch 1. Fasten off – flowerbud completed. Turn.

Row 4: With A, ch 3, 2 rbdtr, *ch 3, 1 dc in ch at top of flowerbud, ch 3, skip 1 ch, 3 rbdtr; rep from * across, turn.

Row 5: as row 2.

Rows 2 to 5 form the pattern.

GO FOR COLOUR

THERE ARE MYRIAD possibilities for using coloured yarn, whether you choose to make traditional granny squares in rainbow colours, or bright, geometric patterns. Left-over pieces of yarn are ideal for making attractive and handy accessories. (See pages 233 to 237.)

MULTICOLOURED GRANNY JACKET

This granny-square wrap cardigan has everlasting appeal. Crochet it square-by-square and join together.

The shawl collar is worked separately

A tiny crocheted heart can be worn as a locket

Bright and cheerful motifs are easily made by working in the round

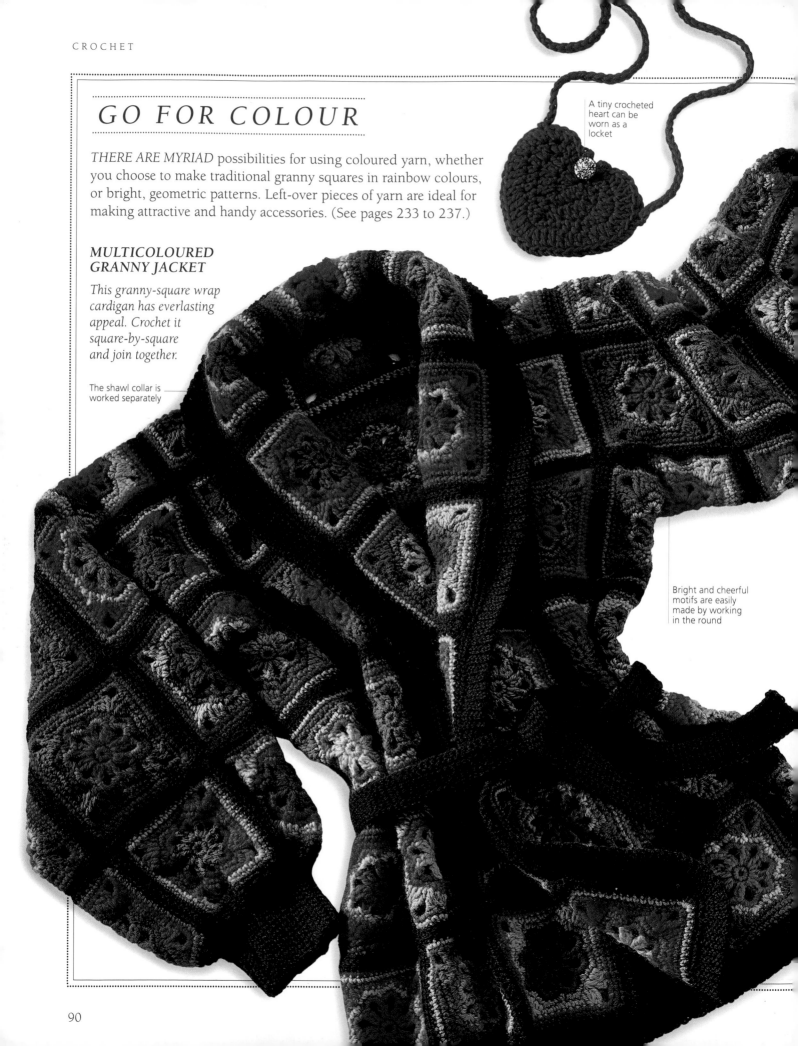

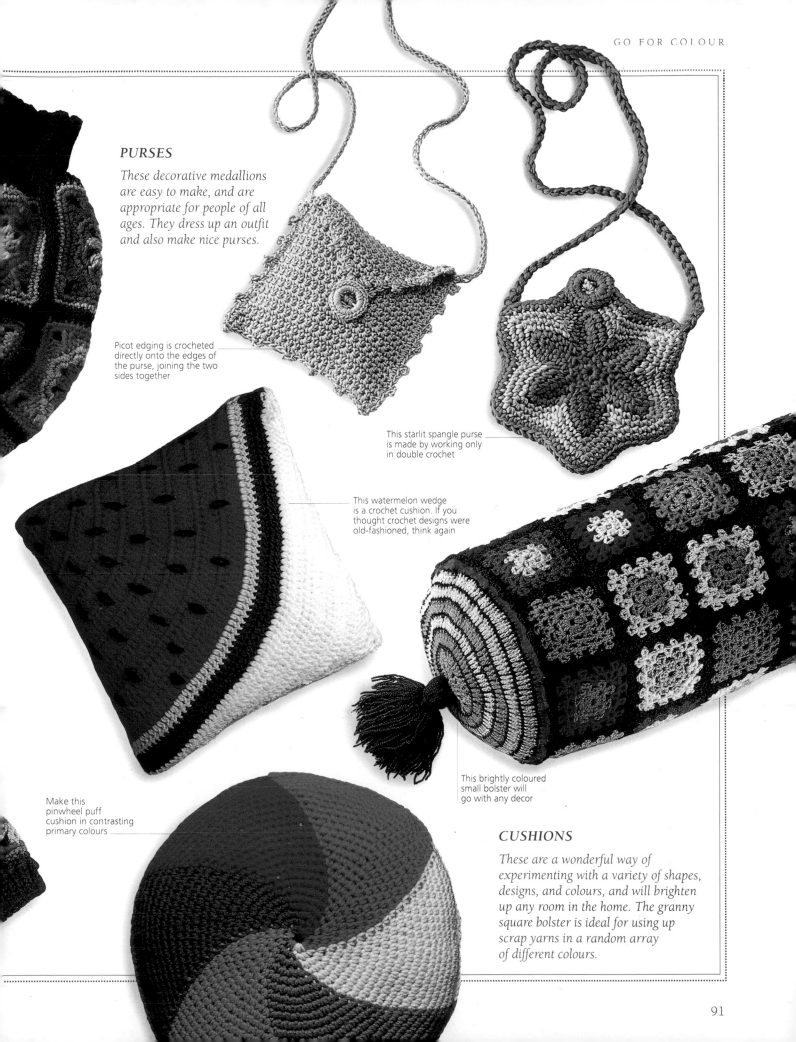

PURSES

These decorative medallions are easy to make, and are appropriate for people of all ages. They dress up an outfit and also make nice purses.

Picot edging is crocheted directly onto the edges of the purse, joining the two sides together

This starlit spangle purse is made by working only in double crochet

This watermelon wedge is a crochet cushion. If you thought crochet designs were old-fashioned, think again

Make this pinwheel puff cushion in contrasting primary colours

This brightly coloured small bolster will go with any decor

CUSHIONS

These are a wonderful way of experimenting with a variety of shapes, designs, and colours, and will brighten up any room in the home. The granny square bolster is ideal for using up scrap yarns in a random array of different colours.

MORE STITCH VARIATIONS

ONE OF THE great strengths of crochet is the versatility of the stitches. Change the height of your stitches from row to row, and you will see many different textures and stripe widths. Within a row, stitches of different heights will produce wave shapes and surface texture. Additional texture can be achieved by crossing stitches to produce a cable effect, or working them into different places. Making long stitches – reaching down below the level of the previous row and picking up around the stem – results in raised surface stitches, which are particularly striking when made in contrasting colours.

Simple crossed stitch

1 To make a pair of simple crossed stitches (tr shown here), first skip 1 and work 1 tr into next stitch (*left*). Then work 1 tr, inserting hook into previous skipped stitch (*right*).

2 The crossed tr wraps up and encases previous tr. (*See page 93, Crossed Double Crochet.*)

Cable crossed stitch (back)

1 To begin cable, first skip 3 sts and then work 3 ttr normally (shown here worked on tr).

2 With hook behind sts, insert it from front. Work 1 ttr into each of 3 skipped sts.

Cable crossed stitch (front)

Work entirely in front of the previous stitches (holding them aside at back if necessary) after inserting hook so as not to encase the stitches, as in Simple Crossed Stitch (*left*).

RAISED SURFACE STITCHES

*There are many variations of raised surface stitches, but they are all made in a similar way. The method shown left involves skipping stitches in the background fabric and working around the stem. The surface stitches must be longer than the background stitches. When skipping a stitch would result in a hole, work the raised surface stitch **together with** the background stitch, like a decrease cluster (see page 85). In this typical example the background is made with alternate rows of dc and tr.*

Skip sts in dc row and work raised surface sts in dtr around stem of chosen stitch. Work at front, alternately a few sts to left and then to right, inserting hook from right to left.

Leaving last loop of each stitch on hook, work raised surface stitch, then background dc (there are now 3 loops on hook). Yrh and draw through all loops to complete cluster.

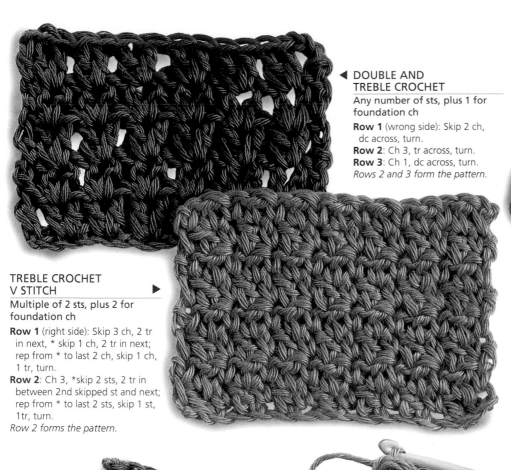

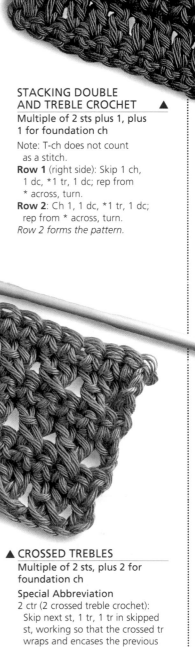

DOUBLE AND TREBLE CROCHET

Any number of sts, plus 1 for foundation ch

Row 1 (wrong side): Skip 2 ch, dc across, turn.
Row 2: Ch 3, tr across, turn.
Row 3: Ch 1, dc across, turn.
Rows 2 and 3 form the pattern.

TREBLE CROCHET V STITCH ▶

Multiple of 2 sts, plus 2 for foundation ch

Row 1 (right side): Skip 3 ch, 2 tr in next, * skip 1 ch, 2 tr in next; rep from * to last 2 ch, skip 1 ch, 1 tr, turn.
Row 2: Ch 3, *skip 2 sts, 2 tr in between 2nd skipped st and next; rep from * to last 2 sts, skip 1 st, 1tr, turn.
Row 2 forms the pattern.

STACKING DOUBLE AND TREBLE CROCHET ▲

Multiple of 2 sts plus 1, plus 1 for foundation ch

Note: T-ch does not count as a stitch.
Row 1 (right side): Skip 1 ch, 1 dc, *1 tr, 1 dc; rep from * across, turn.
Row 2: Ch 1, 1 dc, *1 tr, 1 dc; rep from * across, turn.
Row 2 forms the pattern.

MULTI STITCH WAVE ▲

Multiple of 14 sts plus 1, plus 1 for foundation ch

Special Abbreviation
wave (worked over 14 sts): 1 dc, 2 htr, 2 tr, 3 dtr, 2 tr, 2 htr, 2 dc.
reverse wave (worked over 14 sts): 1 dtr, 2 tr, 2 htr, 3 dc, 2 htr, 2 tr, 2 dtr.
Work 2 rows each in colours A and B alternately throughout.
Row 1 (right side): Skip 2 ch, *wave; rep from * across, turn.
Row 2: Ch 1, dc across, turn.
Row 3: Ch 4, *reverse wave; rep from * across, turn.
Row 4: as row 2.
Row 5: Ch 1, *wave; rep from * across, turn.
Row 6: as row 2.
Rows 3 to 6 form the pattern.

This stitch can also be worked in brightly coloured shapes

TREBLE CROCHET DIAGONAL BLOCKS ▼

Multiple of 7 sts plus 4, plus 3 for foundation ch

Row 1 (right side): Skip 2 ch, 2 tr in next, *skip 3 ch, 1 dc, ch 3, 3 tr; rep from * to last 4 ch, skip 3 ch, 1 dc turn.
Row 2: Ch 3, 2 tr in first dc, *skip 3 tr, (1 dc, ch 3, 2 tr) in 3 ch loop, 1 tr in dc; rep from * ending skip 2 tr, 1 dc, turn.
Row 2 forms the pattern.

▲ CROSSED TREBLES

Multiple of 2 sts, plus 2 for foundation ch

Special Abbreviation
2 ctr (2 crossed treble crochet): Skip next st, 1 tr, 1 tr in skipped st, working so that the crossed tr wraps and encases the previous tr (see Simple crossed stitch, page 92).
Row 1 (right side): Skip 3 ch, *2 ctr; rep from * to last st, 1 tr, turn.
Row 2: Ch 1, dc across, turn.
Row 3: Ch 3, *2 ctr; rep from * to last st, 1 tr, turn.
Rows 2 and 3 form the pattern.

CHEVRONS & MOTIFS

THE BASIC STITCHES can be combined with increasing and decreasing to create zigzags, chevrons, and curves. The same plain stitch, increased and decreased alternately at frequent intervals at the same place in each row, will create a zigzag shape. Using increasing and decreasing in several different ways, you can make a variety of other geometric shapes for motifs to be made up into patchwork items.

SIMPLE CHEVRONS

In these patterns the same row shape is maintained and all rows are parallel throughout. If given the instruction to work even when working chevrons, you must continue increasing and decreasing as established to create the chevrons, but keeping the same number of stitches in each row and the edges of your fabric straight.

1 Increase by working additional stitches into the same place.

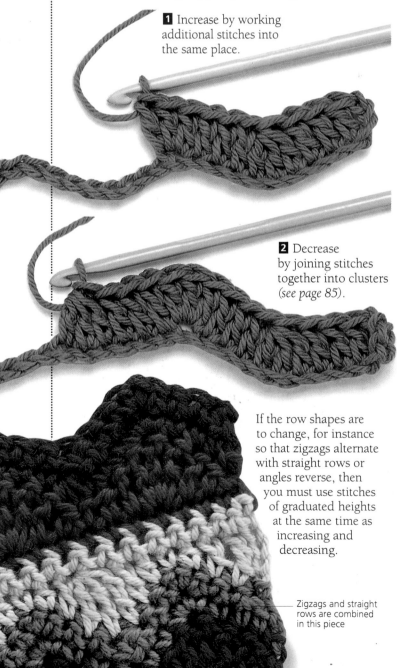

2 Decrease by joining stitches together into clusters (*see page 85*).

If the row shapes are to change, for instance so that zigzags alternate with straight rows or angles reverse, then you must use stitches of graduated heights at the same time as increasing and decreasing.

Zigzags and straight rows are combined in this piece

TRIANGLE MOTIFS

There are numerous ways of combining simple triangles to make patchwork covers or bedspreads. These bedcovers have long formed a large and popular part of traditional crochet.

Increase triangle

Start with a single stitch and increase at both edges simultaneously. Make a foundation chain of 3 ch. Skip 2 ch, 2 dc in next, turn (3 sts – right side). Work 11 more rows in dc, making single inc at end of every row and also at beginning of 4th, 7th, and 10th rows (17 sts at end of Row 12).

Decrease triangle

Start with a foundation row the desired length of a triangle side and then decrease at both edges simultaneously to a single stitch. Work a foundation chain of 18 ch. Skip 2 ch, dc across to last 2 ch, dc2tog, turn (16 sts – right side). Work 11 more rows in dc, making single dec at end of every row and also at beginning of 3rd, 6th, and 10th rows (1 st at end of row 12).

Make a diamond by crocheting an increase triangle followed by a decrease triangle

BOBBLES

CROCHET WAS DEVELOPED mainly to meet the nineteenth century demand for lace. But it can also be used to create a lovely array of textured effects. The easily-made bobbles shown here involve the same skills already learned for increasing and decreasing.

A relief effect is created whenever you work a stitch taller than the stitches on either side, for example, a double treble crochet in a row of double crochet; the taller stitch cannot lie flat, but sticks out from the surface. Similarly, if you work more than one stitch into the same place and then join the group into one at the top, the excess will stand out from the surface. The taller and greater the number of stitches in the cluster, the more pronounced the bobble.

Variations can be made using different numbers of stitches and inserting the hook in different positions.

Completed bobbles on double crochet

Popcorn stitch

Work 5 stitches into same place (*left*). Remove hook from working loop. Insert it from front to back under top 2 loops of first stitch in group. Pick up working loop and draw it through. To make popcorn stand out towards back of work, insert hook from back through to front (*right*).

Puff stitch

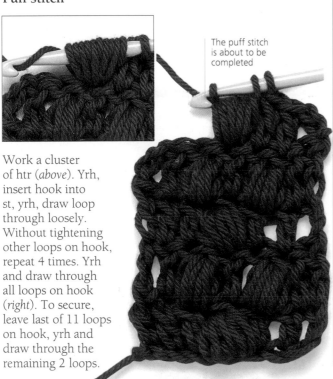

The puff stitch is about to be completed

Work a cluster of htr (*above*). Yrh, insert hook into st, yrh, draw loop through loosely. Without tightening other loops on hook, repeat 4 times. Yrh and draw through all loops on hook (*right*). To secure, leave last of 11 loops on hook, yrh and draw through the remaining 2 loops.

Bobble

Work a decrease cluster of 5 tr (or whatever amount you like) all into same place, in a row made otherwise of dc (*left*). *Yrh, insert hook into st, yrh, draw a loop through, yrh, draw through 2 loops; repeat from * 4 more times always inserting hook into same stitch (6 loops on hook). Yrh and draw yarn through all loops to complete (*right*). The bobble is more pronounced when worked during wrong side rows.

Bullion stitch

1 Yrh, say 7 times, as if making a long stitch. Insert hook, yrh, and draw through st. Yrh, draw through all loops.

2 Allow enough yarn to be drawn through loops to give them enough room to stand up as far as you wish. Yrh once more and, taking care not to allow stem of bullion to tighten, draw through to complete (*right*).

VERTICAL POPCORNS WITH RAISED DOUBLE TREBLES ▼
Multiple of 11 sts plus 3, plus 2 for foundation ch
Special Abbreviation
pop: Popcorn made with 5 dtr
(see page 95).
Row 1 (right side): Skip 3 ch, 2 tr,
*ch 2, skip 3 ch, 1 pop, ch 1,
1 pop, ch 1, skip 3 ch, 3 tr; rep
from * across, turn.
Row 2: Ch 3, 1 rbdtr, 1 tr, *ch 3,
skip (1 ch, 1 pop), 2 dc in ch sp,
ch 3, skip (1 pop, 2 ch), 1 tr,
1 rbdtr, 1 tr; rep

from * across, turn.
Row 3: Ch 3, 1 rfdtr, 1 tr, *ch 2,
skip 3 ch, 1 pop, ch 1, 1 pop,
ch 1, skip 3 ch, 1 tr, 1 rfdtr,
1 tr; rep from * across, turn.
Rows 2 and 3 form the pattern.

DIAGONAL SPIKE PUFF ▲
Multiple of 3 sts plus 2, plus 2 for foundation ch
Special Abbreviation
spfcl (spike puff cluster): Yrh, insert hook in next st, yrh, draw
through, yrh, draw through 2 loops, (yrh, insert hook from front
in 3rd previous st, yrh, draw through loosely) twice (6 loops on
hook), yrh, draw through all loops.
Row 1 (right side): Skip 3 ch, *2 tr, 1 spfcl; rep from * to
last st, 1 tr, turn.
Row 2: Ch 3, *2 tr, 1 spfcl; rep from * to last st,
1 tr, turn.
Row 2 forms the pattern.

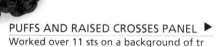

PUFFS AND RAISED CROSSES PANEL ▶
Worked over 11 sts on a background of tr
Special Abbreviation
Puff: Made as htr5tog in same place
(see page 95).
nc (not closed): see Clusters page 102.
Row 1 (right side): 11 tr.
Row 2 (wrong side): *1 rbdtr, 1 puff,
1 rbdtr**, 1 tr; rep from * once more
and from * to ** again.
Row 3: *1 trnc in first, skip puff, 1 rfdtrnc
around next (3 loops on hook), yrh, draw
through all loops, 1 tr in puff, 1 trnc in next,
1 rfdtrnc around st before previous puff crossing
in front of previous rfdtr, yrh, and draw through
3 loops as before**, 1 tr; rep from * once more
and from * to ** again.
Rows 2 and 3 form the pattern.

POPCORNS AND TREBLE CROCHET ▲
**Multiple of 6 sts plus 1, plus
2 for foundation ch**
Special Abbreviation
pop: Popcorn made with 5 tr
(see page 95).
Work 1 row each in colours
A, B and C throughout.
Row 1 (right side): Skip 3 ch,
tr across, turn.
Row 2: Ch 1 (does not count as
st), *1 dc, ch 1, skip 1; rep from
* to last st, 1 dc, turn.
Row 3: Ch 3, *skip (1 ch, 1 dc),
(1 pop, ch 1, 1 tr, ch 1, 1 pop)
in next ch sp, skip (1 dc, 1 ch),
1 tr; rep from * across, turn.
Row 4: as row 2.
Row 5: Ch 3, tr across, turn.
Rows 2 to 5 form the pattern.

◀ BOBBLE PANEL
**Worked over 13 sts on
a background of alt tr
(right side) and dc rows.**
Special Abbreviation
bob (bobble): tr5tog in same
place (see page 95).
Note: Work each rfdtr around
tr st 2 rows below.
Row 1 (right side): 13 tr.
Row 2 (wrong side): 4 dc,
1 bob, 3 dc, 1 bob, 4 dc.
Row 3: 1 rfdtr, 1 tr, 1 rfdtr,
7 tr, 1 rfdtr, 1 tr, 1 rfdtr.
Row 4: 6 dc, 1 bob, 6 dc.
Row 5: as row 3.
Rows 2 to 5 form the pattern.

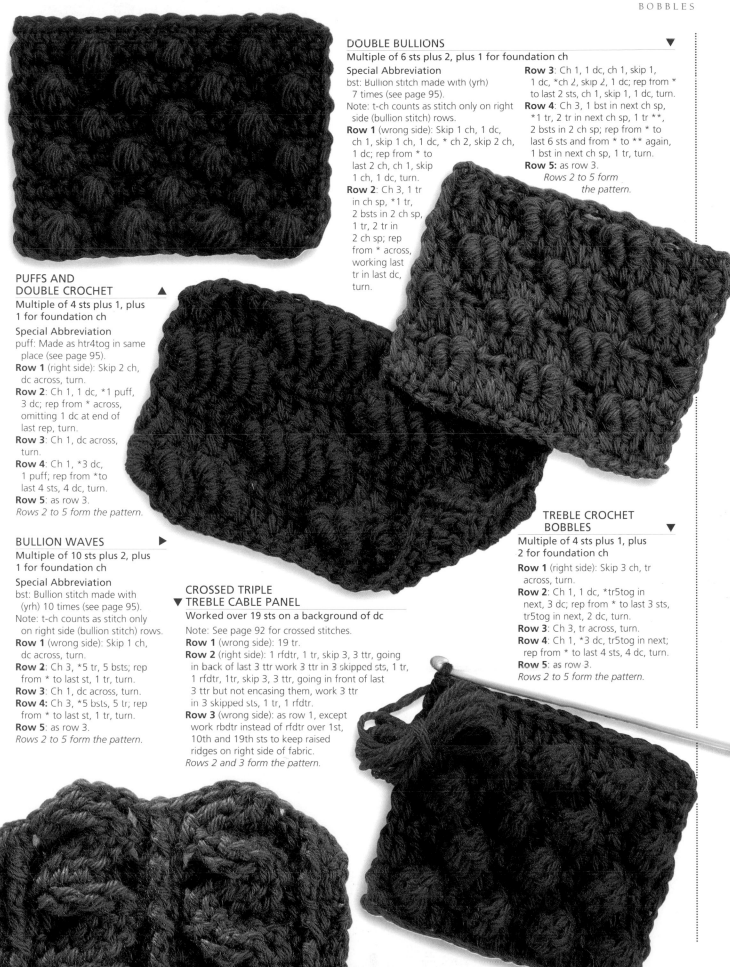

DOUBLE BULLIONS ▼
Multiple of 6 sts plus 2, plus 1 for foundation ch
Special Abbreviation
bst: Bullion stitch made with (yrh) 7 times (see page 95).
Note: t-ch counts as stitch only on right side (bullion stitch) rows.
Row 1 (wrong side): Skip 1 ch, 1 dc, ch 1, skip 1 ch, 1 dc, * ch 2, skip 2 ch, 1 dc; rep from * to last 2 ch, ch 1, skip 1 ch, 1 dc, turn.
Row 2: Ch 3, 1 tr in ch sp, *1 tr, 2 bsts in 2 ch sp, 1 tr, 2 tr in 2 ch sp; rep from * across, working last tr in last dc, turn.
Row 3: Ch 1, 1 dc, ch 1, skip 1, 1 dc, *ch 2, skip 2, 1 dc; rep from * to last 2 sts, ch 1, skip 1, 1 dc, turn.
Row 4: Ch 3, 1 bst in next ch sp, *1 tr, 2 tr in next ch sp, 1 tr **, 2 bsts in 2 ch sp; rep from * to last 6 sts and from * to ** again, 1 bst in next ch sp, 1 tr, turn.
Row 5: as row 3.
Rows 2 to 5 form the pattern.

PUFFS AND DOUBLE CROCHET ▲
Multiple of 4 sts plus 1, plus 1 for foundation ch
Special Abbreviation
puff: Made as htr4tog in same place (see page 95).
Row 1 (right side): Skip 2 ch, dc across, turn.
Row 2: Ch 1, 1 dc, *1 puff, 3 dc; rep from * across, omitting 1 dc at end of last rep, turn.
Row 3: Ch 1, dc across, turn.
Row 4: Ch 1, *3 dc, 1 puff; rep from *to last 4 sts, 4 dc, turn.
Row 5: as row 3.
Rows 2 to 5 form the pattern.

BULLION WAVES ▶
Multiple of 10 sts plus 2, plus 1 for foundation ch
Special Abbreviation
bst: Bullion stitch made with (yrh) 10 times (see page 95).
Note: t-ch counts as stitch only on right side (bullion stitch) rows.
Row 1 (wrong side): Skip 1 ch, dc across, turn.
Row 2: Ch 3, *5 tr, 5 bsts; rep from * to last st, 1 tr, turn.
Row 3: Ch 1, dc across, turn.
Row 4: Ch 3, *5 bsts, 5 tr; rep from * to last st, 1 tr, turn.
Row 5: as row 3.
Rows 2 to 5 form the pattern.

CROSSED TRIPLE
▼ TREBLE CABLE PANEL
Worked over 19 sts on a background of dc
Note: See page 92 for crossed stitches.
Row 1 (wrong side): 19 tr.
Row 2 (right side): 1 rfdtr, 1 tr, skip 3, 3 ttr, going in back of last 3 ttr work 3 ttr in 3 skipped sts, 1 tr, 1 rfdtr, 1tr, skip 3, 3 ttr, going in front of last 3 ttr but not encasing them, work 3 ttr in 3 skipped sts, 1 tr, 1 rfdtr.
Row 3 (wrong side): as row 1, except work rbdtr instead of rfdtr over 1st, 10th and 19th sts to keep raised ridges on right side of fabric.
Rows 2 and 3 form the pattern.

TREBLE CROCHET BOBBLES ▼
Multiple of 4 sts plus 1, plus 2 for foundation ch
Row 1 (right side): Skip 3 ch, tr across, turn.
Row 2: Ch 1, 1 dc, *tr5tog in next, 3 dc; rep from * to last 3 sts, tr5tog in next, 2 dc, turn.
Row 3: Ch 3, tr across, turn.
Row 4: Ch 1, *3 dc, tr5tog in next; rep from * to last 4 sts, 4 dc, turn.
Row 5: as row 3.
Rows 2 to 5 form the pattern.

WORKING IN THE ROUND

THIS TECHNIQUE IS used to make motifs, and larger fabrics such as tablecloths. Unlike normal crochet, you work around a central ring and increase regularly every round to keep the work flat. If you increase too much or too little the fabric will curl. The shape of fabric made in the round may be any shape depending on the position of the increases.

An enormous number of patchwork-style fabrics can be made from motifs. Lace stitches can be incorporated as in the pretty lace doilies shown here. (See page 233 for instructions for the beaded doily).

VICTORIAN STYLE LACE DOILIES

These pretty old-fashioned lace doilies are useful as well as decorative. The beaded doily doubles as a jug cover. To make this herb sachet, place a handful of potpourri in muslin, tie it up firmly and place in the centre of a lace doily. Gather up the edges of the doily with ribbons. Worked in fine 20s cotton thread, these lace doilies will be tomorrow's heirlooms.

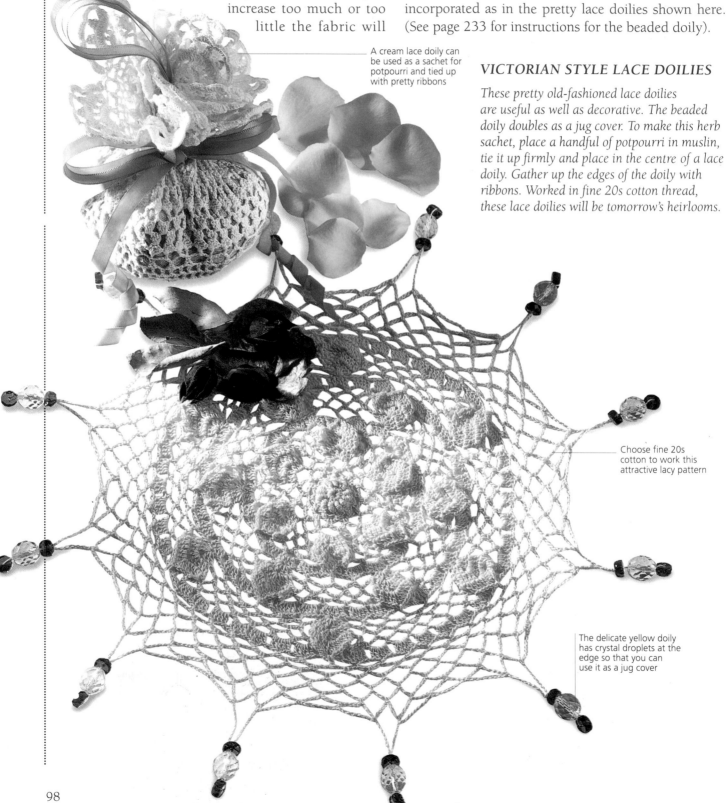

A cream lace doily can be used as a sachet for potpourri and tied up with pretty ribbons

Choose fine 20s cotton to work this attractive lacy pattern

The delicate yellow doily has crystal droplets at the edge so that you can use it as a jug cover

FOUNDATION RING

Working in the round starts with a foundation ring; the one most often used is closed by working a slip stitch into the first chain (first method below). When it is important to be able to close any central hole in the fabric, use the second method.

Chain foundation ring

1 Make a short length of foundation chain as stated in the pattern instructions, for example, ch 5. Insert the hook into the first chain.

The foundation ring is closed by working through the first chain

2 Close the ring with a slip stitch, (yrh and draw through).

Yarn loop foundation ring

1 Make a loop in yarn. Hold bottom of loop with fingers which normally hold work. Insert hook through loop, yrh and draw through. Make correct turning chain (chain 1 for double crochet) and work first round into loop ring, making sure you encase short end of yarn.

2 Close the round with a slip stitch. Close up the centre of the ring by drawing the short end of the yarn tight. Secure it by weaving it into the wrong side of the work.

MOTIFS

On the stich glossary overleaf, unless otherwise specified:

1 Close the foundation chain ring by working a slip stitch into the first chain.

2 At the beginning of each round work a turning chain to stand as the first stitch of the first pattern repeat (see table page 76).

3 At the end of each round close with a slip stitch into the top of this first stitch.

4 Do not turn between rounds – right side is always facing.

WORKING IN THE ROUND

There are two main methods of working in the round: making one continuous spiral or a series of joined rounds. In the latter case, each round is completed and joined with a slip stitch, but before starting the next round, make a turning chain to match the height of the following stitches (even if the work is not actually turned between rounds). For turning chain table see page 76.

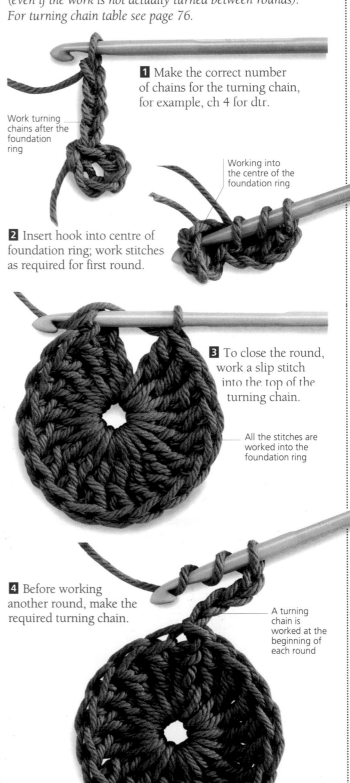

Work turning chains after the foundation ring

1 Make the correct number of chains for the turning chain, for example, ch 4 for dtr.

Working into the centre of the foundation ring

2 Insert hook into centre of foundation ring; work stitches as required for first round.

3 To close the round, work a slip stitch into the top of the turning chain.

All the stitches are worked into the foundation ring

4 Before working another round, make the required turning chain.

A turning chain is worked at the beginning of each round

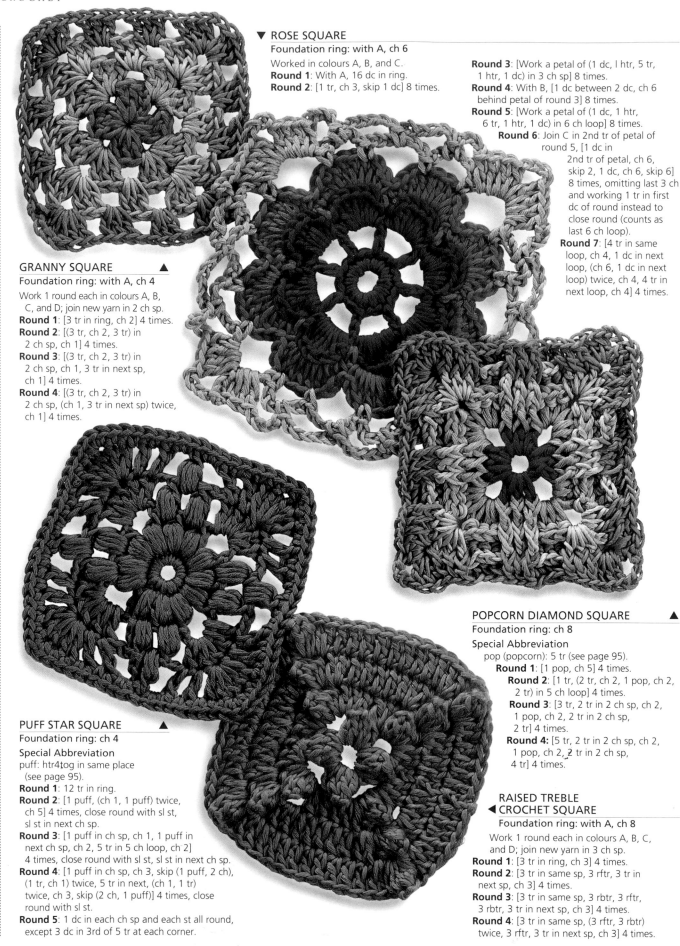

▼ ROSE SQUARE

Foundation ring: with A, ch 6

Worked in colours A, B, and C.
Round 1: With A, 16 dc in ring.
Round 2: [1 tr, ch 3, skip 1 dc] 8 times.

Round 3: [Work a petal of (1 dc, 1 htr, 5 tr, 1 htr, 1 dc) in 3 ch sp] 8 times.
Round 4: With B, [1 dc between 2 dc, ch 6 behind petal of round 3] 8 times.
Round 5: [Work a petal of (1 dc, 1 htr, 6 tr, 1 htr, 1 dc) in 6 ch loop] 8 times.
Round 6: Join C in 2nd tr of petal of round 5, [1 dc in 2nd tr of petal, ch 6, skip 2, 1 dc, ch 6, skip 6] 8 times, omitting last 3 ch and working 1 tr in first dc of round instead to close round (counts as last 6 ch loop).
Round 7: [4 tr in same loop, ch 4, 1 dc in next loop, (ch 6, 1 dc in next loop) twice, ch 4, 4 tr in next loop, ch 4] 4 times.

GRANNY SQUARE ▲

Foundation ring: with A, ch 4

Work 1 round each in colours A, B, C, and D; join new yarn in 2 ch sp.
Round 1: [3 tr in ring, ch 2] 4 times.
Round 2: [(3 tr, ch 2, 3 tr) in 2 ch sp, ch 1] 4 times.
Round 3: [(3 tr, ch 2, 3 tr) in 2 ch sp, ch 1, 3 tr in next sp, ch 1] 4 times.
Round 4: [(3 tr, ch 2, 3 tr) in 2 ch sp, (ch 1, 3 tr in next sp) twice, ch 1] 4 times.

PUFF STAR SQUARE ▲

Foundation ring: ch 4

Special Abbreviation
puff: htr4tog in same place (see page 95).
Round 1: 12 tr in ring.
Round 2: [1 puff, (ch 1, 1 puff) twice, ch 5] 4 times, close round with sl st, sl st in next ch sp.
Round 3: [1 puff in ch sp, ch 1, 1 puff in next ch sp, ch 2, 5 tr in 5 ch loop, ch 2] 4 times, close round with sl st, sl st in next ch sp.
Round 4: [1 puff in ch sp, ch 3, skip (1 puff, 2 ch), (1 tr, ch 1) twice, 5 tr in next, (ch 1, 1 tr) twice, ch 3, skip (2 ch, 1 puff)] 4 times, close round with sl st.
Round 5: 1 dc in each ch sp and each st all round, except 3 dc in 3rd of 5 tr at each corner.

POPCORN DIAMOND SQUARE ▲

Foundation ring: ch 8

Special Abbreviation
pop (popcorn): 5 tr (see page 95).
Round 1: [1 pop, ch 5] 4 times.
Round 2: [1 tr, (2 tr, ch 2, 1 pop, ch 2, 2 tr) in 5 ch loop] 4 times.
Round 3: [3 tr, 2 tr in 2 ch sp, ch 2, 1 pop, ch 2, 2 tr in 2 ch sp, 2 tr] 4 times.
Round 4: [5 tr, 2 tr in 2 ch sp, ch 2, 1 pop, ch 2, 2 tr in 2 ch sp, 4 tr] 4 times.

RAISED TREBLE
◄ CROCHET SQUARE

Foundation ring: with A, ch 8

Work 1 round each in colours A, B, C, and D; join new yarn in 3 ch sp.
Round 1: [3 tr in ring, ch 3] 4 times.
Round 2: [3 tr in same sp, 3 rftr, 3 tr in next sp, ch 3] 4 times.
Round 3: [3 tr in same sp, 3 rbtr, 3 rftr, 3 rbtr, 3 tr in next sp, ch 3] 4 times.
Round 4: [3 tr in same sp, (3 rftr, 3 rbtr) twice, 3 rftr, 3 tr in next sp, ch 3] 4 times.

SPIRAL HEXAGON
Foundation ring: ch 5

Note: This motif is worked as a continuous spiral without joining between rounds. Hint: mark last dc of each round with contrasting thread.

Round 1: [Ch 6, 1 dc in ring] 6 times.
Round 2: [Ch 4, 1 dc in next sp] 6 times.
Round 3: [Ch 4, 1 dc in next sp, 1 dc in next dc] 6 times.
Round 4: [Ch 4, 1 dc in next sp, 2 dc] 6 times.
Round 5: [Ch 4, 1 dc in next sp, 3 dc] 6 times.
Rep for as many rounds as desired, increasing number of dc in each of 6 sections of each round as established. From round 10 work 5 instead of 4 ch in each sp. End with ch sp then 1 sl st in next dc.

FLOWER WHEEL
Foundation ring: ch 5

Round 1: 12 dc in ring.
Round 2: [2 tr, ch 3] 6 times.
Round 3: Sl st in tr and in next ch, [(tr3tog, ch 4, tr3tog) in ch sp, ch 4] 6 times.
Round 4: [(2dc, ch 3, 2 dc) in ch sp] 12 times.

▲ FLOWER POWER
Foundation ring: ch 6

Round 1: 12 dc in ring.
Round 2: [1 dc, ch 7, skip 1] 5 times, 1 dc, ch 3, skip 1, 1 dtr in top of first dc (counts as 6th 7 ch loop).
Round 3: [5 tr in ch loop, ch 3] 6 times.
Round 4: [5 tr, ch 3, 1 dc in ch loop, ch 3] 6 times.
Round 5: [tr5tog, (ch 5, 1 dc in next loop) twice, ch 5] 6 times.
Round 6: Sl st in each of next 3 ch, [1 dc in ch loop, ch 5] 18 times.
Round 7: Sl st in each of next 3 ch, [1 dc in ch loop, ch 5, 1 dc in ch loop, ch 3, (5 tr, ch 3, 5 tr) in ch loop, ch 3] 6 times.

SPIKE MEDALLION ▼
Foundation ring: with A, ch 6

Worked in colors A and B.
Special Abbreviations
dcsp2 (spike double crochet 2 rounds below): insert hook 2 rounds below st indicated, i.e. into top of round 1, yrh, draw loop through and up to height of current round, yrh, draw through both loops on hook (see Spikes, page 77).
pc (picot): Ch 3, sl st in dc first worked.

Round 1: With A, 16 dc in ring.
Round 2: With B, [2 dc, (1 dc, ch 9, 1 dc) in next, 1 dc] 4 times.
Round 3: [1 dc, skip 2 dc, (2 htr, 17 tr, 2 htr) in 9 ch arch, skip 2 dc] 4 times.
Round 4: Rejoin A in dc, [1 dcsp2, ch 5, skip 5, 1 dc, 1 pc, (ch 5, skip 4, 1 dc, 1 pc) twice, ch 5, skip 5] 4 times.

TREBLE CROCHET CLUSTER HEXAGON ▲
Foundation ring: with A, ch 6. Work 1 round each in colours A, B, C, D, and E; join new yarn in ch sp

Round 1: [tr3tog in ring, ch 3] 6 times.
Round 2: [(tr3tog, ch 3, tr3tog) in 3 ch sp, ch 3] 6 times.
Round 3: Join C in 3 ch sp, linking 2 pairs of cls, [(tr3tog, ch 3, tr3tog) in 3 ch sp, ch 3, tr3tog in next sp, ch 3] 6 times.
Round 4: Join D in 3 ch sp between 1st pair of cls, [(3 tr, ch 2, 3tr) in 3 ch sp, (3 tr in next 3 ch sp) twice] 6 times.
Round 5: Join E in 3 ch sp, [2 dc in 3 ch sp, 12 dc] 6 times.

SHELLS, CLUSTERS & LACE

ATTRACTIVE PATTERNS can be made by grouping stitches together in shells or clusters. Shells are formed by working a group of stitches into the same place, whereas a cluster is made of several adjacent stitches joined together at the top. Work these closely together, or for a delicate look, increase the spacing.

SHELLS

These may be all of the same stitch, or of varying stitch heights to create an asymmetric shape. Shells may also contain chains to create spaces. If no stitches are skipped, working more than one stitch into the same place will make an increase (see page 84). If groups of stitches are worked at intervals with other shells between them, no increase is created. See Interlocking Double Crochet Shells, page 89.

CLUSTERS

A cluster is a group of stitches worked into one stitch or space then drawn together at the top with a loop. A shell and a cluster in combination can make a starburst.

1 Work the required number of stitches, leaving last loop of each on hook *(see right)*. These are sometimes called not closed (nc).

2 Yrh; draw the yarn through all loops as in Treble Crochet Whorls *(see page 103).*

LACE

Lacework consists of shells and clusters as well as meshes (see page 104), single chains, and arches or loops, including picots. There are two ways of working over chains. Working into a space underneath a chain is quicker and easier, so use the second method unless otherwise instructed.

Insert the hook in between the threads of a particular chain, as in the Shell Openwork pattern.

Insert the hook into the space underneath a chain or chain loop, as in the Offset Shell pattern.

PICOTS

These single or multiple chain loops are anchored together for decoration. They are often featured in Irish crochet lace networks (see page 104), and are frequently used as edgings (see page 114).

To make this simple picot the instructions would state, *1 dc in ch sp, (ch 3, sl st in 3rd ch from hook – called picot),* as in the Shells with Picot pattern.

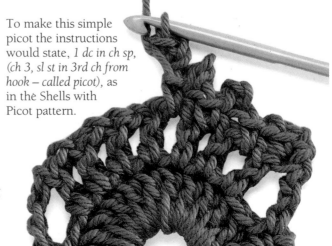

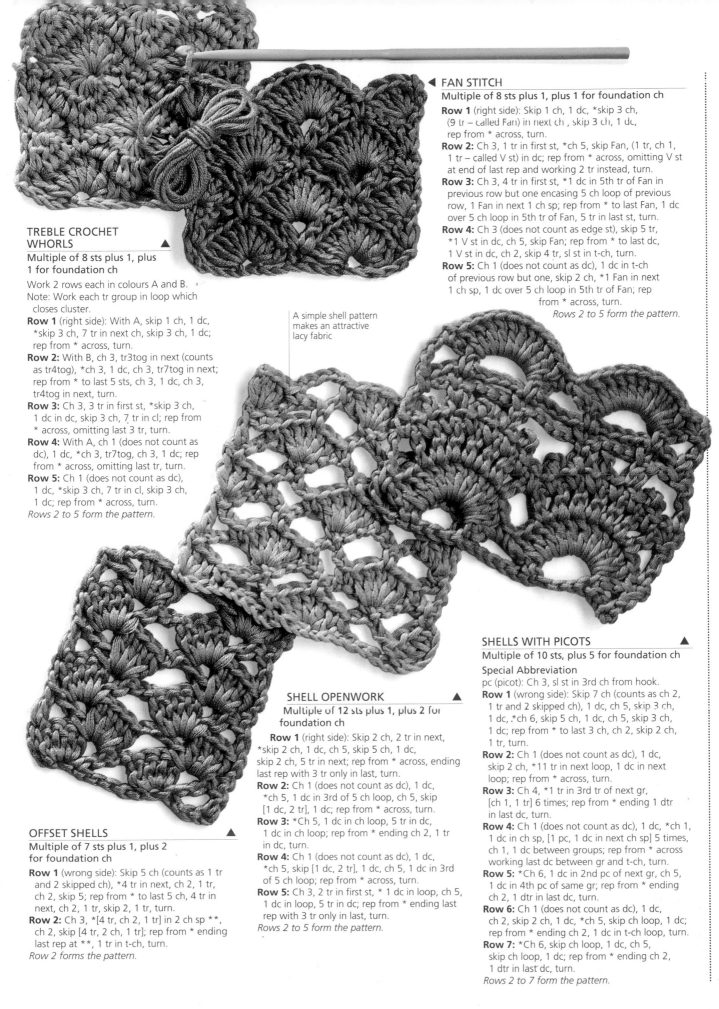

TREBLE CROCHET WHORLS ▲

Multiple of 8 sts plus 1, plus 1 for foundation ch

Work 2 rows each in colours A and B.
Note: Work each tr group in loop which closes cluster.

Row 1 (right side): With A, skip 1 ch, 1 dc, *skip 3 ch, 7 tr in next ch, skip 3 ch, 1 dc; rep from * across, turn.

Row 2: With B, ch 3, tr3tog in next (counts as tr4tog), *ch 3, 1 dc, ch 3, tr7tog in next; rep from * to last 5 sts, ch 3, 1 dc, ch 3, tr4tog in next, turn.

Row 3: Ch 3, 3 tr in first st, *skip 3 ch, 1 dc in dc, skip 3 ch, 7 tr in cl; rep from * across, omitting last 3 tr, turn.

Row 4: With A, ch 1 (does not count as dc), 1 dc, *ch 3, tr7tog, ch 3, 1 dc; rep from * across, omitting last tr, turn.

Row 5: Ch 1 (does not count as dc), 1 dc, *skip 3 ch, 7 tr in cl, skip 3 ch, 1 dc; rep from * across, turn.

Rows 2 to 5 form the pattern.

FAN STITCH ◄

Multiple of 8 sts plus 1, plus 1 for foundation ch

Row 1 (right side): Skip 1 ch, 1 dc, *skip 3 ch, (9 tr – called Fan) in next ch , skip 3 ch, 1 dc, rep from * across, turn.

Row 2: Ch 3, 1 tr in first st, *ch 5, skip Fan, (1 tr, ch 1, 1 tr – called V st) in dc; rep from * across, omitting V st at end of last rep and working 2 tr instead, turn.

Row 3: Ch 3, 4 tr in first st, *1 dc in 5th tr of Fan in previous row but one encasing 5 ch loop of previous row, 1 Fan in next 1 ch sp; rep from * to last Fan, 1 dc over 5 ch loop in 5th tr of Fan, 5 tr in last st, turn.

Row 4: Ch 3 (does not count as edge st), skip 5 tr, *1 V st in dc, ch 5, skip Fan; rep from * to last dc, 1 V st in dc, ch 2, skip 4 tr, sl st in t-ch, turn.

Row 5: Ch 1 (does not count as dc), 1 dc in t-ch of previous row but one, skip 2 ch, *1 Fan in next 1 ch sp, 1 dc over 5 ch loop in 5th tr of Fan; rep from * across, turn.

Rows 2 to 5 form the pattern.

A simple shell pattern makes an attractive lacy fabric

SHELL OPENWORK ▲

Multiple of 12 sts plus 1, plus 2 for foundation ch

Row 1 (right side): Skip 2 ch, 2 tr in next, *skip 2 ch, 1 dc, ch 5, skip 5 ch, 1 dc, skip 2 ch, 5 tr in next; rep from * across, ending last rep with 3 tr only in last, turn.

Row 2: Ch 1 (does not count as dc), 1 dc, *ch 5, 1 dc in 3rd of 5 ch loop, ch 5, skip [1 dc, 2 tr], 1 dc; rep from * across, turn.

Row 3: *Ch 5, 1 dc in ch loop, 5 tr in dc, 1 dc in ch loop; rep from * ending ch 2, 1 tr in dc, turn.

Row 4: Ch 1 (does not count as dc), 1 dc, *ch 5, skip [1 dc, 2 tr], 1 dc, ch 5, 1 dc in 3rd of 5 ch loop; rep from * across, turn.

Row 5: Ch 3, 2 tr in first st, * 1 dc in loop, ch 5, 1 dc in loop, 5 tr in dc; rep from * ending last rep with 3 tr only in last, turn.

Rows 2 to 5 form the pattern.

OFFSET SHELLS ▲

Multiple of 7 sts plus 1, plus 2 for foundation ch

Row 1 (wrong side): Skip 5 ch (counts as 1 tr and 2 skipped ch), *4 tr in next, ch 2, 1 tr, ch 2, skip 5; rep from * to last 5 ch, 4 tr in next, ch 2, 1 tr, skip 2, 1 tr, turn.

Row 2: Ch 3, *[4 tr, ch 2, 1 tr] in 2 ch sp **, ch 2, skip [4 tr, 2 ch, 1 tr]; rep from * ending last rep at **, 1 tr in t-ch, turn.

Row 2 forms the pattern.

SHELLS WITH PICOTS ▲

Multiple of 10 sts, plus 5 for foundation ch

Special Abbreviation

pc (picot): Ch 3, sl st in 3rd ch from hook.

Row 1 (wrong side): Skip 7 ch (counts as ch 2, 1 tr and 2 skipped ch), 1 dc, ch 5, skip 3 ch, 1 dc, *ch 6, skip 5 ch, 1 dc, ch 5, skip 3 ch, 1 dc; rep from * to last 3 ch, ch 2, skip 2 ch, 1 tr, turn.

Row 2: Ch 1 (does not count as dc), 1 dc, skip 2 ch, *11 tr in next loop, 1 dc in next loop; rep from * across, turn.

Row 3: Ch 4, *1 tr in 3rd tr of next gr, [ch 1, 1 tr] 6 times; rep from * ending 1 dtr in last st, turn.

Row 4: Ch 1 (does not count as dc), 1 dc, *ch 1, 1 dc in ch sp, [1 pc, 1 dc in next ch sp] 5 times, ch 1, 1 dc between groups; rep from * across working last dc between gr and t-ch, turn.

Row 5: *Ch 6, 1 dc in 2nd pc of next gr, ch 5, 1 dc in 4th pc of same gr; rep from * ending ch 2, 1 dtr in last st, turn.

Row 6: Ch 1 (does not count as dc), 1 dc, ch 2, skip 2 ch, 1 dc, *ch 5, skip ch loop, 1 dc; rep from * ending ch 2, 1 dc in t-ch loop, turn.

Row 7: *Ch 6, skip ch loop, 1 dc, ch 5, skip ch loop, 1 dc; rep from * ending ch 2, 1 dtr in last dc, turn.

Rows 2 to 7 form the pattern.

MESHES & FILETS

GRIDS OF SQUARES or diamonds characterise most crochet patterns. These can be in the form of closed or openwork fabric. Crochet meshes are often embellished, not only with shells (see page 102) and picots (see page 114), but with Clones knots and with the filled spaces of filet lace.

CLONES KNOTS

These are named after an Irish town that was an early centre for lace making.

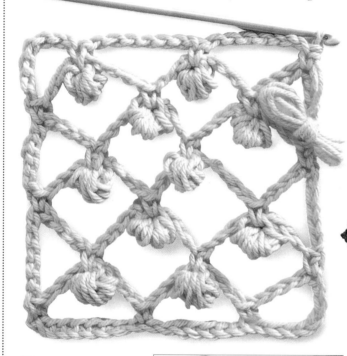

1 To make the knot: Ch 3, *yrh, take hook under ch loop just made, yrh, bring hook back again over ch loop; repeat from * 4 more times (there are now 9 loops on the hook).

2 Yrh and draw through all loops, sl st in 1st of 3 ch.

FILET CROCHET

This is a smooth background of regular squares. Patterns are created by leaving some squares open (spaces) and filling others (blocks). Characteristic images range from simple geometrics to detailed representations of birds and flowers. Filet work is used for edgings as well as for tablecloths, curtains, and clothes.

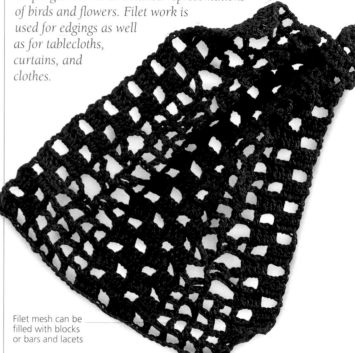

Filet mesh can be filled with blocks or bars and lacets

CHARTS

Pattern instructions usually come on graph paper. Remember, unless otherwise stated, to read odd rows of a chart from right to left, even rows from left to right. You can usually adapt and use any squared chart as a pattern for filet work.

On filet charts, the spaces are represented by blank squares and the blocks by filled-in squares. The filet ground's vertical stitches are usually treble crochet and the horizontal bars ch 2 spaces. Occasional special features called bars and lacets are drawn as they look.

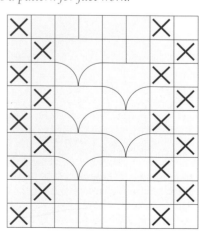

MAKING FILET MESH

For the foundation chain, make a multiple of 3 ch for each square required (which in turn will be a multiple of the number of squares in the pattern repeat), plus 1. Add 4 if the first square is a space, but only 2 if it is a block.

To begin **the first row** with a space, skip 7 ch, then work 1 tr.

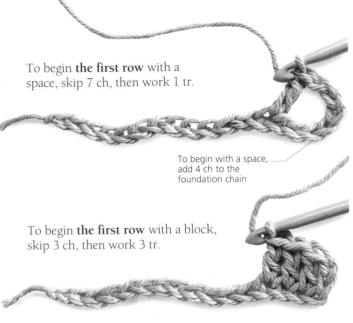

To begin with a space, add 4 ch to the foundation chain

To begin **the first row** with a block, skip 3 ch, then work 3 tr.

The last block in the row is worked

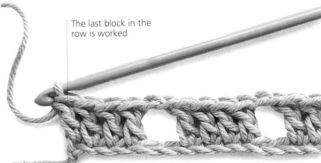

Thereafter, work each space as: ch 2, skip 2, 1 tr. Work each block as: 3 tr.

Alternating blocks and spaces form a simple filet mesh

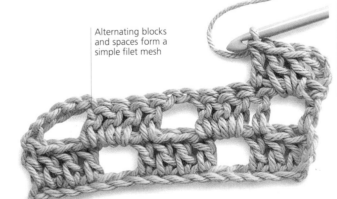

From row 2, at the beginning of each row, ch 3 to count as the edge stitch (tr), skip the first tr, and then, for each space, ch 2, skip 2 ch (or next 2 tr of a block), 1 tr in next tr; and for each block, work 2 tr in 2 ch sp (or in next 2 tr of a block), 1 tr in next tr.

BARS AND LACETS

Each structure occupies 2 squares and is usually worked alternately.

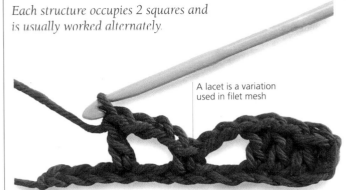

A lacet is a variation used in filet mesh

lacet – ch 3, skip 2, 1 dc, ch 3, skip 2, 1 tr.

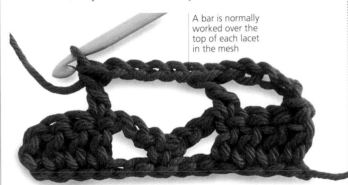

A bar is normally worked over the top of each lacet in the mesh

bar – ch 5, skip lacet (or 2 squares), 1 tr.

Filet Variation 1

Sometimes filet charts are interpreted with 1 ch for the spaces. Each square is then narrower.

Filet Variation 2

A mesh with 1-ch spaces and offset squares, that is, with the vertical stitches (tr) worked into the chain spaces of the previous row, produces a nice effect.

Variation 1

Variation 2

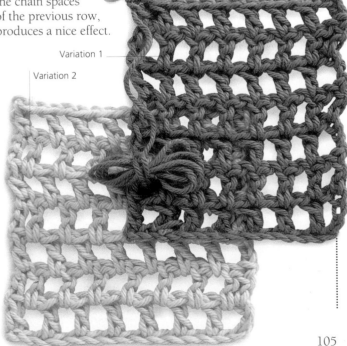

PUFF TRELLIS ▶

Multiple of 3 sts plus 1, plus
1 for foundation ch

Special Abbreviation

Puff V st: [htr3tog, ch 3, htr3tog]
in same place (see page 85).

Row 1 (right side): Skip 1 ch, 1 dc,
*ch 3, skip 2 ch, 1 dc; rep from
* across, turn.

Row 2: Ch 4, 1 dc in ch loop,
*ch 3, 1 dc ch loop; rep from
* across, ending ch 1, 1 tr in
last st, turn.

Row 3: Ch 3,*1 puff V st in dc;
rep from * across, ending 1 tr
in t-ch loop, turn.

Rows 2 and 3 form the pattern.

◀ **FILET ROSE INSERTION**

Foundation: Ch 60

Row 1 (right side): Skip 3 ch, 3 tr,
[ch 2, skip 2, 1 tr] 17 times, 3 tr,
turn (19 squares).

*Follow chart from row 2 for
pattern, repeating rows 3 to 16
as required.*

BASIC TRELLIS ▶

Multiple of 4 sts plus 2, plus
4 for foundation ch

Row 1 (right side): Skip 5 ch, 1 dc,
*ch 5, skip 3 ch, 1 dc; rep from
* across, turn.

Row 2: *Ch 5, 1 dc in 5 ch loop;
rep from * across, turn.

Row 2 forms the pattern.

FILET BUTTERFLIES ▼

Multiple of 54 sts (18 squares) plus 7 (2 squares plus 1 st),
plus 4 for foundation ch

Row 1 (right side): Skip 7 ch, 1 tr,
*ch 2, skip 2, 1 tr; rep from *
across, turn.

*Follow chart from row 2 for
pattern, repeating rows 2 to 33
as required.*

Delicate filet mesh
butterflies are worked in
simple blocks and spaces

FOUNTAIN NETWORK

Multiple of 12 sts plus 5, plus 1 for foundation ch

Row 1 (right side): Skip 1 ch, 1 dc, *ch 5, skip 3 ch, 1 dc, ch 2, skip 3 ch, 5 tr in next, ch 2, skip 3 ch, 1 dc; rep from * to last 4 ch, ch 5, skip 3 ch, 1 dc, turn.

Row 2: Ch 5 (counts as 1 tr and ch 2), *1 dc in 5 ch loop, ch 2, skip 2 ch, 1 tr in tr, [ch 1, 1 tr] 4 times, ch 2, skip 2 ch; rep from * to last 5 ch loop, 1 dc in 5 ch loop, ch 2, 1 tr in dc, turn.

Row 3: Ch 4 (counts as 1 tr and ch 1), 1 tr in first st, *skip [2 ch, 1 dc, 2 ch], 1 tr in tr, [ch 2, skip 1 ch, 1 tr] 4 times; rep from * ending skip [2 ch, 1 dc, 2 ch], [1 tr, ch 1, 1 tr] in t-ch loop, turn.

Row 4: Ch 1 (does not count as dc), 1 dc, skip [1 ch, 2 tr], *ch 5, 1 dc in 2 ch sp, ch 2, skip [1 tr, 2 ch], 5 tr in tr, ch 2, skip [2 ch, 1 tr], 1 dc in 2 ch sp; rep from * ending ch 5, 1 dc in t-ch loop, turn.

Rows 2, 3 and 4 form the pattern.

FILET DIAMOND BORDER ▶

Foundation: ch 36

Note: For multiple increases and decreases see pages 84 to 85.

Row 1 (right side): Skip 3 ch, 3 tr, [ch 2, skip 2, 1 tr] twice, 3 tr, [ch 2, skip 2, 1 tr] 5 times, [3 tr] twice, turn.

Follow chart from row 2 for pattern, repeating rows 2 to 12 as required.

BLOCK, BAR AND LACET ▲

Multiple of 6 sts plus 1, plus 2 for foundation ch

Row 1 (right side): Skip 3 ch, tr across, turn.

Row 2: Ch 3, skip first tr, *ch 5, skip 5, 1 tr; rep from * across, turn.

Row 3: Ch 3, skip first tr, *ch 3, 1 dc in ch loop, ch 3, – called lacet, 1 tr in tr; rep from * across, turn.

Row 4: Ch 3, skip first tr, *ch 5, skip lacet, 1 tr; rep from * across, turn.

Row 5: Ch 3, *5 tr in ch loop, 1 tr in tr; rep from * across, turn.

Rows 2 to 5 form the pattern.

DOUBLE CROCHET NETWORK ▶

Multiple of 8 sts plus 1, plus 1 for foundation ch

Note: t-ch does not count as st, except on row 4, 10, etc.

Row 1 (right side): Skip 1 ch, 3 dc, *ch 5, skip 3 ch, 5 dc; rep from * across, omitting 2 of 5 dc at end of last rep, turn.

Row 2: Ch 1, 1 dc, *1 dc, ch 3, 1 dc in 5 ch loop, ch 3, skip 1 dc, 2 dc; rep from * across, turn.

Row 3: Ch 1, 1 dc, *ch 3, 1 dc in 3 ch sp, 1 dc, 1 dc in 3 ch sp, ch 3, skip 1 dc, 1 dc; rep from * across, turn.

Row 4: Ch 5 (counts as 1 tr and 2 ch), * 1 dc in 3 ch sp, 3 dc, 1 dc in 3 ch sp **, ch 5; rep from * to 2nd last 3 ch sp and from * to ** again, ch 2, 1 tr in last dc, turn.

Row 5: Ch 1, 1 dc, *ch 3, skip 1 dc, 3 dc, ch 3, skip 1 dc, 1 dc in 5 ch loop; rep from * across, turn.

Row 6: Ch 1, 1 dc, *1 dc in 3 ch sp, ch 3, skip 1 dc, 1 dc, ch 3, skip 1 dc, 1 dc in 3 ch sp, 1 dc; rep from * across, turn.

Row 7: Ch 1, 1 dc, *1 dc in 3 ch sp, ch 5, 1 dc in 3 ch sp, 2 dc; rep from * across, turn.

Rows 2 to 7 form the pattern.

SUMMER SENSATIONS

LACY OPENWORK MAKES cardigans and tops look fresh and summery, with a soft, romantic touch. In addition, this technique can completely transform plain cushions into works of art.

Lacy edging around opening and hem sets off the mesh pattern

The same lace edging is used around the openwork panels to make an attractive feature on the body and sleeves of the jacket

LACY JACKET

This lovely lacy cardigan is ideal for slipping over summer dresses, and for adding a feminine look to T-shirts (see page 237).

Varying stitch heights makes this pretty shell stitch

The front motif is made of three squares sewn together

CROCHET SHELL

This cotton top can be dressed up or down — it looks great with a pretty skirt and just as good with jeans (see page 236).

Add a final feminine flounce with lacy edging

Mesh panel makes openwork corners

CUSHIONS

Delicate, lacy decorations for cushion covers are made in the same way as medallions. The doilies are then sewn onto cushions of any colour (see page 238).

A flower-bud pattern makes an attractive motif

TUNISIAN CROCHET

TUNISIAN CROCHET (SOMETIMES referred to as afghan stitch) is traditionally worked with a special hook, which is longer than usual, has a uniform diameter, and a knob (or sometimes another hook) at the other end. The technique is a cross between knitting and crochet. The finished work resembles knitting, but the stitches are thicker and firmer. For Tunisian crochet, you should expect to use a hook at least two sizes larger than you would ordinarily use with the same yarn in regular crochet.

The odd-numbered rows are worked from right to left, as loops are picked up and retained on the hook. In the even-numbered rows, the loops are worked off again from left to right.

FOUNDATION ROW

An enormous range of plain, textured, multicoloured, and openwork stitch patterns are all possible in Tunisian crochet. Most patterns are worked with the same two rows given below. Unless a double-ended hook is involved, the work is never turned and so the right side is always facing.

Make a length of foundation chain with the same number of chains as the number of stitches required in the finished row, plus 1 chain for turning.

Row one (forward)

Skip 1 ch, *insert the hook in the next ch, yrh, draw the loop through the ch only and keep on the hook; rep from * across. Do not turn the work.

Row two (return)

Yrh, draw through 1 loop only, *yrh, draw through 2 loops; rep from * across until 1 loop remains on hook. Do not turn the work.

The finished foundation row forms the basis of most Tunisian crochet patterns.

TUNISIAN SIMPLE STITCH

Work basic forward and return foundation row as at left.

Forward (row 3 and all odd rows): Count loop on hook as first st and start in 2nd st. *Insert hook at front and from right to left around single front vertical thread, yrh, draw through and keep on hook; rep from * across. Do not turn. **Return (even rows):** Same as row two.

TUNISIAN KNIT STITCH

Work basic forward and return foundation row as at left.

Forward: Count loop on hook as first st and start in 2nd st. *Insert hook from front through fabric and below chs formed by previous return row to right of front vertical thread and left of back thread of same loop, yrh, draw loop through and keep on hook; rep from * across. Do not turn. **Return:** Same as row two.

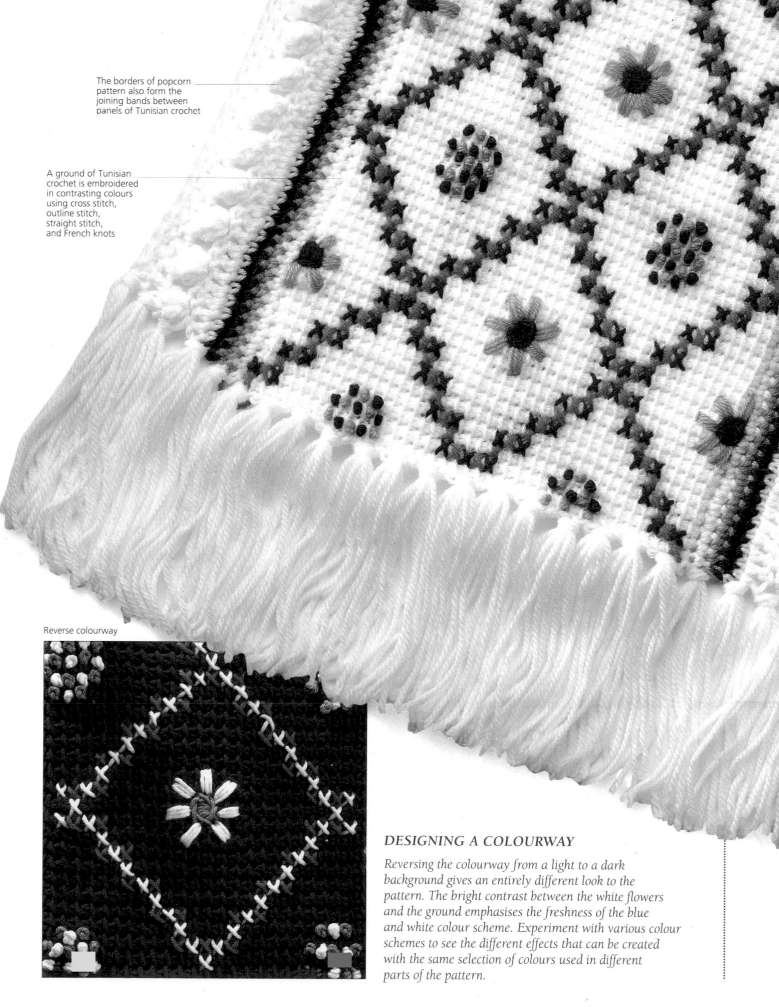

The borders of popcorn pattern also form the joining bands between panels of Tunisian crochet

A ground of Tunisian crochet is embroidered in contrasting colours using cross stitch, outline stitch, straight stitch, and French knots

Reverse colourway

DESIGNING A COLOURWAY

Reversing the colourway from a light to a dark background gives an entirely different look to the pattern. The bright contrast between the white flowers and the ground emphasises the freshness of the blue and white colour scheme. Experiment with various colour schemes to see the different effects that can be created with the same selection of colours used in different parts of the pattern.

111

AFGHANS

THESE THREE AFGHANS are all made
using simple crochet stitches, and will work up
surprisingly quickly. Use them to throw over your
favourite armchair or sofa, or for a little additional
warmth over the foot of the bed.

TRADITIONAL AND MODERN AFGHANS

*This Fan pattern is crocheted in delicate shades of soft
mohair, and has a nostalgic appeal, reminiscent of ladies'
fans of the nineteenth century. Use it as a throw in a room
with a pastel colour scheme. (See page 239.)*

*Crochet the Antique Rose pattern or the Kaleidoscope
pattern in a thick, soft wool of Aran or chunky weight.
The blue background and large rose pattern have a
romantic, feminine look, while the bright, colourful circles
with a border of triangles make a more contemporary
looking afghan. Wrap yourself up in the one of your
choice on chilly evenings, and feel proud of your
handiwork. (To make, see pages 239 and 240.)*

The fan shaped
pattern is completed
with a shell pattern
to make a square

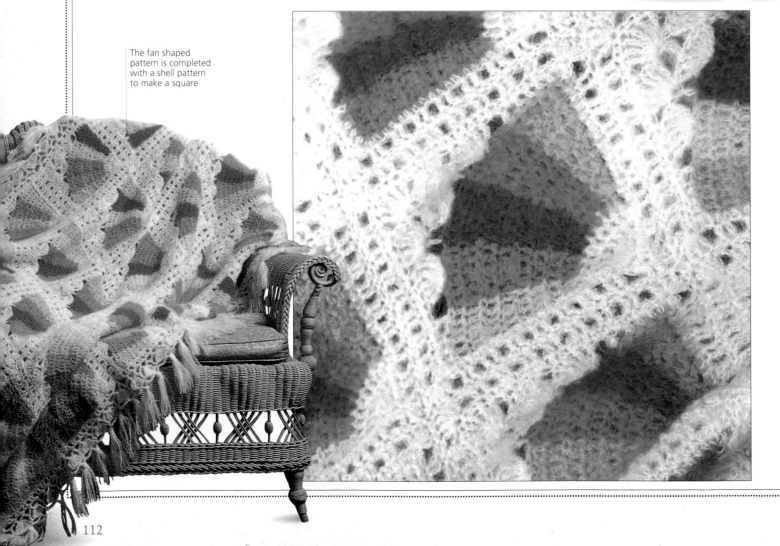

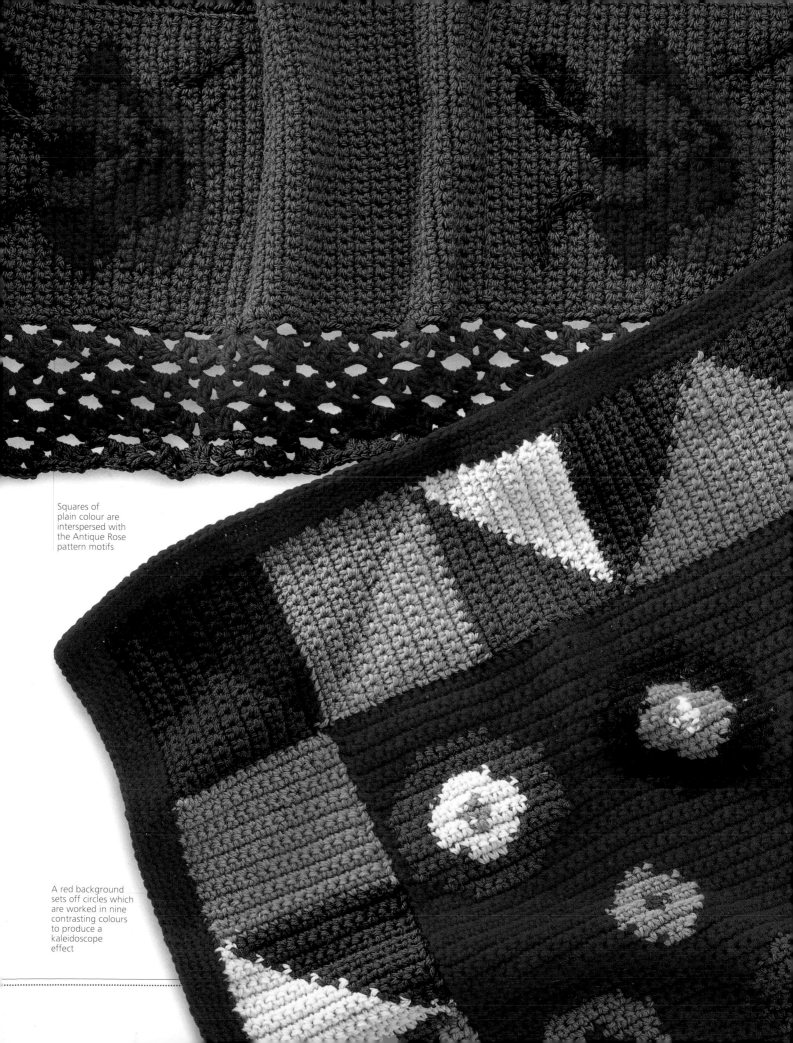

Squares of
plain colour are
interspersed with
the Antique Rose
pattern motifs

A red background
sets off circles which
are worked in nine
contrasting colours
to produce a
kaleidoscope
effect

EDGINGS

CROCHET WORK WILL usually lie flatter and have a better finish if an edging is added. Crochet edges and borders can also be used to trim a finished article. If edges or borders are a foundation for your main piece, make them first. If you are to attach them afterwards, make them separately. When working edgings, use a smaller size hook than you used for the main piece. This will give the edging a firmer finish.

DOUBLE CROCHET EDGING

This basic edging, worked with the right side facing, neatens and strengthens the fabric, and can cover any float threads or stray short ends. (The two rows shown here were worked in a contrasting colour for clarity.) It is also a good foundation for a more decorative edging.

BUTTONHOLE LOOPS

Loops for buttons may be made in an edging row by skipping the required number of stitches and working chains instead. If you need extra edging rows, work dc into the loops.

CORDED EDGE

This is a very effective edging, usually worked after one round of dc and with the right side facing. Work it in dc, but from left to right.

PICOT EDGING

Picots of varying size and complexity are a regular feature of crochet edgings. To make this triple picot work [ch 3, sl st in 3rd ch from hook] 3 times, then sl st into the top of the last dc made (see Triple Picot below).

WORKING CORNERS AND EDGES

Normally you work one stitch into each stitch across the top of a row and into the underside of a foundation chain. Work 3 stitches into a corner and along the side of the fabric at the rate of 1 stitch per dc row. As a guide, you will need to use 1 and 2 stitches alternately per htr row, 2 stitches per tr row, 3 stitches per dtr row, etc.

Making the corded edge

*Working from left to right, insert the hook into the next stitch to the right, yrh. Draw the loop through the work, below the loop which remains on the hook, and up to the left, into the normal working position (left). Yrh and draw the loop through to complete 1 corded dc (right). Repeat from *.

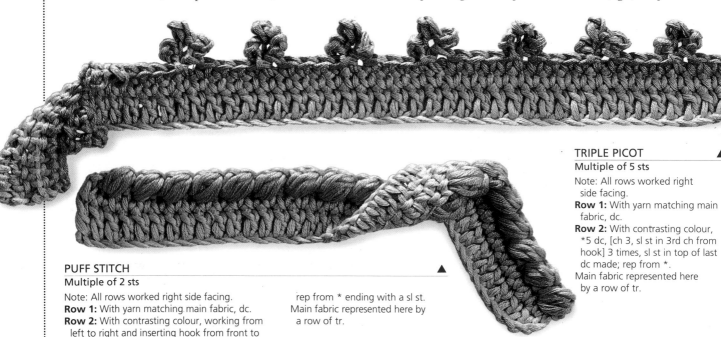

PUFF STITCH
Multiple of 2 sts

Note: All rows worked right side facing.
Row 1: With yarn matching main fabric, dc.
Row 2: With contrasting colour, working from left to right and inserting hook from front to back work * ch1, skip 1, htr3tog;

rep from * ending with a sl st. Main fabric represented here by a row of tr.

TRIPLE PICOT ▲
Multiple of 5 sts

Note: All rows worked right side facing.
Row 1: With yarn matching main fabric, dc.
Row 2: With contrasting colour, *5 dc, [ch 3, sl st in 3rd ch from hook] 3 times, sl st in top of last dc made; rep from *.
Main fabric represented here by a row of tr.

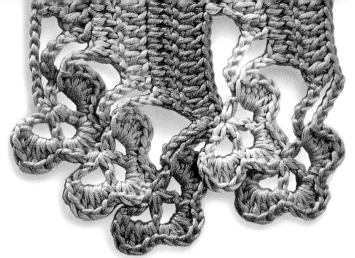

PICOT SCALLOPS

Multiple of 8 sts plus 1, plus 2 for foundation ch

Row 1 (right side): Skip 3 ch, 1 tr, *ch 1, skip 1, 1 tr; rep from * to last ch, 1 tr, turn.

Row 2: Ch 5 (counts as 1 tr, ch 2), tr2tog in first, *skip [1 tr, 1 ch], 3 tr, skip [1 ch, 1 tr], [tr2tog, ch 4, tr2tog – called 2cl] in ch sp; rep from * across, omitting last 2 ch and tr2tog from last 2cl and working 1 tr in same loop, turn.

Row 3: Ch 3 (counts as 1 htr, ch 1), 1 dc in 2 ch sp, *skip cl, [ch 3, 1 dc – called picot], skip 1, 1 pc, 2 pc in 4 ch loop; rep from * across, omiting 2nd pc at end of last rep and working ch 1, 1 htr in same loop, turn.

Row 4: Ch 1 (does not count as dc), 1 dc, *ch 1, skip 1 pc, [tr2tog, (ch 3, tr2tog) twice] in next pc, ch 1, skip 1 pc, 1 dc in next pc; rep from * across, turn.

Row 5: Ch 1 (does not count as dc), 1 dc, skip 1 ch, *[2 pc in next 3 ch loop] twice, skip 1 ch, 1 pc in dc; rep from * across.

SHAMROCK STRIPES

Foundation: with A, ch 19

Work 2 rows each in colours A, B, C and D, throughout.

Row 1 (wrong side): With A, skip 5 ch, 1 tr, ch 1, skip 1, 2 tr, ch 8, skip 9, [1 tr (ch 3, 1 tr) 3 times] in last ch, turn.

Row 2: [In 3 ch sp work (1 dc, 1 htr, 3 tr, 1 htr, 1 dc – called petal)] 3 times, ch 6, skip 6 ch, 1 tr in each of last 2 ch of loop, (2 tr – called blk), [ch 1, skip 1, 1 tr] twice, turn.

Row 3: With B, ch 4 (counts as 1 tr, ch 1), skip 1 ch, 1 tr, ch 1, skip 1, (4 tr – called blk), 1 tr in each of next 2 ch, ch 8, in centre tr of 2nd petal work [1 tr, (ch 3, 1 tr) 3 times], turn.

Row 4: as row 2, except work blk of 6 tr.

Row 5: With C, as row 3, except work blk of 8 tr.

Row 6: as row 2, except work blk of 10 tr.

Row 7: With D, ch 4 (counts as 1 tr, ch 1), skip 1 ch, 1 tr, ch 1, skip 1, 2 tr, ch 8, skip 9, (1 tr, [ch 3, 1 tr] 3 times) in last tr, turn.

Rows 2 to 7 form the pattern.

DEEP SEA SHELLS

Foundation: ch 11

Row 1 (right side): Skip 3 ch, 2 tr, ch 2, skip 2, 1 tr, ch 2, skip 2, [1 tr, ch 3, 1 tr] in last ch, turn.

Row 2: Ch 5, [3 tr, ch 1, 3 tr] in 3 ch sp, ch 2, skip 2, 1 tr, ch 2, skip 2, 3 tr, turn.

Row 3: Ch 3, 2 tr, ch 2, skip 2 ch, 1 tr, ch 2, skip 2 ch, [1 tr, ch 3, 1 tr] in 1 ch sp *, ch 2, (1 tr, [ch 1, 1 tr] 7 times) in 5 ch loop **, 1 dtr in 1st ch made of foundation ch, turn.

Row 4: Ch 2, skip 2, 1 dc in ch sp, [ch 3, 1 dc in ch sp] 6 times, ch 2, skip 2 ch, [3 tr, ch 1, 3 tr] in 3 ch sp, ch 2, skip 2 ch, 1 tr, ch 2, skip 2 ch, 3 tr, turn.

Row 5: as row 3 to *, turn.

Row 6: as row 2.

Row 7: as row 3 to **, 1 dc in 2 ch sp of last-but-two row.

Row 8: as row 4.

Rows 5 to 8 form the pattern.

BULLION SPIRALS

Foundation: ch 12

Special Abbreviation

Bst (Bullion stitch): See page 95, made with yrh 10 times.

Row 1 (right side): Skip 3 ch, 1 tr, skip 3 ch, (1 tr, [1 Bst, 1 tr] 3 times – called shell) in next, skip 3 ch, (3 tr, ch 2, 3 tr – called V st) in next, turn.

Row 2: Ch 7, skip 3 ch, [3 tr in next] 4 times, V st in 2 ch sp, ch 3, 1 dc in centre Bst of shell, ch 3, 1 tr in each of last 2 sts, turn.

Row 3: Ch 3, 1 tr, skip 3 ch, shell in dc, skip 3 ch, V st in 2 ch sp, turn.

Rows 2 and 3 form the pattern.

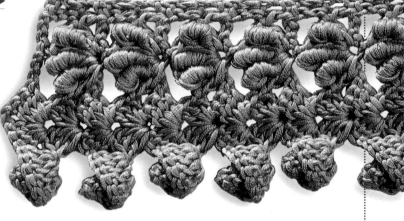

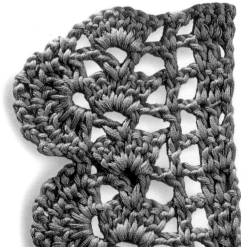

PICOT ARCHWAY

Multiple of 8 sts plus 1, plus 1 for foundation ch

Row 1 (right side): Skip 2 ch, dc across, turn.

Row 2: Ch 1, dc across, turn.

Row 3: Ch 1 (does not count as dc), 1 dc, *ch 3, 2 tr in next, skip 2, 1 dc; rep from * across, turn.

Row 4: Ch 4 (counts as 1 tr, ch 1), 1 tr in first, * 1 dc in 3 ch loop, ch 6, 1 dc in 3 ch loop, (1 tr, ch 3, 1 tr – called V st) in dc; rep from * omitting 2 of 3 ch in last V st, turn.

Row 5: Ch 1, 1 dc in 1 ch sp, *[5 tr, ch 5, sl st in 5th ch from hook, 5 tr] in 6 ch loop, 1 dc in next ch loop; rep from * across.

BUTTONS, CORDS & FINISHES

YOU CAN ADD finishing touches to garments by using matching or contrasting crochet trims. Buttons and cords will liven up children's garments, or women's accessories such as purses. The addition of slip stitches to the surface of a finished crochet piece creates an effect somewhat like weaving.

BUTTONS

Easy to make, chunky crochet buttons offer a colourful, lively way of enhancing handmade garments and accessories. For a crochet loop buttonhole, see page 114.

Bobble Button

Foundation: Ch 2. Note: close each round with sl st in first dc.
Round 1 (right side): 6 dc in 2nd ch from hook.
Round 2: Ch 1, 2 dc in each tr (12 sts).
Round 3: Ch 1, 1 dc in each dc (*top right*).
Round 4: Ch 1, (1 dc, skip 1) 6 times (6 sts). Pack button with small amount of yarn (*bottom right*).
Round 5: Ch 1, (1 dc, skip 1) 3 times. Cut length of yarn to close opening and sew button in place.

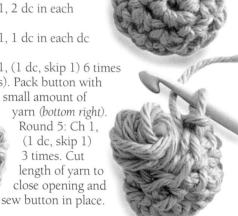

CORDS

Ties and drawstrings can be worked quickly and easily in contrasting colours to add bright and decorative touches to crochet or knitted children's clothes and accessories.

Round Cord

Foundation ring: Ch 5 (or as required for thickness of cord). Work in spiral around ring as follows: 1 sl st in top loop of each ch and then of each sl st, until cord reaches required length. For a faster-growing cord, work in dc or tr.

Flat Cord

Ch 2, 1 dc in 2nd ch from hook, turn and work 1 dc in ch at back of dc just made, *turn and work 1 dc, inserting hook down through 2 loops at back of dc just made; rep from * until cord is required length.

SURFACE CHAINS

Plaids require careful planning, but any crocheted design, particularly one with a network of chain spaces, may be decorated in this way with vertical or horizontal lines.

Making surface chains

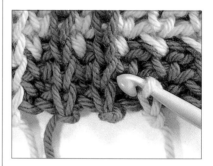

1 Make a slip knot in new yarn. With right or wrong side facing as required, insert hook down through chosen chain space. Yrh underneath work, draw through work and loop on hook.

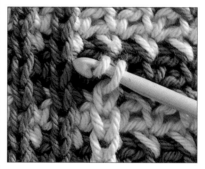

2 *Insert hook down through next chain space or selected position, yrh underneath fabric, draw through fabric and loop on hook; rep from * as required.

Make one chain beyond edge of work and fasten off. It is important to work loosely so as not to distort the background stitches. It may help to use a larger hook than you used for the main work. Short ends of yarn should be worked over and encased during any subsequent edging rounds or darned into the wrong side of the piece.

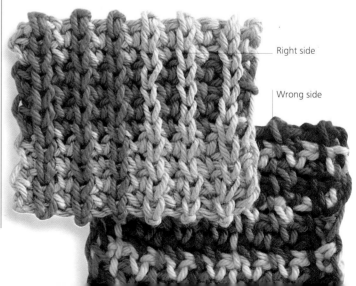

Right side

Wrong side

FINISHING & JOINING

FOR A POLISHED, professional look, take special care when finishing and joining your work – its whole appearance and durability depend on it. Make sure all stray ends of yarn are woven neatly and securely into the wrong side. Seams can be sewn, or joined with a crochet hook as below.

JOINING WITH A HOOK

Crochet seams are strong, and quick to work. Slip stitch is the most invisible, and double crochet makes a ridge that can be a feature on the right side. The number of stitches to work per row end is the same as for edgings (see page 114).

Slip stitch seam

Place the pieces right sides together. *Insert hook through both edge stitches, yrh and draw through to complete 1 sl st; rep from *, working loosely.

Double crochet seam

Place the pieces right sides together (or wrong sides together for a visible seam) and work as for slip stitch seam, using double crochet instead of slip stitch.

Double crochet and chain

A useful variation of the double crochet seam, this is used when less bulk and/or greater flexibility is called for. Work 1 dc and 1 ch alternately.

Flat slip stitch seam

Place the pieces edge to edge and wrong sides up. Work 1 sl st into each edge alternately. (*See also alternative right.*)

JOINING MOTIFS

Straight edges may be joined in the normal way. However, when there are many pieces, particularly squares and triangles, it is worthwhile connecting pairs of motifs in a continuous seam to avoid repeated fastening off.

Alternative flat slip stitch seam

A neat, flat seam may be made using the tops of stitches, as for example, with motifs made in the round. Lay the pieces edge to edge and right sides up. Insert the hook down through the top loop only of each corresponding pair of stitches and join with slip stitch.

Many motifs have a final round of picots or loops, and these may be used to join motifs to each other as that round is being worked. Typically the centre chain of a loop is replaced by a sl st or dc worked into a loop of the adjacent motif.

After joining, small motifs, which add decoration and strength, can be worked in the spaces between. The main motifs shown here are Flower Wheel, (*see page 101*). For the filler motifs work: Foundation ring: Ch 5. Round 1: [1 dc in ring, ch 2, sl st in motif, ch 2, 1 dc in ring] 4 times.

Filler motifs join as well as decorate

BLOCKING AND PRESSING

Cotton lace work usually needs careful pinning and pressing. Other crochet, particularly a textured piece, hardly ever requires this treatment. Pinning the article, misting with a fine spray, and leaving it to dry naturally may be just as effective. Be sure to use rust-proof pins.

EMBROIDERY

Using stitches to decorate a fabric is an ancient craft. The variety of individual stitches is legion and the myriad ways stitches can be combined and applied – to plain or patterned fabric – means that work of great originality is within everyone's reach.

Today, many Good Housekeeping readers enjoy working cross stitch projects but there is always the possibility of decorating garments with more ambitious stitches. Collars, cuffs and pockets offer conveniently small areas for monograms or decorative stitches, as well as larger household items such as bed and table linens.

Museums around the world are filled with examples of embroidery. A good collection will contain embroidered garments such as waistcoats and christening gowns, as well as samplers, pictures, covered boxes and altar pieces. Not content with using silk, wool or cotton threads, skilled embroiderers used metal threads and added beads and sequins. Special effects were, and continue to be, prized and sought after on both garments and household furnishings.

TOOLS & MATERIALS

THERE IS AN enormous range of background fabrics and threads for any embroidery project. The ones you choose will affect the results of your work. When making your selections, keep in mind that the fabric should be suitable for the finished item – for example, hardwearing and washable for a cushion cover. Also be certain that the needle and thread will pass through the fabric easily without splitting the woven threads. Your only other essential piece of equipment is a small, sharp pair of scissors.

FABRICS

Plain or patterned fabric are suitable for embroidery. Woven or geometric patterns are especially useful for stitches that need guidelines to keep them a regular size. A wide range of even-weave fabrics for counted-thread techniques (such as cross stitch) is available. An even-weave fabric has the same number of warp and weft threads per square inch. For example 18-count means that there are 18 threads to the inch. One of the most popular fabrics for embroidered pictures is 14-count Aida cloth. This is also available with a woven coloured grid to make stitch counting from charts easier. The coloured threads are removed when the stitching is finished.

EMBROIDERY THREADS

These come in a wide range of colours. Some popular thread types are shown below, but don't be afraid to experiment with other yarns supplied for knitting, crochet, and canvas work.

Embroidery floss
A loosely twisted 6-strand thread that is easily divided into single threads.

Pearl cotton
A strong, twisted non-divisible thread with a high sheen.

Flower thread
A fine non-divisible thread with a matte finish.

Matte embroidery cotton
A thick, soft, tightly twisted thread.

Crewel yarn
Fine 2-ply wool or acrylic yarn. Also used in tapestry work.

Persian yarn
Loosely twisted 3-strand wool or acrylic yarn; this is easily divisible.

NEEDLES

Needles come in a range of sizes; the higher the number, the finer the needle.

Crewel or embroidery needle
This is the most commonly used embroidery needle. It has a sharp point and a large eye.

Chenille needle
Similar to a crewel needle, but this has a thicker stem. It is suitable for working with heavier threads on a coarse background fabric.

Tapestry or yarn needle
A thick-stemmed, large-eyed needle with a round-pointed end. Used for lacing embroidery stitches and for pulled threadwork.

Beading needle
A fine, long needle for sewing on tiny beads.

Stretcher frames
These stretch the work very evenly. A frame usually consists of four pieces of wood, with a roller at the top and bottom to which strips of webbing are nailed. Two flat sides fit into the rollers and are secured by pegs or screws.

Stretcher frame

Hoops (round frames)
These are made of wood, metal, or plastic, and come in a variety of sizes, ranging from 12.5cm to 25cm (5 to 10 in) in diameter. The frame has two hoops that are placed one inside the other, stretching the fabric between them. The outer hoop opens, and has a screw to adjust the tension.

Hoop

EMBROIDERY FRAMES

These hold the fabric taut while you work. A frame isn't essential for small pieces of embroidery, but it does make the work easier to handle and quicker to stitch. Since the fabric is held at an even tension, the stitches themselves will be more even. Also, holding the frame instead of the fabric keeps the work cleaner than working without one.

There are two basic types of frames, the round frame (called a hoop) and the straight-sided frame. The hoop is the most commonly used because it is lightweight and portable,

and it only takes a few seconds to mount the fabric in it correctly. Straight-sided frames, known as stretcher frames, have a roller at the top and bottom and are generally used for large pieces of embroidery such as wall hangings; it takes longer to mount the work, but the fabric is quickly moved into a new position. Both types of frames are available on floor or lap stands, which allow you to keep both hands free.

OTHER USEFUL EQUIPMENT

Pairs of large and small sharp scissors for cutting your fabric and thread are absolutely essential. You'll also want dressmaker's carbon paper and special pencils for transferring your embroidery designs to fabric. Other useful items include a thimble, needle threader, and masking tape to prevent fabric edges from fraying.

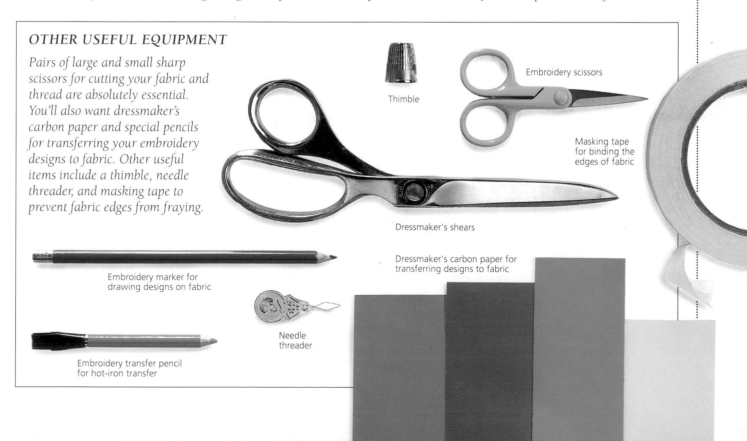

Thimble

Embroidery scissors

Masking tape for binding the edges of fabric

Dressmaker's shears

Dressmaker's carbon paper for transferring designs to fabric

Embroidery marker for drawing designs on fabric

Needle threader

Embroidery transfer pencil for hot-iron transfer

PREPARING A FRAME

LIGHTWEIGHT ROUND FRAMES, called hoops, are ideal for small pieces of fabric, while straight-sided frames, or stretcher frames, are better for larger pieces.

These latter take longer to set up as the fabric has to be stitched to the roller webbing at the top and bottom, and then laced to the sides of the frame.

HOOPS

Before placing the fabric, loosen the tension screw on the outer hoop. The hoop can be repositioned on the fabric as you complete each small area of stitching.

Lay the fabric on top of the inner hoop, with the section to be embroidered facing you *(above)*. Make sure that the fabric is smooth. Push the outer hoop down on top of the fabric on the inner hoop. Gently pull the fabric taut. Tighten the upper hoop by turning the screw, so that the fabric is stretched like a drum and held firmly in position *(right)*.

Irregular shapes

1 Baste the irregular shape onto a larger piece of fabric, with the woven threads of each aligned.

2 Mount the fabric in the usual way. Cut away the supporting fabric on the wrong side of the shape so that it is ready to embroider.

PROTECTING YOUR WORK

You can bind your hoop to prevent fine fabrics from sagging and losing their shape while you work. For a large piece of embroidery, change hoop position every time a section is completed. When you reposition your work be sure to protect finished stitches with a layer of tissue paper.

Wrap woven tape around the inner hoop as shown, and secure the end with a few stitches *(left)*. Place the fabric on the lower hoop and lay white tissue paper on top. Mount the fabric and paper, then tear away the paper *(right)*.

STRAIGHT-SIDED FRAMES

Before you mount the fabric, hem all the edges, or bind them with 2cm (³/₄ in) wide cotton tape. Mark the centre point of the fabric on the top and bottom edges.

Match centre points on rollers and fabric, and work from centre. Herringbone stitch edges of fabric to roller webbing *(above)*. Slot sides into rollers, and pull fabric tight by adjusting frames. Lace the sides of fabric loosely to frame using strong thread. Tighten thread on both sides. Adjust the frame and secure with firm knots *(left)*.

EMBROIDERY TECHNIQUES

ONCE YOU HAVE transferred your design to the fabric, you are ready to start the embroidery. If the fabric weave is very open and loose, you will need to bind the edges so that they don't fray – use one of the simple methods given below. When working, try to keep the back of the work as neat as possible by weaving the thread ends behind existing stitches and avoiding large gaps between stitches.

CUTTING AND BINDING FABRIC

The fabric should be cut 5cm (2 in) larger all around than the overall design. But if you want to mount or frame the completed embroidery, add twice this amount 10cm (4 in). Take care to cut the fabric straight, following the warp and weft threads of the weave of the fabric.

Binding fabric prevents edges from fraying while you work and is essential on loosely woven fabric. Either tape the edges with masking tape or neaten raw edges with machine zigzag stitch. Alternatively, turn the edges under and sew in place.

PREPARING THE THREADS

The working thread should be 45cm (18 in) or less. Longer threads will get tangled, lose their sheen, and fray.

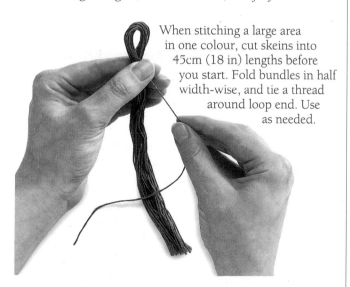

When stitching a large area in one colour, cut skeins into 45cm (18 in) lengths before you start. Fold bundles in half width-wise, and tie a thread around loop end. Use as needed.

Embroidery floss, matte embroidery cotton and Persian yarn are all loosely twisted threads that can be separated into finer strands. It is best to separate them when you need them.

STARTING AND FINISHING WORK

Don't make a knot when you are starting or finishing a length of thread. Knots show through the work, creating an uneven appearance. Instead, use a small backstitch (page 129), or weave the end into existing stitches on the back of the work.

Start a new thread by sliding needle under wrong side of some stitches, keeping thread end about 4cm (1½ in) long. Bring needle up on right side of fabric and continue.

To secure thread at the end of stitching, slide the needle under 4cm (1½ in) of the worked stitches on wrong side of work, and then cut thread.

EMBROIDERING THE DESIGN

Always work in a good light and in a comfortable position. Follow the guidelines carefully, inserting the needle on the outside of each line, so that none of the lines will show when the work is finished.

Choose the right needle for the fabric and thread, and try to keep the stitch tension even. Where possible, use a stabbing motion with the needle, and always pull the thread through carefully. Stitching will make the thread twist, particularly if you are working knotted stitches. If this starts happening, just let the needle drop and hang freely for a few seconds until the thread untwists.

Don't make the stitches too long, especially if you are working an article that will receive a lot of wear or be handled frequently. When your embroidery is finished you may find that the long stitches tend to snag and break if they get caught on other objects. For the same reason, on the back of the work, if there is a gap of more than 2cm (¾ in) between stitches, secure the first stitch and start the next one with a new piece of thread.

ENLARGING & REDUCING

INSPIRATION FOR EMBROIDERY designs can be found almost anywhere. Start by looking at old embroidery, art postcards, photographs, book illustrations, or wallpaper. Since the original design is unlikely to be the right size, you will need to enlarge or reduce it. The easiest way to do this is with a photocopier, or you may use the grid method shown below. This involves transposing the outline shapes of the basic design from one grid to another of a different size. You will need some good quality tracing paper, a ruler, and a set square.

INSPIRATION FOR DESIGN

You can find ideas for designs from all kinds of things such as plates, tiles, leaves, shells, or flowers. Old objects, such as this trinket box or book, often have attractive decorations that could easily be copied for embroidery designs. If the design has a lot of detail, try to simplify the outlines to suit the scale of your work.

To enlarge a design

1 Trace shapes on tracing paper, and go over all lines with a black felt-tip pen. Enclose the design in a rectangle. Draw a diagonal line from bottom left-hand corner to top right-hand corner.

2 Place traced rectangle on a sheet of paper large enough for the final design. Align left-hand and bottom edges. Tape down tracing; extend the diagonal line on the tracing across paper.

3 Remove paper and complete diagonal line. At height of new design, using a set square, draw a horizontal line to cross the diagonal. From this point draw a vertical line down to bottom edge.

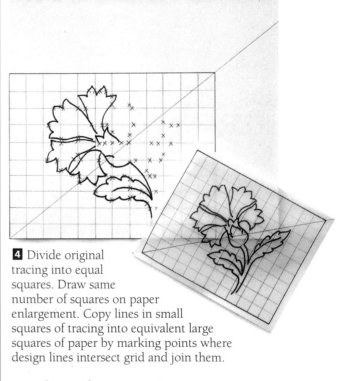

4 Divide original tracing into equal squares. Draw same number of squares on paper enlargement. Copy lines in small squares of tracing into equivalent large squares of paper by marking points where design lines intersect grid and join them.

To reduce a design

Start with step 1 of enlargement instructions; then tape a small piece of paper in the bottom left-hand corner of the tracing. Draw a diagonal line on the paper to correspond to the diagonal line on the tracing. Draw the required width and height of the embroidery on the paper as in step 3. Divide the tracing into squares, and then divide the paper into the same number of squares. Transfer the design as in step 4.

TRANSFERRING A DESIGN

THERE ARE FIVE methods of transferring an original design to fabric. The method you choose as the most suitable will depend on the type of design and texture of the fabric. First iron the fabric, then cut it to size (see page 123). Carefully position the design on the fabric before you transfer it by your chosen method.

Drawing freehand

Designs can be drawn directly onto the right side of fabric with a pencil or embroidery marker – a fine-tipped water-soluble pen. Any lines that show afterward can be removed by damping the fabric. In the case of sheer fabrics such as organdy, muslin, or voile, draw the design on paper and go over the lines with a medium black felt-tip pen. When the ink is dry, place the fabric over the paper, and trace the design onto the fabric.

Hot-iron transfer

Copy your design onto tracing paper. Turn the paper over and trace the lines with an embroidery-transfer pencil. Position the paper, transfer side down, on the fabric, and pin together. With an iron on low heat, press down for a few seconds; do not move the iron because this may cause smudges. Before unpinning, pull back a corner of the tracing paper to check that the transfer is visible on the fabric.

Basting through tissue paper

This method is suitable for coarse fabric. Trace the design onto white tissue paper and pin in position on the fabric. Baste over the traced lines, through the paper and fabric, using small uniform stitches. Gently tear off tissue paper. If it doesn't come away easily, gently score the basting lines with a needle. When you have completed the embroidery, remove the basting stitches with tweezers.

Tracing with dressmaker's carbon paper

Dressmaker's carbon paper is made especially for use on fabrics, and is nothing like stationery carbon paper. It works best on smooth fabrics. Use a light colour on a dark fabric, and a dark colour on a light fabric. Draw the design on thin paper. Place the carbon paper, ink side down, between the fabric and the design. Pin together at the corners, or hold down firmly with one hand. Trace over all the lines of the design with a tracing wheel, or a hard-pointed object, pressing down firmly. Check that you haven't missed any lines before you remove the design and the carbon paper.

Tracing-paper templates

This is a way of transferring simple shapes. It works well on any type of fabric, and is particularly useful for repeating motifs. Draw the design onto thick tracing paper and cut out each separate piece. Pin all the shapes in position on the fabric. Draw around them if the fabric is smooth or baste around them if the fabric is coarse. Use the templates again for a repeating motif. Use clear plastic for a more durable, re-useable template.

HEIRLOOM STITCHES

THROUGHOUT THE AGES, and in every culture, people have made use of needle and thread to create a wide range of decorative textiles – to be worn, used, or displayed. These varied examples from Europe, North America, and the Far East – demonstrating the effects of different stitches – can be used as inspiration for your own imaginative efforts.

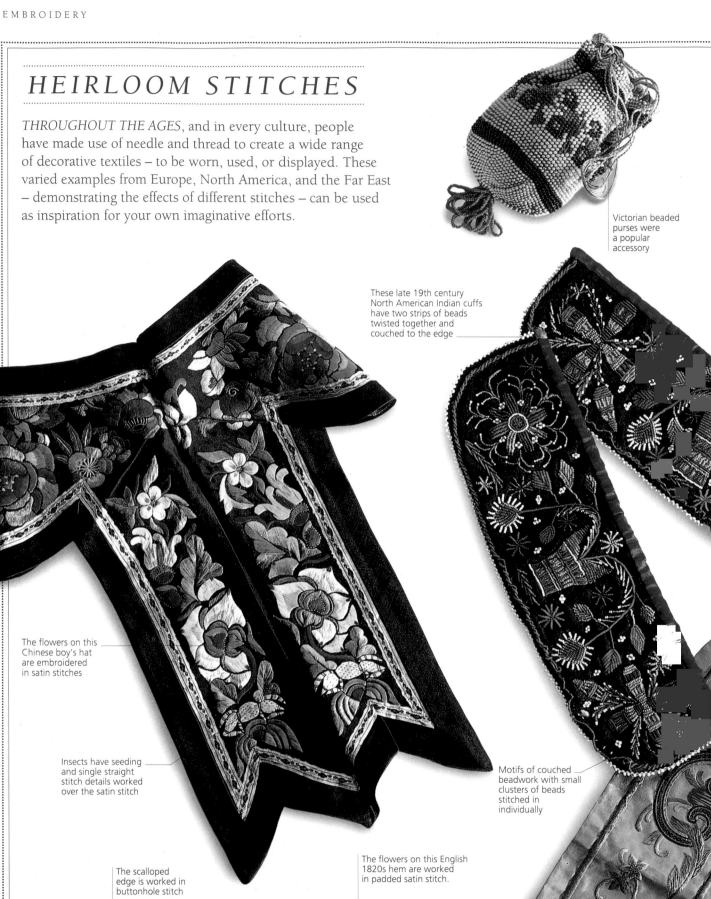

Victorian beaded purses were a popular accessory

These late 19th century North American Indian cuffs have two strips of beads twisted together and couched to the edge

The flowers on this Chinese boy's hat are embroidered in satin stitches

Insects have seeding and single straight stitch details worked over the satin stitch

Motifs of couched beadwork with small clusters of beads stitched in individually

The scalloped edge is worked in buttonhole stitch

The flowers on this English 1820s hem are worked in padded satin stitch.

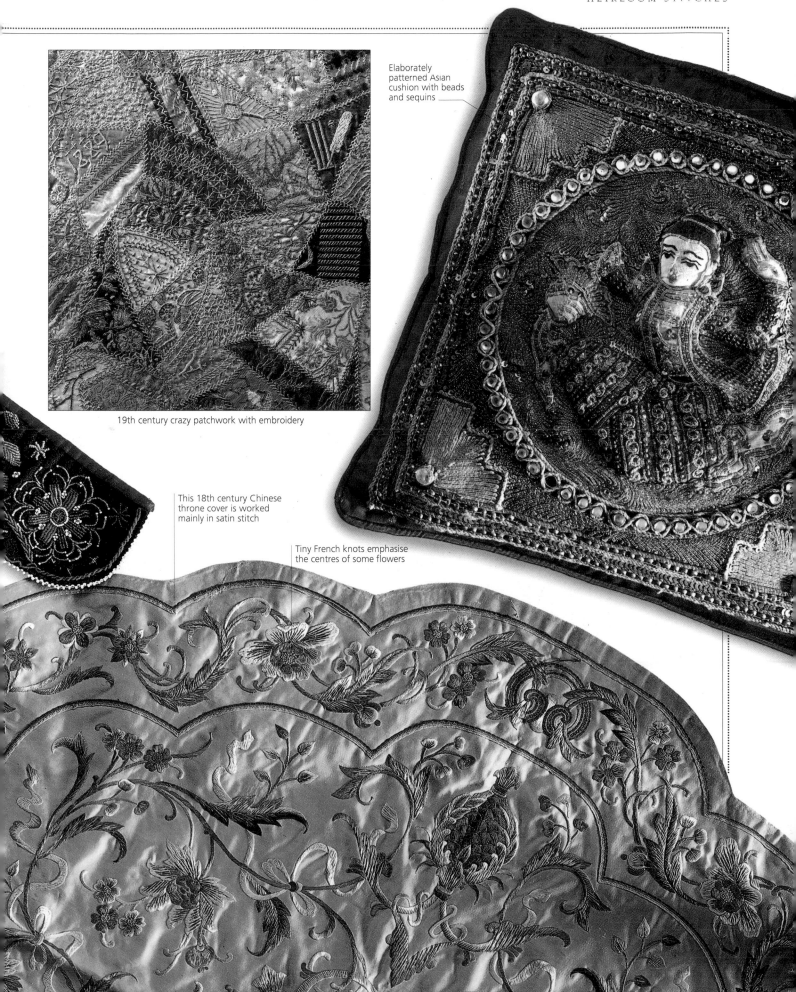

19th century crazy patchwork with embroidery

Elaborately patterned Asian cushion with beads and sequins

This 18th century Chinese throne cover is worked mainly in satin stitch

Tiny French knots emphasise the centres of some flowers

FLAT STITCHES

IT MAY SEEM there is an infinite variety of embroidery stitches. In fact, they are all variations on a few basic stitches, categorised into four groups: flat stitches, crossed stitches, looped stitches, and knot stitches.

The flat stitches are perhaps the simplest and easiest to learn; those shown here are based on two of the oldest known stitches: running stitch and backstitch. They are all formed with flat, straight stitches. The stitches can be worked in a number of different sizes, grouped with other stitches in varying combinations, or worked in different directions to form borders, outlines, and blocks of colour in your designs.

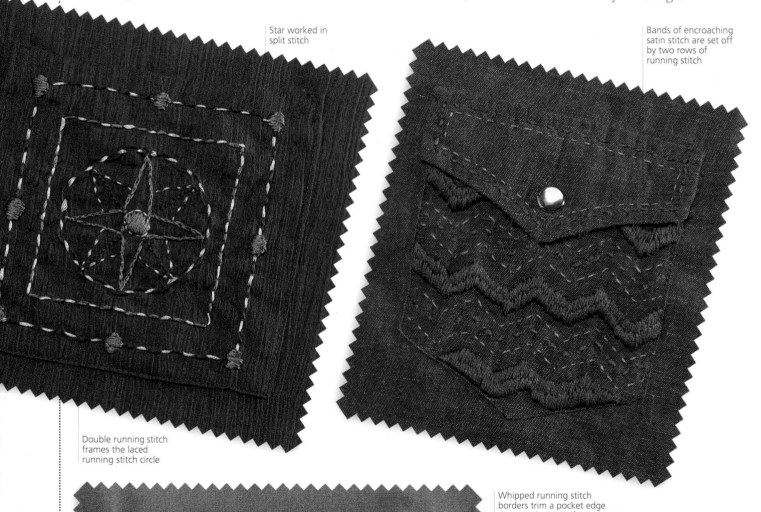

Star worked in
split stitch

Bands of encroaching
satin stitch are set off
by two rows of
running stitch

Double running stitch
frames the laced
running stitch circle

Whipped running stitch
borders trim a pocket edge
decorated with half sun shapes
worked in straight stitches

EMBROIDERED SHIRT POCKETS

Shirt pockets provide an ideal area to decorate with simple or elaborate embroidery motifs. Initials and monograms are the classic embellishment for pockets, but why not let your imagination have free rein: use a variety of stitches worked together to add pattern and colour to shirt pockets for all the family and create a unique effect.

Running stitch

Take several small, even stitches at one time. The stitches on the wrong side of the fabric are usually half the size or less of the stitches on the right side.

Laced running stitch

Lace the running stitches with a round-pointed needle by sliding it between the stitches and the fabric. Take the needle alternately through the bottom of one stitch and then the top of the next stitch. Do not pick up any fabric.

Whipped running stitch

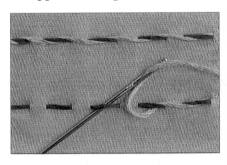

Work a row of running stitches. With a round-pointed needle, weave contrasting thread through each stitch from top to bottom, sliding the needle between the stitches and the fabric. Do not pick up any fabric.

Double running stitch

Work a row of running stitches. In same direction, work a second row, in same or a contrasting colour, to fill spaces between stitches in first row.

Backstitch

Take a small backward stitch, and bring the needle through to the right side again in front of the stitch you just made. Take another backward stitch, inserting the needle at the point where the first stitch stops. Keep the length of the stitches even.

Stem stitch

Work from left to right, taking regular, slanted backstitches. The thread should always emerge slightly above the previous stitch.

Encroaching satin stitch

Work the first row as for satin stitch. Work subsequent rows so that the head of the new stitch is between the bases of the stitches above.

Split stitch

Work in the same way as stem stitch, but the thread of the new stitch should split the thread of the previous stitch.

Straight stitch

These single, spaced stitches may vary in size. Do not make them too long or too loose.

Satin stitch

Work the straight stitches against each other to completely fill area. Make sure stitches are fairly short and uniform.

Seed stitch

Work very small uniform stitches to cover area to be filled, changing stitch direction as desired. For a stronger effect, work two stitches close together instead.

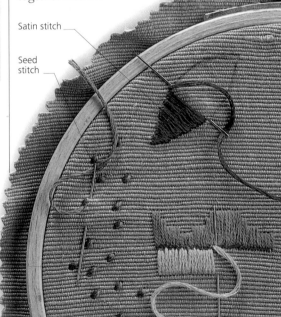

Satin stitch

Seed stitch

Encroaching satin stitch

CROSSED STITCHES

BASIC CROSS STITCH is probably the most popular of all the embroidery stitches; it is quick and easy to master, and can be worked singly or in rows. One stitch fills a small square. This means that designs can be worked out in grid form; it is simple to work out your own design on graph paper, shading the squares with coloured pencils.

There is a wide variety of crossed stitches, and all are formed by stitches crossing each other at differing angles. To work a neat row of crossed stitches, the head and base of each stitch should be the same number of rows apart. If the threads in the fabric are too fine to count, work the stitches between two lines of basting stitches and remove them afterward.

EMBROIDERED HANDKERCHIEFS

A few simple cross stitch patterns can enliven a plain or printed handkerchief and make an attractive, personal gift.

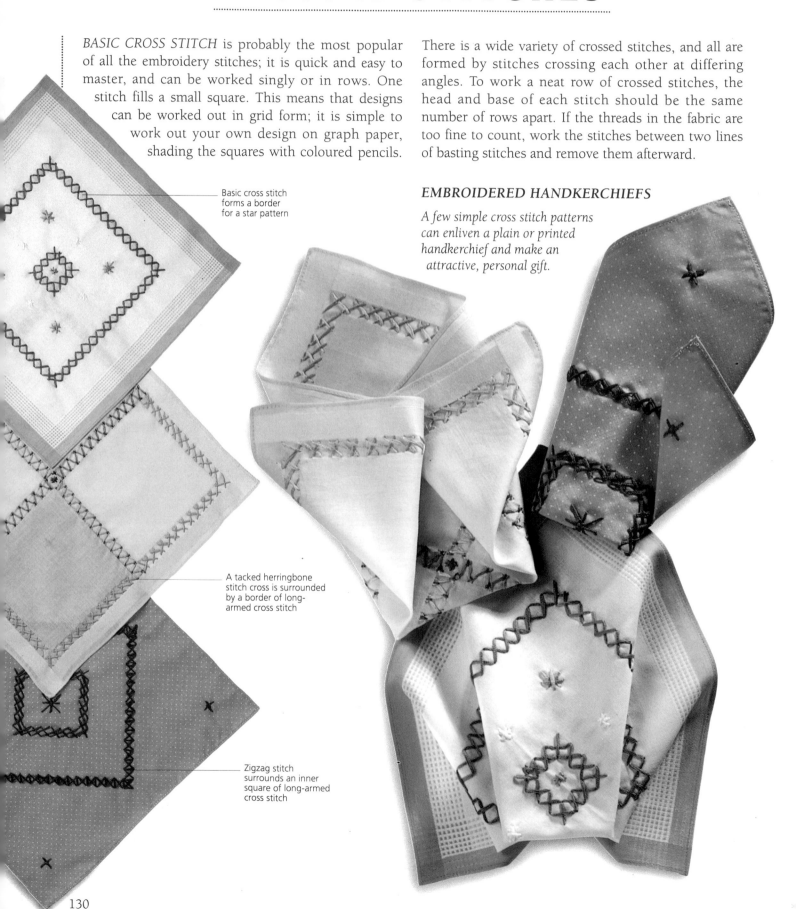

Basic cross stitch forms a border for a star pattern

A tacked herringbone stitch cross is surrounded by a border of long-armed cross stitch

Zigzag stitch surrounds an inner square of long-armed cross stitch

Basic cross stitch

1 Work one or more evenly spaced diagonal stitches in one direction.

2 Cover with one or more diagonal stitches worked in opposite direction.

Long-armed cross stitch

1 Bring the needle through at the stitch base line and take a long diagonal stitch to the right, at desired height of stitches. Measure the diagonal stitch, and bring out needle half this distance to the left, on the top line.

2 Take a diagonal stitch to base line, insert needle directly below the point where needle was inserted on top line. Bring needle out directly below the point where it emerged on the top line.

A wide variety of star shapes can be created using crossed stitches

Herringbone stitch

Work from left to right. Bring needle out on base line, and insert it on top line, a little to the right. Take a small stitch to the left along top line. Then, insert the needle on base line directly below the point where needle first entered. Thread should be above the needle. Keep the spacing even.

Tacked herringbone stitch

Work a row of herringbone stitch. In a contrasting coloured thread, working from right to left, sew each cross together with a small vertical stitch.

Closed herringbone stitch

Work in the same way as herringbone stitch but with no spaces left between the stitches. The diagonals should touch at the top and bottom.

Basket stitch (Step 1)

Basket stitch (Step 2)

Basket stitch

1 Work from left to right. Take a diagonal stitch from the base line to the top line, with the needle inserted vertically downward through the design lines.

2 Take a vertical downward stitch to the left and into the same holes as the two previous crossed stitches.

Zigzag stitch

1 Work from right to left. Take alternate upright and long diagonal stitches to the end of the row.

2 Work from left to right. Take upright stitches into the same holes as the previous upright stitches, and reverse the direction of the diagonal stitches so they cross each other.

131

LOOPED STITCHES

CHAIN STITCH IS the most important of the looped stitches. It is an extremely versatile stitch, which can be worked in thick yarns or fine silk threads.

All the stitches in this group are formed from loops that are held in place with small stitches. They can be used both for outlining and for filling shapes. When used as filling stitches, they are generally worked in rows, and stitched in the same direction, to create an all over texture.

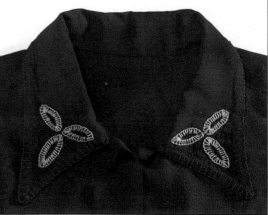

EMBROIDERED SHIRT COLLARS

Shirt collars provide endless opportunity for imaginative stitch decoration. Here, open Cretan stitch is worked in rows to produce a lattice trimmed with closed Cretan stitch and detached chain stitch (above). Blanket stitch trims the edge and forms shapes decorated with feather stitch and open chain stitch (below).

Lazy daisy flowers and feather stitch stems decorate this shirt collar and front

The buttons each have a lazy daisy to match the collar

Chain stitch

Bring the needle out at the position for the first stitch. Loop thread and hold it down with your left thumb. Insert the needle where it first emerged, and bring the tip out a short distance below this point. Keep the thread under the tip of the needle, and pull the needle through. To make the next stitch, insert the needle into the hole from which it has just emerged.

Lazy daisy stitch (detached chain stitch)

Work a single chain stitch, as described above. To secure the stitch, insert the needle just below the base of the loop and bring it out at the position for the next chain stitch.

Blanket stitch

Work from left to right. Bring the thread out at the position for the looped edging. Insert the needle above and a little to the left of this point as shown, and take a straight downward stitch, with the thread under the tip of the needle. Pull up the stitch to form the loop, and repeat.

Chequered chain stitch

Thread the needle with two contrasting coloured threads. Work as for chain stitch, keeping the thread not in use above the point of the needle.

Open chain stitch (ladder stitch)

Bring needle out at left guideline. Hold thread down with left thumb, and insert needle at right guideline, opposite point where thread emerged. Bring needle out again at left guideline, with thread under needle. Continue anchoring right side as for left.

Feather stitch

Work vertically from top to bottom. Bring needle out at top centre. Hold thread down with your left thumb, and insert needle to right and slightly below. Take a small slanting stitch toward the centre, with thread under needle. Insert needle again on left side, and take a slanting stitch down toward the centre, with thread under needle. Work looped stitches to left and right alternately.

Double feather stitch (fancy)

This is worked in the same way as feather stitch, but two stitches are taken instead of one.

Closed Cretan stitch

1 Bring the needle through centrally at left side of shape. Take a small stitch on the lower guideline, with the needle pointing inwards and the thread under the tip of the needle.

2 Take a small stitch on upper guideline, with needle pointing inwards and thread under needle. Repeat steps 1 and 2 until shape is filled.

Open Cretan stitch

Work by making short vertical stitches downwards and upwards alternately, with the thread always held down to the right under the tip of the needle.

Open Cretan stitch

Feather stitch

Double feather stitch (fancy)

KNOTTED STITCHES

KNOTTED STITCHES PRODUCE various exciting surface textures and look particularly attractive when worked with thick thread. They are formed by looping the thread around the needle, and then pulling the needle through the loops to form a knot or twist on the surface of the fabric.

If you haven't tried a particular knotted stitch before, work several samples on a piece of scrap fabric first because it takes a little practice to get the tension of the knots even. To avoid your thread getting into tangles, always hold the loops of thread down with your left thumb when you pull the needle through.

Scroll stitch and French knots are edged with a row of zigzag coral stitch

EMBROIDERED SHIRT CUFFS

Decorating shirt cuffs can be as subtle or as extrovert as you like. Cream and white embroidery on a white shirt can add just a hint of luxury or contrasting colours can be used according to your mood. Either way you can create an entirely individual look.

Zigzag coral stitch rows are decorated with arrows of bullion knots

Knotted chain stitch rows border small bullion knots and four-legged knot stitches

French knot

Bring out the needle at the position for the knot. Twist the needle 2 or 3 times around the thread. Turn the needle and insert it just above where the thread first emerged. Holding the working thread taut with the left hand, pull the thread through to the back of the work. For a larger knot, use 2 or more strands of thread.

Bullion knot

Make a backstitch, the size of the knot required, bringing the needle half way out at the point where it first emerged. Twist the thread around needle as many times as required to equal the size of backstitch. Holding your left thumb on the coiled thread, pull the needle through. Then turn the needle back to where it was inserted, and pull the thread through to the back of the work, so that the bullion knot lies flat.

Scroll stitch

Bring the needle out on the guideline. Loop thread to right. Insert needle in loop, and over working thread as shown. Pull through to form a knot.

Coral stitch

Work from right to left. Bring the thread out, and hold it with your left thumb along the line to be worked. Take a small stitch under and over the looped working thread. Pull thread through to form knot. The spacing of the knots can be varied as required. *(See top right.)*

Zigzag coral stitch

Bring the needle out at top left. Lay thread across fabric to right margin to form first diagonal. Loop the thread; insert the needle and take a small diagonal stitch, bringing the needle tip out at the centre of the loop. Pull the needle through the loop to form the knot. Lay the thread across the fabric to left margin for second diagonal, and repeat knot stitch. Continue knotting at right and left margins alternately for form zigzag.

Four-legged knot stitch

1 Take a vertical stitch and bring the needle out at centre right, ready to form horizontal leg of cross.

2 Slide the needle between the vertical stitch and the fabric, without picking up any fabric. Loop the thread around the needle, and pull the needle through to form the knot. Take a small horizontal stitch to left, to form last leg of cross *(see above right)*.

Zigzag coral stitch

Knotted chain stitch (link stitch)

1 Take an upward diagonal stitch, and bring out the needle directly below the point where it has just been inserted. Slide the needle between the stitch and the fabric, keeping the looped thread on the left.

2 Loop the working thread under the tip of the needle and pull through to form the knot.

135

COUCHING & LAIDWORK

COUCHING IS A quick and easy method of laying one strand of thread on the fabric, and catching it down at intervals with a separate strand of thread. More than one strand can be laid down at a time to create bold outlines. Textured and metallic threads, which won't pass through the fabric easily, can be laid down with finer thread. It is also useful for filling large shapes rapidly to produce solid areas of colour.

Laidwork is really a continuation of couching. Long threads (grid threads) are laid on the fabric in a grid pattern, and then secured at the intersections with a separate thread. The method produces quite complicated looking lattice filling stitches.

For the best results, use an embroidery frame in order to keep the fabric taut, and make sure that the grid threads are evenly spaced.

Basic method

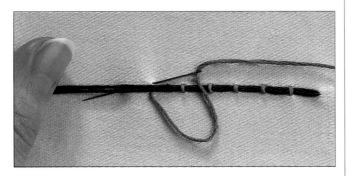

Work from right to left. Bring out the strand to be laid and use your left thumb to hold it in place. Bring out the working (couching) thread just below the laid strand. Take a vertical stitch over the laid strand, bringing the needle out to the left, below the laid strand, ready for the next stitch. At the end of the line, take both the couching thread and laid thread through to back of work, and secure.

To fill an area

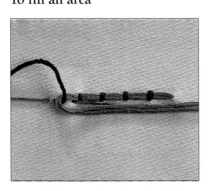

1 Work a line of basic couching. At the end of the line, turn the loose laid thread to the right and take a horizontal stitch across the turning point.

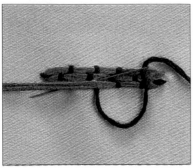

2 Turn the work upside-down and couch second row of threads next to first, placing stitches between those on the previous row. Continue until the area is filled.

To couch a circle

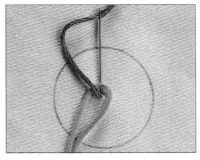

1 Bring out the needle with the laid thread at the centre of the circle, and pass the needle through the looped couching thread.

2 Insert the needle at the centre to secure the laid thread. With your left thumb, guide the laid thread into a spiral, and couch over it.

3 Make sure all the couching stitches line up as shown, as if on the spokes of a wheel. Bring threads to the back and secure.

Variations

Couching can be worked with two contrasting coloured threads, and with open chain stitch as shown here (*see page 133*).

Squared laidwork (open lattice)

1 To lay horizontal threads, bring needle out at top left-hand guideline, lay thread across to opposite point on right guideline. Insert needle, and bring it out below

this stitch, ready to form next horizontal thread. Continue back and forth until all horizontal threads are laid, keeping tension fairly loose so that stitches do not pucker. At end of last stitch, take thread to back of work and secure.

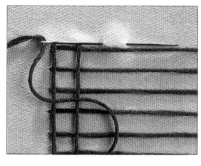

2 To create the lattice effect, lay the vertical stitches across the horizontal threads in the same manner.

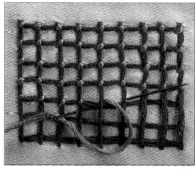

3 Bring out the couching thread at the top left corner of the grid. Secure each intersection of the vertical and horizontal threads with a small, slanting stitch.

Variations

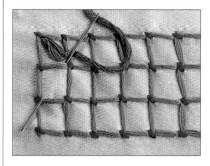

1 Make the squared laidwork, and make a series of 4 detached chain stitches (*see page 133*) within 4 lattice squares. Make the anchoring stitch at the centre of the 4 squares.

2 Work any further chain-stitch groups with a lattice space between them.

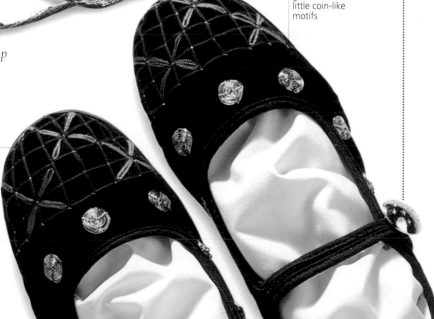

EMBROIDERED PARTY SHOES

Plain black velvet children's shoes can be dressed up with embroidery and circles couched in metallic thread – and transformed into sophisticated party slippers for that first grown-up evening out. The same techniques in cotton thread could be applied to canvas shoes for the beach.

Spirals of metallic gold thread make little coin-like motifs

Lazy daisy stitch decorates an open lattice of laidwork

ALPHABETS & MONOGRAMS

EMBROIDERED INITIALS, MONOGRAMS, and messages are used to personalise clothes and gifts. Cross stitch is the traditional way to work the name and date on samplers, and is still the most popular lettering stitch for embroidered pictures.

The smooth, even look of satin stitch is perfect for scrolled initials on, for example, table linen, pillowcases, towels, and handkerchiefs. You can use techniques such as padded satin stitch, braidwork, and openwork to add variety to your lettering designs.

Any design incorporating lettering should be easy to read. You can trace examples of alphabets from books and magazines. Transfer the outlines of the letters on to your background fabric. If possible, work on a frame or hoop so that you can keep the stitches even and prevent the fabric from puckering.

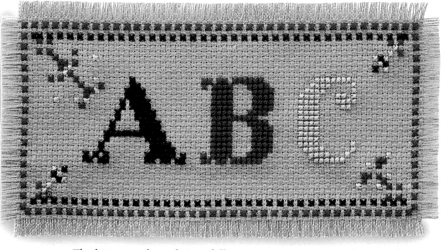

The letters and words in a full name or message must be spaced out carefully. Trace all the words onto paper. Then hold the paper away from you and study the effect. If necessary, adjust the spacing before transferring the lettering to the fabric.

SATIN STITCHES

Two variations on satin stitch (see page 129) are ideal for working initials. Before you embark on a monogram, practice working the shapes to obtain a smooth outline.

Satin stitch initials personalise a blue handkerchief

Padded satin stitch

Raising the satin stitch above the surface of the fabric gives it more definition. Fill in outlined area with satin stitch. Then, working in a different direction, add a 2nd layer of satin stitch.

Negative satin stitch

This is an effective technique for monograms and crests. Choose a simple, well defined letter shape. Work the background in satin stitch, leaving the letters in unstitched fabric. Outline the design in stem stitch (*see page 129*) or chain stitch (*see page 133*).

BRAID AND RIBBON LETTERING

For joined lettering, try to plan out the design so that only one piece of ribbon or braid is required for the complete design. If you must add a separate piece, place it underneath the ribbon or braid previously laid down. Raised braids can be couched in a matching or contrasting colour.

Fine ribbon and braid can be used for lettering. Hem the short ends by pressing the narrow raw edges to the wrong side. Stitch in place down the centre with small running stitches or backstitches.

When you reach an intersection, leave a gap in the running stitches. On the return, thread the ribbon or braid through this gap, and continue stitching.

A wide braid or double-sided ribbon may be twisted over to form angles and corners for straight-sided lettering. Baste in position and press. Then stitch along both edges so that they lie flat and even.

OPENWORK

Satin stitch lettering looks very attractive against a fine openwork background. Work the lettering first, then the background, and outline the letters in stem stitch. Two useful openwork filling stitches are shown below.

Cloud filling stitch

Work rows of small, vertical, evenly spaced stitches across the background area. Use a tapestry needle to lace a second thread through these stitches to form a trellis pattern.

Wave stitch

1 Work a row of small, evenly spaced vertical stitches. Bring out needle below and to the right of last stitch, and work a row of arched loops by passing the needle under the vertical stitches.

2 On following rows, continue to make arched loops by passing the needle under the pairs of stitch bases in the row directly above.

A background of openwork stitches emphasises the satin stitch letter

SAMPLERS

The word sampler comes from the Latin "exemplum", meaning an example to be followed. In the 16th and 17th century, samplers were worked by the high born ladies of the European courts as a method of recording stitches and designs. In the 18th to 19th century they became the province of the school room, to teach the alphabet, a skill necessary for marking bed linen. The designs became more stylised, with decorative borders, religious scripts, and pictures of the home or school. The name of the young embroiderer and the date were usually incorporated.

Detail from a modern cross-stitch sampler

The strawberry (above) is still a favourite motif. It was first used as a Christian symbol denoting perfect righteousness. Flowers and fruit (right) are worked in cross stitch, stem stitch, and satin stitch

A house motif from a modern cross-stitch sampler with straight-stitch detail

Alphabet detail from a modern sampler, based on an 1822 design

Alphabets in cross stitch and Algerian-eye stitch are divided by narrow bands of pulled threadwork

Crowns and coronets were originally embroidered on the household linens of the aristocracy. By the 18th century, they had become a traditional motif for filling awkward spaces in a design

A typical cross-stitch house motif

The peacock was a symbol of eternal life in ancient Christian art, and became a popular sampler motif

SCHOOLROOM SAMPLER

All the details shown here are from a splendid Scottish sampler made by Catherine Gairns in 1831. Two-thirds of it is packed with lettering, and the rest is filled with traditional motifs. It was necessary for a young girl to learn how to embroider lettering so that she could mark her household linens.

19th century schoolroom samplers were worked almost exclusively in cross stitch, called sampler stitch

PULLED THREADWORK

THIS TECHNIQUE HAS been used for centuries to decorate clothing and household items. Stitches are looped around the fabric threads and pulled tightly, to make holes. This combination of stitches and holes creates lacy patterns. Threadwork was traditionally done on cream or white linen with matching thread. Today, we have a wider choice of fabrics, and many of the patterns look lovely when worked in colours.

TOOLS AND MATERIALS

Work on an even-weave fabric, using a thread that is similar in weight to a single thread of the fabric you are using. The working thread must be fairly strong. Pearl cotton, soft embroidery cotton, and crochet cotton are all suitable. Use a round-pointed needle to exaggerate the holes, but make sure it will still slip between the threads easily. Working in a frame isn't essential, but it helps to have both hands free to count the threads and pull the stitches tight.

BASIC WORKING METHOD

If necessary, finish raw edges to prevent fraying (see page 123). Run a line of basting stitches in a contrasting colour across the length and width of the fabric to help you count the stitches, and remove them when the work is finished.

Work the stitch patterns in rows, starting at the centre and moving outward. Count the fabric threads carefully, and always pull the embroidery thread tight.

Secure the first thread with a few backstitches on the wrong side of the work. Then, when you have finished a row of the pattern, unpick the backstitches, and weave the loose thread under some of the embroidery stitches. Secure all other threads by weaving the ends under worked stitches.

The size of stitches can be varied by stitching over more or fewer threads than the numbers stated in the instructions.

Pin stitch hem

1 Bring needle out on right side, 2 threads above folded hem. Insert needle 2 threads down (through single thickness) just under hem, and bring it out 4 threads to left. Backstitch over same 4 threads and pull tight.

2 Take a 2nd backstitch over the 4 threads, and bring out needle 2 stitches above hemline to start next stitch sequence.

TO MITRE THE CORNERS ON A HEM

If you want to make place mats or napkins with pulled-threadwork borders, you must mitre the corners of the hems so that they lie flat.

1 Press raw edges to wrong side of fabric. Turn under folded edge again by the same amount to form a double hem, and press. Open fabric.

2 Crease marks will form 4 squares at each corner. Taking one corner at a time, cut off corner by cutting inner square in half diagonally. Fold in sides so that edges just meet at inner corner of inner square. Turn under raw edges.

3 Refold and baste hems. Slip stitch mitred corner edges. Machine or hand stitch hem.

Coil filling stitch

1 Bring out needle on right side. Take 2 vertical satin stitches across 4 threads, into same holes. Take a 3rd satin stitch into top hole, bringing out needle 4 threads to left, on base line of stitches just worked.

2 To begin next row, bring needle out 4 threads below and 2 threads to right of stitches just worked. Continue working rows from right to left, and left to right, alternately.

Honeycomb stitch

1 Bring the needle out on right side of work. Insert needle 3 threads to right, and bring it out 3 threads down. Take a backstitch into base of stitch just made, and bring it out 3 threads down. Insert needle 3 threads to the left, and bring it out 3 threads down. Take a backstitch into the base of stitch just made, and bring it out 3 threads down. Repeat sequence to end of row.

2 Turn the work at end of row, and embroider the next row in the same way.

Honeycomb stitch forms a regular lattice filling, and is worked from top to bottom

Faggot stitch

1 Bring out needle on right side of fabric. Work diagonally, and take horizontal and then vertical stitches over an equal number of threads alternately.

2 On the next row, make squares by working into the holes of the previous row.

Coil filling stitch is made from groups of satin stitches worked in horizontal rows

Faggot stitch is a useful basic stitch for patterning and background filling

Chessboard filling stitch

1 Work 3 rows of satin stitch from left to right, and right to left, alternately. Each satin stitch is worked over 3 threads, and each block is made up of 3 rows of 8 stitches.

2 At end of 3rd row, turn the work as shown, and bring out needle 3 vertical threads down and one horizontal thread to the left, ready to start next block.

3 Repeat step 1. Work all other blocks in the same way, turning the work after each to change the stitch direction.

Diagonal raised band

1 Bring needle out on right side at bottom right-hand corner. Insert it 6 threads up to form first vertical stitch, and bring it out 3 threads down and 3 to left. Pull thread very tight to make a ridged effect. Repeat.

2 Insert needle 6 threads to right to form first horizontal stitch, and bring it out 3 threads down and 3 to left, ready to start next stitch. Pull tight. Repeat.

Wave stitch

1 Working from right to left, bring needle out on right side of work, and insert it 4 threads down and 2 to the right, to form the first diagonal stitch. Bring it out 4 threads to the left and insert it at the point where the thread emerged.

2 Bring out the needle, 4 threads to the left in line with top of V-shape formed, to start the next diagonal stitch. Repeat to end of row.

3 To start second row, insert needle 8 threads down from top of V-shape formed. Turn the work upside-down and work second row of zigzags as in step 1.

Chessboard filling stitch is shown in blue, diagonal raised band in red, and wave stitch in green

DRAWN THREADWORK BORDERS

IN DRAWN THREADWORK, some of the warp and weft threads of the fabric are removed, and the remaining threads in the drawn area can then be pulled together in clusters with the embroidery thread to form open patterns. The technique is used mainly for border decorations on tablecloths and place mats.

TOOLS AND MATERIALS

If you are a beginner, you will find it easier to remove the threads from a coarse open-weave fabric rather than a closely woven one. To hem stitch the border, use stranded cotton or pearl cotton similar in thickness to a single thread of the ground fabric you have chosen, and work with a round-pointed tapestry needle.

How to remove the fabric threads

1 Cut your chosen fabric to size, allowing for a mitred hem around all 4 sides *(see page 142)*. Mark out the hem allowance with a row of basting stitches or an embroidery marker. Decide on the number of threads that will make up the depth of the border and mark the inner border line, then mark the centre point on each side.

2 Using a pair of sharp embroidery scissors, carefully cut horizontal fabric threads at the centre mark on each side of border. Gently ease out threads with a tapestry needle until you reach corners.

3 Trim loose thread ends. Then fold them back, and backstitch over ends. Remove basting stitches. Turn up hem allowance, and baste in position, ready for hem stitching.

Hem stitch

1 Work from left to right on the wrong side of the fabric. Bring needle out 2 threads below hem, and opposite first loose thread in border. Take a diagonal stitch to right, and insert needle under first 3 or more loose threads in border; pull together.

2 Take vertical stitch, bringing needle out on wrong side, to right of bundle and 2 threads below hem. Repeat.

Ladder stitch variation

Complete a row of hem stitch. Turn the work upside-down and work hem stitch along opposite edge of border, catching the same loose threads into bundles, forming a ladder-like pattern.

To finish corners

If the open squares at the corners are small, they can be left as they are, or they can be reinforced with blanket stitch *(see page 133)*.

SMOCKING

AN ATTRACTIVE WAY of reducing the fullness in fabric is to gather material into tiny pleats, and work over them with embroidery stitches. The patterns can be worked in one stitch only or several stitches can be combined into elaborate patterns, according to the effect desired. When the embroidery is finished, the gathering stitches are removed and the fabric relaxes slightly. Extensively used in the eighteenth and nineteenth centuries to fashion comfortable garments for rural working men, it remains a popular and interesting way to shape and decorate clothes for children and adults. It also can be used for accessories, and all sorts of items for the home such as cushions, lampshades, and curtains.

MATERIALS AND TOOLS

Any type of fabric can be smocked if it is supple enough to be gathered. Regular repeating patterns, such as checks and dots, are popular because the pattern can be used as a guideline for the gathering stitches. Work with a crewel needle and strong cotton thread for the gathering stitches. The embroidery can be worked in either embroidery floss, pearl cotton, or matte embroidery cotton.

CUTTING THE FABRIC

Smocking is always worked before a garment is made up. The amount of fabric needed is usually three times the finished width of the smocked area. Less fabric is required when working on a thick material.

GATHERING THE FABRIC

Work the rows of gathering stitches from right to left, on the wrong side of the fabric, using a strongly contrasting thread. The contrast colour will help you remove the gathering thread easily when the smocking is finished.

To gather fabric

1 Cut a length of thread, longer than row of dots to be gathered, and tie a knot. Make running stitches along each row, picking up a piece of the fabric at each dot. Leave thread ends loose.

2 Pull up each gathering thread to the required width and tie together in pairs at the end of the rows. Make sure all pleats are even and that gathers are not pulled too tightly.

MARKING THE FABRIC FOR GATHERING

In England, the rows for the gathering stitches are marked on the wrong side, in America, on the right. In either case, the easiest way to do this is with a smocking-dot transfer. This is an iron-on transfer with rows of equally spaced dots printed across it. The space between dots is usually 1/4 to 3/8 inch, and 3/8 to 1/2 inch between rows. In general, the finer the fabric, the closer the dots and rows. Make sure the dots are in line with the threads of the fabric, then iron in position, following the hot-iron transfer method on page 125.

To mark a curved area, such as a yoke, slash the transfer and pin in place before ironing.

You can make your own guide from thin cardboard and mark out dots in pencil. Position the points on a row of dots, and mark the next row at the base of each V.

SMOCKING STITCHES

These stitches are worked on the right side of the gathered fabric. All the stitches shown here are worked from left to right, beginning at the top left-hand corner. Make sure the embroidery thread is attached and fastened off very securely. Hold the needle parallel to the gathering threads, and take the stitches through about one-third of the depth of each pleat, to keep them elastic, and to ensure that the embroidery thread doesn't become entangled with the gathering thread. Leave the first row of gathers free of embroidery so that the smocked panel can be joined to another piece. Smocking stitches vary considerably in tension, so work a sample first to see how tight or loose a stitch will be. Intricate patterns can be made with a combination of smocking stitches, although equally impressive results can be achieved by working only one or two. Other embroidery stitches such as lazy daisy (see page 133), cross stitch (see page 131) and chain stitch (see page 133) may be worked over two or more pleats between the rows of smocking for extra decoration. The gaps between rows should not be too wide or the pleats will puff out.

Stem stitch

Working it like a basic stem stitch, use this stitch for the top row of smocking. Bring needle out to left of first fold. Take a stitch through top of each fold, keeping thread below needle.

Cable stitch

1 Bring needle out to left of first fold. With the thread below the needle, take a stitch over the 2nd fold, and bring the needle out between the first and 2nd folds.

2 With thread above needle, take a stitch over 3rd fold, and bring needle out between 2nd and 3rd folds. Continue to the end of the row, keeping the thread alternately above, then below, needle.

Wheat stitch

This variation of stem stitch produces a tight stitch. Work a row of stem stitch, then work a second row just below, keeping the thread above the needle to alter stitch direction.

Double cable stitch

Work one row of cable stitch, starting with the thread below the needle. Work a 2nd row underneath it, starting with the thread above the needle.

Honeycomb stitch

1 This stitch is worked across 2 lines of gathering stitches. Bring needle out at left of first fold on top of line of gathering stitches, and take a backstitch over first 2 folds to draw them together. Take a 2nd stitch over 2 folds, bringing needle out at lower line of gathering stitches, between first and 2nd fold.

2 Take a backstitch over 2nd and 3rd folds to draw them together. Take a 2nd stitch over these folds, bringing needle out at top line of gathering stitches, between 2nd and 3rd fold.

3 Continue working stitches on top and bottom lines of gathering stitches alternately.

Wave stitch

1 Work across 2 lines of gathering. Bring needle out left of first fold on top line. With thread above needle, take a stitch over 2nd fold. Bring it out between first and 2nd folds. With thread at lower line, and above needle, take stitch over 3rd fold. Bring needle out between 2nd and 3rd folds.

2 With thread below needle, take stitch over 4th fold. Bring it out between 3rd and 4th folds. With thread at top line and below needle, take a stitch over 5th fold. Bring it out between 4th and 5th folds.

3 Next row, work between 3rd line of gathering and bases of stitches above.

This drawstring bag is worked in trellis diamond and surface honeycomb stitches

Trellis diamond

1 Work one row of stem stitch in a chevron pattern between 2 lines of gathering stitches, keeping thread below needle when working up, and above needle on the way down.

2 Start at 2nd line of gathering stitches, and work another row of stem stitch chevron pattern between lines 2 and 3, inverting chevrons to form a diamond trellis.

Surface honeycomb stitch

1 Work across 2 lines of gathering. Bring the needle out to left of first fold, on the top line. With the thread above the needle, take a stitch over and to the left of the 2nd fold. With the thread at the lower line and above the needle, insert the needle between the 2nd and 3rd folds; bring it out to the left of the 2nd fold.

2 With the thread below the needle, take a stitch over 2nd and 3rd folds: Bring it out to left of 3rd. With the thread at the top line and below the needle, insert the needle between 3rd and 4th folds. Work next row between the 2nd and 3rd rows of gathering stitches.

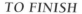

TO FINISH

When a smocked piece is finished, steam press on the wrong side, or lay a damp cloth on top and lightly pass a hot iron over the work, taking care not to flatten it. Then remove the gathering threads.

If you find that the smocking is too tight, take out the gathering stitches, lay the work wrong side on the ironing board, and pin it out to size. Steam press as above.

BEADS & SEQUINS

THROUGHOUT THE AGES, in every culture, and in every part of the world beads and sequins have been used to add extra sparkle and richness to textiles and to denote the wearer's wealth and standing. Fashions change, and today we see beading on everything from glittering evening clothes to T-shirts. However, beads and sequins can also be used creatively to highlight areas on embroidered pictures and hangings – for example, a single pearl bead looks wonderful in the centre of a flower, or two flashing green sequins can suggest a cat's eyes.

BEADING

Use an ordinary sewing needle for beads with large holes. If, however, the beads have very small holes, you will need a fine beading needle, see page 120.

Sewing on beads individually

Bring out the needle and thread the bead. If the bead is round, insert needle back through same hole. With a long shaped bead, hold down with the thumb and insert needle close to edge of bead. Repeat.

Couching rows of beads

Use two needles. Bring out first needle, and thread beads. Bring out 2nd needle close to left of first bead and take a small stitch over thread. Slide next bead up, and repeat.

Strand fringe

Tie first bead onto thread, and knot securely. (If beads are large, start with a small bead.) Thread beads for one fringe strand; secure to hem with a small backstitch. Repeat for each strand.

APPLYING SEQUINS

With matching sewing thread, sequins may be stitched on almost invisibly. An embroidery thread in a contrasting colour can add to the decorative effect.

Two-stitch method

Use to secure one or more sequins. Bring out needle and thread sequin. Take a backstitch over right edge of sequin and bring out needle at left edge. Stitch through sequin again and repeat.

Invisible stitching

Bring out needle and thread on sequin. Take a stitch over its left edge; place a 2nd sequin so that right edge covers eye of first. Bring out needle at left edge of 2nd sequin and insert needle in its eye.

Securing sequins with beads

Bring out needle; thread on a sequin and a bead. Insert needle through sequin eye and pull thread so that bead holds sequin in its place. Bring out needle at position for next sequin.

SPECIAL EFFECTS

ONCE YOU HAVE mastered the basic embroidery stitches, you might like to experiment with some of the traditional forms of embroidery that depend upon a combination of stitches to achieve a particular effect. Four of the the most popular are shown here – blackwork, whitework, stumpwork, and crewel work.

CREWEL WORK

This type of embroidery gets its name from the very fine wool yarn with which it is worked. Since it is difficult to create small, intricate stitches in wool, the designs are generally bold and free-flowing. Crewel work has always been popular for home furnishings, and also looks very decorative on clothing and accessories. Traditional themes include exotic animals, birds, flowers and trees. The basic shapes are usually worked in a simple outline stitch and then filled in with a variety of broader stitches. Choose a firm, medium-weight fabric on which to stitch your designs.

Crewel-work design

This landscape shows how outline shapes can be enhanced with textured filling stitches. Branches are worked in stem stitch, berries are French knots, and the foreground is satin stitch. Useful stitches include split and herringbone.

STUMPWORK

This is an interesting way of making embroidery more three-dimensional. It is done by combining padded appliqué and embroidery stitches. Stumpwork was very popular in the last century for decorating boxes and screens. It is also very effective on pictures and wall hangings. Choose lightweight fabrics for the best results.

Appliqué shapes are stitched to a background fabric and one end is left open for stuffing. Once the appliqué is stitched closed, you can embroider the surrounding area and the padded shapes. Raised stitches with a clearly defined surface texture – such as padded satin stitch, couching – and any of the knotted stitches combine well with padded appliqué. Instructions for the padded appliqué sachet and turkey-stitch sunflower are on page 241.

Padded appliqué

1 Cut out your appliqué shape, slightly larger than finished size, and hand stitch to right side of fabric (*see appliqué, page 200*). Leave a small section open to insert the stuffing. Push in some wadding and distribute it evenly.

2 Sew up the opening neatly by hand. The padded appliqué motif may then be left as it is or decorated with embroidery stitches or even beadwork.

French knots decorate this appliquéd heart

The petals are embroidered with seeding and couching

WHITEWORK

*The general name given to any type of
white embroidery on white fabric, whitework
is a beautiful way of decorating fine bed linen,
tablecloths, and blouses.*

When only one colour is used for both the background and the embroidery, subtle contrasts, such as the look of the thread against the fabric and the texture of the stitch, become important. Most surface stitches will be enhanced by working them in a thread with a high sheen on a matte background fabric. Bands of pulled and drawn threadwork (see pages 142 to 145) will add texture to the design. For a stronger contrast, hem sections of fabric with a close buttonhole stitch to prevent fraying, then cut away sections within the stitching. This is called cutwork, and the basic method is given below.

The pillow-case shown right is worked with high-sheen pearl cotton thread on crisp linen. It has a cutwork border, and strongly defined surface embroidery done with whip stitch and French knot. The narrow satin ribbon is threaded through a band of open chain stitch.

Cutwork border
is edged with
buttonhole stitch

Cutwork

1 This is easier to work in a frame. Outline the section of the background fabric that is to be cut away with a small running stitch in embroidery floss or cotton pearl thread.

2 Work a close buttonhole stitch in matching thread around this outline. The ridged edge of the buttonhole stitch should just cover the running stitch, as shown above.

3 From the wrong side of fabric, carefully cut out the fabric shape close to the base of the buttonhole stitching.

BLACKWORK

A form of counted-thread embroidery, blackwork depends on simple stitches worked in one colour over a precise number of fabric threads; it forms repetitive geometric patterns, and the spacing of the stitches creates dark, medium, and light areas within the design. Traditionally, the embroidery is worked in black thread on linen. It was very popular in Tudor times, and was used to decorate clothing and bed linen.

Work the design using backstitch, running stitch, double running stitch, and cross stitches for stars. Outline different patterned shapes in chain stitch, stem stitch, or couching. Work small parts of the design in satin stitch to create solid black areas to contrast with lighter, open-stitch patterns. A combination of straight and crossed stitches can be used to form elaborate borders and large motifs, as shown below.

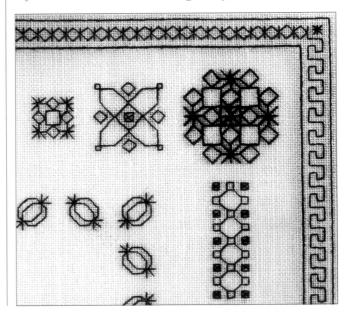

BLOCKING & MOUNTING

ONCE FINISHED, MOST pieces of embroidery only require a light pressing on the wrong side of the background fabric. However, if the work has become badly distorted, it will need to be soaked and blocked to remove any creases and to ease it back into shape. There are as many ways to display finished work as there are different types of embroidery. If you plan on framing your work, it must first be mounted.

PRESSING

Never put an iron on the right side of a piece of embroidery as it will flatten the stitches, and may scorch the piece.

Place embroidery, right side down, on a padded surface. Cover it with a damp or dry cloth (depending on type of fabric). With iron at correct setting for fabric, press very gently all over.

BLOCKING

Check that the background fabric and the yarns will not run when wet (see page 153), otherwise the piece will have to be blocked dry. With modern fabrics this isn't usually a problem, but care should be taken with old or ethnic fabrics.

1 Soak the embroidery in cold water, and roll it in a clean towel to remove the excess moisture.

2 Cover a soft board with plastic or cotton, and pin it in position. Lay the embroidery on top of the covered board, right side up. Using steel pins, pin the embroidery at each corner, keeping the pins outside the area of work. Stretch the piece, and pin at 2.5cm (1 in) intervals, starting at the centre. Leave pinned until completely dry.

MOUNTING

To frame embroidery, the piece first must be mounted on hardboard. The board should be cut to the same size as the work, or slightly larger to accommodate a cardboard mat or a frame with an edge that might hide some of the stitching.

1 Press the finished embroidery, and lay it right side down on a table. Centre the hardboard on top, and turn the edges of the fabric to the back of the board.

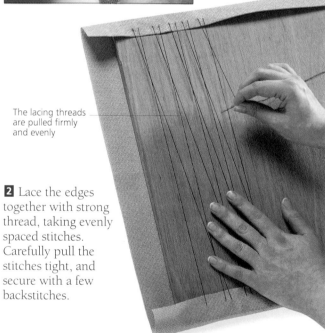

The lacing threads are pulled firmly and evenly

2 Lace the edges together with strong thread, taking evenly spaced stitches. Carefully pull the stitches tight, and secure with a few backstitches.

3 Fold and lace the side edges, in the same way, pulling evenly so that the work is stretched smoothly across the board.

CLEANING

DUST, DIRT AND moths are the three main enemies of embroidered textiles. Regular inspection, a gentle wash when necessary, and careful storage will guard against all three. If the embroidery is delicate, it is better to play it safe; take it to a specialist rather than attempting to clean it yourself.

HAND WASHING

Most modern embroidery threads are colourfast, but you should still make a test before washing. You can either test scraps of the threads in hot water, or press a wet cotton ball against the wrong side of the work, and check for staining. Dark colours and shades of red are the most likely to run; if this happens, take the piece to a reliable dry cleaner.

If the embroidery is lined, the lining should be removed and washed separately. It is a good idea to measure your upholstery covers before washing so that they can be blocked to the correct size afterward.

1 Press a wet ball of cotton onto the threads to see if any dye runs into it. If it does, do not wash.

2 Wash all embroideries very gently by hand in lukewarm water, using pure soap flakes or a mild detergent recommended for delicate fabrics. Do not rub the piece; rinse several times in lukewarm water until the water runs clear. The final rinse should be in cold water.

3 Roll up the embroidery in a thick towel to blot the excess water. Repeat if necessary.

4 Pull gently to shape, or block if necessary, and dry flat at room temperature.

STORAGE

If a piece is not in use, wrap it in plenty of acid free paper and store flat, or roll it up with tissue paper. If it has to be folded, rearrange the piece from time to time so that the creases don't set. Check the embroidery for moths and mildew, and clean it when necessary.

DUST

The best way to keep dust at bay is with a vacuum cleaner. Use an upholstery attachment and keep the nozzle just above the surface of the work. Dust between raised stitches can be gently removed with a sable paint brush.

Brush gently over the stitches to avoid raising the pile

NEEDLEPOINT

Stitches worked on canvas can be used to create
household articles that are both beautiful and
long-lasting. Simple to work, easily portable, and requiring
little equipment, needlepoint is suitable for many different
types of design making it one of the most popular crafts.
Historically, needlepointers usually followed charted designs
but today there is a wide variety of ready-to-work canvases,
many of which are printed with the design.
Needlepoint stitches are used to interpret both historical
and contemporary designs. Very simple stitches can be used
to produce quite complex motifs, while elaborate stitches
can make a simple design more interesting, both visually
and texturally. Inspiration ranges from the mainly geometric
patterns of the Orient to the floral and figurative designs of
Europe and Colonial America. The bold triangular shapes
of Florentine work, for example, suit all types of interior.
As with most traditional crafts, a wide range of patterns and
techniques has been developed over the years but just one
stitch is often enough to work most needlepoint projects.

TOOLS & MATERIALS

THE ESSENTIALS ARE square-mesh canvas, a tapestry needle, and yarn. Needlepoint canvas comes in a wide range of mesh sizes to suit different purposes. It is important to choose a yarn that is sufficiently thick to cover the threads of the mesh, and a needle that will pass through the holes easily.

CANVAS

Most canvases are made from cotton or linen. They are purchased by the metre, and are white, brown, or creamy-beige in colour. If you are going to work with dark colours, choose brown canvas because even a small gap in your stitching can show up as a white dot and spoil the effect.

The mesh size or gauge of canvas is determined by the number of threads to the inch – the larger the number, *the finer the canvas. A fine gauge such as 22 threads per inch is used for detailed work and a coarse gauge of 3 threads per inch for chunky rugs. Many needlepoint projects call for a 10 gauge canvas. Some common types are shown below; others include interlock, rug, and plastic. The first two are suitable for wall hangings and rugs, the latter is often sold pre-cut for making place mats and decorations.*

Interlock canvas
This is made of single horizontal threads, and fine twisted vertical threads in pairs, which make the canvas less liable to distort or fray.

Mono canvas
Sold in the largest range of gauges, the mesh consists of single threads. It is not suitable for working half cross stitch or cross stitch (*see pages 161 and 164*).

Double or Penelope canvas
This mesh is made of pairs of threads. You can work over each pair, or split them if you want to take smaller stitches.

Perforated paper and plastic canvas
Perforated paper (*above right*), available in a variety of colours, is suitable for making decorations and cards. Plastic canvas is moulded into a medium-gauge mesh and sold in pieces.

Rug canvas
Interlocking construction gives rug canvas (*left*) its shape. It has a wide range of mesh sizes and uses – needlepoint and latch-hook are two of the most popular.

YARNS

Crewel, tapestry and Persian are needlepoint yarns. They are durable, colour-fast, and come in a wide variety of lovely shades. Other yarns include rug wool, a thick, long lasting single-strand yarn, crochet and embroidery cottons, silk floss, and metallic thread.

Tapestry
A single-strand yarn is slightly finer than 3 strands of Persian yarn. One strand will cover 10-mesh canvas.

Crewel
This is the finest tapestry yarn – slightly finer than one strand of Persian yarn. It can be worked singly or in 2, 3, or 4 strands together.

Persian
This is made up of 3 easily divisible strands. Use the number of strands to suit the gauge of the canvas.

NEEDLES

Tapestry needles are specially made for needlepoint work. They have large eyes for easy threading and blunt, round-pointed ends which slip through the mesh without piercing it. Choose a size that will fit comfortably through the mesh holes without distorting the canvas. A size 18 needle is suitable for 10- and 12-mesh canvas.

Your needle and yarn should pass easily through the canvas

NEEDLEPOINT FRAMES

Stretching your work on a frame will keep the canvas from being distorted and has the advantage of leaving both hands free. A flat frame (see page 122), is best. Some people prefer to roll up their work and carry it with them.

OTHER USEFUL EQUIPMENT

Only a few additional accessories are necessary: sharp scissors and masking tape. If you make your own designs you will need waterproof pens and paints to outline and colour the canvas.

A waterproof felt-tip pen for transferring designs onto canvas

Acrylic paints to tint canvas or for painting on designs

Masking tape for binding the edges of canvas to stop it from fraying

Paint brush to colour the canvas

Embroidery scissors with small, sharp blades for snipping off thread ends

Dressmaker's shears for cutting canvas to size

GENERAL TECHNIQUES

NO SPECIAL SKILLS are needed for working needlepoint. Aside from learning the basic stitches, all you need to know is how to start and finish off the thread ends neatly, and a few basic rules about handling the canvas and yarn so that your work is not damaged or distorted before the project is completed.

HANDLING CANVAS

It is unusual for modern canvas to fray. However, if you are working on a large piece, it is a good idea to bind the edges with masking tape. A comfortable and convenient way of working a large piece of canvas is to keep it rolled up, with the design on the inside. Use clothes-pegs on the edges to hold the canvas in place while you are stitching a particular area. Make a paper pattern of the finished shape before you start. You will need this to block the canvas when the work is finished.

NUMBERS OF THREADS

The most important thing to remember is that the yarn must cover the canvas, otherwise the mesh will show through. If you are not using a kit, always work a small sample first. If the stitching looks too thin, add extra strands of yarn.

FORMING THE STITCHES

There are two ways of working the stitches – the sewing method and the stabbing method. When using a frame, you will find it easier to use the stabbing method; for hand-held needlepoint, try both and see which method suits you best.

Sewing method

Each stitch is formed in one movement. Insert the needle into the canvas from the right side and bring it out at the position for the next stitch. Pull the thread through.

Stabbing method

Each stitch is formed in two movements. Insert needle into canvas from right side and pull thread through to back. Re-insert needle at position for next stitch, and pull through to front.

BASIC WORKING METHOD

The working thread should be no longer than 45cm (18 in), otherwise it will start to fray as it is pulled through the canvas mesh holes. If the thread starts to twist and tangle, let the needle drop down from the work until the thread has straightened out. Avoid starting and ending new threads in the same place in any area, because the extra thickness of the thread ends will form a ridge on the right side of the work.

Starting a thread

Leave an end at the back, about 2.5cm (1 in) long. Work the first few stitches over this to secure it, and cut off any surplus. Never start with a knot; it may make the work look lumpy and come undone.

Ending a thread

Take the needle and thread through to back of canvas. Weave the thread through the backs of the last few stitches; cut off any surplus.

NEEDLEPOINT KITS

These are ideal because they already contain canvas, needle, and yarns in the amounts required. Moreover, the design is either printed in colour on the canvas or provided in chart form. The chart will resemble graph paper, with each square representing one mesh of the canvas. Unless otherwise stated, start stitching at the centre and work towards the outer edges.

Sometimes a design that will receive hard wear, such as a footstool cover, is marked out with lines of horizontal stitches called tramé. These stitches add extra thickness and strength to the piece, and the needlepoint is worked over them in matching yarn.

CREATING YOUR OWN DESIGNS

DESIGNING YOUR OWN needlepoint is fascinating because there are so many directions your design can take. You start by drawing out a design to full size and paint or trace it onto the canvas. Beginners may find it easiest to start with a tent-stitch design. Add more decorative stitches as you become more inventive.

DESIGN INSPIRATION

Flowers, paintings, plates, and fabrics are all sources of inspiration. Start by making sketches. Be sure that the scale is suitable for your project – a small pattern may look exquisite on a pin cushion but can look weak on a large item. Positioning is also important; if your pattern has small details around the edges of the design they may get lost when the work is sewn up.

After making initial sketches, draw the design to full-size. Use coloured pencils to shade in as much detail you like. Draw a clear outline around the outer edges of the design, and a vertical and horizontal line across the centre.

CHARTING YOUR OWN DESIGNS

If you want to work out the design accurately, chart it on graph paper. Remember, the scale of the graph paper may not be the same as your canvas.

In a chart for a tent stitch design (*see tent stitches, page 161*) each square is usually coloured to represent one stitch taken over one intersection of the canvas. For decorative stitches (*see pages 162 to 168*), treat the lines of the graph paper as the canvas mesh, and mark the colour, length, and direction of each stitch on your chart.

TRANSFERRING THE DESIGN

The design may be marked on the canvas with acrylic paints or felt-tip pens. Make sure these are waterproof, otherwise they may stain the work when it is blocked (see page 178).

1 Cut canvas with at least a 5cm (2 in) border all around. Use a waterproof pen to mark the top of the canvas, and the direction of work. Draw a vertical and horizontal line across the centre.

2 Place the canvas over the drawing, match up the centre lines, and tape or pin them together. Draw the outer edges of the design onto the canvas with a waterproof pen.

3 Now either paint the design on the canvas or draw out the main details with a pen. Use your initial design as a guide to colour and detail. Make sure the ink or paint is dry before stitching.

NEEDLEPOINT STITCHES

NEEDLEPOINT STITCHES ARE worked vertically, diagonally, or horizontally over the threads of the canvas, and normally cover it. Textures and patterns are created by the direction and size of the different stitches. The best way to master the stitches is to work them: stitch a sampler of the ones you like best to serve as a reference for the future. The sampler will also help you discover the variety of ways the various stitches can be combined to produce different designs.

The instructions on the following pages state the number of threads in each direction over which the stitches should be formed. Once you familiarise yourself with the stitches, you can vary their length depending on the effect you want to achieve. But don't work stitches over more than ten canvas threads as the loops will be so long they may snag. Unless otherwise stated, all the stitch patterns given may be worked on either single or double canvas.

NEEDLEPOINT MAGIC

The wall hanging shown above demonstrates the rich variety of patterns and textures that can be achieved by combining different needlepoint stitches. Place bands of smooth texture stitches, such as Tent stitch (see page 161) or Upright Gobelin stitch (see page 166) next to stitches with strongly defined raised patterns such as Scotch stitch (see page 163) and Algerian eye stitch (see page 168).

TENT STITCHES

EACH SMALL DIAGONAL stitch in tent stitch is worked in the same direction over one intersection of canvas. It is versatile enough to translate any detail or subtle shading, so many people use only this stitch.

There are three variations – half cross stitch, Continental stitch, and basketweave stitch. They all look the same from the front. Half cross stitch is the easiest of the three and uses the least yarn. However, it cannot be used on single canvas because the stitches slide. Half cross stitch and Continental stitch tend to distort the canvas, so use a frame if you are working a large area. Basketweave is the best to use over a large area because it doesn't distort the canvas. However, it does use more yarn than the other two stitches.

Half cross stitch

1 Work in horizontal rows from left to right. Bring the needle out and take it up to the right over one canvas intersection. Insert needle under one horizontal thread, and bring it out ready to form the next stitch.

2 At end of row turn canvas upside down and start next row.

Continental stitch

1 Work in rows from right to left. Bring needle out and take it up right over one intersection. Take the needle diagonally under one intersection to left.

2 At end of row turn canvas upside down for return row.

Basketweave stitch

1 Work down and up the canvas diagonally. Take a stitch up to right over one intersection. Insert needle downwards under 2 horizontal threads.

All tent stitches look the same on the front; half cross stitch is shown here

2 To return, take a diagonal stitch up to right over one intersection. Stitch under 2 vertical threads to left.

The back of the work will show the difference between the tent stitches – half cross stitch (left), Continental stitch (centre), basketweave stitch (right)

DIAGONAL STITCHES

ALL THE STITCHES in this section are worked so they slant diagonally over the canvas threads. Each stitch sequence produces a distinctive overall pattern, and many of them can be worked in different colours to form striped, zigzag, and chequer-board designs. Diagonal stitches distort the canvas more than any other type of stitches, so don't work them too tightly and use an embroidery frame if possible.

Slanted Gobelin stitch

1 Work on single canvas only, from right to left, then left to right alternately. Bring needle out, and insert it 2 horizontal threads up, and one vertical thread to right. Bring needle out 2 horizontal threads down, and one vertical thread to left of stitch just made.

2 In next row, work new stitches one stitch length below stitches in previous row; slant them in same direction.

Encroaching Gobelin stitch

Work as above, but take each stitch over 4 or 5 canvas threads. Slant over one vertical thread. On new row, overlap tops of stitches by one thread.

Condensed Scotch stitch

1 Work the graduating stitches in diagonal rows, starting at top right. The basic unit of the pattern is a group of 4 diagonal stitches worked over 2, 3, 4 and 3 canvas intersections. Repeat this 4-stitch sequence to end of row.

2 On next and subsequent rows, repeat the same stitch sequence, placing the shortest stitch next to the longest stitch of the previous row.

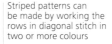

Striped patterns can be made by working the rows in diagonal stitch in two or more colours

Slanted Gobelin stitch is an elongated version of tent stitch and forms neat, ridged rows

Use encroaching Gobelin stitch for shading and blending colours

Scotch stitch

1 This stitch is made of squares of 5 graduated diagonal stitches worked over one, 2, 3, 2, and one canvas intersections. Worked diagonally, each square covers 3 vertical and horizontal threads. Repeat this stitch sequence to the end of the row.

2 Reverse working direction and fit squares of new row in between squares of previous row.

Scotch stitch variation

Work horizontal and vertical lines of tent stitch spaced 3 intersections apart to form a grid. Fill in each square of the grid with Scotch stitch (*see above*).

Work Scotch stitch in one colour for texture or several colours for striped and checked patterns

Scotch stitch variation is made by working a tent-stitch grid and filling in each square

Chequer stitch

1 Work diagonally over 4 horizontal and 4 vertical canvas threads. Start at top left. On first row, fill each square with 7 diagonal stitches, worked over one, 2, 3, 4, 3, 2, and one intersections.

2 On second row, work 16 small tent stitches into each new square, fitting them into squares of previous row.

In chequer stitch, squares of graduated diagonal stitch alternate with tent stitch

Byzantine stitch

Byzantine stitch covers the canvas quickly and is useful for filling large areas of background

1 The zigzag rows of stitches are worked diagonally from top to bottom, then bottom to top of canvas alternately. Each stitch is worked over 2 canvas intersections. Form steps or zigzags by making 3 diagonal stitches across canvas, and then 3 diagonal stitches up or down canvas alternately.

2 Fit the steps of a new row into steps of preceding row.

163

CROSSED STITCHES

BASIC CROSS STITCH is the most important stitch in this category and it is always worked on double canvas. All the other patterns in this section are formed by either diagonal or straight stitches crossing over each other; a backstitch can secure the crossed stitches and be worked in a contrasting colour.

CROSS STITCH

Cross stitch can be worked horizontally or diagonally on double canvas over one or more intersections according to the canvas gauge. The top stitches of the crosses should always lie in the same direction to ensure an even finish.

Horizontal method

1 Work from right to left, then left to right alternately. Bring out needle and take it up to left, over 2 canvas intersections. Insert needle, bringing it out under 2 horizontal threads.

2 Cross this stitch with a diagonal backstitch over same intersection, but slanted in opposite direction. The needle comes out where it just emerged, ready to make the next cross stitch.

Diagonal method

Work from bottom left. Make first stitch as for horizontal method. Cross it with a stitch slanting in opposite direction, bringing out needle under 2 vertical threads in position for next cross stitch.

Cross stitch

Oblong cross stitch

1 Work in 2 steps, from right to left, then left to right. Bring out needle, and take stitch up to left over 4 horizontal and 2 vertical threads. Take stitch under 4 horizontal threads. Repeat to end of row, then cross them with stitches worked in opposite direction.

2 At end of row, bring out needle 4 threads down ready to start first stitch of new row.

Oblong cross-stitch variation

Work oblong cross stitch as above. Then, in a contrasting colour, take a backstitch across centre of each cross. Each backstitch covers 2 vertical threads.

Oblong cross stitch

Oblong cross-stitch variation

Greek stitch is an overlapping cross stitch with one leg twice as long as the other

Rice stitch is really a large cross stitch with its legs tied by a backstitch at each corner

Rice stitch

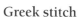

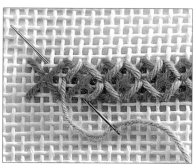

1 Work horizontally in 2 steps. Bring out needle at top left. Work a row of large cross stitches over 4 canvas intersections.

2 On return, work a backstitch at right angles over corner of each cross stitch. Each backstitch covers 2 canvas intersections. Work subsequent rows into bases of stitches in previous row.

To form alternating cross stitch work large oblong cross stitches and small cross stitches

Greek stitch

1 Work from left to right then right to left. Make a diagonal stitch up to right over 2 canvas inter-sections. Take needle to left under 2 vertical (double) threads. Take a stitch down to right over 4 vertical and 2 horizontal threads. Insert needle to left under 2 vertical threads, and bring out. Repeat.

2 On following rows, work stitches in bases of those in previous row.

Alternating cross stitch

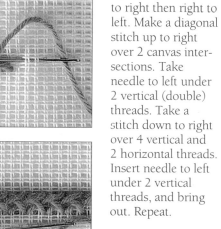

1 Work from right to left on single canvas. Make an oblong cross stitch over 2 vertical and 6 horizontal threads. Bring out needle 4 horizontal threads below top of first stitch. Make a cross stitch over 2 canvas intersections and bring out needle at base of oblong cross stitch. Repeat.

2 On next row, place cross stitches beneath oblong cross stitches.

STRAIGHT STITCHES

QUICK AND SIMPLE to work, straight stitches are most interesting when stitches of different lengths are combined. As a rule, straight stitches cover single canvas best, although there is no reason why you shouldn't try them on double canvas. All the stitches are worked in horizontal rows unless otherwise stated.

Upright Gobelin stitch

1 Work rows from left to right, then right to left. Bring needle out, and take it up over 2 horizontal threads. Insert needle down to right under one vertical and 2 horizontal threads, and bring it out ready to start next stitch.

2 In subsequent rows, work the tops of the stitches into the bases of the stitches above.

Gobelin filling stitch

1 Work a row of stitches as for upright Gobelin stitch, taking each stitch over 6 horizontal threads and spacing them 2 vertical threads apart.

2 When working subsequent rows place the stitches between stitches of the row above. The bases of the new stitches should be 3 horizontal threads below the bases of previous stitches.

Random long stitch

Work as for upright Gobelin stitch, but vary the length of the stitches by taking them over either one, 2, 3 or 4 horizontal threads at random.

Upright Gobelin stitch is a hardwearing stitch producing a close, ridged surface

In Gobelin filling stitch the rows overlap to produce a basketweave effect

Random long stitch is very quick for working large areas of double canvas

Long and short stitch

1 Moving up one thread for each of first 4 stitches, work row of long stitches over 4 horizontal threads. Then work 3 stitches, moving down one thread for each. Repeat.

2 Work next 2 rows in same sequence, taking smaller stitches worked over 2 threads. Continue working one row of long stitch and 2 rows of shorter stitch alternately.

Hungarian stitch

Work groups of 3 stitches over 2, 4 and 2 horizontal threads, with a space of 2 vertical threads between each group. On subsequent rows, work groups into previous spaces.

Hungarian diamond stitch

1 Work stitches one vertical thread apart. Make groups of 4 graduated stitches in a repeated sequence over 2, 4, 6, and 4 horizontal canvas threads.

2 On all subsequent rows, work the longest stitches into the bases of the shortest stitches in the previous row.

Hungarian stitch (bottom left),
Long and short stitch (top left),
Hungarian stitch grounding
(top right), and Hungarian
diamond stitch (bottom right)

Hungarian stitch grounding

1 The first row is worked in same way as zigzag long stitch, but stitch sequence is shorter. Take 3 vertical stitches over 4 horizontal threads moving up, and 2 stitches moving down.

2 On 2nd row, work Hungarian stitch between spaces left in previous row. Work these 2 rows alternately.

STAR STITCHES

THESE ARE COMPOSITE stitches formed from diagonal, crossed, and straight stitches. Star stitches tend to be large stitches, which may be framed in other stitches, and produce clear shapes rather than overall textures. Work them fairly loosely on single canvas with a thick thread that will cover the mesh.

Smyrna cross stitch

1 From top left, work a cross stitch over 4 intersections. Bring needle out through centre hole between bases. Take a vertical stitch up over 4 threads. Bring needle out, 2 threads to left and 2 threads down. Take one horizontal stitch to right.

2 Bring needle out 4 threads to right on baseline. On subsequent rows, work tops of stitches into previous bases.

Large Algerian eye stitch

1 To form star, work 16 stitches clockwise into same central hole over 4 canvas threads or over 4 canvas intersections at corners of square. To space out stitches, leave 2 canvas threads unworked between each converging stitch.

2 When stars are completed, frame each one with backstitches worked over 2 canvas threads.

Algerian eye stitch

Work rows from right to left, then left to right. Start at top right corner. Work 8 stitches clockwise over 2 canvas threads or 2 canvas intersections into same central hole. Leave 2 canvas threads between each. Work next star into sides of last one. On next row, work anticlockwise.

Ray stitch

Work left to right, then right to left. Work 7 stitches anticlockwise over 3 threads or 3 intersections into same hole. Space out stitches one thread apart.

Algerian eye stitch

Smyrna cross stitch

In this version of Algerian eye stitch, each star is framed with backstitches

Ray stitch is one quarter of a very large Algerian star

LOOPED STITCHES

THESE STITCHES FORM a series of knotted loops. The loops can be cut to produce a soft, fluffy pile that looks like the surface of a carpet. The stitches can be worked on their own on rug canvas or combined with areas of smoother, flatter stitching on finer canvas to create interesting changes in texture on the work.

Turkey stitch

1 Start at bottom left, and work horizontally. From front of canvas, insert needle and take it up to left under one horizontal and 2 vertical threads. Bring out needle, leaving a short thread end on surface of work. Insert needle to right over 3 vertical threads, bringing it out one vertical thread to left of yarn end.

2 Work the following stitches in the same way, forming even loops round a knitting needle, as shown above.

3 Work subsequent rows, one horizontal thread above the preceding row. Cut all loops when work is finished.

Work Turkey stitch on single canvas and completely cover the canvas

Velvet stitch is worked as loops and these are then cut to form a soft pile

Velvet stitch

1 Work this loop stitch on single or rug canvas from left to right. Bring out needle and take a diagonal backstitch up to right over 2 canvas intersections.

2 Take needle up to right again and insert in the same place as before, but this time hold the thread down with your finger to form a loop. (Working the loops over a thick knitting needle will ensure that they are all the same size.) Bring needle out 2 horizontal threads down.

3 Hold loop down with finger and take a diagonal backstitch up to left over 2 canvas intersections. Repeat sequence to end of row. On each row, position new stitches above those just done.

4 When work is finished, cut the loops to form the pile, and trim if necessary.

NEEDLEPOINT PROJECTS

NEEDLEPOINT CAN BE worked on furnishings and accessories, and on large or small items. The only constraint on your imagination is the fact that needlepoint is always worked on canvas. You may want to try bold geometric patterns, or decorative florals in the style of classic country house chintzes of the 19th century. Whatever style you choose, you can work these doorstops, cushions, jewellery boxes, and purses to complement your own taste. (See pages 242 to 244).

This strawberry heart box will keep your treasures safe

GIFT BOXES

Small jewellery boxes in different shapes make attractive gifts.

Make a gift of this golden yellow beehive box

A singing bird decorates this pretty chickadee box

DOORSTOP

Show off your needlepoint skills by working the covering for this doorstop – the inside is a brick. As well as this attractive bow, a lot of simple patterns could be adapted to this size.

This surprise parcel is a doorstop that is both useful and decorative

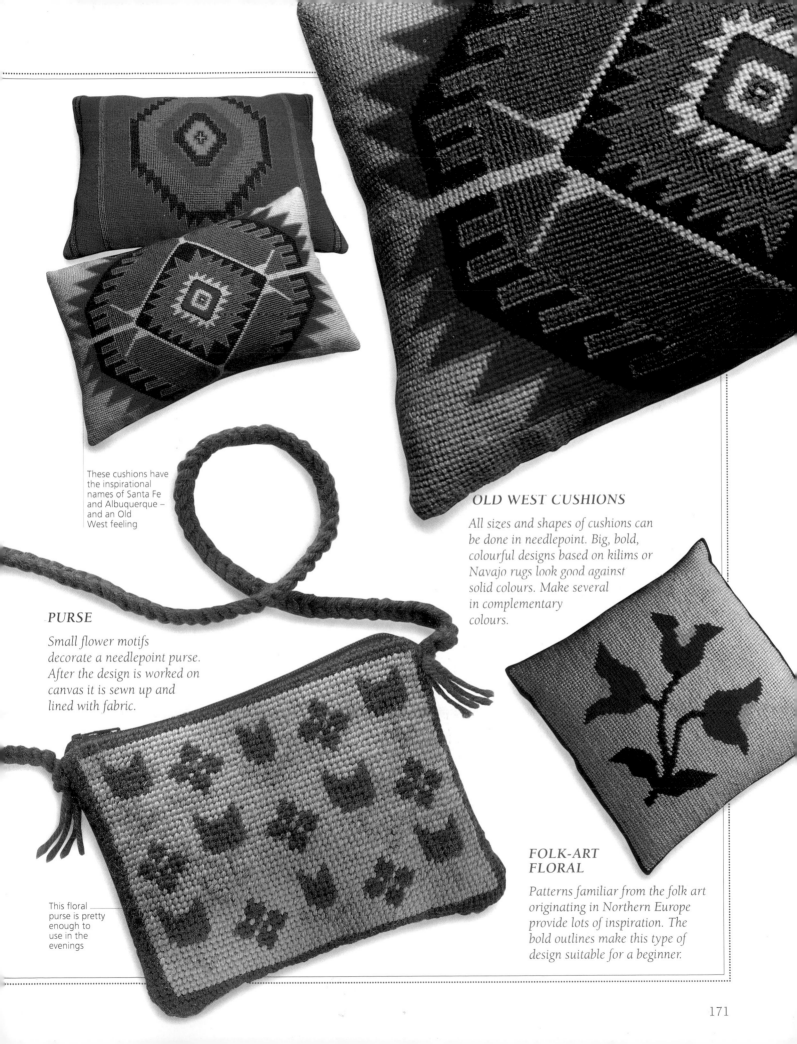

These cushions have the inspirational names of Santa Fe and Albuquerque – and an Old West feeling

OLD WEST CUSHIONS

All sizes and shapes of cushions can be done in needlepoint. Big, bold, colourful designs based on kilims or Navajo rugs look good against solid colours. Make several in complementary colours.

PURSE

Small flower motifs decorate a needlepoint purse. After the design is worked on canvas it is sewn up and lined with fabric.

This floral purse is pretty enough to use in the evenings

FOLK-ART FLORAL

Patterns familiar from the folk art originating in Northern Europe provide lots of inspiration. The bold outlines make this type of design suitable for a beginner.

171

FLORENTINE WORK

SOMETIMES KNOWN AS Bargello or flame stitch, Florentine work is formed of straight, upright stitches repeated in zigzag rows. By altering the size and spacing of stitches, the zigzags can be made into undulating waves or into sharp peaks. Florentine work has always been popular, and with good reason – the basic stitch covers single canvas quickly, and the patterns can be worked in colourful or subtle shades.

This Florentine work bag is worked in an attractive diagonal pattern, which is reflected in the border

BASIC ZIGZAG

To learn the simplest Florentine work, begin with a basic 4-2 zigzag pattern. Each stitch is taken over four horizontal threads, and then up or down two horizontal threads.

1 Bring out needle at centre point of canvas. Insert it 4 horizontal threads up. Bring it out 2 horizontal threads below top of stitch and one vertical thread to the right.

2 Take 3 more stitches in the same way to travel up the canvas. On the 3rd stitch, bring the needle out 6 horizontal threads below top of last stitch.

3 Work next 3 stitches down canvas to form first inverted V of zigzag. Continue working 3 stitches up and down canvas in this way to form zigzag pattern.

4 Work row of stitches of new colour into bases of first row.

CANVAS AND THREADS

Florentine work does not cover double canvas adequately. For the best results, always work on single canvas and make sure the yarn is thick enough to cover the mesh. The working thread can be about 55cm (22 in) long – slightly longer than for other types of needlepoint because these stitches create little friction when the thread is pulled through the canvas. Since you will be changing colour frequently, it saves time to keep several needles threaded with the different colours so that you don't have to keep re-threading the same needle.

ROW DESIGNS

These patterns are worked horizontally across the canvas. The first line of stitching is worked from the centre point of the canvas out to the left- and right-hand edges. This line sets the pattern. All the other rows are worked from right to left or left to right, above and below it, to fill the canvas.

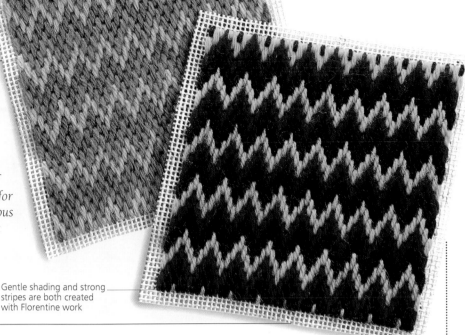

THE EFFECTS OF COLOUR

All Florentine work designs are worked in bands of different colours. A three-colour repeat is effective, but of course you can use as many colours as you like.

Different colour combinations can change the look of the design completely. If you choose three tones of the same colour, for example, you will achieve a soft, harmonious effect. Alternatively, you can make distinct stripes by selecting strongly contrasting colours. Experiment with different colours to see the effects that you can achieve.

Gentle shading and strong stripes are both created with Florentine work

ROW PATTERN VARIATIONS

The Florentine stitch zigzags can either be softened into gentle curves, or be made more spiky, by altering the size of the stitches and the steps between them.

| 4–2 | 3–1 | 5–1 | 6–3 |

The sample shown above demonstrates what happens when the stitch length and step is changed from 4-2. The first number gives the stitch length, and the 2nd number gives the step up or down between stitches. Keep to your chosen stitch length throughout so that each subsequent row can be fitted above or below it.

Step zigzags

To create a squared-off outline, rather than a sharp outline, work 2 or more stitches along the same line of horizontal threads, before taking a step up or down the canvas.

Irregular zigzags

Peaks and valleys at different levels can be created by varying the number of stitches on any horizontal line and by changing the height of the step between them.

Curves

Curves are produced by working 2 or more stitches along the same line of horizontal threads at the top and base of each peak.

These curves are worked in contrasting tones of the same family of colours

Fish scales
Curves and peaks

Fish scales

Curving the tops of the peaks, and keeping the bases pointed, this technique creates a pattern of half-circles which resembles the scales of a fish.

Curves and peaks

To achieve attractive, contrasting shapes, combine curves and steep peaks in the same pattern row. This pattern is especially effective in shaded colours as it gives the effect of a row varying in thickness as well as shape.

Waves

Curves can be made more gradual by altering the step formation, adding extra stitches at each peak.

CHARTING YOUR OWN DESIGNS

It is easy to work out your own Florentine designs on graph paper. Each square of the grid represents one square of the canvas, and the colored lines denote the stitches.

When charting a design, start at the centre and work out toward the edges so that it looks well balanced

The moving mirror may reveal patterns that you can use in your design

To see how a charted design will look in repeat, hold a mirror at right angles to the graph paper. Slide the mirror along the chart to see other interesting patterns.

174

TWO-WAY FLORENTINE WORK

The first row sets the pattern and is worked as usual. The pattern is then reversed to form a mirror-image, and the spaces between the two rows are filled with upright stitches.

Two-way 4-2 zigzag

1 Work the first row as shown on page 172. Work a 2nd row beneath it, reversing direction of zigzags, to form diamonds.

2 Fill in the diamond shapes with bands of stitching, and fit subsequent diamonds above and below this pattern row.

Two-way variations

Any row can be turned into a two-way pattern by reversing the first row. With some patterns, you may need to fill in the motifs with stitches of varying lengths. The spaces between the rows may become an important element in the design.

FOUR-WAY FLORENTINE WORK

Square designs like cushions or bags can be worked in four directions. Each starts from the centre and goes out towards the edges of the canvas to build up one large motif.

Basic method

1 Cut the canvas into a square. Draw 2 diagonal lines from corner to corner. Work 4 stitches into the centre hole of canvas, placing them at right angles to each other to form a cross.

2 Develop the pattern by working out to the edges of the canvas, filling each quarter section of the canvas in an identical way.

Four-way variations

As with any type of Florentine work, the four-way pattern can be quite simple, or you can vary the sizes of stitches and the steps between them to create more intricate and complex designs.

CHRISTMAS TREASURES

LITTLE THINGS MEAN a lot at Christmas, so delight your friends and family with these beautiful miniature needlepoint designs for gift tags, cards, decorations, and a stocking. For instructions, see page 245.

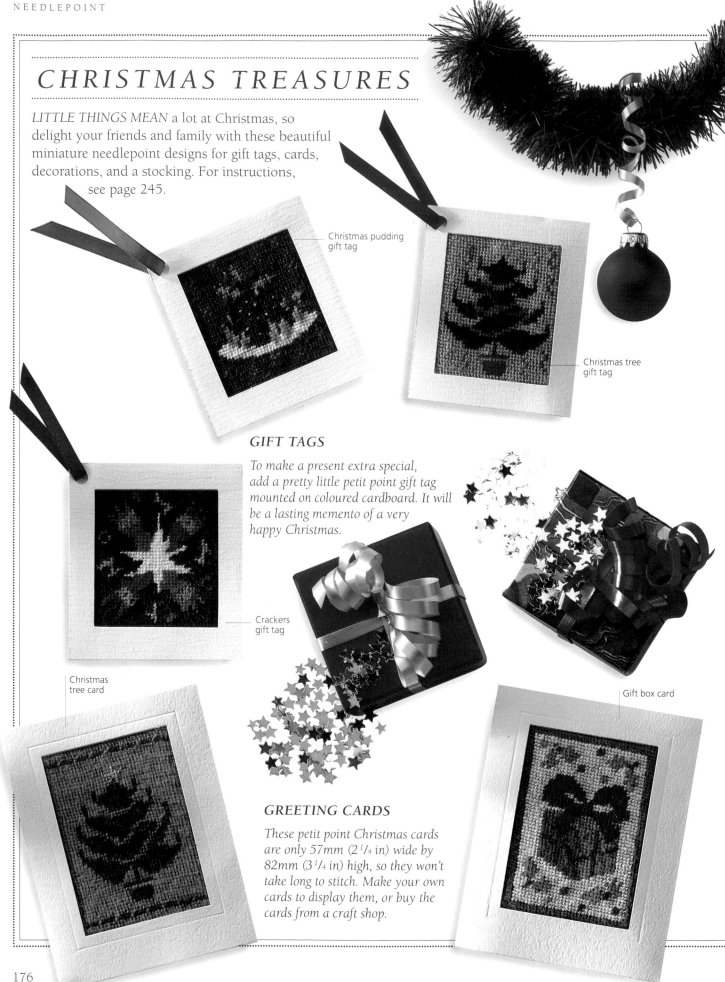

Christmas pudding gift tag

Christmas tree gift tag

GIFT TAGS

To make a present extra special, add a pretty little petit point gift tag mounted on coloured cardboard. It will be a lasting memento of a very happy Christmas.

Crackers gift tag

Christmas tree card

Gift box card

GREETING CARDS

These petit point Christmas cards are only 57mm (2¹/₄ in) wide by 82mm (3¹/₄ in) high, so they won't take long to stitch. Make your own cards to display them, or buy the cards from a craft shop.

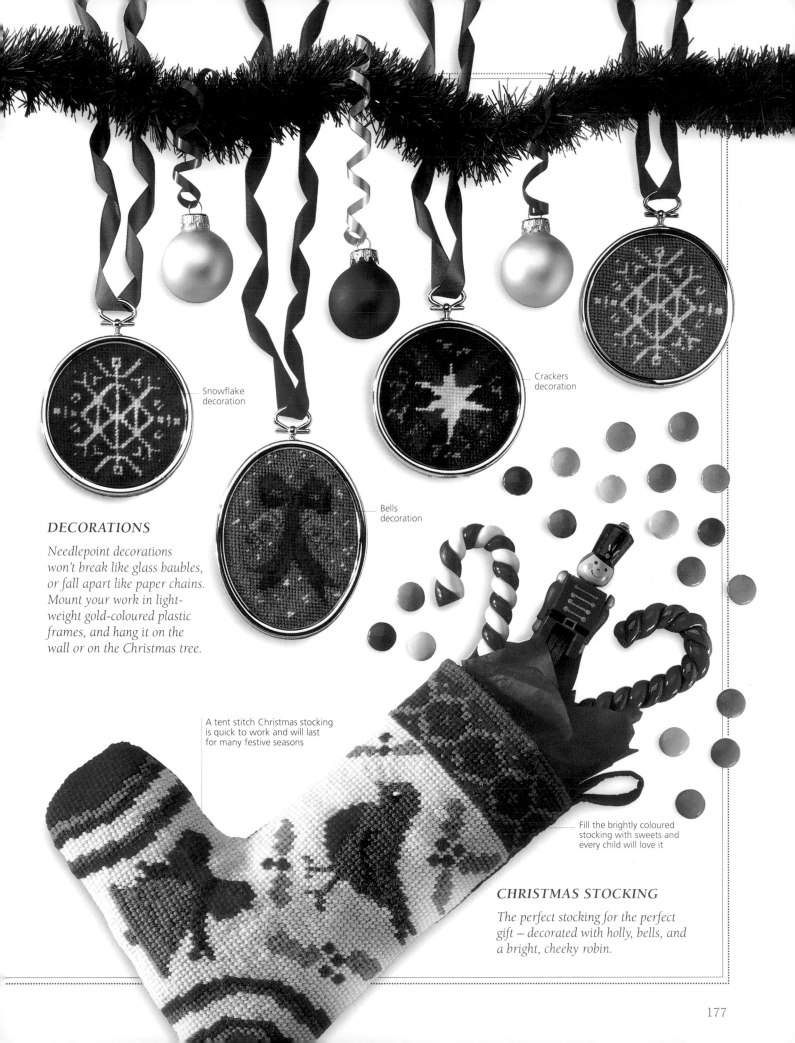

Snowflake
decoration

Crackers
decoration

Bells
decoration

DECORATIONS

Needlepoint decorations won't break like glass baubles, or fall apart like paper chains. Mount your work in light-weight gold-coloured plastic frames, and hang it on the wall or on the Christmas tree.

A tent stitch Christmas stocking
is quick to work and will last
for many festive seasons

Fill the brightly coloured
stocking with sweets and
every child will love it

CHRISTMAS STOCKING

The perfect stocking for the perfect gift – decorated with holly, bells, and a bright, cheeky robin.

177

BLOCKING & JOINING

AFTER COMPLETING YOUR needlepoint, examine it carefully to make sure that you haven't missed any stitches. If you have, you can easily fill these in with matching yarn. The next step is to 'block' or remould the needlepoint back into its original shape using your paper pattern as a guide. Don't worry if your work appears to be quite distorted – this often happens, especially if you have been using diagonal or crossed stitches that pull against the weave of the canvas. If you are making an item such as a bag or cushion, the final step involves joining the needlepoint and the backing together with a visible or invisible seam.

BLOCKING

If your work shows very little distortion, steam the wrong side lightly with a steamer or iron, and leave it to dry thoroughly. If it's badly distorted, use the method below.

Wet and tack method

1 Pin your paper pattern to a piece of board and tape a piece of plastic over the top. Place the needlepoint right side down on top of the pattern and spray with water, or moisten with a sponge or cloth.

2 Starting at the centre top, hammer a tack through the unworked canvas. Stretch the needlepoint gently into shape, using more water if necessary. Tack at centre bottom and sides.

Even stretching will gently block your work back into a perfect shape

3 Continue tacking around the edges, spacing the tacks about 2.5cm (1 in) apart. Leave until it is completely dry. This may take several days.

JOINING

All sections of a needlepoint design should be blocked separately before they are stitched together. Seams can be a decorative feature or relatively invisible.

Half cross-stitch seam

1 Trim the canvas edges to about 15mm (1/2 in). Turn these back onto wrong side, checking that folds run along a thread of canvas. With right sides up, lay the pieces edge to edge, matching pattern row for row.

2 Using matching or contrasting yarn, bring out needle through first hole of left-hand piece. Insert it through 2nd hole of adjacent piece, and bring it out through 2nd hole of left-hand piece. Repeat.

TO SEW A FABRIC BACKING TO A CUSHION COVER

Fine and medium gauge canvas can usually be stitched to a fabric backing with a sewing machine. Check the stitch tension on a scrap of canvas and backing fabric before you start. If you are using a coarse gauge canvas, sew the pieces together with backstitch (see page 129).

Join your backing to your needlepoint work with an even backstitch

CARE & REPAIR

NEEDLEPOINT WORKED WITH wool yarn stays clean with little care. A light, routine cleaning with a vacuum cleaner to remove the dust should be all that is necessary. If you used silk threads, send it to a specialist for cleaning and repairs. If your threads are colourfast, you may be able to wash the piece in warm soapy water. Small tears in the canvas or frayed stitches should be mended quickly.

MINOR REPAIRS

Broken threads can be repaired with a patch of the same canvas type and gauge. A large tear in the canvas calls for expert attention so the patch will not show.

Frayed stitches

Carefully remove frayed stitches and a few good stitches either side, so loose ends can be secured under new stitching. Work new stitches in matching colours.

Broken canvas threads

1 Cut a canvas patch a few meshes larger all around than the damaged area. From the wrong side, use a sharp pair of embroidery scissors and a tapestry needle to remove the stitches around the broken mesh, in an area slightly larger than the patch.

2 Baste patch in position on wrong side, aligning canvas mesh exactly. Trim off any broken mesh threads so that the patch lies flat.

3 Re-stitch area through both layers of canvas with matching yarn, removing basting stitches as you work.

HAND WASHING

Check that the yarn is colourfast by pressing a damp cotton ball onto the back to see if colour comes off. Make a paper pattern of the needlepoint shape to block the washed canvas.

1 Use a container large enough for the piece to lie flat. Fill with warm water, add a mild soap suitable for your fibre, and froth up to make suds; immerse the needlepoint.

2 Let the needlepoint soak, and gently press up and down on the back with a sponge without rubbing. Drain off the water. Then rinse in the same way, until the water runs clear.

3 Place the needlepoint on a flat surface, right side up, and blot off the excess water with a clean dry sponge. Re-block the piece, following the instructions on the opposite page.

STORING NEEDLEPOINT

Ideally, needlepoint should be placed between sheets of acid-free tissue paper and stored flat, away from dust and sunlight. Or cover a cardboard cylinder with acid-free paper and wrap the needlepoint around it, right side out. Then wrap this in acid-free tissue paper.

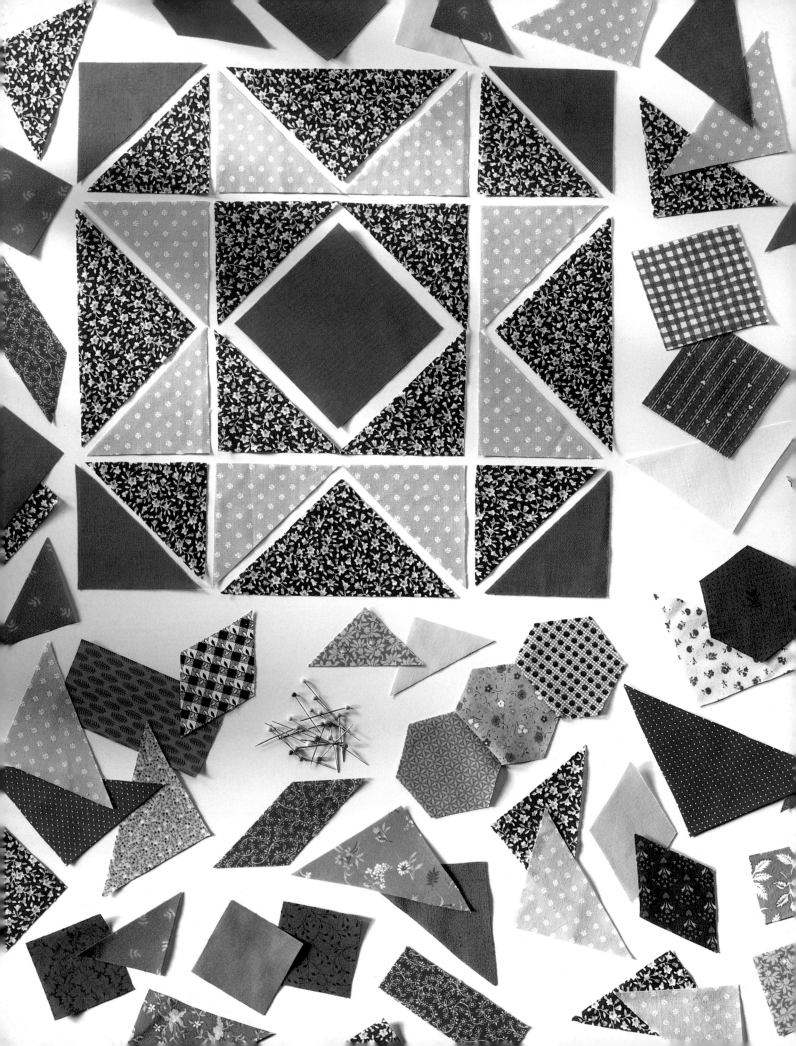

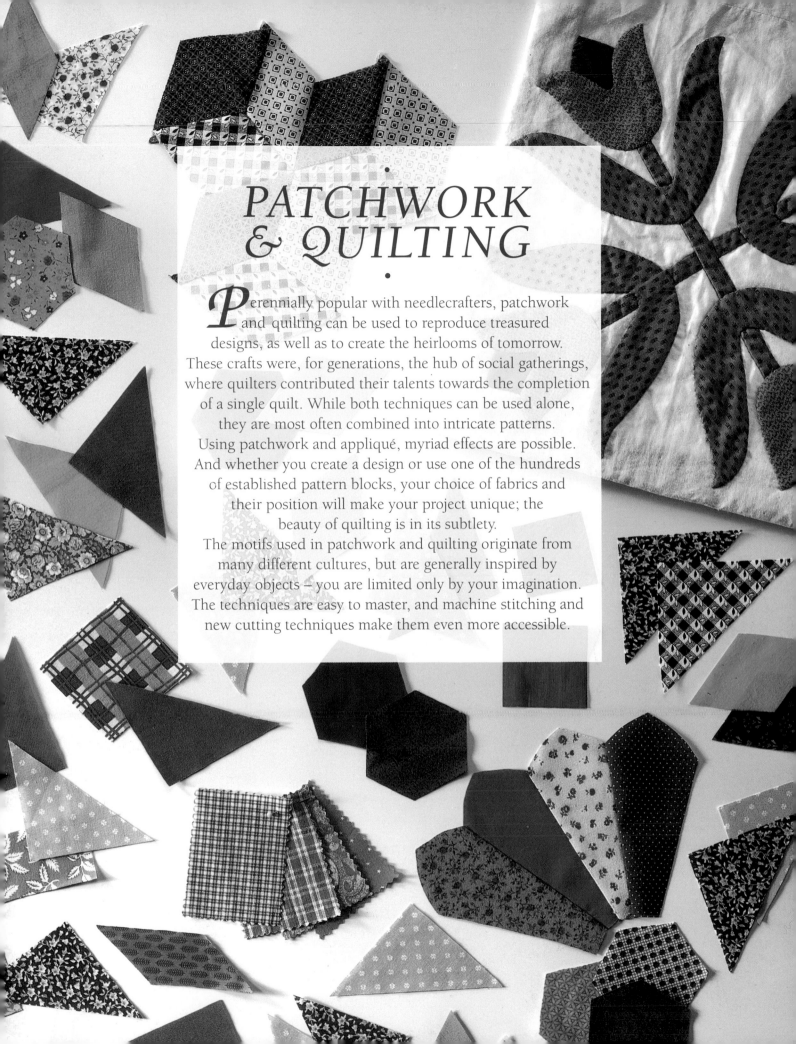

PATCHWORK & QUILTING

Perennially popular with needlecrafters, patchwork and quilting can be used to reproduce treasured designs, as well as to create the heirlooms of tomorrow. These crafts were, for generations, the hub of social gatherings, where quilters contributed their talents towards the completion of a single quilt. While both techniques can be used alone, they are most often combined into intricate patterns. Using patchwork and appliqué, myriad effects are possible. And whether you create a design or use one of the hundreds of established pattern blocks, your choice of fabrics and their position will make your project unique; the beauty of quilting is in its subtlety. The motifs used in patchwork and quilting originate from many different cultures, but are generally inspired by everyday objects – you are limited only by your imagination. The techniques are easy to master, and machine stitching and new cutting techniques make them even more accessible.

EQUIPMENT

PATCHWORK AND QUILTING require little in the way of speciality equipment. The correct needle and thread are important and, depending on the complexity of your design, you may need a template, a rotary cutter and board (see page 186), and a quilting hoop. One other vital piece of equipment is a steam iron, which is used in every step of creating patchwork. Steam helps set seams and removes wrinkles from the fabric.

PATCHWORK AND QUILTING TOOLS

The correct needle will make your patchwork or quilting much easier. Most fabric shops sell packs of needles specifically for quilting. Apart from the equipment described below, most of the other tools needed are likely to be found in your sewing box.

Thimble
Absolutely necessary for quilting – if you have never used a thimble before, you should learn to use one now.

Thread
Use No. 50 cotton thread for hand sewing and a No. 40 cotton thread or a polyester/cotton thread for machine sewing. Always use a 100% cotton thread for quilting.

Needles
Sharps are used for hand sewing; betweens for quilting. A size 8 between needle is recommended for beginners.

Pins
Smooth, fine dressmaker's pins with glass or plastic heads are recommended.

Beeswax
Run your thread over a cake of beeswax to strengthen the thread and prevent it from kinking when hand sewing or quilting.

Seam ripper
To remove machine-sewn stitches.

Embroidery scissors
Use these to clip into seam allowances or to cut thread.

Dressmaker's shears
Use these for cutting fabric only. They should be extremely sharp.

Templates
Used for cutting pattern pieces, these are plastic or metal, or can be made from cardboard or clear acetate (*see page 184*).

Quilting hoop
Wooden hoops, around 35cm (14 in) diameter, help to keep an even tension on your work as you are quilting.

FABRICS & PATTERNS

MOST TRADITIONAL-STYLE patchwork quilts are constructed of printed fabrics. However, this should not keep you from experimenting with a variety of textures, colours, and designs and exploring the different effects created. Let your imagination and taste guide you. Beginners should use only 100% cotton fabrics, which are easy to work with, keep a crease, and wear well. Choose those with a medium weave, since loosely woven fabrics have little strength and tightly woven fabrics will be difficult to quilt. Wash fabrics in hot water to test for shrinkage and colourfastness, and iron carefully before using.

COLOUR VALUE

In art, value is the relative lightness or darkness of a colour. In patchwork, this quality can be more important than the colour itself. A design can differ substantially depending upon the placement of fabrics of different values. For the best results, combine a mix of light, medium, and dark values.

In addition, colour values are affected by surrounding fabrics. This can be a useful point to exploit if you are working with a limited number of colours and wish to make the best possible use of their difference in value.

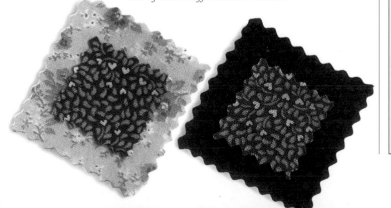

PRINT SCALE

Medium-scale prints, which can be compact or widely-spaced are generally the best for patchwork. Small-scale prints can add a subtle texture to a design, while large-scale prints can give the impression of more than one fabric. Stripes and plaids can also be used.

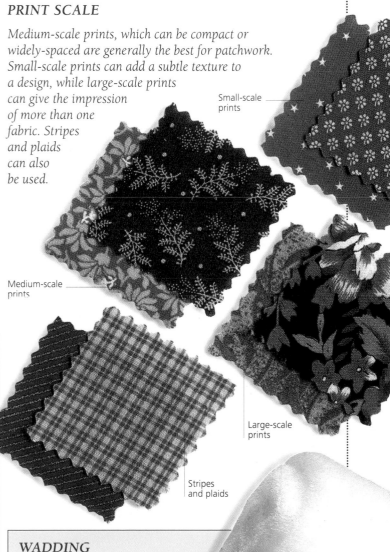

Small-scale prints

Medium-scale prints

Large-scale prints

Stripes and plaids

WADDING

A soft, fibrous material, this is used as a filling between a quilt top and back. Wadding can be bought in a roll of different widths, fibres, and weights. Different weights will suit various quilting purposes.

TEMPLATES

TEMPLATES ARE DURABLE patterns used for cutting out the pieces of a patchwork design. They can be purchased from speciality shops, and are available in metal and plastic in a variety of shapes. Plastic and window templates can be positioned on the fabric to create special effects. Window templates provide for the seam allowance other types do not.

It is also easy to make your own templates. Accuracy is extremely important, so be sure to measure carefully and use sharpened dressmaker's pencils when making the templates and marking the lines on fabric. Always mark patchwork pieces on the wrong side of the fabric. Sharp cutting tools are also necessary for making templates from cardboard or plastic.

TEMPLATE-MAKING SUPPLIES

If you are making a quilt with many pieces, make several templates for each piece and discard when they are worn out.

Marking tools
Use a dressmaker's pencil for all types of fabric.

Template material
Medium-weight cardboard and plastic can be used. Graph paper can be glued to the template to aid cutting.

Cutting tools
A utility knife and a metal-edge ruler or scissors will cut through cardboard or plastic.

Temporary adhesive
Use this for sticking paper templates to cardboard and for securing appliqué pieces temporarily to base fabric.

Measuring equipment
A transparent plastic ruler is useful for marking out seam allowances and templates. A compass is extremely useful for drafting curved templates.

MAKING TEMPLATES

Trace pattern pieces from a book, magazine or other source. Alternatively, draw your own design on graph paper. For machine sewing templates or window templates you will need to add a 6mm (¹/₄ in) seam allowance all around each pattern piece. Label the pieces with letters and the pattern name, then draw a grainline (see below).

1 Cut out your paper pieces and spray the wrong side with temporary adhesive. Leaving 12mm (¹/₂ in) between pieces, press onto sheet of medium-weight cardboard or clear acetate.

2 Place the cardboard or acetate on a cutting mat or stack of newspaper and use a utility knife and a metal-edge ruler to cut out the templates – either along the edge of the paper or along the marked seamline.

3 For complicated or curved designs, mark notches in the edges of templates to aid in matching the pieces when you sew them together. Cut out notches using a utility knife.

CUTTING OUT FABRIC PIECES

Mark the seamline and cutting lines on the wrong side of the fabric if you are hand sewing. Mark just the outer cutting line if you are machine sewing. As a general rule, mark the longest edge of a patchwork piece along the fabric grain.

For hand sewing

1 Position the pieces at least 12mm (¹/₂ in) apart when marking them on fabric.

2 Either mark the cutting lines, or judge by eye, and cut the pieces apart.

For machine sewing

When marking the shapes on fabric, position pieces with edges touching.

GRAIN OF FABRIC

Selvedges are the finished edges of fabric. The lengthwise grain or warp runs parallel to the selvedges and has little give. The crosswise grain or weft runs perpendicular to selvedges and has a slight give. A fabric has its maximum give when it is cut on the bias, which runs at a 45° angle to the selvedges. This information is essential when it comes to positioning and cutting out patchwork pieces. For example, the borders of a quilt should be strong, therefore cut them with the longest edges on the length-wise grain of the fabric. Curved patchwork should be cut with the curves on the bias of the fabric so that the pieces are easier to manipulate.

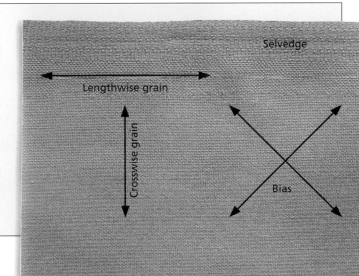

ROTARY CUTTING

ROTARY CUTTING is a fast and accurate method of cutting patchwork pieces without using templates. It is particularly effective when cutting long strips for sashing, borders, bindings, and for Seminole patchwork (see page 194).

ROTARY CUTTING EQUIPMENT

A few simple tools will enable you to cut your pieces without templates.

Roll the blade of the cutter against the ruler. The lines aid in measuring fabric

Cutting mat
This self-healing surface will grip the fabric to prevent slipping, and will keep the rotary cutter's blade sharp.

Rotary ruler
Made in clear plastic and marked with straight and angled lines. Roll the blade against the ruler's edge.

Rotary cutter
This accurately cuts through several fabric layers. Buy one with a large blade, and change the blade often.

Cutting material

1 Align the selvedges evenly, and iron fabric. If the grain of the fabric is not straight, align it before cutting pattern pieces.

2 Place fabric on cutting board with raw edges at right and selvedges at top. Place a set square along straight fold of fabric. Place rotary ruler against left edge of set square. Remove set square.

3 Press down firmly on the rotary ruler to prevent shifting. Run the blade of rotary cutter along edge of the ruler, keeping the blade upright. Move your hand carefully up the ruler as you cut. Always push the blade away from you.

4 Fold fabric in half again, aligning fold with selvedges and matching cut edges. Using rotary ruler, measure desired width of strip. With line of ruler along cut edge, cut a strip as you did in Step 3.

5 To make squares, cut a strip 12mm (½ in) wider than the finished size of the square. Cut off selvedges, then place the ruler over the strip and cut a piece to the same width as the strip to create 4 squares.

6 For half-square triangles, cut strip 22mm (⁷⁄₈ in) wider than finished square. Follow steps 1 to 5. Cut squares in half.

7 For quarter-square triangles, use strip 32mm (1¼ in) larger than finished long edge. Repeat to step 6 and cut triangles in half.

PATTERNS

A QUICK WAY to determine the difficulty of a patchwork design is to count the number of pieces in the design – the more pieces there are, the more difficult the design will be, and the more time it will take you to complete it. It is also helpful to study a design to see how many seams need matching, whether several seams must match at one point, and whether there are set-in patches or curved seams. Beginning quilters should select designs with few pieces and seams that are easy to match, such as the Shoo Fly design. The designs shown on here are graded in order of difficulty. Work your way up gradually to the more challenging designs and have the satisfaction of seeing your skills improve.

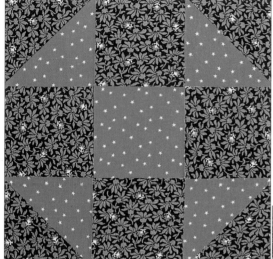

Shoo Fly

EASY

Shoo Fly is one of the easiest patchwork patterns to construct. It is composed of nine squares, four of which are pieced from right-angle triangles. Both blocks are made using fabrics in the same colour family. The same design can look very different depending upon the scale of the overall pattern; experiment to see the various effects.

MEDIUM

Grape Basket is a block of medium difficulty. There are many more seams than in Shoo Fly. The illustrations show a variety of fabrics, creating an old-fashioned block, and the graphic look achieved by using solid colours.

DIFFICULT

Diamond Star is a challenging block because there is an eight-seam join in the middle and the pieces at the edges must be inset (see page 193). The large illustration shows plaids and stripes, which have to be carefully matched. The inset illustration shows how contrasting values create a feeling of depth.

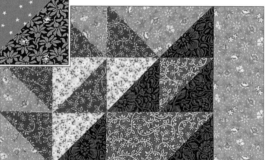

Diamond Star

Shoo Fly variation

Grape Basket

Grape Basket variation

Diamond Star variation

PIECING

ACCURACY IS CRUCIAL when joining many little patchwork seams together. Always sew pieces with the right sides of the fabric together and the raw edges exactly even with each other.

Seam allowances in patchwork are 6 millimetres (quarter of an inch) wide whether you are sewing by hand or machine, and must be marked on the patches when sewing by hand. Hand sewing takes more time but produces a unique look. Stitches made by hand must be evenly spaced, and not too crowded. Today, quilters often machine-piece the quilt top, to save time, and do the quilting by hand.

If machine sewing, use a standard straight stitch at 10 to 12 stitches per 2.5cm (one inch). The edge of the presser foot or a line on the throat plate of the sewing machine should be used as a stitching guide.

HAND PIECING

Work with 45cm (18 in) lengths of matching thread knotted at the end. It helps to run the thread over a cake of beeswax to strengthen it and prevent it tangling as you work. Sewing lines are marked on the wrong side of the fabric; seams are sewn from corner to corner along the marked lines.

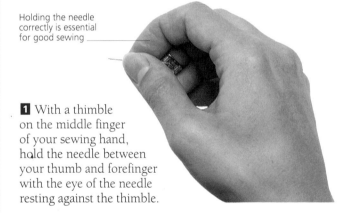

Holding the needle correctly is essential for good sewing

1 With a thimble on the middle finger of your sewing hand, hold the needle between your thumb and forefinger with the eye of the needle resting against the thimble.

2 Hold the fabric so that you can see the sewing lines on each side. Make 2 backstitches at the beginning of the seam and work evenly spaced running stitches along the marked seam lines.

3 Check your stitching to ensure that they are exactly on the marked lines, front and back. Make 2 backstitches at the opposite corner.

Basting

Use a temporary stitch to secure the pieces before sewing them together. For easy removal, use light coloured thread that will contrast with the fabric. Make spaced running stitches about 6mm (¼ in) long.

Joining rows

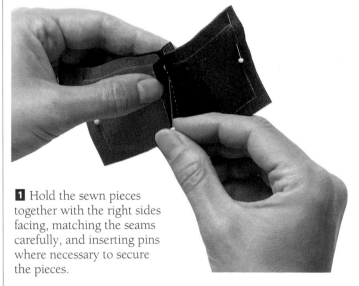

1 Hold the sewn pieces together with the right sides facing, matching the seams carefully, and inserting pins where necessary to secure the pieces.

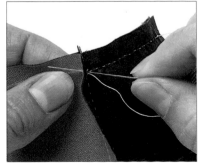

2 At each seam, knot or backstitch the thread, then insert needle through seam allowance to other side so that you are leaving seam allowances free. Knot or backstitch again before sewing the rest of the seam.

Hand sewing over papers

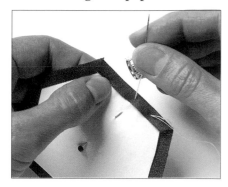

1 Using outer edge of a window template, cut out fabric pieces. Use inner edge to cut out papers. Centre a paper on wrong side of a fabric piece, then pin. Fold one seam allowance over paper without creasing it; baste one stitch through fabric and paper, leaving tail of thread free and unknotted.

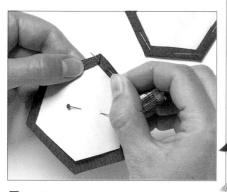

2 Fold adjacent seam allowance over paper, forming a sharp corner. Baste over corner to secure, bringing needle up in middle of next seam allowance. Repeat for remaining edges. Cut thread, leaving end free. Remove pin. Press gently and repeat for other patches.

3 To join, place pieces with right sides facing, matching corners. Whip stitch edges together from corner to corner, backstitching at each end. Do not sew in papers. Remove basting stitches and papers. Gently press finished work.

MACHINE SEWING

Before joining the patchwork pieces, test the sewing machine's tension by stitching on a fabric scrap.

1 Hold the patches together; pin if necessary. Place the edge of the patches beneath the presser foot. Lower it and needle into the edge of the fabric. Stitch forward slowly, guiding the fabric with your hand. At end of the seam, pull out a length of thread and break it.

2 Backstitch to secure stitches, using reverse lever on sewing machine, or make stitches tiny. It isn't necessary to backstitch at each edge of each patch — only where you know that a seam or edge will be under stress, or when insetting (*see page 193*).

3 Patches can be sewed together in a chain to save time and thread. Feed each new set of patches beneath presser foot. Feed dogs will draw them beneath needle. Cut chain apart with scissors after sewing, and press seam allowances.

CORRECTING MISTAKES

If stitches cause the fabric to pucker, remove them carefully.

Use a seam ripper to remove unwanted stitches. Cut through every 3rd or 4th stitch on one side. On the opposite side, pull the thread — it should lift away easily.

Joining rows

Make sure that the matching seam allowances are pressed in opposite directions to reduce bulk and to make matching the seam easier. Pin the pieces together directly through the stitching, and to the right and left of the seam to prevent the pieces from shifting as you sew.

To save time, several sections of patches can be sewn up at one sitting and then snipped apart

BASIC PATCHWORK

FOR YOUR FIRST patchwork pattern, choose one of the simpler ones – we show some patterns here in order of increasing difficulty. The assembly diagrams will help you construct the patchwork blocks. Draw these patterns on graph paper to the desired size, and make templates (see page 184) to mark and cut out the patches you need. When pieces are asymmetrical, such as in the Box design, you will need to reverse some of the pieces when cutting out. Simply flip the template over and mark the outline on the fabric as usual. Blocks are assembled in sections, starting with the smallest pieces and building up from these.

Turnstyle

This four-patch design is relatively simple, and a good starting point for beginners. It is made up of identical quarters which are rotated through a circle in order to make the pattern. It is also known as Oh Susannah. Cut 4 dark and 4 light of A, and 4 medium of B. (Total of 12 pieces.)

Prairie Queen

This is a nine-patch block where all the patches are pieced except the centre one. The corner patches are half-square triangles, and the others simple quarters. Cut 8 medium and 8 dark of shape A, 4 light and 4 bright of B; and 1 bright of C, making 25 pieces in all.

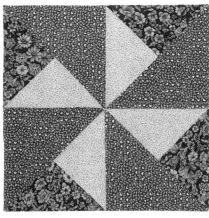

Old Tippecanoe

Irregular sized patches make up this block. If shape A is the basic square, shape B is its quarter-square triangle, and shape C is its half-square triangle. You will need 1 dark of shape A; 8 light, 4 medium, and 8 bright of shape B; and 4 dark of shape C. There are 25 pieces in all.

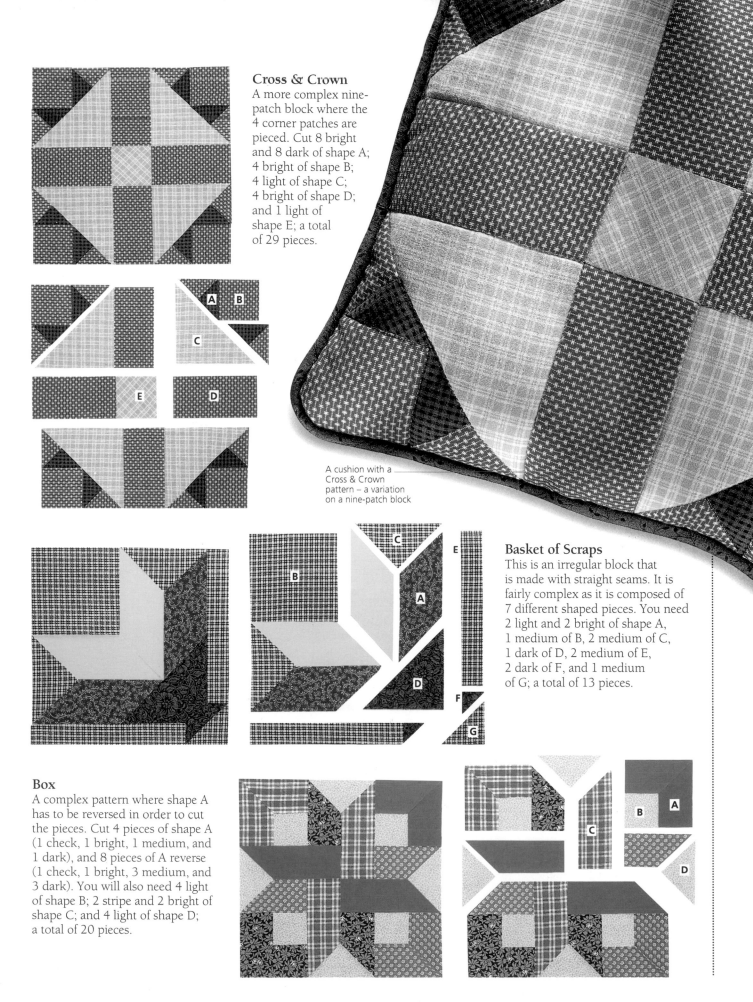

Cross & Crown

A more complex nine-patch block where the 4 corner patches are pieced. Cut 8 bright and 8 dark of shape A; 4 bright of shape B; 4 light of shape C; 4 bright of shape D; and 1 light of shape E; a total of 29 pieces.

A cushion with a Cross & Crown pattern – a variation on a nine-patch block

Basket of Scraps

This is an irregular block that is made with straight seams. It is fairly complex as it is composed of 7 different shaped pieces. You need 2 light and 2 bright of shape A, 1 medium of B, 2 medium of C, 1 dark of D, 2 medium of E, 2 dark of F, and 1 medium of G; a total of 13 pieces.

Box

A complex pattern where shape A has to be reversed in order to cut the pieces. Cut 4 pieces of shape A (1 check, 1 bright, 1 medium, and 1 dark), and 8 pieces of A reverse (1 check, 1 bright, 3 medium, and 3 dark). You will also need 4 light of shape B; 2 stripe and 2 bright of shape C; and 4 light of shape D; a total of 20 pieces.

SPECIAL TECHNIQUES

PATCHWORK CHALLENGES a sewer's ingenuity. There are times when you will need to execute some intricate manoeuvres to create certain types of designs involving complex seams and joins. These techniques may seem daunting to the beginner patchworker, but are easily mastered with a bit of experience. Practise some of these techniques with scrap fabrics so that you'll be confident when you begin a project.

CURVED SEAMS

Curved seams have to be eased to fit so the pieces join smoothly and the seam does not pull or pucker.

1 Cut out pieces with curves on bias of fabric. When joining curved edges, curves bend in opposite directions. Mark evenly spaced notches on seamline for matching.

2 Match central notches on both pieces and pin together, then align side edges and pin. Match and pin any other notches, then continue pinning, easing and smoothing pieces to fit.

3 Sew pieces together by hand or machine, securing beginning and end of seam with backstitches. Carefully press seam allowance toward darker fabrics, clipping where necessary so seam allowance lies flat and the front of the work lies flat.

EIGHT-SEAM JOIN

Sew the diamonds together, beginning and ending the seam with backstitches 6mm (¹/₄ in) from the edges. Sew two pairs of diamonds together to form each half of the design.

1. To hand sew halves together, insert a pin through point of centre diamond on wrong side of one piece, 6mm (¹/₄ in) away from edge to be joined. The same pin should be inserted through right side of other piece at same point.

2 Pin the remainder of the seam, then stitch carefully. Press from the wrong side, opening up the seam allowance around the centre point to reduce the bulk.

The points of the pieces should all meet accurately at one centre point in the finished point.

The stitching passes directly over the point of the uppermost diamond

A machine-sewn eight-seam join should look like this on the back.

SETTING IN

This is done when you have to sew a piece into an angle formed by joined pieces. When sewing the initial pieces, end your stitching 6mm (¹/₄ in) from the edge. Backstitch or knot the end. Mark a dot on the corner of the piece to be inset to show the position of the corner.

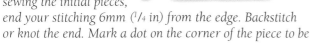

Hand sewing

1 If sewing by hand, pin the patch to be inset into the angle with right sides together, matching the dots exactly. Stitch seam from the outer edge toward the centre. Make a backstitch at the central dot.

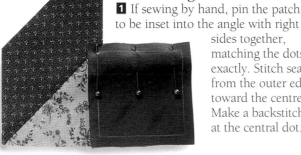

2 Swing the adjacent edge of the patch to align it with the other edge of the angled piece, then continue stitching the adjacent seam backstitching at the end.

Machine sewing

1 To sew by machine, pin the patch to be inset into the angle with right sides together, matching the dots exactly. Stitch the seam from the centre toward the outer edge. Break the thread.

2 Swing the adjacent angled piece to the other edge of the patch and pin. Stitch from centre to outer edge. There should be no puckers on the right side of the work. Clip off any threads. Press carefully.

The seams are carefully matched at the corners

PRESSING

Always press seam allowances to one side to make the seams stronger, not open as in dressmaking. If possible, press seam allowances toward the darker fabric. If this is not possible, trim the seam allowance so that the dark fabric does not show through to the right side. If you are pressing small patchwork pieces, it may be easier to press from the right side: place the light piece of the patchwork wrong side down on the ironing board, then with the tip of the iron, smooth the dark fabric upward and open.

Finger pressing

To save time or when sewing over wadding, use this method to crease fabrics in position without an iron. Run your index finger or a thumb-nail several times over the area until the crease holds.

Hand sewing

Because the seam allowances are left free, you must open them up before pressing, in order to reduce the bulk at the join.

Machine sewing

Press every piece before it is crossed by another. Always press intersecting seam allowances in opposite directions. After joining, press the new seam allowance toward darker fabric.

SEMINOLE PATCHWORK

CREATED BY THE Seminole Indians of Florida around the turn of the century, this form of patchwork is a variation on strip piecing. Seminole patchwork has become increasingly popular and is often used for long borders and insertions. You will need a rotary cutter, and it is essential that you are accurate when matching and sewing seams. Although the finished result looks intricate, the method is not difficult.

Cutting and sewing the strips

1 Choose a pattern from below and, using a rotary cutter, cut the required number of strips. Coat the strips lightly with spray starch to make them easier to handle, and press. Sew the strips together in the combinations given with the design. Press the seam allowances toward the darker fabrics.

2 Cut the strips into pieces of the required width, and arrange on your cutting mat to follow the design shown.

3 Sew the pieces together in a chain (*see page 189*) either alternating the pieces or offsetting them as directed. Press the strip carefully.

4 Use a rotary cutter to trim the top and bottom edges evenly if necessary. Remember to leave a 6mm (¹/₄ in) seam allowance all round.

5 You can straighten the angled ends of Seminole patchwork by making a straight cut through the patchwork. If you have seams that do not quite match, make your cut through this area.

6 Re-arrange the pieces, aligning the diagonal edges. Sew these edges together, matching the seams carefully.

NOTE:
The instructions on these pages assume you are working with 112cm (45 in) wide fabrics. Cut all the strips across the full width of the fabric, then trim off 1cm (¹/₂ in) from selvedge ends, to leave you with a 110 cm (44 in) long strip.

The colourful strips of Seminole patchwork are easy to master

Pattern 1

Cut one light ³/₄ inch strip, one dark ³/₄ inch strip, and 2 medium 1¹/₂ inch strips. Sew together to make a pieced strip 3 inches wide. Cut the strip into 1¹/₂ inch pieces. Invert one pieces and sew the pieces together, matching the seams.

Pattern 2

For the A pieces, cut 2 dark 1³/₄ inch strips, 2 medium 1¹/₂ inch strips and one bright 1¹/₂ inch strip. Sew together to make a pieced strip 6 inches wide. For the B pieces, make a pieced strip as follows: cut one dark 3³/₄ inch strip, one medium 1¹/₂ inch strip, and one dark 1³/₄ inch strip. Sew together to make a pieced strip, 6 inches wide. Cut the pieced A and B strips into 1¹/₂ inch pieces. Arrange one B piece on each side of A piece, with one of the B pieces in an inverted position, as shown. Arrange the pieces so that the medium squares line up on each side of the bright square. Sew together, matching the seams.

Invert every alternate B piece in order to complete the pattern sequence

The basic pieced strip made up of five strips in graded widths

Pattern 3

For A, cut 2 dark 1¹/₂ inch strips, 2 medium 2 inch strips and one bright 1 inch strip. Sew together to make a pieced strip 6 inches wide. Cut strip into 1¹/₂ inch pieces. For B, cut 5 bright 1¹/₂ inch strips. Cut these strips into 6 inch lengths – make a total of 28 pieces. Arrange an A piece on each side of a B piece. Offset the pieces by ¹/₂ inch and sew together, alternating A and B.

195

FOLDED STAR

THIS TYPE OF patchwork is composed of folded rectangles or circles, arranged in overlapping layers to form a star design on a base of lightweight foundation fabric. Folded star pattern is ideal for wallhangings and cushions or could be framed as a sampler. Use highly contrasting fabrics to make the most of this technique and arrange one colour of fabric in each round. To achieve a perfect star, ensure that the points of each round are the same distance away from the centre. The instructions for making a folded star are given in the project instructions (page 247). This pattern is not suitable for a quilt that will receive heavy use as the folds conceal unfinished edges that could fray from wear and frequent washing. The technique of folding also means that the amount of fabric used makes the finished work thick and heavy.

CRAZY PATCHWORK

PROBABLY THE EARLIEST type of patchwork, this technique was born out of the necessity to mend tattered clothing or blankets. During the Victorian era crazy patchwork evolved into an art form in its own right when women used it as a medium for displaying their fine needlework skills.

Crazy patchwork can be as simple or as elaborate as you wish to make it. It is an enjoyable technique that can make use of all the bits of fabric that you hate to part with, but that you can't use in a larger project. To make a Victorian-style crazy quilt, collect all the rich silks, brocades, and velvet fabrics you can find. Sew them in a random fashion to a base fabric, then embroider over the seams with silk embroidery floss in a variety of fancy patterns. You can also stitch small motifs in the middle of some of the patches.

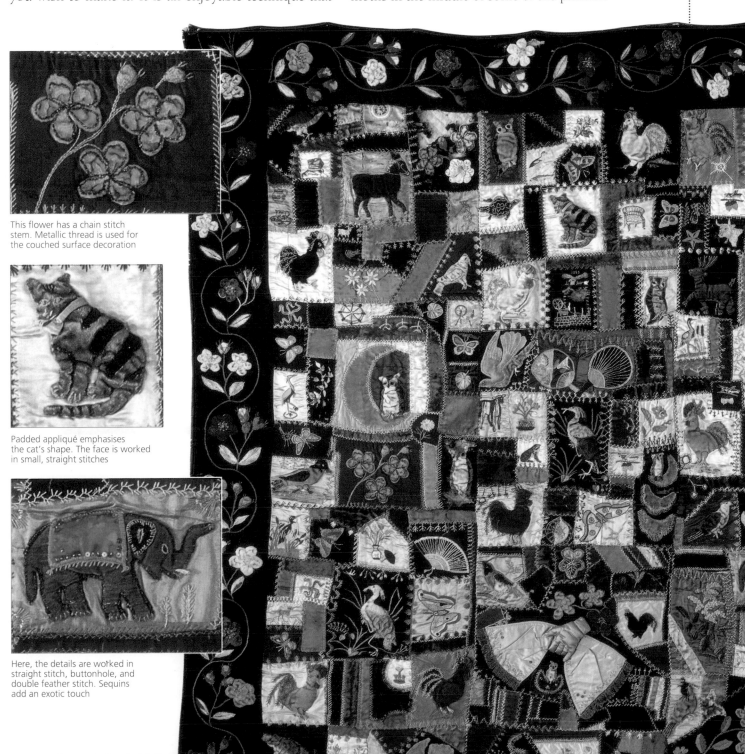

This flower has a chain stitch stem. Metallic thread is used for the couched surface decoration

Padded appliqué emphasises the cat's shape. The face is worked in small, straight stitches

Here, the details are worked in straight stitch, buttonhole, and double feather stitch. Sequins add an exotic touch

LOG CABIN PATCHWORK

THIS PATCHWORK TECHNIQUE involves sewing strips of fabric around a central shape to produce a variety of effects. It is essential that you work with strongly contrasting fabrics so that one half of the block is light and the other half is dark. Identical Log Cabin blocks can be arranged to make numerous different pattern combinations.

There are two main ways to sew a Log Cabin block. One is to sew all the pieces onto a muslin base. This is a good method for combining fabrics of different weights and textures as the base provides a firm foundation. However, the finished product will be difficult to quilt since there is an extra layer of fabric that must be sewn through. You can get around this by using wadding for the base, or placing the wadding on the base and sewing and quilting at the same time.

The second method, shown here, does not require any templates, unless you are using an unusual shape for the centre of the block. Rotary cutting will simplify the cutting process and save time.

TRADITIONAL LOG CABIN BLOCK

The red square in the middle represents the hearth of the log cabin, while the strips symbolise the logs of the cabin walls. The dark and light portions of the block show the effect of sunshine and shadow on the cabin in day and night. To construct the block, begin in the middle and work around in a anticlockwise direction.

Working without templates

1 Make sure the light and dark fabric you choose contrast sharply. Cut strips to desired width plus 12mm (¹/₂ in) seam allowance – making sure to cut across entire width of fabric.

2 The centre can be any shape, although it is usually a square. If you choose another shape, you must make a template and cut the shape with a rotary cutter. Red is traditionally used for the centre.

3 With right sides facing, place the centre square against a light strip, matching the edges. Stitch, then cut the strip even with the square. Press the seam allowance towards the centre.

4 Alternatively, if you wish to use the same fabric for all the first strips in your quilt, sew the centre pieces to the first strip one after another, leaving only a small space between each. Cut the pieces apart, trimming them to the same size as the centre square.

5 Choose a different light fabric for the 2nd strip and sew to the pieced centre, trimming away the excess fabric so it is even with the centre. Press lightly.

6 Again, to make all the blocks exactly the same, sew these pieces to the 2nd strip leaving only a small space between each. Cut the pieces apart, trimming them to the same size as the pieced centre. Continue adding around centre if you want every block to have the same fabric arrangement.

7 Pick a dark fabric for the 3rd strip. Continuing anticlockwise, sew the pieced centre to the 3rd strip, trimming away the excess strip so it is even with the centre. Press lightly.

8 Select a different dark fabric for the 4th strip. Sew to the pieced centre, trimming away the excess fabric as before. Press lightly.

9 Continue working anticlockwise, adding 2 light strips, then 2 dark strips in turn around the centre. Avoid placing the same fabrics next to each other. Trim the strips and press lightly after each addition.

10 Once you have made the required number of blocks for your quilt or wall hanging, arrange the blocks in a variety of positions to see the different effects you can achieve by transposing the dark and light portions of the blocks. Examples are shown here.

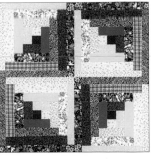

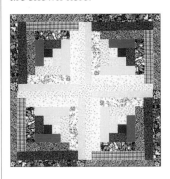

An arrangement of Log Cabin blocks makes a strong pattern

APPLIQUÉ

If you have ever patched a pair of jeans or sewn a badge onto a child's school uniform then you have appliquéd. The word means applied, and the technique is simply to stitch one fabric on top of another. Functional or purely decorative, appliqués can be hand or machine made, and the stitches used to secure the appliqués to the background fabric can be invisible, such as a slip stitch, or visible and part of the decorative effect, such as satin stitch.

APPLIQUÉ QUILT

Huge stylized flower motifs are appliquéd around the border of this quilt, and the shape of the motif is echoed in the quilting on the plain white background.

In appliqué work, you can use many different fabrics in one project, provided that the finished item will not be subjected to heavy wear and frequent washing. The combination of diverse fabrics, such as tweeds, corduroys, silks, and satins, and the use of buttons, beads, and sequins, can create marvellous effects. Beginners may wish to appliqué using felt because it is easy to work with and doesn't fray. Or, choose tightly woven 100% cotton fabrics that are not likely to fray.

APPLIQUÉ DESIGNS

If you are a beginner, select an appliqué design with straight lines or gradual curves and a relatively small number of large or medium-sized pieces. As you become adept at turning the edges under smoothly and sewing them invisibly to a fabric background, you can graduate to more complex shapes and designs. Templates for hand and machine appliqué have no seam allowances so that you can mark the exact outline of the piece on the fabric. Basting lines on your base fabric will help you place the appliqué pieces.

Cutting appliqués

Make templates to finished size (*see page 184*). Mark outline on right side of fabric, leaving 12mm (¹/₂ in) in between each. Cut out pieces, adding a 6mm (¹/₄ in) seam allowance.

Preparing the base fabric

Cut fabric for base 2.5cm (1 in) larger than desired size. Fold base in half horizontally, vertically, and then diagonally, and press folds. Open fabric and baste along each fold with contrasting thread. Press flat.

HAND APPLIQUÉ

Floral, geometric, or pictorial themes all work well in appliqué. If necessary, enlarge or reduce your design and transfer it to paper.

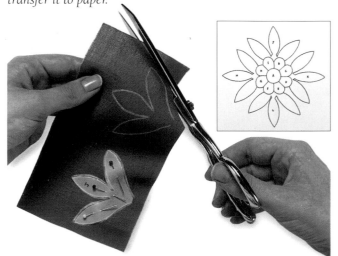

1 Draw design and label each piece by letter. Trace design and make a template for each appliqué. Label each template with the correct letter. Mark outline of appliqués on right side of fabric and cut, adding a 6mm (¹/₄ in) seam allowance.

2 Use tip of a sharp pair of scissors to clip into curved edges perpendicular to marked outline of piece; do not clip beyond the outline. Make extra clips along deep curves for ease in turning.

3 Using a design tracing, pencil outlines of pieces on right side of base about 6mm (¹/₄ in) within outline, to avoid marks showing around edges.

4 Following placement lines, arrange appliqués on the base. Position the background pieces first, with foreground pieces overlapping if necessary. Pin or baste pieces to base.

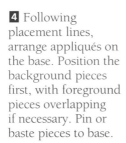

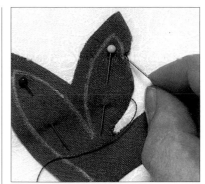

5 Turn raw edges of the appliqués 6mm (¹/₄ in) to the wrong side, using the tip of your needle as a tool for turning.

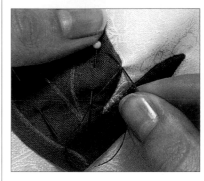

6 Using matching thread and making tiny invisible slip stitches, sew the appliqués to the base fabric, starting with the background pieces and finishing with the appliqués that are topmost.

7 Turn completed design to wrong side and very carefully cut away base fabric within all the larger appliqué pieces, leaving a 6mm (¹/₄ in) seam allowance. This prevents any puckers, and makes quilting easier.

8 Remove the pins or basting threads after the appliqué work is finished. Press the appliqués lightly on a thick towel so that the seam allowances do not show through to the right side.

SPECIAL APPLIQUÉ TECHNIQUES

Complex shapes will require you to use special techniques in order to achieve a smooth edge to your appliqué pieces, and prevent the seam allowance from distorting the shape.

Points

Trimming your seam allowance will help you make neat points

1 First clip into seam allowance 6mm (¹/₄ in) from tip on each side and trim seam to 3mm (¹/₈ in). Trim off point 3mm (¹/₈ in) from turning line. Fold point to wrong side along turning line.

2 Fold one edge of appliqué 6mm (¹/₄ in) to wrong side. Press, then baste in place. Fold 2nd edge to wrong side, overlapping first edge at top and bottom. Steam and baste.

Valleys

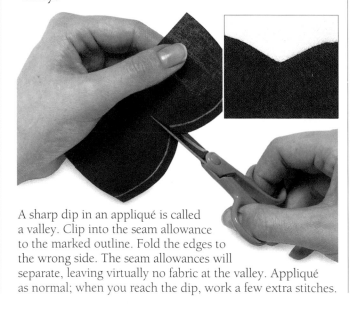

A sharp dip in an appliqué is called a valley. Clip into the seam allowance to the marked outline. Fold the edges to the wrong side. The seam allowances will separate, leaving virtually no fabric at the valley. Appliqué as normal; when you reach the dip, work a few extra stitches.

Circles

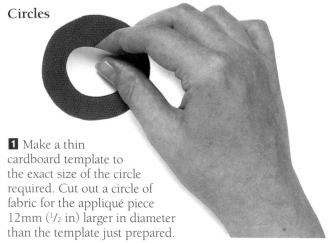

1 Make a thin cardboard template to the exact size of the circle required. Cut out a circle of fabric for the appliqué piece 12mm (¹/₂ in) larger in diameter than the template just prepared.

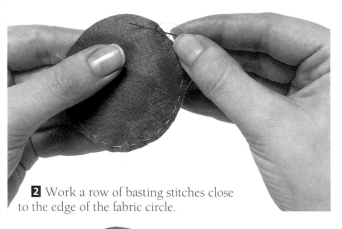

2 Work a row of basting stitches close to the edge of the fabric circle.

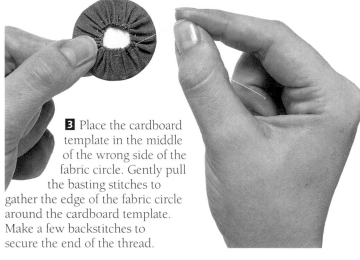

3 Place the cardboard template in the middle of the wrong side of the fabric circle. Gently pull the basting stitches to gather the edge of the fabric circle around the cardboard template. Make a few backstitches to secure the end of the thread.

4 Press the circle gently so that there are no puckers on right side. Then, remove the cardboard from the circle without distorting shape.

MACHINE APPLIQUÉ

Before starting, change to a new needle and a zigzag foot; use 100% cotton thread to match the appliqué. Because the seam allowances are not turned under, technically you do not need to add an allowance when cutting out your pieces. However, it is not easy to keep the pieces from puckering when stitching very close to the edges. Therefore, the steps shown here show a seam allowance, which is trimmed away after stitching. Test your stitch on a scrap of fabric. Use a standard width of 3mm (1/8 in) for medium-weight fabrics. Fine fabrics will require a narrow stitch width, and heavy fabrics need a wider one. The tension should be even and should not pucker the fabric. If the bobbin thread shows through to the right side, loosen the top tension of the sewing machine .

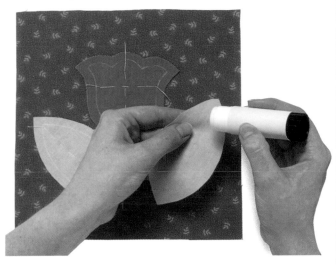

1 Cut out the appliqués and prepare the base as directed on page 200. Follow steps 1, 2, and 4 for Hand Appliqué. Arrange the pieces in their correct position on the base fabric and attach, using a fabric glue stick and basting stitches.

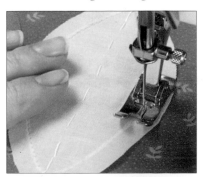

2 Machine stitch along the marked outline of each appliqué, using matching thread to make short straight stitches.

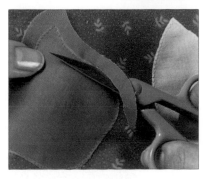

3 Using sharp embroidery scissors, carefully trim away the excess seam allowance beyond the stitching line, cutting as close to your machine stitches as possible.

4 Zigzag stitch over line of stitches, covering raw edges of fabric. Gently guide fabric around curves so that machine sews smoothly. Work slowly so that you have complete control over your stitching.

STITCH EFFECTS

Use zigzag satin stitch to add details that are too small to make in fabric, such as veining on leaves, or to delineate flower petals. You can also use machine embroidery stitches to create a variety of other embellishments. A highly contrasting thread will also create special effects in machine appliqué, with black or dark grey creating a stained glass appearance.

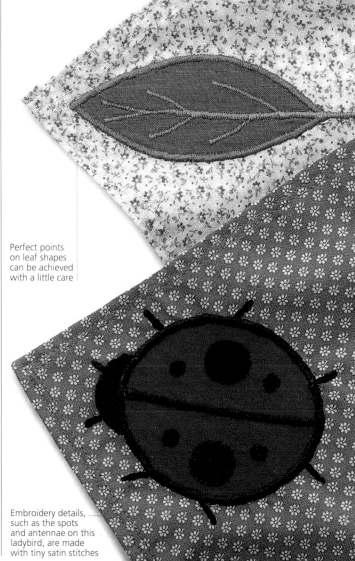

Perfect points on leaf shapes can be achieved with a little care

Embroidery details, such as the spots and antennae on this ladybird, are made with tiny satin stitches

CONSTRUCTING A QUILT

THERE ARE MANY ways to join patchwork blocks together to make a quilt. Each method produces very different results, even when the same patchwork blocks are used. Shown here are some of the traditional ways of joining patchwork blocks. Sashing refers to fabric strips that surround each block of a quilt. In edge-to-edge, the blocks are sewn directly together. Connector squares, or posts, join the short sashing strips that frame individual blocks. Appliqué is used to hide seams and decorate the blocks.

SCRAP QUILT

This Evening Star scrap quilt features blocks set together with grey sashing strips and navy posts (connector squares).

SASHING

The medallion style blocks of this Lone Star quilt are framed with green sashing.

EDGE-TO-EDGE SETTING

This variation on the Card Trick design has a pieced ribbon border. The blocks form a secondary pattern.

BALTIMORE QUILT

The seams between the blocks of this Baltimore Album style quilt are decorated with red appliqué made to resemble lace.

ASSEMBLING A QUILT

A QUILT IS a sandwich composed of three layers – the quilt top, the wadding, and the quilt back. The layers are held together with quilting stitches or by tying (see pages 206 to 210). Baste the layers carefully before you quilt to prevent creases and puckers forming on the back of the finished quilt.

Putting quilt layers together

1 Measure your quilt top to find the size of quilt back. Add a 5cm (2 in) margin all round. This will be trimmed off later. You may have to join pieces for quilt back, but usually only one central seam is required. If the quilt is large, you may need to join 3 pieces.

2 Press the quilt back carefully and lay it on a large flat surface, wrong side up. If you can, tape edges of quilt back in place to prevent fabric from shifting as you work.

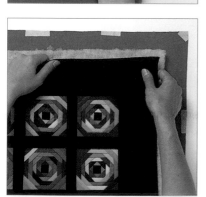

3 Cut a piece of wadding the same size as the quilt top. Place in the centre of the quilt back. Carefully iron the quilt top and remove any loose threads or bits of fabric. Then, place it right side up on the wadding.

4 Pin the layers together with long straight pins so that they don't shift while basting.

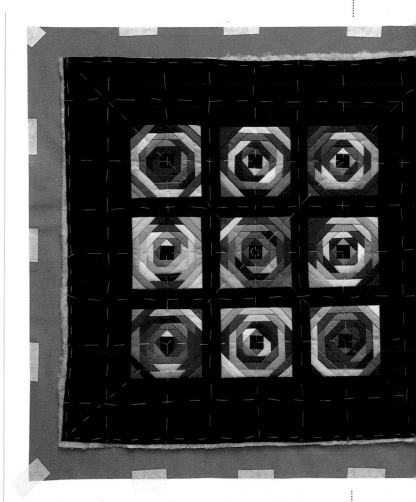

5 Baste the quilt together from the centre out to the edges, first horizontally and vertically, then diagonally in each direction. Secure any open areas of quilt with additional basting, working out from the centre.

HAND QUILTING

THE MAIN PURPOSE of quilting is to hold the top, wadding, and backing layers together to prevent them from shifting when the quilt is being used or washed. Quilting stitches are simply running stitches that pass through all three layers, anchoring the layers together firmly. The stitches can be worked on plain fabric or pieced work, according to the design. Quilting stitches also help bring your quilt to life by providing another design that adds dimension to your work, and serves to highlight or offset the piecing.

1 Cut a 45cm (18 in) length of quilting thread and knot the end. Pass thread through top of quilt, pulling it so that knot becomes buried in wadding. The knot will make a popping sound as it passes through quilt top.

2 You may want to use a thimble. With one hand below the quilt to guide the needle upward, begin working a series of running stitches through all 3 layers of quilt. The stitches should be the same length on the front and back.

3 Try to make 3 or 4 stitches at a time, rocking needle from surface to quilt back and up to surface again, then pull stitches through. If quilt is in a frame, you can pull quite firmly, which will give your stitches greater definition.

4 If you have trouble pulling the needle through, use a balloon to grip the needle.

5 When you reach the end of your length of thread, make a knot close to the surface of the quilt. Then make a backstitch through the quilt top and wadding, pulling the knot beneath the surface and burying it in the wadding.

USING A HOOP

Quilting frames can be quite bulky, and few of us have the room for one. Luckily, any size project can be quilted using a large (50cm/20 in) hoop specifically designed for this purpose. (You will still need to baste the quilt.) The tautness, or surface tension, of the quilt in the hoop can vary from very firm to slightly pliant – experiment to find the tension you prefer.

1 Unscrew wing nut on your hoop and separate inner and outer rings. Place inner ring on a flat surface, then position centre of your project over it. Place outer ring over inner, and tighten screw after adjusting tension.

2 To quilt the outer edges, baste strips of muslin to sides, then insert in the hoop.

MACHINE QUILTING

QUICKER THAN HAND quilting, machine quilting is sometimes an effective way of finishing those quilts that are too thick to stitch by hand. Use a medium colour printed fabric for the quilt back. The secret to successful machine quilting is to maintain an even tension between the top thread and the bobbin, so test your tension on a scrap quilt "sandwich", and adjust before sewing the quilt itself.

SETTING UP THE MACHINE

Use a size 80/12 needle, and use a 50 three-ply mercerized cotton thread. Wind the bobbin with thread to match the quilt back so that any uneven stitches will not show. If the quilt is well basted and not too thick, you can use a regular presser foot. Work at a table large enough to support the entire quilt – if it hangs off, it will hinder the operation. If the top is being pushed ahead of the wadding, use a walking foot (see below).

Quilting by machine

1 To secure the thread ends at the beginning or end of a line of stitching, stitch forward and reverse several times, then cut off the surplus threads close to the surface of the quilt.

2 You can use a spacer guide, which attaches to the walking foot, to sew parallel lines without marking them.

3 Place your hands on each side of the needle and smooth the quilt as you sew. Pulling or pushing the fabric may cause skipped stitches or puckers on the back. Check the back often to catch problems as they occur.

4 First stabilise the quilt by basting as straight a line as possible down the horizontal and vertical centres of piece. Then quilt each quarter in turn, from centre outward to edges.

5 Beginners should try a small project first. The simplest technique is to stitch-in-the-ditch, which means to stitch as close to the seam as possible, opposite the pressed seam allowances.

6 If you are sewing along a seam where the position of the seam allowances alternate, just make a small stitch across the intersection and alternate your quilting line too.

7 Roll large quilts in a scroll-like fashion and only uncover the area you wish to quilt. Secure the roll with bicycle clips.

WALKING FOOT

You can use a walking foot (or even feed foot) with most sewing machines. This contains a set of feed dogs similar to those in the throat plate. With both sets working in unison, the fabric layers move evenly beneath the needle.

QUILTING PATTERNS

THE EARLIEST QUILTS were often stitched in straight and diagonal lines, creating simple squares and diamond shapes. The elaborate use of interwoven curves and circles creates a more decorative effect. These medallions set on a plain coloured fabric are called wholecloth motifs.

If you want to create your own filling designs for a simple outline shape, bear in mind that the filling lines are there to secure the wadding. Always try to create an evenly spaced design. See page 248 for the pattern designs to trace for yourself.

GRAPE VINE PATTERN

This variation on a grape vine pattern makes a suitable border to work continuously around a quilt.

LEAF PATTERN

In this early American quilt, the outline of the leaf is filled with an elaborate pattern of veins. The outer rows of stitches become progressively wider apart.

JAPANESE PATTERN

Sashiko is the name for the folk quilting of Japan, and is often worked in strongly contrasting colors or in white on black. This repeating pattern is called Asanoha or hemp leaf.

PETAL BORDER

An interlacing of simple curves makes a petal design border, with a motif based on the same pattern at each corner.

WHOLECLOTH MOTIFS

This medallion design (above left) shows a feathered circle with lattice centre. The centre can be varied according to taste. The clam shell is another traditional motif (below).

CONNECTED HEARTS

A border of linked hearts and curves is based on a traditional pattern. It can form a filling pattern or a border.

TIED QUILTING

TIED QUILTING IS a quick and simple alternative to hand or machine quilting. It is effective when making quilts for children or projects that have a thick layer of wadding. It is worked by making a series of double knots through all three layers to secure them. If the quilt is tied from the back, the ties will be virtually invisible on the front, leaving only small indentations that can form an attractive pattern of their own.

Alternatively, if you wish to make the ties a decorative feature, tie the quilt from the front so that the ends are visible, or use a contrasting colour thread to make the ties stand out from the background.

TYING THE QUILT

Ties must be spaced every 6cm (2¹/₂ in) if you are using polyester wadding, and closer if using cotton wadding. You can use silk or cotton thread, embroidery floss, or yarn for the ties. Work with a crewel needle and a 45cm to 60cm (18 to 24 in) length of your chosen thread.

Separate ties

1 Assemble the quilt layers as directed on page 205. Decide on where you wish the ends of the ties to show, and work from that side of the quilt. Leaving a short end of thread, make a backstitch through all three layers.

Knotted ties on the front of a quilt can be used as decoration

2 Make another backstitch in the same spot and cut the thread, leaving a short end.

3 Tie the ends together in a double knot. Trim the ends evenly. Continue tying knots across the quilt, spacing them evenly.

Joined ties

1 If the ties are going to be spaced close together, work the 2 backstitches, then go on to the next area without cutting the thread. Continue with the same length of thread until you run out.

2 Cut the thread in between the ties, then tie the ends into a double knot.

BINDING A QUILT

ADDING THE BINDING is the last step in making a quilt, and it is the finishing touch that determines the overall appearance. The edges should lie smoothly without puckers or ripples. Therefore, you should bind the quilt carefully, using binding that matches the rest of the quilt in weight and quality.

JOINING THE BINDING

Cut 4cm (1 1/2 in) wide strips across the width of fabric on straight grain. Cut enough strips to fit around the raw edges of the quilt plus 10cm (4 in). Sew the strips together, then press the seams to one side. Press the binding in half lengthwise with wrong sides facing one another; then press one long edge to the centre crease, again with wrong sides facing. You will need room to spread out, so choose a suitable work space.

Adding the binding

1 Place the middle of one side edge of the quilt on your sewing machine, right side up. Fold one end of binding 12mm (1/2 in) to wrong side and place on quilt top with right sides together and raw edges even. Stitch the binding to the quilt making a 6mm (1/4 in) seam.

2 As you approach first corner, shorten your stitch length and align binding to next edge of quilt, leaving a fold of binding that lines up with quilt edge. Stitch up to edge of fold. Stop stitching.

3 Lift the needle and the presser foot and refold the binding so that the fold is on the edge of the quilt that you have just sewn. Lower the needle exactly into the fold so that it does not catch your previous fold; lower the presser foot and continue stitching.

Adjust the stitch length to normal after about 12mm (1/2 in). Continue machine stitching to the next corner.

4 Sew each corner in the same way. When you reach the starting point, allow the binding to overlap the beginning fold by 12mm (1/2 in). Trim away any excess binding.

5 Wrap the folded pressed edge of the binding over to the back, overlapping the stitching line. Pin in place. Slip stitch the binding to the quilt back using matching thread.

6 When you reach the end of the binding strip, fold the end of the binding 12mm (1/2 in) to the wrong side to make a neat join at the point the ends overlap.

7 Use a pin to adjust the tucks at each corner into a perfect mitre. Carefully stitch the mitred corners in place.

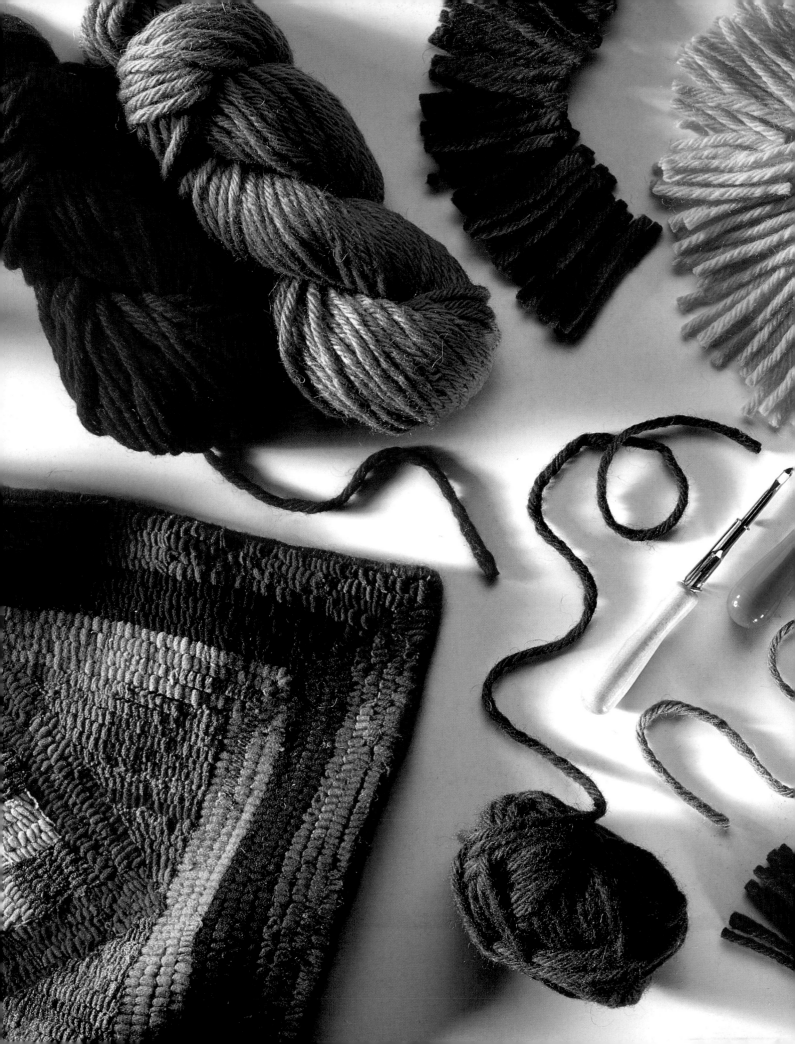

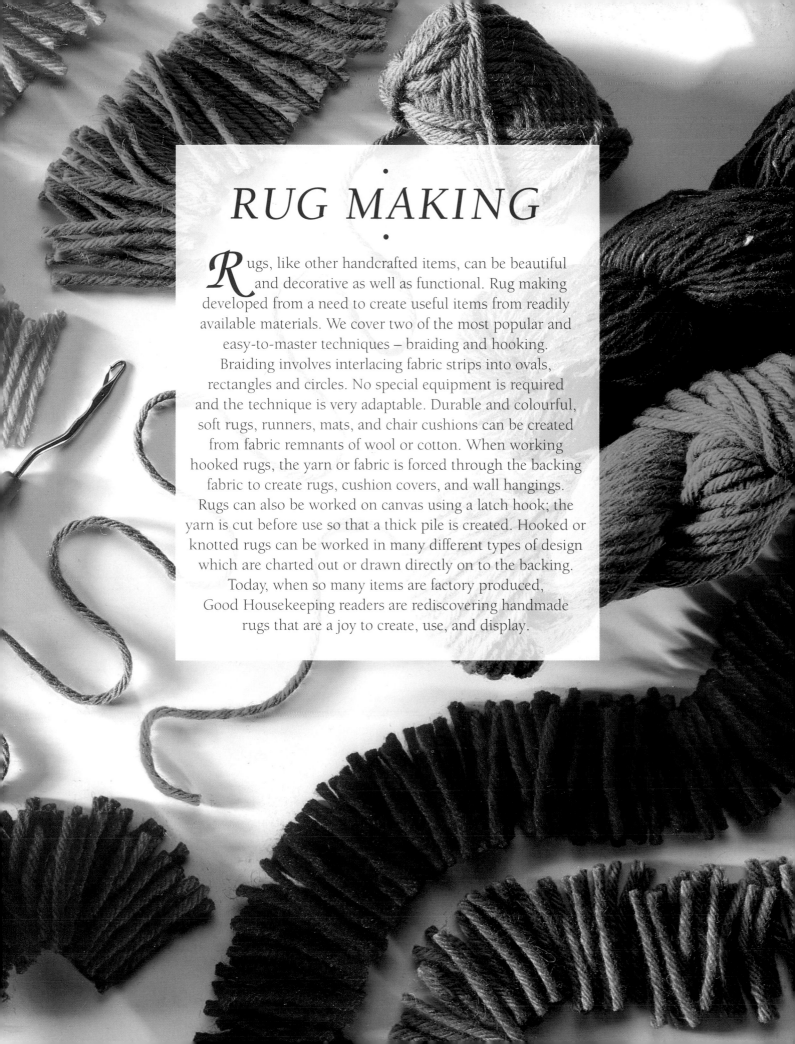

RUG MAKING

Rugs, like other handcrafted items, can be beautiful and decorative as well as functional. Rug making developed from a need to create useful items from readily available materials. We cover two of the most popular and easy-to-master techniques – braiding and hooking. Braiding involves interlacing fabric strips into ovals, rectangles and circles. No special equipment is required and the technique is very adaptable. Durable and colourful, soft rugs, runners, mats, and chair cushions can be created from fabric remnants of wool or cotton. When working hooked rugs, the yarn or fabric is forced through the backing fabric to create rugs, cushion covers, and wall hangings. Rugs can also be worked on canvas using a latch hook; the yarn is cut before use so that a thick pile is created. Hooked or knotted rugs can be worked in many different types of design which are charted out or drawn directly on to the backing. Today, when so many items are factory produced, Good Housekeeping readers are rediscovering handmade rugs that are a joy to create, use, and display.

TOOLS & EQUIPMENT

THREE BASIC METHODS of rugmaking are described in this section – hooking, knotting, and braiding. They can all be used as colourful wallhangings and cushions as well as on the floor. Hooked rugs are worked by pulling loops of fabric or yarn through a woven backing fabric with a hand hook or a punch hook. The pile on knotted rugs is formed by tying yarn to open mesh canvas with a latch hook. No special tools or backing fabrics are required for braided rugs. Instead, braided strips of fabric are laced together with strong thread to form a solid mat. If your rug is to be used on the floor you should choose materials that are very hardwearing, particularly if it is in area that has constant use.

Hand hook method

Punch hook method

Latch hook method

Braided method

TOOLS AND BACKING FABRICS

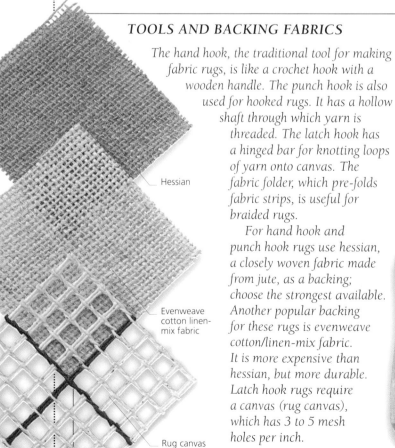

Hessian

Evenweave cotton linen-mix fabric

Rug canvas

The hand hook, the traditional tool for making fabric rugs, is like a crochet hook with a wooden handle. The punch hook is also used for hooked rugs. It has a hollow shaft through which yarn is threaded. The latch hook has a hinged bar for knotting loops of yarn onto canvas. The fabric folder, which pre-folds fabric strips, is useful for braided rugs.

For hand hook and punch hook rugs use hessian, a closely woven fabric made from jute, as a backing; choose the strongest available. Another popular backing for these rugs is evenweave cotton/linen-mix fabric. It is more expensive than hessian, but more durable. Latch hook rugs require a canvas (rug canvas), which has 3 to 5 mesh holes per inch.

Fabric folder

Punch hook

Latch hook

Hand hook

Lacing needle

Hot-iron transfer pen

YARNS AND FABRICS

Rug yarn is a smooth, heavy, 4- to 6- ply yarn suitable for hand hook, punch hook, and latch hook rugs. It is available in balls and hanks. You can use Rya yarn for both punch hook and latch hook rugs; several strands of the twisted 2-ply yarn are generally used together. Both these yarns can be bought in ready-cut lengths for latch hook rugs, which is more convenient but more expensive than cutting the yarn into lengths yourself. Any scraps of closely woven fabric can be used for hand hooked and braided rugs. The fabric should be washed first to pre-shrink it. Wool is the most hard wearing fabric to use and repels dirt best.

Rug yarn

Rya yarn

Pre-cut yarn

Fabric strips

PREPARATION OF BACKING

The edges of the backing must be strengthened to prevent fraying while the rug is being worked.

For a hand hook or punch hook rug, cut the woven backing to size, allowing an extra 10cm (4 in) round the edges so that it can be secured to a frame. Turn a 12mm (½ in) hem around each edge, and machine stitch.

For a latch hook rug, cut the canvas to size, leaving a 2.5cm to 5cm (1 to 2 in) hem allowance round the edges. Turn the hems to the back of the canvas and work the first knots through both layers of canvas.

TRANSFERRING DESIGNS TO THE BACKING

Once you have made initial sketches for your design, you can draw it out freehand on the backing fabric with a waterproof marking pen. Or make a full-size drawing and transfer it using one of the methods given below.

Hand hook and punch hook rugs

Draw your design onto tracing paper with a hot-iron transfer pen (*left*), then turn the tracing face down on to the backing and press carefully (*right*).
Note: If you are making a punch hook rug, remember that you will be working the design on the wrong side of the backing. This means that the design should be transferred to the underside of the backing as a mirror image to the way you want it to look on the pile of the rug.

Latch hook rugs

Centre the design (right side up) underneath the canvas, and tape or pin them together. The design outlines are quite visible through the canvas. Trace the design onto it with a waterproof felt-tip pen.

TO FINISH RUGS

To sew a large rug together, and for lacing braided rugs, use carpet thread. The edges of hooked rugs can be finished with a woven cloth tape called rug binding.

Carpet thread

Rug binding

HAND HOOKED RUGS

HAND HOOKED RUGS are worked by pulling loops of a continuous strip of fabric or yarn through a woven backing fabric. The loops stay in place because they are tightly packed together. In order to keep the loops at an even height, the backing must be stretched taut on a straight sided frame before you start hooking (see page 121). The hand hook is the traditional tool that was used by early American settlers to make superb, finely detailed rag rugs from strips cut from worn out clothing. Thin strips of fabric work best, as hand hooks tend to split the strands of wool when they are pulled through the backing.

The beribboned toy sheep is framed with a rustic fence border

SHEEP RUG

The folk art simplicity of early American rugs is captured in this charming design, with the curly texture of the sheep formed by the wool strips. To make, see page 249.

PATCHWORK RUG

A traditional patchwork design is combined with the art of rug making to produce a beautiful and useful object. For instructions, see page 249.

Amish quilt patterns in glowing colours are the inspiration for this hand hooked rug

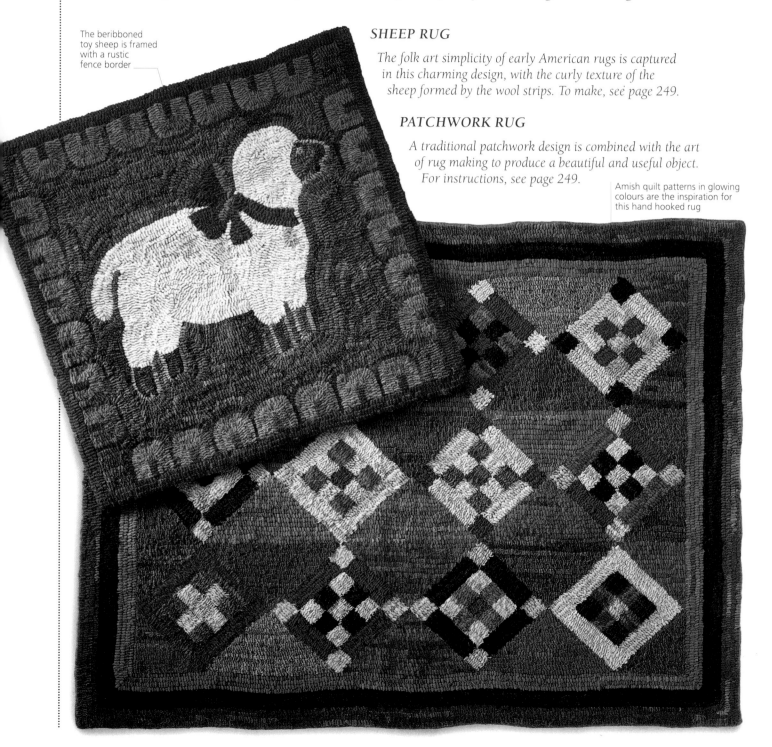

PREPARATION OF FABRIC

Wash the fabric to remove any finishings, especially if new. Use a sharp pair of scissors to cut the fabric into long, thin strips. The width of strips will depend on the fabric used and the effect you want to achieve, so experiment on a piece of backing fabric first. For a homespun look, 6mm (¹/₄ in) strips usually work well. Fabric strips can be cut as wide as 12mm (¹/₂ in) or as thin as 3mm (¹/₈ in) depending on the look you want. Cut woven fabrics along their grain, and knitted fabrics along their length. Never cut strips on the bias.

Basic method

1 Work from right to left. Hold the fabric strip on the wrong side of the backing with your left hand, letting it run loosely between your thumb and forefinger.

2 Hold the hook like a pencil in your right hand, with the hook facing upward. From right side, push hook between 2 threads of backing. Hook around fabric strip, and pull up one end to right side of the backing.

3 To form first loop, push hook through backing fabric again, 2 threads to left of fabric end that you have just pulled up to right side. Keep holding strip loosely on underside of work with your left hand. If you hold it too tightly, you may pull out the end as you hook up loop.

4 Hook around the fabric and pull up a loop the required size to the right side of work. As a rule, the height of the loop is the same size as the width of the strip.

5 Continue pulling up loops of the fabric strip, leaving one or 2 threads of backing fabric between them. On the wrong side of the work, the hooking should look like a smooth row of running stitches. If any of these stitches are forming loops on the wrong side, you are not pulling up the loops on the right side far enough.

6 Leave one or 2 threads of backing between each row of loops. Always start and finish each row by pulling up ends of strip to right side of work. Trim these ends to same height as loops if necessary, when the rug is completed.

WORKING A DESIGN

Create the details of the design first, and then fill in the background. First, outline the detail with a row of loops. Then, fill in the outlined area with rows of loops. Never carry the yarn or fabric strips from one area to another, because the trailing loops on the wrong side may break as you continue hooking. If the rug starts to buckle, you may be spacing the loops and rows too close together. If so, increase the space by one thread of the backing fabric. If too much of the backing fabric is showing through, decrease the spacing by one thread of the backing.

PUNCH HOOKED RUGS

PUNCH HOOKED RUGS are worked on a woven backing fabric stretched in a straight-sided frame. The finished effect is similar to a hand hooked rug because the technique produces a raised pile formed by tightly packed loops of yarn or fabric. The main difference is that a punch hooked rug is worked with the wrong side of the rug facing toward you, so you must remember to transfer a mirror image of your design onto this side. Once you have got the knack, a punch hook is quicker to manipulate than a hand hook because it automatically feeds the yarn through the backing, and regulates the height of the loops. Yarns are easier to use than strips of fabric because they slide more freely up and down the shaft of the hook.

TOOLS

Punch hooks come in several sizes for a range of different weights of yarns. Be sure to choose a size that allows the yarn to pass easily through the eye of the hook's needle. The punch hook can be adjusted to form loops of different height, from about 6mm (¹/4 in) to 18mm (³/4 in), by turning and locking the handle.

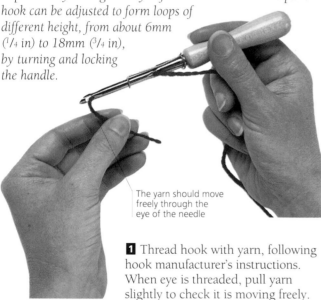

The yarn should move freely through the eye of the needle

1 Thread hook with yarn, following hook manufacturer's instructions. When eye is threaded, pull yarn slightly to check it is moving freely.

2 Hold the hook like a pencil, with the grooved side facing in the direction you are working. If the grooved side is not facing the correct way, the yarn will not feed through the needle properly.

3 Push needle portion down through backing fabric up to the wooden handle.

4 Withdraw the needle until it just touches the surface of backing. Do not lift it off. Slide the needle along the surface of backing for a few threads, and push it in again.

5 Continue in this way, changing direction when necessary. Leave a few threads of the backing fabric between each row of loops.

6 Check to make sure loops are even. If not, slip a knitting needle through them and pull them up to same level as the rest.

To end a piece of yarn

When you come to the end of a length of yarn, push hook through backing (*left*). Pull yarn slightly, and cut it off behind eye. Remove hook. Trim yarn ends even with pile (*right*).

LATCH HOOKED RUGS

LATCH HOOKED RUGS are worked on canvas, and no frame is needed. The yarn is pre-cut to a given length, and each piece is knotted separately onto the backing. It is easiest to work with rug yarn, but different types and textures of yarn, as well as strips of ribbon and braid can also be knotted with the hook. Since this type of rug has a dense pile, fine details get lost. You will find that strong patterns work best.

HOOKING

Cut the yarn into lengths and hem the canvas, as shown right. Work the rows of knots horizontally, starting at the bottom. Check that all knots lie in the same direction.

1 Fold length of yarn in half around shank of hook. Hold yarn ends together; insert tip of hook under one horizontal canvas thread and push it through to right side until latch of hook opens.

2 Take the 2 yarn ends through the latch, and place them underneath the hook.

3 Pull hook toward you so that the latch closes around the yarn. Keep pulling until the 2 ends of the yarn have been drawn through the loop to form a knot.

4 Check that the knot is tight by giving the 2 ends of the yarn a tug. Work one knot between each pair of vertical canvas threads along the same horizontal row.

YARN AND FINISHING TECHNIQUES

Pre-cut yarn is available, or you can cut your own. Each strand should be twice the required pile length plus about 12mm (¹/₂ in) to allow for the knot. The minimum convenient length is about 6.5cm (2¹/₂ in), giving a pile of about 2.5cm (1 in). Try out a few knots on the canvas first. Finish your rug with a concealed hem that can be left plain, or fringed.

Preparing the yarn

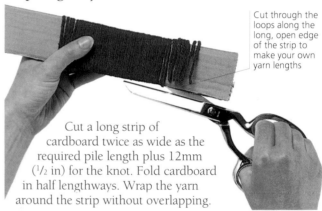

Cut through the loops along the long, open edge of the strip to make your own yarn lengths

Cut a long strip of cardboard twice as wide as the required pile length plus 12mm (¹/₂ in) for the knot. Fold cardboard in half lengthways. Wrap the yarn around the strip without overlapping.

How to make a hem

Fold outer 2.5cm to 5cm (1 to 2 in) to back of canvas. Check that warp and weft threads on both layers of canvas are aligned, and work first few rows of knots through double thickness.

How to add a fringe

Turn up a hem, as shown. Leave the first row of canvas mesh holes along the folded hem edge unworked. When the rug is finished, knot longer lengths of yarn onto the hem to form a fringe.

BRAIDED RUGS

THIS TYPE OF rug is made from braided strips of fabric. The braids are then coiled and laced together, until the rug is the desired size. You will need a large quantity of fabric because the strips will be reduced to about a third of their length when braided. Wool is the best fabric for a hardwearing rug, while medium weight cottons are also attractive and colourful. Use the same type and weight of fabric throughout so that the texture of the rug is even. There are two basic ways of using colour. Stripes or bands can be made by braiding in one colour, and then changing to another. Alternatively, multicolour effects can be created by braiding the strips in three different colours, or by introducing strips of patterned fabric.

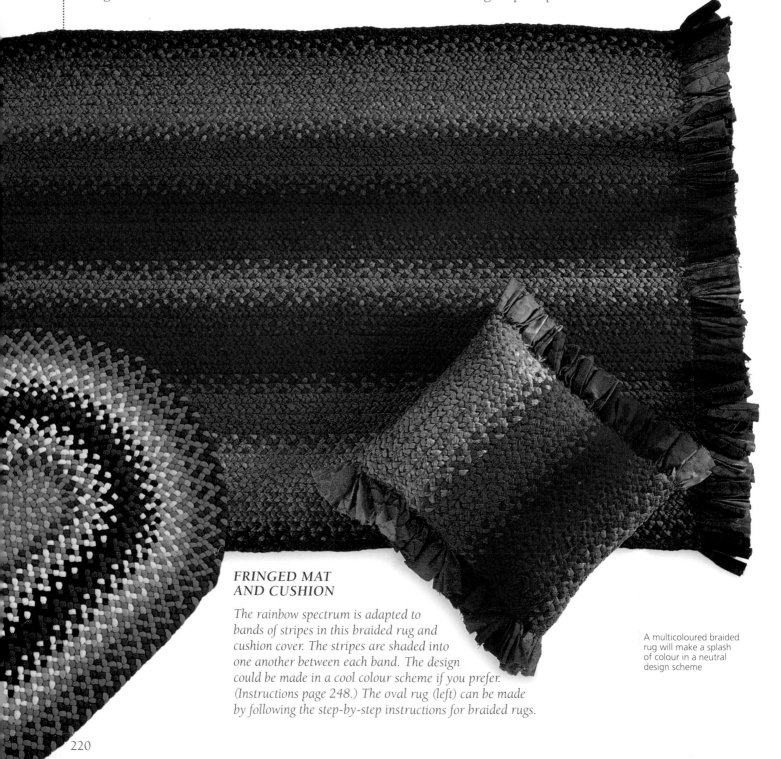

FRINGED MAT AND CUSHION

The rainbow spectrum is adapted to bands of stripes in this braided rug and cushion cover. The stripes are shaded into one another between each band. The design could be made in a cool colour scheme if you prefer. (Instructions page 248.) The oval rug (left) can be made by following the step-by-step instructions for braided rugs.

A multicoloured braided rug will make a splash of colour in a neutral design scheme

PREPARING THE FABRIC

Wash the fabric first, especially if it is new. Cut it into strips of equal width along the lengthwise grain of the fabric. These are usually 2.5cm to 4cm (1 to 1½ in) wide, depending on the weight of the fabric, and how thick you want the finished braids to be. Before you cut up all the fabric, experiment by making a few short braids with different strip widths.

Joining the strips

1 Cut diagonally across one short end of each strip.

2 Place the 2 strips with right sides together, and with diagonal ends matching, as shown above. Machine stitch or backstitch together across the diagonal.

3 Open out the joined strips. Press seam open, and trim off the protruding corners.

Folding the strips

1 Lay each strip out flat, right side down. Fold the side edges into the centre.

2 Fold in half again down the centre line. Baste along the open edges to hold the folded strip in position, or press flat with an iron. Pressing will produce a flatter finished braid.

BRAIDING THE STRIPS

It helps to have both hands free when braiding. Once you have joined the three strips together, you can use a table clamp to anchor the braid while you work, or pin a safety pin to the top of the braid and slip it onto a cup hook screwed into the wall. When you want to stop braiding, clip a clothes-peg to the braid end to keep it from unravelling. Using a fabric folder on each strip will help keep the folds even.

1 Join 2 strips together, as shown at right. Insert a 3rd strip inside the fold, with the open edge facing right. Stitch across the top 3 strips to hold them in position.

2 Fold the right strip over the centre strip, keeping the open edge to the right.

3 Fold the left strip over the new centre strip, keeping open edge to the right.

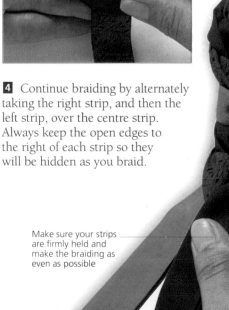

4 Continue braiding by alternately taking the right strip, and then the left strip, over the centre strip. Always keep the open edges to the right of each strip so they will be hidden as you braid.

Make sure your strips are firmly held and make the braiding as even as possible

JOINING STRIPS TO THE BRAID

Every so often, you will need to stitch new fabric strips to the ends of the braiding strips to increase the overall length of the braid. Trim the braided strips to different lengths so that the joins don't fall in the same place. Stitch a new strip to a braided strip when it is about to come over to the centre, so that the seam will be hidden by the next strip that is crossed over it.

1 Clip a clothes-peg onto the ends of the braid to keep it from unravelling. Cut diagonally across the end of the strip.

2 Cut across the end of the new strip and stitch the 2 strips together across the diagonal. Refold them and continue braiding.

ROUND RUGS

A braided round rug must be worked in a spiral. In order to make the curved braid lie flat, extra loops have to be added to the outer edge. These extra loops are called "round turns". A round turn may need to be repeated as many as twelve times when forming the tight curves at the centre of a rug. As the rug gets larger, fewer round turns are necessary, and you can continue braiding in the normal way.

1 Join the 3 fabric strips together and braid in the usual way.

2 To start making a round turn, bring the left strip over to the centre.

3 Bring what is now the left strip over the centre strip again.

4 Bring the right strip over to the centre tightly, so that the braid curves to the right. Continue braiding normally until you want to make another round turn.

OVAL RUGS

To make an oval rug, start with a length of straight braid in the centre and then coil the remaining braid around it in a spiral. To curve the braid, you will need to make three round turns at each end of your length of straight braid (see steps 1 to 4 for making round rugs).

1 The length of straight braid that starts off the spiral depends on the size of the finished rug. The length of braid equals the difference between the length and width of the finished rug.

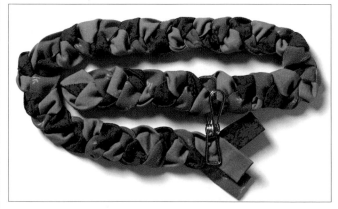

2 Lay out the straight length of braid, then work 3 round turns to coil the braiding back on itself. Braid straight to the next turn, and make 3 round turns so the braid wraps around the starting end. Continue straight braiding, making round turns as necessary.

LACING THE BRAIDS

This method of joining is quicker and stronger than sewing through the fabric. You will need a darning needle to secure the lacing thread to the fabric and a blunt-ended tapestry needle or a lacing needle (specially designed for braided work) for the lacing. Lace heavy weight braids together with carpet thread, and lighter fabrics with strong quilting thread. Always work on a flat surface. Here, a contrasting thread was used to show detail, but thread usually matches.

Straight lacing

Lay braids side by side. Slide needle through first loop of right-hand braid, then corresponding left-hand loop. Pull the thread tight. Continue lacing, pulling thread tight so that the join is nearly invisible.

Curved lacing

On a circular mat, the outer braid will be longer than the inner. Working as for straight lacing, skip an occasional loop on the outer braid so that the rug stays flat.

Oval lacing

1 For an oval mat, you need to use a combination of straight and curved lacing. Begin lacing about halfway down the centre braid, and work toward the first curve.

2 When you reach the curve, change direction, and work to the 2nd curve.

INTERBRAIDING

Another joining method requires the use of a large crochet hook. The braids do not lie as flat as when laced, and the method is easier to work with straight braids. On curves, you must bring two successive strips through the same loop.

Make one braid, and work the second next to it. As each strip comes to the inside (*left*), pull it through the corresponding loop of the finished braid with the crochet hook (*right*).

FINISHING OFF

When the rug is completed, the end of the braid must be turned back and secured. Neatly stitch the ends into the rug.

To finish a straight braid

Thread the ends of the strips back into the loops of the braid on the wrong side. Secure with small stitches in matching thread. Trim off excess fabric at ends.

To finish a curved braid

1 Before completing the braid, taper the end of each strip into a long, thin point.

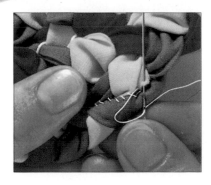

2 As you continue braiding, the braid will get thinner and thinner. Tuck the ends into the loops of the adjoining row, and secure with small stitches in matching thread.

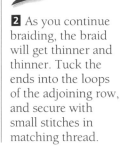

223

FINISHING TECHNIQUES

THE RAW EDGES of a hooked rug are usually finished with rug binding. A knotted rug will also be more hardwearing if you sew a strip of rug binding over the back of the hem on all sides. Lining is worth considering, but it isn't absolutely necessary to line your rug. In fact some people say it is better for dirt and grit to drop through the backing fabric rather than for it to get trapped between the backing and the lining. However, if you wish to do so, choose a heavy hessian or other strong, closely woven fabric.

BINDING

In order to protect the raw edges of a rug from wear and tear, it is necessary to bind them. Rug binding is a strong woven tape designed for this purpose. Buy enough to go around the edge of the rug, plus an extra 5cm (2 in) to overlap the ends. To attach the binding you will need heavy linen or cotton thread, a strong needle, and a thimble.

Binding a rectangular rug

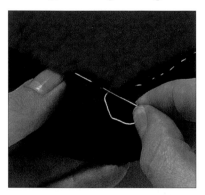

1 Trim backing, leaving 20mm (³/₄ in) around worked area. Lay binding on right side of rug, so that inner edge of binding is in line with outer edge of worked area. Ease tape around corners, and stitch in position close to inner edge of tape.

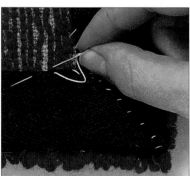

2 Fold binding and backing over to wrong side of rug. Mitre corners by folding excess binding inside to form a neat diagonal pleat. Sew tape to rug, and sew mitred corners together.

Binding a round or oval rug

Trim backing fabric, leaving 20mm (³/₄ in) allowance. Cut out notches around curves so that backing will lie flat when folded over to wrong side. Bind as for a rectangular rug, folding excess tape into narrow darts on wrong side of rug.

LINING

If you want to line your rug, use a strong, closely woven fabric like heavy hessian. The turn-through method is a quick way of lining small mats that can be turned inside-out easily. For large rugs, use the back-to-back method. When stitching the lining to the rug, check that the grain on both pieces is running in the same direction.

Turn-through method

Trim rug to size, leaving 12mm (¹/₂ in) of backing. Cut lining to same size. Place rug and lining right sides together. Sew together at edge of work, leaving an opening. Turn to right side and slip stitch opening.

Back-to-back method

Cut backing and lining 2.5cm (1 in) larger than worked area. Mitre corners of both, and fold hem of each to wrong side. Pin wrong side of lining and rug together. Stitch edges together with herringbone stitch (*see page 131*).

AFTERCARE

Keep some of your spare yarn or fabric for future repairs. To repair a hooked rug, carefully cut and pull out the stitches in the damaged area from the wrong side. Hook or knot the area with the spare yarn.

Shake out your rug, and vacuum it regularly. Clean off stains quickly with a damp cloth, and then use a reliable stain remover. To store a rug, roll it up (do not fold) with the pile inside, and wrap it in a clean sheet.

PATTERN INSTRUCTIONS

KNITTING

SQUARE KNITTED CUSHION
Page 26

Materials: Use scrap yarn, and knit on appropriate needles. Purchased 35cm (14") square cushion pad.

Front: Knit 4 pieces 11.5cm (4½") by 23cm (9") in the following patterns: A Marriage Lines (see page 29), B Ladder stitch (see page 27), C Basketweave (see page 29), D Three by Three Rib (see page 27) and one piece 11.5cm (4½") square in E Garter Stitch Ridges (see page 29).

Back: Knit piece 34cm (13½") square in st st.

Arrange the pieces according to the chart, or as you desire. Join pieces. Sew the front and back together along three sides. Insert the cushion pad and ladder stitch along the fourth side.

Square knitted cushion

RECTANGULAR KNITTED CUSHION
Page 26

Materials: Use scrap yarn, and knit on appropriate needles. Purchased 45cm (18") by 36cm (14") cushion pad.

Front: Knit 6 pieces 18cm (7") by 15cm (6"), in the following patterns: A Seeded Texture (see page 28), B Mock Fisherman's Rib (see page 27), C Square Lattice (see page 29), D Chevron Rib (see page 28), E Double Moss Stitch (see page 28), F Diamond Brocade (see page 28).

Back: Knit piece 45cm (18") by 36cm (14") in st st.

Arrange the patterns according to the chart, or as you desire. Join 3 pieces together in a strip along their long sides; repeat with the other 3 pieces. Join the 2 strips horizontally. Sew the front and back along 3 sides. Insert the cushion pad and ladder stitch along the 4th side.

Rectangular knitted cushion

HERRINGBONE SWEATER
Page 37

Materials: Chunky weight yarn, 460 (570 – 570)g; knitting needles 6mm or size for tension.

Sizes: Directions are for Small size. Medium and Large sizes are in (). If only one number appears it applies to all sizes.

Gauge: 4 sts = 2.5cm (1"); 6 rows = 2.5cm (1").

Finished measurements: Bust: 90cm (35½") (96cm/37¾" – 103cm/40½"); Front width at underarm: 46cm (18¼") (49cm/19¼" – 53cm/20¾"); Back width at underarm: 44cm (17¼") (46cm/18¼" – 50cm/19¾"); Length to underarm:

44.5cm (17½"); Sleeve width at underarm: 33.5cm (13¼") (35cm/13¾" – 36cm/14¼)".

Front: Cast on 73 (77 – 83) sts. Work in k1, p1 ribbing for 4cm (1½"), inc'g 0 (1 – 0) st on last row – 73 (78 – 83) sts.

Next row (wrong side):

Herringbone pattern:

Row 1 (right side): K3, [p2, k3] across.

Row 2: P2, [k2, p3] to last st, k1.

Row 3: P2, [k3, p2] to last st, k1.

Row 4: K2, [p3, k2] to last st, p1.

Row 5: K2, [p2, k3] to last st, p1.

Row 6: P3, [k2, p3] across.

Row 7: P1, [k3, p2] to last 2 sts, k2.

Row 8: P1, [k2, p3] to last 2 sts, k2.

Row 9: K1, [p2, k3] to last 2 sts, p2.

Row 10: K1, [p3, k2] to last 2 sts, p2.

Rows 11 to 20: Rep rows 1 to 10.

Row 21: Rep row 1.

Rows 22 to 27: Rep rows 6, 5, 4, 3, 2, 1, thus reversing patt.

Rows 28 to 32: Rep rows 10, 9, 8, 7, 6.

Rows 33 to 42: Rep rows 23–32. Rep rows 1 through 42 once more, then rep rows 1 through 12 once.

Shape armholes: Continuing in patt, cast off 2 sts at beg of next 2 rows – 69 (74 – 79) sts. Work Herringbone patt for 6 more rows, dec'g 0 (1 – 0) sts at end of last row – 69 (73 – 79) sts.

Ribbed yoke: Work in k1, p1 ribbing until armholes measure 18cm (7") (18.5cm/7¼" – 19cm/7½").

Shape shoulders: Cast off ribbing 17 (18 – 21) sts at beg of next 2 rows, then rem 35 (37 – 37) sts loosely for neck.

Back: Cast on 69 (73 – 79) sts. Work in k1, p1 ribbing for 4cm (1½"). P one row. Work in st st until same length as front to underarm. Place a marker each end for underarm. Work 8 rows more.

Ribbed yoke and shoulders: Work as for front.

Sleeves: Cast on 41 (43 – 43) sts. Work in k1, p1 ribbing for 11.5cm (4½") for turned cuff. Continue in st st, inc'g 1 st each end on 13th row, then every 16th (16th – 12th) row 5 (5 – 6) times more – 53 (55 – 57) sts. Work even until 53.5cm (21") from beg, or desired length including turned cuff. Bind off.

Finishing: Sew shoulder seam. Mark centre top of sleeves. With marker at shoulder seam, sew sleeves in place, sewing upper side edges to cast-off sts at underarm of sweater. Sew side and sleeve seams.

HONEYCOMB, BLACKBERRY & DOUBLE DIAMOND SWEATER

Page 30

Materials: Traditional Aran yarn 850 (910 – 970 – 1020 – 1080)g; 1 pr 4mm needles,1 pr 6mm needles.

Sizes: Instructions given for 91.5cm (36"). Changes for 96.5cm (38"), 101.5cm (40"), 107cm (42"), 112cm (44") are in (). If only one number appears it applies to all sizes.

Finished measurements: 96.5cm (38") (101.5cm/40" – 107cm/42" – 112cm/44" – 117cm/46").

Tension: 16 sts/20 rows = 10cm (4") over double moss st using 6mm needles.

Special abbreviations

K2B = knit into back of next 2 knit sts.

T3B = slip next st onto cn, hold at back of work, K2B from left-hand needle, p1 from cn.

T3F = slip next 2 sts onto cn, hold at front of work, purl st from left-hand needle, K2B from cn.

C2F = knit into back of 2nd stitch on needle, then knit into 1st stitch, slipping both sts off needle at same time.

C4B = slip next 2 sts onto cn, hold at back of work, knit 2 sts from left-hand needle, k2 from cn.

C4F = slip next 2 sts onto cn, hold at front of work, k2 from left-hand needle, k2 from cn.

C5F = slip next 3 sts onto cn, hold at front of work, k2 from left-hand needle, K2B, p1 from cn.

Double moss (odd no of sts):

Row 1: K1, *p1, k1, rep from * as directed.

Row 2: P1, *k1, p1, rep from * as directed.

Row 3: as row 2.

Row 4: as row 1.

PANEL A – Honeycomb pattern: 8 st, 8 row repeat.

Row 1: K8.

Row 2: P8.

Row 3: C4B, C4F.

Row 4: P8.

Row 5: K8.

Row 6: P8.

Row 7: C4F, C4B.

Row 8: P8.

PANEL B – Blackberry pattern: 8 st, 4 row rep.

Row 1: P8.

Row 2: P3tog, [k1, p1, k1] into next st; rep once more.

Row 3: P8.

Row 4: [K1, p1, k1] into next st, p3tog; rep once more.

PANEL C – Double Diamond pattern: 15 sts, 24 row rep.

Row 1: P5, K2B, p1, K2B, p5.

Row 2: K5, p2, k1, p2, k5.

Row 3: P4, T3B, k1, T3F, p4.

Row 4: K4, p2, k1, p1, k1, p2, k4.

Row 5: P3, T3B, k1, p1, k1, T3F, p3.

Row 6: K3, p2, [k1, p1] twice, k1, p2, k3.

Row 7: P2, T3B, [k1, p1] twice, k1, T3F, p2.

Row 8: K2, p2, [k1, p1] 3 times, k1, p2, k2.

Row 9: P1, T3B [k1, p1] 3 times, k1, T3F, p1.

Row 10: K1, p2, [k1, p1] 4 times, k1, p2, k1.

Row 11: T3B, [k1, p1] 4 times, k1, T3F.

Row 12: P2, [k1, p1] 5 times, k1, p2.

Row 13: T3F, [p1, k1] 4 times, p1, T3B.

Row 14: as row 10.

Row 15: P1, T3F, [p1, k1] 3 times, p1, T3B, p1.

Row 16: as row 8.

Row 17: P2, T3F, [p1, k1] twice, p1, T3B, p2.

Row 18: as row 6.

Row 19: P3, T3F, p1, k1, p1, T3B, p3.

Row 20: as row 4.

Row 21: P4, T3F, p1, T3B, p4.

Row 22: as row 2.

Row 23: P5, C5F, p5.

Row 24: K6, p4, k5.

Row 25: P5, K2B, T3F, p5.

Repeat rows 2–25.

Back: On 4mm needles, cast on 88 (91 – 97 – 100 – 103) sts. Work 20 rows in twist rib as follows:

Row 1: *P1, C2F, rep from * to last st, p1.

Row 2: *K1, p2; rep from * to last st, k1.

Inc 1 (2 – 0 – 1 – 2) sts on last row – 89 (93 – 97 – 101 – 105) sts. Change to 6mm needles.

Row 1: Double moss st 5 (7 – 9 – 11 – 13) sts, p1, row 1 panel A twice, p1, C2F, p1, row 1 panel B, p1, C2F, row 1 panel C, C2F, p1, row 1 panel B, p1, C2F, p1, row 1 panel A twice, p1, double moss st 5 (7 – 9 – 11 – 13) sts.

Row 2: Double moss st 5 (7 – 9 – 11 – 13) sts, k1, row 2 panel A twice, k1, p2, k1, row 2 panel B, k1, p2, row 2 panel C, p2, k1, row 2 panel B, k1, p2, k1, row 2 panel A twice, k1, double moss st 5 (7 – 9 – 11 – 13) sts.

Continue with pattern as set working 5 (7 – 9 – 11 – 13) sts double moss st at each end of rows till length from cast on edge 44.5cm (17½") (46cm/18" – 46cm/18" – 47cm/18½" – 47cm/18½"), ending with row 2.

Shape raglan: Cast off 6 sts at beg next 2 rows.

Row 1: K1, C2F, p2tog, work in pattern to last 5 sts, p2tog, C2F, k1.

Row 2: K1, p2, k1, work in pattern to last 4 sts, k1, p2, k1.

Repeat these 2 rows 21 times more – 33 (37 – 41 – 45 – 49) sts remain; continue decreasing inside twist rib on every row until 25 sts left. Transfer sts to stitch holder.

Front: As back till 51 sts remain. Divide for neck and transfer centre 9 sts to stitch holder. Dec 1 st neck edge on alternate rows 8 times, at same time continue raglan shaping as for back till 2 sts remain. Work other side of neck.

Sleeves:

Note: Sleeves have a central panel of 35 sts consisting of 2 purl sts, 8 sts panel A, 15 sts panel C, 8 sts panel A, 2 purl sts. The rest of the sleeve and the increases consist of double moss st.

With 4mm needles, cast on 43 sts. Work 20 rows in twist rib as back, inc 0 (2 – 2 – 2 – 2) sts on last row – 43 (45 – 45 – 45 – 45) sts. Change to 6mm needles. Work 4 (5 – 5 – 5 – 5) sts in double moss st at each edge of sleeve. Inc 1 st each end every 4th row 15 times – 73 (75 – 75 – 75 – 75) sts. Work until length at centre of sleeve measures 43cm (17")

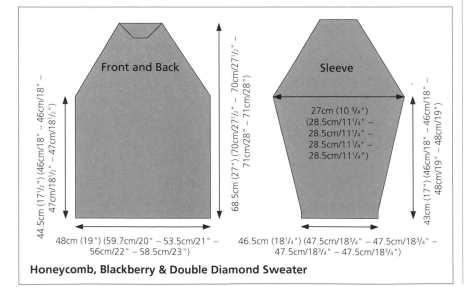

Front and Back

44.5cm (17½") (46cm/18" – 47cm/18½" – 47cm/18½")

68.5cm (27") (70cm/27½" – 70cm/27½" – 71cm/28" – 71cm/28")

48cm (19") (59.7cm/20" – 53.5cm/21" – 56cm/22" – 58.5cm/23")

Sleeve

27cm (10 ¾") (28.5cm/11¼" – 28.5cm/11¼" – 28.5cm/11¼" – 28.5cm/11¼")

43cm (17") (46cm/18" – 46cm/18" – 48cm/19" – 48cm/19")

46.5cm (18¼") (47.5cm/18¾" – 47.5cm/18¾" – 47.5cm/18¾" – 47.5cm/18¾")

Honeycomb, Blackberry & Double Diamond Sweater

(16cm/18" – 16cm/18" – 18cm/19" – 48cm/19").

Shape raglan as back until 17 (19 – 19 – 19 – 19) sts left. Leave sts on holder.

Neckband: Join both raglan seams of left sleeve and front raglan seam of right sleeve. Using 4mm needles, right side facing, pick up 25 sts from back neck, 17 (19 – 19 – 19 – 19) sts from top left sleeve, 14 sts down left front, 9 sts from centre front, 14 sts up right front, 17 (19 – 19 – 19 – 19) sts from top right sleeve – 96 (100 – 100 – 100 – 100) sts. Work 22 rows in k1, p1 rib. Cast off loosely in rib. Sew neckband seam, fold to inside and slip stitch in place, loosely enough to pass over head.

Finishing: Join back raglan seam of right sleeve. Join side and sleeve seams.

EMERALD ISLE VEST

Page 36

Materials: Aran weight yarn 310 (310 – 400 – 400)g; 4.5mm knitting needles or size for tension; 4.25mm crochet hook; double pointed or cable needle; five 20mm (³/₄") buttons.

Size: Instructions are for Size 10, Sizes 12, 14, and 16 are in (). If only one number appears, it applies to all sizes.

Tension: 9 sts = 5cm (2"); 6 rows = 2.5cm (1"). Cable panel: 18 sts = 9cm (3¹/₂").

Finished measurements: Bust: 82.5cm (32¹/₂") (87.5cm/34¹/₂" – 93cm/36³/₄" – 99cm/39"). Back width at underarm: 40.5cm (16") (43cm/17" – 47cm/18¹/₄" – 49cm/19¹/₄"). Each front width at underarm: 22cm (8³/₄") (23.5cm/9¹/₄" – 25.5cm/10" – 26cm/10¹/₄").

Special abbreviations

TW2: Sl next st to cn and hold in front of work, k1, k1 from cn.

TW6: Sl next 3 sts to cn and hold in back of work, k3, k3 from cn.

Cable pattern (worked over 18 sts):

Rows 1, 3, 5, 7 (wrong side): K2, p2, k2, p6, k2, p2, k2.

Rows 2, 4, 6: P2, TW2, p2, k6, p2, TW2, p2.

Row 8: P2, TW2, p2, TW6, p2, TW2, p2. Rep these 8 rows for cable panel.

Back: Cast on 66 (71 – 76 – 81) sts. Beg p row, work in st st until 7.5cm (3") from beg, ending p row. Mark each end for waistline. Continuing in st st, inc 1 st each end of next row, then every 6.5cm (2¹/₂") twice more – 72 (77 – 82 – 87) sts. Work even until 28cm (11") from beg, or desired length to underarm, end p row.

Shape armholes: Cast off 5 (6 – 6 – 7) sts at beg of next 2 rows. Dec 1 st each end every row twice, then every k row 3 (3 – 4 – 4) times – 52 (55 – 58 – 61) sts. Work even until armholes measure

Emerald Isle Vest
Left Front Rows 1–13

–TW2

–TW6

⬤ Purl on right side; knit on wrong side.

18cm (7") (19cm/7¹/₂" – 19cm/7¹/₂" – 46cm/8"), ending p row.

Shape shoulders: Cast off 7 (8 – 8 – 9) sts at beg of next 2 rows, 8 (8 – 9 – 9) sts at beg of next 2 rows. Cast off rem 22 (23 – 24 – 25) sts for neck.

Left front: Cast on 2 sts.

Row 1 (wrong side): Inc in each st – 4 sts; mark beg of row 1 for front edge.

Row 2: Inc in first st, k2, inc in last st.

Row 3: Inc, p4, inc.

Row 4: Inc, p1, k5, inc – 10 sts.

Row 5: Inc, p6, k2, inc.

Row 6: Inc, k1, p2, k6, p1, inc.

Row 7: Inc, k2, p6, k2, p2, inc.

Row 8: Inc, p1, TW2, p2, TW6, p2, k1, inc – 18 sts.

Row 9: Inc, p2, k2, p6, k2, p2, k2, inc.

Row 10: Inc, k1, p2, TW2, p2, k6, p2, TW2, p1, inc.

Row 11: Inc, k2, p2, k2, p6, [k2, p2] twice, inc – 24 sts.

Row 12: Inc, k3, place marker on needle, p2, TW2, p2, k6, p2, TW2, p2, place marker, k1, inc. (Note: carry markers).

Row 13: Inc, p to marker, k2, p2, k2, p6, k2, p2, k2, p to last st, inc – 28 sts, with 6 st sts at side edge, 18 sts in cable panel, and 4 st sts at front edge.

Working cable patt, beg row 6, over the 18 sts between markers, and st st outside markers, continue to inc 1 st every row at side edge 1 (3 – 3 – 5) times more and at front edge 10 (10 – 13 – 13) times more, working inc's in st st and working side edge even when side inc's are completed – 39 (41 – 44 – 46) sts after all inc's are completed. Keeping cable patt and st st, work even until 7.5cm (3") above last inc at side edge. Mark side edge for waistline. Working front edge even, inc 1 st at side edge on next row, then every 6.5cm (2¹/₂") twice more – 42 (44 – 47 – 49) sts. Work even until side edge measures same as back to underarm, end with wrong-side row.

Shape armhole and V-neck:

Row 1 (right side): Cast off 5 (6 – 6 – 7) sts, work in patt to last 2 sts, k2tog

(neck dec).

Keeping patt, at arm edge dec 1 st every row twice, then every 2nd row 3 (3 – 4 – 4) times; at same time, at neck edge, dec 1 st every 2nd row twice more, then every 3rd row 11 (11 – 12 – 12) times – 18 (19 – 20 – 21) sts. Work even until 2 rows more than Back to shoulder, end at arm edge.

Shape shoulder: Keeping patt, at arm edge cast off 9 (9 – 10 – 10) sts once, 9 (10 – 10 – 11) sts once. Mark straight edge of front for 5 buttons evenly spaced, having first just below beg of V-neck and last just above end of lower shaping.

Right front: Work same as left front through row 2, marking end of row 1 for front edge.

Row 3 (wrong side): Inc, p4, inc – 8 sts.

Row 4: Inc, k5, p1, inc.

Row 5: Inc, k2, p6, inc.

Row 6: Inc, p1, k6, p2, k1, inc.

Row 7: Inc, p2, k2, p6, k2, inc.

Row 8: Inc, k1, p2, TW6, p2, TW2, p1, inc.

Row 9: Inc, k2, p2, k2, p6, k2, p2, inc.

Row 10: Inc, p1, TW2, p2, k6, p2, TW2, p2, k1, inc.

Row 11: Inc, [p2, k2] twice, p6, k2, p2, k2, inc – 24 sts.

Row 12: Inc, k1, place marker, p2, TW2, p2, k6, p2, TW2, p2, place marker, k3, inc. Beg row 13, work to correspond to left front, reversing all shaping and making buttonholes opposite markers of left front as follows: from front edge, k2, cast off 2, complete row in patt. On next row cast on 2 sts over cast-off sts.

Finishing: Back ties: make 2. With crochet hook, ch about 48cm (19") (50cm/20" – 53cm/21" – 56cm/22") or desired length; sl st in 2nd ch from hook and each rem ch. Fasten off. Sew shoulder seams, easing fronts to match back shoulder edges. Sew side seams, sewing in end of a tie at waistline.

Crochet edging:

Round 1: From right side, with crochet

hook, join at centre of lower back edge; keeping edge flat, dc around entire outer edge of vest, join with sl st in first dc.

Round 2: Do not turn, working left to right, dc in each dc around for corded edge, join. Fasten off. Work same edging around each armhole edge.

DIAMOND KNIT SHAWL
Page 42

Materials: Double knitting 400g; 80cm (29") – 100cm (36") circular knitting needle 5mm or size for tension. 3.5mm crochet hook.

Finished measurements: Upper edge: 160cm (63½"). Length to point: 87.5cm (34½").

Tension: 12 sts (1 patt) = 6.5cm (2½").
Note: Work back and forth on circular needle; do not join round.
Beg upper edge, cast on 297 sts.
Next Row: K2, p to last 2 sts, k2.

Pattern:
Row 1 (right side): K2, sl 1, k1, psso, k4, k2tog, * yo, k1, yo, sl 1, k1, psso, k7, k2tog; rep from * to last 11 sts, yo, k1, yo, sl 1, k1, psso, k4, k2tog, k2.
Rows 2, 4, 6 and 8: K2, p to last 2 sts, k2.
Row 3: K2, sl 1, k1, psso; k2, k2tog, k1, * [yo, k1] twice, sl 1, k1, psso, k5, k2tog, k1; rep from * to last 10 sts, [yo, k1] twice, sl 1, k1, psso, k2, k2tog, k2.
Row 5: K2, sl 1, k1, psso, k2tog, k2, * yo, k1, yo, k2, sl 1, k1, psso, k3, k2tog, k2; rep from * to last 9 sts, yo, k1, yo, k2, sl 1, k1, psso, k2tog, k2.
Row 7: K2, sl 1, k1, psso, k2tog, k1, * yo, k1, yo, k3, sl 1, k1, psso, k1, k2tog, k3; rep from * to last 8 sts, [yo, k1] twice, sl 1, k1, psso, k2tog, k2.
Row 9: K2, sl 1, k1, psso, k2tog, * yo, k1, yo, k4, sl 1, k2tog, psso, k4; rep from * to last 7 sts, yo, k1, yo, [k2tog] twice, k2.
Row 10: K2, p2tog, p to last 4 sts, p2tog tbl, k2.
Rep rows 1 through 10 for patt until 9 sts rem. Then work as follows:
Row 1: K2, sl 1, k1, psso, k1, k2tog, k2.
Row 2: K2, p3, k2.
Row 3: K2, sl 1, k2tog, psso, k2.
Row 4: K2, p1, k2.
Row 5: K2tog, k1, k2tog.
Row 6: K1, p1, k1.
Row 7: Sl 1, k2tog, psso.
Fasten off.
Edging: Cast on 4 sts.
Row 1 (wrong side): K2, yo, k2.
Rows 2, 4 and 6: K.
Row 3: K3, yo, k2.
Row 5: K2, yo, k2tog, yo, k2.
Row 7: K3, yo, k2tog, yo, k2.
Row 8: Cast off 4 sts, k to end.
Continue working these 8 rows until edging when slightly stretched fits around shawl. Cast off and sew in place.

KALEIDOSCOPE
Page 51

Materials: Aran weight yarn, 200g Red A, 100g Yellow B, 250g Blue C, 150g Green D, 250g Blue-mix E. (Note B and D are mercerized cotton; A, C and E are novelty yarns of same weight); pair each 3.75mm and 5mm knitting needles or size for tension: Two 12mm (½") buttons.

Size: One size fits all. This is a very loose fitting garment.

Tension: 17 sts = 10cm (4"); 24 rows = 10cm (4").

Note 1: Garment is worked sideways in vertical rows.

Note 2: For front, k row 1 and all odd-numbered rows for right side of work; p all even-numbered rows. For back, p row 1 and all odd-numbered rows for wrong side of work; k all even-numbered rows.

Houndstooth pattern for front (see above, Note 2 for back):

Row 1 (right side): K1 D, *k1 B, k3 D; rep from * to last 3 sts, end k1 B, k2 D.
Row 2: *P3 B, p1 D; rep from * to end.
Row 3: *K3 B, k1 D; rep from * to end.
Row 4: P1 D, *p1 B, p3 D; rep from * to last 3 sts, end p1 B, p2 D. Rep rows 1 to 4 for pattern.

Underarm increasing for right front:
K and then p in same st on k rows; p and then k in same st on p rows. When several sts are added at one time, cast on instead of inc'g.

Centre back | Shape neck | End right front

Begin left front

Kaleidoscope

☐ Red

▨ Yellow

▨ Blue

☐ Blue-mix

▣ Green

○ Border marker

Underarm decreasing for left front:
For k rows: k1, sl next st k-wise, k next st, psso. When several sts are decreased at one time, cast off at beg of row instead of dec'g. For p rows: p to last 3 sts, p2tog, p last st.

Neck edge decreasing for right front:
For k rows: k to last 3 sts, k2tog, k last st. When 2 dec's are indicated, k to last 5 sts, [k2tog] twice, k last st. For p rows. *p1, p2tog. When 2 dec's are indicated, p1 [p2tog] twice.

Neck edge increasing for left front:
For k rows: k to last 2 sts, *insert needle under thread between last st knitted and next st and k, k1*, k last st. When 2 incs are indicated, k to last 3 sts, rep between *s twice, k last st. For p rows: p2, * insert needle under thread and p1 between last purled st and next st, p1*, p to end. When 2 incs are indicated, rep between *s once more, then p to end.

Right front: With larger needles and A, cast on 34 sts for wrist edge. Following chart for colours and shaping, work in st st. For example, with yarn A, work 18 rows even on 34 sts. **Next Row:** Inc 1 st at beg of row, then inc 1 st at beg of every 3 rows 5 times more, being sure to

work the two rows of Yellow (B) where indicated on chart, and starting the next pattern on the chart. Begin Houndstooth pattern, given above, on row 67, keeping patt as established while increasing along the underarm.

Left front: With larger needles and A, cast on 79 sts for centre front. Following

chart for patterns, neck shaping and underarm decreases, work in st st out to wrist edge.

Back: Note: Back is a duplicate of the front pieces, except that it is worked in one piece from right sleeve wrist edge across to left sleeve wrist edge, with a vertical stripe of 6 rows of colour C at the centre back. The back neck is worked straight across without shaping. With larger needles and A, cast on 34 sts for right sleeve wrist edge. Following chart, purl odd number rows, knit even rows.

Finishing: Sew front to back at upper edge of sleeves and shoulders, matching patterns.

Cuffs: With C and smaller needles, with right side of work facing, pick up 1 st in every other row along wrist edge – 33 sts. Work in p1, k1 ribbing for 6.5cm (2½"). Cast off in ribbing. Sew side and sleeve seams.

Waistline ribbing: With C and smaller needles, with right side facing, pick up 1 st in every row around entire lower edge. P 1 row, dec'g 73 sts evenly spaced – 161 sts. Work in k1, p1 ribbing for 6.5cm (2½"). Cast off in ribbing.

Left front border: As indicated on chart, place markers at neck edge for border shaping. With colour C and smaller needles, starting at shoulder seam, with right side of work facing, pick up and k 16 sts up to the first marker; pick up and k 7 sts between this and next marker; pick up and k 95 sts along centre front, and waistline ribbing, ending at lower edge. Work 1 row in k1, p1 ribbing.

Next Row: Keeping ribbing as established, work 16 sts, (k1, p1, k1) in next st, p1, k1, p1, k1, p1, (k1, p1, k1) in next st; continue in rib over rem'g 95 sts. Work 4 rows more in rib. Cast off in ribbing. Mark for 2 buttons, placing the lower one 2.5cm (1") up from bottom and second 4 cm (1½") above.

Right front border: As indicated on chart, place markers at neck edge for border shaping. With C and smaller needles, starting at lower edge, pick up and k 95 sts to first marker; pick up and k 7 sts between markers; pick up and k 16 sts to shoulder seam, and 46 sts along back of neck. Work 1 row in k1, p1 ribbing. **Next Row:** keeping ribbing as established, work 95 sts; (p1, k1, p1) in next st, k1, p1, k1, p1, k1, (p1, k1, p1) in next st; continue in ribbing over rem'g 62 sts.

Buttonhole row: Keeping established ribbing, cast off 2 sts in line with each button marker. **Next Row:** Cast on 2 sts over cast-off sts. Work 2 rows even. Cast off in ribbing. Sew on buttons. Sew neckband seam.

LOG CABIN SWEATER
Page 56

Materials: Aran weight tweed yarn, 100g balls: 5 Purple MC, 1 each of Dark Blue, Fuchsia, Red, Teal, Grey, Medium Blue; 4mm and 4.5mm (5mm – 5.5mm) knitting needles or size for tension and 40cm (16") long 4mm, 4.5mm, and 5mm circular needles; 4 stitch holders.

Size: Instructions are for Small (8–10). Changes for Medium (12–14) and Large (16) are in (). If only one number appears, it applies to all sizes.

Note: This sweater is made with the same number of sts for all sizes; the sizes are knitted with different size needles.

Tension: 17 sts = 10cm (4"); 13 rows = 5cm (2") on 4.5mm needles; 16 sts = 10cm (4"); 12 rows = 5cm (2") on 5mm needles; 15 sts = 10cm (4"); 11 rows = 5cm (2") on 5.5mm needles.

Finished measurements: Bust: 99cm (39") (105.5cm/41½" – 112cm/44¼"). Width of sleeve at underarm: 47cm (18½") (51cm/20" – 55cm/21¾").

Front: With smaller needles and MC, cast on 83 sts. Work in k1, p1 rib for 7.5cm (3"), inc'g one st at end of last row – 84 sts. Change to larger needles and work in st st, following chart for pattern. Work chart once, then repeat chart to row 56.

Row 57: Following chart, work 36 sts and place on holder; work centre 12 sts and place on another holder; work rem 36 sts and place on a third holder.

Shape neck and shoulders: Right side:

Rows 1, 3, 5, and 7: P.
Rows 2, 4, 6 and 8: Cast off 2 sts at beg of each row – 28 sts. Work even until chart is complete. Cast off all sts across row.

Left side: Complete as for right side, reversing shaping.

Back: Work same as for front, eliminating pattern. Work even in st st in MC until back measures same as front.

Shape neck and shoulders: Cast off 28 sts. K centre 28 sts and place on holder for back of neck. Cast off rem 28 sts.

Sleeve: With smaller needles and MC, cast on 31 (33 – 35) sts. Work in k1, p1 rib for 7.5cm (3"). With larger needles, p1 row, inc'g 19 sts evenly spaced – 50 (52 – 54) sts. Work even in st st until piece is 13cm (5") from beg. Inc 1 st at each end of next row and every 5 rows 14 times – 78 (80 – 82) sts. When sleeve measures 51cm (20") from beg, cast off loosely.

Finishing: Sew front to back at shoulders.

Collar: With smallest circular needle and MC, with RS facing, pick up and k 76 (80 – 84) sts around neck edge including sts from front and back holders. Place marker at beg of round; work in k1, p1 ribbing for 6.5cm (2½") more. Change to largest circular needle and continue in ribbing for 5cm (2") more. Cast off in rib. For placement of sleeves, mark front and back at each side edge 23.5cm (9¼") (25.5cm/10" – 27.5cm/10¾") from shoulder seams. Sew sleeves between markers. Sew side and sleeve seams.

CARDIGAN WITH CREWEL-EMBROIDERED POPPIES
Page 57

Materials: Chunky acrylic yarn 100g balls – 5 (5 – 6) balls Dark Blue MC, 1 ball Terra Cotta CC. For embroidery: 45cm (½ yd) lightweight Dark Blue fabric; Persian Yarn, 38m (40yd) skeins – 1 each Green, Red, and Terra Cotta; 10m (8 yd) skeins – 2 each Lt. Green, Maroon, Lt. Terra Cotta, Yellow, Lt. Blue, Blue, 1 skein Gold, 3 skeins Pink; 4.5mm and 5.5mm knitting needles or size for tension; 3 stitch holders; six 15mm (⅝") diameter buttons; tapestry needle.

Sizes: Instructions are for Small (8–10). Changes for Medium (12–14) and Large (16–18) are in (). If only one number appears, it applies to all sizes.

Tension: 15 sts = 10cm (4"); 20 rows = 10cm (4").

Finished measurements: Bust: 92cm (36¼") (99.5cm/39¼" – 108.5cm/42¾"); sleeve width at underarm: 54.5cm (21½").

Back: With smaller needles and MC, cast on 69 (75 – 81) sts. Work twisted ribbing as follows:

Row 1 (right side): K1, p1, *k1 tbl, p1; rep from *, ending k1.

Row 2: P1, *k1 tbl, p1; rep from *. Rep rows 1 and 2 for 7.5cm (3"), ending with a wrong-side row. Change to larger needles and work in st st with MC only until piece measures 16.5cm (6½") from beg, ending with a p row. Continue in st st, working in pattern as follows:

Note: When changing colours, to prevent holes, twist colours together on wrong side and carry unused colour loosely across back.

Row 1: With MC, k.
Row 2: With MC, p.
Row 3: K1 MC, *k1 CC, k5 MC; rep from *, ending k1 CC, k1 MC.
Rows 4, 6 and 8: With MC, p.
Rows 5, 7, and 9: With MC, k.
Row 10: P4 MC, *p1 CC, p5 MC; rep from *, ending last rep, p4 MC.
Rows 11 and 13: With MC, k.
Rows 12 and 14: With MC, p.
Rep rows 1 to 14 for patt until piece measures 53cm (21") from beg, ending with a p row.

Shape shoulders and neck: With MC, cast off 22 (24 – 26) sts; k across centre 25 (27 – 29) sts and place them on a holder for neck; cast off rem sts.

Left front: With smaller needles and MC, cast on 31 (35 – 37) sts. Work twisted ribbing for 7.5cm (3"), ending with a wrong-side row, inc'g 1 st at end of row on small and large sizes only – 32 (35 – 38) sts. Change to larger needles and work in st st with MC only until piece

Log cabin turtleneck

- ■ Purple MC
- ■ Dark blue
- □ Fuchsia
- ▨ Red
- ■ Teal
- □ Grey
- ▨ Medium blue

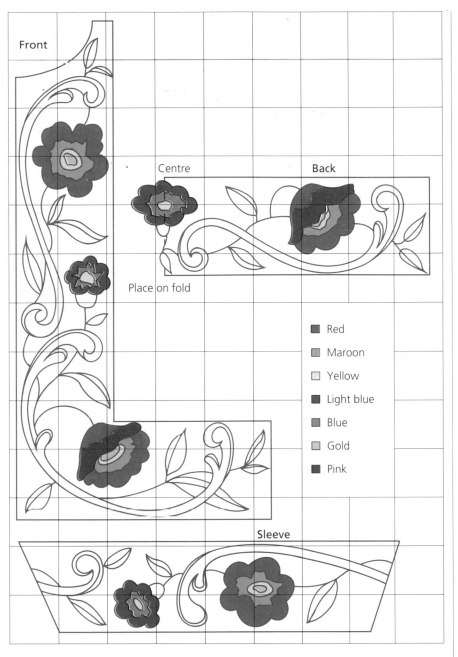

Front

Centre

Back

Place on fold

■ Red

■ Maroon

☐ Yellow

■ Light blue

■ Blue

☐ Gold

■ Pink

Sleeve

Cardigan with crewel-embroidered poppies

1 square = 2.5cm (1")

measures 16.5cm (6½") from beg, ending with a p row – working p row as follows: p 13 (12 – 13), place marker on needle, p rem sts. Note: Move marker up on each row and continue to work the 13 (12 – 13) sts to marker with MC only, and remainder of sts in patt as follows:

Row 1: With MC, k.

Row 2: With MC, p.

Row 3: K1 (0 – 1) CC, *k5 MC, k1 CC; rep from *, ending k0 (5 – 0) MC.

Rows 4, 6, and 8: With MC, p.

Rows 5, 7, and 9: With MC, k.

Row 10: P3 (2 – 3) MC, *p1 CC, p5 MC; rep from *, ending p1 CC, 3 (2 – 3) MC.

Rows 11 and 13: With MC, k.

Rows 12 and 14: With MC, p.

Rep rows 1 to 14 for patt. Work as established until piece measures 48cm (19") from beg, ending with a right-side row.

Shape neck: Continuing in patt established, work 4 (4 – 5) sts and place them on a holder. At same edge, cast off 2 sts every other row 3 times; then dec 1 st 0 (1 – 1) time – 22 (24 – 26) sts rem. Work even until front measures same as back to shoulders. For shoulder, at side edge, cast off 22 (24 – 26) sts.

Right Front: Work as for left front, reversing patt and shaping.

Sleeves: With smaller needles and MC, cast on 37 (39 – 41) sts. Work twisted ribbing for 7.5cm (3"), ending with a

right-side row. Change to larger needles and p one row, inc'g 8 (6 – 4) sts evenly spaced – 45 sts. With MC only, work in st st until piece measures 11.5cm (4½") from beg. Inc 1 st each end every 4 rows 3 times – 51 sts. Work patt as follows, continuing increases every 4th row until you have 81 sts.

Row 1: With MC, k.

Row 2: With MC, p.

Row 3: K1 MC, *k1 CC, k5 MC; rep from *, ending k1 CC, k1 MC.

Rows 4, 6, and 8: With MC, p.

Rows 5, 7, and 9: With MC, k.

Row 10: P4 MC, *p1 CC, p5 MC; rep from *, ending last rep p4 MC.

Rows 11 and 13: With MC, k.

Rows 12 and 14: With MC, p.

Rep rows 1 to 14 for patt until sleeve measures 51cm (20") from beg. Cast off loosely.

Finishing: Lightly block pieces. Enlarge and trace patterns to dark blue fabric, reversing design for left front and sleeve. Cut fabric round outline of patterns and baste to WS of sweater pieces 1 to 2 rows from edges and ribbing. From WS, baste over patterns to right side of sweater pieces, using basting as a guide for embroidery. Work scroll motifs in rows of Terra Cotta outline stitch with Lt. Terra Cotta outline stitch details. In outline stitch, work Green vines and stems; use outline stitch to fill in lower part of leaves with Green and upper part with Lt. Green. Work flowers with long and short satin stitch and centres with French knots, see chart for colours. Remove basting and trim and clip fabric close to embroidery. After embroidery is complete, sew front to back at shoulders.

Neckband: With smaller needles and right side facing, with MC pick up and k all sts from holders and 4½ sts per 2.5cm (1") along front neck edges. Work in twisted ribbing for 8 rows. Cast off in ribbing.

Left front band: With smaller needles and right side facing, with MC, pick up and k 4½ sts per 2.5cm (1") along centre front. Work in twisted ribbing for 8 rows. Cast off in ribbing. Mark for 6 buttons, placing the top one 2.5cm (1") down from the neck edge and the bottom one 4cm (1½") up from the lower edge, with the others evenly spaced between.

Right front band: With smaller needles and right-side facing, with MC, work same as left front band in twisted ribbing for 3 rows.

Buttonhole row: Cast off 2 sts to correspond to each marker.

Next Row: Cast on 2 sts over cast-off sts. Work 3 more rows in ribbing. Cast off in ribbing. Sew on buttons. Sew in sleeves; sew side and sleeve seams.

MULTICOLOUR SCARF
Page 57

Materials: Approximately 250g of Chunky yarn in ten colours; 6mm knitting needles or size for tension.

Tension: 4 sts = 2.5cm (1") in st st. Cast on 33 sts. With A colour, work moss stitch as follows: K1, *p1, k1; repeat from * to end. Repeat this row for 11.5cm (4½"); ending on wrong side row. Change to colour B. Work popcorn pattern as follows:

Row 1: K.

Row 2: P.

Row 3: K1, *make popcorn as follows: k into front and back of lp twice, then slip 2nd, 3rd, and 4th sts over 1st st, k5; repeat from * to last 7 sts, k5, make popcorn, k1.

Row 4: P.

Row 5: K.

Row 6: P.

Row 7: K4, *make popcorn, k5; repeat from * to last 5 sts, make popcorn, k4.

Rows 1 to 7 form the pattern; repeat for 11.5cm (4½"), ending on RS. With C, p 1 row, work double moss stitch as follows:

Row 1: *K2, p2; repeat from * to last st, k1.

Row 2: P1, *k2, p2; repeat from * to end.

Row 3: *P2, k2; repeat from * to last st, p1.

Row 4: K1, *p2, k2; repeat from * to end.

Rows 1 to 4 form the pattern; repeat these rows for 11.5cm (4½"), ending on WS. With D, rep popcorn pattern for 11.5cm (4½"), ending on RS. With E, p 1 row. Rep moss stitch for 11.5cm (4½"), ending on RS. With F, p 1 row. Rep popcorn pattern for 11.5cm (4½"), ending on RS. With G, p 1 row. Rep double moss for 11.5cm (4½"), ending on WS. With H, rep popcorn pattern for 11.5cm (4½"), ending on RS. With I, p 1 row. Rep moss stitch for 11.5cm (4½"), ending on WS. With J, rep popcorn pattern for 11.5cm (4½"). Cast off.

To make fringe: In A and J, cut 25.5cm (10") lengths. With 6 lengths double, pull through end of scarf with crochet hook and knot to form fringe on each end.

FAIR ISLE MITTENS AND HAT
Page 60

Materials: Double knitting, 50g balls: 3 Cream A, 1 each Blue B, Ochre C, Rust D. Set of 3.25mm and 3.75mm double-pointed needles.

Size: One size.

Tension: 7 sts and 7½ rows = 2.5cm (1") on 3.75mm needles, over patt.

Finished measurements: Mittens: 10cm (4") width across back. Length 26.5cm (10½"). Hat: width around 48cm (18"),

depth 28cm (11").

Right mitten: With 3.25mm needles and A cast on 58 sts; divide on 3 needles. Taking care not to twist sts, join and work around in k1, p1 rib for 7.5cm (3"). Change to 3.75mm needles. Work in st st (k every round) for 11 rounds. Join D.

Next round 1: *K1 A, k1 D; rep from * around.

Round 2: *K1 D, k1 A, rep from * around Break off D. With A, k two rounds.

Thumb opening: K 32 sts in pattern from chart (round 1) slip next 8 sts on st holder, cast on 8 sts, work in patt to end. Follow chart rounds 2 to 26.

Round 27 to 29: With A, k.

Round 30: Join in D, *k1 A, k1 D; rep from * around.

Round 31: *K1 D, k1 A, rep from * around.

Shape top:

Round 1: *K1, sl 1, k1, psso, k23, k2tog, k1, place marker on needle; rep from * once, carry markers.

Dec round 2: *K1, sl 1, k1, psso, k to within 3 sts of marker, k2tog, k1; rep from * once.

Rep Dec round 2, 8 times more – 18 sts. Break yarn, leaving a 38cm (15") end. Graft sts tog (see page 65).

Thumb: With A, k sts from holder, pick up 1 st in sp before cast-on sts, 1 st in each cast on st, 1 st in next sp – 18 sts. Divide evenly on 3 needles. Work in st st until thumb measures 6.5cm (2½") or desired length.

Dec round: K2tog around. Rep last round once – 5 sts. Break A, leaving 20cm (8") end. Thread end through sts and sl from needles; draw up tightly, fasten securely.

Left mitten: Work to correspond to right mitten, following chart for left mitten and working thumb opening as follows: k 18 sts in patt, sl next 8 sts to holder, cast on 8 sts, work in patt to end.

Hat: With 3 needles and A, cast on 128 sts; divide on 3 needles. Taking care not to twist sts, join and work around in k1, p1 rib for 10cm (4"). Change to 3.75mm needles. Work in st st for 5 rounds.

Round 6: Join D, *k1 A, k1 D; rep from * around.

Round 7: *K1 D, k1 A; rep from * around.

Break D, k two rounds A. Join B. Follow hat chart, rounds 1 through 25 once, 4 patt reps round hat. Break B. With A k two rounds. Rep rounds 6 and 7 once. Break D.

Shape top:

Dec round: *K2tog, k14; rep from * around – 120 sts.

Having 1 less st between decs on each successive round (k13, k12, k11, etc.), rep Dec round 14 times more – 8 sts. Break yarn, leaving a 30cm (12") end. Thread through sts and sl from needles; draw up tightly, fasten securely.

Pompom: Around two 5cm (2") cardboard circles together, wind yarn in colour B. For finishing pompom, see page 63.

Palm Begin right mitten | Back Begin left mitten

Fair Isle mittens and hat

- ● Blue B
- ⊙ Rust D
- ⧄ Ochre C
- ☐ Cream A

CROCHET

BEADED DOILY
Page 98

Materials: 25g (1 oz) No 20 Crochet cotton; 24 small glass or ceramic beads approx 6mm (¼") diameter and 12 large beads; 1.5mm steel crochet hook or size for tension; needle small enough to fit through beads.

Size: 23cm (9") diameter.

Tension: Doily measures 8cm (3¼") diameter after round 10.

Special abbreviation

Bst = Bullion stitch (see page 95) made with [yrh] 10 times.

Note: Do not turn between rounds – right side is always facing.

To make: Ch 4, join with sl st to form ring.

Round 1: Ch 3 (does not count as st), 12 Bsts in ring, sl st to top of first Bst.

Round 2: Ch 1 (does not count as st), 2 dc in each Bst all round, sl st to first dc.

Round 3: Ch 1 (does not count as st), 1 dc in same place, [ch 3, skip 1, 1 dc] 11 times, ch 1, skip 1, 1 htr in first dc – 12 lps.

Round 4: [Ch 4, 1 dc in next lp] 11 times, ch 2, 1 tr in htr.

Round 5: [Ch 5, 1 dc in next lp] 11 times, ch 2, 1 tr in tr.

Round 6: [Ch 4, (3 tr, ch 2, 3 tr) in next lp, ch 4, 1 dc in next lp] 6 times, [sl st in next ch of first 4 ch loop] twice.

Round 7: Ch 1 (does not count as st), *1 dc in ch lp, ch 4, 3 tr, (2 tr, ch 2, 2 tr) in 2 ch sp, 3 tr, ch 4, 1 dc in next lp, ch 4; rep from * 5 more times omitting last ch 4 and ending ch 2, 1 tr in first dc.

Round 8: *Ch 4, 1 dc in next lp, ch 4, 5 tr, (2 tr, ch 2 – called tip of V, 2 tr) in 2 ch sp, 5 tr, [ch 4, 1 dc in next lp] twice; rep from * 5 more times omitting last (ch 4, 1 dc) and ending ch 2, 1 tr in tr.

Round 9: *[Ch 4, 1 dc in next lp] twice, ch 4, skip (7 tr, 2 ch, 7 tr), 1 dc in next lp, ch 4, 1 dc in next lp; rep from * 5 more times omitting last (ch 4, 1 dc) and ending ch 2, 1 tr in tr.

Round 10: Ch 3 (counts as first tr), 2 tr inserting hook under stem of tr which closed previous round, ch 1, *5 tr in next lp, ch 1; rep from * all round, 2 tr in first lp, sl st to top of 3 ch – 24 blocks of 5 tr.

Round 11: Ch 1 (does not count as st), * 1 dc in 3rd of 5 tr, ch 4, (3 tr, ch 2, 3 tr) in 3rd of next 5 tr, ch 4, 1 dc in 3rd of next 5 tr, ch 4, inserting hook through 2 ch sp at tip of V in Round 8 and then in 3rd of next 5 tr work 1 tr, ch 4; rep from * 5 more times omitting last ch 4 and ending ch 2, 1 tr in first dc.

Round 12: *Ch 4, 1 dc in next lp, ch 4, 3 tr, (2 tr, ch 2, 2 tr) in 2 ch sp, 3 tr, [ch 4, 1 dc in next lp] 3 times; rep from * 5 more times omitting last (ch 4, 1 dc) and ending ch 2, 1 tr in tr.

Round 13: *[Ch 4, 1 dc in next lp] twice, ch 4, 5 tr, (2 tr, ch 2, 2 tr) in 2 ch sp, 5 tr, [ch 4, 1 dc in next lp] 3 times; rep from * 5 more times omitting last (ch 4, 1 dc) and ending ch 2, 1 tr in tr.

Round 14: *[Ch 4, 1 dc in next lp] 3 times, ch 4, skip (7 tr, 2 ch, 7 tr), 1 dc in next lp [ch 4, 1 dc in next lp] twice; rep from * 5 more times omitting last (ch 4, 1 dc) and ending ch 2, 1 tr in tr.

Round 15: as round 10 – 36 blocks of 5 tr.

Round 16: Ch 1 (does not count as st), *1 dc in 3rd of 5 tr, ch 4, (3 tr, ch 2, 3 tr) in 3rd of next 5 tr, ch 4, [1 dc in 3rd of next 5 tr, ch 4] twice, inserting hook through 2 ch sp at tip of V in round 13 and then in 3rd of next 5 tr work 1 tr, ch 4, 1 dc in 3rd of next 5 tr, ch 4; rep from * 5 more times omitting last ch 4 and ending ch 2, 1 tr in first dc.

Rounds 17 to 19: Work as for rounds 12 to 14 with additional ch 4 lps as established.

Round 20: as round 10 – 48 blocks of 5 tr.

Round 21: Ch 1 (does not count as st), *1 dc in 3rd of 5 tr, [ch 4, 1 dc in 3rd of next 5 tr] 3 times, ch 4, inserting hook through 2 ch sp at tip of V in round 18 and then in 3rd of next 5 tr work 1 tr, ch 4, [1 dc in 3rd of next 5 tr, ch 4] 3 times; rep from * 5 more times omitting last ch 4 and ending ch 2, 1 tr in first dc.

Round 22: *Ch 5, 1 dc in next lp; rep from * all round, ending ch 2, 1 tr in tr.

Round 23: *Ch 6, 1 dc in next lp; rep from * all round, ending ch 3, 1 tr in tr.

Round 24: *Ch 7, 1 dc in next lp; rep from * all round, ending ch 3, 1 dtr in tr.

Round 25: *Ch 8, 1 dc in next lp; rep from * all round, ending ch 4, 1 dtr in dtr. Fasten off.

Round 26: Thread all beads onto yarn to form drops of 3 beads as follows: * thread through 1 small, 1 large and 1 small bead, then around last small and back through large and first small beads in opposite direction; rep from * 11 more times. (Note: To move drops along yarn, pull gently on last small bead.) Rejoin yarn in centre of any ch lp. *Ch 10, locate drop directly under hook and close firmly with ch 1, ch 9, 1 dc in next lp, [ch 8, 1 dc in next lp] 3 times; rep from * 11 more times, sl st where yarn was joined. Fasten off.

WATERMELON WEDGE
Page 91

Materials: Double knitting, 50g each Red A, White B and 25g each Pale Green C, and Dark Green D, few metres (yds) Black E; 5mm crochet hook or size for tension; 30cm (12") square cushion pad; yarn needle.

Size: 30cm (12") square.

Tension: 15 tr = 10cm (4"); 2 tr rows = 2.5cm (1").

To make: Front and back alike: using A, ch 4.

Row 1 (right side): Skip 2 ch, 2 tr in next, turn – 3 sts.

Rows 2 to 22: Always turning at end of row and working ch 3 to stand as first tr of first rep of next row, cont as follows:

Row 2: [2 tr in next] 3 times – 6 sts.

Row 3: [1 tr, 2 tr in next] 3 times – 9 sts.

Row 4: [2 tr, 2 tr in next] 3 times – 12 sts.

Row 5: [3 tr, 2 tr in next] 3 times – 15 sts.

Row 6: [4 tr, 2 tr in next] 3 times – 18 sts.

Cont working 1 additional single tr at beg of each of 3 reps every row as established and change colour to work row 20 using C and rows 21 and 22 using D – 66 sts.

Row 23: Using B, ch 1, 1 dc, 1 htr, 16 tr, 2 tr in next, 26 tr, 2 tr in next, 16 tr, 1 htr, 2 dc, turn.

Row 24: 5 sl sts, 2 dc, 1 htr, 25 tr, 2 tr in next, 26 tr, 1 htr, 2 dc, sl st, turn.

Row 25: Ch 1, skip sl st, 2 dc, 1 htr, 10 tr, [2 tr in next, 11 tr] twice, 2 tr in next, 10 tr, 1 htr, 2 tr, sl st, turn.

Row 26: Ch 1, skip sl st, 4 sl sts, 2 dc, 1 htr, 40 tr, 1 htr, 2 dc, sl st, turn.

Row 27: Ch 1, skip sl st, 5 sl sts, 2 dc, 1 htr, 9 tr, 2 tr in next, 10 tr, 2 tr in next, 9 tr, 1 htr, 2 dc, sl st, turn.

Row 28: Ch 1, skip sl st, 4 sl sts, 2 dc, 1 htr, 24 tr, 1 htr, 2 dc, sl st, turn.

Row 29: Ch 1, skip sl st, 4 sl sts, 1 dc, 1 htr, 5 tr, 2 tr in next, 6 tr, 2 tr in next, 5 tr, 1 htr, 1 dc, sl st, turn.

Row 30: Ch 1, skip sl st, 4 sl sts, 1 dc, 1 htr, 12 tr, 1 htr, 1 dc, sl st, turn.

Row 31: Ch 1, skip sl st, 4 sl sts, 1 dc, 1 htr, 4 tr, 1 htr, 1 dc, sl st, turn.

Row 32: Ch 1, skip sl st, 3 sl sts, ch 3, htr3tog, turn.

Edging: Ch 1, dc along edge of piece, matching colours and working 3 dc in each corner; sl st in first dc and fasten off. Thread yarn needle with black and work lazy daisy stitch seeds (see page 133) at random on portion of piece in A. With wrong sides together and sewing through back loops only, sew front to back on 3 sides. Insert cushion pad and sew 4th side.

STARLIT
Page 91

Materials: Double knitting, 50g. each colours A, B, and C; 3.5mm crochet hook or size for tension; 12mm (¹/₂") ring for button.

Tension: 4 dc = 2.5cm (1").

Note: At the end of each round close with a slip stitch into the top of the first stitch. From round 2, at the beginning of each round work ch 1 (does not count as first stitch). Do not turn between rounds – right side is always facing.

To make: With A, ch 2.

Round 1: Sk 1, 6 dc in next.

Round 2: 1 dc, [ch 5 to beg point, sk 1 ch, 4 dc, 1 dc in next dc on centre] 5 times, ending ch 5 to beg point, sk 1 dc, 4 dc – 6 dc on centre and 6 points.

Round 3: Join B in dc nearest tip of any point, [4 dc, sk 1 dc in centre, working in underside of ch of next point, 4 dc, ch 2, sk 1 ch] 6 times.

Round 4: [3 dc, 2 sl st, 3 dc, 3 dc in 2 ch sp] 6 times. Fasten off B.

Round 5: Join C in centre dc of any point, [3 dc in centre dc of point, 4 dc, sk 2 sl sts, 4 dc] 6 times.

Round 6: Sl st in next dc, [3 dc in centre dc of point, 4 dc, dc2tog, 4 dc] 6 times.

Round 7: Sl st in next dc, [3 dc in centre dc of point, 5 dc, sk 1, 5 dc] 6 times. Fasten off C.

Round 8: Join B in any dc, 1 dc in each dc around. Fasten off. Make 2nd star.

Finishing: Wrong sides tog, whip st through back lps only from centre st of one point to centre st of 5th point.

Strap: With 2 strands B, make ch 70cm (28)". Sew ends to centre st of first and 5th points.

Button: Dc over plastic ring until it is covered. Sew to sixth point of front. Make ch lp to fit button on 6th point of back.

SWEET HEART
Page 90

Materials: Double knitting (25g skein) – 1 skein red; 5mm crochet hook or size for tension; button.

Tension: 4 tr = 2.5cm (1").

Note: Work rounds in continuous spiral.

To make: (Make 2): Chain 8.

Round 1 (right side): Sk 2, 2 tr in next, 1 tr, 1 htr, 1 dc, ch 1; holding rem 2 ch in back and working along other side of ch, 1 dc in same ch, 1 htr, 1 tr, 2 tr in next, ch 2, sl st in same ch as first tr of round – top centre of heart.

Round 2: 1 dc in next ch made at beg of Round 1, (1 dc, 1 htr) in next ch, (1 htr, 1 tr) in tr, 2 tr in next, 2 tr, 1 htr, 1 dc in each of 2 rem ch of ch 8, ch 1; working on other side of ch, 2 dc, sk ch 1 of

Round 1, 1 htr, 2 tr, 2 tr in next, (1 tr, 1 htr) in next, (1 htr, 1 dc) in next ch, 1 dc in next ch, sl st in sl st.

Round 3: 2 sl sts, (1 dc, 1 htr) in next, *(1 htr, 1 tr) in next, 2 tr in next, (1 tr, 1 htr) in next, ** 3 htr, 3 dc, 1 dc in ch, 3 dc, 3 htr; rep from * to ** once, (1 htr, 1 dc) in next, 2 sl sts.

Round 4: 3 sl sts, (1 dc, 1 htr) in htr, (1htr, 1 tr) in next, 2 tr in next, 1 tr, 2 tr in each of next 2, 2 tr, 2 tr in next, 4 tr, (1 tr, ch 1, 1 tr) in next, 4 tr, 2 tr in next, 2 tr, 2 tr in each of next 2, 1 tr, 2 tr in next, (1 tr, 1 htr) in next, (1 htr, 1 dc) in next, sl st to centre. Fasten off.

Strap: Make 115cm (45") ch. Turn, sk 1 ch, sl st across. Fasten off, leaving a 50cm (20") end.

Finishing: Block pieces. Holding hearts with wrong side tog, working through both pieces, with crochet hook or needle, attach strap securely to one side of heart as in photograph; continue joining pieces tog around bottom to opposite side, attach other end of strap. Sew button to one side. Make ch loop on other side.

GRANNY SQUARE BOLSTER
Page 91

Approximate size: 60cm (23⁵/₈") x 17cm (6³/₄") (diameter).

Materials: 120g 4-ply yarn, main colour MC and total of 170g 4-ply yarn in at least 20 assorted contrast colours C of your choice. 2.25mm crochet hook (or size for tension). Polyester stuffing for bolster; material for bolster, 1 piece 62cm (24¹/₂") x 56cm (22") and two circular pieces 18.5cm (7¹/₄") diameter.

Tension: Square motif measures 6.5cm (2⁵/₈"); square and circular motif 17cm (6³/₄") diameter.

Note: At the beginning of each round work a turning chain to stand as the first stitch of the first pattern repeat as follows: Dc – ch 1; tr – ch 3. At the end of each round close with a slip stitch into the top of this first stitch. Do not turn between rounds – the right side is always facing.

To make square motif: (Make 72) using any C, ch 6, join with sl st to form ring.

Round 1: [3 tr in ring, ch 2] 4 times.

Round 2: Sl st in each st to corner in 2 ch sp, [(1 tr, ch 1, 1 tr, ch 2, 1 tr, ch 1, 1 tr) in 2 ch sp, ch 1, skip 3 tr] 4 times. Fasten off.

Round 3: Join next C in any corner 2 ch sp, [(1 tr, ch 1, 1 tr, ch 2, 1 tr, ch 1, 1 tr) in 2 ch sp, ch 1, skip (1 tr, 1 ch, 1 tr), (1 tr, ch 1, 1 tr) in ch sp, ch 1, skip (1 tr, 1 ch, 1 tr)] 4 times.

Round 4: Sl st in each st to corner 2 ch sp, {(1 tr, ch 1, 1 tr, ch 2, 1 tr, ch 1, 1 tr) in

2 ch sp, [ch 1, skip (1 tr, 1 ch, 1 tr), (1 tr, ch 1, 1 tr) in ch sp] twice, ch 1, skip (1 tr, 1 ch, 1 tr)} 4 times. Fasten off.

Round 5: Join MC in any corner 2 ch sp, {(1 tr, ch 1, 1 tr, ch 2, 1 tr, ch 1, 1 tr) in 2 ch sp, [ch 1, skip (1 tr, 1 ch, 1 tr), (1 tr, ch 1, 1 tr) in ch sp] 3 times, ch 1, skip (1 tr, 1 ch, 1 tr)} 4 times. Fasten off.

To make circular motif: (Make 2).

Note: Avoid joining in new colours in same place as previous round ended. Using any C, ch 4, join with sl st to form ring.

Round 1: [1 tr in ring, ch 1] 12 times.

Round 2: Sl st in ch sp, [2 tr in ch sp, ch 1, skip 1] 12 times.

Round 3: [2 tr, 1 tr in ch sp] 12 times – 36 sts. Fasten off.

Round 4: (and every alt round): With MC, dc all around. Fasten off.

Round 5: With next C, [2 tr, ch 1] 18 times. Fasten off.

Round 7: With next C, [3 tr, ch 1] 18 times. Fasten off.

Round 9: With next C, [4 tr, ch 1] 18 times. Fasten off.

Round 11: With next C, [5 tr, ch 1] 18 times. Fasten off.

Round 13: With next C, [6 tr, ch 1] 18 times. Fasten off.

Round 15: With next C, [7 tr, ch 1] 18 times. Fasten off.

Sew square motifs to make panel of 9 by 8 motifs.

Shell edging: With right side facing and using MC, work along both short sides of panel as follows: join in corner ch sp, *(1 dc, ch 3, 3 tr – called shell) in corner 2 ch sp, [skip (1 tr, 1 ch, 1 tr), 1 shell in ch sp] 4 times, skip (1 tr, 1 ch, 1 tr), 1 shell in corner 2 ch sp; rep from * 7 more times, omitting final shell and ending with 1 dc in corner 2 ch sp. Fasten off. Leaving shell edging free, sew short sides of panel to circular motifs to complete crochet bolster cover.

Using 12mm (¹/₂") seam allowances, stitch and stuff bolster. Insert bolster into crochet cover and sew up seam.

Tassels (Make 2): For each tassel wind yarn approx 100 times around 10cm (4") wide card and cut through one edge to make strands. Fold strands in half and tie firmly. Attach to each end of bolster in centre of circular motif.

GOLDEN GIRL

Page 91

Materials: 1 100m. ball 4-ply yarn; 2.25mm steel crochet hook or size for tension; 5mm (6⅝") plastic ring.

Tension: 5 dc = 2.5cm (1"); 6 rows = 2.5cm (1").

To make: Ch 23.

Row 1: Sk 1, dc across, turn – 22 dc.

Row 2: Ch 1, dc across, turn. Rep row 2 until piece measures 20cm (8"); mark edge for beg of flap.

Flap: Work 4 rows even, then dec 1 st each end every row until 2 sts rem. Fasten off.

Joining and edging: Fold up 10cm (4") at straight end; pin in place. With folded end up, join yarn at beg of pocket at right-hand side working through both thicknesses, work 1 dc, * ch 3, sl st between vertical threads of same dc (picot made), work 4 dc**; rep from * to **, working 3 dc in corners and working along folded lower edge, side, then along flap to point; ch 10 from button lp, continue as from * to **, ending sl st in first dc. Fasten off.

Strap: Join yarn on right side at beg of flap, ch to desired length, turn, sl st in each ch. Fasten off. Join end to left-hand side.

Button: Dc over plastic ring until it is covered. Fasten off. Join yarn in back of button, ch 1, join at opposite point. Fasten off. Sew button to bag.

MULTICOLOURED GRANNY JACKET

Page 90

Materials: 400g knitting worsted Black A, 120g each Green B, Dark pink C, Pink D, Orange E, Scarlet F, Blue G, Purple H, Emerald I, and 60g Mauve J; crochet hook 4.25mm or size to give tension.

Size: One size fits all.

Tension: Each motif = 11.5cm (4½") square.

Finished measurements: Bust (incl ribbing): 1156cm (45½"). Back at underarm: 48cm (19").

Motif: Make 93.

Note: Rounds 1 and 2 form centre of motif; make 5 centres in J and 11 centres each in B, C, D, E, F, G, H, and I. Make each motif different, with a new colour for each round up to round 6; on round 7 rep centre colour. At the beginning of each round work a turning chain to stand as the first stitch of the first pattern repeat, as follows: Dc – ch 1; tr – ch 3; dtr – ch 4. At the end of each round, close with a slip stitch into the top of this first stitch. Do not turn between rounds – the right side is always facing.

Round 1: Ch 2, sk 1, 8 dc.

Round 2: [2 tr in dc, ch 3] 8 times. Fasten off.

Round 3: Join new colour in any 3 ch lp, [5 dc in 3 ch lp] 8 times. Fasten off.

Round 4: Join new colour in centre dc of any 5 dc grp, [3 dc in centre dc, 1dc, dc2tog, 1 dc] 8 times. Fasten off.

Round 5: Join colour in any dc2tog, [(1 dtr, ch 3, 1 dtr – corner) in dc2tog, tr2tog, 7dc, tr2tog] 4 times. Fasten off.

Round 6: Join colour in any corner sp, [5 dc in corner sp, 11 dc] 4 times. Fasten off.

Round 7: Join centre colour in centre dc of any corner, [3 dc in corner dc, 15 dc] 4 times. Fasten off.

Round 8: Join A in centre dc of any corner, [3 dc in corner dc, 17 dc] 4 times. Fasten off.

Half motif: Make 1. With any colour ch 2, 5 dc in 2nd ch from hook. Fasten off.

Row 2: Join same colour in first dc, ch 6, [2 tr in next, ch 3] 3 times, 1 tr. Fasten off.

Row 3: Join new colour in 3rd ch at beg of row 2, 1 dc in same ch, 4 dc in next 6 ch lp, [5 dc in next lp] twice, 4 dc in next lp, 1 dc in last tr. Fasten off.

Row 4: Join new colour in first dc of row 3, ch 1, sk first, 1 dc (counts as dc2tog), [3 dc in next, 1 dc, dc2tog, 1 dc] 3 times, 3 dc in next, dc2tog. Fasten off.

Row 5: Join new colour in first st of row 4, 1 dc in same st, 2 dc, * tr2tog, (1 dtr, ch 3, 1 dtr) in next, tr2tog, **7dc; rep from * to **, 3 dc. Fasten off.

Row 6: Join new colour in first dc, 5 dc, 5 dc in corner sp, 11 dc, 5 dc in corner sp, 5 dc. Fasten off.

Row 7: Join centre colour in first dc, 7 dc, 3 dc in corner dc, 15 dc, 3 dc in corner dc, 7 dc. Fasten off.

Row 8: Join A in first dc, 3 dc in same dc, 7 dc, 3 dc in corner dc, 17 dc, 3 dc in corner dc, 7 dc, 3 dc in last dc, do not fasten off.

Finishing: With colours evenly distributed, arrange motifs, following charts and having centre edge of half motif to outside. From right side, with A, working through lps from centre dc of one corner to centre dc of next corner, oversew together. Sew shoulders. Sew sleeve seams (C to C).

Collar: With A, work 1 row dc along one long edge of facing strip (outer edge); do not work in seams. With wrong sides tog, pin collar and facing strips tog. Having facing strip to underside, sew inner edges of collar and facing strips to front edge of jacket through all thicknesses, sewing A and B motifs of strips to A and B section of jacket neck and centre motif of strip to half motif.

Sleeve ribbing: Right side facing, join A in corner dc of any motif on one free edge; ch 16, sl st in 2nd ch from hook and each rem ch; 15 sl sts. Insert hook, yrh and draw up lp in next 3 dc on motif edge, draw last lp on hook through rem 3 lps on hook, turn.

*** Row 1:** Ch 1, working in back lps only, sl st in each sl st, turn.

Row 2: Ch 1, working through back lps only, sl st in each sl st, insert hook, yrh and draw up a lp in next 3 dc on motif, draw last lp through 3 lps on hook. Rep from * around, end at motif edge. Break A, leaving 30cm (12") end. Sew rib closed.

Jacket ribbing: Pin collar and facing tog along outer edges. Work ribbing through both thicknesses. Right side facing, join A in any dc on lower edge at side; ch 6, sl st in 2nd ch from hook and each rem ch; 5 sl sts. Sl st in next dc on motif edge.

*** Row 1:** Ch 1, turn, working in back lps only, sl st in each sl st.

Row 2: Ch 1, turn, working in back lps only, sl st in each sl st; sl st in next dc on motif edge through both lps. Rep last 2 rows twice; at end of last row, insert hook, yrh and draw up a lp in each of next 2 dc on motif edge, drawing last lp through 2 lps on hook. Rep from * to within 3 sts of centre dc at corner. Work 3 ribs to each of next 5 dc, work up front edge as before, end at seam between 4th and 5th motif. Work 1 rib to 1 st around neck to seam between 4th and 5th motif on left front. Finish ribbing to correspond to first half, working around to beg. Sew ends tog same as for sleeves. Sew in sleeves.

Tie: With A make ch 120cm (48") long, sk 1, sl st across, turn.

Row 2: Ch 1, sl st in back lp across. Rep row 2 for 3cm (1¼"). Fasten off.

Half Motif

Shoulder A|B Shoulder

Body

C Sleeve (Make 2)

A B

Collar/Band (Make 2: 1 for facing)

Multicoloured Granny Jacket

PINWHEEL PUFF

Page 91

Materials: Double knitting – 100g each Red A, Amethyst B, Blue C, Green D, Yellow E, Orange F, 5mm crochet hook or size for tension; 30cm (12") diameter round cushion pad.

Size: 30cm (12") diameter.

Tension: 4 dc = 2.5cm (1"); 4 rows = 2.5cm (1").

Note: Leave each yarn at end of each colour section. On rounds 2–16, bring yarn across back to beg of section, then work over strand. On rounds 17–22, cut yarn at end of each section.

To make: With A, ch 4, join with sl st in first ch to form ring, ch 1.

Round 1: Working into ring, work 2 dc each A, B, C, D, E and F; do not join.

Round 2: Working around in a spiral, skip first dc, *2 dc in next, 1 dc in first dc of next colour, changing to new colour; repeat from * around.

Round 3: *1 dc, 2 dc in next, 2 dc in first dc of next colour, changing to new colour in last st; repeat from * around.

Round 4: *2 dc, 2 dc in next, 1 dc, 1 dc in first dc of next colour, changing to new colour; repeat from * around.

Round 5: *2 dc in next, 1 dc in each dc of section, 1 dc in first dc of next colour, changing to new colour; repeat from * around.

Rounds 6 to 22: Staggering increases so they do not fall over one another, continue increasing 1 st in each section on each round and moving each section 1 st to left on each round; end last round with sl st in last st; fasten off – 24 sts in each section. Make second piece in same way, but in following colour order – A, F, E, D, C and B. Hold pieces together, right side out. Using matching colours, dc around through both layers, inserting cushion pad before closing completely.

CROCHETED SHELL

Page 109

Materials: 12 250m balls 4-ply cotton yarn, 2.75 crochet hook or size for tension.

Size: 8–10. Changes for size 12–14 are in (). If only one number appears, it applies to all sizes.

Tension: 10 mesh = 7.5cm (3"); 5 rows = 5cm (2").

Finished measurements: Bust: 79cm (31") (85 cm/33½"). (Garment will give to fit.) Sleeve width: 26.5cm (10½") (30cm/11¾").

Note: Ch 3 at beg of each row counts as 1 tr. To work 1 mesh, following initial ch 3 or tr, work ch 1, sk 1, 1 tr.

Back: Ch 108 (116).

Row 1 (right side): Sk 3 ch, 1 tr, *ch 1, sk 1 ch, 1 tr; rep from * across, turn – 52 (56) mesh.

Row 2: Ch 3, 1 tr in first ch sp, *ch 1, 1 tr in next ch sp; rep from * across, ending in top of t-ch, turn.

Rep row 2, called mesh pattern, until 28 rows have been completed.

Shape armholes:

Row 1: Sl st in each st across to 4th tr, ch 3, 1 tr in next ch sp, cont in mesh patt to last 2 sps – 46 (50) mesh, turn.

Row 2 (Dec): Ch 3, sk first sp, 1tr in next sp (dec), cont in mesh patt, ending sk 1 tr, 1 tr in top of t-ch (dec), turn.

Row 3: as row 2.

Row 4: Ch 3, 1 tr in next sp, cont in mesh patt across, ending ch 1, 1 tr in t-ch, turn – 42 (46) mesh. Work even in patt until armholes measure 16.5cm (6½") (18cm/7"). Fasten off. Mark centre 22 sps on last row for neck edge.

Front Square Motif (make three 10cm/4" sq.):

Special abbreviation

Puff – made as htr4tog in same place (see page 95).

Note: Beg each round with ch 2 (does not count as st) and end with sl st in top of first st and in next ch; work all rounds with RS facing.

Ch 5, sl st in first ch made to form ring.

Round 1: In ring work [1 Puff, ch 3, 1 Puff, ch 2] 4 times.

Round 2: [(1 Puff, ch 3, 1 Puff) in 3 ch sp, ch 2, 4 tr in 2 ch sp, ch 1] 4 times.

Round 3: [(1 Puff, ch 3, 1 Puff) in 3 ch sp, ch 2, 3 tr in 2 ch sp, sk 1 tr, 3 tr, 3 tr in 1 ch sp, ch 1] 4 times.

Round 4: [(1 Puff, ch 3, 1 Puff) in 3 ch sp, ch 2, 3 tr in 2 ch sp, sk 1 tr, 8 tr, 3 tr in 1 ch sp, ch 1] 4 times.

Round 5: [(1 Puff, ch 3, 1 Puff) in 3 ch sp, ch 2, 3 tr in 2 ch sp, sk 1 tr, 13 tr, 3 tr in 1 ch sp, ch 1] 4 times.

Fasten off. Sew squares tog to form a strip.

Edging: Working across long side of strip, from RS join yarn in right corner, 2 dc in corner sp, *1 dc in each st and sp to seam, 1 dc in seam; rep from * twice, end 2 dc in last corner sp – 79 dc. Fasten off. Rep on opposite side, do not fasten off.

Side mesh:

Row 1: Ch 3, working along short side, 1 tr in corner sp, ch 1, sk Puff, 1 tr in 2 ch sp, [ch 1, sk 1, 1 tr] 4 times, ch 1, sk 1 tr, (1 tr, ch 1, 1 tr) in next , [ch 1, sk 1, 1 tr] 5 times, ch 1, sk Puff, (1 tr, ch 1, 1 tr) in corner sp, turn. Work 5 (7) more rows even in mesh patt; fasten off. With RS facing, join yarn in right corner at opposite end of strip and rep mesh patt to match first side.

Lower front:

Row 1: With RS facing, join in lower left corner (i.e. garment right), ch 3; working in sps along side of row [1 tr in sp, ch 1] 6 (8) times, [1 tr in dc, ch 1, sk 1 dc] 39 times, 1 tr in dc, [ch 1, 1 tr in sp] 6 (8) times, turn – 51 (55) mesh.

Row 2: Work mesh patt, turn.

Puff St pattern:

Row 1: Ch 3, 1 tr in first sp, work 5 (7) mesh, ch 1, 1 Puff in next sp, *[ch 1, 1 tr in next sp] 10 times, ch 1, 1 Puff in next sp; rep from * twice more, [ch 1, 1 tr in next sp] 11 (13) times, ch 1, 1 tr in top of 3 ch, turn.

Row 2: Ch 3, 1 tr in first sp, work 10 (12) mesh, *[ch 1, 1 Puff in next sp] twice, [ch 1, 1 tr in next sp] 9 times; rep from * twice more, ending [ch 1, 1 Puff in next sp] twice, [ch 1, 1 tr in next sp] 5 (7) times, ch 1, 1 tr in top of 3 ch.

Row 3: Rep Puff St patt row 1.

Rows 4 to 6: Rep Puff St patt rows 1–3.

Repeat last 6 rows once. Repeat row 2 of lower front once; fasten off.

Upper front:

Row 1: With RS facing, join in upper right corner (i.e. garment left), work as for row 1 of lower front.

Row 2: Rep row 1 of Puff St patt.

Shape armholes:

Next 4 rows: Keeping Puff St patt, dec at armholes as for back – 41 (45) mesh Keeping Puff St patt, work 2 rows even.

Shape neck:

Mark 14 (16th) ch sp in from each side. Working on first side cont patt as established, ending with last tr in first marked sp, turn.

Dec Row: Ch 3, sk first sp (dec); beg in next sp, work Puff St patt across.

Keeping patt, rep Dec row every 2nd row twice more. Work even in patt until same length as back to shoulder – 10 (12) mesh. Fasten off. Join in next tr following 2nd marked sp, and work 2nd side to correspond to first.

Sleeve (Make 2): Ch 74 (82).

Row 1: Rep row 1 of back – 35 (39) mesh. Work as for back for 6.5cm (2½").

Shape cap: Work as for back armhole shaping through row 3. Rep row 3, 9 (10) times more – 7 (9) mesh. Fasten off.

Finishing: Sew side and sleeve seams; sew in sleeves.

Lower edge:

Round 1: With RS facing, join and work 1 dc in first sp at lower left of back, *ch 2, sk 1 sp, 5 tr in next ch sp, ch 2, sk 1 sp, 1 dc in next sp; rep from * around, ending ch 2, sk 1 sp, sl st in first dc; do not turn.

Round 2: *Ch 2, 1 tr in next tr, [ch 3, 1 rfdc around post of same tr (picot made), 1 tr in sp before next tr] 4 times, work picot, ch 2, 1 dc in next dc; rep

from * around. (Note: Thread round elastic through base of first row of edging, fit to waist and fasten, if desired.)

Sleeve edging: Same as for lower edge.

Neck edging: With right side facing, join yarn in right shoulder seam, work approx 41 dc across back neck; keeping shape of neck, continue to dc around, having approx 28 dc across the centre 14 mesh at front neck, and the total number of dc a multiple of 8. Join in first dc.

Round 1: 1 dc, *ch 2, sk 3 dc, 5 tr in next dc, ch 2, sk 3 dc, 1 dc; rep from * around, sl st in first st.

Round 2: Rep round 2 of lower edge.

LACY JACKET
Page 108

Sizes: Directions are for size Small. Medium and Large sizes are in (). If only one number is given, it applies to all sizes.

Materials: (175m ball); 14 (14 – 16) 4-ply cotton; crochet hook 3.75mm or size to give tension.

Tension: 18 sts and 12 rows = 10cm (4").

Finished measurements: Bust: 91.5cm (36") (99cm/39" – 105.5cm/41½"). Sleeve width: 35.5cm (14") (37cm/14½" – 39cm/15½").

Note: Ch 2 at beg of each row counts as 1 htr. To work 1 mesh, following initial ch 2 or htr, work ch 1, 1 htr.

Back Panel: Ch 44 (52 – 56).

Row 1 (right side): Sk 2 ch, 1 htr as follows: yrh, insert hook, yrh, draw lp through and up to about 6mm (¼"), yrh, draw through 3 lps on hook (long htr made; make htr in same way throughout); htr across, turn – 43 (51– 55) htr.

Row 2: Ch 2, sk first st, *ch 1, sk 1, 1 htr; rep from * across, turn – 21 (25 – 27) mesh.

Row 3: Ch 2, * 1 htr in ch sp, 1 htr in htr, rep from * across, turn.

Rows 4, 5, 6: Rep rows 2, 3, 2.

Diamond patt:

Row 7: Ch 2, work 9 (11 – 12) mesh, ch 1, sk 1 mesh, 4 htr (block) in next ch sp, ch 1, sk sp, 1 htr in htr, continue mesh across, turn – 1 block at centre, 10 (12 – 13) mesh each side.

Row 8: Ch 2, work 8 (10 – 11) mesh, ch 1, sk 1 mesh, 4 htr in next ch sp, ch 1, sk block, 4 htr in next ch sp, ch 1, sk sp, 1 htr in htr, continue mesh across, turn.

Row 9: Ch 2, work 7 (9 – 10) mesh, ch 1, sk 1 mesh, 4 htr in sp, ch 1, sk 3 htr of block, 1 htr, ch 1, sk sp, 1 htr in htr, ch 1, sk 3 htr of block, 4 htr in sp, continue mesh across, turn. Continue Diamond patt rows 10–17 from chart, then rep rows 8–17, 3 times more.

Work even in mesh until 56cm (22") from beg, or 12mm (½") less than desired length to shoulders. Fasten off.

Edging:

Row 1: With right side facing, working along side edge, join in corner, ch 2, work 2 htr at end of each row across side edge only, turn.

Row 2: Ch 2, htr across, turn.

Row 3: Ch 1, (1 dc and 3 htr) in first st – shell made, * sk 2 sts, (1 dc and 3 htr) in next; rep from * across. Fasten off. Work same edging on opposite side edge.

Left front panel: Ch 28 (32 – 32). Work rows 1–6 of back panel – 27 (31 – 31) htr; 13 (15 – 15) mesh.

Diamond patt:

Row 7: Ch 2, work 5 (6 – 6) mesh, ch 1, sk 1 mesh, 4 htr in next ch sp, ch 1, sk sp, continue mesh across – 1 block at centre, 6 (7 – 7) mesh each side. Work even in Diamond patt as established, following chart rows 8–17, 4 times. Work even until about 5cm (2") less than back to shoulder, ending at side edge.

Shape neck:

Row 1: Ch 2, work 6 (7 – 7) mesh, sk 1 ch, 1 htr in htr (mesh dec), turn.

Row 2: Ch 2, sk first sp, 1 htr in htr, work 5 (6 – 6) mesh. Work even on 5 (6 – 6) mesh until same length as back to shoulders. Fasten off.

Edging: Along side edge only, work same as back edging.

Right front panel: Work same as left front panel, reversing shaping.

Side panels (Make 2): Ch 20 (20 – 24). Work rows 1–6 of back panel – 19 (19 – 23) htr. Rep'g row 2 of back, work even in mesh until 18.5cm (7¼") (19cm/7½" – 20cm/8") less than back to shoulder. Fasten off.

Edging: On each side edge, work edging as for back panel.

Sleeve, upper panel: Ch 28 (32 – 32).

Work rows 1–6 of back panel – 27 (31 – 31) htr.

Diamond patt:

Row 7: Ch 2, work 5 (6 – 6) mesh, ch 1, sk 1 mesh, 4 htr in next ch sp, ch 1, sk sp, work mesh across – 1 block at centre, 6 (7 – 7) mesh each side. Work even in Diamond Patt as established until 3 diamonds are completed. Work 1 row mesh. Fasten off.

Under panel: Ch 24 (24 – 28). Work same as side panel until 7.5cm (3") (7.5cm/3" – 8cm/3¼") less than length of upper sleeve panel – 23 (23 – 27) htr.

Divide for underarm:

First half: Work even on 5 (5 – 6) mesh until panel is same length as upper panel. Fasten off.

Second half: Sk centre sp on last full row. Work on rem 5 (5 – 6) mesh to same length as first half. Fasten off.

Edging: On each side edge of upper and under sleeve panels, work edging as for back panel.

Finishing: Block pieces. Sew front shoulders to corresponding sts on upper edge of back panel. Beg lower edge, sew side panels to front and back panels by tacking centre sts of shells tog. In same way, sew upper and under sleeve panels tog. Mark centre of side panels at underarm. Sew sleeves in place, sewing underarm edges to upper edge of side panel each side of marker.

Outer edging:

Round 1: With right side facing, beg lower edge back seam, work 1 round htr evenly spaced around entire outer edge, inc at corners and dec around neck edge as required to keep work flat, and end with sl st into first st, do not turn.

Round 2: *(1 dc and 3 htr) in next htr – called shell, sk 2 sts; rep from * around, sl st in first st. Fasten off. Work same edging on sleeves.

☐ Mesh
■ 1 Block

Lacy Jacket

DECORATIVE DOILY

Page 109

Materials: 1 ball 250m 10s cotton, 1.8mm steel crochet hook or size for tension; 40cm (16") square cushion; ecru sewing thread.

Tension: Rounds 1 to 3, 7.5cm (3") sq.

Finished size: 33cm (13") square.

Special abbreviation

Pc (picot) – ch 3, sl st in 3rd ch from hook.

Note: At the beginning of each round, work a turning chain to stand as the first stitch of the first pattern repeat as follows: Dc – ch 1; tr – ch 3; dtr – ch 4. At the end of each round, close with a slip stitch into the top of this first stitch. Do not turn between rounds – the right side is always facing.

To make: Ch 5, join with sl st into first ch to form ring.

Round 1: [Dtr3tog in ring, ch 5] 5 times.

Round 2: [1 dtr, ch 4, sk 1, 1 dtr, ch 4, sk2] 6 times.

Round 3: *(Dtr3tog, [ch 3, dtr3tog] twice) in dtr, ch 4, skip 4 ch, [1 htr in dtr, ch 4, skip 4 ch] twice; rep from * 3 more times.

Round 4: Sl st across to 2nd of 3 cls, *(1 dtr, ch 9, 1 dtr) in 2nd of 3 cls, ch 5, skip 3 ch, 1 dtr in next cl, [ch 5, skip 4 ch, 1 dtr] 3 times, ch 5, skip 3 ch; rep from * 3 more times.

Round 5: Sl st across to 5th of 9 ch loop, *(1 tr, ch 5, 1 tr) in 5th of 9 ch loop, ch 2, skip 1 ch, 1 tr, [ch 2, skip 2 ch, 1 tr] 12 times, ch 2, skip 1 ch; rep from * 3 more times.

Round 6: Sl st across to 3rd of 5 ch loop, *(1 tr, ch 5, 1 tr) in 3rd of 5 ch loop, [ch 2, skip 2 ch, 1 tr] 15 times, ch 2, skip 2 ch; rep from * 3 more times.

Round 7: Sl st across to 3rd of 5 ch loop, *(2 tr, ch 5, 2 tr) in 3rd of 5 ch loop, [ch 5, skip 2 tr, (1 tr, ch 5, 1 tr) in next tr, ch 5, skip 2 tr, 2 tr in next tr] twice, ch 5, skip 2 tr, (1 tr, ch 5, 1 tr) in next tr, ch 5, skip (2 tr, 2 ch); rep from * 3 more times.

Round 8: *2 tr, ch 5, 1 dc in ch lp, ch 5, [2 tr, ch 5, skip ch lp, 1 tr in tr, 8 tr in ch lp, 1 tr in tr, ch 5, skip ch lp] 3 times; rep from * 3 more times.

Round 9: *2 tr, ch 4, [1 dc in ch lp, ch 4] twice, [2 tr, ch 4, skip ch lp, 10 dc, ch 4, skip ch lp] 3 times; rep from * 3 more times.

Round 10: * 2 tr, ch 4, [1 dc in ch lp, ch 4] 3 times, [2 tr, ch 4, skip ch lp, 10 dc, ch 4, skip ch lp] 3 times; rep from * 3 more times.

Round 11: *2 tr, ch 4, [1 dc in ch lp, ch 4] 4 times, [2 tr, ch 4, skip ch lp, 10 dc, ch 4, skip ch lp] 3 times; rep from * 3 more times.

Round 12: *2 tr in first of 2 tr, ch 4, 2 tr in next tr, ch 4, [1 dc in ch lp, ch 4] 5 times, [2 tr in next tr, ch 4, 2 tr in next tr, ch 4, skip ch lp, dc2tog, 6 dc, dc2tog, ch 4, skip ch lp] 3 times; rep from * 3 more times.

Round 13: *2 tr, ch 4, 1 dc in ch lp, ch 4, 2 tr, ch 4, [1 dc in ch lp, ch 4] 6 times, [2 tr, ch 4, 1 dc in ch lp, ch 4, 2 tr, ch 5, skip ch lp, dc2tog, 4 dc, dc2tog, ch 5, skip ch lp] 3 times; rep from * 3 more times.

Round 14: *2 tr, ch 4, [1 dc in ch lp, ch 4] twice, 2 tr, ch 4, [1 dc in ch lp, ch 4] 7 times, [2 tr, ch 5, skip ch lp, dc2tog, 2 dc, dc2tog, ch 5, skip ch lp] 3 times; rep from * 3 more times.

Round 15: *2 tr, ch 4, [1 dc in ch lp, ch 4] 3 times, 2 tr, ch 4, [1 dc in ch lp, ch 4] 8 times, [2 tr, ch 5, skip ch lp, {dc2tog} twice, ch 5, turn, 1 dc in last tr made, turn, skip ch lp] 3 times; rep from * 3 more times.

Round 16: Sl st across to 2nd of 4 ch loop, *[1 dc in 4 ch lp, ch 4] 4 times, 1 dc in each of 2 tr, ch 4, [1 dc in ch lp, ch 4] 9 times, 1 dc in each of 2 tr, ch 4, [1 dc in ch lp, ch 4] 12 times, skipping (2 tr, 1 dc, 2 tr) over each pineapple motif; rep from * 3 more times.

Round 17: 4 tr in each ch lp and 1 dc in each of 2 dc at corners around – 448 sts.

Round 18: *7 dc, 1 Pc; rep from * around

To complete: Centre doily on cushion top and tack in place with ecru thread.

DUTCH TILES AFGHAN

Page 111

Materials: Double knitting, 110g ball: 14 balls – White MC; 2 balls each Light blue B, and Royal D; one ball of Medium blue C; Tunisian crochet hook 6mm or size for tension; standard crochet hook 5mm; tapestry needle.

Tension: 4 sts, 3 rows = 2.5cm (1") in Tunisian simple stitch (see page 110).

Size: Approx. 120cm (47") by 170cm (68") plus fringe.

Special abbreviaton

Pop – popcorn made with 5 tr (see page 95).

Panel: Make 3. With Tunisian crochet hook and MC, ch 43 loosely. Work in Tunisian simple stitch for 201 rows.

Next Row: Sl st in each vertical bar across; fasten off.

Embroidery: Following chart, embroider each panel, repeating rows 1 through 40; end row 41. Work cross sts over vertical bar.

Panel borders:

Row 1: With RS facing, using standard crochet hook and A, join in right corner of long edge of one panel, ch 1, 1 dc in end of each row across, ending 1 dc in sl st row – 202 dc. Fasten off.

Row 2: With RS facing, join B in first st, ch 1, dc across. Fasten off.

Row 3: With D, rep row 2.

Row 4: With A, rep row 2; do not fasten off, turn.

Row 5: Ch 3, tr across, turn.

Row 6: Ch 3, *1 Pop, ch 2, sk 1; rep from * to last st, 1 tr, turn.

Row 7: Ch 3, *1 tr in 2 ch sp, 1 tr in Pop; rep from *to last st, 1 tr, turn.

Row 8: Ch 1, dc across. Fasten off.

Work border on each long edge of panels. Sew panels together.

Fringe: Wind A around 14cm (5½") piece of card; cut yarn strands at one end. Knot strands in every third st across short ends of afghan. Trim and steam lightly.

☒	Cross stitch D
△	Cross stitch C
●	French knot D
◎	French knot B
—	Satin stitch B
··	Satin stitch D

Dutch Tiles Afghan

ANTIQUE ROSES AFGHAN
Page 113

☐ MC ⚫ A ▣ B
△ C ⊠ D ▽ E

Materials: Aran weight yarn, 750g Blue MC, 250g Pale rose B, 150g each of Light green A, Dark rose C, Medium rose D, and Dark green E; yarn bobbins; yarn needle; 6.5mm crochet hook or size for tension.

Tension: 6 sts, 7 rows = 5cm (2") in dc.

Size: Approximately 107cm (42") by 130cm (51½").

To make: Solid blocks (make 10) – With MC, ch 28.

Row 1 (right side): Sk 1 ch (does not count as st), dc across, turn – 27 sts.

Row 2: Ch 1 (does not count as st) dc across, turn. Rep row 2 30 more times. Fasten off.

Rose blocks (make 10) – Following chart for colours, work as for solid block. Along the centre of each leaf in A, work a row of surface chain st in E. On each leaf in E, chain st a row in A (see page 116 Surface Chains).

To assemble: Be sure all blocks are right side up and aligned in the same direction. Alternating blocks, invisibly sew a strip of two solid and two rose blocks with solid block at left side of strip. Make two more strips the same. In same manner, sew together two more strips with rose block at left side. Being sure that blocks alternate chequerboard-style, sew strips together invisibly.

Border: Join MC at a corner of afghan with sl st. Work 498 dc evenly spaced around afghan as follows: 108 dc across top and across bottom: 138 dc along each side; 1 dc in each corner.

Round 1: With B [1 dc in corner st, *ch 4, sk 3 dc, 1 dc in each of next 2 dc; rep from * to last 3 sts before next corner, ch 4, sk 3 dc] 4 times, sl st in first dc.

Round 2: With B, sl st in 4 ch sp, working ch 3 to count as first tr of round (2 tr, ch 2, 2 tr) in each 4 ch lp and in each corner dc all round, sl st in top of first ch 3. Fasten off.

Round 3: Join D in corner 2 ch sp, [(2 dc, ch 4, 2 dc) in corner 2 ch sp, *ch 4, 2 dc in next 2 ch sp; rep from * to next corner] 4 times, sl st in first dc.

Round 4: With D, sl st in next dc and in next ch lp, working ch 3 to count as first tr of round (2 tr, ch 2, 2 tr) in each 4 ch lp all round, sl st in top of ch 3 sp. Fasten off.

Round 5: With C, rep Round 3.

Round 6: With C, rep Round 4.

Round 7: With E, rep Round 3.

Round 8: With E, rep Round 4. Fasten off.

FAN AFGHAN
Page 112

Materials: Brushed mohair, 800g White MC; 90g each Rose A, Turquoise B, Orange C, Gold D, and Yellow E. Crochet hook 5.5mm or size for tension. 5 large yarn bobbins.

Tension: 3 sts = 2.5cm (1"); 3 rows = 5cm (2").

Finished measurements (without fringe): Approximately 127cm (50") by 173cm (68"). Each square: approx. 23cm (9").

Square: Wind 5m each A, B, C, D and E on separate bobbins. Beg at corner, with MC ch 4.

Row 1 (wrong side): Sk 3 ch, 4 tr in next, turn – 5 tr.

Row 2: Ch 3, 1 tr in first tr (inc made), 3 tr, 2 tr in last, turn – 7 tr.

Row 3: Ch 3, 1 tr in first tr, [2 tr, 2 tr in next] twice, changing to next colour on last st, turn – 10 tr.

Fan pattern:

Row 1 (right side): Ch 3, 1 tr in first tr, 1 tr, changing to B; *2 tr in next – called inc, 1 tr, changing to C **; rep from * to ** once, changing to D, then again, changing to E; turn – 15 tr in 5 colours.

Row 2: Ch 3, tr across in colours as established, turn.

Row 3: Ch 3, tr across, working inc toward centre of each colour, turn – 5 sts inc'd.

Rows 4 to 8: Rep Fan patt rows 2 and 3 twice more, then rep row 2 once, joining MC at end – 30 tr. Cut bobbins.

Shell pattern:

Row 1: With MC, ch 1, 3 dc, ch 1, sk 1, 1 tr, ch 1 [sk 2, 6 dtr in next, sk 2, 1 tr] twice, sk 2, 6 dtr in next, ch 1, sk 3, 1 tr, ch 1, sk 1, 4 dc, turn – 34 sts.

Row 2: Ch 1, sl st in back lp of first 10 sts, 1 dc, sk 2 dtr, 6 dtr in next, sk 2 dtr, 1 dtr, sk 3 dtr, 6 dtr in next tr, sk 2 dtr,

1 dc, turn.

Row 3: Ch 1, sl st in front lp of next 4 sts, 1dc, sk 2 dtr, 6 dtr in next dtr, sk 2 dtr, 1dc. Fasten off.

Border:

Round 1: Right side facing, join MC at point of fan, 3 dc in point (corner), * work 22 dc evenly spaced to next corner, 3 dc in corner; repeat from * twice more, work 22 dc along last side, join with sl st to first dc, sl st in corner dc. Do not turn – 100 dc.

Round 2: Working ch 3 to count as first tr of round, [(5 tr in corner dc – called shell), ch 1, sk 2, {2 tr, ch 1, sk 1} 6 times, 2 tr, ch 1, sk 2], 4 times, sl st in top of 3 ch – 22 sts each side, shell in each corner. Fasten off.

Make 34 more squares, following the same colour sequence, but having A in each of the 5 colour positions 7 times.

Finishing: Block squares very lightly to same measurement. Arrange right side up, following chart and alternating chart rows 1 and 2 for 7 rows of 5 squares each.

Joining: Beg at side edge, holding 2 squares right sides tog and working through both lps of corresponding sts on each square at same time, join MC in centre tr of shells at first corner, 1 dc in same tr, ‡ * 1 dc in next 2 tr, ch 1, sk 1 ch **; rep from * to ** to next shell, 1 dc in first 3 tr of shell; hold next 2 squares tog, 1 dc in 3rd tr of first shell; rep from ‡ across. Fasten off. Join all short rows, then join long rows in same manner, working over previous joinings at corners as follows: 1 dc in 3rd tr of corner shell at end of squares, ch 1, 1 dc in 3rd tr of corner shell on next 2 squares.

Border:

Round 1: From wrong side, join in 3rd tr of shell at one corner, working along edge * [ch 5, sk 2 tr, 1 dc in ch sp] 8 times, ch 5, 1 dc in joining between squares; rep from * around, end 1 dc in joining, turn – 45 lps on each short side, 63 lps on long sides.

Round 2: Sl st to 3rd ch on first lp, working ch 4 to count as first dtr of round, [6 dtr in first lp of side,* 1 tr in 3rd ch of next lp, 6 dtr in 3rd ch of next lp **; rep from * to ** to next corner], 4 times, join in top of 4 ch.

Round 3: [Inserting hook between 6 dtr groups at corner work 1 dc, ch 5, sk 3 dtr, 1 dc, * ch 5, sk 2 dtr, 1 dc in tr, ch 5, sk 3 dtr, 1 dc **; rep from * to ** across one side, ch 5] 4 times, join with sl st in first dc. Fasten off.

Fringe: Wind yarn around a 13cm (5") cardboard, cut at one edge. Knot 8 strands tog in every 2nd lp around.

□ White MC
■ Yellow E
■ Gold D
■ Orange C
■ Turquoise B
■ Rose A

Fan Afghan

KALEIDOSCOPE AFGHAN
Page 113

Materials: Chunky yarn – 700g Red MC, 300g Pink A, 120g each Burgundy B, Natural C, Light teal D, Mustard E, Cobalt F, Pale blue G, Lilac H, and Beige I; 6.5mm crochet hook or size for tension.

Tension: 6 sts, 7 rows = 5cm (2") in double crochet (dc).

Size: Approximately 132cm (52") by 160cm (63").

Note: Turning chain does not count as a stitch.

To make: Centre: With MC, ch 118.

Row 1 (right side): Skip 1 ch, dc across, turn – 117 dc. (This is row 1 of Chart 1.)

Row 2: Ch 1, dc across, turn. Row 2 forms pattern. (Row 2 of Chart 1.)

Beginning with row 1 of Chart 1, work to row 100, changing colours as indicated, then repeat rows 1 to 72. Work 2 more rows with MC – 176 rows. Fasten off.

Border: Each border strip is made up of eleven squares – 176 rows; make four strips. Following border stitch chart from row 1, ch 17 with colour indicated on border colour chart. Work in patt as for centre, changing colours as indicated – 16 dc.

Finishing: Sew appropriate border strip to each long side edge of afghan. Sew remaining borders to top and bottom edges, easing as required. Join MC with sl st in one corner. Work 5 rounds of dc, with 3 dc in each corner. Fasten off.

Kaleidoscope Afghan
Border Stitch Chart (above)
Border Colour Chart (left)
Chart 1 (below)

EMBROIDERY

SMOCKED EVENING BAG
Page 148

Finished size: Approximately 13cm (5") wide across smocking by 19cm (7½") long, excluding tassel.

Materials: Purple iridescent fabric, 112cm (45") wide and 41cm (16") long; strong thread to gather rows of smocking; 1 skein each of wine, peach, and red pearl cotton; fusible webbing; 1 large tassel; 1 bead; 90cm (36") thin wine coloured cording; sewing thread.

Smocking: Measure 10cm (4") at one end of the fabric. Mark 10cm (4") along 112cm (45") edge of one fabric; make a line. Make 10 more lines, 12mm (½") apart, parallel to first. Mark the dots for smocking on these lines, 12mm (½") apart. Gather each row with strong thread and knot threads together in pairs (see page 146).

Smock as follows:

Row 1: 1 row of double cable stitch, in peach pearl cotton.

Rows 2, 3 and 4: 1 row of surface honeycomb stitch in wine pearl cotton.

Rows 4, 5 and 6: 1 row of trellis diamond stitch in red pearl cotton.

Rows 6, 7 and 8: 1 row of trellis diamond stitch in red pearl cotton.

Rows 8, 9 and 10: 1 row of surface honeycomb stitch in wine pearl cotton.

Row 11: 1 row of double cable stitch, in peach pearl cotton.

Remove the gathering threads, turn to wrong side and steam press.

To assemble bag: With right sides together, and matching rows of smocking carefully, stitch side edges together with a 6mm (¼") seam to form a tube of fabric. The bottom end of bag is now the end with the smallest amount of fabric below the band of smocking. Press a 12mm (½") hem to wrong side around top edge of bag, and stitch in place. Press a 6mm (¼") hem to wrong side around bottom edge of bag. Turn under this edge again by 12mm (½"). Stitch in place, close to open folded edge, leaving a small opening to form a casing. Knot the end of a long piece of thread, and insert it through the casing. Pull up ends of thread to gather bottom edge of bag as tightly as possible, and tie off securely. You will have a small hole at centre of gathers.

Cut 4 circles of fabric, each 5cm (2") in diameter. Fuse all 4 circles together with fusible webbing. Turn bag to right side. Place fused circle inside bag to cover hole at centre bottom. Hand stitch in place. Work a row of gathering stitches around top hem. Pull up gathers to same width as smocking. Turn under this gathered edge to wrong side of bag and stitch in place just above first row of smocking. Make a second line of stitching 2cm (¾") above first row of smocking to form a casing. Cut cording into 2 equal pieces. Make a small hole in casing at side seam edge, and at opposite side edge. Thread one length of cording through casing from each side of bag. Knot ends of cording. Pass a length of knotted thread through tassel. Thread on bead. Sew bead and tassel to centre of fused circle at bottom of bag.

STUMPWORK SUNFLOWER
Pages 150

Finished size: 6.5cm (2½") diameter.

Materials: One 9cm (3½") diameter flexi-hoop; 20cm (8") square of off-white fabric; small square of yellow felt; matching sewing thread; 7.5cm (3") square even-weave fabric; 1 skein each orange and brown embroidery floss; fabric glue; waterproof felt-tip pen; crewel needle; tapestry needle.

To make: Cut out 12 flower petals from felt. Start by positioning 6 petals evenly spaced on the centre (right side) of the calico square. Sew down petal edges with small over stitches in matching thread. Arrange the remaining 6 petals on top, and sew down the edges in the same way. Work seeding (see page 129) over alternate petals, using 6 strands of orange embroidery floss. Leave each stitch loose so that it forms a raised bump on the felt. Draw a 2.5cm (1") diameter circle in centre of evenweave fabric with a waterproof pen. Using 3 strands of orange, and 3 strands of brown embroidery floss together, work rows of turkey stitch across fabric to fill the circle (see page 169). The loops formed by the stitch may be left uncut, or they can be around circle, close to stitching. Smear glue on wrong side of circle to hold stitches in position. Leave glue to dry. Sew turkey stitch circle to centre of felt petals with matching thread. Using 6 strands of orange embroidery floss, work a row of couching (see page 136) around the turkey stitch circle, and around the edge of each embroidered petal. To give the couching a raised look, pull up the laid thread with your needle to form a loop between each couching stitch instead of stitching it down flat.

Stumpwork Sunflower
Flower Petal
Template

HERB SACHET
Page 150

Finished size: 14cm (5½") by 9cm (3½").

Materials: Two rectangles of calico, both 17cm (6¾") by 10cm (4"); thread to match calico; 6.5cm (2½") square red gingham; small amount of wadding; strip of green gingham, 2.5cm (1") by 10cm (4") wide; narrow ribbon, 30cm (12") long; 1 skein each of red, dark and light green embroidery floss; embroidery needle; small amount of dried herbs.

To make: Use 6mm (¼") seams. Embroider with 3 strands of embroidery floss unless otherwise stated. Draw or transfer position of appliqué heart and embroidered leaf design on to RS of front sachet piece 9cm (3½") from top raw edge. Cut heart from red gingham, allowing an extra 6mm (¼") all around edges. Sew heart to front sachet and pad with wadding, (see page 150). Outline heart with couching (6 strands red embroidery floss, stitched down with 3 strands light green). Embroider French knot design on padded heart in red and light green. Embroider leaf design below heart, using dark green stem stitch for stems, light green lazy daisy stitch for leaves, and red French knots for berries. Press under one long edge of green gingham strip by 6mm (¼") to WS. With WS of strip to RS of sachet, baste lower edge of strip to bottom of front sachet, matching raw edges. Hand stitch turned edge of strip to sachet front. Place sachet pieces RS together, and stitch along side seams and lower edges. Turn right side out. Turn 12mm (½") double hem around open end of bag, baste in position, and sew in place with a row of red and green whipstitch on RS of sachet. Fill sachet with herbs, and tie top with ribbon.

Herb Sachet
○ Red French knot
● Green French knot

NEEDLEPOINT

GIFT BOXES

Page 170

Finished sizes: Each is 11.5cm (4½") by 14cm (5½") or less.

Materials: (For each box) – 2 sheets 7 holes-to-the-inch plastic canvas; yarn needle; tapestry yarn **used double throughout. Strawberry heart** – 130m (140 yds) mauve, 92m (100 yds) cream, 18m (20 yds) each dark green and pink, 14m (16 yds) red; **Beehive** – 190m (200 yds) dark gold, 14m (16 yds) each light yellow, black, brown, white, rose and light pink, 9m (10 yds) medium green; **Chickadee** – 175m (190 yds) cream, 90m (100 yds) sage green, 18m (20 yds) each light grey and medium blue, 9m (10 yds) each dark grey, black, yellow.

To make: From canvas, cut 1 top and 1 bottom, 2 sides and 2 lid bands. Chickadee box has one 54-hole and one 55-hole lid band. (Beehive – 1 side and 1 lid band). Work designs in continental tent stitch. Beehive: Work side and lid band in long stitch 4 holes high. Fill in with long stitch of varying sizes. Work design on top and bottom; complete background in continental and long stitches.

To assemble: Beehive and Chickadee – sew lid bands together at side edges, overlapping one hole. Sew band to top. In same manner, assemble bottom of box. **Strawberry** – sew lid bands together at front edges. Place this seam at lower point top; sew band to lid. Sew band seam from inside at indentation of heart. Sew side to bottom as for lid. For all boxes: Cover raw edges of box with overcast stitch. **Handle for Beehive:** Cut 280cm (3 yds) length rose yarn. Double it. Secure one end; twist other end until it begins to kink. Holding centre of yarn, bring ends together. Unpin and let yarn twist around itself. Sew an end through each side of box just below lid band. Adjust cord length; knot and trim ends from inside box.

Top Bottom

Lid

Side

Chickadee Box

- ⬤ Light grey
- ▲ Dark grey
- ⊙ Sage green
- ⊠ Medium blue
- ╱ Yellow
- ⊞ Black
- ☐ Cream

Beehive Box

- ☐ Dark gold
- ▩ Brown
- ⊞ Rose
- ⊠ Black
- ⊙ Light yellow ╱ Medium green
- ⬤ Light pink ▲ White

Top Bottom

Side

Lid

Bottom Top Side

Lid

Strawberry Heart Box ⊙ Red ⬤ Cream ⊠ Pink ▩ Dark green ☐ Mauve

SURPRISE PARCEL DOORSTOP

Page 170

Finished size: Cover to fit a brick, 20.5cm (8") by 9.5cm (3³/₄") by 5.5cm (2¹/₄").

Materials: Brick; 48cm (19") square piece 10 holes-to-the-inch mono canvas. Tapestry yarn skeins: 6 yellow, 5 white, 2 dark blue, 2 light blue, 1 turquoise; water-proof marker, tapestry needle, tape.

To make: Adjust size of design if necessary (see chart). Bind edges of canvas to prevent fraying. Transfer top design onto canvas. Continue ribbon and background design across side and bottom sections of canvas. Work design in tent stitch, following chart. Block finished needlepoint. Trim edges of canvas to 12mm (¹/₂"). Wrap needlepoint around brick. Turn edges of canvas to wrong side. Stitch together with matching thread.

OLD WEST NEEDLEPOINT CUSHIONS

Page 171

Finished sizes: Santa Fe, 28cm (11") by 35.5cm (14") Albuquerque, 20cm (8") by 32cm (12¹/₂").

Materials: Santa Fe – tapestry yarn skeins: 17 red, 3 each black, brown, 1 each orange, blue, green; 35.5cm (14") by 43cm (17") piece 12 holes-to-the-inch mono canvas; 30.5cm (12") by 38cm (15") black velveteen for backing.

Albuquerque – tapestry wool: 4 skeins each dark brown, beige, 3 skeins black, 2 skeins each red, blue, and 1 skein each orange, light brown; 28cm (11") by 38cm (15") piece 12 holes-to-the-inch mono canvas; 23cm (9") by 34cm (13¹/₂") black velveteen for backing. **For both** – tapestry needle; polyester filling; masking tape; waterproof marker; black thread.

To make (for both): Bind edges of canvas with tape. Mark horizontal and vertical centres. Beginning at centre and following charts, work in half cross stitch.

Note: Charts are ¹/₄ of designs. DO NOT REPEAT horizontal and vertical centre rows. Block, and trim canvas 12mm (¹/₂") from design. Right sides in, with 12mm (¹/₂") seams, stitch backing to front, leaving a 5cm (2") opening at one side. Clip corners and turn right side out. Stuff with filling and slip stitch opening.

Surprise parcel doorstop

☐ White ☒ Dark blue ▲ Turquoise
▨ Yellow ◉ Light blue

Sante Fe Cushion

☐ Blue ▨ Black ◉ Brown
▪ Red ☒ Orange ⊡ Green

Albuquerque cushion

☐ Blue ◉ Beige ▨ Black
⊡ Orange ▪ Dark brown ☒ Light brown ⊙ Red

FOLK-ART FLORAL

Page 171

Finished size: 45.5cm (18") square.
Materials: 61cm (24") square piece 5 holes-to-the-inch rug canvas; rug yarn – 90m (100 yds) khaki, 18m (20 yds) navy, 14m (15 yds) red, and 2.75m (3 yds) gold; 46cm (½ yd) navy cotton fabric for back; 45.5cm (18") navy zip; 45.5cm (18") square cushion pad; tapestry needle; masking tape; needlepoint marker; fabric and cotton cord if desired; sewing thread.
To make: Use 12mm (½") seams. Bind canvas. Mark an 45.5cm (18") square on canvas; mark centre. Starting at the centre and following chart, work flowers in continental tent stitch. Work two rows of navy around, inside marked edge; fill in ground with khaki. Block. Trim edges of canvas to 12mm (½"). Cut two 26cm (10¼") by 48cm (19") navy back pieces. Press under 2cm (¾") on centre edges of back. Stitch one folded edge along teeth of zip; lap second edge over zip and stitch. Trim to size of top. For cording, cut bias strips 5cm (2") to 6.5cm (2½") wide; piece to make strip to go around cushion plus about 5cm (2"). Right side out, fold bias strip over cord; pin to hold cord at fold. Using zip foot, stitch close to cord. Trim seam to 12mm (½"). Matching edges, pin cord around right side of top, clipping seam at corners. Lap ends neatly and run into seam allowance. Baste close to cord. Right sides in, pin cushion top to back, leaving zip open. Stitch. Clip corners. Turn right side out and insert cushion pad.

<div align="right">Floral purse</div>

Maroon
Turquoise
Pale blue
Purple
Bright blue

FLORAL PURSE

Page 171

Finished size: 16.5cm (6½") by 12.5cm (5").
Materials: Two pieces 10 holes-to-the-inch mono canvas, 26.5cm (10½") by 23cm (9"); skeins tapestry yarn – 4 maroon, 3 pale blue, 1 each purple, turquoise, bright blue; piece lining fabric 19cm (7½") by 28cm (11"); sewing thread; 15cm (6") zip (optional).
To make: Front and back pieces both alike. Bind edges of canvas with tape. Mark a 13cm (5") by 16.5cm (6½") rectangle on canvas; mark centre. Starting at centre, work in continental tent stitch, following chart. Block finished pieces. Trim raw edges of canvas to 12mm (½"). Turn back edges to wrong side. Place front and back pieces, wrong sides together, lining up rows. Hand stitch together with tapestry yarn down side seams and across bottom. Hand sew zip to top edge of purse. Fold lining fabric in half lengthways, right sides together. Stitch side seams together with a 12mm (½") seam. Turn right side out. Press a 12mm (½") hem to wrong side around opening. Insert lining. Slip stitch turned edge of lining to open edge of purse. To make handle; cut six 1m (40") lengths of maroon yarn. Knot strands of yarn tightly, about 2.5cm (1") from the end to form a tassel. Braid strands together, and knot the ends as before. Sew ends of cord to each side seam.

Folk-art floral	Red	Navy
	Gold	Khaki

Florentine bag	_ Dark green	_ Light blue
	_ Dark blue	_ Lilac

FLORENTINE WORK BAG
Page 172

Finished size: 30.50cm (12") square.

Materials: Tapestry yarn – 5 skeins dark green A, 4 skeins each light blue B, dark blue C, lilac D; 40.5cm (16") square 10 holes-to-the-inch mono needlepoint canvas; 33cm (13") square of fabric for backing; 33cm (³/8 yd) fabric for lining; masking tape, tapestry needle.

To make: Bind edges of canvas with tape; mark centre hole. Chart represents one quarter of design; rotate chart for each quarter. Beginning at centre, work one quarter at a time. Centre design is made up of small blocks. Following chart, work centre diagonal row of block in D. Work a row of C then B on either side of D. Fill corners of blocks with continental tent stitch (to be worked sloping to right) – D at outer edge of centre design, A on inside. Following chart, work a row of A around centre design. In continental tent stitch, work 1 row each B, D, B. Work a second row of A around. Wide border is worked in diagonal rows with continental stitch triangles at centres of bag. X's on chart represent D continental stitches. Diagonal row next to continental stitch is worked in B. Remaining diagonal rows are worked in following colour sequence: C, D and B. Work this sequence 4 times. Then work 1 row each C and D at corner. Repeat sequence C, D, B 4 times then one row B. Work outer border as for border of centre design. Block work (see page 178); trim canvas to 12mm (½"). Right sides in, using 12mm (½") seam, stitch backing to work around 3 edges. Cut two 33cm (13") squares for lining. Right sides in, stitch lining together along 2 opposite sides; press seams open. Right sides together, slip lining over bag. Stitch around top edge. Turn lining to inside; slip stitch raw edges together. For each handle cut 6 60cm (24") lengths of A. Hold together and tie one end to a stationary object. Twist strands together tightly. Grasping centre, bring ends together. Release centre and allow to twist. Tie ends. Sew a handle to each side of bag, having ends 15cm (6") apart.

CHRISTMAS STOCKING
Pages 176 –177

Finished size: 11.5cm (4½") across top, 23cm (9") from top to base of heel, 18cm (7") from toe to heel.

Materials: 35.5cm (14") by 30.5cm (12") rectangle 10 holes-to-the-inch mono canvas. 30.5cm (12") by 25.5cm (10") backing fabric. 23cm (¼ yd) lining fabric, 56cm (22") wide. Matching sewing thread. Tapestry yarn: 4 skeins cream; 1 skein each: scarlet, emerald green, dark pink, turquoise, gold, light and dark brown. Tapestry needle, masking tape, waterproof marker.

To make: Bind canvas edges with tape. Transfer design on to canvas. Work design in continental tent stitch, following chart. Block finished needlepoint if necessary. Trim raw canvas around needlepoint to 12mm (½").

To finish stocking: Cut backing fabric to size of trimmed needlepoint. Place backing and needlepoint right sides together. Clip curves. Stitch together with 12mm (½") seams, leaving top open. Turn right side out. Press lightly. Cut 2 lining pieces, both 6mm (¼") larger all round than finished stocking. Place lining pieces right sides together. Stitch together with 6mm (¼") seams, leaving top open. Turn right side out. Insert lining in stocking. Fold 12mm (½") around top of stocking to wrong side, and 6mm (¼") around top of lining to wrong side. Hand stitch turned (top) edges of stocking and lining together.

To make stocking loop: Cut a strip of backing fabric 16.5cm (6½") by 5cm (2"). Turn 6mm (¼") to wrong side across both short ends. Fold long edges into centre. Fold in half again, lengthways. Stitch along length of strip, close to open edges. Fold in half crosswise, to form loop. Hand stitch ends of loop just inside top of stocking.

CHRISTMAS DECORATIONS
Pages 176 177

Finished size: Snowflakes, circle 7.5cm (3") diameter; crackers – circle 7.5cm (3") diameter; bells – oval 10cm (4") deep by 7.5cm (3") wide.

Materials: All decorations worked on 14 holes-to-the-inch mono canvas in tapestry yarn; for colours, see below. Small gold-coloured plastic frames to mount decorations (available from craft shops). Masking tape, waterproof pen, tapestry needle. If frames of the exact size are unavailable, work slightly more or less background to fit. **Snowflakes** – piece of canvas 17.5cm (7") square. 1 skein of tapestry yarn in white, and either blue or red. **Crackers** – piece of canvas 17.5cm (7") square. 1 skein of tapestry yarn in each: purple, white, scarlet, green, golden yellow, light blue. **Bells** – piece of canvas 20cm (8") by 17.5cm (7"). One skein of tapestry yarn in each: light blue, white, crimson, scarlet, dark gold, light gold.

To make: Bind canvas with tape. Transfer design on to canvas. Work design in continental tent stitch, following chart. Block finished work if necessary. Trim raw canvas around needlepoint to fit frames.

CHRISTMAS CARDS
Pages 176–177

Finished size: Christmas tree 5.7cm (2¼") by 8cm (3¼"); Gift box 5.7cm (2¼") by 8cm (3¼").

Materials: Both cards worked on 18 holes-to-the-inch petit point canvas in crewel yarn; for colours, see below. Masking tape, tapestry needle, waterproof marker. Ready bought cards from craft shops. **Christmas tree** – piece of canvas 16cm (6¼") by 18.5cm (7¼"). 1 skein crewel yarn in each: emerald green, scarlet, golden yellow, dark green, mauve, orange, bright pink. **Gift box** – piece of canvas 16cm (6¼") by 18.5 cm (7¼"). 1 skein crewel yarn in each: dark turquoise, mid turquoise, light turquoise, cream, scarlet, emerald green, bright pink; double-sided adhesive tape.

To make: Bind canvas with tape. Transfer design on to canvas. Work design in continental tent stitch, following chart. Block if necessary. Trim raw canvas around needlepoint to 12mm (½").

To mount: With double-sided adhesive tape, carefully stick worked needlepoint in position behind window mount.

GIFT TAGS
Pages 176–177

Finished sizes: Approximately 5cm (2") by 5.5cm (2¼").

Materials: Tags worked on 18 holes-to-the-inch petit point canvas. For colours of crewel yarns, see below. To mount tags: craft knife, ruler, coloured cardboard, ribbon, double-sided adhesive tape, adhesive for card. Masking tape, waterpoof marker, tapestry needle. **Cracker** – canvas 15cm (6") by 16cm (6¼"). 1 skein crewel yarn in each: white, orange, bright pink, golden yellow, blue, lime green, bottle green. **Christmas tree** – canvas 15cm (6") by 16cm (6¼"). 1 skein crewel yarn in each: pale blue, scarlet, golden yellow, brown, dark green, mauve, bright pink, orange. **Christmas pudding** – canvas 15cm (6") by 16cm (6¼"). 1 skein crewel yarn in each: rust brown, orange, white, golden yellow, dark brown, light green, scarlet.

To make: Follow instructions for Christmas cards, above.

To mount: Allowing for border of desired width, cut piece of card twice width of finished tag. Lightly score the card at centre line with craft knife. Cut window in one half of card to size of needlepoint. Using double-sided adhesive tape, stick needlepoint to back of card, behind window. Fold card along score line, and stick folded portion to border of window mount. Trim if necessary.

Christmas Pudding Gift Tag

- ☐ Dark brown
- ▨ White
- ▦ Rust brown
- ⊡ Scarlet
- ☒ Golden yellow
- △ Light green
- ⊘ Orange

Christmas Cracker Gift Tag

- ☐ Bottle green
- ▨ White
- ☐ Bright pink
- ▦ Orange
- ⊡ Blue
- ⊙ Lime green
- ☒ Golden yellow

Christmas Tree Gift Tag

- ☐ Bright pink
- ▨ Dark green
- ▦ Orange
- ⊙ Mauve
- ⊡ Scarlet
- ☒ Golden yellow
- ⊘ Brown ☐ Pale blue

Gift box card

- ☐ Cream
- ▨ Dark turqoise
- ▦ Mid turquoise
- ▼ Light turquoise
- ⊙ Emerald green
- ⊡ Bright pink
- ☒ Scarlet

Christmas Stocking

- ☐ Cream
- ▨ Scarlet
- ▦ Dark pink
- ☒ Light brown
- △ Turquoise
- ▼ Dark brown
- ⊙ Gold
- ⊡ Emerald green

Christmas Tree Card

☐ Emerald green

▦ Dark green

⊙ Orange

⬤ Scarlet

☒ Mauve

⊞ Golden yellow

△ Bright pink

Bells decoration

☐ Light blue

▦ Scarlet

▦ Light gold

⬤ White

⊙ Crimson

△ Dark gold

Christmas Crackers Decoration

☐ Purple

▦ White

☐ Scarlet

▦ Green

⬤ Golden yellow

☒ Light blue

Snow Flake Decoration

☐ Blue or Red

⬤ White

PATCHWORK & QUILTING

FOLDED STAR

Page 196

Materials: Lightweight cotton fabric for base 38cm (15") square; cotton fabric, 112cm (45") wide: ivory print 23cm (1/4 yd) (32 rectangles), medium rust 23cm (1/4 yd) (20 rectangles), dark rust 11.5cm (1/8 yd) (24 rectangles), brown print 11.5cm (1/8 yd) (8 rectangles), black print 11.5cm (1/8 yd) (8 rectangles).

To make: Draw 2 diagonal lines from corner to corner on fabric base, and then horizontal and vertical lines to cross at same point.

Cut rectangles 5.7cm (2¼") by 10cm (4") from cotton fabric. Turn one long edge 6mm (¼") to wrong side. Press. Wrong side up, with hem at top edge of rectangle, fold top left hand and right hand corners down to meet at centre of lower edge; press to form a triangle. Position triangles on base in rounds, using one colour of fabric for each round, and arranging them so that centre of triangles are aligned with lines on base. Stitch each round of triangles to base with a running stitch around edges, and secure point of each triangle with a small stitch within fold. To achieve a perfect star, measure to ensure that points of each round are same distance away from base.

QUILTING PATTERNS
Page 208

Enlarge these patterns to use when making up your own designs.

RUGS

FRINGED MAT & CUSHION
Page 220

Finished size: About 51cm (20") by 81cm (32") (including 7.5cm/3" fringe).

Materials: 72 13.5cm (6") by 112cm (45") calico strips or 23cm (¼ yd) of 112cm (45") wide fabric in the following assortment of colours: 12 blues, 12 yellows, 12 off whites and beiges, 12 greens, 12 roses, 12 purples; 230cm (2½ yds) of lacing cord. The colours are given as a guide for selecting your colours; any varied assortment will produce similar results.

To make: Cut or tear 13.5cm (6") wide braiding strips from all of the different colour fabrics. Each strip should be 112cm (45") long.

Braiding: The fringed mat is made up of 24 straight braids. Three assorted colour strips are braided together to make each braid. Select the colours for each braid yourself, keeping the colours varied. Any mix of colours looks good as long as the assorted shades are evenly dispersed when the braids are laced together. Fold in the long raw edges on each strip so they are about 4cm (1½") wide. Do not make a starting T. Braid straight for a distance of about 80cm (32"). Hold the ends together with a safety pin. Repeat this, making 24 80cm (32") braids.

Lacing: Lay the braids out in the colour order that you want to have in the finished mat. Work on a flat surface. Hold the first 2 braids next to each other and lace them together. Do not knot the cord at the end of the braids so you can adjust the length of the finished braid. The braids that are being laced must have the same number of loops so they are all the same length. As you finish lacing each one, adjust the braid length to match the previous one, tack the braiding together to prevent unravelling, knot the lacing cord and cut the ends of the braids evenly to make a 7.5cm (3") fringe. Repeat this until all 24 braids are laced together.

Finishing: Steam the completed mat lightly. Press the fabric fringe flat, tucking all the raw edges inside. The short, cut ends of the fringe are left raw.

Cushion: Make a smaller version and turn it into a cushion. Braid a 35.5cm (14") by 30.5cm (12") mat; add a back and stuff it with a cushion pad. Slip stitch closed.

SHEEP RUG

Page 216

Finished size: 56cm (22") square.

Materials: 71cm (28") square piece of foundation fabric; fabrics for hooking – white, dark grey, light grey, and very pale yellow for sheep; gold for bell, dark rust and light rust for bow and for border, assorted deep olive greens for background; 5" primitive-type hand hook; frame to fit.

To make: To hand hook, see pages 215–216. Enlarge design and transfer it to foundation fabric. If you wish, you can add your initials and/or the date on the lower right and left sides.

Mount foundation fabric in a frame. Cut the strips for hooking 1cm (³/₈") wide. Outline the sheep, the ears, the tops of the legs (but not feet or nose) with very pale yellow. Work bow with rust fabrics, using dark rust for outside of ribbon and light rust for inside. Work gold bell. Work light grey eye, edge of nose, and edge of feet. Fill in nose and feet with dark grey. Outline each scallop with dark rust. Work one row of dark rust on either side of line inside of each scallop. Work remainder of each scallop in light rust. Work outer border of rug in dark rust. Work background in various deep olive greens.

For finishing, see page 224.

Sheep Rug

PATCHWORK RUG

Page 216

Finished size: 73.5cm (29") by 96.5cm (38").

Materials: 6mm (¼") wide strips of wool fabric in the following colours – black A, light blue B, medium blue C, rust brown D, light grey E, dark grey F, green G, pink H, plum I, light rust J, bright rust K, sapphire L, and tan M; 94cm (37") by 117cm (46") piece of hessian; frame to fit hessian; 5" primitive-type hand hook; carpet tape; carpet thread; strong needle.

To make: Enlarge design and transfer it to hessian. To hand hook, see page 216. Follow chart for colour guide. Although it is possible to hook in many directions, this rug is best handled by hooking in parallel rows, a technique that must be continued throughout for consistency. Loops should be parallel to one another and not appear twisted.

For finishing, see page 224.

Patchwork Rug

INDEX